PROBLEMS OF STYLE

ALOIS RIEGL

◇

PROBLEMS
OF STYLE

FOUNDATIONS
FOR A HISTORY OF
ORNAMENT

TRANSLATED BY
EVELYN KAIN

ANNOTATIONS, GLOSSARY, AND
INTRODUCTION BY
DAVID CASTRIOTA

PREFACE BY
HENRI ZERNER

PRINCETON UNIVERSITY PRESS

PRINCETON, NEW JERSEY

The preparation of this volume was made possible in part by
a grant from the National Endowment for the Humanities,
an independent federal agency.

Library of Congress Cataloging-in-Publication Data

Riegl, Alois, 1858–1905
[Stilfragen. English]
Problems of style : foundations for a history of
ornament / by Alois Riegl ; translated by Evelyn Kain ;
annotations and introduction by David Castriota ;
and preface by Henri Zerner.
p. cm.
Translation of : Stilfragen.
Includes index.
ISBN 0-8071-1706-4
1. Decoration and ornament—History. I. Castriota, David,
1950–. II. Title.
NK1175.R513 1993 91-22797
745.4′4—dc20

This book has been composed in Adobe Caledonia

Princeton University Press books are printed on
acid-free paper, and meet the guidelines for permanence
and durability of the Committee on Production Guidelines
for Book Longevity of the Council on
Library Resources

Printed in the United States of America

1 3 5 7 9 10 8 6 4 2

TABLE OF CONTENTS

———— ◇ ————

LIST OF ILLUSTRATIONS ... ix

TRANSLATOR'S NOTE ... xix

PREFACE ... xxi

ANNOTATOR'S INTRODUCTION AND ACKNOWLEDGMENTS ... xxv

INTRODUCTION ... 3

CHAPTER 1. The Geometric Style ... 14

CHAPTER 2. The Heraldic Style ... 41

CHAPTER 3. The Introduction of Vegetal Ornament and the Development of the Ornamental Tendril ... 48

 A. Near Eastern ... 53
 1. *Egyptian. The Development of Vegetal Ornament* ... 53
 2. *Mesopotamian* ... 83
 3. *Phoenician* ... 96
 4. *Persian* ... 102

 B. Vegetal Ornament in Greek Art ... 104
 1. *Mycenaean. The Origin of the Tendril* ... 106
 2. *The Dipylon Style* ... 137
 3. *Melian* ... 140
 4. *Rhodian* ... 145
 5. *Early Boeotian and Early Attic* ... 156
 6. *The Interlacing Tendril* ... 161
 7. *The Development of the Tendril Frieze* ... 172
 8. *The Further Development of the All-over Tendril Pattern* ... 178
 9. *The Emergence of Acanthus Ornament* ... 187
 10. *Hellenistic and Roman Tendril Ornament* ... 207
 a. Two-Dimensional Palmette-Tendrils ... 214
 b. The Acanthus Tendril ... 220

CHAPTER 4. The Arabesque: Introduction ... 229

 A. Tendril Ornament in Byzantine Art ... 240
 B. Early Islamic Tendril Ornament ... 266

ANNOTATIONS ... 307

GLOSSARY OF TERMS AND CONCEPTS USED BY RIEGL ... 397

LIST OF ILLUSTRATIONS

———— ◇ ————

NOTE: This list of illustrations has been added for the reader's convenience, complete with sources wherever possible. An asterisk follows each listing where the illustration taken from the Riegl's source has been cropped less than in the 1893 edition of *Stilfragen*, in order to give a better sense of the context.

1. Carved reindeer bone spear thrower from Laugerie-Basse, detail of handle. After Bertrand *La Gaule avant les gaulois*, 89, fig. 61.
2. Engraved reindeer bone from La Madeleine. After *Dictionnaire archéologique de la Gaule*, vol. 1, "Cavernes," no. 21.
3. Marrow spoon of reindeer bone with engraved decoration from Laugerie-Basse. After *Dictionnaire archéologique de la Gaule*, vol. 1, "Cavernes," no. 1.
4. Assyrian relief from Nimrud, engraved detail of Heraldic Style composition with winged bulls. Adapted from Layard, *Monuments of Nineveh*, vol. 1, pl. 45, no. 3.
5. Late antique Egyptian textile appliqué from the cemetery at Saqqara. After Riegl, *Aegyptische Textilfunde*, no. 416.
6. Reindeer bone with engraved flowers from La Madeleine. After *Dictionnaire archéologique de La Gaule*, vol. 1, "Cavernes," no. 23.
7. Lotus blossom in profile view.
8. Lotus blossom in profile view (so-called papyrus).
9. Lotus leaf.
10. Lotus buds.
11. A series of lotus blossoms alternating with buds.
12. Lotus blossom in frontal view (rosette) with rounded petals.
13. Lotus blossom in profile view with schematically rendered corolla.
14. Bell-shaped lotus-blossom capital.
15. Column with lotus-bud capital.
16. Lotus blossom in the combined view (Egyptian palmette).
17. Lotus blossom in profile view with volute-calyx.
18. Lotus blossom in nature with overflowing calycal leaves. After Goodyear, *Grammar of the Lotus*, fig. 4.
19. Egyptian palmette with schematically rendered leaf-fan.
20. Volute-calyx with simple cone as axil filler, from Karnak.
21. Border with alternating series of opposed palmettes and profile lotus blossoms, wall painting from Medinet Habu. Adapted from Prisse d'Avennes, *L'art égyptien*, atlas 1, "Ornementation des plafonds; postes et frises," fig. 9.
22. Arcuated band frieze with lotus blossoms and buds, wall painting from Necropolis at Thebes. Adapted from Prisse d'Avennes, *L'art égyptien*, atlas 1, "Couronnements et frises fleuronnées," fig. 6.
23. Painted ceiling decoration with opposed arcuated band friezes of palmettes and profile lotus blossoms from the Harem of Rameses III at Medinet

Habu. Adapted from Prisse d'Avennes, *L'art égyptien*, atlas 1, "Ornementation des plafonds, postes et fleurs," fig. 7.

24. Frieze of tendril-like elements connecting lotus blossoms and buds, wall painting from tomb 75, Necropolis at Thebes. Adapted from Prisse d'Avennes, *L'art égyptien*, atlas 1, "Frises fleuronnées," fig. 3.

25. Frieze of spirals with lotus blossoms as axil fillers, wall painting from Necropolis at Thebes. Adapted from Prisse d'Avennes, *L'art égyptien*, atlas 1, "Couronnements et frises fleuronnées," fig. 12.

26. Painted ceiling decoration with spirals and lotus axil fillers from tomb 33, Necropolis at Thebes. Adapted from Prisse d'Avennes, *L'art égyptien*, atlas 1, "Ornementation des plafonds," pl. 31, fig. 1.

27. Painted ceiling decoration with spirals, lotus axil fillers, and bucrania from tomb 65, Necropolis at Thebes. Adapted from Prisse d'Avennes, *L'art égyptien*, atlas 1, "Ornementation des plafonds, bucrânes," top.

28. Detail of carved openwork prow of Maori canoe. After *Mitteilungen der Anthropologischen Gesellschaft in Wien*, 20 (1890): 85, fig. 22.

29. Engraving on Maori fruit rind. *Mitteilungen der Anthropologischen Gesellschaft*, fig. 23.

30. Engraving on the sinker of a Maori fishing net. *Mitteilungen der Anthropologischen Gesellschaft*, fig. 24.

31–32. Maori facial tattoos. After Lubbock, *Origin of Civilization*, 47, figs. 13–14.

33. Border decoration on Assyrian glazed brick from Nimrud. After Layard, *Monuments of Nineveh*, vol. 1, pl. 86, no. 3.

34. Relief ornament of alabaster doorsill from the Assyrian palace at Nineveh (Kuyunjik). Excerpted from Layard, *Monuments of Nineveh*, vol. 2, pl. 56.

35. Assyrian relief showing canopy with supports crowned by palmettes, from the bronze doors at Fort Shalmaneser (Balawat). After Perrot and Chipiez *Histoire de l'art*, vol. 2, fig. 68.

36. Assyrian depiction of pomegranate.

37. Egyptian crowning pattern or "khaker."

38. Assyrian border decoration, wall painting from the palace at Nimrud. After Layard, *Monuments of Nineveh*, vol. 1, pl. 87, bottom.

39. The so-called sacred tree of Assyria, detail of the stone reliefs from the palace at Nimrud. Adapted from Layard, *Monuments of Nineveh*, vol. 1, pl. 7.

40. Egyptian palmette tree, border of painted ceiling decoration from the Necropolis at Thebes. Adapted from Prisse d'Avennes, *L'art égyptien*, atlas 1, "Ornementations des plafonds: légendes et symboles".

41. Cypriote stone pilaster capital with palmette tree, from Atheniu. After Perrot and Chipiez, *Histoire de l'art*, vol. 3, fig. 52.

42. Phoenician palmette.

43. Achaemenid Persian border of glazed brick from the palace at Susa, detail of corner decoration. Excerpted from Perrot and Chipiez, *Histoire de l'art*, vol. 5, pl. 11.

44. Achaemenid Persian palmette tree, glazed brick decoration from the palace at Susa. After Perrot and Chipiez, *Histoire de l'art*, vol. 5, fig. 346. *

45. Upper portion of a Mycenaean pitcher. Excerpted from Furtwängler and Loeschke, *Mykenische Vasen*, 81.

46. Mycenaean pot with "ivy leaf" ornament on its shoulder (after Furtwängler and Loeschke, *Mykenische Vasen*, pl. 18, no. 121.

47. Mycenaean vase decoration. Excerpted from Furtwängler and Loeschke, *Mykenische Vasen*, pl. 13, no. 82.

48. Diagonal rosette on embossed gold sheathing over bone, from Mycenae, Shaft Grave I. After Schliemann, *Mykenae*, abb. 459.

49. Mycenaean vase, detail of painted ornament, from Mycenae, Shaft Grave I. Excerpted from Furtwängler and Loeschke, *Mykenische Thongefässe*, pl. 2. *

50. Mycenaean potsherd painted with a continuous tendril, from Thera. After Furtwängler and Loeschke, *Mykenische Vasen*, pl. 12, no. 79.

51. Ceramic cup from Megara, Mycenaean. After *Archäologischer Anzeiger*, (1891), 15.

52. Painted vase, Mycenae, Shaft Grave VI, detail of ivy tendril. Excerpted from Furtwängler and Loeschke, *Mykenische Thongefässe*, pl. 11, no. 56. *

53. Intermittent tendril, the painted border of a Melian amphora, from Melos. After Conze, *Melische Thongefässe*, pl. 1, no. 5.

54. Embossed gold plaque, Mycenae, Shaft Grave III. After Schliemann, *Mykenae*, abb. 266.

55. Relief ornament on the stone ceiling from the tholos at Orchomenos, detail. Excerpted from Schliemann, *Orchomenos*, pl. 2.

56. Painted ceiling from the Necropolis at Thebes. Adapted from Prisse d'Avennes, *L'art égyptien*, atlas 1, "Ornementation des plafonds, postes et fleurs," no. 3.

57. Painted wall ornament from the Mycenaean palace at Tiryns. Adapted from Schliemann, *Tiryns*, pl. 5.

58. Stamped gold plaque from Mycenae, Shaft Grave III. After Schliemann, *Mykenae*, fig. 249.

59. Carved ivory casket plaque, from a Shaft Grave at Mycenae. After Schliemann, *Mykenae*, fig. 222.

60. Gold pectoral with embossed ornament from Mycenae, Shaft Grave V. After Schliemann, *Mykenae*, fig. 458.

61. Gold plaque with embossed ornament from Mycenae, Shaft Grave III. After Schliemann, *Mykenae*, fig. 245.

62. Limestone relief stele from the Grave Circle at Mycenae, detail of curvilinear meander ornament in border. Excerpted from Schliemann, *Mykenae*, fig. 142.

63. Electrum goblet with gold inlay from Mycenae, Shaft Grave IV. After Schliemann, *Mykenae*, fig. 348.

64. Embossed gold plaque from Mycenae, Shaft Grave III. After Schliemann, *Mykenae*, fig. 305.

65. Embossed gold plaque from Mycenae, Shaft Grave IV. After Schliemann, *Mykenae*, fig. 369.

66. Melian amphora, from Melos. After Conze, *Melische Thongefässe*, pl. 1, no. 1.

67. Melian amphora, detail of ornament on neck. After Conze, *Melische Thongefässe*, pl. 1, no. 4.

68. Klazomenian terra-cotta sarcophagus, detail of painted border. Excerpted

from *Antike Denkmäler*, Deutsches Archäologisches Institut, vol. 1 (1886), pl. 44, center.

69. Painted filler ornament from a Melian vase. After Conze, *Melische Thongefässe*, pl. 4.

70. Painted decoration of Rhodian bowl from Kameiros. Excerpted from Salzmann, *Nécropole de Camiros*, pl. 51.

71. Painted decoration from a Rhodian oinochoe from Kameiros. Excerpted from Salzmann, *Nécropole de Camiros*, pl. 37.

72. Rhodian plate from Kameiros. After Salzmann, *Nécropole de Camiros*, pl. 52.

73. Arcuated band frieze on a Rhodian oinochoe from Kameiros. Excerpted from Salzmann, *Nécropole de Camiros*, pl. 37.

74. Fragment of a Rhodian plate from Kameiros. Excerpted from Salzmann, *Nécropole de Camiros*, pl. 29.

75. Rhodian amphora from Kameiros. After Salzmann, *Nécropole de Camiros*, pl. 46.

76. Painted border from a Klazomenian terra-cotta sarcophagus. Excerpted from *Antike Denkmäler*, Deutsches Archäologisches Institut, vol. 1, (1886), pl. 46, no. 2, top.

77. Painted border from a Klazomenian terra-cotta sarcophagus. Excerpted from *Antike Denkmäler*, Deutsches Archäologisches Institut, vol. 1 (1886) pl. 46, no. 2, bottom.

78. Portion of a painted Rhodian plate from Kameiros. Excerpted from Salzmann, *Nécropole de Camiros*, pl. 33.

79. Painted border of a Klazomenian terra-cotta sarcophagus. Excerpted from *Monumenti inediti*, Deutsches Archäologisches Institut, vol. 11 (1879–83) pl. 54, top. *

80. Boeotian kylix. After *Jahrbuch des Deutschen Archäologischen Instituts*, vol. 3 (1883), 333, fig. 5.

81. Boeotian kylix. After *Jahrbuch dec Deutschen Archäologischen Instituts*, vol. 3 (1883), 335, fig. 8.

82. Ivy-tendril border from a later Boeotian vase. After *Athenische Mitteilungen*, vol. 13 (1888), 418, fig. 6.

83. Interlacing tendril on an Attic bowl from Aegina. Excerpted from *Archäologische Zeitung* 40 (1882), pl. 10, top. *

84. Decorated bronze plaque in the Berlin Antiquarium. After *Archäologischer Anzeiger* (1891), 125, fig. 12e.

85. Decorated bronze plaque from Thebes in the Berlin Antiquarium. After *Archäologischer Anzeiger* (1891), 124, fig. 12a.

86. Painted border decoration from a Greek vase. After Brunn and Lau, *Die Griechischen Vasen*, pl. 11, no. 8.

87. Dalmatian corded embroidery from Ragusa Yugoslavia.

88. Chalcidian amphora. After Masner, *Vasen und Terracotten*, pl. 3, no. 219.

89. Lakonian kylix. After Masner, *Vasen und Terracotten*, no. 140, fig. 9.

90–91. Painted ornaments from Attic black-figure vases.

92. Painted border of a Klazomenian terra-cotta sarcophagus. Excerpted from *Antike Denkmäler*, Deutsches Archäologisches Institut, vol. 1 (1886), pl. 45, center.

93. Painted Greek vase ornament.

94–95. Details of ornament on an Etruscan ivory situla from the Pania tomb at Chiusi. Excerpted from *Monumenti inediti*, Deutsches Archäologisches Institut, vol. 10 (1874–78), pl. 39a.

96. Painted ornament from Attic red-figure vase.

97. Painted ornament from Attic red-figure vase.

98. Painted ornament from Attic red-figure vase.

99. Corinthian skyphos. After Masner, *Vasen und Terracotten*, fig. 6, no. 89.

100. Handle ornament of a Corinthian[izing Attic] drinking cup.

101. Handle ornament of an Attic black-figure amphora. After Feldscharek, *Ornamente griechischer Thongefässe*, pl. 4a.

102. Handle ornament of an Attic amphora in mixed red- and black-figure style. After Feldscharek, *Ornamente griechischer Thongefässe*, pl. 3.

103. Handle ornament of Attic black-figure amphora. After Feldscharek, *Ornamente griechischer Thongefässe*, pl. 3c.

104. Handle ornament of an Attic red-figure stamnos. After Feldscharek, *Ornamente griechischer Thongefässe*, pl. 2a.

105. Handle ornament of a red-figure "Nolan" vase. After Brunn and Lau, *Griechischen Vasen*, pl. 25, no. 3.

106. Handle ornament from an Attic red-figure vase.

107. Neck ornament of a black-figure vase. After Brunn and Lau, *Griechischen Vasen*, pl. 11, no. 4.

108. Shoulder ornament of Attic white-ground lekythos. After *Archäologische Zeitung* 38 (1880), pl. 11, top.

109. "Overflowing palmette" from the cornice of the Parthenon.

110. "Split palmette" on the acroterion of an Attic grave stele. Excerpted from Quast, *Das Erechtheion*, vol. 2, pl. 17, no. 3.

111. Corinthian capital from the Choregic Monument of Lysikrates in Athens. After Jacobsthal.

112. Leaf of *acanthus spinosa*, from life. After Jones, *The Grammar of Ornament*, 46.

113. Ornament from the necking of the columns in the north porch of the Erechtheion in Athens. After Quast, *Das Erechtheion*, vol. 1, pl. 7, no. 2.

114. Painting from an Attic white-ground lekythos. After Benndorf, *Griechische und sicelische Vasenbilder*, pl. 15.

115. Lotus and palmette molding from the door of the north porch of the Erechtheion in Athens. After Quast, *Das Erechtheion*.

116. Detail from the anta capital on the east porch of the Erechtheion. Excerpted from Quast, *Das Erechtheion*, vol. 1, pl. 6, no. 1.

117. Corinthian capital from the temple of Apollo at Bassae-Phigalia. After Stackelberg, *Apollotempel zu Bassae*, 44.

118. Painting from an Attic white-ground lekythos. Excerpted from *Archäologische Zeitung* 43 (1885), pl. 3. *

119. Painting from an Attic white-ground lekythos. Excerpted from Benndorf, *Griechische und sicelische Vasenbilder*, pl. 22, no. 2.

120. Painting from an Attic white-ground lekythos. After Stackelberg, *Gräber der Hellenen*, pl. 44, no. 1. *

121. Gilt silver amphora from Nikopol-Chertomlyk. After *Compte rendu de la Commission Impériale Archéologique, St. Petersburg* (1864), atlas, pl. 1.

122. Gold diadem from Elaia. After *Archäologische Zeitung* 42 (1884), pl. 7, no. 1.

123. Gold diadem from Abydos. After *Archäologische Zeitung* 42 (1884), ill., cols. 93–94.

124. Crowning terminals of Egyptian stylized date palms. Adapted from Lepsius, *Denkmäler aus Ägypten*, Abth. III, Bl. 69.

125. Apulian red-figure vase ornament. After Jones, *The Grammar of Ornament*, pl. 19, no. 7.

126. Greek vase decoration. Adapted from Jones, *The Grammar of Ornament*, pl. 20, no. 1.

127. Painted tendril ornament from an Attic lekythos of the fourth century B.C.

128. Ornament from a Greek red-figure vase. Excerpted from *Compte rendu de la Commission Impériale Archéologique, St. Petersburg* (1880), atlas, pl. 5, no. 1.

129. Embossed gold bow case from Nikopol-Chertomlyk, detail of border. Excerpted from *Compte rendu de la Commission Impériale Archéologique, St. Petersburg* (1864), atlas, pl. 4.

130. Stucco relief frieze on the Temple of Isis, Pompeii. After Niccolini, *Le case ed monumenti di Pompeii*, vol. 1, part 2, "Tempio d'Iside," pl. 10.

131. Decorated cornice molding from the exterior entablature of the Mausoleum of Diocletian at Spalato. Excerpted from Adam, *Palace of Diocletian at Spalato*, pl. 37, top.

132. Decorated cornice molding from the entablature of the outer colonnade of the Mausoleum of Diocletian at Spalato. Excerpted from Adam, *Palace of Diocletian at Spalato*, pl. 30, top.

133. Decorated cornice from the door of the temple near Diocletian's palace at Spalato. Excerpted from Adam, *Palace of Diocletian at Spalato*, pl. 46, top.

134. Decorated cornice molding from upper interior entablature of the Mausoleum of Diocletian at Spalato. Excerpted from Adam, *Palace of Diocletian at Spalato*, pl. 36, top.

135. Frieze from the Forum of Nerva, Rome. After Moreau, *Fragments et ornements d'architecture*, pl. 14, no. 3.

136. Frieze from the Forum of Nerva, Rome. After Moreau, *Fragments et ornements d'architecture*, pl. 14, no. 5.

137. Border from a polychromed stucco wall decoration, Pompeii. After Niccolini, *Le case ed monumenti di Pompeii*, vol. 2, part 2, "Descrizione generale," pl. 45, center. *

138. Painted Arabesque wall decoration from the Palace of Sultan Abdul Aziz, Istanbul. After *L'architecture ottomane*, "Peintures murales," pl. 3.

139. Detail of frame ornament from the Koran of the Mamluk Sultan Mou'ayyed, dated 1411, written by Abdar'Rahman ibn as-Faïgh. Excerpted from Bourgoin, *Précis de l'art arabe*, part 4, pl. 27, center.

140. Roman mosaic border from the entrance hall of the basilica at Trier. Excerpted from Wilmowsky, *Römische Mosaiken aus Trier*, pl. 3. *

141. Roman mosaic from Simeon-Strasse, Trier. Excerpted from Wilmow-sky, *Römische Mosaiken aus Trier*, pl. 8. *

142. Capital and entablature from the Basilica of St. John Studios, Istanbul. After Salzenberg, *Alt-christliche Baudenkmale*, pl. 3, no. 1. *

143. Decorative sculptural details from the Church of Sts. Sergius and Bacchus, Istanbul. After Pulgher, *Les anciennes églises byzantines*, pl. 3, no. 2.

144. Relief decoration from the spandrels of the lower nave arcade in the Church of Hagia Sophia, Istanbul. Excerpted from Salzenberg, *Alt-christliche Baudenkmale*, pl. 15. *

145. Capital and portion of the intrados decoration from the Church of Hagia Sophia, Istanbul. Excerpted from Salzenberg, *Alt-christliche Bandenk-male*, pl. 15, no. 7.

146. Capital with entablature from the outer gallery in the Church of Hagia Sophia, Istanbul. Excerpted from Salzenberg, *Alt-christliche Baudenkmale*, pl. 17, no. 4.

147–148. Details of relief ornament from the Church of Sts. Sergius and Bacchus, Istanbul. Adapted from Salzenberg, *Alt-christliche Baudenkmale*, pl. 5, nos. 3, 7.

149. Detail of wall painting from the Macellum at Pompeii. Adapted from Niccolini, *Case ed monumenti di Pompeii*, vol. 1, part 1, "Panteone," pl. 2, top center.

150. Detail of relief ornament from the Church of Hagia Sophia, Istanbul. Adapted from Salzenberg, *Alt-christliche Baudenkmale*, pl. 17, no. 4.

151. Decoration on a wooden tie beam from the Church of Hagia Sophia, Istanbul. Excerpted from Salzenberg, *Alt-christliche Baudenkmale*, pl. 20, no. 14.

152. Ornamental details of a third style wall painting from Herculaneum. Adapted from Niccolini, *Le case ed monumenti di Pompeii*, vol. 2, part 2, "Descrizione generale," pl. 90, top center.

153. Detail of relief ornament from the Church of Hagia Sophia, Istanbul. Adapted from Salzenberg, *Alt-christliche Baudenkmale*, pl. 17, no. 13.

154–155. Details from the marble *opus sectile* decoration in the Church of Hagia Sophia, Istanbul.

156. Detail of a cornice from the Church of the Pantocrator, Istanbul. Excerpted from Pulgher, *Les anciennes églises byzantines*, pl. 10, no. 4.

157. Decorated cornice from the Early Christian Church at El Barah, Syria. Excerpted from De Vogüé, *Syrie centrale*, pl. 76.

158. Border from the main apse in the Early Christian Church at Qalb Lozeh, Syria. Excerpted from De Vogüé, *Syrie centrale*, pl. 129.

159. Decorated late antique pediment from Ahnas, Egypt. After *Archaeologia* 87 (1938), pl. 70, no. 4.

160. Decorated border from a late antique or early medieval Egyptian grave stele. Excerpted from Gayet, *Les monuments coptes du Musée de Bulaq*, pl. 98.

161. Sassanian Persian impost capital from Bisutun, Iran. After Jones, *The Grammar of Ornament*, pl. 14, no. 24.

162. Pilaster capital in the grotto of the Sassanian Persian king Chosroes II

at Taq-i-Bustan, Iran. After Jones, *The Grammar of Ornament*, pl. 14, no. 25.

163. Detail of an acanthus leaf on a Sassanian Persian impost capital from Isfahan.

164. Lower border of a Sassanian impost capital from Bisutun. Excerpted from Jones, *The Grammar of Ornament*, pl. 14, no. 16. *

165. Stucco ornament from the Mosque of Ibn Tulun, Cairo. After Prisse d'Avennes, *L'art arabe*, pl. 44, no. 31. *

166. Stucco ornament from the Mosque of Ibn Tulun, Cairo. After Prisse d'Avennes, *L'art arabe*, pl. 44, no. 34. *

167. Stucco ornament from the Mosque of Ibn Tulun, Cairo. After Prisse d'Avennes, *L'art arabe*, pl. 44, no. 33. *

167a. Greek "translation" of fig. 167.

168. Stucco ornament from the Mosque of Ibn Tulun, Cairo. After Prisse d'Avennes, *L'art arabe*, pl. 44, no. 6. *

168a. Islamic wood carving of the twelfth century.

169. Mosaic pavement from the temple of Isis, Pompeii. Excerpted from Niccolini, *Le case ed monumenti di Pompeii*, vol. 1, part 2, "Tempio d'Iside," pl. 2, bottom.

170. Polychrome stucco vaulting decoration from the Apodyterium of the Stabian Baths at Pompeii (after Niccolini, *Le case ed monumenti di Pompeii*, vol. 1, part 2, "Terme presso la porta stabiana," pl. 3.

171. Mosaic column from the Villa of the Mosaic Columns near Pompeii. Excerpted from Niccolini, *Le case ed monumenti di Pompeii*, vol. 2, part 2, "Descrizione generale," pl. 63, center. *

172. Decorated marble soffit from the architrave of the Temple of Jupiter Tonnans, Rome. After Desgodetz, *Les édifices antiques de Rome*, 137, Temple du Jupiter Tonnant, pl. 3.

173. Relief panel from Betursa, Syria. Excerpted from De Vogüé, *Syrie centrale*, pl. 43.

174. Moorish ivory casket from Spain, dated A.D. 965. After Kühnel, *Islamische Elfenbeinskulpturen*, pl. 15, no. 25b. *

175. Moorish ivory casket from Spain. Kühnel, *Islamische Elfenbeinskulpturen*, pl. 9, no. 21a.

176. Illumminated ornament from the Codex Vigilanus in the Escorial, ninth century.

177–178. Marble puteals or well heads from Pompeii. After Niccolini, *Le case ed monumenti di Pompeii*, vol. 2, part 2, "Descrizione generale," pl. 96.

179. Frieze with acanthus tendril and blossoms from the Temple of the Genius Augusti (Temple of Vespasian) at Pompeii. After Niccolini, *Le case ed monumenti di Pompeii*, vol. 1, part 2, "Tempio detto volgarmente di Mercurio," no. 8.

180–183. Blossoms based on the acanthus, from a Byzantine illuminated manuscript of the eleventh century. Excerpted from Stassoff, *Ornement slave et oriental*, pl. 124, no. 24.

184. Decorative heading from a Byzantine illuminated manuscript of the tenth century. Excerpted from Stassoff, *Ornement slave et oriental*, pl. 124, no. 17.

185. Decorative heading from an Armenian illuminated manuscript. Excerpted from Collinot et Beaumont, *Ornements turcs*, pl. 28. *

186. Window grill from the Mosque of Al Zahir, Cairo. After Prisse d'Avennes, *L'art arabe*, pl. 8.

187. Frieze from the mihrab of the Great Mosque at Cordoba. After Girault de Prangey, *L'architecture des arabes et des mores*, pl. 4, no. 8.

188. Stucco ornament from the Cuba, Palermo. After Girault de Prangey, *L'architecture des arabes et des mores*, pl. 12, no. 1.

189. Carved wooden chancel from the mimbar in the Mosque of Al Amri at Qus, Egypt. Excerpted from Prisse d'Avennes, *L'art arabe*, pl. 79.

189a–190. Details from fig. 189.

191. Tendril decoration from a Byzantine manuscript. Excerpted from Stassoff, *Ornement slave et oriental*, pl. 123, no. 10.

192. Arabesque filler ornament from a circular wall inset in the house of the fourteenth-century Emir Bardak in Cairo. Excerpted from Bourgoin, *Précis de l'art arabe*, part 1, pl. 32.

192a. Greek "translation" of fig. 192.

193. Decorated panel from the mimbar in the Mosque of Barquq, Cairo. Excerpted from Prisse d'Avennes, *L'art arabe*, pl. 49, bottom left.

194. Acanthus tendril-volute from the apse mosiac of the Church of San Clemente, Rome. Excerpted from de Rossi, *Musaici antichi delle chiese di Roma*, pl. 21.

195. Border from a Persian carpet of the Safavid period. Excerpted from Sarre and Trenkwald, *Old Oriental Carpets*, vol. 1, pl. 10. *

196. Calyx-palmette from the mosaic decoration in the Dome of the Rock, Jerusalem. Excerpted from de Vogüé, *Temple de Jerusalem*, pl. 21.

197. Calyx-palmette and tendril decoration from a "Mosul Bronze," the inlaid copper inkstand of the Mamluk Sultan Bahrit Shaban. Excerpted from Prisse d'Avennes, *L'art arabe*, pl. 171, center left. *

TRANSLATOR'S NOTE

◇

I would like to give a brief account of the genesis of this annotated English version of Riegl's *Stilfragen*, say a few words about the characteristics of the original German text, offer some thoughts on the translating process, and then make my acknowledgments.

It was Tom Kaufmann who, in the early 1980s, first gave me the idea to do an English translation of Riegl's *Stilfragen*. Tom felt that it was time to make Riegl's ideas more available to English-speaking scholars and that, as an American who had studied art history at the University of Vienna and accumulated some translating experience, I was the one to do it. It seemed a daunting task at best. However, at Tom's urging and with the encouragement of Otto Pächt, one of whose lifelong wishes had been to see greater appreciation of his predecessor's contribution, I met with Christine Ivusic, who gave enthusiastic support to the project. It was clear from the start that *Stilfragen*'s introduction to the English-speaking world required a respectable critical apparatus, to which purpose Henri Zerner and David Castriota agreed to contribute their expertise. The project received a grant from the National Endowment for the Humanities, and work began in 1985. Neither Otto Pächt nor Christine Ivusic lived to see the completion of the undertaking that they helped call into life; therefore, the present volume is dedicated to their memory.

Riegl's German syntax is like the Arabesques that the author so exhaustively describes in *Stilfragen*: in both instances, the first impression is of bewildering complexity, so that one initially despairs of ever deciphering the basic pattern. However, just as Riegl was able to break down, through painstaking observation, the perplexing effect of Islamic decoration into its simple, constituent parts, so Riegl's prose reveals its clear, underlying structure to anyone patient enough to subject it to analysis. There are no instances of what I refer to in general as the "translator's nightmare," namely places where the thinking of the author was obviously ambiguous and unresolved in his or her own mind to begin with, and therefore impossible to translate. On the contrary, Riegl was always quite certain about what he wanted to say, though he expressed his ideas in a style that represents a challenge to the contemporary reader.

Riegl meant *Stilfragen* to be read closely, at a pace essentially slower than what one is used to today. He expected the reader to sit back and share his delight in observing minute detail and unraveling its dazzling

complexity. One enters, so to speak, on a kind of fantastic journey through the very bloodstream of ornamental existence. Reading *Stilfragen* is, therefore, a myopic experience, and as a whole, this inspired study of humble decoration is a testament to the belief in the profundity of small things, a textual equivalent to such images as Dürer's "Great Piece of Turf."

The translator, as I see it, is always in an inherently awkward and decidedly unenviable position: ill-cast to play the role of the author in the production of a work that can never do more than masquerade as the original, one is always acutely aware of one's personal shortcomings and of the serious obstacles involved that are far greater than the obvious linguistic kind. Is it even possible, one asks oneself in this particular case, to make a piece of scholarship that was written for a public dressed in starched collars or corsets, seated comfortably in overstuffed armchairs, understandable to a readership one hundred years later, which is more likely to be wearing sweatshirts and sneakers while working out on an exercise bicycle? And yet, the overriding desire to understand and to communicate that understanding to others manages to keep one from despair during such an undertaking and finally to win out in the end. *Problems of Style* was written in this spirit of communication. Neither a literal nor a literary translation, it makes no effort to recreate the flavor of the original Viennese Academese (for that fascinating aspect, the reader is referred to the original text). The present volume is an attempt to make Riegl's ideas accessible to a contemporary English-reading public, and if it is at all successful, there should be times when readers of *Problems of Style* can forget that they are reading *Stilfragen* in translation.

Finally, I would like to thank the people who gave support and encouragement to my work on this project. They include Tom Lyman, Gerhard Schmidt and Margaret Olin; Ted Jones, Louise Schang, Jeffrey and Sarah Quilter, plus Doug Northrop along with many other colleagues at Ripon College; and, of course, Gene, Jascha, and Nico, who helped me every step of the way.

PREFACE

How many of our graduate students, indeed how many of us who teach them, can read German with sufficient ease to appreciate the full significance of Riegl's *Stilfragen*, to grasp the relation between the large sweeping historical design, the detailed analyses or scholarly discussions, and the theoretical theses? As for myself, I found it most rewarding to read Evelyn Kain's excellent translation. It has the flow of idiomatic English, and this is essential to render Riegl's work. The rhythm of his prose is often that of the spoken word and in fact we know that by the time he taught at the university his publications were directly related to his lectures.

Something also that the translation will, I hope, convey is the passion invested in Riegl's enterprise. We are made to feel that the issues he discussed mattered vitally to him; it was the very nature of art and its relation to human life that were at stake, art as an absolute necessity. This is the fundamental significance of formalism at its inception, not that art is divorced from life but, on the contrary, that it is a human urge so fundamental that it does not depend on anything else.

Stilfragen occupies a key position in the development of Riegl's work and thought. Up to then, he had published a whole cycle of specialized contributions to the study of the decorative arts, especially textiles. This was the outcome of his activity as curator of textiles at the Museum of Art and Industry in Vienna, an institution modeled on London's South Kensington Museum (now called the Victoria and Albert Museum). Institutionally as well as intellectually his work went hand in hand with the arts and crafts movement, which was particularly brilliant in Vienna. At the museum, Riegl's most sustained task was to catalogue oriental rugs, and this gave him the occasion to develop exceptional skills for the description and analysis of the intricate patterns. This rigorous discipline in the discussion of ornamental motifs is the backbone of *Stilfragen*.

In 1889, Riegl, who was thirty-one years old, submitted a successful application to enter a university career. In 1890 and 1891 he lectured on the history of ornament, and *Stilfragen* was the first work to result from this new activity. Riegl's increased intellectual ambition takes shape here in the form of a bold historical thesis: he claimed that there had been an uninterrupted continuity in the history of ornament from the ancient kingdom of Egypt until the Islamic world (and consequently until the present).

More specifically, Riegl saw this continuity embodied in the permanence of a few fundamental motifs that undergo drastic changes in their superficial appearance. This appearance can vary from the most abstract formulation to the most naturalistic embodiments, yet the basic scheme of the palmette, the rosette, the wavy line or tendril, or the zigzag can be recognized under these sundry disguises.

Stilfragen is a polemical work. Its principal target is the thesis defended by the followers of Gottfried Semper, who derived the forms of ornament from the techniques of production and the nature of the materials, especially in weaving crafts. On the other hand, Riegl also opposed a mimetic interpretation according to which vegetal ornament would occur as a spontaneous imitation or transcription of natural forms, with stylization as a secondary phenomenon. Although this is a less sustained theme in the book than the attack on the "materialist" theory, it was of great importance to Riegl, who persued it with increased vigor in later years. What these two antithetical claims have in common, making them equally pernicious in Riegl's eye, is that both tear the production of ornamental art away from its history, an independent history of its own.

Riegl, then, envisages the history of ornament as the endless, tireless, compulsive reiteration of a very few fundamental motifs. Only in a long, long, while, due to the intervention of a different human group, does a new motif appear, like the tendril: that is, the basic motif of a wavy line introduced by Myceanean culture and added to the heritage of Egypt and the ancient Near East. In Riegl's mind this unbroken historical continuity of an underlying core of fundamental motifs was the guarantee of the independence of the artistic urge, of the irreducibility and freedom of art.

Stilfragen is Riegl's most formalistic statement: the combination of unbroken historical continuity and endless inventiveness in the constant restatement of the same few motifs implies an art completely independent from exterior conditions and other human endeavors. In this work, Riegl's concept of *Kunstwollen* (which can be rendered variously as "artistic intention," "intentionality," "will," or whatever) was just taking shape—and the term makes only a timid appearance in the book. Later this concept was to assume a most prominent role and embody the worldview of a period. But when he wrote *Stilfragen*, Riegl was above all anxious to demonstrate the autonomy and freedom of an aesthetic urge in man.

Riegl's theoretical thinking had not by any means reached maturity. He still thought of an urge to form in terms of beauty, and his attitude remained normative. He seems still to have felt that Greek art was a sort of ultimate attainment. By the time he wrote *Spätrömische Kunstindustrie*

he had gone beyond this aestheticizing formulation, expression had assumed a greater role, and he was increasingly concerned with an understanding of the relation between the coherence of a culture and the autonomy of the visual domain. He would consider "beauty" as the special contribution of Greece, but as only one particular option within a larger, more expressionist view of artistic possibilities. He came to distrust any notion of decline or decadence, to consider evaluation as strictly a relative activity; as expression took on a more prominent position, the expressive aim systematically justified the formal means. Or conversely, the formal means were to be understood strictly in relation to their inherent expressive motivations and not judged according to preestablished formal standards.

These theoretical issues became all-engrossing for Riegl as the years went by, and he was increasingly concerned with the finality of art as it expresses itself at a given time (*Spätrömische Kunstindustrie*, 1901), or in a given genre (*Holländische Gruppenporträt*, 1902).

In *Stilfragen*, however, Riegl was still principally concerned with establishing the continuity of a historical narrative. Consequently, the methods of philology or historical criticism in the positivist tradition were directly operative. It is therefore particularly interesting to see how well the work has withstood the test of time.

Thanks to David Castriota we are now able to do so. For this new edition, he has assumed the formidable undertaking of testing the book against a hundred years of scholarship. Many details have to be corrected, of course, and some of the ideas are untenable, like Riegl's presentation of Egyptian ornament as an absolute beginning. But all in all, Riegl's basic narrative holds good, and many of his hypotheses and intuitions have been confirmed by later research and archeological finds. Quite extraordinarily, the book has not been replaced or superseded as an exposition of the history of ornamental art in antiquity and the medieval period—no small tribute to a scholarly book on the eve of its first centennial.

Henri Zerner

ANNOTATOR'S INTRODUCTION
AND ACKNOWLEDGMENTS

When, in the period before 1893, Alois Riegl undertook the much needed task of laying the groundwork for a comprehensive understanding or history of ancient and medieval ornament in western Asia and the Mediterranean, the circumstances could hardly have been less favorable for such an enormous and ambitious endeavor. Historians of art had already come to recognize the importance of applied decoration or ornament as a major form of artistic expression in all media, both great and small, among the peoples of antiquity and the periods that followed. This awareness was due largely to the vast array of new material collected by early archaeologists, antiquarians, and ethnographers in the course the nineteenth century. Nevertheless, the study of the preclassical cultures of Greece, Egypt, and the Near East was in its infancy. The recent and important discoveries of Heinrich Schliemann at Troy and on the Greek mainland had opened the door to the study of Aegean Bronze Age cultures, but the Minoan civilization of Crete, which had played such a decisive role in this process, still awaited the excavations and researches of Sir Arthur Evans. Pioneers like Henry Layard or Flandin and Coste had also excited the nascent archaeological community with the finds and illustrations that they brought back from their expeditions into Mesopotamia and Iran. Yet the major sites or capitals of the ancient Near East, like Assur, Babylon, and Ur in Mesopotamia, Ugarit in Syria, and Susa or Persepolis in Iran, remained largely unknown until the monumental campaigns of the German, French, British, and American archaeologists at the turn of the century and the decades that followed.

Ancient Egyptian culture was a good deal more accessible, owing to the scale and preservation of the monuments in the Nile Valley, to the widespread use of stone in such works, and also to the abundant and informative decoration of the monuments with hieroglyphic texts, which were deciphered relatively soon after the European penetration into Egypt. But even here one must conceive of an Egyptian archaeology that still knew little or nothing of many important sites and artifacts, like those from the tomb of Tutankamun or Amarna, for example, which have contributed so much to our understanding of Egyptian art, religion, and society. Even the more well-established field of classical archaeology was relatively undeveloped at this time; major monuments like the Altar of Zeus

at Pergamon or the Ara Pacis Augustae in Rome were still poorly known, only partially excavated, and not yet properly published.

If one considers the sheer wealth of art historical or archaeological material that has accumulated since Riegl's death in 1905, in comparison to the rather limited corpus of artifacts and monuments that was available to him for study, it is not surprising that *Stilfragen* has for many scholars become a kind of period piece. It appears as an interesting document of its time from a historiographical point of view, but a work whose observations, content, and conclusions are assumed to be hopelessly skewed and distorted by the limited data sample upon which they were based, and therefore no longer of any immediate, practical value. Yet such a view of *Stilfragen* is as simplistic and erroneous as it is insensitive. As the eminent art historian and critic Meyer Schapiro once pointed out to me, the validity and value of a study does not depend entirely upon an exhaustive survey of the data. One may contribute a great deal by studying a smaller, well-chosen body of material, so long as the objects are representative of their class or type and provided that the mode of analysis applied to them is careful, penetrating, and methodologically sound.

There is no denying the constraints or lacunae that inevitably marred Riegl's study of ancient and early medieval ornament, but it would be naive and ungenerous for anyone today to disregard the positive contributions of *Stilfragen*, which far outweigh its deficiencies. Nor can one ignore the considerable debt that subsequent scholarship in the field of ancient, late antique, and Islamic decorative arts owes to this fundamental and seminal work. For the art historian or archaeologist who becomes concerned with the analysis of ornamental design as a historical phenomenon, Riegl's early study remains a valuable introduction or point of departure.

When Riegl originally conceived this project, however, he was already sensitive to the paucity of accessible material and the problems that this posed, yet even so he did not see this as the primary obstacle to the kind of approach that he advocated constantly in his work. For Riegl, the whole notion of historical continuity was the real issue at stake in a study that purported to trace the outlines of the evolution of the decorative arts from ancient Egypt to Islamic times as a single, unified, or interrelated phenomenon. By the late nineteenth century, the study of ornament had come to be dominated in European circles by certain positivist notions, especially the materialist theory of art, which ascribed the formal properties of ornamental style and composition overwhemingly to the dictates of raw material and technique. In the case of stylized representations of plants or animals, one could substitute the natural model or analog for the

material and technique as a governing principle, but the result was the same. Formal or stylistic analogies in geometric and stylized vegetal and animal ornament appeared simply as the passive result of common technologies and mimetic skills; they were thereby rendered meaningless in historical terms, incapable of being understood as vestiges or evidence of artistic transmission or diffusion.

Riegl stubbornly resisted and challenged such notions against enormous and entrenched opposition. Instead he viewed the production of art as a creative, intellectual achievement. Artistic forms, especially to the extent that they departed from those of nature, were the material expression of ideas that originated actively in the creative human mind rather than as passive responses to some technological expedient or natural prototype. Artistic design could undoubtedly yield to the differing possibilities and requirements of medium and technique, but Riegl always adhered to the principle of creative autonomy and choice as fundamental to the artistic process. In such an outlook, artistic forms were highly distinctive products whose recurrence could and should be explained in terms of human interaction. Distinctive artistic concepts were not only ideas but traditions, that were transmitted from one generation to the next and from one culture to another. In the hands of a creative artist, traditional forms could also be mutated to produce innovations as they were handed down or diffused transculturally. In the spirit of Darwin, Riegl sought to trace, map, and classify this evolutionary process and the phenomenal range of forms or styles that it could engender.

The methodological or ideological polarity between Riegl and his opponents helps us to understand why at times he tended to overstate his case, perhaps as a deliberate rhetorical or polemic technique, although this led him to some conclusions that must now be modified. For the critical reader, there is also ample room for disagreement with *Stilfragen* on the basis of the historical or factual gaps in the data. The art of Syria and the Levant, and the Aegean as well, all played a more vital role in the international current of decorative arts across the eastern Mediterranean in the later second millennium B.C. than Riegl could possibly have anticipated or surmised from what was known in the 1890s. Egypt was highly receptive to artistic motifs and themes from these regions, just as the Levant served as a major conduit or intermediary for Egyptian forms and design principles that eventually became basic in the Mesopotamian decorative arts of the early first millennium B.C.

Riegl's Egyptocentric bias in the early development corresponds to his Hellenocentric tendencies in assessing the ornament of later periods. The

various tendril patterns that he considered to be the peculiar contribution of the "Greek spirit" now appear as inventions of Minoan or Cretan and Syrian artists, although such patterns did ultimately attain their classic form and maximum currency in Greek art. In more general methodological terms, one may fault Riegl for his excessive formalism, his desire to attribute so much of ornamental pattern or design to artistic imagination, even where the evidence of natural analogs or technical considerations does speak against this. At times his emphasis upon causality in the gradual process of artistic change and transformation smacks uncomfortably of historicism or historical determinism. Riegl's frequent assertions regarding the unparalleled aesthetic achievement of the Greeks, as opposed to those of earlier cultures, are no less a product of his time as were his assumptions about the "purely decorative" function of ornament, or his notion of *Kunstwollen*, a pervasive spirit or impulse motivating and shaping the art of certain ethnic groups or periods. Nowadays, one is prone to be a good deal more circumspect in attempting to understand or explain the root causes of major stylistic trends and developments.

Yet on balance, the general historical construct and conclusions of *Stilfragen* have stood the test of time and subsequent study remarkably well. Today Egyptian decorative art still appears as the first successful effort to establish a systematic and consistent approach to floral or vegetal ornament, an approach that was enormously influential in the decoration that subsequently became current in the ancient Near East and the Aegean in the Middle and Late Bronze Ages. Today there is no doubt that the radical changes in the Greek ornament of post-Geometric times resulted from the assimilation of motifs and design principles from the Near East and Egypt, which the Greeks gradually modified in the course of time to produce something essentially new. Nor do scholars nowadays have any difficulty in understanding the further development of ornament in Classical and Hellenistic Greek, Roman, and late antique art as a series of progressive transformations reaching back unbroken to the Archaic phase. Among Islamicists as well, there are few who would dispute the notion or indeed the fact that Arabesque and geometric ornament in the medieval Near East was an extension of motifs, design principles, and tendencies inherited from the Hellenistic, Roman, and late antique art in the same regions.

Riegl never intended *Stilfragen* to be a definitive history of ornament as a whole, or even of any of the various individual developments that he treated. It was, as his subtitle made clear, a foundation upon which subsequent scholarship could build. And this is what it soon became. Within

two decades Ernst Herzfeld applied Riegl's mode of analysis and terminology in the publication of the rich architectural decorations of the Abbasid palace at Samarra, opening up a whole new phase in the study of early Islamic ornament. Riegl's work also provided the point of departure for the only other extended study of the Arabesque by the Egyptian scholar Shafi'i, just as it paved the way for the comprehensive treatment of ancient Egyptian and Near Eastern ornament in Helene Kantor's doctoral dissertation (University of Chicago), which has unfortunately remained unpublished since 1945. In the domain of classical and European archaeology, *Stilfragen* spawned a long list of more specific studies, above all the influential work of Paul Jacobsthal in Greek ornament and his investigations of the Greek impact upon the decorative arts of the Celts in Iron Age Europe. Via Jacobsthal, Riegl's legacy continues in the ongoing scholarship on La Tène Celtic art by British and Continental archaeologists. Even classical archaeologists who have approached Riegl more critically, like Imma Kleemann, have nevertheless done so in the mode of discourse, analysis, and terminology initially established in *Stilfragen*.

From this perspective, the present volume has a number of objectives. Most immediately, it is intended to increase the awareness or appreciation of Riegl's contribution to the study of ornament and to make this contribution more accessible to those less able or inclined to tangle with the difficulties of *fin de siècle* Viennese German. But it is intended in more practical as well as historiographic terms. There is still no available comprehensive survey of ancient or early medieval ornament in any language that treats the major phases or the larger developments. *Stilfragen* remains the only solid and detailed introduction to the classification, analysis, and terminology basic to the study of stylized vegetal ornament in the Near East and the West during these periods. For this reason alone it is still a valuable piece of scholarship whose benefits and lessons can now become available to a wider audience of scholars and students.

To maximize such positive value, this English translation of *Stilfragen* is equipped with extensive scholarly apparatus or annotations; these are keyed to the text by letters rather than numbers, to avoid confusion with Riegl's footnotes. They refer the reader to the relevant scholarship on a given point or subject that has accumulated since Riegl's time, as well as to new additions to the corpus of artifacts or monuments that may test, dispute, or corroborate Riegl's findings. Often these annotations are somewhat discursive so as to provide a more substantive and critical indication of how the bibliography bears upon the discussion of *Stilfragen*, and how Riegl's arguments apply to new material. As a result, the text is

no longer outdated, and the reader has the option of pursuing an issue on the basis of more recent work and new data.

To some extent, the annotations and other additions are editorial. They alert the reader to newer, more accessible publications of material that Riegl cited as additional comparanda in his footnotes. The footnotes too have been reorganized or expanded according to more modern conventions and standards. The once familiar abbreviations of 1893 may often be obscure or confusing to today's reader; these have now been cited fully. The many abbreviated references that once encumbered the body of the text itself have also been expanded and moved down into supplemental footnotes. Simple factual errors in date, medium, or provenance, etc., within the footnotes or the text itself have also been emended, but all such changes have been indicated through the use of brackets or discussion in the annotations. The list of illustrations has been expanded to include full citations of the sources, both as a convenience to the reader and to compensate for those instances where Reigl neglected to indicate such sources in his footnotes. Thus the present volume is not only a new translation but a new edition, whose additional material will hopefully render it useful even to those readers who are fluent in the language of the original text.

There has been a similar attempt to improve the illustrations as well. The halftone illustrations of the original edition were inferior copies made from earlier publications. Those halftones which reproduced actual photographs of the objects have sometimes been replaced by new black-and-white prints. However, all illustrations consisting of artistic renderings of the objects have been retained. These include the halftones that reproduce ink or watercolor versions, as well as the various line drawings that comprise the majority of the illustrations in *Stilfragen*. In order to maximize their graphic quality, these have been rephotographed directly from the original sources used by Riegl. Many of Riegl's illustrations were excerpted from more extensive renderings of patterns or objects, although the radical and adroit cropping of the images in the original edition of *Stilfragen* often tends to obscure this fact. Consequently, the illustrations of the present edition have been cropped somewhat less severely so as to provide an indication of context.

It is certainly true that nineteenth-century renderings of this kind introduce in varying degree qualities and inaccuracies that are alien to the original works of art. Yet one should never lose sight of the extent to which such artistic renderings shaped the conception or impression of ancient ornament shared by Riegl and his contempories. These were the illus-

trations that Riegl had before him as he developed his arguments; there-
fore they constitute an inextricable component of his text, and as such
they remain essentially beyond any notion of improvement or emenda-
tion. Nor is it justified to dismiss the archaeological value of such drawings
and watercolors too lightly; often enough they provide an invaluable re-
cord of the design and detail of works that have unfortunately deteriorated
or disappeared since the time of their discovery.

The technical vocabulary or terminology of this edition is the result of
careful consideration and collaboration between the translator and the an-
notator. Wherever possible, it follows the English adaptation of Riegl's
terms established by Jacobsthal in *Early Celtic Art* and current among the
British scholars influenced by Jacobsthal. Nevertheless, Jacobsthal's dis-
cussion of Greek and Near Eastern ornament here was limited, emphasiz-
ing only those forms and issues that were relevant to his primary subject,
Celtic art. In many instances it has been necessary to start fresh and to
settle upon terms that approximate the sense of Riegl's German, while
also avoiding the excessively lengthy and descriptive or cumbersome
quality of some of his vocabulary. To make the sense and usage of the
English terminology as clear and precise as possible, the annotator has
also contributed a glossary, which defines the terms and provides some
indication of their application, while also referring to relevant text and
illustrations. The original German terms have been included in each entry
of the glossary (unless phonetically equivalent to the English).

From all of this it should be clear that the present volume is no longer
the text of 1893. It is first of all a translation of that text and reflects every-
thing that is inherent to the process of translation. Through the addition
of annotations, it now becomes a dialogue between Riegl and the scholar-
ship that has followed. This scholarship, like the discovery of new artifacts
and monuments, invites or demands a new reading of Riegl in the light of
new contexts, perspectives, and potentialities that have arisen since the
1890s and that will no doubt continue to arise. As such, the text is now a
Stilfragen for the 1990s and beyond, through which new generations of
scholars may contemplate the challenges and intricacies of ornamental
design that so preoccupied the artistic imagination in the past.

As a text, *Stilfragen* may also have achieved a new currency or rele-
vance owing to the concerns peculiar to our own time, a period when
practitioners and theoreticians of postmodern architecture and interior
design have come to look anew at the role of ornament and the burden of
tradition in the creative process that shapes the built environment. Ours
is also a period in which historians, critics, and epistemologists have come

to question the basic assumptions behind the whole notion of historical or cultural continuity and evolution. In place of continuity, relation, and order, it has now become preferable to seek discontinuity, difference, and fragmentation. *Stilfragen* remains very much a focus or target for such a reevaluation, and it is an enticing prospect to speculate upon what sort of rereading this new perspective may engender.

Continuity is ultimately a polar conception; it can only be gauged against the process of change with which it perpetually coexists or interacts. If the corpus of artifacts treated in this volume does indeed constitute the links in a chain connecting the decorative arts of antiquity with those of relatively recent times, as Riegl argued so passionately, then one need only compare examples from various intervals of the chain to see the volatile and dynamic process of transformation that constantly attended such continuity, and to appreciate how effectively Riegl's analysis brought this protean dimension of artistic production into focus. *Stilfragen* bears eloquent witness to the cultural and creative forces that engender disruption and innovation even as they stimulate the borrowing and preservation of existing artistic concepts and norms. As the end of another century approaches amidst new intellectual anxieties and polemics, historians of art would do well to reexamine and debate the implications of the long and complex artistic process that Riegl's study sought to disclose.

I WOULD like to express my deep gratitude to all those whose help and skill contributed so substantially to the production of annotations in this volume. First of all, I want to thank my research assistant, Heather Hornbuckle, for the time and care that she put into running down all potentially relevant bibliographic references. Her diligence and thoroughness were instrumental in making the annotations as complete and up-to-date as possible. I also want to thank the team of librarians here at Duke University whose expertise and professionalism also facilitated access to the wide range of material that the project required. On the reference staff these included Ken Berger, Ilene Nelson, Joe Rees, and Johannah Sherrer. Among the librarians of the Interlibrary Loan Office at Duke, I especially want to thank Rebecca Gomez, Jade Kelly, Linda Purnell, and Clifford Sanderson. I know that the masses of material that they acquired for me must at times have pressed their resources to the limit, and I appreciate not only their abilities, but their forbearance as well. I am extremely grateful to Henri Zerner for his wisdom and support in overseeing the entire project, and to the translator, Evelyn Kain, for her care, patience, and flexibility. I would also like to thank Elizabeth Powers, Fine Arts

Editor at Princeton University Press. Although she came to the project when it was well underway, she has been enormously helpful all through the final stages. This undertaking has ultimately been the result of teamwork. Without the participation of everyone involved, it would never have been possible.

David Castriota
Duke University

PROBLEMS OF STYLE

The subtitle of this book announces its theme: "Foundations for a History of Ornament." How many of you are now shrugging your shoulders in disbelief merely in response to the title? What, you ask, does ornament also have a history? Even in an era such as ours, marked by a passion for historical research, this question still awaits a positive, unqualified answer. Nor is this purely the reaction of radicals who consider all decoration original and the direct result of the specific material and purpose involved. Alongside these radical extremists, there are also those of a more moderate bent, who would accord to the decorative arts some degree of historical development from teacher to pupil, from generation to generation, and from culture to culture, at least insofar as they have to do with so-called high art, devoted to the representation of man, his achievements, and struggles.

Certainly, from the very inception of art historical research, there have always been some scholars in the field who also conceived of pure decoration in terms of a progressive development, i.e., according to the principles of historical methodology. But these were, of course, mainly learned academicians who adapted the rigorous training in philology and history acquired at gymnasia and universities to the study of ornamental phenomena as well. However, the drastic impact of this more extremist position upon the general attitude toward the decorative arts is revealed by the way in which historical methodology has been applied to the study of ornament up to now. For example, scholars have been extremely reticent to propose any sort of historical interrelationships, and even then, only in the case of limited time periods and closely neighboring regions. Their courage seems to fail them completely the moment an ornament ceases to have any direct relationship with objective realities—to organic, living creatures or to works fashioned by the human hand. As soon as they deal with the so-called Geometric Style, which is characterized by the mathematical expression of symmetry and rhythm in abstract lines, all consideration of artistic, mimetic impulses or of variation in the creative abilities of various cultures immediately ceases. The degree to which the terrorism of extremists has successfully intimidated even the "historians" involved in the study of ornament emerges clearly in the haste of scholars to assure us that they would never be so foolish and naive as to believe, for example, that one culture could have ever copied a "simple" meander band from

another, or by their repeated apologies whenever they do venture to assert even a loose connection between, shall we say, the stylized two-dimensional vegetal motifs current in two geographic areas.

What led to this situation, which has had such a decisive and, in many respects, paralyzing effect upon all art historical research in the last twenty-five years? The blame can be placed squarely on the materialist interpretation of the origin of art that developed in the 1860s, and which succeeded in winning over, virtually overnight, everyone concerned with art, including artists, art lovers, and scholars. The theory of the technical, materialist origin of the earliest ornaments and art forms is usually attributed to Gottfried Semper. This association is, however, no more justified than the one made between contemporary Darwinism and Darwin. I find the analogy between Darwinism and artistic materialism especially appropriate, since there is unquestionably a close and causal relationship between the two: the materialist interpretation of the origin of art is nothing other than Darwinism imposed upon an intellectual discipline. However, one must distinguish just as much and just as sharply between Semper and his followers as between Darwin and his adherents. Whereas Semper did suggest that material and technique play a role in the genesis of art forms, the Semperians jumped to the conclusion that all art forms were always the direct product of materials and techniques. "Technique" quickly emerged as a popular buzzword; in common usage, it soon became interchangeable with "art" itself and eventually began to replace it. Only the naive talked about "art"; experts spoke in terms of "technique."

It may seem paradoxical that so many practicing artists also joined the extreme faction of art materialism. They were, of course, not acting in the spirit of Gottfried Semper, who would never have agreed to exchanging free and creative artistic impulse [*Kunstwollen*] for an essentially mechanical and materialist drive to imitate. Nevertheless, their misinterpretation was taken to reflect the genuine thinking of the great artist and scholar. Furthermore, the natural authority that practicing artists exert in matters of technique resulted in an environment where scholars, archaeologists, and art historians swallowed their pride and beat a hasty retreat whenever the question of technique arose. For they—mere scholars that they were—could have little or no competence in this regard. Only recently have scholars become bolder. The word "technique" proved to be extremely flexible: first came the discovery that most ornamental motifs could be (and had actually been) rendered in a variety of techniques; then came the pleasant realization that techniques were an excellent source of controversy. In time, archaeological publications, as well as journals de-

voted to arts and crafts, joined in the wild chase for techniques, a pastime that will probably continue until all the technical possibilities for each and every humble motif have been exhausted, only to return—one may be sure—precisely to the point where it all began.

In the midst of such a spirited intellectual atmosphere, this book ventures to come forward with foundations for a history of ornament. The wisdom of beginning with foundations that pretend to be nothing more than that is obvious. In a situation where not only the field of action is hotly contested at every step along the way but even the groundwork itself is constantly in dispute, our first concern is to secure a few positions, a connected series of strongholds from which a comprehensive, systematic, and complete offensive can later be launched. The nature of the situation militates further that "negative arguments" take up a far greater portion of this book than is customary in a positive, pragmatic description of history. Here our most immediate and urgent objective is to address the most fundamental and harmful of the misconceptions and preconceptions that still hinder research today. This is another reason why, for the present, the concepts of this study are presented in the form of "foundations."

Having said this, I still feel compelled to justify the existence of this book. However, anything one might say in this regard will sound unconvincing as long as the technical-materialist theory of the origin of the earliest primeval art forms and ornamental motifs remains unchallenged, even though it has failed to define the precise moment when the spontaneous generation of art ends, and the historical development effected by laws of transmission and acquisition begins. The first chapter, therefore, is devoted to challenging the validity of the technical-materialist theory of the origin of art. As its title indicates, it deals with the nature and origin of the Geometric Style. Here, I hope to demonstrate that not only is there no cogent reason for assuming a priori that the oldest geometric decorations were executed in any particular technique, least of all weaving, but that the earliest, genuinely historical artistic monuments we possess in fact contradict this assumption. Similar conclusions will also emerge from deliberations of a more general nature. It will become evident, namely, that the human desire to adorn the body is far more elementary than the desire to cover it with woven garments, and that the decorative motifs that satisfy the simple desire for adornment, such as linear, geometric configurations, surely existed long before textiles were used for physical protection. As a result, this eliminates one principle that has ruled the entire field of art theory for the past quarter century: the absolute equation of textile patterns with surface decoration or ornament. The

moment it becomes untenable to assume that the earliest surface decoration first appeared in textile material and technique, then the two can no longer be considered identical. Surface decoration becomes the larger unit within which woven ornament is but a subset, equivalent to any other category of surface decoration.

In general then, one of the main objectives of this book is to reduce the importance of textile decoration to the level it deserves. At the same time, I must admit that this medium has been the point of departure for all the research that I have gathered from eight years of service in the textile collection of the k. k. Österreichisches Museum für art und Industrie [Österreichisches Museum für Angewandte Kunst]. At the risk of ridiculous sentimentality, I cannot help feeling some regret at robbing textile art of its nimbus, in view of the personal relationship which I acquired with textiles in the course of curating the museum's collection for so many years.

Once the momentous proposition about the original identity of surface decoration and textile ornament had become accepted, there were almost no limits placed on its application. Beginning with rectilinear geometric shapes, it quickly expanded to include artistic representations of even the most complex natural forms, namely, human beings and animals. For example, the origin of motifs consisting of two figures symmetrically arranged to either side of a central axis was attributed to tapestry weaving. The Heraldic Style, as this type of decorative arrangement has come to be known, is so common that it warrants its own separate discussion. In the second chapter, therefore, I explain why there is neither proof nor even a possibility that heraldic motifs resulted from tapestry weaving, since the advanced technical knowledge necessary to produce such complicated forms simply did not exist during the period when the earliest heraldic motifs originated. And, at any rate, we shall see that there are other, albeit less tangibly materialist explanations for the Heraldic Style.

As a result, the basic tone of the two first chapters is somewhat negative, even though I have made every effort to replace the things that were discredited with something new and positive. In the case of the Geometric Style, it is especially necessary to dispel once and for all the misconceptions surrounding its purely technical, material origin and the allegedly ahistorical nature of its development. Yet one fact enormously complicates any historical approach to the Geometric Style: whereas organic nature and the handicrafts inspired by it allow the artist manifold alternatives, the mathematical laws of symmetry and rhythm that govern the simple motifs of the Geometric Style are more or less the same the

world over. Spontaneous generation of the same geometric decorative motifs in different parts of the world is, therefore, not out of the question; but even so, one can take specific historical factors into account with complete objectivity. Certainly, some cultures were always leading the way for others, just as more talented individuals have always distinguished themselves from their peers. And surely it was just as true in the remote past as it is today that the vast majority of people find it easier to imitate than to invent.

Once plants are used as decorative motifs, the study of ornament finds itself on more solid ground. There are infinitely more species of plants that can be used as the basis for patterns than there are abstract, symmetrical shapes, limited as these are to the triangle, the rectangle, the rhombus, and only a few others. This is the point where classical archaeology begins to take an interest in vegetal ornament; in particular, the connection between Greek plant motifs and their ancient Near Eastern prototypes, which mark the beginning of art history proper, has already provided the subject of intense study and extensive debate. Nevertheless, German archaeology has not yet attempted a systematic description of the history of the vegetal ornament that was so crucial to antique art from ancient Egyptian to Roman times; this is a consequence of the enormous resistance to making "mere ornament" the basic theme of a more ambitious historical study. However, an American, has recently taken the step that German-trained scholars timidly avoided. W. G. Goodyear, in his book, *The Grammar of the Lotus*, was the first to argue that all antique vegetal ornament, and a good deal more, was a continuation of ancient Egyptian lotus ornament. The driving force behind the ubiquitous diffusion of this ornament was, in his opinion, the sun cult. This American scholar is apparently no more concerned with the technical-materialist theory of the origin of art than he is with Europe's crumbling castles and basalt deposits—unless I am mistaken, Gottfried Semper's name is not mentioned once in the entire book.

Strictly speaking, Goodyear's main thesis is not completely new; what is indisputably unique, however, is his radical determination to accord his ideas a universal significance, as well as the motivation that he cites for the entire development.

As far as the latter is concerned, however, the idea that the sun cult had such an overwhelming influence on decoration is surely erroneous. It is not even certain whether sun-cult symbolism played such a preponderant role in ancient Egyptian ornament, much less outside of Egypt, where there is absolutely no proof and, moreover, no likelihood that it did. Sym-

bolism was unquestionably one of the factors that contributed to the grad-
ual creation of a wealth of traditional ornament. However, by proclaiming
symbolism the sole and decisive factor, Goodyear makes the same mistake
as the materialists who single out technique in this way. Moreover, both
interpretations share an obvious desire to avoid at all costs the purely
psychological, artistic motivation behind decoration. In cases where the
artist is obviously responding to an immanent, artistic, creative drive,
Goodyear sees symbolism at work, just as the artistic-materialists in the
same instance utilize technique as their incidental, lifeless objective.

Moreover, Goodyear places almost no limitations on the influence that
the lotus motif exerted as a model for all sorts of ancient ornament, includ-
ing even the prehistoric zigzag, and this amounts to the same kind of over-
statement indulged in by artistic-materialists and Darwinists. As a result,
Goodyear often makes historical connections that a more dispassionate
observer would flatly reject. Since he seizes only upon those things which
serve his purpose, he has become willfully blind to finer distinctions.
Therefore, it is not surprising that he overlooked, among other things, the
genuinely Greek core of Mycenaean ornament, thereby missing what may
well have been the most important point of the entire development of
classical ornament.

As many a scholar before him, Goodyear clearly recognized the vital
importance of vegetal decoration in ancient ornament, not only for its
own sake but also for the proper assessment and appreciation of ancient
ornament within the overall history of the decorative arts. My lectures
on the history of ornament, delivered during the winter term of 1890–91
at the University of Vienna, gave special emphasis to the development of
the vegetal ornament that began in the earliest period of antiquity. A part
of the content of these lectures appears in the third chapter along with
a few minor additions; it consists mainly of responses to Goodyear's work,
which had since appeared. I would agree with him that the Greeks bor-
rowed motifs extensively from the ancient Near East; moreover, the way
that they infused such forms with formal beauty has long been acknowl-
edged as a Greek accomplishment. However, Goodyear, along with other
scholars interested in determining the essentially Western elements and
impulses in early Greek art, ignored the Greeks' most characteristic,
autonomous, and influential invention, namely the tendril. One seeks in
vain for dynamic, rhythmic vegetal tendrils among the various ancient
Near Eastern styles, though they already appear fully developed in Myce-
naean art on what would later become Greek soil. While Greek blossom
motifs have a Near Eastern origin, the lovely undulating lines connecting

them are specifically Greek. From this point on, the development of the tendril is a major aspect of the subsequent history of ornament. The tendril begins as an undulating band emitting spirals within a narrow border; by the late Hellenistic period, it has turned into an elaborately branching, leafy vine capable of spreading out over large areas. In this form it continues in Roman art and beyond to the Middle Ages, in the West as well as in the East, in Islamic no less than in Renaissance art. The curling foliage of the Little Masters of the sixteenth century is as much a direct descendant of antique classical tendril ornament as late Gothic crocket-work. By tracing vegetal decoration throughout the centuries from its first appearance up to the present day, it becomes evident that ornament experiences the same continuous, coherent development that prevails in the art of all periods, as in the historical relationship between antique mythological imagery and Christian iconographic types. But this is too vast a theme to take up in depth within the framework of this book. Therefore, I will concentrate solely on describing in detail the development of tendril ornament from its origins down through the Hellenistic and Roman periods. Chapter 3, because it deals with a topic of such obvious importance, represents a truly significant "foundation" for the history of ornament.

It is very easy to trace the historical development of traditional stylized vegetal motifs. The same is not true, however, the moment that man attempts to produce ornament related to the natural appearance of an actual vegetal prototype. For example, the projection of the palmette found in Egypt and Greece cannot have been invented independently in both places, since the motif bears no resemblance to the actual plant. One can only conclude, therefore, that it originated in one place and was subsequently transmitted to the other. It is quite another matter, however, in the case of two ornamental works of differing origin that depict a rose, for instance, as it appears in nature; since the natural appearance of the rose is generally the same even in the most diverse countries, it is conceivable that similar depictions could arise independently. It becomes readily apparent from the study of vegetal ornament as a whole, however, that realistic renderings of flowers for decorative purposes, as is nowadays the vogue, is a recent phenomenon. The naive approach to art characteristic of earlier cultures insisted adamantly on symmetry, even in the case of reproductions of nature. Representations of humans and animals soon departed from symmetry by way of the Heraldic Style and other similar arrangements. Yet plants—subordinate and seemingly lifeless as they are—remained symmetrical and stylized throughout the centuries even in

the most sophisticated styles, particularly as long as they functioned as pure decoration and had no representational value. The transition from ancient stylization to modern realism, of course, did not come about in a day. Naturalism, the tendency to make ornamental forms resemble actual plants seen in perspective, crops up repeatedly in the history of vegetal ornament. Indeed, there was even a period in antiquity when naturalism was quite advanced; however, it represents only a brief interlude in the otherwise constant use of traditional, stylized forms. Generally speaking, the naturalistic vegetal motifs of antiquity and of almost the entire medieval period were never copied directly from nature.

The acanthus motif provides us with the best, and probably most crucial, insight into how naturalized vegetal motifs were understood and executed in antiquity. Nevertheless, Vitruvius's story that decorative acanthus motifs were originally based directly upon the actual plant is still accepted without question today. No one seems disturbed by the improbable suggestion that a common ordinary weed could suddenly and miraculously be transformed into an artistic motif. Seen within the context of the history of ornament as a whole, the situation is unprecedented, without parallel, and downright absurd. Furthermore, it is the earliest acanthus motifs that least resemble the actual plant. Only in the course of time did the stylized motifs begin to acquire the characteristics of the acanthus plant itself; obviously, no one referred to them as acanthus motifs until much later in their development, when they actually began to resemble the plant. Chapter 3 will prove that the earliest acanthus ornaments are nothing more than palmettes that were either executed in sculpture or else conceived sculpturally. As a result, the acanthus motif, by far the most important vegetal ornament of all time, makes its debut in art history not as a *deus ex machina* but with a role that is fully integrated into the coherent course of development of antique ornament.

From the time it first fell under the influence of the more refined culture and art of Greece, the Orient resisted the naturalizing tendencies of Western art epitomized in the development of acanthus motifs and the like. Nevertheless, it fully accepted Hellenistic forms; surely no one doubts this anymore except those stubbornly committed to upholding a cherished theory. That there should be any question at all today in this regard, in view of the convincing evidence offered by the monuments themselves, is due primarily to the deeply-rooted antihistorical attitudes in evaluating decorative forms. In actual fact, however, the stylized blossom forms of Late Hellenistic and Alexandrian art occur frequently on Oriental works from the Roman Imperial period side by side with the

naturalistic forms of the Roman West. Byzantine decoration is in part directly related to the Hellenistic forms that were clearly still in use in Greece and Asia Minor even during the Roman Empire. The same is true of Islamic art, though less obviously, since there were so many intervening stages.

A strong Byzantine element has long been recognized as a factor in the origin of Islamic ornament, in fact, even more so in the 1840s and 50s than today, a circumstance once again attributable to the ill-advised technical-materialist theory that doggedly insists upon the spontaneous, autochthonous origin of the art of different cultures. In contrast, the Arabesque remains uncontested as a special creation of the Orient, and particularly of the Arabs. And yet the history of antique ornament demonstrates clearly that the tendrils basic to Arabesque decoration were unknown in the ancient Near East and therefore could only have been adopted from the Hellenistic West. In addition, a closer look at the dense entanglements of Arabesque decoration discloses a number of more conspicuous motifs whose volute-shaped calyces and leaf-fans clearly betray their connection to ancient palmette ornament. What does appear as an entirely new feature of the Arabesque, and completely unattested in the decorative approach to plants in classical antiquity, however, is the peculiar placement of Islamic blossoms. These occur not only at the ends of tendrils, as they are in nature and in Western decoration in general, but they often appear integrated within the tendril. This arrangement suppresses the character of the blossom and obscures the concept of the tendril as a stem, so much that it is sometimes difficult to recognize the Arabesque as a form of vegetal tendril ornament at all.

However, even these fundamental and characteristic idiosyncracies of the Arabesque, in which the antinaturalistic and abstract quality of all early Islamic art emerges so perfectly, have their antecedents in ancient tendril ornament, as the conclusion of the third and the fourth chapters will demonstrate. Here I am able to address a number of additional issues that could not be accommodated in my *Altorientalische Teppiche*, mostly because of the limitations on space. I am happy for the opportunity to expand upon the subject since I realize that many are still unconvinced that antique art was also the evident point of departure for the early medieval art of the Near East. This shows how profoundly modern thinking has been biased by the ahistorical attitude that maintains that art must have originated here and there spontaneously and autochthonously, yet even so the Occident must be a passive recipient, with the Orient always on the giving end. The Orient, of course, represents a land of fable and enchant-

ment, not only for poets but also for art historians, who blithely attribute to it the invention of every imaginable "technique," particularly those that have anything to do with surface decoration. And once a particular "technique" is declared indigenous to the East, one can be certain, according to this viewpoint, that its corresponding artistic progeny is following close behind it.

Conditions are more favorable for an historical approach to vegetal tendril ornament in Western medieval art. This is not to say that the effects of artistic materialism have not taken their toll; on the contrary, they are apparent everywhere. Their pernicious influence is undoubtedly responsible for our vague, contradictory, and fragmented understanding of what transpired during the early stages of medieval art, the so-called Migration Period, and even later in the Carolingian and Ottonian periods, despite the relatively abundant material that has survived. Nevertheless, I am convinced that there are still fewer deep-seated preconceptions and less blind resistance to impede an attempt at treating the historical development of Western medieval vegetal decoration from the twilight of classical antiquity up through the beginning of the Renaissance. Since the present context does not permit me to touch upon everything related to the historical development of vegetal tendril ornament, I have concentrated on the aspects that seemed to require clarification most urgently, and that could, once clarified, provide a firm foundation upon which a history of ornament could continue to build. This involves, as stated above, antique tendril ornament, along with its most faithful follower in the conservative Orient, the Arabesque. Even in the scholarly literature dealing with the history of medieval art, one often encounters certain decorative motifs referred to vaguely as an "ornament," which then have to be described at greater length. This procedure would be totally superfluous if the motif involved had already been assigned its proper place within the overall historical development. Since the creation of this historical order is not without its difficulties, at least in the case of antique and Islamic tendril ornament, the main purpose of the third and fourth chapters will be to establish the historical foundations that will make this possible.

Even though the principle task of historical and art historical research is usually to make critical distinctions, this book tends decidedly in the opposite direction. Things once considered to have nothing in common will be connected and related from a unified perspective. In fact, the most pressing problem that confronts historians of the decorative arts today is to reintegrate the historical thread that has been severed into a thousand pieces.

Since this book threatens to undermine so many deeply-ingrained and fondly-cherished opinions, it is bound to create a storm of protest. I am acutely aware of this. However, I also know that there are many who already share my views, and still others who may be in tacit agreement but who are not yet ready to speak out. And as for those who remain unpersuaded by my arguments, I shall have accomplished something even if I succeed only in compelling them to realize that they must go back and reexamine their premises and seek better and stronger evidence to support their cherished theories. For even limited success is worth the effort, if it sheds some light on the fundamental issues that concern us in this book. Only through trial and error can one approach the truth.

◇

The Geometric Style

All art, and that includes decorative art as well, is inextricably tied to nature. All art forms are based on models in nature. This is true not only when they actually resemble their natural prototypes but even when they have been drastically altered by the human beings who created them, either for practical purposes or simple pleasure.

This intimate connection between art and nature, however, is more evident in some media than in others. It is most evident in sculpture, where the natural model is directly reproduced in all three physical dimensions. However, whenever artists abandon the third dimension and the realm of complete physical appearances—which is what happens when an image is rendered on a flat surface—then they begin to deviate more radically from natural prototypes, so that the connection between art and nature becomes obscured.

Let us take this point a little further. What we have just done is to describe the two major divisions of the decorative arts: sculpture in the round and surface decoration. Furthermore, we can already draw conclusions about their genetic relationship. If we ignore concrete examples for a moment and try in a purely deductive way to reason out abstractly which of them came first in the development, then we will find ourselves forced a priori—in the face of considerable opinion to the contrary—to conclude that three-dimensional sculpture is the earlier, more primitive medium, while surface decoration is the later and more refined.[a] That is to say, once human beings acquired a mimetic instinct, there was nothing very complicated about modeling an animal reasonably well in wet clay, since the model—the living animal—already existed in nature. When, however, they first attempted to draw, engrave, or paint the same animal on a flat surface, they were involving themselves in a truly creative act. In this case, they could no longer copy the three-dimensional physical model; instead, they had to invent the silhouette or contour line freely, since it does not exist in reality.[1] Only after this creative act did art begin to ac-

[1] Travelers often describe how Hottentotts and Australian aborigines fail to recognize their own image in a drawing or photograph: they can comprehend things physically, but not two-dimensionally—proof that the latter kind of perception presupposes an advanced stage of culture.

quire its endless representational possibilities. This turning away from three-dimensional corporeality toward two-dimensional illusion was a crucial step; it unleashed the imagination from the constraints of the strict observation of nature and allowed a greater freedom in the manipulation and combination of forms.

No matter how divorced from nature a freely invented decorative form may seem, the natural model is always discernible in its individual details. This is true of both sculpture and surface decoration. The snakelike feet of a Titan, for example, are based just as much on prototypes from nature as is the human upper torso, even though Titans as such do not actually exist in the real world. Similarly, the purely linear, three-pronged flowers found, for example, on Cypriote vases were obviously derived from lotus blossoms, regardless of whether the Cypriote potters who made the designs were conscious of their connection to a particular species of Egyptian flora or not.

Therefore, nature continued to provide models for art even after the third dimension was abandoned and the imaginary encircling line had become an element of representation. Even though they are not three-dimensional, animal figures rendered in terms of contour lines are still very much representations of animals. Ultimately, however, line became an art form in and of itself and was used without direct reference to any particular model in nature. Since, of course, not just any irregular scribble can claim to be an art form, linear shapes were made to obey the fundamental artistic laws of symmetry and rhythm. As a result, straight lines became triangles, squares, rhombuses, zigzag patterns, etc., while curved lines produced circles, undulating lines, and spirals. These are the shapes familiar to us from plane geometry; in art history, they are generally referred to as *geometric*. Consequently, the style based on the exclusive or predominant use of these patterns is called the Geometric Style.

Even if the forms of the Geometric Style do not seem to be based on real things, they are nevertheless not completely divorced from nature. The same laws of symmetry and rhythm that govern geometric shapes are apparent in the natural forms of humans, animals, plants, and crystals as well. In fact, it does not require any particular insight to perceive how the basic shapes and configurations of plane geometry are latent in natural things. Therefore, the proposition made at the beginning of the chapter about the intimate relationship between all art forms and the physical appearance of nature is also true of the Geometric Style. Geometric forms in art behave in respect to other art forms precisely in the same way that laws of mathematics do with regard to the laws of natural living things. Nature, it seems, can claim as few examples of absolute perfection as

humans can of their ethical behavior; after all, the kinds of things that make history, that immediately capture our attention and save us from the monotonous pace of everyday life tend to be the exceptions to abstract laws. The Geometric Style, strictly constructed in accordance with the highest laws of symmetry and rhythm, is from the standpoint of regularity the most perfect of styles; on our scale of values, however, it occupies the lowest rank. Our present understanding of how the arts developed associates the Geometric Style as a rule with cultures still at a relatively low stage of development.

Despite this limited aesthetic appreciation, interest in the Geometric Style has mounted considerably in the last two decades, first of all within archaeological circles. Excavations at the earliest burial sites on Cyprus, the pre-Homeric strata of Troy-Hissarlik, the Terramare burials of the Po River Valley, and the graves of prehistoric northern and central Europe, to name a few, have unearthed objects in the Geometric Style whose origins, according to very convincing evidence, date back to relatively early periods. This information has been supplemented by the research of ethnologists, who often discover the typical linear motifs of the Geometric Style adorning the utensils of modern primitive peoples. If, following the spirit of today's natural science, we are justified in assuming that contemporary primitive cultures are the rudimentary survivors of the human race from earlier cultural periods, then their geometric ornament must represent an earlier phase of development in the decorative arts and is therefore of great historical significance.

The few basic motifs of the Geometric Style occur in the same manner among practically all prehistoric and contemporary primitive cultures in Europe and Asia, in Africa as well as in America and Polynesia, although they may occur in different combinations and with varying preferences for a particular motif. Consequently, some scholars have concluded that the Geometric Style could not have been invented at one geographic location, from whence it spread throughout the world, but that it spontaneously came into existence within most, if not all of the cultures where it occurred. As a result, anyone who tried to argue that two pots with the same zigzag pattern but of disparate geographic provenance were somehow connected to each other—and it need not have been a very direct connection but only a distant relationship separated by a long chain of intermediaries—was considered rather naive and ignorant. The Geometric Style originated spontaneously throughout the entire world: this is the first doctrinaire proposition that is nowadays considered valid for the Geometric Style.

Once this was firmly established, it led immediately to the further conclusion that the impetus for the invention and development of the style must have been the same everywhere. The spirit of our scientific age, in its hectic pursuit of causal relationships, attempted straightaway to get to the bottom of whatever it was that had allowed the Geometric Style to spring spontaneously to life at so many different locations. Moreover, whatever it was, it had to be tangible and material; the simple suggestion that intangible psychological processes might have been involved would not have sufficed. Furthermore, this motivating something could not be sought in the open countryside: the abstract, linear patterns of the Geometric Style are, of course, not obvious in nature; releasing them from their latent existence in nature into an independent existence in art requires a conscious mental act whose intervention, however, was to be ignored at all costs. Therefore, the only tangible things left were the objects made by the human hand. Since this involved technical processes from the most primitive, nascent periods of the human race, then only the most primitive objects and the most fundamental products of the elementary drive for basic necessities made by human hands could come under consideration. The need to protect the body was believed to be one such drive. Very early on, so it seemed, humans must have sought refuge from the hostile outer world within the wickerwork fence, or protection against the weather from woven textiles.[1a]

Because of the technical procedures they involve, wickerwork and textile weaving seem to be those very crafts which are especially limited to producing linear ornaments. Now, let us try to reconstruct how the linear patterns of the Geometric Style might have come into being had they first appeared to human eyes in the crisscrossing structure of a wickerwork fence or a coarsely woven garment. For example, a fortuitous interweaving of colored fibers might have prompted the creation of a zigzag line; the

[1a] [Riegl often refers to "die textilen Techniken" (textile techniques), which for him always include the weaving of the wickerwork fence (*geflochtener Zaun, Pferch, Ruthenzaun*), baskets (*Korb*), and cloth (*Gewand*, etc.). "Flechterei" (wickerwork) sometimes refers exclusively to basketry or basket weaving, but is often meant to include the weaving of both fences and baskets, as distinct from "Weberei" (weaving), which is strictly the weaving of cloth. More so than in German, the English word "weaving" is specifically associated with cloth production, as is the word "textile" with cloth or fabric. When Riegl uses these terms, however, he is most often referring to the larger concept: by "weaving," he usually means the process of crisscrossing and interweaving that is common to the wickerworking of both fences and baskets, and the weaving of cloth. With the word "textile," used both as a noun and an adjective, he is usually referring to the products or qualities of that process, whether they involve the use of branches, wicker, bast, fibers, or spun threads. I have attempted to keep the terminology as clear as possible without unnecessary wordiness and repetition, but the reader should be alerted to the fact that "weaving" is most often understood as the larger, more inclusive process.]

symmetry of its slanting bands and rhythmic repetition would surely have delighted the human beings who accidently produced it. Of course, should the question arise at this point as to the source of this delight and what might have caused it in primitive people, it would have to be fastidiously ignored; the conclusions made thus far apparently suffice. The reasoning goes like this: the human hand produced the first geometric ornaments in an unconscious, nonspeculative way, guided only by the necessities of a purely practical purpose. Once they were available, people were then capable of using them however they liked. For example, a zigzag line could be pressed into a cup of wet clay. Even though it was not necessitated by technique on a ceramic cup, like crisscrossed fibers in weaving, it was nevertheless just as appealing in ceramics, so that it began to be used even in techniques where it had not spontaneously originated. The geometric zigzag motif, originally the fortuitous product of a purely technical process, had thereby been promoted to an ornament and an artistic motif. The simplest and most important artistic motifs of the Geometric Style were originally generated by the techniques of wicker and textile weaving: this is the second absolute proposition about the Geometric Style considered valid today.

This second proposition overlaps with the first one regarding the spontaneous, independent generation of the style at different locations in the world, to the extent that the elementary need to protect the body must have come into force independently at a number of different places throughout the world and therefore could at the same time have prompted the spontaneous invention of weaving wickerwork fences and cloth at a number of different locations. In this manner, one proposition supports the other; together they present an even more convincing and harmonious picture of the formation of the Geometric Style and of the earliest, most primitive artistic activity.

It was Gottfried Semper who first traced the linear ornaments of the Geometric Style back to the techniques of weaving, wickerwork, and textiles. This conclusion, however, did not occur to him in isolation as we described above; it was related to the fundamental theory he sought to establish and demonstrate systematically in his book *Der Stil*: the theory of dressing as the origin of all monumental architecture. As a result, he was able to associate all flat decoration with the idea of a protective blanket and its trimmed, bound border, terms that are already linguistically connected with textiles. It is obvious in numerous passages in *Der Stil* that Semper originally conceived of the prototypes of blanket and border primarily as abstractions and not really in a concrete materialist way, for

Semper would surely have been the last person to discard thoughtlessly truly creative, artistic ideas in favor of the physical-materialist imitative impulse; it was his numerous followers who subsequently modified the theory into its crassly materialist form. Nevertheless, the desire to fit things into a materialist context was evident, and in at least one place in *Der Stil*,[2] it is clear beyond a doubt that Semper is espousing the theory of the technical-materialist origin of geometric ornament, specifically in regard to the emergence of pattern from wickerwork and weaving.

Semper's theory was readily accepted in art historical circles. The historical, scientific spirit of our age, ever ready to probe in reverse the causal relationships of all phenomena, was more than charmed and satisfied by a hypothesis that could claim an origin so natural and so astonishingly simple for so eminent an intellectual sphere as that of art. Classical archaeology was especially enthusiastic, since it was groping for some way to deal with the protoclassical art that had been unearthed in Greece. Conze's work of twenty years ago is crucial in this respect.[b] This scholar, who is still the most distinguished exponent of the two propositions, applied Semper's theory to the vases of the Greek Geometric Style. His accomplishment loomed so large that there was no immediate demand to go beyond the general wording of the propositions. It was considered superfluous to examine the process any more closely or to discuss any other questions, such as which of the various weaving techniques might have been involved or which geometric motifs should be properly associated with them, etc. Only recently, as we shall see later, have there been any attempts to delve somewhat more deeply into these problems. However, the propositions concerning the spontaneous generation of the Geometric Style at various locations from weaving techniques not only went unchallenged by these efforts but actually began to receive greater support.

Let us now test the validity of the currently accepted view about the origin of the Geometric Style. The first of the two propositions asserts that the Geometric Style originated spontaneously wherever it still exists or has been discovered among the remains of earlier millennia. This is an issue, however, that cannot be settled conclusively. Consequently, at the very least, the authoritative wording of the proposition that presently makes a claim for universal validity must be declared premature. It is obviously no longer possible to observe directly anywhere in the world today how an ethnic group spontaneously acquires its linear motifs. Consequently, the proposition that geometric motifs originated spontaneously

[2] G. Semper, *Der Stil in den technischen Künsten; oder praktischer Ästhetik* (Munich, 1878–1879), 1:213, to which we shall return.

throughout the world at a number of different locations can be neither conclusively proven nor disproven. The evidence upon which a reliable judgment might have been based simply no longer exists. On the other hand, there is almost nothing at present to support the idea that the Geometric Style was diffused from one single location.[c] Even today, we still find groups of people producing highly remarkable decorative art whose extreme isolation, extending back through incalculably long periods of time, to judge from their complete lack of metals and metal implements, virtually rules out the possibility of contact with another culture. The most interesting of these people are the Maori of New Zealand, whom we will have several opportunities to discuss later on.

Only one thing can be stated with any certainty at present; based on the research done in the last few years, there are very few places that qualify as sites for the independent origin of the Geometric Style. The dates of the various findings are shifting closer and closer to our own era as rapidly as they are distancing themselves from any presumed primordial state. The same goes for what is left of the so-called northern and central European Bronze Age. Furthermore, it has become quite clear that peaceful relationships among widely scattered cultures through trade on land and sea, sometimes involving numerous intermediaries, went on from the very earliest periods.[d] Consequently, since time immemorial, there was always something available to spark the sensitive and receptive mimetic instinct. Even with regard to the Geometric Style, a great deal of interaction, at least among the cultures settled around the Mediterranean basin, is undeniable.[e] Moreover, one must now be especially cautious when dealing with the seemingly rudimentary geometric ornament of contemporary primitive cultures since, in light of F. Hirth's research about the intense relations between China and the Roman Empire, even the Great Wall has begun to develop alarming cracks.[3]

At least one conclusion emerges from all of this: the outright condemnation of those scholars who have occasionally been daring enough to assert historical relationships among the various geometric styles is, at the very least, unjustified.[f] Furthermore, it is essential to reject entirely the idea that the Geometric Style represents an absolute stage of primitiveness wherever it may happen to occur. The Dipylon Style, for example, is definitely a geometric style, but it is highly refined and by no means primi-

[3] F. Hirth, *China and the Roman Orient. Researches into their Ancient and Medieval Relation as Represented in Old Chinese Records* (Leipzig and Munich, 1885). It is interesting to note in this regard that in spite of the multitude of analogies now coming to light, no one thus far has dared to draw comparable conclusions in the field of art history.

tive.[g] Cultures are never so equally endowed with the same degree of creative artistic ability that some will not be more advanced than others. At the same time, the mimetic impulse is so powerful that there is no stopping less talented cultures from borrowing from those with more ability. Enlightened archaeological research has long taken this for granted.

The geographic problems surrounding the origin of the Geometric Style can be roughly summarized as follows: there is no compelling reason to assume that geometric motifs spread out from a single center of activity; the likelihood that there were diverse points of origin remains relatively undisputed for the time being. As far as the art of Mediterranean peoples is concerned, we should assume extensive contact and cultural interaction; we need not go into this here, since archaeologists have already proven it in great detail. Evidence derived from the geometric ornament of modern primitive cultures, on the other hand, is still too inconclusive to provide definite answers.

We can now go on to the second proposition, which claims that the characteristic motifs of the Geometric Style originated from wickerwork and textile weaving. Since Semper and Conze, this proposition has been considered infallible. As a result, no one has raised so much as the slightest objection against it. Up to most recent times, it has even been considered superfluous to examine more closely the overall process, which might have led from weaving techniques to the geometric embellishments on early Greek vases. Considering the strictly scientific methods normally followed by classical archaeology today, this unquestioned belief in the authority of the second proposition only makes sense within the context of the general characteristics of the times and the predominant intellectual tendencies of the last thirty years. By this I mean the materialist, scientific worldview, first promulgated by Lamarck and Goethe and subsequently brought to maturity by Darwin, which has left such grave consequences in its wake even in the field of art history. As a parallel to the effort to explain the evolution of the species by means of the purely physical drive for survival, there was also an effort to discover primary and intrinsically physical mechanisms for the intellectual evolution of the human race. Art obviously represented—or so one thought—a higher stage of intellectual evolution and therefore could not have been present from the very beginning. First came technology, which concentrated on purely practical matters; then, out of this experience, and only after the culture had somewhat advanced, did art appear on the scene. Wickerworking and textile weaving are considered to be the oldest mechanical skills, while the rectilinear, geometric shapes count as the oldest decorative or artistic forms. Since

their versatility and ease of execution make straight-sided geometric shapes especially well suited as patterns in simple woven objects, it seemed most natural to relate both phenomena in causal terms and to declare that the rectilinear geometric figures were not originally the result of artistic invention but were generated spontaneously by technology.

The rectilinear geometric ornaments, however, are not the only ones found on the earliest proto- and early Greek vases: there are also curvilinear forms such as undulating lines, circles, and spirals, etc., whose origin cannot be as convincingly attributed to the weaving techniques as it can for the rectilinear ornaments.[h] Consequently, a number of other crafts had to be called into action. This resulted in what has increasingly become over the past twenty years a fundamental method of classical archaeology: it consists of taking motifs whose origins could not be traced back systematically beyond a certain point and matching them up with the techniques from which, unaided by conscious, artistic invention, they had been spontaneously generated. This is the theory of the technical-materialist origin of primal art forms, which archaeology has elevated to a position of unlimited authority. Within this theory, the origin of rectilinear geometric ornaments from weaving is a mere subcategory, just as the rectilinear geometric ornaments themselves comprise but a fraction of all of the basic ornamental motifs that have come to our attention. Almost as if they had been looking directly over the shoulders of prehistoric people in their first moments of artistic inspiration, as though they had witnessed the actual materials and tools, archaeologists proceeded to point out the specific technique, be it weaving, metalworking, or stonecutting, that was responsible for each of the individual decorative motifs on the earliest vases. An enormous amount of energy was squandered on these investigations, a wide variety of combinations investigated, and as was to be expected, a wide variety of techniques suggested for one and the same motif. And just as it had been a German, Häckel, who developed Darwin's theory most systematically and authoritatively, so it was the German archaeologists who once again strode staunchly in the forefront. How far they strayed from the ideas of the actual father of the theory, Gottfried Semper, is revealed by the following excerpt from *Der Stil* 2: 87:

> The rule that the decorative aspects of a vessel are directly related to the material and mode of manufacture leads to problematic uncertainties regarding the original technique and medium of many common decorative forms. This is due to interactions among the various media, which were already influencing and modifying one another at an early stage. Therefore, it is difficult to determine whether the

consistent rendering of bands of zigzag ornaments, waves, and scrolls in painted and incised technique on the earliest ceramic vessels was derived from the same shallowly engraved embellishments on the oldest bronze utensils and metal weapons, or vice versa, or whether such patterns originally had no relation to either material. . . . *The conscious recognition and artistic exploitation of the limitations and possibilities* inherent in the various materials available for artistic activity *does not begin until an advanced stage of art.*

This is the cautious wording of an author who, as both artist and scholar knew and understood better than most others of his century the technical procedures involved in the creation of art as a larger, mutually interactive process. According to Semper, as quoted above, technology played its formative role at a more advanced stage of artistic development and not at the very inception of artistic activity. This is precisely my conviction. Nothing is further from my mind than to deny the important role that technical processes play in the evolution and further development of certain ornamental motifs, and it will always remain Gottfried Semper's most valuable achievement to have opened our eyes in this respect. Should this point become obscured or insufficiently emphasized in what follows, it is only because I have set myself the special task of refuting the exaggerated claims made for technology in regard to a particular stage of development, namely the one in which the very earliest art forms were created. I do not intend to dispute the value and significance of the materialist movement in art of the last twenty years, or even less to criticize the theory of Darwin and his followers. It is clear that the theory of the technical-materialist origin of all primitive art forms represented a necessary phase of archaeological scholarship, which, as things stood, had to be worked through. This is confirmed not only by the prominence of its first pioneers, Semper and Conze, but also no less by the fact that the theory enjoyed immediate and widespread dissemination throughout all of Germany and far beyond. Nevertheless, it is now time to admit that we have gone too far in this direction as regards art, and that serious concerns, which I will elaborate shortly, compel us to discredit this tendency to use technical-materialist premises to account for the earliest art works made by human beings.

There will be many opportunities in the following chapters to test the validity of the technical-materialist explanations for the origin of particular ornaments that have been attempted thus far. Since this chapter is devoted to the Geometric Style, however, we will concentrate on the derivation of rectilinear geometric motifs from weaving techniques.

Now, how were the motifs of the Geometric Style supposed to have emerged from the technique of weaving?

We can return to Gottfried Semper for this, since what others have said is only a hollow echo of what he imagined most vividly and stated most clearly. The crucial passage is in *Der Stil* 1:213. After he had finished discussing the wickerwork fence as the first upright spatial enclosure and the earliest wall, he continued: ". . . the shift from the plaiting of branches to the planting of basts (organic fibers) was easy and natural. Then came the invention of weaving, first with blades of grass or natural plant fibers, later with threads spun from vegetable or animal materials. The variation in the natural colors of the fibers soon prompted their arrangement in an alternating system, and in this way, *pattern* came into being."

This last sentence is crucial for our purposes. Admittedly, it is not clear if Semper was attributing the origin of *pattern* to wickerworking or to weaving, which he believed represented a higher stage of development. Moreover, he also neglected to illustrate his idea of the process with a concrete example. It is nevertheless apparent from his wording that he was not discounting the intervention of a nonmaterialist factor. "The variation in the natural colors of the fibers soon prompted their arrangement in an alternating system." Therefore, it was not pure chance that brought the first pattern into the world; someone had made a conscious, "prompted" choice of the variously colored fibers whose interweaving in rhythmic alternation, "in an alternating arrangement," subsequently produced a pattern. Consequently, human beings are explicitly granted a creative, artistic contribution to the whole process. The passages in *Der Stil* in which Semper stands in direct contradiction to the technical-materialist interpretation are, incidentally, not at all rare. Later we shall address another instance of this kind, which concerns something very fundamental and which, moreover, occurs frequently.

As already stated, Semper did not attempt to demonstrate in detail how the most common motifs of the Geometric Style actually came into being as a result of the fortuitous intertwining of fibers, and neither did his numerous followers, with the exception of Kekulé, whose recent efforts will soon receive our special attention. The reasoning for how it took place, however, goes something like this: in the beginning there were handicrafts (not in an economic but a technical sense), but there was no art. Weaving was the earliest handicraft. The two-dimensional, rectilinear decorative motifs came into being via the wickerwork fence and woven cloth and were then applied to other materials and techniques by human beings who were captivated by their formal beauty.

The materials generally used to illustrate this theory are predominantly ceramic and, to a lesser extent, metal. The ornaments of the clay vases and potsherds found in the prehistoric strata in almost all Mediterranean countries are mainly in the Geometric Style. If these ornaments really can be traced back directly to the interweaving of wickerwork and to the criss-crossing of threads in textile weaving, then they must date back to a very, very early period. After all, the emergence of pattern from wickerwork and weaving is supposed to have taken place at the very inception of all artistic activity. Now the question arises: do the ceramic remains from the Mediterranean area actually date back even remotely to such early times?

The Dipylon Style, which was formerly thought of as the Geometric Style in its narrowest sense, is no longer considered by anyone to be particularly ancient. At present, it still remains to be seen whether the tribes responsible for its spread to Greece—let us assume they were the migrating Dorians—actually did invent the style from weaving in some bygone age. Be that as it may, the Dipylon Style of the first millenium B.C. is by no means a rudimentary style of art; on the contrary, it is well calculated, consistent, and refined. A culture that knew how to work metal would not have invented the most primitive ornaments from the most primitive technique.[i]

However, the excavations of Schliemann and others have shown us that the Dipylon Style was by no means the earliest Geometric Style produced around the Mediterranean. The oldest geometric motifs are now considered to be the engraved linear decorations found on vessels from the lowest strata of Troy-Hissarlik and from certain burial sites on Cyprus. And how old are these vessels? According to excavation reports, the period involved was immediately followed by the Mycenaean Age, and according to the most recent and reliable opinion of scholars in the field, the Mycenaean Style dates from approximately the second half of the second millenium B.C.[j] Therefore, the engraved geometric decorations from Cyprus and Hissarlik cannot be any earlier than the third millenium B.C. Is this the period then to which we should assign the first invention of pattern in the Mediterranean area? What of the art of the Nile Valley, which had flowered at least a thousand years earlier and already advanced far beyond the geometric stage? Obviously, the assumption that the geometric decorations found on Mediterranean potsherds were borrowed from textile art is completely arbitrary and unsupported. There is no evidence available today that dates back even remotely to the age in which the first pattern came into the world—with the single exception of the discoveries in the caves of Dordogne, to be discussed shortly. If we are to believe the

theory that textile technique generated the earliest patterns, then it must be demonstrated and proven by something other than the potsherds found around the Mediterranean. And should it turn out that the vase ornaments in question are indeed based on the technique of weaving, then the period in which the conversion took place would have to date back thousands of years earlier than the available vases.[k]

To be sure, cultures vary enormously in artistic ability—a discrepancy that can only partially be explained by external conditions such as climate and geography. However, it is futile to search for a group of people on the island of Cyprus around 2000 or even 3000 B.C. who were ignorant of or disinterested in design, but who then spontaneously rallied to create two-dimensional patterns, just as it is futile to interpret the geometric ornaments on vases found in the ruins of Assyria or Jerusalem from the period of the greatest artistic flowering in the Near East as direct translations of textiles. Moreover, it will be even more difficult than it was in the case of Mediterranean potsherds to claim the clay and metal objects from the north and central European Bronze Age, decorated with similar geometric motifs, as evidence of the direct carryover of linear ornament from textiles to other materials, since according to epoch-making discoveries still being made they are even later than, and often dependent upon, the Mediterranean examples.[l]

Consequently, there are no monuments to substantiate the period and the process in which pattern supposedly originated from textile technique. Nothing proves that the prehistoric finds from the Mediterranean region and northern Europe represent the earliest artistic activity in those areas and that there could not have been a totally different kind of art produced at the same sites even earlier. There is, as a matter of fact, evidence that directly contradicts the assumption that the Geometric Style was the earliest style of art in Europe.

We now know beyond a doubt that there were groups of human beings who developed a highly remarkable form of art even though they never possessed a textile technology, except for sewn animal skins. They were apparently able to protect their bodies, to meet the elemental need generally considered to be the impetus for textile art, supposedly the first and earliest technique, without resorting to wickerwork enclosures and woven clothing. These groups of people lived in caves and clothed themselves with the skins of the animals they hunted. Their low cultural standard can be gauged from the fact that they sucked the marrow from the bones of the animals they killed and left the uneaten meat to rot in the caves. We are confronted by a form of cannibalism. The many needles of animal and fish

bone that have been discovered show that these cave dwellers were able to sew skins together using the sinews of animals, as the grooves often found on leg bones serve to demonstrate. One might be tempted to interpret the zigzag pattern as the spontaneous product of the sewn seam, were it not for evidence that proves that the cave dwellers were capable of far greater and much more accomplished things, for these quasi cannibals with their roughly hewn, unpolished axes, practiced a genuine and unquestionable form of sculpture.

The carvings (fig. 1) and the engraved reliefs (fig. 2) on animal bones that have been discovered at several locations in western Europe, especially in the caves of Aquitaine, and whose authenticity has been largely established beyond any doubt by the very precise and conscientious excavations and records of Lartet and Christy, have already been known and published for a number of decades.[4] Up until now, however, only anthropology has taken proper notice of these objects, while art history has chosen to ignore them. I will admit that Georges Perrot was completely justified when he explained in his introduction to *Histoire de l'art dans l'antiquité*[4a] that they were outside the realm of his historical context and that he was therefore forced to omit them. And it is quite true that, as far as we can tell at the moment, the discoveries made in Aquitanian caves have nothing conspicuously in common with the development of antique art. One can take any one of the oldest ceramic potsherds with geometric motifs and discover more historical points of contact with later Hellenistic art there than on the best carved handles and engraved animal figures from Dordogne. These objects, therefore, apparently represent an isolated development—isolated at least in regard to later Mediterranean art. On the contrary, the history of antique art usually focuses on the kinds of art that were either interacting with each other from the very beginning of the development or began to influence each other over time. It investigates the constant exchanges that went on between East and West, and how these influences joined forces to produce the ultimate goal of all the arts of antiquity: the creation of an international Greco-Roman art. And as far as we know, the art of the cave dwellers of Aquitaine never had anything either directly or indirectly to do with this development.

[4] Consult in particular E. A. Lartet and H. Christy, *Reliquiae Aquitanicae; Being Contributions to the Archaeology and Palaeontology of Périgord and the Adjoining Provinces of Southern France* (London, 1875); furthermore, the *Dictionnaire archéologique de la Gaule, époque celtique*, Commission de la Topographie des Gaules (Paris, 1875), from which figures 2, 3, and 6 have been taken; and the concise summary of the enlightened A. Bertrand, *La Gaule avant les gaulois d'après les monuments et les textes* (Paris, 1884), the source of figure 1.

[4a] [G. Perrot and C. Chipiez, *Histoire de l'art dans l'antiquité*, vol. 1, (Paris, 1882).]

Even though there seem to be sufficient and compelling reasons to explain the indifference of historians of ancient art toward the discoveries from the caves of Dordogne, this is certainly not the case for historians of the technical arts who, one assumes, are fundamentally and intensely committed to clarifying the (allegedly technical) origin of art. And here we have examples of art that date back to a stage of human culture that cannot even be estimated.[5] Furthermore, there is no reason to assume that any of the European and west Asiatic cultures that produced the Geometric Style were still on the barbaric cultural level represented by the cave dwellers of Aquitaine. Now, it would be very unfair to the scholars who are selflessly and conscientiously devoted to the scholarly investigation of these problems to suggest that the evident difficulty of fitting these figurative carvings and engravings into the theory of the technical-materialist origin of art is responsible for the undeniable and dogged silence on the subject. Surely they see these works as expressions of an isolated, bizarre phenomenon that no one can as yet explain, but that will in time and after further excavations find a satisfactory interpretation. Those of us who represent a different point of view, however, and who harbor doubts about the universal validity of the theory of the technical-materialist origin of art have a stake in becoming more familiar with what may well be the earliest artworks ever discovered. And even if a scholar as circumspect and knowledgeable about ornament as Sophus Müller is capable of saying that "an interpretation of Paleolithic art will never be able to rise above the level of uncertain hypotheses because of the meager amount of material,"[6] our response is that at least some evidence is finally available—and the amount could be even more meager than it actually is. The popular theory of the technical derivations of primal motifs, on the other hand, is left hanging in midair since its supporting evidence does not date back to this remote period of origin. Now, what kind of art did the semicannibal cave dwellers of Aquitaine actually produce?

The best place at present to get an overall impression of the art of the cave dwellers is in the collection of the Musée des antiquités nationales in the old castle at Saint-Germain-en-Laye, where almost all of the objects found to date are exhibited either in the original or in plaster casts. The

[5] The problem of whether or not cave art was produced while there were still mammoths in France, or later, during the period associated with the reindeer, is irrelevant in our case. No one disputes the fact, which is geologically verified, that the Paleolithic period or Old Stone Age dates back much earlier than the proto-Greek, Geometric finds treated by classical archaeology, or the finds from the Bronze Age.

[6] S. O. Müller, *Thier-Ornamentik im Norden. Ursprung, Entwicklung, and Verhältnis derselben zu gleichzeitigen Stilarten* (Hamburg and Leipzig, 1881), 177.

material involved is almost exclusively animal bone, mostly reindeer, and the main technique is carving or engraving. It is very enlightening to observe the relationship that exists between the techniques of carving and engraving on these earliest of artworks. There are many fully round objects, such as handles of weapons or knives carved in the shape of a reindeer (fig. 1).[7] There are even frequent repetitions of the same motif. Then comes a whole series of developmental phases during which the sculptural characteristics gradually disappear: at first, three-dimensional sculpture becomes flattened, then various degrees of high relief are followed by low relief, finally resulting in pure engraving (fig. 2), which is frequently combined with low relief as one merges into the other.[m]

This corresponds exactly to the natural development established at the beginning of the chapter in a purely speculative way. The earliest works of art are sculptural; consequently, all artistic activity begins with the direct reproduction of the actual physical appearance of natural things in response to an imitative impulse that has been spurred into action by a psychic process to be described below. Since things in nature, however, are only seen from one side, relief sculpture began to satisfy the same purpose; it renders just enough of the three-dimensional appearance of a thing to convince the human eye. Subsequently, two-dimensional representation was established and led to the idea of the outline. Finally, sculptural qualities were abandoned all together and replaced by drawing.

Fig. 1. Carved reindeer bone spear thrower from Laugerie-Basse, detail of handle.

[7] The well-conceived way in which the forelegs conform to the shape of the animal's torso without ruining the naturalistic effect deserves considerable attention, according to Lartet, moreover, this piece remained unfinished.

Fig. 2. Engraved reindeer bone from La Madeleine.

The most important part of the whole process is undoubtedly the appearance of the outline, which captures the image of any entity in nature on any given surface. This is the moment when line, the basic component of all drawing, all painting, and in fact, all art that is restricted to two dimensions, was invented. And this was the step that the cave dwellers of Aquitaine had already taken, even though they had never seen the interwoven threads of textile art or felt the need for them. Technical factors surely played a role as well, even within the process described above, but it was by no means the leading role that the supporters of the technical-materialist theory of origin assumed. The impetus did not arise from the technique but, on the contrary, from the particular artistic impulse. First came the desire to create the likeness of a creature from nature in lifeless material, and then came the invention of whatever technique was appropriate. A carved reindeer on the hilt of a dagger certainly does not make it any easier to handle. Therefore, it must have been an immanent artistic drive, alert and restless for action, that human beings possessed long before they invented woven protective coverings for their bodies, and that impelled them to carve bone handles in the shape of reindeer.[11]

Before proceeding to describe the nature of this drive in more detail, however, we should take another look at the evolution of two-dimensional decoration from sculpture in order to show that there is nothing at all outlandish about our assertion.

For example, a glimpse at ancient Egyptian art, an art that dates back further into the human past than any other in antiquity, corroborates what we have just described. The images in the tombs of the Old Kingdom are painted reliefs *en creux*. It is only in the art of the Middle Kingdom, such as in the rock-cut tombs at Beni Hassan, that we encounter pure, two-dimensional figurative painting, even though the transition from relief to painting had already begun in the Old Kingdom. Our assertion is further confirmed when we step back and examine the history of art as a whole.

Sculpture, for example, has never flourished again as it did in the days of Pheidias; since the Hellenistic period a more or less strong painterly element came to exert itself upon sculpture, indeed emerging as a dominant trait of the period and its art. The development of modern art convincingly illustrates that there is no turning back from this order of events, but that everything gravitates toward the refinement of painting and its greater potential for representation.[o]

The techniques employed by the cave dwellers of Aquitaine are not, strictly speaking, peculiar to the so-called applied arts and crafts but are much more characteristic of so-called fine art, namely figurative sculpture. This fact reveals how senseless and unjustifiable it is from the scholarly point of view to make such a distinction. The same is true for content, since as we have seen, cave art consists mostly of reproductions of creatures from nature, not insignificant, "purely ornamental" two-dimensional designs. The animals depicted on the various implements were either a source of food or a source of danger: reindeer, horses, bison, goats, cattle, bear, and fish. We also find the human figure, both engraved and in the round, but rendered much more awkwardly than the animals: an ubiquitous phenomenon in primitive art.[p]

The objects discovered in the caves of Dordogne, therefore, overwhelmingly contradict the general assumption that the purely practical technique of weaving represents the first creative activity, since they are executed specifically in the kind of techniques where the subject and artistic content are already determined before the material is worked. The reason for shaping the material into an animal, whether in three or two dimensions, was purely artistic and decorative. The intention was specifically to decorate the tools. It is the urge to decorate that is one of the most elementary of human drives, more elementary in fact than the need to protect the body. This is not the first time such a proposition has been made; Semper himself expressed it several times.[8] It is thus even more difficult to understand why, in the face of all this evidence, the origin of creative activity is still believed to postdate the invention of the techniques used to create protection for the body. Do we not still encounter Polynesian tribes today who do without any form of clothing, while they tattoo their bodies from head to toe, thereby making full use of linear

[8] He states in the same passage cited above from *Der Stil* (1:213): "The art of covering the nakedness of the body (*excluding the painting of the body itself* [Riegl's emphasis]) is presumably a later invention than the use of protective surfaces for shelters and spatial enclosures." *Der Stil* contains the statement: ". . . the adornment of the body itself for cultural, philosophical reasons initially activates the sense of beauty" (2:466).

decorative motifs?[9] Unfortunately, we have no way of knowing whether the cave dwellers of Aquitaine tattooed their skin as well; there is, at any rate, no evidence for it on their representations of human figures. We know for certain, however, that they wore jewelry. Otherwise, what would have been the purpose of the large number of perforated cattle and bear teeth found in caves partially engraved with animals except to be strung on a sinew or strip of raffia and worn around the neck? Here people are already following the elementary artistic principle of arranging things in rows and, moreover, without any inspiration from crisscrossed fibers, since the cave dwellers apparently had not felt the need to invent and practice the technique of weaving. The same goes for symmetry. Already Lartet and Bertrand noted symmetrically arranged ornaments in relief on a tool that Lartet believed was used for scooping out marrow.[10] However, there are also ornaments on the objects produced by the Aquitanian cave dwellers, which are based on pure rhythm and abstract symmetry. In other words, there are also examples of the linear motifs of the Geometric Style.

Zigzag lines occur on engraved reindeer bones (fig. 3).[11] They are arranged in rhythmic variations of the so-called fish-bone pattern, which include sets of three dashes alternating with each other, networks of crossed lines (the pattern supposedly most closely connected to weaving), and crosses arranged on their sides in rows, as well as many others. They have obviously not been copied from nature but are purely decorative patterns intended to adorn a given surface. Their creation was guided by the same desire to decorate, or *horror vacui*, that informed the animal images. It is important to note, however, that these geometric "patterns" are far fewer in number than the animal images. Whoever agrees that this preference for animal images is not accidental must concede that they predate geometric patterns and acknowledge that the creative drive in

[9] Semper's statement in *Der Stil* (1:92), contradicts what was quoted above: "The motifs on the skin of these people consist of painted or tattoed *threads*. . ." He mitigates this contradiction by explaining that tattooing might not be characteristic of a primitive, but of a more advanced state of culture. This assumption, once again, only makes sense within the context of Semper's frequently expressed idea about the perfect original state of the human race. How does this idea, however, fit in with the theory of evolution and its accompanying technical-materialist theory of the origin of art?

[10] Bertrand, *La Gaule avant les gaulois* (66): ". . . porte des ornements en relief disposés symétriquement et d'un très bon goût." See also Lartet and Christy, *Reliquiae Aquitanicae*.

[11] Publications to date have naturally devoted considerably less attention to geometric decoration than to the astonishing carvings. Figure 3 is a relatively good example of the ones published in the *Dictionnaire archéologique de la Gaule*; however, the patterns on the objects not yet published are far better and much stronger than the perfunctory zigzag in figure 3.

Fig. 3. Marrow spoon of graved decoration from Laugerie- Basse.

primitive people initially expressed itself primarily in sculpture. How then did these patterns come into being? The cave dwellers were obviously not familiar with the crisscrossed fibers and threads of the weaving technique that are supposed to have provided the model. But there is really no need to assume this familiarity in the first place, since we have already described how the cave dwellers' experience with sculpture might have led them to invent the line, which is the basic component of all two-dimensional drawing and surface decoration. The invention of line apparently took place during the natural course of an essentially artistic process. Consequently, the cave dwellers were already well acquainted with lines. All they needed to do was to arrange them according to the principles of rhythm and symmetry with which, as we have likewise seen, they were just as familiar. Anyone who can string bear's teeth into a necklace can do the same with engraved lines. The Geometric Style of the cave dwellers of Aquitaine, therefore, was not the material product of a handicraft but the pure fruit of an elementary artistic desire for decoration.

All of art history presents itself as a continuous struggle with material; it is not the tool—which is determined by the technique—but the artistically creative idea that strives to expand its creative realm and increase its formal potential. Why should this situation, which obtains throughout the history of art, have been any different during its initial stages?

The surviving cultural data concerning the artistic activity of the earliest, apparently semicannibal people does not require us in any way to assume a technical-materialist origin for art, and especially for decorative motifs of the Geometric Style: in fact, the evidence directly contradicts such an origin.

In light of this conclusion, it is no longer necessary to speculate about how, for example, one geometric motif or another arose spontaneously from one of the weaving techniques and then was applied to another material in a different technique. We have already seen that weaving by itself could not satisfactorily account for the origin of all geometric ornaments in every case, and that other techniques had to be pressed into service, especially metalworking, which presupposes a relatively advanced level of culture. We will be examining specific examples of this kind of scholarship in the following chapters. However, because at this point we have only dealt with the weaving techniques, which dominate the whole controversy, we will now turn to the one and only concrete attempt ever made to explain in more than simple generalities precisely how geometric ornamental motifs may have been transferred from weaving techniques to other materials, in this instance, specifically to ceramics.

During the July session of 1890 of the Berliner Archäologischen Gesellschaft, Kekulé made a preliminary report, which he intended to follow up with a more detailed account. To date, nothing further has appeared beyond the minutes of the meeting, which were later published in the society's *Anzeiger*.[11a] Since the limited context unfortunately allowed for little more than generalizations, the following response remains general as well.

Kekulé began with the ethnological premise that basket weaving was practiced considerably earlier than pottery making. He found that "within the so-called Mycenaean style on so-called Dipylon and Cypriote vases and related examples, as well as on ancient Rhodian and Melian ceramic vessels and the like, shapes resembling baskets often coincide with decoration analogous to that of basketry." As a result, he went on to conclude that "the first definite models for the vases and their decoration were actual baskets and basket-weaving motifs." Kekulé almost seems to place more weight on the derivation of the shapes of the vases, which he insists directly imitate baskets, than on the origin of the geometric ornaments from basket-weaving motifs. The woven objects he cites as evidence are, of course, almost without exception of more recent date, although rather comprehensive.

First of all, even though the ethnological premise assumed by Kekulé may have some merit, the issue is far from settled. I for one would not feel the least bit inhibited if I were suddenly asked to model, as best I could,

[11a] R. Kekulé, "Ursprung der Form und Ornament der ältesten griechischen und vorgriechischen Vasen," Sitzungsberichte der Archäologischen Gesellschaft, in *Archäologischer Anzeiger* (July 1890): 106–7.

wet clay into a vessel that looked something like a cupped hand or a hollow gourd. On the other hand, I would surely be at a complete loss if I were expected to weave a basket. Furthermore, the baskets used as evidence by Kekulé are not indisputably the earliest examples of their kind or of a primitive stage of basket weaving. Just as there is an art of pottery making, there is also an art of basket weaving, and it is in this category that the exotic examples of basketry cited by Kekulé belong. He is unquestionably justified in praising their beauty and their sensitive style; however, their complicated, diagonally woven patterns are obviously not the result of pure technique. Nevertheless, let us assume for a moment that human beings actually did weave baskets before they modeled clay bowls. Even in this case, would baskets have been the only available prototypes for ceramic vessels, or could something else have served this purpose? The main function of clay pots, which distinguishes them from baskets, was to store liquids. Forerunners in nature with the same function include the cupped hand and fruit rinds; therefore, there were already models with rounded shapes available for clay pots even without the help of baskets. Furthermore, rounding off clay vessels made them easier to handle even before the invention of the potter's wheel finally established the circular form as a "technical" postulate. Indeed, a four-sided shape is more appropriate to basketry technique than to ceramics. Now we reach a point where, regrettably, the minutes of the meeting provide only a spotty account of Kekulé's ideas. He states that, "one can easily conceive of other shapes for clay vessels that would be just as appropriate as the ones that have in fact been selected and developed; moreover, the aesthetic explanations for these shapes that have been advanced are inadequate." My only response is that the section in *Der Stil* to which Kekulé is obviously referring remains, in my opinion, one of the most persuasive chapters in Semper's work, particularly because Semper did not just pursue "aesthetic interpretations" but also took into account the factor of experience in quite a direct and convincing manner. Undoubtedly, Kekulé had something very definite in mind when he made this statement, and this is why it is so important that his observations be published in full and made available to the public. The only two points he does make are not difficult to refute. He goes on to claim that "in basket weaving, for example, it is perfectly natural to take the main round part of the vessel, which is open at the top and narrower at the bottom, turn it upside down, and repeat it on a smaller scale for the base; the same shape is then repeated a second time to serve as a lid, surmounted by a knotted button of raffia—there is no real reason for the potter to choose these very forms." First of all, vases

with foot rings are simply more stable than those without them; they are required on baskets as well as on vases for obvious practical reasons. Second, as difficult as it may be for us today to reconstruct the thinking of primitive potters, it would be far more difficult for us to come up with a lid that would be more natural to the potter than the one described above. The following statement is just as farfetched: "No potter could ever have independently come up with the flatly rounded handle forms which, for example, are conspicuous on ancient Boeotian bowls."[q]

Enough said about the relationship of the earliest vase shapes to baskets. Let us now turn to the problem of how the most common ornamental vase motifs were derived from those of basket-weaving. Unfortunately, Kekulé's remarks on the subject are even more meager than they were in regard to shape. "The mere outward appearance of the ornament on many handles plainly points to its origin." This, as it turns out, is the most specific comment in the entire report; the handles referred to here are the ones sculpted or painted to resemble twisted rope and frequently seen, for example, on beaked pitchers and anthropoid vessels, though by no means on the very earliest, truly prehistoric vases. No reasonable person will deny that the transfer of motifs from one medium to another did occur from time to time. However, such transfers were surely the products of more mature and refined stages of artistic development already involved in exploiting the rich variety of available formal and technical possibilities; they were not the necessary result of an imitative stage of art struggling to rise above its humble beginnings. Let me repeat what I have said before: almost all of the surviving vases that Kekulé used as the basis for his investigations are relatively late and do not come remotely close to prehistoric times. How likely is it that the Mycenaeans, who were capable of elaborate metalwork, would have taken the time to copy forms and ornaments produced by the most primitive handicrafts? And to think that the Dipylon Style is later than Mycenaean art! Even if there were sufficient evidence to prove that the forms and ornaments in question could only have originated on woven baskets, it would still be nothing short of miraculous that ceramics should cling tenaciously and atavistically to them from a presumed primitive period right up to the illustrious centuries of Mycenaean culture. We have, however, discovered basket-weaving motifs on the bone carvings of a people who had no knowledge of and no need for the art of weaving, just as we found by purely speculative deduction that two-dimensional combinations of lines based on the principles of rhythm and symmetry do not have to be inspired by the physical stimulus of a woven mat in order to come into being.[r]

Although I must admit that I am not persuaded by Kekulé's argument, at least not by the abridged version currently available, I do not in the least intend to deny his significant and enlightening investigations the respect that they deserve.

> The existence of a repertory of ornamental forms, which are, of course, predominantly of technical origin and derived mainly from the weaving techniques as well as from braiding and embroidery, has often been assumed. Next comes the bronze technique, and from these various techniques arose a bewildering number of individual ornaments and systems of ornament, which have either been collected and transmitted by a particular ethnic group or gathered gradually into an abstract repertory of forms in some other manner, and were then available for a variety of uses. This abstract repertory of forms was then quite superficially applied at will to the surface of clay vessels.

The condemnation of the twenty-year hunt for techniques contained in these words of Kekulé represents the most substantial advance in the field of classical archaeology that has been made since Conze first made clear the importance of the geometric category of early Greek vases.

The question still remains as to why purely geometric "patterns" or linear decorations have survived so persistently on textile products like weaving and wickerwork right into our own time. It is no doubt because these patterns are best suited to textile technique, or better said, because it is more difficult in these techniques to go beyond angular, linear patterns. As is well known, weaving in particular finally did succeed in creating roughly rounded shapes: the human artistic impulse has always aimed unswervingly at transcending technical limitations. At the same time, however, the geometric patterns that could be executed with less effort remained continuously in use, particularly in minor arts. The late antique weaving workshops in Egypt are a good example. There was no curvilinear form that the Egyptians could not execute, and yet it is always the Gamma, the Tau, and other geometric patterns that decorate hems and simple borders, especially on the less prominent parts that served mainly as binding or neutral trimming. This was not because they were throwbacks to the erstwhile primary, weaving motifs but simply because they were the easiest and simplest motifs to represent.

Rectilinear geometric motifs arranged according to the principles of rhythm and symmetry do indeed seem to be most appropriate for the simpler types of textile art. This does not at all imply, however, that these

patterns were originally peculiar to textile technology alone, which then, so to speak, gave birth to them. No one today is in a position to say whether the earliest linear ornaments, as they appear, for instance, on the tools of Aquitanian cave dwellers, were first incised on bones, carved into wood or fruit rinds, or tattooed on the skin.

Contrary to current opinion, I do not find it at all unnatural that the geometric decoration of the so-called Bronze Age should have succeeded the figurative carvings and engravings of the Stone Age.[12] Once the possibilities of line and of its various rhythmic and symmetrical combinations on a plane were recognized, it is easy to understand why they were particularly singled out for surface decoration: they were simply easier to create than the silhouettes of animals or human beings. Moreover, figurative shapes could still be executed in sculpture. However, the simpler, more easily-rendered ornaments readily sufficed as decoration for the countless tools and vessels required by advancing civilization, especially for ceramic examples. These included the geometric motifs, which were first incised and then sketched in paint on ceramic vases. It was not until the next great stage of artistic development that the Geometric Style was abandoned or at least relegated to cheap, mass-produced objects. One of the distinguishing characteristics of this next stage is the introduction of ornamental vegetal motifs. What is extremely enlightening to note in the context of our present discussion is that once plants were established in the repertory of decorative motifs, they—the lotus especially—were immediately geometricized, and clearly because of the technical and artistic advantages inherent in two-dimensional shapes. Animal and human images were occasionally reduced to the Geometric Style even earlier than vegetal motifs. The works produced by the cave dwellers, which we examined earlier, however, prove beyond a doubt that these geometric stylizations were not simply a result of technical necessity or inability; these works aimed unmistakably to capture as much as possible the actual appearance of animals and human beings in the silhouette. Originally, human beings

[12] Hjalmar Stolpe seems to have discovered an analogous process in the ornament of certain Polynesian island people: first, human figures carved out of wood are increasingly stylized. Finally, the various parts of the figures, which have been reduced to geometric lines, are used as independent motifs that can be repeated and rhythmically arranged in rows. Stolpe's article first appeared in the Swedish journal *Ymer* and then, translated into German, in *Mittheilungen der Wiener Anthropologischen Gesellschaft* pamphlets 1 and 2, (1892). Stolpe's tendency to concentrate on narrow, isolated aspects of ornament for his studies and to temporarily ignore large, universal issues seems to me to be the only sensible thing to do in a field like ethnology where only a small amount of rather unsystematic work has been done in regard to art. For this reason, the results of his research, as recorded in the article I have cited, are quite admirable.

and animals were consciously stylized into linear patterns, just as geometric ornaments were conscious combinations of lines arranged according to the principles of symmetry and rhythm.[s] That is why it is incorrect, as one is often inclined to interpret geometricized figures like those of the Dipylon vases or the art of primitive peoples as the vestigial remains of a supposedly primal geometric style arising from textile technique. On the contrary, geometricized figures, no less than pure geometric shapes, were the result of an artistic process that had already progressed beyond any primary state, a process that was by no means primitive.[t]

The use of geometric configurations for symbolic purposes represents a doubly advanced stage of development. Because of the sensual character of all primitive nature religions, it is certain that symbols such as the swastika were originally associated with actual prototypes in nature. Therefore, the geometric stylization of natural forms in art must have preceded the formation of symbols. Seen in this light, symbolism may have originally been nothing more than fetishism. Whereas fetishes are either objects appropriated from nature itself or, if manufactured, still retain the appearance of something in nature, symbols very often lose their resemblance to nature through geometric stylization. This is why it is so difficult to distinguish ornament from symbol, a problem that has received little attention to date, and then almost exclusively from dilettantes. The problem opens up a vast field of potential research for astute scholars, although at the moment it appears doubtful whether anyone will ever succeed in finding any satisfying solution.[13, u]

Now that we have completed this digression into the obscure intermediate period between the creation of geometric decorative forms (artistic level of the cave dwellers) and their refined use in proto-Greek styles, let us return to our main theme. We can now discard the second of the two propositions generally considered valid for the Geometric Style, the claim that most geometric motifs originated from the textile techniques of wickerwork and weaving in a purely practical, materialist way. Do we really lose much by doing so? The theory, now hopelessly outdated, has never been able to explain the actual source of the pleasure that human beings, according to the proposition, derived from the rhythmic interweaving of threads; nor does it explain what induced them to repeat the patterns in other materials even when it was no longer technically necessary. As a

[13] Noteworthy attempts in this direction, among others, have been made by H. R. Hein, *Mäander, Kreuze, Hakenkreuze und urmotivische Wirbelornamente in Amerika* (Vienna, 1891).

result, the whole theory appears simply as a function of the materialist worldview and its physical-material explanation of human intellectual expression. It is an attempt to advance this view a step further. But why take such a step at all only to have to admit finally that it will not reveal the true nature of the issue? Our counter argument has rested from the very outset on the assumption that whatever capacity allows human beings to take pleasure in formal beauty—a phenomenon we can no more define than the proponents of the technical-materialist theory of evolution—also enabled them to create combinations of geometric lines freely and independently without the intervention of material factors, the emphasis on such factors ultimately does nothing to clarify the situation; at most it serves only to confirm in some small way the seeming validity of the materialist worldview.

In order to avoid any misunderstanding, I would like to stress once again that I consider Gottfried Semper in no way responsible for the subsequent interpretation and extension of his ideas as described above. He was not at all intent on finding the supreme materialist explanation for the earliest forms of human artistic expression. His cherished theory, advancing a principle of dressing as the origin of all architecture, caused him to exaggerate the status of textile arts over other media, something that we can no longer prudently accept. Following his own line of thinking, he began to describe primitive stages of art in terms of textile concepts and aesthetic distinctions such as cover and border, which can only be applied to more advanced and refined periods of artistic activity. Therefore, we must subsequently return to Semper's overestimation of textile art in more detail; notwithstanding, the passage in *Der Stil* that discusses the topic is still well worth reading, even if it is no longer authoritative.

◇

The Heraldic Style

The common identification of textile ornament with surface decoration as a whole has resulted in a further set of misconceptions. One of the most deeply rooted of these, which still commands boundless respect today, involves the system of ornament based on the symmetrical grouping of opposed pairs.

Ernst Curtius[1] was the first to distinguish between a *Carpet Style* and *Heraldic Style*. He defined the Carpet Style as the kind of surface decoration where, for example, animals are arranged in regular rows that in turn are superimposed one above the other. The Heraldic Style, on the other hand, consists of paired animals arranged symmetrically to either side of an intervening central element.

What Curtius calls the Carpet Style actually has nothing to do either with textile art generally or with tapestries and carpets in particular.[1a] The most obvious means of decorating any given surface (and it need not be a woven one) is to divide the area into a number of horizontal registers and then to arrange the various ornaments within them. Historically, this *decorative arrangement in registers* already occurs in ancient Egypt in the rows of figurative scenes arranged one above the other on the walls of tombs as well as in Assyrian art,[2] and it recurs repeatedly in the most highly developed styles of later periods.[3] In order to justify the term Car-

[1] E. Curtius, "Über Wappengebrauch und Wappenstil im griechischen Alterthum," *Akademie der Wissenschaften zu Berlin, Philologisch-historische Klasse. Abhandlungen* (1874): 53–120.

[1a] [Both Riegl and Curtius had in mind a programmed setup of harnesses and treadling that can be used to repeat similar designs along the width of the warp usually on a horizontal loom. They saw such an apparatus as essential to the production of tapestries and Sassanian Persian silks. Riegl then contrasted this relatively mechanical technique, which is more accurately described as overshot pattern weaving, to that of Gobelin, where each color of the weft is set in by hand to produce free designs oriented to the length of the warp and usually produced on a vertical loom. This distinction must be kept in mind, because the present use of the word "tapestry" in English is almost exclusively associated with the freer Gobelin technique.]

[2] For example, see Sir A. H. Layard, *The Monuments of Nineveh: From Drawings Made on the Spot by Austen Henry Layard*, vol. 1 (London, 1849), pl. 23, on the lower part of the garment of the figure furthest to the right, with individual, purely geometric motifs.

[3] According to T. Schreiber, *Die Wiener Brunnenreliefs aus Palazzo Grimani, Eine Studie über die bildende Kunst in Alexandrien* (Leipzig, 1888), 84, this kind of decorative arrangement in registers was also standard for Hellenistic decorative art.

pet Style, one must first demonstrate that this type of decoration was first applied to textiles of this kind. But if, in keeping with the discussion in chapter one, we abandon the unproven and dogmatic proposition that weaving techniques gave rise to the earliest surface decoration, then a history of ornament can be written that accords no more importance to the various kinds of weaving than, for example, to mural painting, engraving, enameling, and the like. It would therefore be just as permissible—and perhaps more justified—to speak of the decorative arrangement in registers as the Carved Style or the Engraved Style, since human beings had been decorating surfaces in these techniques for at least as long as they had been using the medium of carpet weaving.[a]

As regards the symmetrical grouping of pairs of animals and the like about a central element, Curtius expressly states that his study of Sassanian textiles prompted him to trace the origin of the Heraldic Style, no less than the Carpet Style, back to the art of weaving.[4] The proof, as he sees it, comes from the technical requirements of the color worker (by which he obviously meant the weaver), who also seeks, for technical reasons, to fill up a surface as much as possible with a constantly repeating pattern that avoids long, loose threads on the back and exposes the precious weft threads on the right side. There are, however, examples of Orientalizing Greek vase painting and metalwork that exhibit the same heraldic arrangement of the main motif, as well as backgrounds that are amply filled with designs.

Such heraldic ornament occurs quite frequently on Assyrian works of art (fig. 4),[5] and since early Greek art was demonstrably receptive to Oriental influences, the conclusions that classical archaeology naturally drew from Curtius's hypothesis readily emerged. One of the more renowned classicists, who is also most familiar with the related material in the ancient Near East, recently summarized the prevailing scholarly opinion on the subject as follows: "The typology of ancient Near Eastern imagery

[4] E. Curtius, "Das archaische Bronzerelief aus Olympia, " *Akademie der Wissenschaften zu Berlin. Abhandlungen* 3 (1879): 23. The esteemed "Nestor" [senior member] of the Berlin School of Archeology, which has made so many brilliant contributions, must forgive me if I refer to papers that he wrote quite a while ago and that may perhaps no longer represent his present opinions. These essays, however, as subsequent literature has shown, have been widely influential in archaeology, so that I have no other recourse but to refer to the author who first brought the theme to public attention. Moreover, the context of my remarks in this and the previous chapter clearly demonstrate my conviction that the theory set up by Curtius about the Tapestry Style and the Heraldic Style, among others, is rooted in the general trend of the time. In this respect, this highly respected scholar has done us a service in carrying such notions to their logical conclusions, for only in this way, can one clarify the ideas further.

[5] From Layard, *The Monuments of Nineveh*, vol. 1, pl. 45, no. 3 [from the garment of a eunuch represented in the reliefs of Room G in the Northwest palace at Nimrud].

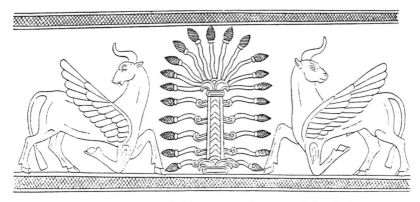

Fig. 4. Assyrian relief from Nimrud, engraved detail of
Heraldic Style composition with winged bulls.

depends, for the most part, on the woven patterns of the great wall hang-
ings, as do many of the stylistic features of its sculpture: the exaggerated
contouring of the muscles, for example, is most naturally explained in this
way."[6] We shall also have to investigate whether this proposition can be
justified historically or whether there may be another way of explaining
the basis of these phenomena.

How do we know that the Assyrians were already so skilled at the art of
weaving that they could execute textiles designed with pairs of animals in
the Heraldic Style? And, moreover, are we truly dealing here with the
"art" of weaving in the full sense of the word? Was this the kind of weaving
that produced figures of any desired shape by means of the shuttle in
combination with a complicated setup of harnesses? It is only this kind of
relatively mechanical weaving that has a need for the symmetrical repeti-
tion of individual figures, as Curtius[7] quite rightly observed in the case of
Sassanian silks.

Curtius's supposition is based on observations of Assyrian reliefs. There
the borders of the robes of several kings, particularly those of Assurnasir-
pal at Nimrud, are decorated with a series of heraldic groups consisting of
pairs of animals, human beings, and fabulous creatures arranged accord-
ing to a scheme also found on Sassanian silks. As a result, Curtius con-
cluded that the direct, autochthonous prototypes of the heraldic groups
were woven silks. Semper had also characterized the wall reliefs of the
Assyrian royal palaces as "tapestries in stone";[b] yet he was considerably
more cautious in his technical explanation of the animals arranged in the
Heraldic Style. As a craftsman, he no doubt sensed the pitfalls of Curtius's

[6] Schreiber, *Wiener Brunnenreliefs*, 37.
[7] Apparently under A. Pabst's (Cologne) expert guidance.

assertion, for he interpreted the depictions on Assyrian garments not as woven works but as embroideries,[8] a much more plausible idea, since in that case the technical execution would present far fewer difficulties.

The hypothesis of the origin of the Heraldic Style from an ancient Assyrian weaving industry becomes even more untenable in light of recent inquiry into the textile art of antiquity. The leading technique by far was Gobelin.[9] Numerous woven pieces with figures arranged in precisely the same kind of heraldic symmetry, though in a more classical style, have been discovered in Coptic burials of late antique and early Islamic Egypt (fig. 5). The silk weaving from the same excavations, however, still appeared to be at a rather low stage of development during late antiquity. Essenwein reports the following in regard to one of the late antique silks now in the possession of the Germanisches Museum: "It is easy to see how the weaver wrapped each thread around the warp threads individually, and it could almost be said that the work was done more with the needle than with the shuttle. Once we recognize the greater proportion of handwork to mechanical work in the execution of the woven piece, then its many irregularities are no longer puzzling." At that time silk had only recently begun to be processed outside the Far East, and in no case does our information go back to the time of the ancient Near Eastern monarchies. There is no proof of an uninterrupted technical continuity between the alleged ancient Assyrian silk industry and that of the Sassanian period; of course, the expansion of the Hellenistic and Roman culture lies between them stylistically, and although this culture originated and developed under direct contact with ancient Oriental art, it was nevertheless very skillful at fully adapting the luxurious arts of the Orient to its own standards.

The principle of the Heraldic Style, which consists of absolute, bilateral symmetry, actually played a very decisive role in late antique art, probably because of the diminishing creative energies of the period. Hellenistic art had observed only relative symmetry in decoration and avoided the monotony of absolute symmetry whenever possible. It is therefore hard to understand why the heraldic system of ornament on Sassanian silks seems so exotically Asiatic, so completely and totally non-Western to us. Though initially difficult, the mastery of the technique of tapestry weaving seems to have progressed rapidly by the end of antiquity. This no doubt

[8] G. Semper, *Der Stil in den technischen Künsten: oder praktischer Ästhetik* (Munich, 1878–1879), 1:325.
[9] The heraldic animals on the Assyrian kings' robes were, in all probability, executed in this technique. [See annotation *d* to chapter 2 for alternative possibilities.]

stemmed from the urgent need to develop an appropriate technique for the new raw material—silk—something of paramount importance, since the antique Gobelin technique was totally unsuitable for weaving silk, as I have discussed elsewhere.[10] The ornamental system of the Heraldic Style, which had again become widespread, possessed those important advantages for silk weaving that Curtius has also pointed out; it is surely for this reason, and not because of a supposed Assyrian weaving tradition, that we find this type of decorative device used so widely for silk fabrics, from the late antique period (fig. 5) into the later Middle Ages. The technique had not given rise to the scheme, for the scheme already existed and was simply adopted because of its eminent suitability to this type of weaving, which then went on to exploit the pattern for its own purposes.

Because Egyptian late antique textiles are evidently so important for clarifying the questions surrounding the Heraldic Style, fig. 5 reproduces

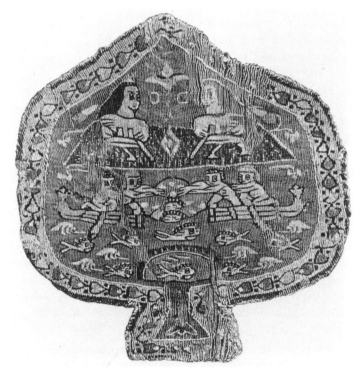

Fig. 5. Late antique Egyptian textile appliqué
from the cemetery at Saqqara.

[10] See B. Bucher, *Geschichte der technischen Künste. Im Verein mit Justus Brinckman* (Stuttgart, 1875), 3:361ff.

a leaf-shaped appliqué for a garment from these excavations, now in the collection of the Österreiches Museum für Angewandte Kunst.[11] Almost all of the essential parts of the pattern are arranged symmetrically: in the upper half there are figures flanking a central three-leafed flower; below are two skiffs, each containing two fishermen, as well as various fish and leafy plants in the water. And yet the technique does not at all demand the symmetrical arrangement in which the appliqué has been worked. As the ribbed texture clearly discernible in the reproduction reveals, this is not an example of the kind of silk weaving that is based on repeating the same treadling and sheds at short intervals. It is instead a very simple piece of handicraft that has no interest in technical shortcuts, because there are none in this particular technique. Therefore, the idea for the symmetrical design preceded its execution in thread, not the other way around. Symmetrically decorated woven patches are, moreover, not rare among the handwork in question.[12]

Is there really anything that compels us to reverse the situation and derive the Heraldic Style from the technique of fine weaving, as Curtius and others have done? Human beings had already been aware of the principle of symmetry, which lies at the basis of the scheme; they had exploited it in art long before the Assyrians founded their great monarchies. As we have seen in the previous chapter, the cave dwellers were already aware of it: the entire Geometric Style is nothing other than abstract rhythm and abstract symmetry. As soon as plants entered the domain of ornament, all efforts concentrated on making them appear symmetrical. The following chapter will present some of the results of these efforts, such as the symmetrical profile view of the lotus, the symmetrical frontal view of the rosette, and a third kind of projection, which will be referred to as the combined view of the equally symmetrical palmette. Now what happens to symmetry in the depiction of animals? The frontal view of humans and animals is, of course, bilaterally symmetrical, but at least as far as animals are concerned, this view is less characteristic. This view is also much too difficult for the primitive artist to depict on a flat surface because of the necessary foreshortening involved. For these reasons, artists chose the more characteristic profile view which, although it dispenses with symmetry, does exist roughly in one plane. There were still

[11] A. Riegl, *Die ägyptischen Textilfunde im Kaiserlich-Königlich Österreichisches Museum für Kunst und Industrie. Allgemeine Charakteristik und Katalog*, no. 416, (Vienna, 1889) [now the Österreichisches Museum für Angewandte Kunst]. The piece is significant for its content as well, since it is one of the extremely rare examples of the survival of ancient Egyptian art forms into later antiquity.
[12] Bucher, *Geschichte der technischen Künste*, vol. 2, figs. 356, 357.

two possible decorative arrangements for the profile views of animals.[13] First, the animals could be repeated simply and rhythmically in rows one behind the other with no attention paid to symmetry at all; such is the case with Curtius's so-called Carpet Style. Secondly, the animals could be placed in pairs opposite each other in absolute bilateral symmetry, and moreover, whenever possible, to either side of an equally symmetrical median for which a plant motif was best suited. This is roughly the way we should explain the Assyrian beasts grouped in pairs to either side of the so-called "sacred tree" (fig. 4) rather than by relying on a technique whose role is in no way certain.

Symmetry thus proves to be an immanent postulate of all decorative art, ingrained in human beings since the very beginning of artistic activity. The Chinese were aware of it, as were the ancient Egyptians, and not only in regard to geometric ornament, despite attempts to deny them this knowledge. And so, for example, two rams symmetrically grouped around a tree already appear in the Sixth Dynasty of the Old Kingdom,[14] more than a thousand years before the construction of the Assyrian royal palaces. The early maturation and isolation of both ancient Egyptian and Chinese art, followed by the relative stagnation of these age-old cultures during their later phases, may explain why neither of them went beyond a modest observation of symmetry in their figurative compositions. However, a people in a position to build upon the achievements of other cultures and respond to new impulses could appreciate the artistic significance of symmetry instantly and more keenly. This was the case with the Assyrians; from the outset they clearly understood the difference between a covering and its edging, between field and border, contents and frame, and they were also capable of taking complete, practical advantage of these distinctions. Unfortunately, we do not have the means at present to evaluate the earlier contribution of their relatives, the Babylonians.[c] But is it really necessary to conjure up a textile industry in order to explain how this culture came to practice the symmetrical Heraldic Style?[d]

[13] But with no descriptive or objective significance intended, as for example, with the herds of animals on ancient Egyptian tomb reliefs.

[14] R. Lepsius, *Denkmäler aus Ägypten und Äthiopien nach den Zeichnungen der von Seiner Majestät dem Könige von Preussen Friedrich-Wilhelm IV nach diesen Ländern gesendeten in den Jahren 1842–1845 angeführten wissenschaftlichen Expedition*, (Berlin, 1849–1856), Abtheilung 4, Blätter 108, 111.

◇

The Introduction of
Vegetal Ornament and the
Development of the
Ornamental Tendril

Today it is difficult to say which natural domain, animals or plants, posed the greater difficulties to those who first attempted to reproduce their outline upon a flat surface. Since the components of plants are absolutely static, it might seem easier, at least to the casual observer, to arrive at a characteristic image of a plant than of an animal that is always changing its position. The various parts of plants, however, are no more planimetric than those of the quadrupeds which first attracted human attention. Therefore, in order for plants to be drawn or engraved on stone, bone, or clay, they first had to be stylized. This is apparent in the earliest known representations of plants. Leaves, which in nature radiate around the stem, are depicted on a flat surface either symmetrically branching off to the right and left of an upright stalk as if seen from above, even though they are normally seen in profile. This two-dimensional *stylization* remained in force until the discovery of perspective, modeling, and proportion gradually made it possible to create the illusion of space and volume on a flat plane.

As the prehistoric finds discovered thus far indicate, however, and contrary to what we might expect, human beings attempted to draw animals before they drew plants. The carved reindeer bones found in the caves of Dordogne have yielded only one single instance of motifs (fig. 6) that can be construed as flowers because of their rosettelike shapes, in contrast to the striking number of animal images.[1] Ethnologists have made similar observations about the art of modern primitive cultures. Geometric

[1] Were it not for the high quality craftsmanship of cave art, astonishing as it is in view of the early date and the primitive cultural circumstances, one could point to the inherent difficulty involved in carving the complicated parts of plants as opposed to the relatively simple shapes of animals. The discussion in chapter 1 has shown that sculpture was the oldest technique. Its almost exclusive use of animal imagery may have created a tradition which then led to the initial exclusion of vegetal motifs in subsequent two-dimensional media.

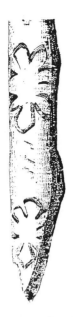

Fig. 6. Reindeer bone
with engraved flowers
from La Madeleine.

ornament and animal imagery always precede the depiction of plants. Some relatively highly-developed systems of ornament like that of the Incas seem to have had no plant imagery at all. This phenomenon may well be explained by the fact that animals, active and moving about at will, engaged the attention of human beings to a far greater degree than plants did. Furthermore, animals play a greater role in fetishism than plants. The remnants of an animal cult are still clearly evident in the myths surrounding ancient Egyptian gods. Similarly, the priority that animals have over plants is apparent even in later phases of art: human figures and animals were rendered in accurate perspective earlier than plants. Moreover, flowers remain in the category of surface decoration much longer than other motifs, while landscape comes into being far later than other types of painting, not only religious and history painting but even portrait and genre painting. The later introduction of plants into the visual arts, therefore, should be explained mainly by the lesser interest of people in the apparently static plant kingdom.

Another pressing question immediately arises at the beginning of this chapter: were the earliest depictions of plants thought of as ornaments, or were they understood to have inherent representational (hieratic, symbolic) meaning? The latter assumption presupposes a more advanced stage of culture for the people who first developed vegetal imagery—a stage of culture where art had already developed considerably beyond the simple, elementary need for adornment mentioned earlier. And, as a matter of fact, wherever we have come to know an ancient but nevertheless fully developed and self-contained culture, we find that religion and fine art enjoy a most intimate, reciprocal relationship. Consequently, after a certain point, which would now be impossible to determine, we can no longer ascribe the impetus for developing a truly "visual" art (meaning one that consciously aims to capture the physical appearances of nature) merely to an immanent drive to adorn or imitate three-dimensional forms in sculpture (as is the case with the cave dwellers of Aquitaine) but to

religious, that is to say, representational incentives. The earliest depictions of vegetal motifs known today date from the Old Kingdom in Egypt. Because of the conspicuously representational character of all ancient Egyptian art, especially that found in Old Kingdom tombs, its vegetal motifs must be seen as religious symbols, and not as simple ornaments. Strictly speaking then, they do not belong in a chapter on vegetal ornament. Nevertheless, since the vegetal motifs of ancient Egypt are clearly linked to the subsequent purely ornamental development, they will provide the point of departure for this entire examination of ornament.

Any religious symbol can become a predominantly or purely decorative motif in the course of time if it has artistic potential. When a motif is frequently and continuously executed in a variety of materials because of its religious associations, a stereotype is created, which can then become so familiar as to seem to a certain extent ingrained. The simple customs of the ancients encouraged this process considerably: symbols are found on clothing, implements, and generally on the kinds of things that were seen daily. There was hardly a household item in the homes of the ancient Egyptians that was not decorated with a lotus. The cultures that adopted Egyptian symbols no longer understood their hieratic meaning, to judge from the arbitrary way in which they usually applied them. The symbolic significance of the lotus diminished among the Assyrians, Phoenicians, and Greeks. The whole development culminates in Greco-Roman art, which ultimately owes most of its decorative vocabulary to Near Eastern symbolism. The Greeks, however, with their consummate sense of the beautiful, chose only those motifs with a potential for artistic elaboration.[2]

The ancient Egyptians had already taken care to insure that most of their vegetal motifs had inherent artistic potential. The art that first created vegetal motifs also brought about the stylization required by their translation onto a two-dimensional surface in relief and painting. Symmetry was again a guiding principle. Although the motif might have been rendered initially for its objective meaning, there was still the same strict observation of basic design principles involved in its formation as for the purely decorative ones satisfying the urge for adornment. The ancient Egyptians themselves must have appreciated the decorative qualities of their fully-developed symbols and this is even more likely for the less sophisticated cultures that gradually came to use them. If these cultures lacked their own decorative vegetal motifs before their contact with Egypt, as appears likely, they were henceforth able to acquire them com-

[2] Motifs such as palmettes, sphinxes, and centaurs, as opposed to animal-headed gods or scarabs and the like.

mercially or copy them themselves. Once a fully developed vegetal motif was available from somewhere else, no one thought of taking the trouble to create new stylizations from their own local flora.[3] For the same reason, our decorative vocabulary still predominantly consists of traditional antique motifs, although there are more inventors and designers of ornament today than there had been in antiquity.[4]

As far as we know at present, the ancient Egyptians were the first to create an historically important art. And, as far as the remaining cultures of antiquity contemporary with Pharaonic Egypt are concerned, the history of their art begins the moment they come into closer contact with Egypt. Although this moment cannot be fixed precisely in any particular case, it is also no longer a matter of dispute, considering how extensively the characteristic decorative forms of Egyptian art spread throughout the oldest cultures of antiquity. Surely, the fundamental importance of ancient Egyptian vegetal motifs for all subsequent vegetal ornament has now been sufficiently demonstrated.

This does not mean, however, that we are now compelled to examine all the traditional vegetal motifs found on ancient Egyptian monuments. In representational Egyptian art, there are many cases of vegetal motifs, particularly trees (Tell-el-Armarna), that apparently had no symbolic significance attached to them and were therefore never exploited as ornaments. Actually, it is not so much the plant as a whole, as tree, bush, or even decorative shrub, that has been used as a symbol but the individual parts of plants, the blossoms or leaves. As we shall see, even on the earliest examples of Egyptian art, these parts were often already stylized beyond recognition. And even though they were being used in an objective sense, they already possessed an obvious potential for further decorative elaboration.

The *blossom*, with its colorful corolla usually growing radially from the calyx, is artistically the most important and perfect portion of a plant. Next is the *bud*, usually pointed and therefore well suited as a crowning element. The third important part is the *leaf*. The *fruit*, on the other hand, is not prominent in early symbolism and is therefore also less noteworthy for early ornament. The simplest explanation for this remarkable fact is

[3] Consequently, there is no need to point to the religious symbolism of the sun cult, as Goodyear does, or to any other cult for that matter, to explain the spread of ancient Egyptian art motifs throughout the early ancient world, when the overwhelming human drive to imitate, duplicate, and copy suffices by itself.

[4] The conscious copying of plants from nature for decorative purposes is a distinctly modern tendency that is especially characteristic of contemporary art. Notwithstanding, the acanthus and the classical blossom profile still dominate all vegetal ornament today.

probably that the uncomplicated and often asymmetrical forms of fruits did not particularly lend themselves to artistic elaboration.

Finally, a very important element in vegetal imagery, especially in regard to the later development of ornament, is the *stem*, for it is this part that actually connects the various blossoms, buds, and leaves. The stem makes it possible for vegetal motifs to fill a surface coherently, whether they are arra ged as friezes within a register or spread out over a field. In ancient Egyptian art, the stem is seldom shown naturalistically but mostly as a linear, geometric element. As a result, it could, from the very outset, assume the variety of undulating and curling forms that provide the basis of all curved, purely geometric shapes. Consequently, the stem played a particularly important role in the progressive ornamentalization of originally representational, symbolic vegetal motifs. Early in ancient Egyptian art, we will be able to observe arrangements of blossoms, leaves, and stems that are not at all characteristic of the same plants in nature and can only be understood as an enlivening of geometric art forms with representational vegetal motifs.

Our objective, therefore, will be to examine how the blossoms, buds, and leaves of each style in question are connected as they fill up the decorative field. A continuous historical thread can be followed throughout, from the earliest Egyptian period up to Hellenistic times, when the Greeks brought the development to a climax, both by perfecting the formal beauty of the individual parts of each motif and by creating the most aesthetically pleasing way of unifying the motifs by means of the "line of beauty," or rhythmic dynamic *tendril*, the decorative conception that is their special achievement. Our investigation is chronologically divided into two parts: (1) a demonstration of how the vegetal motifs spread by Greco-Roman (Mediterranean) art originated from and gradually developed within Near Eastern art; (2) a discussion of how the Greeks further developed these motifs into the Hellenistic Period, paying special attention to the evolution of the specifically Greek motif, the ornamental tendril. The first section is only a brief introduction to the second part, which constitutes the major undertaking.

We shall become familiar with a continuous development that follows its own definite path. The first vegetal forms were probably created for their symbolic, representational significance. Further developments were built upon these basic types, and in essence only upon these few types. At the time, and for a thousand years thereafter, no one thought again of exploiting the natural appearance of specific plants artistically. And even when a naturalizing tendency clearly did arise, it did not begin by copying

actual plants from nature but by gradually and subtly naturalizing and enlivening the traditional, geometricized vegetal ornaments. The conclusions about the history of ornament in general that can be drawn from this observation are obvious; they are the reason we feel justified in ascribing such importance to the problems dealt with in this chapter.

A. Near Eastern

1. Egyptian. The Development of Vegetal Ornament

There are two plants that are inseparable from Egyptian culture and that appear to be the most common symbols found on ancient Egyptian monuments—the *lotus* and the *papyrus*. Herodotus has left us a valuable account of the cultural importance of these two plants in the daily lives of the ancient Egyptians. Furthermore, there are two stylized floral shapes in Egyptian art that date back to the earliest periods: the one identified with the lotus has clearly articulated, triangular petals (fig. 7), while the other is identified with the papyrus because of its bell shape and lack of leaves (fig. 8). The opened flower of the species of plant associated with the lotus of ancient Egypt does, in fact, have a ring of triangular petals. The head of the papyrus plant, on the other hand, consists of individual, hairlike filaments that fall separately in all directions from the stem. Since the realistic rendering of such an elusive shape would have been virtually impossible in Egyptian art, given the nonperspectival approach that restricted forms to contour lines on a flat plane, one assumed that Egyptian artists had abstracted the filaments of the papyrus into a compact bell shape that could easily be expressed in terms of a definite outline. Another factor that

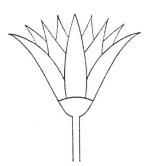

Fig. 7. Lotus blossom in
profile view.

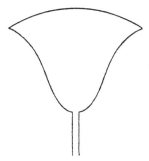

Fig. 8. Lotus blossom in
profile view
(so-called papyrus).

has contributed to the continued distinction between lotus and papyrus shapes is the alleged symbolism involved, for the papyrus is associated with the reedy swamps of the Nile Delta and the lotus with arid Upper Egypt.[a]

In the art of the Old Kingdom, the two shapes can be distinguished fairly easily. By the time of the New Kingdom, however, which is nevertheless still quite early compared to other ancient cultures, they can no longer be easily differentiated. Although this difficulty has not escaped the scholars who have taken the trouble to approach the Egyptian material from an art historical standpoint, no one has yet dared to question the validity of the distinction. A good example of this is Perrot, who is responsible for the only truly scientific study of ancient Egyptian art to date. He himself was at a loss when he came upon bell-shaped papyrus forms with three-pronged lotus calyces and avoided the issue by using the noncommittal term, aquatic plants,[5] which could mean either the lotus or the papyrus. I, too, originally thought that the obvious propensity in the art of the New Kingdom to treat traditional symbols ornamentally, which is apparent in the development of other motifs as well, might eventually have led to the confusion of the lotus and papyrus types. This would have presumed, however, that the Egyptians of the New Kingdom had also become confused about the religious associations of the two symbols, but since there is no evidence of any kind to support this assumption, I had to consider my explanation as inadequate.[b]

W. G. Goodyear[6] has recently clarified the issue by demonstrating that the association of the bell shape with the papyrus plant is erroneous. He claims that the motif with the three-pronged calyx and the bell shape are in fact both lotuses.[7] His main argument is based on the observation that the hieroglyph surmounted by a bell does not necessarily refer to the papyrus plant alone, for the crowning motif associated with the land of papyrus, Lower Egypt, occurs not only on what seems to be the papyrus shape but also on the shape with the three-pronged calyx, which is decidedly a lotus, hence on a form supposedly representing Upper Egypt. Goodyear's argument has at last removed the insurmountable obstacles that Egyptology had placed in the path of art historical research. We can now go on to clarify the relationship between these two motifs, which in actuality symbolize one and the same flower.

[5] G. Perrot and C. Chipiez, *Histoire de l'art dans l'antiquité*, vol. 1 (Paris, 1882), 885, fig. 586.
[6] W. G. Goodyear, *The Grammar of the Lotus. A New History of Classic Ornament As a Development of Sun Worship* (London, 1891).
[7] Ibid., 43ff.

Goodyear has contributed a further, fundamental clarification. As he so convincingly pointed out,[7a] the ancient Egyptian lotus motif has been consistently identified with a species of plant that is not at all suggested by the motif itself, namely with *nymphaea nelumbo* (*nelumbium speciosum*), which strictly speaking does not even belong to the same botanical group as the lotus. The error ultimately goes back to Herodotus, who referred to a widespread genus of lotus in Egypt that had edible seeds. This is true, however, only of *nymphaea nelumbo*, which was never native to Egypt and is found nowhere in the country today. The plant flourishes mainly in India, whence it was transplanted for a short time into ancient Egypt, only to disappear from the soil of the Nile Valley from lack of cultivation. The true sacred lotus, however, which still grows in Egypt today, is the *nymphaea lotus* (the white lotus) with its blue subspecies (*nymphaea caerulea*). I won't go into Goodyear's entire line of reasoning, but I would like to mention one of the most persuasive points of his argument, namely, that the cleft lotus leaf found most often on Egyptian art is identical to the leaf shape of *nymphaea lotus*, whereas the funnel-shaped leaves of *nelumbium speciosum* in no way resemble those leaf shapes, no matter how hard one may try to rationalize them as the eccentric products of the ancient Egyptian conception of form.[8, c]

Of all the various parts of the lotus plant the Egyptians utilized in their art, the most interesting for us by far is the blossom. I would, therefore, first like to deal with the less important parts, the bud and the leaf, so as not to have to come back to them later. As just mentioned, the characteristic feature of the lotus leaf (fig. 9) is the cleft, which often extends nearly to the center of the leaf. The basic shape is best compared to a spade. Opposite the cleft, the leaf is usually semicircular, though it is not rare to find a point, which can even sometimes be slightly curved. It is this latter shape, most closely resembling ivy, that may have been passed down to Greek art, assuming Goodyear was right in interpreting Mycenaean ivy leaves as imitations of the pointed Egyptian lotus leaf. I hesitate to

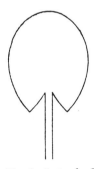

Fig. 9. Lotus leaf.

[7a] Ibid., 25ff.

[8] Naturalizing Greco-Roman art did, however, depict the edible *nelumbium speciosum* mentioned by Herodotus as seen in the Pompeiian Nile mosaics in Naples: scalloped buds, seedpods shaped like watering can spouts, and funnel-shaped leaves rendered nearly in perspective.

agree wholeheartedly with Goodyear's idea because the Mycenaean ivy leaf occurs in contexts unknown in Egyptian art but characteristic of later Hellenic art. The chapter about Mycenaean vegetal ornament will go into detail about this.

The typical Egyptian lotus bud is drop shaped (fig. 10) and often has no articulation. In nature, the inner core of the bud of *nymphaea lotus* is completely sheathed by four leaves of equal length. The lotus bud is most frequently found alternating with the lotus blossom (fig. 11). The two motifs—the blossom and the bud—are juxtaposed in series. The blossom is the larger motif: its calycal leaves often meet over the intervening bud. It has been frequently noted, and recently substantiated in detail by Goodyear,[9] that these rows of alternating lotus blossoms and buds are the source of the Greek cyma and egg-and-dart molding.[d] The lotus bud, however, also occurs without the blossom, either by itself or in a row; it can serve to crown a shaft (column) or a horizontal entablature. A further clarification of this function will develop out of our examination of the lotus capital.

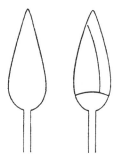

Fig. 10. Lotus buds.

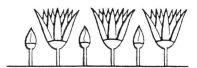

Fig. 11. A series of lotus blossoms alternating with buds.

The lotus blossom occurs in ancient Egyptian art in all of the three views in which flowers were generally represented as long as art remained at the stage of two-dimensional stylization. These include: (1) the frontal view; (2) the profile view; and (3) the combined view.

The frontal view of the lotus blossom is the *rosette* (fig. 12). Indeed, Goodyear[10] considers the rosette to be inspired by the ovary stigma of

[9] Goodyear, *Grammar*, 155 ff. Goodyear was thinking mainly of the Doric cyma, but it is also true of the Lesbian cyma; see A. Prisse d'Avennes, *Histoire de l'art égyptien d'après les monuments, depuis les temps les plus reculés jusqu'à la domination romaine* (Paris, 1878–1879), atlas 1, "Frises fleuronnées," nos. 5–6.

[10] Goodyear, *Grammar*, 103.

nymphaea lotus, which it in fact resembles. But later on, there is no doubt that the rosette represents the fully opened flower.[e] It is hard to believe that the ancient Egyptians would have been more captivated by the ovary stigma of the withered flower than the artistically more attractive configuration of centralized, radiating petals. Goodyear's opinion is based mainly on the fact that, aside from the examples with pointy leaves which definitely resemble the lotus blossom corolla, there are also drop-shaped types with rounded ends (fig. 12),[11] which look very much like an ovary stigma. It is, moreover, quite clear that they are also meant to represent parts of the lotus plant because there are examples where they are used interchangeably with obvious lotus motifs. The type with rounded leaves, however, is probably only a variation of the pointed blossom, which naturally resulted as the centralized rosette motif was developing and the main interest shifted from the delineation of individual leaves to the contour of the radiating petals. Even Goodyear conceded the possibility that the rosette might be the frontal view of a lotus blossom. The fact that he ultimately opted for the ovary stigma as the model, however, is symptomatic of his tendency to base his deductions upon appearances rather than artistic premises.

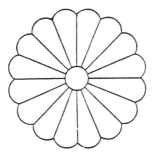

Fig. 12. Lotus blossom in frontal view (rosette)
with rounded petals.

As far as we can gather from the art that has survived, the rosette first began to appear with regularity only in the art of the New Kingdom. We do have one example from the Old Kingdom, and that is the statue of Nofret,[12] whose diadem is decorated with rosettes that have rounded petals. Later on, the rosette is especially characteristic of Assyrian ornament.

[11] Compiled by Goodyear, (*Grammar,* pl. 20).

[12] G. Maspero, *Ägyptische Kunstgeschichte,* German trans., G. Steindorff (Leipzig, 1889), 213, fig. 191.

I do not agree with Ludwig von Sybel,[13] who maintains that the rosette was therefore brought to Egypt by Semites from Asia. During the imperial phase of the New Kingdom, there are no securely dated monuments with vegetal ornament from Babylonia, or from elsewhere in Asia for that matter. This does not discount the possibility that the Babylonians might have been using the rosette for decoration in the sixteenth and seventeenth centuries, but the rarity of the rosette in the art of the Old Kingdom in comparison to its prominence in later Mesopotamian art cannot alone justify claims for an Asiatic origin for the motif. Furthermore, the basic attitude of the Egyptians, who disdained everything outside their culture as barbaric, speaks against such an assumption. After the expulsion of the Hyksos, the victorious re-establishment of national independence was accompanied by an intense cultural upswing that may also have stimulated greater creativity in the field of decorative arts. All aspects of artistic life during the Thutmosid and Ramesid dynasties were obviously undergoing a period of great revitalization. Von Sybel's explanation for it, however, as the result of an infusion of Asiatic luxury into an Egyptian tradition that had run dry, will remain unconvincing as long as there are no Asiatic monuments of the period to document the existence of such Oriental luxury in the first place.[f]

The profile view of the lotus blossom is by far the most important in ancient Egyptian art. Several types can be distinguished.[g]

The type that was originally most common, though perhaps not the earliest, is the one in figure 7 used above in the comparison with the alleged papyrus motif. It is characterized by three pointed calycal leaves, one in the middle and two on either side, which can be either rectilinear or—more typically—curved slightly outward. In the pointed spaces or triangular axils between the calycal leaves, a second row of two similar leaves appears, followed by a third row of four proportionally smaller ones. The three largest leaves represent the calyx, while the ones in the interstices correspond to the petals of the blossom. Goodyear has pointed out that the blossom of *nymphaea lotus*, when viewed from the side, does in fact exhibit three of its four calycal leaves.[13a] The petals, moreover, grow out of the calyx and fill up each other's axils in a manner quite similar

[13] L. von Sybel, *Kritik des aegyptischen Ornaments* (Marburg, 1883), 17. This brief essay, which was published in 1883, should not be underestimated, for it was one of the first isolated attempts to come to terms with the importance of the study of ornament for the history of ancient art. I cannot agree, however, with its attempt to attribute new aspects of the art in the New Kingdom to Asiatic influence. Goodyear (*Grammar*, 99) has also recently challenged von Sybel's thesis while persuasively discussing his view, which I fully share, about the relationship between ancient Egyptian and Mesopotamian art.

[13a] Goodyear, *Grammar*, 25.

to the way they do in figure 7. Goodyear also went on to demonstrate on the other hand how the *nelumbium speciosum*, the species usually mistaken for the model of the Egyptian lotus motif, has a calyx with more than four leaves and petals that are not distinct enough to qualify it as the basis of the stylization represented by the type in figure 7.[h]

This first version of the profile view of the lotus was abbreviated and varied slightly in the course of time. It is not necessary to go into detail here about all of the variations that Goodyear has compiled.[14] One simplification, however, is worth mentioning in this context, since it seems to have had a bearing on the development of the type eventually mistaken for papyrus. In this version, no petals are indicated, but the tips of the three calycal leaves are joined together by a single line (fig. 13).[i]

The second version of the profile view of the lotus blossom is bell shaped (fig. 8), one which, without exception, has been identified with the papyrus. It is distinguished from the first type by a bell-shaped profile lacking any indication of leaves. When the two are placed next to each other, however, even without the aid of any additional intervening examples, they still have enough traits in common to establish an interrelationship. The cyma-shaped curve of the two outer

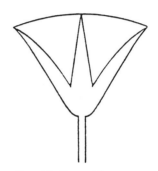

Fig. 13. Lotus blossom in profile view with schematically rendered corolla.

calycal leaves characteristic of the first version (fig. 7) seems to be the forerunner of the more pronounced bell-shaped curve of the second. The absence of leaves on the so-called papyrus type, moreover, can be partially explained by the ancient Egyptian tendency to suppress details within a firm contour, as witnessed by the simplification of the first version (fig. 13) discussed a moment ago. However, because the papyrus shape occurs so very frequently,[15] we will have to go beyond this simple general explanation and find a more specific, external cause for the adoption of the bell-shaped profile view of the lotus blossom.[j]

Goodyear, to whom we owe the clarification of the lotus as the model for the bell-shaped blossom, has also offered a convincing explanation for

[14] Consult especially *Grammar*, pl. 3.
[15] According to Goodyear (*Grammar*) it accounts for half of all of the profile views of the lotus motif dating since the Old Kingdom.

the origin of the bell shape. According to him,[16] the leafless bell shape resulted naturally when the lotus blossom motif was sculpted in the round in a hard material like stone. As evidence, Goodyear points to the bell-shaped capital (fig. 14), which is really nothing more than a lotus blossom translated into three dimensions with painted rather than carved leaves. Furthermore, the little colonettes with bell-shaped capitals found in tombs, obviously amulets, prove that the sculpting of lotus blossoms was both common and extensive. As a result, Goodyear assumes that the bell-shaped blossom was not inspired by the lotus itself but represents the lotus amulet translated into two-dimensional painting or relief. It is no longer easy to determine what for the Egyptians distinguished the bell-shaped lotus from first type. Yet it will be difficult to improve upon Goodyear's hypothesis that the motif resulted from its translation in and out of the sculptural medium.[k]

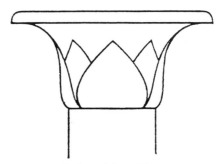

Fig. 14. Bell-shaped lotus-blossom capital.

At this point I would like to interject some remarks about the significance of the lotus motif within ancient Egyptian architecture. We have just become acquainted with one kind of lotus capital, the bell-shaped type. Another kind, which is just as common, is based on the lotus bud (fig. 15). These delicate floral or bud motifs do not really seem to be appropriate intermediaries between the weight-bearing columns and heavy architraves, especially in view of the massive forms of Egyptian architecture. However, the notion that the architectural use of these motifs goes back to an ancient custom of winding festive garlands of lotus around the column shaft is too farfetched and inconsistent with the basic character of Egyptian art to be persuasive. It was probably a much more basic artistic idea, akin to the principle of symmetry, though somewhat less exacting,

[16] Ibid., 51ff.

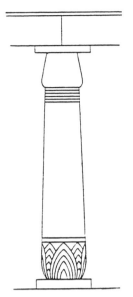

Fig. 15. Column with
lotus-bud capital.

that determined the use of the lotus motif as a capital, a principle that was extraordinarily compelling to the Egyptians, as the monuments all demonstrate: namely, that any unattached termination demands some sort of artistic articulation. Whenever an object of any importance ended in a point, especially a long, thin one such as a staff, the ancient Egyptian artistic sensibility demanded some sort of ornamental articulation of the termination or ending. This was especially true when the termination was an apex of some kind, so that even walls much wider than they are tall are clearly surmounted by a crowning decorative element, the well-known cavetto profile.[17]

There were various artistic ways to treat terminations and crowning elements in Egyptian and Mesopotamian art. Animal heads, for example, often decorate the tops of furniture posts in analogy to the way the human head surmounts the body.[18] However, throughout ancient Egyptian art the most common motif by far used to complete an unattached termination has always been the lotus blossom. Already in the art of the Old Kingdom, lotus blossoms decorate the ends of knotted headbands,[19] while so- called papyrus motifs adorn the backs of chair seats. The ropes binding the prisoners of New Kingdom pharaohs all

[17] Ornaments surely do not, as a rule, come into being in the artless and rationalistic manner suggested by von Sybel (*Kritik*, 5), who maintains that the Egyptian cavetto profile developed from the heads of the upright reeds used in prehistoric Egyptian architecture, which were distended by the weight of the wooden beams they supported. The Egyptian cavetto profile is better understood as a crowning element completely analogous to the headdress of a goddess (Prisse d'Avennes, *L'art égyptien*, atlas 2, "La déesse Anouke et Ramses II."). For the prototype of the latter, I would again like to suggest the crown-shaped feather headdress worn by the Ethiopians in, for example, Prisse d'Avennes, atlas 2, "Arrivée à Thèbes d'une princesse d'Ethiopie".

[18] The chair legs found in the earliest tombs of Memphis provide a parallel example. Instead of ending abruptly on the floor, they rest on hooves or lions' paws which clearly underscore the special function of the leg.

[19] R. Lepsius, *Denkmäler aus Ägypten und Äthiopien nach den Zeichnungen der von Seiner Majestät dem Könige von Preussen Friedrich-Wilhelm IV nach diesen Ländern gesendeten und in den Jahren 1842–1845 ausgeführten wissenschaftlichen Expedition* (Berlin, 1849–1856), Abtheilung 2, Blatt 73, right.

terminate in the profile view of the lotus just as the prows of the boats of the Nile have since the earliest period. We can explain the Egyptian lotus capital in the same way. There is no real need for farfetched explanations of the lotus calyx and lotus bud capitals, since originally the column was not a weight-bearing roof support at all but a freely ending post like a tent pole or a Greek stele crowned by a palmette. The capital, therefore, was originally a crowning element and nothing but a crowning element. Only later did architects recognize the need for a transition between the supporting column and the weight-bearing architrave, which then became an aesthetically significant factor. The Egyptian lotus blossom or bud capital expresses the unattached termination of the column; hence the insertion of the abacus between the capital and the architrave whenever the column takes up its supporting function.[1]

The third view of the lotus blossom found on ancient Egyptian monuments is the combined view (fig. 16), which has three distinct parts. The lower part consists of a calyx (a) borrowed from the profile view of the lotus blossom (fig. 7) and two diverging volutes (b); in each of the outer axils of the volutes is a small drop-shaped appendage, or droplet (c). The middle part is an arclike cone (d) that fills out the axil or angle created by the two diverging volutes, while the upper part (e) is a crowning fan of leaves. The Greek version of this motif is usually referred to as the palmette.

The volutes are the most distinguishing and important feature of the palmette. They represent the profile view of the calyx, as revealed by an intermediary stage of the motif illustrated in figure 17 (a so-called porcelain amulet in the Louvre), where the space between the volutes is filled up by the triangular petals characteristic of the first version of the profile view of the lotus blossom (fig. 7) and not by the arc and leaf fan of the palmette.[m]

The first appearance of the *volute-calyx* is of extraordinary importance to the entire history of ornament. It has long been assumed that the various volute-calycal forms are somehow related to each other, at least in their antique forms. The volutes of the Ionic capital in particular and their apparent relationship to those on Near Eastern volute capitals have provided scholars with much food for thought. The subject has gradually acquired its own literature, which Puchstein[20] and also, to a certain extent, Goodyear[21] have compiled. The majority of scholars support an Asiatic

[20] See the appendix of O. Puchstein, *Das jonische Kapital*, 47. Program zum Winckelmannsfeste zu Berlin (Berlin, 1887).

[21] Goodyear, *Grammar*, 71ff., scattered among the notes.

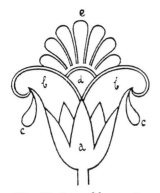

Fig. 16. Lotus blossom in
the combined view
(Egyptian palmette).

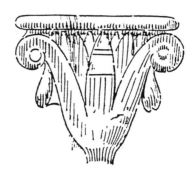

Fig. 17. Lotus blossom in
profile view with
volute-calyx.

origin. This obstinate misinterpretation of the historical relationship be-
tween Mesopotamian and ancient Egyptian art—obviously influenced by
the popular theory that most early art forms enjoyed an essentially autoch-
thonous development—has obscured the crucial fact that the ancient
Egyptian volute form was the true point of departure for the whole devel-
opment. This is so, moreover, despite the conclusions made several years
ago by the French engineer M. Dieulafoy,[22] who demonstrated that cer-
tain ancient Egyptian leaf forms were clearly predecessors of the Ionic
capital. Goodyear (71ff.) has resolutely supported the idea that the Egyp-
tian volute-calyx was the point of departure for all other antique palmette
forms, at the same time that he attempted to explain how the volute motif
came about.[n]

Goodyear's explanation for the rise of the volute-calyx is again tied to
the natural appearance of *nymphaea lotus*. He observed how the four caly-
cal leaves of the blossom frequently curl under, so that the flower, when
seen in profile, really does show the petals emerging from a calyx formed
by a volute on each side (fig. 18). The simplicity of his argument and the
apparent correctness of this observation initially appear very engaging.
However, it is hard to believe that the origin of a motif as important as the
volute-calyx should be attributed to the haphazard drooping of the sepals
of *nymphaea lotus*. The motif has lived on in the stylized flower ornament
of all later cultures and styles, not only of antiquity but also of the Middle
Ages, especially in Islamic art, and it still survives in modern times up to
the present day. At the bottom of it all there must have been something

[22] M. A. Dieulafoy, *L'art antique de la Perse. Achéménides, Parthes, Sassanides* (Paris,
1884–1889), 3: 34ff.

Fig. 18. Lotus blossom in
nature with overflowing
calycal leaves.

enduring, universally valid, and classic for the motif to have found such consistent acceptance and ubiquitous diffusion.

What distinguishes the lotus blossom with a volute-calyx artistically from one with straight sepals is the sharper distinction between the calyx and the crown (fig. 7). And there is, in fact, an artistic principle conscientiously observed in the art of the ancient Egyptians, at least in the period of the New Kingdom, that virtually required the accentuation of the calycal portion. Before I go into this principle in detail, however, I would like to discuss the other two parts of the Egyptian palmette, including the droplets inserted under the volutes.

Although the volute-calyx is seen from the side, the crowning *fan of petals* in fig. 16 (*e*) is obviously a section of the frontal rosette (fig. 12). Goodyear's interpretation[23] of the fan of the palmette is the same as for the rosette. According to him, the palmette is a combination of the lotus calyx and the ovary stigma. I have already explained the factors indicating that the prototype of the rosette was not the ovary stigma, as Goodyear says, but the full view of the blooming lotus. What the palmette does is to unite this frontal view of the open lotus with the calyx, seen in its proper and natural profile view,[24] so that the rays of the crown can be displayed without sacrificing the profile view completely. That is why I call this version the "combined view."

There is still one more element to consider that is characteristic of the Egyptian palmette (fig. 16), and that is the little *cone* (*e*) that fills the axil between the volutes. The filler itself is not part of the rosette. On the contrary, it is the expression of a primitive artistic principle prevailing in ancient Egyptian art and one of its fundamental stylistic concepts, namely the principle of *axil filling*. The Egyptian stylistic sensibility demanded that wherever two diverging lines create an angle, it be filled with a motif.

[23] Goodyear, *Grammar*, 109ff.
[24] Islamic art expresses the same artistic intention, particularly on tiles and carpets, when it combines a tulip or bud-shaped profile view of a flower with a frontal rosette in the very same floral motif.

The principle no doubt goes back to the phenomenon of *horror vacui*, which in turn has its roots in the decorative urge that was a driving force in all primitive arts. There is little evidence for this in the art of the Old Kingdom, because what has survived from this early period in tombs is predominantly representational. The richest source of axil-filling motifs is the ceiling decoration of the New Kingdom. Here, the individual motifs still retain their original symbolic value but they were obviously arranged according to decorative and artistic considerations with the express purpose of filling out a surface. And the same tendency is still plainly evident in the basic arrangement of the age-old, straight-leafed profile view of the lotus blossom (fig. 7): the axils of the calycal leaves are filled by petals, whose axils are in turn filled by smaller petals.[o]

The two *droplets* (c) inserted into the outer axils of the volutes of the palmette in figure 16 and the amulet of figure 17 serve the same space-filling purpose.[25] Goodyear, in keeping with his tendency to see things only in terms of symbolism (indeed, he interprets all of ancient Egyptian ornament as a manifestation of the sun cult), and to ignore almost on principle the artistic, decorative sense that guided the ancient Egyptians and all other ancient cultures, has declared these droplets, on the contrary, to be lotus buds. Just as he construed the palmette to be a combination of the floral calyx and the ovary stigma, so he pronounced this arrangement to be the simple combination of two symbols, the blossom and the bud.[p]

Goodyear tries to explain the conical filler (d) in figure 16 in a similar way. In examples where there are no crowning petals and this filler serves only to fill the axil between the volutes, as we shall see shortly in figure 20, Goodyear sees it as an inverted lotus bud, like the droplike shapes on the outer volutes. On occasion, he has also interpreted the central filler as the foreshortened midsection of the central calycal leaf, shown receding into space, in contrast to the two outermost calycal leaves, which curl under in profile. This second suggestion is not at all convincing. The first one is illuminating only insofar as the lotus bud motif might have had some influence on the drop-shaped stylization of the axil filler. In any case, the bud-like shape was surely not inserted into the axil for symbolic reasons but for decorative and aesthetic ones.[q]

The essential function of the volute-calyx as a component of the Egyptian palmette is most evident from the numerous examples in which the crowning petals are de-emphasized. In figure 19, the crown is not yet

[25] We will frequently have occasion to test the importance of this postulate for antique ornament. The proof that it represents a widely shared, primitive aesthetic perception will be brought to bear at a more appropriate time.

Fig. 19. Egyptian palmette
with schematically rendered
leaf-fan.

Fig. 20. Volute-calyx with
simple cone as axil filler,
from Karnak.

eliminated completely: even though the individual petals are not indi-
cated, their contour is clearly outlined. Indeed, this stylization of the
crown is very similar to the one in figure 13, where petals are suggested
by the general outline but not expressly indicated.[26] The pillar from the
period of Thutmoses III in figure 20, on the other hand, is a more radical
reduction of the palmette motif, for, aside from the lower row of leaves, it
has only the volute-calyx and the conical axil filler. We now have to prove,
however, that this motif is the reduction of an already developed palmette
motif, and not just an earlier, more elementary forerunner that subse-
quently acquired the palmette-fan. As far as we can tell today, the palm-
ette is attested earlier[27] in Egyptian art than the simple volute-calyx.
What is more important, however, is that we can scarcely explain the
subsequent appearance of the crowning fan of petals above the arc,
whereas the occasional omission of the fan seems to be well motivated.

I have already mentioned that the sharp distinction between calyx and
crown exhibited by the volute-calyx must have reflected a particular artis-
tic principle that was extremely compelling, above all in the New King-
dom. Now I would like to resume this train of my discussion. The artistic
principle to which I am referring demanded that the point of inception at
the bottom of an elongated pattern be emphasized in some way. The most
common means of achieving this was to make it seem as if the larger pat-
tern were growing out of a calyx or a row of triangular leaves (which were
probably also derived from the earliest lotus blossom type). The bottoms

[26] This parallel, moreover, seems to strengthen thoroughly our conviction that the crown-
ing fan of the palmette represents the open flower and not, as Goodyear suggests, the ovary
stigma.

[27] According to Goodyear (*Grammar*, 112), who is relying on Flinders Petrie, it occurs on
amulets from the Twelfth Dynasty, while palmettes that have their fans indicated by a gen-
eral contour line date back to the Fourth Dynasty.

of column shafts are generally sheathed in this way (figure 15), and it is the same basic motif of triangular leaves from which the palmettes of figures 16 and 19 emerge, as well as on the lower part of figure 20. This kind of arrangement was adequate for two-dimensional work, particularly painting, but when one chose to sculpt hard material in the round, the lotus blossom had once and for all to assume a form in keeping with the basic artistic principle described above. As revealed in our preceding discussion the bell-shaped profile view of the lotus, the so-called papyrus, was particularly well suited for this purpose and, along with it, the volute-calyx favored by the art of the New Kingdom.[28] I believe that the crowning fan of petals, bothersome to execute in sculpture, was abandoned when these motifs were carved in the round. At first, the fan was eliminated wherever the volute-calyx functioned artistically and symbolically as a sheath. Later, after the abbreviated motif had become more familiar, it was also used to complete unattached terminations, as, for example, on the pillar from Karnak (figure 20). By this time, however, the use of the conical axil filler between the volutes had apparently become so ingrained a principle of ancient Egyptian art that even though the fan was falling into disuse, I have not come across a single example of a freely terminating volute-calyx that does not have conical axil filler.[29, r]

The elimination of the crowning fan on the reduced palmette motif naturally resulted in the complete suppression of the combined view. What remained was simply the profile view of the calyx. And, in fact, the freely terminating volute-calyx appears fully equivalent in the art of the New Kingdom with the profile view of the pure lotus blossom types (figs. 7, 8) discussed earlier. The sheathing of triangular leaves on the volutes of the calyx in figures 16 and 19 are therefore no cause for surprise if one regards them as pleonasms, for the overlapping calyces exhibited by numerous examples, and particularly on painted capitals, are also the result of a definable tendency in ancient Egyptian art.

This explanation for the origin of the volute motif in ancient Egyptian art is further supported by the fact that even the bell-shaped or so-called papyrus profile view is sometimes curved at the sides like a volute but, most revealingly, only on objects where it functions as a point of inception for the handles of standards, mirrors, or the like.[30]

We have now become familiar with the most important of the vegetal

[28] For examples of the use of both forms on utensils, fans, flails, and similar things, see Lepsius, *Denkmäler aus Ägypten*, Abtheilung 3, Blätter 1–2.

[29] The way the arc has naturally grown in size and length in examples such as these has encouraged Goodyear even further to maintain that it is nothing but an inverted lotus bud.

[30] For examples, see Goodyear, *Grammar*, pl. 7, nos. 2–3.

forms used and apparently invented by the ancient Egyptians. We have traced them all, including the papyrus (thanks to Goodyear), back to the true Egyptian lotus. A few of the less important varieties remain to be discussed. The presentation of the ones that influenced the development of vegetal ornament outside of Egypt, however, will follow at a more appropriate time.

Now it is necessary to examine how the individual vegetal motifs were interconnected in order to decorate longitudinal spaces or larger surfaces. Often they were only minimally connected, i.e., simply juxtaposed in a row so that the artistic motif consisted of an alternation of open blossoms and small, pointy buds (figure 11). These rows of lotus blossoms and buds (or palmettes) were appropriate for filling continuous bands, such as cornices, friezes, or borders, though less suitable for producing an overall pattern, since all of the motifs were oriented in the same direction. It was soon discovered, however, that two rows could be placed opposite each other, with the motifs of one row inserted into the spaces between the motifs of the opposite row (figure 21). This arrangement neutralized the monodirectional quality and could be repeated in bands any number of times to fill a field of any size without favoring one orientation. However, it did not amount to much more than a simple strip or border pattern.

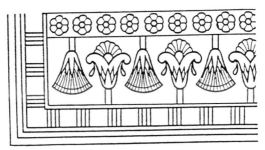

Fig. 21. Border with alternating series of
opposed palmettes and profile lotus blossoms,
wall painting from Medinet Habu.

The art of the New Kingdom, of course, did not remain content with this simple, disconnected arrangement in rows; vegetal motifs were also connected to one another by *arcuated bands.*[5] Let us examine the border strip in figure 22.[30a] There we find lotus blossoms alternating with both lotus buds and with a variety of lotus profile views reminiscent of the

[30a] From Prisse d'Avennes, *L'art égyptien*, atlas 1, pl. 13, "Couronnements et frises fleuronnées," no. 6.

palmette-fan, which in the relatively uninhibited medium of wall painting probably evolved quite naturally from the more familiar version of the lotus.¹ All three motifs, however, are connected by repeating arcuated stems. This was the most attractive means of connection for blossom motifs current in pre-Greek styles—those of the ancient Near Eastern peoples like the Egyptians, Assyrians, Phoenicians, and Persians—and even among the Orientalizing Greek styles found on Rhodian and Cypriote vases." It is important to note that three motifs are involved, which, as each is repeated, create rhythmic groupings among themselves. The rosette fillers and the small, drop-shaped buds in the tomb painting illustrated in figure 22 have been omitted from the drawing, so that such painterly excesses might not hinder us from establishing the basic schema of the pattern.

Fig. 22. Arcuated band frieze with
lotus blossoms and buds, wall painting
from Necropolis at Thebes.

Like simple serial juxtaposition, the vegetal motifs connected by an arcuated frieze are oriented in one direction and are therefore more suitable for filling up border strips than large fields. In order to adapt them to this purpose, they were arranged, like the disconnected motifs above, in two interlocking rows facing each other (figure 23).[31]

[31] This alternative solution is related to the strong tendency in purely decorative art, particularly in the Geometric Style, to place corresponding decorative motifs, whenever appropriate, opposite other. Of these so-called reciprocal ornaments, the running-dog and the simple meander are the best known. However, the integration of gamma (γ) and tau (τ) shapes opposite each other on borders reflects the same desire to neutralize the direction of an ornament by repeating it in the opposite direction. In geometric ornament, the whole surface of a border could, in fact, be divided up into equivalent motifs that were continuously interlocked with each other above and below. In vegetal ornament, however, this was difficult, so the Egyptians simply repeated the motifs in the opposite direction and left a field free on either side. Moorish art, however, managed to bring vegetal motifs into a reciprocal scheme, which was then imitated for a time in certain areas of Europe influenced by Moorish art during the Renaissance. See A. Riegl, "Spanische Aufnäharbeiten," *Zeitschrift des bayrischen Kunst und Handwerk, München* (Dec., 1892): 65–73.

Fig. 23. Painted ceiling decoration with opposed
arcuated band friezes of palmettes and
profile lotus blossoms from the
Harem of Rameses III at Medinet Habu.

There is still one more, albeit isolated, means of connecting ornamental lotus motifs to consider. Though it is only of general interest and has no real bearing on further developments, it shows once again that the ancient Egyptians did not simply cling tenaciously to their initial solutions but constantly rearranged traditional elements in rich and varied ways. In figure 24, for example, a narrow band, which could be construed as a tendril, forms circles connected to each other by short segments, which branch off into lotus blossoms and buds.[v] The individual circles are filled with rosettes. The short, connecting tangents are similar to those used in early Greek art, especially in the Dipylon Style, which is, however, purely geometric and devoid of any vegetal elements.[w] Nevertheless, this stiff, one-sided arrangement is still a world apart from the vivacious and rhythmic Greek tendril.

A combination of curving stems with lotus blossoms in the various profile views encountered thus far also occurs on the interlacing forms thought to symbolize the two kingdoms of Upper and Lower Egypt.[31a] The

[31a] [Lepsius, *Denkmäler aus Ägypten*, Abtheilung 2, Blatt 120f; Abtheilung 3, Blatt 19, nos. 1c and 2c.]

Fig. 24. Frieze of tendril-like elements connecting
lotus blossoms and buds, wall painting from
tomb 75, Necropolis at Thebes.

elegant curve of the lines and the grouping of the blossoms offer us a
foretaste of how the Greeks would later allow these motifs to move about
freely. However, the importance of this interlacing form rests primarily
on its representational value and not on its decorative characteristics; it
does not contribute, as far as we know, to any further development.[x]

Rows of lotus motifs connected by arcuated bands have no prototypes in
nature; they are therefore a purely decorative device. At one point we
might have been been tempted to attribute the discrepancy between the
stylization of the lotus blossom and its actual appearance in nature (which
can be considerable, especially in the case of the bell-shaped type and the
volute-calyx) to the limitations of an artistic style that was still relatively
primitive and insulated from external influence. But these connecting
arcuated lines now render this impossible: they prove that there was abso-
lutely no intention to copy nature overtly. The object was simply to con-
nect the rows of blossom motifs in an attractive manner, for reasons that
could only have been purely artistic in nature. The ancient Egyptian arcu-
ated frieze is therefore nothing other than pure decoration.[32]

Ancient Egyptian art, especially from the New Kingdom, however, had
another scheme of surface decoration in which the connecting elements
were the primary determinants of the pattern, while the vegetal motifs
were subordinate. This was a surface decoration based on the spiral.

The *spiral* in decorative art is initially a purely linear, and therefore
geometric, element. Later on, when we take up the question of the origin

[32] The same could be said about another way the lotus motifs are joined: blossoms are often
found crowning long stems, which are themselves studded by small, drop-shaped forms
similar to the ones beneath the volutes of the palmette. Goodyear (*Grammar*, 50) immedi-
ately identified them as lotus buds, though he was quick to point out that the arrangement
is contrary to nature, since in reality each bud is supported by its own stem rising out of the
water. This arrangement of bud and blossom is obviously also a purely decorative solution.
In this case, as well as in the arrangement with connecting arcuated lines, the blossom (or
bud) motifs are always of major importance, while the connecting lines are of secondary
interest.

of the spiral, which has been the object of so much discussion, we will be examining examples of primitive art that developed in isolation and have no vegetal motifs at all but exploited the spiral to an astonishing degree. Now, however, let us examine how the spiral was used in ancient Egyptian art. The original scheme is also that of a strip, border, or frieze (figure 25). The spiral curls under and then again out. The center in this instance is clearly marked by a rosette. Whenever the motif is used on a smaller scale, however, particularly on metal vessels, then the center, or so-called eye, is left blank. The axils formed where the connecting lines merge with the circular outline of the involutions are filled with readily identifiable lotus blossom profiles. Beyond a doubt, the spiral is the major decorative element, while the floral motifs are mere accessories prompted only by the decorative need to fill the axil.

Fig. 25. Frieze of spirals with lotus blossoms as axil fillers, wall painting from Necropolis at Thebes.

Spirals, however, also lend themselves to decorating entire surfaces in an overall, connected pattern. Figure 26 shows a simple example based on the spiral scheme of figure 25. The motifs are repeated in series with their involutions aligned but their spirals running in opposing directions, so that, for example, if one spiral is curling to the right, its neighbor will curl to the left. Vegetal motifs occupy the rest of the field. They are not, however, inserted into the axils created by the individual running spirals, as in figure 25, but into the axils left between two neighboring spirals. In this case, therefore, the lotus blossoms do not only fill up axils but are actually instrumental in creating the continuous overall pattern by joining together the individual spirals. Another look at the simpler example in figure 25, however, will remind us that, despite the increased status of the vegetal motifs in this spiral arrangement, the main element of this kind of surface decoration was originally the geometric spiral.[y]

Figure 27 is an even more elaborate example. Here the circular involutions are connected in a number of ways, so that there are five instead of

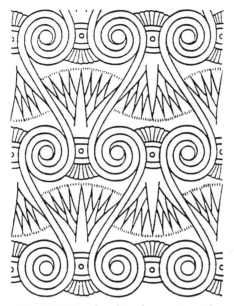

Fig. 26. Painted ceiling decoration with spirals and lotus axil fillers from tomb 33, Necropolis at Thebes.

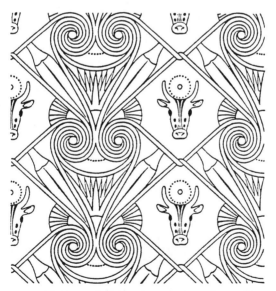

Fig. 27. Painted ceiling decoration with spirals, lotus axil fillers, and bucrania from tomb 65, Necropolis at Thebes.

two lines running into each eye. The axils are filled with lotus blossoms as well as with buds, which in retrospect is important for the interpretation of the drop-shaped fillers of the volute-calyx of figures 16, 17, and 19.[33]

While we have been describing the spiral as the dominant element in all of these examples (figs. 25–27), and the vegetal motifs, on the other hand, as mere accessories filling up the axils, Goodyear is of the opposite opinion. In accordance with the main thesis of his book, which argues that virtually all ancient ornament originates from the lotus motif, he refuses to recognize the spiral as an independent element that need not be derived from the lotus. For Goodyear, the spiral is essentially a volute that developed from the kind of lotus blossoms that have voluted calyces. From this point of view, however, we would have to interpret the lotus blossoms in figures 25–27 in all instances as the main motifs and not simply as accessories filling up the axils. For the most part, Goodyear[34] used the concentric rings decorating scarabs for evidence, concluding that they were the end products of the rearrangement and reduction of volutes. He himself admitted, however, that it was impossible to trace the process chronologically using dated material. Although the spiral ornament that has survived dates mainly from the New Kingdom, it must have already been used extensively in the Old Kingdom, even if the number of examples is very small. In any case, Flinders Petrie has dated[35] one scarab with the elaborate arrangement of figure 25 to the early period of the Eleventh Dynasty, and another without axil fillers to the Fifth Dynasty. The only examples that seem to justify Goodyear's hypothesis are the ones where the lotus blossoms fill the space between two independently spiraling circles (figure 26) and could be taken for the volute-calyx of the blossom. The simplest examples, however, as in figure 25, have not two but only one spiraling circle associated with the flower filling the axil. Goodyear casually accounts for the omission of the second volute by explaining that it was the only way a continuous pattern of connected lotus blossoms could be created in the first place. He fails to demonstrate, however, why the ancient Egyptians would have made such a drastic change in their characteristic hieratic patterns for such minor decorative purposes, and this is where his argument breaks down.

We confront the same problem in finding dated material from the early stages of the development to substantiate our line of reasoning as

[33] The cow heads represent Isis-Hathor and are considered by Goodyear, among others, to be the earliest predecessors of the bucrania found in Greco-Roman decorative art.²

[34] Goodyear, *Grammar*, 81ff., pl. 8.

[35] Ibid., pl. 8, no. 17.

Goodyear does with his. Our argument, however, can be supported by the examination of analogous phenomena in documented primitive art, which yields two observations fundamental to our hypothesis: first, that the spiral is purely geometric, and second, that the postulate of axil filling was very important and a determinative factor in these primitive artistic styles.

One such kind of primitive art was created by the Maori, the natives of New Zealand. The Maori art of today has been more or less contaminated by European influence, but enough of the earlier work was saved in European museums just in time. A very significant and instructive collection gathered by the Austrian world traveler Andreas Reischek has been installed in the Naturhistorisches Museum in Vienna. We gain a self-contained and well-rounded picture of the ornament of the Maori from studying this collection, but one that differs in a particular way from everything else we know about the arts of primitive peoples. We can only assume that the Maori experienced a long-lasting development that proceeded along its own independent path. New Zealand, moreover, had no metals, so that its natives had to rely on stone implements, which they were very skilled at producing. If it is true, as some (naturally Goodyear among them) have maintained, that the Maori were in contact with Malayan culture, then it is hard to understand why metal utensils were never introduced onto the island. It is still perhaps possible that the Maori worked metals very early, at a time before they became isolated on New Zealand. However, an enormous amount of time would have to have elapsed for a Stone Age culture as self-contained as that of the Maori to have developed.

In view of the difficulty we usually have in distinguishing the truly indigenous and most ancient traditions in the art of primitive peoples from what has been admixed through steady or sporadic trading, it is a rare opportunity to come across a culture with a completely independent development, uninfluenced by outside sources presumably for thousands of years.[36]

It is extremely interesting to find that the spiral plays a dominant role in the ornament of the Maori. The motif is found in wood carving either in chip carved or openwork technique like that of ironwork (fig. 28). Smooth spirals are also engraved in bands on hard fruit rinds (fig. 29), where they contrast with a hatched background blackened by grime. Lastly, spirals are found incised in stone where they are frequently accompanied by dots (fig. 30). The Maori spiral is very closely related to the ancient Egyptian

[36] See my note, "Neuseeländische Ornamentik," *Mitteilungen der Anthropologischen Gesellschaft in Wien*, 20 (1890): 84–87, figs. 22–24, the source for figs. 28–30 here.

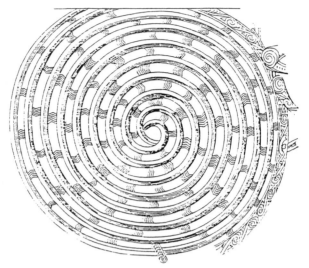

Fig. 28. Detail of carved openwork prow of Maori canoe.

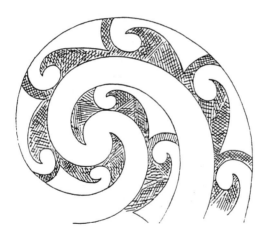

Fig. 29. Engraving on Maori fruit rind.

Fig. 30. Engraving on
the sinker of a Maori
fishing net.

motif because, like the latter, it first coils inward to a central point and
then runs back out again. The large prow and stern spirals on sides of
canoes (fig. 28) wind around and around a number of times, until the band
curling in and the band curling out meet in the middle. On the outermost
turn of the large spiral to the right of figure 28, however, there are some
smaller, carved spirals connected by tangents, which have essentially the

same scheme as the ancient Egyptian example in figure 25. Along the narrow border, triangular shapes or little broken lines fill the axils formed where the margins of the band meet the involutions. This is where the two examples are most similar; the only difference is that the Egyptian example has lotus blossoms filling the axils, while the New Zealand carving, in keeping with the exclusively geometric character of its ornament, has simple, linear configurations.[aa]

We now have to determine whether the New Zealand spiral ornament, which is similar to that of the ancient Egyptian, was prompted by external causes of any kind. If we find that the New Zealand spiral came into being and reached its high degree of refinement because of the purely technical demands of the materials involved, or because of any other technical constraints, then we would also have to investigate whether this applied to the Egyptian motif as well. Remarkably enough, however, the usual explanations given for the technical derivation of the spiral do not work at all in the case of the New Zealand spiral. The motif is considered, on the one hand, to be typical of the kind of decoration derived from metalwork, especially the wire spirals of filigree; however, since there is no metal on New Zealand, there is, of course, no metal wire. Gottfried Semper,[36a] on the other hand, found the inspiration for the spiral in the twisting of threads: the Maori, however, never produced any thread. There are not even any strips of leather on New Zealand, which when rolled up into a spiral might have struck the Maori with their formal beauty. Certainly there were, and still are, baskets produced on the island that are woven in a spiral which, though not very obvious in the finished product, can be discerned with a certain amount of effort. But can this seriously be the source of the entire spiral ornament of the Maori? The great pains that the Maori took to carve out their spiral decorations with obsidian tools in inherently hard materials such as wood and stone become incomprehensible. They did use one medium, however, that offers less resistance: the skin of their own bodies, though even here there is no connection with metalwork or textiles. Their tattooing consists of very delicate and intricate spiraling forms. The examples in figures 31 and 32 have been taken from Lubbock.[36b] This kind of development of spiral ornament would seem astonishing to us even if we knew for certain that the Maori knew how to work metals and draw wire at some time in their past. What this

[36a] [G. Semper, *Der Stil in der technischen Künsten; oder praktischer Ästhetik* (Munich, 1878–1879), 1:167.]

[36b] [J. Lubbock, marquis of Avebury, *The Origin of Civilization and the Primitive Condition of Man, Mental and Social Condition of Savages*, 2d. ed. (London, 1870), 47, figs. 13–14.]

Fig. 31. Maori facial tattoos. Fig. 32. Maori facial tattoos.

example does point out so powerfully is that, quite to the contrary, techni-
cal processes did not have to play a major role in the formation of these
motifs at all.[37]

For contrast now, let us see what happens when we approach the spiral
in art as a geometric shape produced by the purely creative activity de-
scribed in the first chapter. We are no longer going to be looking for mod-
els in nature or examples of technical dexterity to explain the invention of
the spiral motif but will be asking ourselves what the next simplest geo-
metric form might be from which the spiral could have developed through
an artistic process. The basic two-dimensional shape closest to the spiral
is the circle. The circle is the most perfect of all two-dimensional shapes;
it fulfills the postulate of symmetry in all directions. This quality alone is
enough to account for the widespread use of the circle within geometric
styles. The optimum articulation of the circle consists of smaller concen-
tric circles or of a dot placed in the center. When these concentric circles
are connected to each other by tangent lines, the whole arrangement al-
ready superficially resembles the simple spiral band in figure 25. To draw
this arrangement in one continuous stroke, one need only begin with the
line tangent to the outer circle, then wind around each inner circle in
succession to the central point, and finally circle out again to the next
tangent line. This is, of course, an a priori hypothesis that must eventually

[37] A. Anděl presented a very instructive and clear survey of the many ways the spiral
appears in art in a program at the k. k. Staats-Unterrealschule in Graz in 1892: "Die Spirale
in der dekorativen Kunst."

be substantiated by surviving monuments. However, a glance at the progressive development of concentric rings as arranged by Goodyear on his plate 8 will convince many viewers—even in the absence of a secure chronology—that our description of the process is far more natural than the reverse order espoused by Goodyear; he assumes that the spiral was originally a vegetal motif, specifically the volute-calyx of the lotus blossom, that was progressively denatured and geometricized until it gradually dwindled to the simple arrangement of concentric circles with a central point.

I would like to make it clear from the outset, however, that I do not consider what I have just proposed about the possible derivation of the spiral from concentric designs to be the only cogent explanation. I have absolutely no intention of adding just another speculative explanation for the spiral or any other basic, time-honored ornament, to the numerous ones now in vogue. What I really wanted to show was the possibility of arguing from the point of view of the decorative development itself without referring to primitive techniques or to particular models in nature that are ultimately of little consequence. Such an argument—should a satisfactory one ever be found—can remain well within the realm of art itself without referring to a lifeless technique or to the blind copying of objects in nature that are obviously of such trifling significance that they could never have attracted the attention of primitive human beings in the first place.[38, bb]

For the sake of completeness, I will mention the hypothesis of Stübel,[38a] which overlaps with my tentative theory of the development of the spiral motif inasmuch as it also begins with a discussion of concentric circles. It is unlikely, however, that ornaments, least of all those which are found throughout the entire world, arose accidentally when painted potsherds were placed next to each other or pieces of patterned cloth were sewn together. Nevertheless, anyone who is interested in the history of geometric ornament will certainly profit from reading Stübel's article.

Professor A. R. Hein in Vienna approached the matter from a different perspective in a recently published essay.[38b] He pointed out that a whole series of widely used, simple decorative forms like the swastika inherently

[38] The cave dwellers were adept at reproducing the kinds of animals either dangerous or useful to them, but they did not copy spiraling vine tendrils and certainly not weaving patterns, since they did no weaving themselves.

[38a] [Stübel, "Über altperuanische Gewebemuster," *Festschrift des Vereins für Erdkunde in Dresden* (1888).]

[38b] [A. R. Hein, *Mäander, Kreuze, Hakenkreuze und urmotivische Wirbelornamente in Amerika* (Vienna, 1891).]

express the idea of rotation or revolution. The spiral obviously conveys the same idea and may very well have had symbolic value in certain cultures at certain times. Nevertheless, Hein would certainly not suggest that symbolism gave rise to the first spiral motif, for although he does not discuss the spiral as such in his article, he expressly states that symbolism adapted existing geometric forms for its own purposes.[39]

We do not, therefore, need the volute-calyx of the lotus blossom to account for the invention of the spiral in ancient Egyptian art, because we now view the motif just as we view zigzag patterns, concentric rings (both of which Goodyear, of course, derives from the lotus blossom), or the checkerboard pattern, etc. It was a geometric motif handed down from much earlier decorative art that can still be found in the decorative geometric styles of contemporary primitive cultures like that of the Maori of New Zealand. And the same is true of the postulate of axil filling, which we found to be similar in both ancient Egyptian and New Zealand art, as illustrated by the outer turn of the spiral in figure 28. The tattoos in figures 31 and 32 can also be entered as evidence. The spirals that decorate the bridge of the nose have been filled in with hatching on both sides in a way also characteristic of Mycenaean art, to which we shall later return.[cc]

Now that we have finished examining how the ancient Egyptians adapted the plant for purely decorative purposes, I would like to add some general remarks about the place and significance of ancient Egyptian art within the overall history of the decorative arts. As far as we know, the art of the ancient Egyptians was the first to adopt motifs that are clearly derived from plants into its repertory of purely decorative forms. If the Egyptians had any predecessors, their traces have been completely erased; at any rate, nothing of the sort has ever been discovered.[dd] In the chapter on the Geometric Style, however, we became acquainted with the relatively early art of the Aquitanian cave dwellers, which can now be used as a certain standard against which to measure the development of the decorative arts of the Egyptians, who had the earliest civilization discovered thus far. What importance did Egyptian art have for the development of the decorative arts in general?

The answer is very contradictory. Even though the Egyptians did create decorative patterns that can be considered of lasting value, it is evident at the same time that others would subsequently handle this task

[39] Ibid., 28. The author is also to be applauded when he states that the "invention of forms is based primarily on the creative aptitude of human beings and on the desire to satisfy the artistic urge" However, he contradicts himself a few lines later when he concurs with the absolute statement that "geometric ornament is the offspring of technique."

much more effectively, and not only the divinely-favored Greeks but even the Assyrians and the Phoenicians. The Egyptians' apparent lack of natural ability for creating decorative art is especially obvious in their treatment of borders, which seldom relate harmoniously to the fields that they frame. The solutions used for corners are even less successful and often strike the eye as downright unpleasant. Even the geometric patterns, which make up most of the motifs in the narrow borders, betray a neglect of decorative concerns, just as they do in ancient Egyptian ceramics, where they also play the main role. Of course, the human figure is also frequently used for purely decorative purposes. This is not a bit surprising to us, since we know that human beings have been imitating creatures from nature in sculpture for these purposes since the time of the cave dwellers. The skill of the cave artists might have lagged far behind that of the Egyptians, but, as far as artistic impulse is concerned, there is no unbridgeable gap between them. A human figure sculpted on the handle of a spoon is by no means essentially nobler than a reindeer carved for the same purpose, particularly when the animal is executed as artistically as that in figure 1.

From what I have just said, it may seem as though the ancient Egyptians did not really advance as far beyond the stage of the cave dwellers as one might have expected, considering they were the first to develop the important types of vegetal ornament. That would, however, be a very narrow assessment, for in order to judge the Egyptians fairly they must be examined within the context of art history in general, where the balance tips instantly in their favor. Egyptian art was the first, as far as we know, to establish objectives well beyond the satisfaction of a mere decorative urge. The art of the Egyptians was basically representational. It no longer served merely as decoration, for its overriding purpose was to express perceptions, feelings, and ideas that had nothing in common with pure delight in beauty alone; this is apparent from the extensive use of art in Egyptian funerary customs. If this kind of purpose in art is to be understood as the definite sign of a higher, more advanced stage of culture, then the Egyptians, as far as we now know, were the first to achieve it.

So grand were the artistic concerns arising from the Egyptians' new and more elevated cultural level, and so great were the difficulties involved in their solution, as they had no recourse to any sort of prototype, that everything else pales in comparison to their efforts and goals. The naive *horror vacui* that spatters surfaces with colorful decoration is essentially a world apart from the mature artistic sensibility that strives to capture in physical form the supreme and the divine. The Egyptians were inspired in their art

by religious and political ideals; they were much less concerned with the sheer joy of decoration itself.

Much less concerned, to be sure, but it would be going too far to maintain that the Egyptians completely ignored pure decoration. Originally, the various types of lotus blossoms were surely not carved and painted by Egyptian artists on the walls of tomb chambers or sculpted in the round in stone purely as decoration but because of what the lotus represented in Egyptian culture. But just as surely the same types found their way as early as the Old Kingdom onto jewelry and practical utensils precisely for the sake of their formal beauty. To deny the Egyptians any sensitivity to the delights of decoration for its own sake would mean overlooking the whole wealth of exquisitely decorated minor art that has been preserved in the tombs of the pharaohs. This culture was no doubt already trying to strike a balance between the two poles of artistic concern—at one end a decorative urge demanding a feast for the eyes and at the other a desire to give concrete expression to the most significant ideas and feelings of humanity. The Egyptians were the first to be keenly aware of this polarity. They can hardly be blamed for not having found an ultimately satisfying solution. Just as there are limits to what an individual can accomplish, so it seems that cultures also have their limitations. The achievements of the Egyptians in the history of art were already so great and fundamental that it is easy to understand how they could not ultimately attain the goal first achieved by the Greeks—the harmonious fusion of formal beauty and profound content—i.e., to be both pleasing and meaningful.[ee]

This point is important enough for us to linger on it for one more moment. To broaden our understanding of the Egyptians' artistic limitations, I would like to point to a parallel phenomenon involving another aspect of art. The ancient Egyptians were the first to create truly monumental architecture, the prerequisite for which is the use of permanent materials such as stone or its substitute, brick. The Egyptians built temples in stone so permanent that many of them remain standing, as is well known, to this very day. The development of stone construction is, of course, quite a respectable technical accomplishment. The Egyptian hypostyle hall with its stone roof is, furthermore, also a highly significant artistic achievement, a first attempt that marks the very beginning of all monumental architecture. The aesthetic qualities of the Egyptian temple, however, are essentially confined to the interior: the simple, massive outer walls slant upward with virtually no articulation except for the decoration superficially applied to the pylon facade. The Mesopotamians also tried in their own way to balance structure and decoration, but their results were not really satisfactory. It was the Hellenes who first managed to infuse the

exterior of their columned buildings with such harmonious formal perfection that the Greek temple still stands today as an artistically integrated whole, incomparable and unique in the entire history of art. This is true even of Greek decorative arts, where the forms are supposed to be "pleasing" and where no pointed "meaning" is intended. The Hellenes brought ornament to its most mature, perfect, and formally beautiful stage, while at the same time they used forms with significant content, which, however, always bowed graciously to the overriding decorative demands. It would be unreasonable to expect the Egyptians to have also reached this stage of perfection. They accomplished more than enough as it was; it would now be the task f younger, more vigorous, and energetic cultures to take over what the Egyptians had begun. It will now be extremely enlightening to observe how Near Eastern cultures, which seem to have received their first decisive artistic impulses from the Egyptians, went beyond their mentors and slowly but surely followed a path in their ornament that would eventually be completed by the Greeks. The strong challenges created by Egyptian art because of its integration of religion and politics also obtained among the Oriental cultures who succeeded them, but to a far lesser degree. In a moment, we will examine the extent to which the founders of the next international empire in the Near East after the Egyptians, the Mesopotamians, were able to transcend the decorative achievements of their predecessors.

2. Mesopotamian

The second oldest art and culture in the history of the ancient Orient to attain widespread importance was that of Mesopotamia. Unfortunately, the surviving artistic monuments date almost exclusively from the relatively late period of Assyrian rule. Our knowledge about Mesopotamian art before 1000 B.C. is very spotty, based as it is upon a few sporadic monuments, the earliest of which are not even as early as the the New Kingdom under the Thutmosid line [Eighteenth Dynasty], which came relatively late in Egyptian history. As a result, we cannot determine with any certainty the extent to which the Babylonians of the lower Euphrates and Tigris Valleys were actually the founders of the higher culture and art of the whole vast Mesopotamian river basin, as is generally assumed. Therefore, even though I will be speaking in terms of Assyrian ornament in the following discussion, I am not discounting the possibility, in fact the probability, that the Babylonians, and perhaps even the Elamites, should be given some credit for the creation of Mesopotamian art.[a]

I cannot go into the full impact that Assyrian art exerted upon the development of ornament. That would involve clarifying the relationship between Assyrian decoration and its figural and animal representations, which we touched upon briefly in the chapter on the Heraldic Style. What must be generally and expressly stated here, however, is that Assyrian art was the first to establish more or less consciously that distinction between border and field, frame and fill—in other words between the active and passive parts of a design—that was fundamental to the later development of Mediterranean art.[40] The Egyptians had also placed two-dimensional figurative motifs in fields enclosed by borders. With few exceptions, however, these borders were limited to very simple patterns, which did not amount to much more than rows of dashes or zigzag lines.[41] The weak side of the Egyptian decorative sensibility is especially apparent in the treatment of corners wherever two borders converge at right angles. The borders often consist of different patterns, which simply collide and come to a halt.[42] The Assyrians, on the other hand, were the first to develop uniform framing systems with artistically satisfying solutions for the corners.[43] They decisively appropriated the individual vegetal motifs and the effective solutions for extending them that the Egyptians had achieved and then applied such ornament in a far more comprehensive and purposeful way.

The elements of Assyrian vegetal ornament are rooted in Egyptian decoration. I, for one, see no reason to assume, along with von Sybel, that New Kingdom vegetal ornament originated in Asia.[44] The circumstance that the palmette and the rosette were the most beloved motifs in Assyrian art during the first millennium B.C. does not mean that they were invented in Mesopotamia. The palmette was used even more extensively later on in Greek art, and yet no one would argue for its independent

[40] Culturally and historically, Mesopotamia and Iran should be associated with Mediterranean culture, since the politics and religions of these regions have always gravitated toward the Mediterranean and not toward eastern Asia.

[41] The most successful examples are from the so-called minor arts, such as the wooden spoons edged with zigzag lines illustrated by Prisse d'Avennes (*L'art égyptien*, atlas 2, pl. 92, "Boîtes et utensiles de toilette," nos. 4 and 6).

[42] Attempts to deal with corner solutions in ceiling decoration are illustrated in Prisse d'Avennes, *L'art égyptien*, atlas 1, pl. 29, no. 1, "Guilloches et méandres," in the upper left corner with zigzag; ibid., pl. 32, no. 7, "Postes et fleurs," in the lower left corner with the forerunner of the egg-and-dart motif (fig. 23). These examples show that the ancient Egyptians were well aware of the problems involved but did not pursue them further.

[43] For example, the stone doorsill of figure 34 taken from A. H. Layard, *The Monuments of Nineveh: From Drawings Made on the Spot by Austen Henry Layard*, vol. 2 (London, 1853), pl. 56, no. 1.

[44] According to von Sybel, only the earlier form of the lotus blossom (fig. 7) and the so-called papyrus came from Egypt.

Greek origin. Furthermore, it would be hard to explain why the Egyptians, assuming that they had borrowed the rosette and the palmette, never adopted the most popular Mesopotamian border motif of all, namely the guilloche, which we are about to discuss.

Let us examine the border pattern of a glazed wall tile (figure 33)[45] found in the rubble of the northwest palace at Nimrud from the time of Assurnasirpal II (ninth cent. B.C.). It consists of a central band containing a guilloche pattern bordered on both sides by a row of vegetal motifs connected by means of flattened, arcuated bands.

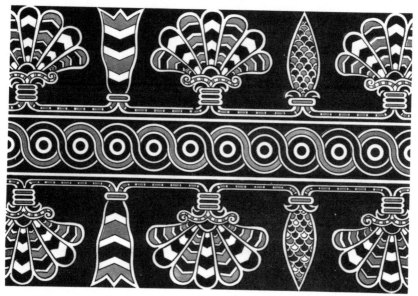

Fig. 33. Border decoration on Assyrian glazed brick from Nimrud.

The *guilloche* is especially characteristic of Mesopotamian art; similar patterns have never been found on Egyptian monuments.[46] Until now, there has been little doubt about its origin.[b] Ever since Semper's discussion of the primeval braid, there has been unanimity about the descent of

[45] A. H. Layard, *The Monuments of Nineveh: From Drawings Made on the Spot by Austen Henry Layard*, vol. 1 (London, 1849), pl. 86, bottom. [A color reproduction of this tile also appears in G. Perrot and C. Chipiez, *Histoire de l'art dans l'antiquité*, vol. 2 (Paris, 1884), pl. 13. Riegl's original attribution of this tile and the reign of Ashurnasirpal II to the tenth century was incorrect and has been emended accordingly.]

[46] Goodyear also integrated the guilloche into his lotus theory: "the guilloche is an abbreviated spiral scroll." According to him, the guilloche originated from the spiral's wave. I can think of only one single example from the relatively late Mycenaean period (H. Schliemann, *Mykenae; Bericht über meine Forschungen und Entdeckungen in Mykenae und Tiryns* [Leipzig, 1878], 288, fig. 359) that could serve as an intervening example, but in my opinion, the guilloche has nothing to do with the lotus motif.

the guilloche from twisted plaitwork. However, those of us who are not unquestioning followers of the artistic materialism currently in vogue would like to know just what prompted human beings to copy something as insignificant as a braid to decorate monuments that were built to last forever. Those of us who no longer detect the influence of woven fences or baskets behind linear geometric ornaments also have no need to look to the braid for similar purposes. Human beings copied their own image directly from nature for decorative purposes. They also copied the kinds of animals that were particularly strong or useful. Later on, they fashioned beautifully articulated vases and slender candelabras, etc. The notion that the braid should have somehow impressed human beings with its formal beauty during this whole process can only be taken seriously by a materialist art historian. And the fact that in our own time we do not find anything peculiar about this line of thinking will surely cause later ages to look back upon our strangely distorted attitudes toward art with a scorn not altogether unjustified.

In the history of vegetal ornament, the guilloche has only once played a minor role—in Greek art, and that, moreover, at a relatively late date (figure 84). Therefore, I will not even bother making another pointless attempt to concoct some sort of derivation for it. It is surely clear by this time that I see the guilloche as a linear shape formed exclusively according to the principles of symmetry and rhythm.[c] What is more important at present, however, is the examination of the vegetal motifs flanking the guilloche in figure 33. There are three different kinds of motifs: a bud, a palmette, and a three-pronged blossom; they are repeated in the following rhythmic sequence: palmette, bud, palmette, blossom, palmette, bud, and so forth. This manner of arranging a group of three elements is familiar to us from Egyptian ornament (figure 22), the only difference being that in the Egyptian example the lotus blossom is the main motif, which is repeated twice, while in the Assyrian example it is the palmette. Moreover, the blossom motif of the Egyptian border, which resembles the palmette-fan, is exchanged in the Assyrian example for a motif that is unquestionably the palmette itself.

Let us first discuss the individual forms, leaving aside for the moment the way in which they are interconnected. There is very little to say about the bud. It is distinguished from its Egyptian equivalent only by the scalloped articulation.[47] The palmette, on the other hand, deviates more radi-

[47] Perhaps the Mesopotamians really did, as is sometimes assumed, confuse the bud motif with the pinecone.

cally from the combined view of the Egyptian lotus or the lotus-palmette of figure 16. Whereas the Egyptian calyx and fan are about equal in size, with the calyx perhaps slightly larger, it is the fan on the Assyrian example that is the most prominent part by far. The strong volutes of the Egyptian calyx are gone and replaced by two hornlike little forms curling down to either side. In addition, there is a second, more pronounced calyx comprised by strongly emphasized upwardly-curling volutes, which has been inserted between the smaller calyx and the fan. Despite these differences, I still find the similarity to the Egyptian palmette undeniable. The same peculiar structure is common to both motifs and could hardly have been invented independently in both cases. Intermediary forms from Phoenician art, which are thought to show the progression from the Egyptian lotus to the Assyrian palmette, have been suggested; I will discuss them later in the chapter on Phoenician ornament. Here I would only like to mention that, although they may seem to be something new, there are in fact prototypes in Egyptian vegetal ornament for the upper, upwardly-curling volute-calyces of the Assyrian palmette. At any rate, it would be completely inappropriate to seize upon the palm tree as the natural model of the Assyrian palmette. The fans on the palm trees depicted in Assyrian reliefs do, of course, resemble the ones on palmettes, but the volute-calyx, that characteristic component of every palmette, is always missing on the trees. It is much more likely that the fan in renderings of palm trees was modeled on the developed decorative form of the palmette, which would have been a readily available solution, but certainly not the reverse.[48]

Finally, the third motif of the Assyrian border pattern, the three-petaled *blossom*, is also related to the Egyptian lotus, though not to the typical form of the lotus blossom but to the crowning motif (figure 37), which became very common during the Middle Kingdom (Eleventh and Twelfth Dynasties) and occurred already in the Old Kingdom.[49] Von Sybel[50] saw the motif as a vase, because it often narrows to a point and

[48] Sometimes pinecones appear on stems between the leaves of the palmette-fan (Layard, *Monuments of Nineveh*, vol. 1, pl. 47; Perrot and Chipiez, *Histoire de l'art*, vol. 2, fig. 137), probably for symbolic purposes. The fruits of the palm trees on Assyrian historical reliefs, however, hang down from the trunk on the lower edge of the fan.

[49] R. Lepsius, *Denkmäler aus Ägypten und Äthiopien nach den Zeichnungen der von Seiner Majestät dem Könige von Preussen Friedrich-Wilhelm IV nach diesen Ländern gesendeten in den Jahren 1842–1845 angeführten wissenschaft-* lichen Expedition (Berlin, 1849–1856), Abtheilung 2, Blatt 101, bottom left, and center. [On this motif see annotation g for chapter 3A.2.]

[50] L. Von Sybel, *Kritik des aegyptischen Ornaments* (Marburg, 1883), 6.

in this form resembles the depiction of vases. Frequently, however, it does not come to a point but assumes the pattern of the lotus blossom.[51] For this reason, I associate this Egyptian motif with the lotus blossom and the bud, whose main function as a crowning element has been discussed above. What strengthens my belief in the derivation of the Assyrian border blossom from the Egyptian crowning element even more is, first of all, the curved contour line of the blossom and, second, the flattened shape of the connecting arcuated bands; for the Egyptian motif is also frequently mounted on two diverging stems, although they do not continue as arcs to the right and left but rest on the ground line like two independent, supporting legs.[52]

In the purely decorative sense, Assyrian vegetal motifs generally represent an unmistakable improvement over those of Egypt. It is much more difficult to sense the underlying natural forms of the Assyrian motifs than it was for the Egyptian stylizations. The colorful zigzag patterning falls into the same category, as does the new combination of elements, which the Egyptians had kept strictly segregated: the upwardly curling volute-calyx and common palmette-fan. Finally, the peculiar way in which the various motifs are interconnected should be seen in the same context. That brings us to our next topic.

The continuous arcuated bands, which serve to unify the rows of vegetal motifs, are familiar to us from Egyptian art from the later New Kingdom under the Ramesids. The flattened examples of the Assyrian border in figure 33 make a less favorable impression than the nicely curved, round Egyptian arcs. Nevertheless we have just been examining, the extent to which this could still be related to Egyptian models. In contrast, we noticed certain additional elements in the connective structure of figure 33, which are missing in the Egyptian models and represent a decorative improvement as well as an important point of departure for subsequent developments. The connecting bands of the Assyrian border, which run along in very shallow arcs, look as though they are being held in place by a kind of binding or juncture, unlike the rounded Egyptian versions (figure 22), which begin immediately at the lower end of the vegetal motif. In the case of the bud, moreover, the two connecting bands running toward it from right and left appear above the binding and curve down to either side like volutes. They form a calyx for the bud that is like the one on the Assyrian palmette inspired by Egyptian models. The blossom, however, is connected to the arcuated bands solely by the binding. Together the

[52] Ibid.

calyx at the inception point of the bud and the bindings are conscious, decorative innovations of the Mesopotamians.[53]

The dependence of the Mesopotamians on the art of Egypt, rather than vice versa, is attested by the circumstance that the monuments of the later Sargonid [Neo-Assyrian] period (eighth and seventh centuries B.C.), when the Assyrians had direct contact with the Egyptians, imitate Egyptian models more obviously than the earlier ones dating from the ninth century.[54] As a result, the earlier forms from Assurnasirpal's time, which are different in character and contrast with the later, more obviously Egyptian-inspired examples, seem to be original Mesopotamian inventions. Egypt, herefore, may still seem to have been on the receiving end of the relationship between the two cultural regions after its intimate contact with Asiatic Semites during the Hyksos invasion. However, there is another explanation for the stylistic change in Assyrian vegetal ornament that is at least as persuasive, and it is actually more compatible with the greater age of Egyptian art as compared to the art of Mesopotamia. It could have been, namely, that the earlier Assyrian imitations of Egyptian vegetal motifs arrived in Mesopotamia indirectly, perhaps even before the period of the New Kingdom. Then, when the Assyrians experienced renewed and this time more direct contact with the Egyptians, they adopted the more characteristically Egyptian form of lotus blossoms and buds, perhaps without realizing that they were not adding anything basically new to their ornament. The art of the Babylonians and the Assyrians, as a whole, creates the distinct impression that these cultures were the conscious continuation of the older cultures out of which they arose, just as the Greeks, later on, built upon the achievements of Near Eastern ornament.[d]

Now let us take a look at one of the Egyptian-inspired border motifs from the [Neo-Assyrian] period (figure 34), one that decorates the corner of a doorsill. Since Semper, it has invariably been compared to a carpet pattern, although the Assyrians at that time did not have the technical skill

[53] Although even here, timid beginnings can already be found in Egyptian art: for the junctures, for example, by A. Prisse d'Avennes, *Histoire de l'art égyptien d'après les monuments, depuis les temps les plus reculés jusqu'à la domination romaine* (Paris, 1878–1879), atlas 1, "Couronnements et frises fleuronnées," no. 8; "Frises fleuronnées," no. 4; for lotus buds with volute-calyces, see Lepsius, *Denkmäler aus Ägypten*, Abtheilung 3, Blatt 62.

[54] The Assyrians were not at all as unreceptive to foreign art forms as the Egyptians were. This is probably one of the crucial reasons why their culture surpassed that of the Egyptians in the decorative arts, because only an admixture of foreign elements can lead to something new. [The Egyptians can no longer be considered unreceptive to foreign artistic concepts or elements. See the annotations concerning floralized geometric patterns and the sacred tree: *y* for chapter 3A.1; *k* for chapter 3A.3; and *n* for chapter 3B.1.]

Fig. 34. Relief ornament of alabaster doorsill from the
Assyrian palace at Nineveh (Kuyunjik).

necessary for producing a pattern of rounded forms either by knotting or
weaving.[e] Generally speaking, I would like to draw attention to the consis-
tent distinction made between the central field, the intervening margin,
and the border, each of which is treated in a completely decorative man-
ner, and to the ingenious corner solution in the border; this illustrates
what I said about Assyrian ornament at the beginning of the chapter.
These are things that we do not, as a rule, encounter in Egyptian surface
decoration.

We will only be focusing on the border in figure 34 with its alternation
of lotus blossoms and buds. The motifs themselves correspond completely
with their Egyptian models; even the three-notched calyx that contains
the individual buds and blossoms occurs in both instances in the same
way.[f] The connecting round arcs are also familiar to us from Egyptian

models. The only element that is new and specifically Assyrian about these vegetal motifs is the calyx at each point of inception. As in the example from Nimrud discussed earlier (figure 33), the calyx is a continuation of the connecting arcuated bands, which extend above the horizontal binding and curl down to either side.[55] The small, pointy leaf rising in the center between the two calycal leaves of the lotus blossom in figure 34 is obviously the same as the one found at Nimrud, though only on the palmette, which we found likewise to be related to the Egyptian palmette. In fact, the abbreviated Egyptian palmette system, the one we have been calling the lotus blossom with volute-calyx, was one of the most common Assyrian ornamental motifs of all (figure 35). What is different about the motif in comparison to its Egyptian model are the slimmer forms of the volutes, which often do not curl up at all, and the pointy shape of the central leaf. What, however, underscores once again the connection of the Assyrian motif to its Egyptian model is the completely analogous

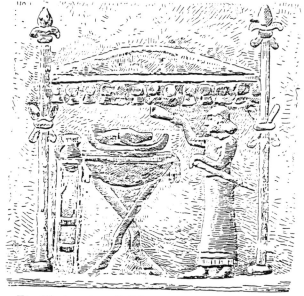

Fig. 35. Assyrian relief showing canopy with supports
crowned by palmettes, from the
bronze doors at Fort Shalmaneser (Balawat).

[55] As far as the volute calyx is concerned, there was ample precedent in the lotus palmette of Egyptian art. The specifically Assyrian element here resides in the further adaptation of this fruitful ornamental motif into buds and profile blossoms.

use of both forms. The Assyrian blossom is also routinely used either to crown or terminate something in a free ending,[56] or to mark the inception point of a long, thin object. We will return to this second use in our discussion of the so-called sacred tree below.

There is still one more vegetal motif in Assyrian ornament, widely used in later art, that seems to have a Mesopotamian origin because of its frequency in Assyrian art: the so-called pomegranate. It usually consists of a circle crowned by three little leaves (figure 36). In Assyrian art, the motif is frequently[57] arranged in rows in a border and connected by arcuated lines; here the individual pomegranates look as though they are attached to the arcuated bands with bindings (fig. 38). It is possible, however, that the pomegranate was also related to that Egyptian crowning motif derived from the lotus (figure 37), for its crowning leaves also rise above a disk, albeit separated by a balusterlike shape.[58, g]

Fig. 36. Assyrian
depiction of
pomegranate.

Fig. 37. Egyptian
crowning
pattern or "khaker."

The pure Mesopotamian form of the pomegranate, the simple disk with three-pronged crown, has so far been documented only once in Egyptian art. Goodyear[59] found it on a statue of a Nile god in the British Museum alternating with obvious lotus blossoms and buds in a row. Without hesitation, he identified the motif as the seed capsule of the true lotus and saw it as sufficient proof of the Egyptian origin of the pomegranate. Consider-

[56] Compare, for example, the tips of the tabernacle columns in figure 35 (from Perrot and Chipiez, *Histoire de l'art*, vol. 2, fig. 68) with the column supporting an architrave by Perrot and Chipiez (fig. 71), for a direct analogy with the meaning of Egyptian lotus capital columns. [For a more recent illustration of the latter work, the ninth-century B.C. Neo-Babylonian relief of King Nabuapaliddina, see H. Frankfort, *The Art and Architecture of the Ancient Orient* (Harmondsworth, 1985), fig. 231.]

[57] Perrot and Chipiez, *Histoire de l'art*, 2:311, figs. 127–28, Assyrian glazed ceramics.

[58] cf. Lepsius, *Denkmäler aus Ägypten*, Abtheilung 2, Blatt 126, 130; Abtheilung 3, Blatt 21.

[59] W. G. Goodyear, *The Grammar of the Lotus. A New History of Classic Ornament As a Development of Sun Worship* (London, 1891), 181, fig. 125.

ing the rarity of the motif in Egyptian art and its frequency in Assyrian art, I prefer to wait before accepting Goodyear's view, at least until the date of the statue has been satisfactorily clarified. As I said in regard to figure 37, I do not find a causal connection between the Mesopotamian pomegranate and Egyptian art at all out of the question but, on the contrary, highly probable.

The pomegranates set on arcs are found later, particularly on Cyrenean [Lakonian] vases. I refer to them here rather prematurely only to call attention to the arrangement of their arcs in two overlapping rows, for the motif of *overlapping arcuated bands* also occurs in Assyrian art, as proven by a fragment in Layard.[59a] This example is one more instance of the Assyrian effort to infuse their ornament with greater life and movement.[h]

Aside from the guilloche, the most common ornamental motif of the Assyrians was the rosette. Its origin and significance for ancient Egyptian art were already discussed. The embellishment of the petals of the Assyrian rosette with transverse zigzags (see the lower register of figure 38) is characteristic of Assyrian color patterning in general; we have already seen this in other examples (fig. 33), and it is what often distinguishes the Assyrian rosette from the ancient Egyptian version. The conjectures of

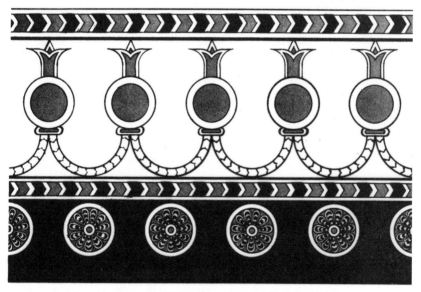

Fig. 38. Assyrian border decoration, wall painting from
the palace at Nimrud.

[59a] [Layard, *Monuments of Nineveh*, vol. 2, pl. 84, no. 13, glazed brick from the northwest palace at Nimrud.]

those attempting to argue for a technical origin of the rosette from embossed metalwork are totally unfounded.[60] The fact that the Assyrian rosette does not reveal its vegetal origins as blatantly as the Egyptian version, which often has a long stem, can be explained by the ever-increasing stylization that affected the profile view of the Assyrian lotus blossom and the palmette in the same way.

At the conclusion of this overview of ancient Mesopotamian vegetal ornament, there is one more motif to be considered, which I find has been unjustifiably credited with far too much importance and influence: the so-called sacred tree. This kind of tree was the most appropriate means of separating two opposed animals in the Heraldic Style. The lofty, symbolic associations that have often been read into the motif may have played a role, which we can no longer document, in its initial emergence as a motif. Its subsequent importance, however, is basically decorative, as evidenced by the way it was adopted in a wide variety of styles, in particular by the Greeks, even as a flower vase! Here we are only concerned with the relationship of the sacred tree to the development of vegetal ornament.[i]

Trees in nature do not generally display the relatively thorough symmetry of this little shrubbery and, as a result, they have never been used extensively in ornament. In ancient Egyptian art, they are rendered in naturalistic, if stylized asymmetry, wherever they are needed for their representational value, for example to indicate a garden (Tell-el-Armarna).[j] In similar instances, the Assyrians used the symmetrical palmette-fan, at least for the fronds of palm trees. The alleged sacred tree of the Assyrians (figure 39),[61] however, does not deserve to be called a tree at all. It looks more like a piece of furniture fitted together from various components which include two rectangular shafts connected by sheaths[62] like those on Assyrian furniture. The lower shaft rises from an abbreviated (fanless) palmette; the upper one is crowned by a palmette with a fan.[63] The sheaths are each composed of two fanless palmettes,[64] one pointing up-

[60] Moreover, rosettelike motifs have already been found engraved in bone among the cave dwellers of Dordogne (fig. 6).

[61] From Layard, *Monuments of Nineveh*, vol. 1, pl. 7.

[62] A metal sheath like these, which no doubt functioned as a connecting binding, was discovered at Nimrud and illustrated by Layard (pl. 96); the stool in the relief in Layard (pl. 5) shows how it was used.

[63] The Assyrian palmette, like the Egyptian lotus and "papyrus," is used to mark an unattached termination. This function is clearly expressed by the palmettes on the tips of the ropes held by two half figures in the central upper part of the relief illustrated by Perrot and Chipiez, *Histoire de l'art*, vol. 2, fig. 71, which are like the lotuses used to terminate the ropes binding prisoners on Egyptian reliefs.[l] See also figure 35, above.

[64] The lower calyx of the sheaths sometimes has notched leaves, possibly of Babylonian origin (see the Neo-Babylonian relief in Perrot and Chipiez, *Histoire de l'art*, vol. 2, fig. 71. [Cf. Frankfort, *Ancient Orient*, fig. 231.]

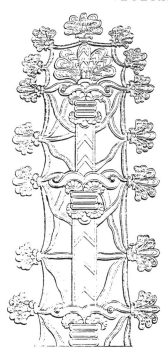

Fig. 39. The so-called sacred
tree of Assyria, detail of
the stone reliefs from the
palace at Nimrud.

ward, the other downward, both marking the points of inception in precisely the same way as the abbreviated Egyptian palmette.[k]

The interlacing wreath of palmettes surrounding the shaft no more resembles tree foliage than the shaft itself does a tree trunk, for the palmettes are linked in series by flattened arcuated bands running all around the tree. The palmettes, except for the uppermost ones, are also connected by bands to the trunk. Sometimes pine cones occur in place of palmettes.[64a] They are, however, linked only to the trunk and not to one another. This would seem to be a more treelike arrangement were it not for the fact that the trunk still has the sheaths reminiscent of furniture joints.[65, m]

We are about to study a similar motif from Phoenician art, considered to be the intermediary between the Egyptian and Assyrian versions. This will be hard to prove, however, since the Phoenician motif, at least in the form in which it has survived on monuments, is later than the Mesopotamian sacred trees, which can be traced as far back as the twelfth century B.C. on the relief of King Marduk-nadin-akhe.[66, n]

The ornamental flower and bud forms of Mesopotamian art, as already mentioned, are usually interconnected by continuous arcuated bands; the Assyrians had virtually no spiral ornament. The spiral is used, to be sure, to indicate beards and curly hair, but as an ornamental motif, and especially as a connecting element between vegetal ornaments, it is nowhere to be found in Mesopotamian art. This fact must be stressed, especially in

[64a] [Layard, *Monuments of Nineveh*, vol. 1, pl. 6.]

[65] The similarity between the blossoms on the *sacred tree* and the various lotus motifs did not escape Goodyear (*Grammar*, 175ff.). Moreover, his rejection of the popular hypothesis that finds a connection between the sacred tree and the Arian Soma or Hom concurs completely with my conviction.

[66] Perrot and Chipiez, *Histoire de l'art*, vol. 2, fig. 233.

light of the important role of the spiral as a connecting element in the history of vegetal ornament for the Egyptians, as we have already seen, and for the Greeks, as we are about to see. There is possibly one exception to this which can be cited: the decoration on the upper rim of the vessel held by the fish god in an Assyrian relief.[66a] Thus is, however, not so much a row of continuous spirals; it is a distinct running-dog motif, apparently very closely related to the spiral but belonging to the category of so-called reciprocal ornaments, which developed in its best known form in Greek art.[67]

Where there is no spiral ornament, there can be no recurrent need for decorative axil filling. It is therefore no surprise that the postulate of axil filling, which was so fundamental to ancient Egyptian art in the New Kingdom, was unknown in Assyrian art. This situation clearly contradicts von Sybel's theory that the Egyptians of the New Kingdom adopted their characteristic decorative forms from Mesopotamia. Consequently, it should therefore also be strongly emphasized in this context that the spiral ornament and axil filling neglected by the Mesopotamians acquired enormous importance for the Phoenicians and the Greeks.

3. Phoenician

The Phoenicians figure prominently in the development of Near Eastern art not because they formulated an independent art of their own but for two other reasons that significantly influenced further historical development, especially of ornament. First of all, as seafaring merchants, the Phoenicians carried Egyptian and, to a lesser extent, Mesopotamian art forms far and wide, both by selling the original products of these regions or—and this should be stressed—by trading Phoenician imitations. The latter possibility touches directly upon the crucial role of the Phoenicians in the diffusion and currency of ornament throughout the Mediterranean littoral. Because these Phoenician imitations were mainly mass-produced decorative objects and household items, any representational meaning that might still have been attached to the original Egyptian and Babylonian conception of composite animals (sphinx, griffin, etc.) or vegetal

[66a] [Layard, *Monuments of Nineveh*, vol. 2, pl. 6.]

[67] The example of the "running-dog" motif from ancient Egyptian art that I can cite is just as isolated as this Assyrian example from a relatively late period, namely the border on a tablet held by worshippers in Lepsius, *Denkmäler aus Ägypten* (Abtheilung 3, Blatt 187d) from the time of Rameses the Great. The illustrations in Layard and Lepsius, which often do not measure up to today's scholarly standards, are not always reliable, particularly in the case of an isolated example. See O. Jones, *The Grammar of Ornament* (London, 1856), pl. 7, no. 16 [Riegl's original citation of Lepsius here as Abtheilung 7, Blatt 187 is incorrect].

motifs (lotus) was bound to evaporate completely. In the hands of the
Phoenicians, motifs that at one time had representational value now be-
came purely and simply decoration.[a]

The Phoenicians also observed and exploited the distinction between
frame and fill, as well as the application of the ornament according to
certain rules that result from the technical means and structure of the
objects to be decorated, type of decoration usually referred to as "tec-
tonic." Typical examples of this occur in the minor arts, which still provide
the most opportune insights into the particular characteristics of Phoeni-
cian art. These are the metal bowls organized in concentric zones with
vertical internal subdivisions, which are generally able to strike a balance
between uncontrolled variety and constrained geometric uniformity.

After my introductory remarks, we would expect the Phoenicians to
have contributed at least slightly to the further development of individual
ornamental motifs, even if they did not contribute decisively to ancient
decorative art in a larger sense. And in fact they did not limit themselves
simply to enriching Mediterranean ornament by combining motifs of dis-
parate origin, such as the Assyrian guilloche and the Egyptian zigzag.
They were also responsible for the development of at least one motif as far
as we know, and indeed a vegetal motif that was used in a purely decora-
tive manner. We will call this treelike, blooming, composite motif the
Phoenician *palmette-tree*.[68]

The Phoenician palmette-tree consists of blossom calyces, arranged
vertically one above the other and crowned by a spray of radiating vegetal
forms. Von Sybel[69] called the motif a *bouquet*. It occurs not infrequently
in the art of New Kingdom Egypt, most often in an arrangement re- sem-
bling superimposed flower pots with blossoms growing out to either side.[b]
Besides this, there are also other kinds of arrangements. The only one we
will be discussing, however, is the one reproduced in figure 40, which has
been taken from Prisse d'Avennes.[70] There we see a row of two alternating
blossom forms arranged vertically one above the other: the ones with their
volutes curling downward are obviously lotus blossoms with volute-ca-
lyces; the others, which curl upward, can also be defined as volute-calyces
with conical fillers at their centers.[71] The crown at the top consists of a

[68] Admittedly, this term is a bit awkward, but I could not find another expression that
emphasized with the same clarity the idea of the palmette as a main component of the motif
together with its apparent relationship to the sacred tree.

[69] L. Von Sybel, *Kritik des aegyptischen Ornaments* (Marburg, 1883), 24ff.

[70] A. Prisse d'Avennes, *Histoire de l'art égyptien d'après les monuments, depuis les temps
les plus reculés jusqu'à la domination romaine* (Paris, 1878–1879), atlas 1, "Ornementation
des plafonds; légendes et symboles," Eighteenth Dynasty.

[71] See above, chap. 3A.2.

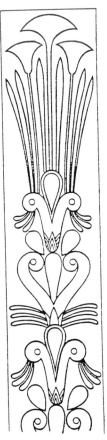

Fig. 40. Egyptian palmette tree, border of painted ceiling decoration from the Necropolis at Thebes.

radiating bunch of leaf shafts and long stems ending in bell- shaped lotus blossoms. Also worthy of note are the drop-shaped appendages of the axils created by the involutions.[c]

Other Egyptian examples of this superimposed volute-calyx motif include a bracelet in Prisse d'Avennes and a handle in Goodyear.[71a] In these two instances, the vertically oriented volute-calyces are also crowned by a spray of long-stemmed lotus blossoms. In fact, I know of no example in Egyptian art where these volute-calyces are crowned by the usual palmette-fan. Therefore, at least in Egyptian art, the typical lotus-palmette must be strictly distinguished from the multistaged variety illustrated in figure 40.[72] Now let us examine the Phoenician version of the same motif, the Cypriote capital in figure 41.[73, d] There we find below a strongly pronounced calyx with its volutes curling downward, above it the inverted volute-calyx repeated several times, and finally, the crowning, radiating vegetal spray. The palmette-trees on metal bowls have the same basic scheme; for example, the one on the silver bowl from Larnaka.[73a] In this case, the palmette-tree is used to separate figure groups that are repeated in systematic alternation. In other

[71a] [Ibid., atlas 2, "Choix de bijoux," no. 14, and W. G. Goodyear, *The Grammar of the Lotus. A New History of Classic Ornament As a Development of Sun Worship* (London, 1891), pl. 9 (after Champollion).]

[72] Figure 40 is part of a wall painting, a technique whose characteristically free and easy execution, as we know from experience, encourages deviations from traditional patterns more readily than other techniques. The two other examples I have cited, however, were executed in hard materials (metal and wood), which proves that what we are dealing with is a firmly established motif whose origin was not perfunctory or casual. Therefore, this motif of superimposed volute-calyces cannot be dismissed merely as "a purely decorative variant," or as the simple inversion of the downward curling volute-calyx, as Goodyear (*Grammar* 89) casually assumes. Then there would be no explanation for why the variation is never combined with the simple fan (combined view).

[73] From Perrot and Chipiez, *Histoire de l'art dans l'antiquité* (Paris, 1885), fig. 52.

[73a] [H. A. Longpérier, *Musée Napoléon III. Choix des monuments antiques pour servir à l'histoire de l'art en orient et occident* (Paris, 1880), pl. 10.]

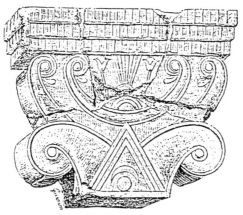

Fig. 41. Cypriote stone pilaster capital with
palmette tree, from Atheniu.

cases, such as the bowl from Amathus,[73b] it fulfills precisely the same function as the sacred tree on the Assyrian reliefs, i.e., to separate two figures placed symmetrically opposite each other.[e] It is easy to see how the Phoenicians were able to exploit this ornamental heraldic scheme for predominantly decorative purposes. The upwardly curling volute-calyx, however, is always combined with a fan of lotus flowers and stems and never with the common form of the palmette-fan. Nonetheless, the Phoenicians were familiar with the common Egyptian lotus-palmette, as attested by the number of examples compiled by Goodyear.[73c] The Phoenicians, therefore, made the same sharp distinction between palmette and palmette-tree that we observed in Egyptian art.

The crowning bulrush fan often occurs in abbreviated form without the bell-shaped blossoms, encircled by the upper hemispherical, upwardly curling volute-calyx. This is the design usually described as the Phoenician palmette in its narrower sense (fig. 42), though it is really a purely decorative reduction of the palmette-tree on Phoenician soil.[f]

Now we must resume our discussion of the historical place of the Assyrian palmette, for the Assyrian motif is a combination of the Egyptian lotus-palmette and the so-called Phoenician bouquet or palmette-tree; this is evident in the way the simple palmette-fan is set into an upwardly curling,

Fig. 42. Phoenician palmette.

[73b] [From Perrot and Chipiez, *Histoire de l'art*, vol. 3, fig. 547.]
[73c] [Goodyear, *Grammar*, pl. 12, nos. 4, 5, 8, 11, 15.]

upper volute-calyx. There is no such combination in either Egyptian or in Phoenician art. In spite of its upwardly involuted calyx, the Assyrian palmette is a single vegetal motif like the Egyptian lotus-palmette, with which it is otherwise identical. The Egyptian and the Phoenician versions of the upwardly curling volute-calyx, on the other hand, are treelike, blossoming, composite motifs, which consist of a number of blossom calyces superimposed one above the other and branching off into axilar flowers. I find that there is an undoubtedly close relationship between the Assyrian palmette and both Egyptian palmette motifs; but it is uncertain whether the Phoenician palmette played an intermediary role, however, as Furtwängler[74] assumes. The simple fan of the Assyrian palmette would then have to be interpreted as a schematization of the spray of lotuses crowning the palmette-tree, whereas in all probability the process was reversed, and the simple fan was decoratively elaborated into groups of lotus stems and blossoms. The same is true of the rosette, moreover, whose simpler forms are definitely earlier than the ones where the individual petals are indicated, for example, by lotus blossoms. It is still uncertain what prompted the Mesopotamians to combine the common form of Egyptian palmette with the upwardly curling calyx that they had also encountered on Egyptian objects.[g]

In its basic organization, the Egypto-Phoenician palmette-tree resembles the Assyrian "sacred tree," hence the analogous terminology, for the latter type also exhibits a system of volute-calyces connecting the individual shafts of the trunk.[75] The whole motif, however, is crowned by the Assyrian palmette, so that even in this comparison with the sacred tree we encounter difficulties in understanding the palmette. Yet this time we can with good conscience postpone the answer, since it is not absolutely essential to the further development. Von Sybel, of course, did not overlook the organic relationship between the Phoenician palmette-tree and certain bouquet motifs from Egyptian tombs. In conformity with his theory, however, he denies the Egyptian origin of the motifs and explains them[76] as the "earlier Phoenician bouquet" which then gave rise through simple stylistic evolution over the centuries to the "later Phoenician bouquets" found on metal bowls. The Egyptian origin of von Sybel's "early Phoenician bouquet," however, becomes ever clearer as more examples are discovered on ancient Egyptian monuments. Only a few years ago,

[74] A. Furtwängler, *La collection Sabouroff, monuments de l'art grec* (Berlin, 1883–1887), introduction, 10.

[75] See figure 39, above. [76] Von Sybel, *Kritik*, 25.

Dümmler found the motif on an Egyptian wooden trunk in the Museum at Bologna.[77]

We have now accomplished what we set out to do in this discussion, namely, to establish the close genetic relationship between the Egyptian stylized floral motifs, on the one hand, and the Phoenician and Assyrian ones, on the other. The nature of the connection between the last two still remains an open question. I find it more probable, however, that the Mesopotamian forms were directly derived from Egyptian art, without any intervention from Phoenician monuments. The influence of the age-old Egyptian culture on Mesopotamia surely occurred much earlier than that of the Phoenicians and need not date back to the very early millennia, but only to the period of the Eighteenth and Nineteenth Dynasties. The Mesopotamians by this time were already enjoying a relatively high level of culture, while no securely dated Phoenician monuments of this period have been preserved. Hence, the sacred tree and rosette typical of later Assyrian ornament already adorn the clothing of the twelfth-century Babylonian king Marduk-nadin-akhe.[77a] Moreover, if Renan is correct in dating the inscription on the well-known silver dish from Palestrina[77b] to the sixth century B.C., then the high point of Phoenician artistic production, by virtue of the close stylistic relationship among all preserved Phoenician and Cypro-Phoenician monuments, was relatively late and cannot date back much beyond the year 1000 B.C. There is absolutely no proof that Phoenician art flourished any earlier.[h] The significance of depictions of the Kafa (Phoenicians) offering vases as tribute to the Thutmosid [Eighteenth-Dynasty] pharaohs on Egyptian wall paintings of the fifteenth century B.C. has been exaggerated by von Sybel and others. Even in the unlikely case that the vases depicted in the wall paintings really are accurate reflections of original Phoenician products, that does not rule out the possibility that the decoration was derived from Egyptian art. At any rate, it is precisely those spirals and animal heads which adorn the Kafa's gifts and frequently occur on Egyptian works of art, albeit from the New Kingdom, that are missing in later Phoenician art.[i] It might, in fact, have been the Hittites who carried Egyptian art forms, if not to the Greeks, then to the Mesopotamians; though certainly they did not do so by means of the crude

[77] F. Dümmler, "Bemerkungen zum ältesten Kunsthandwerk auf griechischem Boden," *Athenische Mitteilungen* 13 (1888): 302, fig. 9. It goes without saying that the symmetrical jumping rams on the trunk need not be of Assyrian origin, as Dümmler assumed, since the motif can be found in Egypt already in the Sixth Dynasty (see chap. 2, n. 14).

[77a] [Perrot and Chipiez, *Histoire de l'art dans l'antiquité*, vol. 2 (Paris, 1884), fig. 233.]

[77b] [*Monumenti inediti*, Deutsches Archäologisches Institut, 10 (1874–1878), pl. 32.]

carvings presently ascribed to the Hittites, which are coarse versions of a higher, developed art.[j]

The Phoenician version of the palmette-tree should be seen as a pleasing decorative elaboration of the basic Egyptian form, which was still in use even after Greek art became dominant. It was apparently unrelated to any further developments in the West, at least not for a considerable length of time.[78] The Phoenician palmette-tree did, however, fiure very significantly in the developments of the seventh and sixth centuries, when its numerous nooks and crannies encouraged a zealous observation of the postulate of axil filling, which had already been practiced in ancient Egyptian ornament during the New Kingdom.[k]

In summary, Phoenician vegetal ornament, was rooted predominantly in Egyptian artistic soil. This is clear from the palmette motifs with their axil filling. Phoenician artisans and merchants, however, did what they pleased with motifs that had been sacred to the Egyptians for their representational value. In the hands of the Phoenicians, the motifs became ornaments that existed purely or primarily for decorative reasons. The Phoenicians also borrowed whatever they found to be good and useful in Mesopotamian art, including individual motifs such as the guilloche, which is so useful for framing purposes. They borrowed general principles as well, above all the sharper distinction between fill and frame, although it is surely difficult to determine whether the Phoenicians really made an independent contribution in this regard.

4. Persian

We will now briefly examine the art of the Achaemenid Persians, not so much because it was of particular significance but more for the sake of thoroughness. Persian art, in many instances, is still overestimated today. Yet, the very fact that the ancient Persians abandoned the technical achievement of vaulted stone roofing attained by their Mesopotamian predecessors and reverted to flat, wooden roofs in their palace architecture already indicates the lack of any progressive ascent in the art of this empire.[79] In fact, there is little originality in any of the favored motifs of

[78] Von Sybel (*Kritik*, 26) derives the Greek enclosed palmette with its upper part contained within a circle from the Phoenician palmette in the narrower sense. This is completely false, however, for the Greek motif originated from rows of lotus blossoms and buds.

[79] The Persians were not at all artistically developed when they first became an oriental world power. And perhaps they never became so later because the triumphal advance of Hellenism in the Near East during the sixth century already caused them to feel so powerless that they no longer seriously considered taking up the artistic challenge.

ancient Persian ornament; nor do they display any of the virtues of eclectic art.[a] Although the Assyrian roots of Persian vegetal ornament are unmistakable, its Egyptian character is even more distinct, to judge by lotus blossoms[80] and palmettes (figure 43).[81] The calyx of the palmettes consists

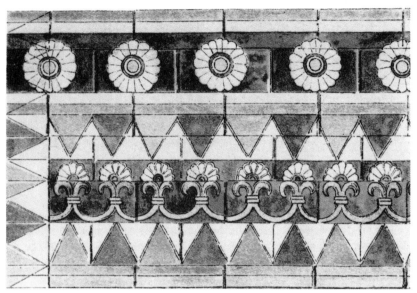

Fig. 43. Achaemenid Persian border of glazed brick from the palace at Susa, detail of corner decoration.

only of downward curling volutes (admittedly though, in the meager Assyrian form) with no upwardly curling volutes inserted above them.[b] In this regard, and also in the slight dimensions of the fan, the Persian palmette comes closer to the Egyptian version than to the Assyrian. The horizontal border in figure 43, which was concocted from a number of motifs (a row of palmettes between zigzag bands beneath a row of rosettes), runs dead against the crosswise strip of zigzags, and this too is characteristically Egyptian, not Assyrian. The "bouquet" or "palmette-tree" also had its place in ancient Persian ornament; not, however, in the form of the Assyrian sacred tree but in the Egyptian version, where forms like flowerpots (in this case they look more like calyces) are superimposed one above the other and crowned by a simple palmette-fan (figure 44).[82, c]

[80] Perrot and Chipiez, *Histoire de l'art dans l'antiquité*, vol. 5 (Paris, 1890) fig. 532, from Susa; the curve of the contours, however, already betrays Greek influence.
[81] Ibid., pl. 11.
[82] Ibid., fig. 346.

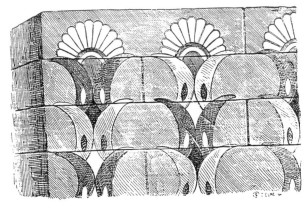

Fig. 44. Achaemenid Persian palmette tree,
glazed brick decoration from the
palace at Susa.

Ancient Persian ornament therefore presents us with an already well-known vocabulary of forms, lacking any new departures either in individual motifs (lotus, palmette) or in the connective structure (arcuated bands with bindings and volute-calyces). Persian art, moreover, was already influenced by the Greeks in many ways. This was quite natural, considering that the Persians did not rise to power until 538 B.C.[d] The Greeks saw the Persians as the incarnation of everything Oriental only because the Persians were the sole heirs of this ancestral culture remaining on Asiatic soil—even though they were, of course, not increasing their artistic heritage but narrowing it. Among all of the cultures of antiquity, the Persians contributed the least to the progress and lasting achievements of ancient Near Eastern art. Fortunately for them, however, they coexisted with the flowering of Greek art, which immortalized the Persians and transmitted their memory to later generations as the traditional embodiment of all that was Oriental. The effects of this phenomenon were still discernible in the Roman Imperial period, which may also explain why Sassanian Persian culture and art are still generally overestimated today.

B. Vegetal Ornament in Greek Art

We have been following the origin and development of vegetal ornament among ancient Near Eastern cultures up to the later period when the dynamic Hellenic spirit first began to dominate the Orient, initially by

peaceful means. By the Hellenistic period, Greek art had supplanted Near Eastern ornament, just as it had invaded all other areas of artistic activity. But long before the Persian Wars, both the basic principles and the individual motifs of Western decoration were unquestionably more mature and more vigorous than their Eastern counterparts. There were, of course, objectives that had been guiding ancient Near Eastern ornament in general and toward which the various cultures in turn had been moving in a gradual, if faltering way. But the Greeks first realized these goals. This involved the harmonious application of decorative forms so as to accord with the inherent nature of every work of art, with its mode of manufacture and its purpose. It also involved the tectonic differentiation between physical structure and ornamental embellishment, between what is visually active and visually passive. It is this conscious and gradual distinction between frame and fill that fundamentally distinguishes the whole artistic development of the Mediterranean world from that of the great Oriental cultures. Mediterranean influence extended as far as the Asiatic regions to the north beyond Iran, which has also always gravitated toward the Mediterranean rather than the great eastern Asiatic cultural domain.

The rhythmically undulating vegetal tendril, a goal to which Near Eastern art had also aspired, is the most beautiful and significant achievement of Hellenic ornament. It represents the Greeks' most invaluable contribution to the development of vegetal ornament. The individual vegetal motifs that had developed in Greek art roughly up to the end of the Persian Wars were nevertheless clearly and consistently adopted from the earlier, ancient Near Eastern styles. Under the Greeks, however, they acquired a perfect formal beauty. Both components of this arrangement—the authentic Hellenic tendril as well as the various stylized vegetal motifs that were assimilated from Near Eastern art and then reorganized and perfected by the Greeks—have remained, for all subsequent styles up to the present day, the ultimate ideal of all vegetal ornament. I will attempt to describe how this came about in the following chapters.

As things now stand, it is just as difficult to determine when a specifically Greek art came into being as it is to establish the origins of the Greek people as an ethnographic unit. The very earliest artistic monuments that could come under consideration are currently designated as Greek only because they were found on territory inhabited by Greeks in the less obscure historical period. These include the discoveries dating from the earliest levels of Troy-Hissarlik and Cyprus, which consist mostly of ceramic objects with purely geometric decoration. Since there is no vegetal

ornament on these earliest finds,[1] it is unnecessary for us to consider them. Mycenaean art, on the other hand, possesses an indisputably vegetal ornament and will therefore provide us with the point of departure for our investigation.

1. Mycenaean. The Origin of the Tendril

The earliest works of art excavated in the region later known as Hellas that have indisputably vegetal ornament belong to the Mycenaean culture. Opinions still differ widely as to the ethnic origin of the creators of Mycenaean art. There are those who believe they were a truly Hellenic race; others relate them to the Carians, while still others, in view of the wide distribution of their artifacts, consider them a mixed stock of people who may have inhabited the islands and the surrounding mainland coast, corresponding to the composition of the later Hellenic population. In view of such conflicting opinions, we are at this point, compelled to disregard the ethnographic question in our investigation of the vegetal ornament in Mycenaean art. We will restrict ourselves solely to describing the particular qualities of Mycenaean decoration. This will, however, eventually provide an opportunity to draw some conclusions about the ethnographic origins of the Mycenaeans.[a]

No one has yet succeeded in describing all of the various aspects of Mycenaean art, nor has anyone even attempted such a task. This undoubtedly results from the artifacts involved; despite certain familiar traits, they display various peculiarities that make it difficult to fit them into the conventional Near Eastern mold, while furthermore, they display no evident relation to later Hellenic art. For various reasons, it is assumed that Mycenaean art flourished very early, probably several centuries before the year 1000 B.C.; yet it is, admittedly difficult to reconcile this date with the advanced technical and artistic quality of such artifacts as, for example, the Vapheio Cups.

Goodyear, of course, was quick to assign an entirely Egyptian origin to Mycenaean art.[1a] In his opinion, only the octopus among all of its ornamental motifs was not dependent on Egyptian influence. Since the discovery in Egypt of two Mycenaean vases with octopus decoration, however, he has begun to waver even on this point. At present, classical archae-

[1] W. G. Goodyear, (*The grammar of the Lotus. A New History of Classic Ornament As a Development of Sun Worship* [London, 1891], 381) has also traced the model for the earliest Cypriote ornament of engraved triangles and zigzags back to rows of Egyptian lotus blossoms. This is an exaggerated claim that makes sense only within the context of Goodyear's radical theory of a single source for all later art forms.
[1a] Ibid., 311ff.

ology tends to be strongly oriented toward the Near East; at any rate, there has been no enthusiastic acceptance of the kind of research pursued by Michlhöfer, for example, which argues for an indigenous European, non-Oriental component in Mycenaean art. However, considering that Goodyear stands alone—at least for the moment—with his radical theory of the exclusively Egyptian[2] origin of Mycenaean art, the situation cannot be as clear and convincing as he would have us believe. Moreover, Mycenaean ornament has, in addition to the octopus, a whole series of motifs that may be original inventions of Mycenaean culture. Some of them are obviously based on vegetal forms, which brings us to our main topic of interest.

Mycenaean art made extensive use of vegetal decoration. We will treat the elements of the most important and most common Mycenaean motifs in the same order used in the discussion of Near Eastern ornament: first the blossom, the bud, and the leaf motifs individually, and then the means by which they were connected and their decorative application as surface patterning.

The most refined of the blossom motifs seem to confirm Goodyear's interpretation. They are seldom direct copies of Egyptian models down to the last detail, but in many cases they have enough in common with them to establish a clear connection. The use of the volute-calyx makes the relationship especially obvious (fig. 45).[2a] Furtwängler correctly recognized the situation even before Goodyear.[3] Furtwängler, however, considered the model to be the type of volute-lotus with only a conical filler in the axil between the two volutes of the calyx (fig. 20); therefore, the fan in figure 45 that surrounds the upper part of the blossom in a semicircle would have

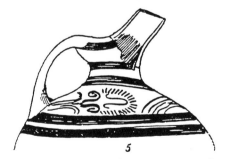

Fig. 45. Upper portion of a Mycenaean pitcher.

[2] Egyptian art, of course, in the broadest sense, belongs to the ancient Near East.

[2a] A. Furtwängler and G. Loeschke, *Mykenische Vasen; vorhellenische Thongefässe aus dem Gebiet des Mittelmeeres* (Berlin, 1886), 81.

[3] A. Furtwängler, *La collection Sabouroff monuments de l'art grec* (Berlin, 1883–1887), 9; Furtwängler and Loeschke, *Mykenische Vasen*, 60.

to be interpreted, according to Furtwängler, as a gratuitous addition, possibly representing the filaments of the stamen.[b] However, if we use the Egyptian lotus-palmettes of figures 16 and 19 as models—since they in fact display all of the various features of the blossom of figure 45, the palmette-fan as well as the volute-calyx and the conical axil filler—then Furtwängler's interpretation is no longer necessary.[4] Further points of similarity with the Egyptian solution include the way the calyces fit into each other as well as the alternation of downward and upward curling volutes, which are surmounted by a crowning flower.[5, c] Even simple three-leafed lotus profiles are not rare; they are used, for example, on a golden diadem alongside volute-calyces as axil fillers.[6] Voluted calycal forms outfitted with a simple axil filler or also with a crowning palmette-fan can be found on jewelry, executed in a less perfunctory manner than in vase painting.[7] The three-leafed palmette with its calyx curling more or less like a volute also occurs on precious metalwork, albeit with a treatment of detail that begins to look naturalistic.[8] We will return to this point later in another context. Finally, there is another type of vegetal motif with volutes (fig. 49) that should be mentioned. Although it resembles a leaf more than a blossom, its strongly emphasized volutes place it squarely into the category of stylized floral forms: the crowning petals of the basic three-leafed form have been drawn together and fused with the calyx to create a unified, unarticulated whole.[d]

So far, we have been dealing with profile or combined views of blossoms, although it is difficult to distinguish them in the Mycenaean versions of the Egyptian models. However, the frontal view of the flower or the rosette also occurs frequently, such as on the alabaster frieze at Tiryns and wall paintings at the same site. In both cases, the motifs are arranged simply in rows in an almost geometric fashion. More naturalistic, on the other hand, is the arrangement on a painted vase from Shaft Grave IV in Mycenae,[9] where the motifs are accompanied by a branch.

Mycenaean art apparently did not make much use of pronounced bud

[4] For an example of a volute-calyx and palmette-fan without the conical element between them, see H. Schliemann, *Mykenae; Bericht über meine Forschungen und Entdeckungen in Mykenae und Tiryns* (Leipzig, 1878), fig. 87.

[5] Schliemann, *Mykenae*, fig. 86, is an example that conforms completely to the scheme of the Phoenician palmette tree. Goodyear (*Grammar*) illustrates a selection of them on pl. 54.

[6] Ibid., fig. 281.

[7] Ibid., figs. 162, 163, 278, 303.

[8] Ibid., figs. 264–66.

[9] A. Furtwängler and G. Loeschke, *Mykenische Thongefässe. Festschrift zu fünfzigjährigen Bestehens des Deutschen Archäeologischen Instituts in Rom* (Berlin, 1879), pl. 9, no. 54.

motifs applied typically in alternation with blossoms, as we see them in Egyptian art. The only leaf form that requires attention is the so-called ivy leaf (fig. 46),[10] which later became very widespread in the decorative arts. Goodyear (161ff.) has already found models or, at any rate, parallels in Egyptian art for this motif, as mentioned above.[e]

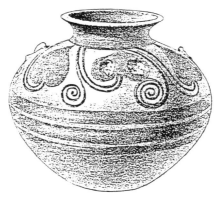

Fig. 46. Mycenaean pot with "ivy leaf" ornament
on its shoulder.

This review of the most important blossom motifs occurring in Mycenaean art has therefore confirmed what Furtwängler and Goodyear suggested: the voluted calycal forms of the ancient Egyptian lotus types were the models for the Mycenaean motifs. For now, we will not attempt to describe how it happened that the Mycenaeans adopted Egyptian motifs; suffice it to say that they were by no means slavish copyists. Our next task is to examine how the various blossom types were combined on one and the same field.

A simple serial arrangement in rows was used not only for the rosettes, which, on the diadems, for example, almost seem to illustrate a development toward rigid geometric motifs based on the circle; it was also applied to volute-calyx forms, which are often simply repeated next to one another around the belly or the shoulder of a vessel. Just as in the Egyptian lotus blossom and bud friezes, they are oriented at right angles to the band on which they rest. Whenever the individual blossoms occur with longer stems, however, the motifs begin to diverge quite drastically from the Egyptian model: whereas long stems in Egyptian art are always rigid and straight, the flexible Mycenaean stems are, as a rule, oriented diagonally

[10] Furtwängler and Loeschke, *Mykenische Vasen*, pl. 18, no. 121; 21, no. 152; 27, no. 208.

at various angles (fig. 47).[11, f] They create a movement that catches the viewer's attention precisely because it runs counter to the axis of the vessel. The same is true of the branch of ivy leaves in figure 46. And it is evidently this same tendency that is responsible for the diagonal orientation of the petals in rosettes like those in figure 48, instead of a rigid radial arrangement.[12] We are able to detect this underlying tendency only because of its effect. Should this effect in fact be intentional, then the goal of the "Mycenaean" artist was to enliven and animate the stiffly stylized motifs of the Egyptian models.

Another example of this (fig. 49)[13] is found on a potsherd from Shaft Grave I at Mycenae. In this instance, the plant stems run next to each other parallel to the axis of the vessel. What distinguishes this arrangement fundamentally from that of the Egyptians is, once again, the treatment of the stems. They are not stiff and straight but wind their way

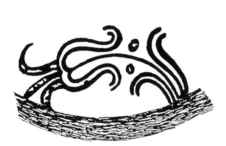

Fig. 47. Mycenaean vase decoration.

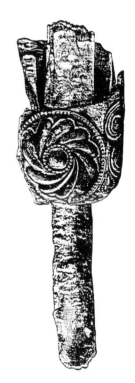

Fig. 48. Diagonal rosette on embossed gold sheathing over bone, from Mycenae, Shaft Grave I.

[11] Furtwängler and Loeschke, *Mykenische Vasen*, pls. 13, no. 82; 18, no. 121; 20, no. 142.
[12] Schliemann, *Mykenae*, fig. 459; other examples are found particularly on diadems, Schliemann, *Mykenae*, figs. 282, 358.
[13] Furtwängler and Loeschke, *Mykenische Thongefässe*, pl. 2.

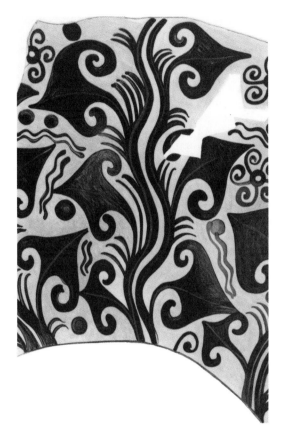

Fig. 49. Mycenaean vase,
detail of painted ornament,
from Mycenae,
Shaft Grave I.

upward in gentle, undulating movements, giving rise to slightly curved rushes and volute blossoms rhythmically branching off to the side. A preference for curving lines is just as apparent here as it was in figures 46 and 47; the uninhibited draftsmanship and the artistic effect are also the same. The curving line, which the Egyptians used almost exclusively in conjunction with geometric patterns such as the spiral,[14] was adapted by the "Mycenaean" artists to floral ornament.[15] The curves occurring in ancient

[14] Exceptions such as the grapevine, which is uncommon in Egyptian ornament and depicted solely when needed for its representational value, only serve to prove the rule. See A. Prisse d'Avennes, *Histoire de l'art égyptien d'après les monuments, depuis les temps les plus reculés jusqu'à la domination romaine* (Paris, 1878–1879), atlas 2, pl. 82, "Jarres et amphores," lower left. Even when the blossoms slant slightly above their vertical stems, the rigid underlying scheme is still apparent. [On the grapevine and other tendril decoration in Egyptian art also see annotation *i* for chapter 3B.1.]

[15] Further examples of this, among other things, came from Shaft Grave IV (Furtwängler and Loeschke, *Mykenische Thongefässe*, pl. 6, nos. 30–32, 34).

111

Egyptian art, as in the case of arcuated lines, are rigid and lifeless compared to the freedom of their treatment in Mycenaean art.

Any lingering doubt that the curved line is an essential and crucial ingredient of Mycenaean vegetal ornament must give way before the fact that Mycenaean art discovered the only truly artistic means of connecting vegetal motifs within a horizontal band—by means of the undulating line. Since figures 46 and 49 compel us to acknowledge that Mycenaean artists were the first to discover the lively and dynamic vegetal tendril, we can now proceed to demonstrate how they also consciously utilized the two schemes of undulating tendrils, those best suited to an arrangement within a border and which therefore acquired a permanent validity.

The first true is the *continuous tendril* (fig. 50).[16] It consists of a continuous undulating line that branches off into tendrils loosely spiraling backward at a point about halfway between each undulation. Although there are no blossoms, buds, or leaves on any of the tendrils, the underlying idea of a plant comes through clearly when the motif is compared to figure 46, where a similar tendril branches off into what is unmistakably an ivy leaf. A fragment from Shaft Grave IV at Mycenae[16a] can probably also be reconstructed as the same kind of continuous tendril pattern seen in figure 50. It is also obvious that the purely geometric spiral may have adopted this scheme. There is at least one example of this, which is illustrated by

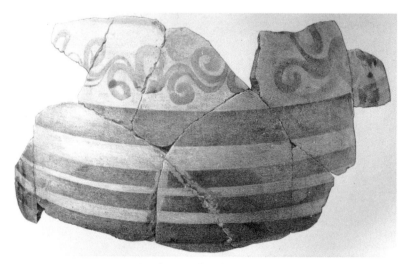

Fig. 50. Mycenaean potsherd painted with a continuous tendril, from Thera.

[16] Furtwängler and Loeschke, *Mykenische Vasen*, pl. 12, no. 79, found on Thera and associated by authors with their second Mycenaean vase style.
[16a] [Furtwängler and Loeschke, *Mykenische Thongefässe*, pl. 6, no. 34.]

Schliemann, *Mykenae*, figure 460, on the outermost disk at lower left (from Shaft Grave I), provided this was not just an arbitrary whim of the artist. Indeed, I would not even balk at the suggestion that the Egyptian spiral prompted the creation of the continuous tendril: the crucial factor would still be whether it was the Egyptians or the Mycenaeans who took the first decisive step. However, another look at figure 49 shows that even larger individual vegetal motifs were arranged in rows on the continuous tendril: the curving stem is really nothing more than an undulating tendril that branches off into pairs of stems and larger leaves with volutes. In this instance, there is more freedom of movement because the motifs are not restricted to the narrow band of a border. [17, g]

In Hellenic art, the continuous tendril was one of the most common of all motifs, and it has remained so for all subsequent styles up to the present day. Nevertheless, it is not attested in ancient Near Eastern art. The simplicity of the scheme brings to mind Columbus's egg. If we think back, however, to the way the ancient Near Eastern styles approached the same situation, then it becomes obvious that "Mycenaean" artists, after considerable trial and error, were the first to make the great breakthrough. The Egyptians had already attempted to place vegetal motifs in rows opposite each other. Their most mature solution in this respect was the arcuated frieze (fig. 22) inserted into a second opposing row (fig. 23) to create a pattern of alternating direction within a border. The peoples of Western Asia themselves did not progress beyond this solution. [18] By inventing the continuous tendril and arranging motifs on it so that they pointed alternately

Fig. 51. Ceramic cup from Megara, Mycenaean.

[17] See also Furtwängler and Loeschke, *Mykenische Thongefässe*, pl. 4, no. 19: the main motif in this case is an undulating line, where each of the indentations has a circle with an inscribed, fan-shaped branch. Furthermore, I see a continuous tendril in the decoration of a cup from Megara (fig. 51), which G. Loeschke published in the *Archäologischer Anzeiger* (1891): 15.[h] Loeschke thinks the ornament should be derived from the nautilus depictions. What I find, however, is an undulating line whose concavities are filled with almond-shaped buds or leaves slanted to the side, and not connected to the main stem. The little snaky lines with the dots obviously serve to fill out the axil.

[18] Perrot and Chipiez, *Histoire de l'art dans l'antiquité* (Paris, 1885), vol. 3, fig. 576 D, illustrate a piece of jewelry from Curium decorated with an undulating tendril to which Perrot assigns a Phoenician origin. J. Böhlau ("Böotische Vasen," *Jahrbuch des Deutschen Archäeolgischen Instituts* 3 [1888]: 333) probably also had this example in mind when he was compared Cyriote-Greek goldsmith work to the Boeotian example of an undulating tendril in fig. 80. Considering how isolated and late in date this piece of jewelry appears to be, it is no doubt, as Böhlau says, of Greek origin.

up and down, Mycenaean artists were the first to succeed in correcting not only the monodirectionality of the simple arcuated frieze (fig. 22) but also the unattractive stiffness of the double rows of opposing arcuated friezes (fig. 23). On the other hand, and quite significantly I might add, in all of Mycenaean art there is not a single example of an arcuated floral frieze, although the Mycenaeans were well acquainted with continuous friezes of both round and pointed arcs, which they used especially on chased metal cups.[19] The purely geometric arcuated frieze is also not rare on vases.[20, i]

As simple as the solution of the continuous tendril may seem from our standpoint today, looking back over the vast artistic activity of the past, it was nevertheless nothing short of an epoch-making achievement for the history of ornament at the time of its creation. And that is not all, for Mycenaean art also utilized the second possible variation of the undulating tendril motif—the *intermittent tendril*. Evidence for this is found on a vase from Shaft Grave VI at Mycenae (fig. 52).[21, j] The typical form that the motif commonly takes in later Greek art and, indeed, in all later arts, is represented by the very next illustration of a Melian vase, figure 53,[21a] which readily enables us to make a comparison between the two examples. The course of the undulating line in figure 53 is not continuous; it is interrupted on its hills and valleys by blossom motifs placed exactly the same as the lotus blossoms and buds on the one-sided arcuated rows of Egyptian (fig. 22) and Assyrian (fig. 34) examples. The blossom forms in

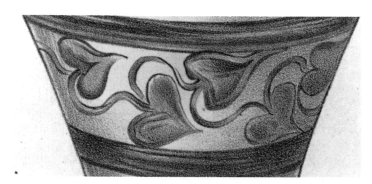

Fig. 52. Painted vase, Mycenae, Shaft Grave VI,
detail of ivy tendril.

[19] Schliemann, *Mykenae*, figs. 475, 453.
[20] For example, Furtwängler and Loeschke, *Mykenische Thongefässe*, pl. 4, no. 17.
[21] Ibid., pl. 11, no. 56.
[21a] [A. Conze, *Melische Thongefässe* (Leipzig, 1862), pl. 1, no. 5.]

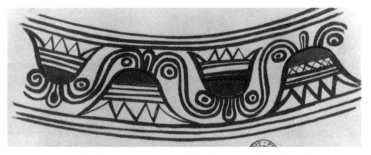

Fig. 53. Intermittent tendril, the painted border of a
Melian amphora, from Melos.

figure 53 are, moreover, unmistakable descendants of Egyptian models, as is evident in the pointed leafed lotus profile and the volute-calyx. With the exception of the outermost blossom to the left of figure 53, which still has a clearly spiraling volute, the other volute-calyces have been misinterpreted and transformed into circles. The only way in which the Mycenaean example in figure 52 differs from the one in figure 53 is that the intermittent vegetal motifs are not placed on the hills and valleys. The undulating line in figure 52 is still unquestionably the basic component, but unlike figure 53, its course is interrupted roughly in the middle of every rise and fall. This distinction, however small it may seem, must nevertheless be stressed, for it is extremely characteristic of Mycenaean art and serves conveniently to confirm what we have already said about the nature of Mycenaean vegetal ornament in general.

The art that we see on the Melian vases already reflects a renewed phase of decisive Oriental influence whose impact was far more direct and authoritative than it had been for the Mycenaean artists and their blossom motifs. This influence is related to events that transpired in the post-Mycenaean period and will be discussed later in a more appropriate context. Although Greek artists never relinquished the undulating tendril in the post-Mycenaean period, they did begin to stylize it more severely under the influence of the more rigid Near Eastern styles. Like their Egyptian counterparts, the lotus blossoms in figure 53 are pointing upward and downward, parallel to the axis of the vessel.[22] The Mycenaean undulating tendril in figure 52, on the other hand, has the same tendency to wander freely and unfettered as those in figures 46–49. Its ivy leaves

[22] Structural symbolists, of course, interpret this pointing upward and downward as a subtle allusion to the vessel's function of pouring. This might, at best, be appropriate for the neck of a vase; figure 53, however, is located on the shoulder of a vessel like that in figure 66. Once again, it seems that Semper's proponents have been splitting too many hairs.

are not pointing straight up and down but are tilted diagonally so as to break up the mono-directional orientation; nevertheless, the leaves are still pointing alternately up and down in conformity with the general scheme. This delightful motif is truly captivating in a way that must baffle scholars who feel that the developmental acme of Mycenaean art should be dated as early as possible. In figure 53, the intermittent tendril is quite apparent, although we have to examine it very closely in order to recognize it as the same scheme used in figure 52.

If the atypically restrained form of figure 53 is attributable to the influence of Near Eastern stylization, then it becomes quite obvious that before the Hellenistic period, the ancient Near East was just as unfamiliar with the intermittent tendril as it was with the continuous tendril—and logically so, since the intermittent scheme is actually a further development and elaboration of the continuous one. Unlike other Mycenaean examples of the continuous tendril, which lack flowers or leaves, the ivy leaves punctuating the undulating tendril in figure 52 assure us that we really are dealing with a plant-inspired undulating line and a true vegetal tendril.

As indicated earlier, Goodyear[23] has adduced examples of Egyptian lotus leaves stylized in a similar way and consequently assigned the ivy leaf an Egyptian origin. What speaks against this possibility is that the "ivy leaf" in Mycenaean art always appears in a context that has nothing Egyptian about it. We have already discussed the specifically Mycenaean character of the stems in figure 46; the same is true to an even greater degree of figure 52. In later Greek art, the ivy leaves are usually part of the curving tendril; wherever they occur loosely arranged in a row, their forms become, quite characteristically, extremely free, as revealed on the shoulder of a vase illustrated by Salzmann.[23a] Even the frequent examples of Etruscan "ivy leaves" (which did not escape Goodyear's sharp eye) are usually connected to curving tendril stems. Nevertheless, at this point in the history of ornament, or even much later for that matter, it would be unusual and entirely unprecedented for an element as insignificant as a leaf to be assimilated into the decorative repertory for its own sake, and because of this Egypt is still the most likely source of the ivy leaf. It is therefore most probable that "Mycenaean" artists adopted the "ivy leaf" as a blossom form from a foreign artistic repertory.[k]

Let us summarize what we have concluded thus far. The free and

[23] Goodyear, *Grammar*, 161ff.
[23a] [A. Salzmann, *Nécropole de Camiros. Journal des fouilles executées dans cette nécropole pendant les années 1855 à 1865* (Paris, 1875), pl. 47.]

dynamic vegetal tendril is first used for decorative purposes in Mycenaean art. In addition, Mycenaean art also created, as far as we can see, the continuous as well as the intermittent tendril. These are the two types of vegetal tendril motif that became especially characteristic of Greek art at the very beginning of the history of ancient art. Anyone who takes into account what was to follow and is conscious of the crucial role that tendril decoration subsequently played, first in Hellenistic Greek and Roman art, then during the Middle Ages, particularly for Islamic art,[23b] and finally in the art of the Renaissance up to the present day, will fully appreciate the epoch-making importance of the period and the culture that evidently employed it for the very first time. Seen in this light, the motif of the freely undulating vegetal tendril is a remarkably eloquent expression of the Greek artistic spirit in general. Just as the Greeks restyled age-old Egyptian blossom motifs in the most delightful way imaginable to accord with their own standards of formal beauty, they also discovered the most perfect way of linking them together, namely with the tendril, moving to and fro in a mellifluous rhythm. Obviously nothing in nature could have had a direct influence on the appearance of the undulating tendril, since both of its characteristic forms, especially the intermittent type, imitate no known plants: it is a product of the imagination, freely created by the Greek artistic spirit.

From this perspective, moreover, we gain a fundamentally new view of the historical position of Mycenaean art itself: Mycenaean art now looms as the direct predecessor of the Hellenic art that we know more clearly from the historical period. The Dipylon Style, and whatever else separated the two periods, was only an obscure interlude, a haze cast over a development already well underway. And if there is any relationship between the ethnographic character of a culture and what we observe in its art, then it looks as though whatever ethnic group was responsible for Mycenaean art—whether we refer to them as the Carians or by any other name—also contributed an essential component to the later ethnic make-up of the Greeks. Mycenaean artists had already ascended the second great step in the history of early Greek art. We are justified in claiming the decoration on Mycenaean vases to be genuine Proto-Hellenic ornament, just as Puchstein was in proclaiming the columns on the Treasury of the Atreus to be genuine Proto-Doric columns. Similarly, the

[23b] The intermittent tendril is, among other things, still the most common border motif on Persian carpets today. In the absence of any examples of Assyrian or Achaemenid art that go beyond the mono-directional series of arcs, there can no longer be any doubt that the motif first arrived with the Hellenistic invasion of the Asiatic continent.

depictions of purely human activities found on the Warrior Vase, the Vapheio Cups, and other works, are the direct forerunners of the kind pictured on mature Hellenic art even on the humblest everyday objects.

Little attention has been paid to the importance of tendril ornament in Mycenaean art, especially the undulating tendril. To my knowledge, only Böhlau[24] has made any note of this pattern in Proto- and Early Greek styles. He made the connection, quite correctly, between the continuous tendrils on the Boeotian vases and the ones on the Mycenaean example in figure 50, which he recognized as specifically Greek, although without exploring the matter further. Goodyear apparently overlooked the continuous tendril in Mycenaean art, but he was aware of the intermittent type illustrated in figure 52. He even conceded that the motif was common to both Mycenaean and later Greek art, even though he believed it was the only motif they shared.[25] He could not, however, go so far as to admit a causal relationship between them because of his preconceptions about the character of Mycenaean art in general and the artists who produced it. For Goodyear, the "Mycenaeans" were nothing more than Carian mercenaries and warlike plunderers who made sloppy local imitations of the art they had seen in Egypt. As usual, he ignored the more essential artistic considerations. Nevertheless, we will still consider his explanation for the occurrence of the intermittent tendril in Mycenaean and later Greek art.

Goodyear's argument runs something like this: the motif in figure 52, does not occur in Greek art until the fifth century—though this is already contradicted by the Melian example in figure 53—and no intervening examples are available; therefore, it must be assumed that the motif was borrowed in both cases from an outside source, which Goodyear designates as Cyprus, citing as evidence a stone vase and a terracotta sarcophagus from Cesnola's publications.[25a] Neither of these two examples, however, has an intermittent tendril, and besides, both are unquestionably of Greek origin. The stone vase has ivy leaves on straight stems arranged in a row; the attached handle, shaped like a palmette, clearly betrays the Greek origin of the piece. The sarcophagus does in fact have ivy leaves arranged on a continuous (though not intermittent) ivy tendril, but the whole arrangement looks decidedly Greek. Moreover, since Cesnola himself made no attempt to date the piece and since even the circumstances surrounding its excavation have not led to any conclusion, the sarcopha-

[24] *Jahrbuch des Deutschen Archäologischen Instituts* 3 (1888): 333.

[25] Goodyear, *Grammar*, 314.

[25a] [L. P. di Cesnola, *Cyprus. Its Ancient Cities, Tombs, and Temples* (New York, 1878), illustrations on pp. 145, 190.]

gus cannot serve to document the occurrence of the undulating tendril in Cypro-Phoenician art. Characteristically, Goodyear's treatment of this problem lacks careful analysis. Consequently, Flinders Petrie's discovery in Egypt in 1890 of two examples of the tendril motif of the kind illustrated in figure 52 and dating to the Nineteenth or Twentieth Dynasty seems to strengthen Goodyear's argument. However, even if one could establish a connection between these two Egyptian examples and the intermittent tendril of figure 52, it is still not conclusive proof of Egyptian origin, considering the tremendous quantities of Mycenaean utensils that have been found in Egypt, particularly by Petrie. The restrictive character of Egyptian art was obviously a world apart from the spirit that informed the Greek vegetal tendril.

The free, naturalistic character of Mycenaean tendril ornament, which Goodyear flatly denies, is also clearly discernible in certain individual Mycenaean blossom motifs. As we have already seen, the Mycenaeans did not slavishly copy the most common Egyptian volute blossom motifs but loosely patterned their motifs on Egyptian prototypes. Perhaps they even had the filaments of the stamen in mind when they drew their palmette-fans, as Furtwängler has suggested. This would also speak in favor of a naturalizing tendency that sought to bring the motif, adopted for its formal beauty (or symbolic significance?), closer to the more familiar appearance of plants as they actually occur in nature. The proof that the Mycenaeans tended to naturalize Egyptian volute motifs is furnished by at least one decorative form, which we saved for this occasion.

I am referring to the pure *trefoil* made up of two leaves shaped roughly like volutes and which function like a calyx, and a third crowning leaf, which fills in the axil. The embossed gold ornament in figure 54[26] with its pair of opposed panthers perched above the trefoil motif will serve as our example. The individual blades with their central veins and smaller side veins show a discernibly vegetal stylization that is foreign to analogous Egyptian three-leafed

Fig. 54. Embossed gold plaque, Mycenae, Shaft Grave III.

[26] Schliemann, *Mykenae*, fig. 266. For other examples, also see his figures 87, 264, 265, 470.

lotuses.[27] The Mycenaean trefoil illustrated in figure 54 could almost be taken for an independent Mycenaean invention. Its relationship to Egyptian prototypes, however, is easy to demonstrate.

Our demonstration will begin with the famous stone ceiling relief from Orchomenos.[1] Anyone who has been keeping track of the course that the history of ornament has taken thus far will immediately be struck by the clear distinction made between field and border.[27a] However, we shall postpone discussion of this point for the moment and concentrate on the aspects of the ceiling pattern that relate it directly to Egyptian models.

Fig. 55. Relief ornament on the stone ceiling from the tholos
at Orchomenos, detail.

These include particularly the spiral pattern made up of four bands running into a central eye. Exactly the same scheme occurs on an Egyptian ceiling fresco (fig. 56).[28] In the Egyptian example, the four curving axils created by each pair of neighboring spirals are filled by a lotus, with room left over for a central rosette. In the Mycenaean example in figure 55, on the other hand, only one of the four axils gives rise to a filler motif. It, however, was no doubt inspired by a similar kind of Egyptian model, for its basic shape is the same profile view of a flower formed by three long and pointed leaves. The smaller, secondary leaves in figure 56 are

[27] Such as figure 20, which is carved, but also in the freer medium of painting.

[27a] [H. Schliemann, *Orchomenos. Bericht über meine Ausgrabungen in böotischen Orchomenos* (Leipzig, 1881), pls. 1–2.]

[28] Prisse d'Avennes, *L'art égyptien*, atlas 1, pl. 32, "Ornementation des plafonds; postes et fleurs," no. 3.

Fig. 56. Painted ceiling from the
Necropolis at Thebes.

pointed, while those in figure 55 are rounded off. This is, however, no cause for alarm, for there are also Egyptian models for the rounded stylization of the lotus axil filler, specifically the lotus-palmette, which occurs as an axil filler in Egyptian art within bands of spiral patterns on a par with the profile view of the pointed leafed lotus. The way the fan in figure 55 is subdivided into four zones of rounded leaves is no less Egyptian and might have something to do with the technique involved.[29] A very important detail that deserves emphasis is the hatching of the two calycal leaves that fit into the curve of the spiraling bands. The third pointed leaf, filling in between them, is not diagonally hatched but grooved along its length. If we discount the hatching of the calycal leaves, the whole motif begins to look rather severe, revealing just how closely it followed the presumed Egyptian model.

The fact that the ceiling from Orchomenos is a stone relief may account for its striking similarity to Egyptian prototypes. A freer technique, such as wall painting, would naturally allow for a freer treatment. A detail from a mural at Tiryns (fig. 57)[30] provides us with another excellent opportunity to observe how Mycenaean artists exploited the motif in painting.[m] Its basic scheme is the same as at Orchomenos, namely, spirals with lotus axil

[29] Perhaps the cells created by the bars were meant to be filled with enamel paste.
[30] H. Schliemann, *Tiryns; der prähistorische Palast der Könige von Tiryns* (Leipzig, 1886), pl. 5.

Fig. 57. Painted wall ornament from the Mycenaean
palace at Tiryns.

fillers.[31] In addition, there are rosettes in the margin and, outermost, little
rods resembling dentils, just as on the ceiling from Orchomenos. The
lotus axil fillers, however, are our main focus. Three pointed leaves form
the basic structure, all of which are articulated with featherlike hatch-
marks, not only the ones at the side but the central one as well: this is clear
evidence of a naturalizing tendency found nowhere in comparable Egyp-
tian examples. The Mycenaean artist in this instance made short work of
the palmette-fan by leaving out the individual, radiating leaflets of figure
55 and indicating only the concentric zones by means of simple lines.
Compared to the lotus axil fillers in figure 55, however, those in figure 57
have been enriched by three-leafed calyces at their points of origin within
the axils created by the spiraling bands. Once again, this proves to be
closely related to the characteristically Egyptian way of thinking discussed
earlier.[n]

The lotus leaves with feathered hatching of figure 57 are clearly con-
nected to those in figure 55, but they are probably most closely related to
the feathered trefoils in figure 54. The naturalizing tendency, which is
immediately apparent in the little gold leaves of figure 54, is also present
in the example of wall painting illustrated in figure 57, whose model in
Egyptian art is beyond any doubt, even without the intermediary example
of the ceiling from Orchomenos. The motifs in figure 55 are copied from
the Egyptian model quite faithfully. Even in this case, however, the
hatching on the two pointed lateral leaves of the lotus axil fillers reveals
an incipient tendency toward naturalism. This is also a specifically Greek
tendency, which the Dipylon and Orientalizing Styles only camouflaged
temporarily, although to the degree that it did not regain its strong and
formative authority again until the Periclean period, the direct predeces-

[31] There are only two bands spiraling into each eye because the pattern is confined to a
narrow border. This does not, however, alter the basic similarity between the two patterns.

sor, in many respects, of the Hellenistic period. Proof of this—to antici-
pate a point from later in the development—are the split-palmette and the
acanthus.

It is, therefore, not the vegetal motifs themselves but their treatment in
the surviving examples of Mycenaean art that testifies to the formation of
an independent development. As comparisons have shown, the most com-
mon Mycenaean blossoms were derived from the ancient Egyptian lotus
motifs with volute-calyces. I think it is erroneous to interpret them as
aquatic plants, as many have assumed, apparently thinking of the kind of
narrow reeds that branch off from the main, undulating stem, in figure 49,
for example. Similar reedlike leaves also occur, however, on Egyptian
prototypes, as seen in figure 40 in the crowning motif alternating with the
lotus. The only real difference between the Egyptian and the Mycenaean
examples is that the Egyptian reeds rise up straight and independently
from one another, while the Mycenaean ones branch off from a common
stem. Once again, there is a variation in the treatment of the same basic
motif, which—as we have seen—characterizes the relationship of Myce-
naean to Egyptian vegetal ornament in general.

Mycenaean ornament, however, also includes a series of motifs whose
origin cannot in any way be derived from Egyptian art and which, there-
fore, should be considered original Mycenaean creations, at least for the
time being. The motifs consist primarily of animals, which is not surpris-
ing when we recall that the earliest examples[32] of sculpture or drawing
represented living creatures from the environment. Since the Mycenae-
ans inhabited the coasts and islands, they would have been more familiar
with the edible octopus or cuttlefish,[33] which might have been the main-
stay of their diet, than, for example, with the ibis or the cobra. The octo-
pus is, of course, the one and only motif that Goodyear thinks (311) was
originally Mycenaean; he points quite convincingly to the importance this
sea creature still enjoys among the people living in the Levant today.
Furthermore, the butterfly[34] should also be accorded an independent,
Mycenaean origin; its stylization (head and antennae) is a result of both
the Egyptian and the Mycenaean manner. There is, however, a vegetal

[32] Like the cave dwellers of Dordogne, see above.

[33] Cuttlefish were used on Assyrian reliefs (A. H. Layard, *Monuments of Nineveh: From
Drawings Made on the Spot by Austen Henry Layard*, vol. 1 [London, 1849] pl. 71) for their
representational value and have, art historically speaking, nothing whatsoever to do with
either the Mycenaean examples or with any Egyptian prototypes.

[34] Schliemann, *Mykenae*, fig. 243; the grasshopper was the insect that the Egyptians rep-
resented in art (Prisse d'Avennes, *L'art égyptien*, atlas 1, "Ornementation des plafonds,
bucrânes," below).

motif in Mycenaean art (fig. 58),[35] which has no known Egyptian model and which seems, moreover, to be inherently naturalistic. The motif is presented in the combined view, though it apparently has nothing to do with the Egyptian palmette. The acanthus palmette is a similar motif, but there are no intervening examples that connect the two. As a result, it seems that the vegetal motif, along with the octopus and the butterfly, disappeared from the further course of the artistic development on Greek soil, thus leaving room for the more severe Orientalizing motifs.[o]

Fig. 58. Stamped gold plaque from Mycenae,
Shaft Grave III.

Because the spiral was so important to the development of vegetal ornament in Egyptian art, we will have to examine its role in Mycenaean art, even though it is basically a geometric motif that, on its own, would be out of place in a study restricted to vegetal ornament.

One of the simplest spiral patterns arranged as a border is found on the side of a small ivory plaque (fig. 59).[36, p] The continuous spirals wind around a central eye, just as they do on the Egyptian example in figure 25, where the eyes are filled with rosettes. In both cases, the basic component is a geometric shape arranged in a narrow register: figure 25 is painted, and figure 59 is a carved relief. So far, the similarity is complete in all essentials; however, a closer look at the axil fillers does reveal a notable discrepancy. The spherical triangular fillers on the Mycenaean relief are merely the space left over between the grooves enclosing the spiraling

[35] Schliemann, *Mykenae*, fig. 249, and then figs. 247, 248, 250.
[36] Ibid., fig. 222.

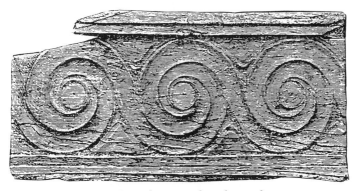

Fig. 59. Carved ivory casket plaque, from a
Shaft Grave at Mycenae.

bands and the outer border strips on the edge of the box, and may perhaps
have been completely unintentional or incidental. In this case, there is
some justice in the claim that the triangular axil was a product of the "tech-
nique": it is certainly one of the most rudimentary of all axil fillers.[37] Sig-
nificantly, the same thing also occurs in the art of the New Zealand Maori:
in figure 28, the triangles on the outermost convolution at upper right are
nothing more than axil fillers of the spirals. In the Egyptian wall painting
of figure 25, on the other hand, it is the distinctive profile view of the lotus
calyx that fills the axil. This indicates how the Egyptians had already be-
come conscious of the artistic necessity of filling the neutral axil with an
ornamental motif.

Mycenaean spiral ornament also includes much more than mere deco-
rative border strips. A vase illustrated by Furtwängler and Loeschke[37a] has
two parallel running spirals, whose undulations create a continuous row of
heart shapes, albeit without any axil fillers. The same motif, but with axil
fillers in the Egyptian manner, occurs with geometrically stylized axil-
palmettes on the vase illustrated by Furtwängler and Loeschke.[37b] When
a number of these spirals were juxtaposed a whole field could be covered,
as in the case of the gold pectoral in figure 60.[38] The scheme is familiar to
us from the Egyptian example in figure 26. Here too the axil filler is what
distinguishes one from the other. The Mycenaean breastplate has oval
fillers, which are related to the drop-shaped axil fillers of Egyptian art

[37] It occurs repeatedly in Mycenaean art: in stone (Schliemann, *Tiryns*, pl. 4) but also in
wall painting (ibid., pl. 10a); on vases (Furtwängler and Loeschke, *Mykenische Thongefässe*,
pl. 4, no. 14); and on a gold button illustrated by Schliemann (*Mykenae*, fig. 422).

[37a] [Furtwängler and Loeschke, *Mykenische Thongefässe*, pl. 1, no. 1.]

[37b] [Furtwängler and Loeschke, *Mykenische Vasen*, pl. 12, no. 58.]

[38] From Schliemann, *Mykenae*, fig. 458.

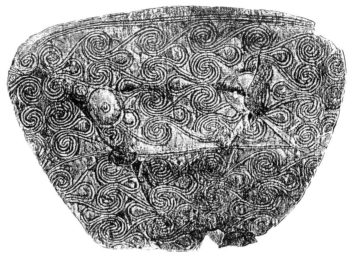

Fig. 60. Gold pectoral with embossed ornament from Mycenae,
Shaft Grave V.

(fig. 20). The example of Egyptian wall painting, on the other hand, once again makes use of the typical axiliar lotus blossom.

Even if our inquiry thus far has shown that spirals with lotus axil fillers are a specifically Egyptian solution, another glance at figures 55 and 57 serves to remind us that they also occur in Mycenaean art. More ver, the similarity between these two patterns and the Egyptian one in figure 56 is so great that there can no longer be any doubt of their relation, despite minor deviations in detail. Spirals used in a quite similar manner are also found on a stone grave stele illustrated by Schliemann;[38a] in this case there are, significantly, no axil fillers. One can conclude, therefore, that, for the Mycenaeans, the postulate of axil filling was by no means absolute. This is confirmed by figure 59 and the related examples already cited.

Is it necessary to assume from all of this that the Mycenaeans adopted the ornamental motif of the spiral from the Egyptians? The ceiling of Orchomenos proves beyond a doubt that the Mycenaeans imitated Egyptian spiral patterns, but does it necessarily follow that the motif appeared in Mycenaean art only as a result of exposure to Egyptian prototypes? It is extremely difficult to settle this question conclusively. For now, I would just like to express my reservations that the evidence of the available monuments can support an Egyptian derivation for Mycenaean spiral ornament, an assertion that Goodyear considered beyond any doubt.

[38a] [Ibid., fig. 140.]

This does not mean, however, that I am reverting to the popular notion that the spiral resulted from material-technical preconditions, least of all from those involved in wire coiling, the technique most frequently cited in this respect. If one had to choose a technique, however, a far better source of origin would be the technique of fabric cording, which is arranged on a backing and whipstitched into place. The continuous strands wind themselves naturally into spiraling coils and then back out again. This spiraling, overcast cording is a form of embroidery still used today as the main decoration on traditional costumes in the Balkans and beyond to Asia Minor and Syria, namely in all of those countries which succumbed to Hellenism at the latest by the second half of the first millenium B.C. Later, we will discuss examples of corded embroidery (fig. 87) from the Balkan Peninsula that still preserve specifically ancient Greek ornamental motifs even up to the present day. Nonetheless, we are still not in the least justified in attributing the origin of the spiral to this particular technique. Corded embroidery may very well have seized upon the spiral as a motif most suitable to its purpose, but the initial creation of the spiral can still be ascribed to autonomous, human artistic impulse. On the contrary, what really makes me hesitate to agree that the Mycenaean spiral was totally dependent on Egyptian prototypes is the Mycenaean use of a motif closely related to the spiral but never found, as far as we know, in Egyptian ornament.

The main component of spiral ornament in Mycenaean as well as in Egyptian art is the *band*.[39] In Mycenaean art, however, bands are not only wound into spirals but also into other configurations such as the band ornament that appears on small embossed disks of gold (fig. 61).[40] It is important to emphasize that in this type of decoration, the bands are always clearly juxtaposed, in contrast to the overlapping or "interlaced bands" of early medieval Scandinavian art. Should we not also attribute this regularity, along with the rhythmically undulating course of Mycenaean band ornament, to the classical artistic spirit latent in Mycenaean art?[41]

It should also be noted in figure 61 that the individual, curving bands

[39] In view of the dominant and widespread tendency to assume the influence of textiles on primitive decorative forms, I would like to make it clear that the term "band," as used above, has absolutely no connection with cloth bands or ribbons. In the present case, a "band" is nothing more than an emphatically rendered line. Band ornament of this kind can be found in cultures such as that of the Maori, who never wove textile bands.

[40] Schliemann, *Mykenae*, fig. 245.

[41] The later Greek labyrinth is no exception to the rule, because its abstruse qualities were intentional; the Greek labyrinth is, however, all the more typical in that it avoids entanglements, as opposed to the complicated character of the "Nordic" labyrinth [interlace in early medieval Scandinavia] which relies mainly on the frequent interlacing of the bands.

are looped around *eyes*. Of course, we have already seen a similar treatment of spiral ornament in Egyptian art (fig. 26). Since the Mycenaeans made their spirals encircle eyes as in figure 59, it might seem as if this arrangement, along with the spiral itself, should be attributed to Egyptian influence. Be that as it may, there are no known examples in Egyptian art of such *bands* rolled around eyes. Is it not then possible that the eyes in examples like figure 61 came into use independently and attained artistic importance in the same manner as, for example, the spherical axilar triangles in figure 59?[42]

Another example of Mycenaean band ornament appears on a stone grave stele (fig. 62).[43] The reciprocal pattern of convoluted bands is a very simple one, and yet how far removed it is artistically from the common,

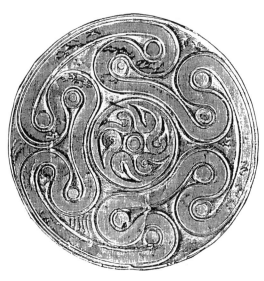

Fig. 61. Gold plaque with embossed ornament from Mycenae, Shaft Grave III.

Fig. 62. Limestone relief stele from the Grave Circle at Mycenae, detail of curvilinear meander ornament in border.

[42] In this light, the Mesopotamian guilloche (fig. 33), which also encircles an eye, could also be considered independent of both Egyptian and Mycenaean forms. Mycenaean examples related but by no means identical to the guilloche are illustrated by Schliemann, *Mykenae*, fig. 359; Furtwängler and Loeschke, *Mykenische Vasen* pl. 34, no. 338.

[43] Schliemann, *Mykenae*, fig. 142.

stiff zigzag fillers in Egyptian borders! Indeed, even the undulating band, the simplest of all band configurations, is found on Mycenaean vases,[43a] although not its angular counterpart, the zigzag. That is why no single example of a rectilinear meander has been found to date in the entire stock of Mycenaean monuments, although there are examples of the running-dog motif, which is a curvilinear form of the meander (fig. 63).[44] Seen in this context, the running-dog motif in the middle of the cup in figure 63 is a reciprocal band ornament like the one in figure 62, whose derivation need not be explained by the intervention of the Egyptian spiral.[45, q]

Fig. 63. Electrum goblet with gold inlay from Mycenae, Shaft Grave IV.

I believe, therefore, that the spiral is only a special class of band ornament. Band ornament is, however, geometric ornament constructed from curved lines, which represents a higher, perhaps even the highest stage of the Geometric Style. It seems to require a special artistic aptitude.

[43a] [Furtwängler and Loeschke, *Mykenische Thongefässe*, pl. 10, no. 46.]

[44] Gilded cup in Schliemann (*Mykenae*, fig. 348).

[45] The S-shaped curves that fill out the circle in the middle of figure 61, as well as the triquetra, for example, in Schliemann, *Mykenae* (figs. 138–39) and the like are also derived from band ornament. In Egyptian art, there is no comparable example where the spiral is used to fill up a field as it is on a sheet of gold illustrated by Schliemann (*Mykenae*, fig. 246), which is completely analogous to the band ornament seen in figs. 244–45 from the same volume. There is a definite connection between this kind of spiral ornament and the characteristics of the vase decoration referred to by Furtwängler and Loeschke as the fourth style in their *Mykenische Vasen*, pl. 36, nos. 370–71.

Among the primitive cultures that have continued to create spiral and band ornament up to more modern times, the New Zealand Maori are a special case. We have already discussed the importance of the art of this culture for the developmental history of the arts in their primitive stages, assuming that it really did remain isolated and independent from time immemorial, as seems to be the case. Goodyear,[46] to be sure, believes that Malayan influence on New Zealand is well documented, although without expanding further or citing any evidnece, as he usually does in similar cases. The spiral plays such a predominant role in the ornament of the Maori that Malayan influence, if it really is the source of the Maori spiral, must have been extremely strong. Yet how can this be reconciled with the fact that no metal objects have ever been found in New Zealand? In order for this to be the case, all contact with the southeast Asian archipelago must have been severed for some centuries at least, if not for millennia. And how did the Malayans become exposed to Egyptian spiral ornament? Goodyear assumes that Malaya was a trading link between Egypt and India, although there is not a shred of evidence for this. Yet if the creative aptitude of the Maori, did in fact enable them to invent spiral ornament autonomously (as seems to be the case on the evidence of their "Stone technology"), and thereby ascend the ladder of artistic development to the highest stage of the Geometric Style and attain the decorative use of circular lines,[47] then it must have also been possible for the "Mycenaeans" to have utilized and developed the same ornament even before their contact with ancient Egyptian culture. The subsequent exposure to similar Egyptian formulations became a source of stimulation and enrichment that they developed further along the lines of their own artistic sensibility. We must only reject outright the hypothesis that the Egyptians adopted the spiral motif from Mycenaean art. During the "Mycenaean" period, Egyptian culture was unquestionably the more highly developed, and there is no example in history where such a people has borrowed anything so decisive from a culture inferior to their own.[r]

Here it is most appropriate to consider a particular usage of the spiral motif in Mycenaean art that also occurs in the art of New Zealand and also has remarkable analogies with later Greek ornament.[48] The decoration on

[46] Goodyear, *Grammar*, 373.

[47] In this regard they progressed as little as the Incas of Peru, among whom only geometric and animal ornament is attested as well, perhaps because they too were never exposed to vegetal ornament by an outside source at the decisive moment.

[48] Patterns within a band consisting of individual spirals like the ones seen on the New Zealand fruit rind in figure 29 also occur in a similar manner on a wall painting at Tiryns (Schliemann, *Tiryns*, pl. 6 e).

the gold foil in figure 64[49] is a good example. The middle of the larger, lower half assumes a shape formed by two tangent double spirals; beneath each of the spirals are rows of concentric hatchmarks that become progressively smaller. When both sets of hatchmarks are viewed as a whole, they create the fan of a palmette of sorts with the two tangent volutes above acting as the calyx. The palmettelike motif formed in this way, however, represents a stage that is by no means primary; similar hatchmarks occur frequently on Mycenaean goldsmith work, where they always serve, however, as a kind of axil filler for simple spirals and form, half palmettes, so to speak, as in figure 65.[50] Here smaller spirals branch off from the large double spiral; wherever axils are created by the contour lines of the smaller spirals, either bounded by the edge of the whole piece or by the larger spiral, they are filled with parallel, tapering hatchmarks that follow concentrically the curve of the spiral.[s]

Fig. 64. Embossed gold plaque from Mycenae, Shaft Grave III.

Fig. 65. Embossed gold plaque from Mycenae, Shaft Grave IV.

The axils of New Zealand spirals exhibit the same system. There are several below on the outermost curve of the spiral in figure 28 and, furthermore, some especially distinctive examples on the noses of the figures in figures 31 and 32, where in both cases two spirals and fanlike hatchmarks converge to create the same kind of palmette that we have seen in figure 64. I cannot suggest any other explanation for the use of this motif

[49] Schliemann, *Mykenae*, fig. 305, p. 230.
[50] From Schliemann, *Mykenae*, fig. 369; see also figs. 418, 484, 487–88, 491. I suspect that a similar arrangement forms the basis of the ornament of several vases of the so-called fourth style (Furtwängler and Loeschke, *Mykenische Vasen*, pl. 37, nos. 378–79, 382).

among the Maori except for the postulate of axil filling; this seems to be apparent at least in figure 28, where the bent (as opposed to roundly curved) hatchmarks alternate with triangles (cf. fig. 59).

Furthermore, a rather striking analogy can be drawn between this phenomenon and later Greek tendril ornament (see figs. 125 and 127). The freely-flowing lines of later palmette tendrils, particularly the ones painted beneath vase handles, spread out symmetrically over the surface to form spirals crowned by palmette-fans. Yet wherever there was no room for a whole palmette,—for example where an axil comes to a point— there was only enough space for a half palmette with a single volute and half a fan. The main difference between the Mycenaean and the mature Hellenic motifs is that the fans of the later Greek palmettes consist of stiff rays projecting from the Calyx, like their direct prototypes in Egyptian-Asiatic art appear as feathered arclike striations.[51] The freely undulating tendril was punctuated by individually attached blossoms and used to fill a surface in place of the bands of rigid Egyptian spirals, where blossoms serve only to fill the axils. This pattern was—as we shall see—a fundamental, classical achievement of mature Greek art. And I would go so far as to consider figures 64 and 65 to be the forerunners of this development, forerunners for which there were no prototypes in the ancient Near East, any more than there were prototypes for the undulating tendril or for any tendril ornament at all.

The introduction of the living vegetal tendril into ornament represented an essential step forward that Mycenaean art added to the earlier achievements of its Egyptian predecessor. The move in this direction was at the same time an enduring one, as we shall see. As a result, it deserves particular emphasis, since most of the other peculiarities of Mycenaean ornament, such as the band and spiral patterns or the octopuses and butterflies, do not appear in later Greek art. The development of later blossom forms was also not connected to the Mycenaean versions of Egyptian motifs but to renewed influence of the original Near Eastern types. In contrast, Mycenaean tendril ornament had, as already stated, a lasting impact. This new perspective also explains some of the other surprisingly advanced and highly developed aspects of Mycenaean art that do not fit into the otherwise seemingly primitive context. I would like to pursue some of these aspects further, even if they are not directly related to

[51] Compare, however, the incised double spiral in the border of one of the grave stelai illustrated in Schliemann (*Mykenae*, fig. 24), which has unfortunately not been drawn very clearly. The axils of the spirals are filled with half palmettes of an almost abstract, Islamic character.

vegetal ornament in particular, because one explanation serves to clarify the other.

Indications of an advanced development in Mycenaean art are apparent not only within the realm of pure decoration but in figurative depictions as well.

For Mycenaean decoration in general, let us return to the sculptured ceiling from Orchomenos (fig. 55). Our earlier discussion of the ceiling already emphasized the unexpected way in which this highly revealing monument of Mycenaean decorative art distinguished between the interior field and the border. We have already characterized the basic tendency that gave rise to this distinction, one to which all Mediterranean cultures participating in the development of art history aspired. Naturally the goal could only be attained step by step; we have also already discussed in detail how the Egyptians were still far from reaching it. Assyrian art manifests the first indications of a consistent and conscious system of fill and frame, interior field and outside border. Seen in this light, the basic decorative scheme of the ceiling from Orchomenos is an advance over the otherwise exemplary manner characteristic of Egyptian art; it is comparable, for example, to the doorsill from Nineveh (fig. 34) with which it even shares direct points of contact (the rosettes adjacent to the inner fields and borders). The ceiling from Orchomenos is, however, considerably earlier than any Assyrian monuments. Aside from the doorsill, which dates from the Sargonid [Neo-Assyrian] period, the earliest known monuments from Assyrian royal palaces were not executed before the first millenium B.C.[t] The highpoint of Mycenaean culture, however, is usually placed between the sixteenth and the twelfth centuries B.C. Moreover, Phoenician art, which makes a rigorous distinction between structural framing and neutral fill as well, could also not have served as model for Mycenaean art, since, according to the argument made above in chapter 3 A 3. Phoenician metal bowls and similar objects could not have originated much earlier than the Sargonid [Neo-Assyrian] period. Mycenaean culture, however, was probably contemporary with the Ramesid period [Nineteenth Dynasty]. This is the period of the Egyptian wall painting reproduced by Prisse d'Avennes, where the treatment of the framing border is, in many respects, still imperfect and unresolved. If all this is true, then one must conclude that the Mycenaeans made considerable improvements beyond what the Egyptians had achieved in the way that space could be apportioned decoratively and had come one step closer to the later, pivotal accomplishments of the Greeks, just as they had in the case of the individual motif of the freely undulating tendril.

Another characteristic of Mycenaean art, encountered on numerous monuments, is directly related to this: it consists of the free arrangement of the ornament on the ground in a manner that is no longer at all inhibited but sometimes quite grand and audacious. For example, one can see how confidently and boldly the birds on a vase from Shaft Grave VI at Mycenae[51a] have been quickly improvised between the two enclosing border strips on the belly of the vessel, though the painting itself is not at all distinguished by careful attention to detail. The same applies to the lions that romp around the golden cup illustrated by Schliemann,[51b] filling the available space perfectly with their figures in full gallop. There is one vase among the Egyptian vessels reproduced by Prisse d'Avennes whose decoration is no longer meticulously arranged in registers as it is on Dipylon vases. Its composition, however, hardly approaches the freedom and grandness of the numerous Mycenaean examples. The same is true for the shapes of the vessels; Egyptian vase forms remain restricted, while those in Mycenae are connected to the later Greek types.

According to the prevailing methods of art historical study, one only crosses the line between ethnology and art history when depictions of human struggle and accomplishment are involved. Geometric, vegetal, and animal motifs are always seen as pure decoration. Whenever human figures appear in decorative works of art, however, they assume an objective interest. Regardless of its intricate spiral ornament, the art of the New Zealanders will never awaken much more than an exotic interest in us, because its human figures are never more than crude and monstrous idols. Mycenaean art, however, often portrayed human figures, and not only on the kinds of objects expressly designed for them, the category in which the intaglios probably belong, but also for a purely decorative purpose, is the decoration of works in the applied arts.

This factor is extremely important, because it is symptomatic of the fundamental difference between Mycenaean and Egyptian art. The subject matter of the Warrior Vase, for example, is already on completely equal footing with that of later Greek vase painting, as is the niello cup with human heads found by Tsountas.[u] It can no longer be determined to what extent the Mycenaeans relied in the beginning for their depictions of human figures on Egyptian ideas. At any rate, Egyptian characteristics are not completely absent from figurative scenes: for example, the "Mycenaeans" stylized human figures the same way the Egyptians did, in the man-

[51a] [Furtwängler and Loeschke, *Mykenische Thongefässe*, pl. 9, no. 44.]
[51b] [Schliemann, *Mycenae*, fig. 477.]

ner well known from Egyptian reliefs, where the upper torso is shown in frontal view while the head and the feet are in profile. The Mycenaean figures also retain the characteristic "wasp waists" of the Egyptian stylization that are still evident in the Dipylon Style. The dependence on Egyptian models may even apply to particular scenes. Goodyear found a parallel for the "juggler" from Tiryns in a mastaba tomb published by Lepsius. Moreover, the Egyptian vase published by Prisse d'Avennes[51c] may actually depict a bull-catching scene; it shows a bull kicking out its hind legs in a position closely related to that of one of the bulls on the cup from Vapheio. Still, no one would be tempted to claim that the cup from Vapheio is an Egyptian work. Each of the figures has been carefully individualized in spite of the Egyptian stylization of the upper torso. Moreover, the appearance of genrelike scenes and subjects as well as the careful attention to the landscape[52] setting found on the Vapheio cup already exhibit the free and easy approach of Mycenaean art to the essentials of nature and everyday life, an approach that later Greek art did not achieve again until just before the Hellenistic period. Again, the genrelike scenes in Egyptian tombs may have served as models; however, while the Egyptian scenes were strictly representational and had specific significance in connection to the Egyptian conception of the afterlife, the bull-catching episodes on the cup from Vapheio were surely meant to be simply decorative: in this instance, they are truly genre scenes. The same goes for the lion hunt on one of the niello dagger blades; and even the so-called Nile border on the second dagger was the result of no more than general Egyptian influence.[v]

Goodyear's assertion that Mycenaean art could have acquired some features, such as the intermittent tendril (fig. 52), from the repertory of so-called Cypriote-Greek art, which we of course refuted above, compels me to describe briefly the place of vegetal ornament within this style. Cypriote-Greek vegetal ornament relied heavily—much more heavily than Mycenaean art—on Egyptian models, and as a result it did not contribute anything creative to the development. Phoenician influence did not alter the situation. What is different and distinctly Cypriote is mainly the isolated use of lotus blossoms, etc., in response to specific decorative demands. The figurative elements remain completely in the grip of their Egyptian models. The man on the much discussed vase from

[51c] [Prisse d'Avennes, *L'art égyptien*, atlas 2, "Amphores, jarres et autres vases," no. 1.]

[52] O. Puchstein, in his discussion of the small, highly intriguing wooden panel in the Berlin Antiquarium, "Sitzungsberichte der Archäologischen Gesellschaft zu Berlin," *Archäologischer Anzeiger* (1891): 40–42, ill., col. 40, also noted this as not characteristically Near Eastern.

Athienu[53] is not merely Egyptianized; he portrays an actual Egyptian (although this has not yet been emphasized sufficiently as far as I know). In addition to the Egyptian characteristics already observed by Ohnefalsch-Richter,[54] the man on this vase, naked except for a necklace, wears a short skirt wrapped around the hips precisely in the Egyptian fashion. The occurrence of a specifically Greek motif, the continuous tendril, on an object found on Cyprus has been discussed earlier. A second example of the same undulating tendril with pointed, oblong leaves (which Goodyear failed to note) appears on a vase from Curium illustrated by Perrot and Chipiez.[55] This is also not an example of an indigenous Cypriote trait, nor a case of Phoenician-Egyptian influence, but a clear echo of the Greek-Mycenaean manner, as proved beyond a doubt by the twisting ivy branch on the shoulder of the vessel. Perrot, who considers the piece to be Cypriote, dates it relatively late. The chronological situation, therefore, ought to be re-examined by the scholars who feel they have arrived at a definite date for Mycenaean art, and moreover a very early one.[w]

In any event, this example provides no more proof that the momentous invention of the undulating tendril took place on Cypriote soil than the other example discussed earlier. The blossom motifs on Cypriote vases are usually scattered randomly on the field without any interconnection. Where they are interconnected, they conform to the schemes established by the Egyptians or, at most, the Mesopotamians. The only motif that can be interpreted as an improvement over Egyptian models is the double row of overlapping arcs running in the same direction, which is often found on Cypriote vases.[56] It is much livelier and has more variety than the single row of arcs. Whether or not this improvement should be interpreted as a sign of Cypriote creativity remains to be seen, however, for the motif seems to have appeared earliest in Mesopotamia,[57] and the sites where it has been discovered, dating from the first half of the first millenium B.C., are scattered far beyond the cultural sphere of the Mediterranean (Cyrenean [Lakonian] vases, Kameiros on Rhodes; moreover, Vulci in Italy).

[53] M. Ohnefalsch-Richter, "Cyprische Vasen aus Atheniu," *Jahrbuch des Deutschen Archäologischen Instituts* 1 (1886): 78–82, pl. 8.

[54] Ibid.

[55] Perrot and Chipiez, *Histoire de l'art*, vol. 3, fig. 506. Perrot's drawing is unfortunately not very clear. The tendril seems to be exactly the same one found on the cup from Bonn (fig. 51).

[56] For example, on the vase from Ormidia (Perrot and Chipiez, *Histoire de l'art*, 3:699, fig. 507).

[57] Layard, *Monuments of Nineveh*, vol. 1, pl. 84, no. 13.

Cypriote-Greek art, therefore, played no independent role in the history of the development of vegetal ornament. It shared the inheritance of the ancient Near Eastern cultures, of the Egyptians and the Mesopotamians; it exploited Phoenician variations such as the palmette-tree, and beginning with the Mycenaean period, partook of the few available seeds of what would later be the fruitful developments of the Greeks. In this respect, the art can justifiably be termed Cypriote-Greek.

2. The Dipylon Style

The natural development of Mycenaean ornament was halted by the appearance of the geometric Dipylon Style. Strictly speaking, however, the Dipylon Style is not equivalent to the Geometric Style per se and should not be considered the paradigm of purely geometric ornament. It lacks the naïveté of primitive styles, particularly in its organization of the decoration as a whole: the placement of the ornament has something refined about it. Admittedly, the Dipylon Style relies heavily on the use of registers, an elementary means of dividing a surface that the Mycenaeans had long since left behind; however, the variation in the width of the registers, the kind of sensitivity to "tectonic" considerations evident in this variation, along with the inclusion of figurative scenes, all betray a more advanced and more calculated decorative art than we are used to encountering in the purely geometric styles such as that of the Northern European [Bronze Age], the earliest [Bronze Age] Cypriote, the Native American, or the Polynesian. The Dipylon Style cannot be summarized in a few short words. It is not just an exchange of new angular forms for the curvilinear ones that had dominated Mycenaean art; in the Dipylon Style, curved lines occur beside angular forms, circles alongside squares, rosettelike quatrefoils and multileafed motifs along with radiating rosettes.[a]

Aside from the use of registers, however, it is the *horror vacui* of the Dipylon Style that indicates how it still has some connection with a naive stage of art, preoccupied only with decorative concerns. Particularly in representational depictions, all of the space around the figures or their accessories is strewn with filler motifs. "Mycenaean" art had long since progressed beyond this point.[b] To be sure, the sheer presence of figurative scenes within the decoration seems to indicate a higher stage of development; however, the figures themselves, particularly the human figures, are not nearly as advanced as those of Mycenaean art, like the lively, animated forms on the Vapheio Cup or on the dagger blade with the lion hunt. Regardless of whether we view the treatment of the figures in the Dipylon Style as an original contribution of its makers or as an imitation of

the Egyptian canon (a notion that has some merit),[58, c] we are always deal-
ing with a stage of artistic development that is lower than the one attained
by Mycenaean art.

A characteristic of the Dipylon Style, noted already by Conze,[59] is the
absence of vegetal ornament. In fact, despite the abundant material that
has come to light in the past twenty years, there are only isolated exam-
ples of geometric vases from the Dipylon period decorated with unques-
tionably vegetal motifs.[60] Goodyear, for whom the continuous zigzag is
just a row of vestigial lotus blossoms, traces all the essentials of Dipylon
Style, as well as the Northern European [Bronze Age] style, back to Egyp-
tian roots. Be that as it may, the Dipylon Style still adds nothing of sig-
nificance to our present inquiry, since no fruitful development of vegetal
ornament and the vegetal tendril could arise from this apparent reversion
to geometric motifs. Yet we must deal with the Dipylon Style in spite of
this because it provides an explanation for the interruption of the Myce-
naean development and for what was to follow in general. The Dipylon
Style had a profound effect even on the centers of what would later be
known as Hellas, where Mycenaean traditions were preserved in rela-
tively pure form. Vases manufactured on the island of Melos, for example,
also display, aside from qualities unmistakably derived from the Myce-
naean heritage, the scattered filler motifs characteristic of geometric *hor-
ror vacui* and of a primitive decorative drive.[d]

Excavations to date have shown that the invasion of this geometric style
extended to all the regions that later became centers of Greek culture and
art, densely on the European mainland and then becoming progressively
less intense further east toward Cyprus.[e] There have also been attempts
to answer ethnographic questions, whereby the creators of the Dipylon
Style were a people who migrated not from the East but from Europe,
probably through the Balkan region, into Greece. They are often associ-
ated with the incoming Dorians. If this is so, then it would logically have
to follow that the creators of Mycenaean culture in Greece were Achae-
ans, and therefore Greeks as well. This interpretation does not sit well
with the scholars who believe that Mycenaean culture was created by the
Carians. Their assumptions rely mainly on evidence that has nothing to do

[58] In particular, the upper torsos of the human figures are kept much more rigidly frontal
than in Mycenaean art; for the Egyptian elements of the Dipylon style, see E. Kroker, "Die
Dipylonvasen," *Jahrbuch des Deutschen Archäologischen Instituts* 1 (1886): 95ff.

[59] A. Conze, "Zur Geschichte der Anfänge der griechischen Kunst," parts 1–2,
Sitzungsberichte der k.k. Akademie der Wissenschaften, Wien, Philosophische und Historis-
che Classe, vol. 64 (1870): 505–34; vol. 73 (1873): 221–50.

[60] As on the vase from Kameiros (Kroker, *Jahrbuch des Deutschen Archäologischen Insti-
tuts* 1 [1886]: 135).

with art; nevertheless, from Ulrich Köhler to Goodyear, they have felt obliged to address the un-Greek aspects of Mycenaean art and the Greek qualities of the Dipylon Style. The un-Greek qualities of Mycenaean art were, of course, not difficult to find; they were also revealed by our examination of the numerous, obviously Egyptian elements apparent in Mycenaean forms. Of those who have dealt with the Greek character of the Dipylon Style, however, Studniczka's[61] contribution is the most concise. For him, the geometric style of the migratory Hellenic tribes was distinguished by the principle of strict discipline that succeeded in transforming all borrowings from the overflowing formal repertory of the Orient, from the Mycenaean period onward, into what came to bear the genuine Hellenic stamp.[f]

We cannot expect to find an answer to the "Mycenaean question" any more than we can expect to clarify the relationship that might have existed between the creators of the Mycenaean and the Dipylon cultures. However, let us not forget the specifically Greek characteristics that surfaced in the examination of Mycenaean vegetal ornament, characteristics nowhere to be found in Near Eastern art or in the Dipylon Style. No one is disputing the fact that the creators of the Dipylon Style were later absorbed by the Greeks; nevertheless, the formative "seeds of Hellenism" reach much further back into the Mycenaean period. This is why we concluded above that whatever ethnic group gave rise to Mycenaean culture, whether the Carians or the Achaeans, it must have remained an essential component of the later Hellenic population.[g]

If any more evidence is required to prove that the displacement of Mycenaean culture by the Geometric Style represented a retrogression, and only a retrogression, it can be found in the behavior of the Greeks themselves, who, in recognizing the futility of developing the Dipylon Style any further, reverted once again to the Orient, the original source of the most significant decorative forms.[62] Our intention now is to show how vegetal ornament during and after the Dipylon Style regained its honored place in Greek art and how it sometimes mechanically imitated Eastern conventions. Most of all, however, we will examine how the freely undulating vegetal tendril, that great invention of the Mycenaean tradition, as

[61] F. Studniczka, "Zur Herkunft der mykenischen Kultur," *Athenische Mitteilungen* 12 (1887): 24.
[62] We have already observed an analogous situation in Assyrian art, where the stylized blossom motifs from the Sargonid [Neo-Assyrian] period are stylized in more purely Egyptian fashion than they are on the older monuments from the period of Assurnasirpal, etc. Certainly, the reasons for this in each case were not the same. [See annotation *d* for chapter 3A.2.]

well as the attached blossoms, were refined into a motif of great formal beauty, which gradually expanded to fill large areas and ultimately subordinated itself to decorative human and animal figures. Since this mainly involves the description of a continuous development, the motifs and monuments will generally be presented in chronological order. Because of the great number of geographic and personal variations characteristic of the material, however, this will not always be possible. Therefore, I would again like to make it clear that this is not an attempt to fix the chronology or establish more accurate dates for the various categories of vases and so forth; problems of this sort could never be solved solely on the basis of vegetal ornament. Our aim is only to define the place of the individual monuments within the developing history of vegetal tendril ornament, so far as circumstances permit; classical archaeology may then be free to draw the conclusions that seem warranted on a much broader basis, by comparing this to the evidence of the remaining characteristics of the monuments.

3. Melian

The Melian vases have top priority, since the Mycenaean element still appears most clearly in this category of early Greek vase, and since they also display elements that carried over into later Greek art. The example in figure 66 is from Conze's study, where the details of the same vase illustrated in figures 67 and 53 were also first published.[62a, a]

If we disregard the rosettelike shapes and concentrate on the various individual motifs in figure 66, we will find both of the basic types of Egyptian lotus: the pointed-leafed profile view (fig. 53) as well as the lotus- palmette of figure 66, under the rear legs of the horses. However unmistakable the Egyptian origin of these motifs may be, starting with the volute-calyx, the distinctions between them and their Egyptian prototypes immediately comes to the fore. The palmettes between the rear legs of the horses are neither Egyptian because of their strongly coiling volutes, nor Assyrian, since they lack the characteristic, upwardly curling volutes. The palmettes in figure 66 are simply Greek. They are distinguished by the characteristic, strongly coiling volutes of the calyx and by the corresponding size of the crowning fan; the cattail-like leaves of the fan are placed loosely, not tightly, next to each other.[b] All of the essential components of the complete Greek palmette motif are present; the only thing still missing is the delicate attuning and adjustment of the details

[62a] [A. Conze, *Melische Thongefässe* (Leipzig, 1862), pl. 1, nos. 1, 4–5.]

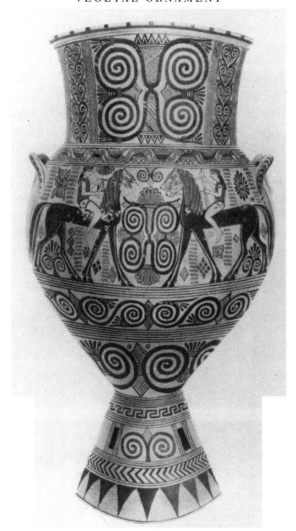

Fig. 66. Melian amphora, from Melos.

according to a pure sense of formal beauty, a process that did not culmi-
nate until the fifth century. The volute blossom is repeated in abbreviated
form, this time as a double volute with its peaked axil fillers, both on the
foot of the vase and in the middle of the upper edge of the field containing
the horsemen.

The profile views of the lotuses and palmettes in Melian vase painting
display much stronger similarities to Near Eastern models than to Myce-
naean ornament. This is especially true of the profile view of the lotus, but
there is also no known Mycenaean example of the palmette with such a

141

regularly arranged fan of leaves connected to a volute-calyx. Conse-
quently, there must have been renewed influence from the Near East
either directly from Egypt or some indirect derivation. The freedom of
the Melian vase painters in treating those adopted blossoms is apparent
not only in the way that the lotus profile connects to its volute-calyx, as
clearly revealed in the left side of figure 53, but particularly in the ar-
rangement of the two large volute flowers decorating the middle part of
the neck in figure 66. The pointed leaves that crown each of these flowers
between the spirals are clearly related to those of the profile lotuses in
figure 53. There is also a similar motif in figure 66 lower down between
the two horses; the pointed crowning leaves of the upper motif, however,
have been replaced below by the leafy fans of palmette motifs. In both
cases, the volutes are so dominant and basic to the motif that the calyces,
which are bounded by the spiraling volutes at both sides, function merely
as axil fillers; they make no greater impression than any of the numerous
other axil fillers that crop up wherever the spirals meet or tendrils branch
off. The motif as a whole resembles the Egyptian spiral patterns with blos-
soms as axil fillers in figures 26 and 27. But as the short tendril branches
that appear above and below alongside the volutes demonstrate, the Me-
lian vase painters did not base their motifs on rigid, geometric spirals but
on the natural twining of plants. We will return to these tendril branches
a little later.[c]

We will now examine how the individual vegetal motifs on Melian vases
are connected. The preceding discussion has already given us a start in
this direction. The spirals dominate the motif, while the blossoms function
only as fillers. In figure 66, the postulate of axil filling is obeyed in every
respect. Let us refer to the detail in figure 67. Here we see two rows of
tangent spirals. The axils created where the spirals meet in the middle are
filled with palmette-fans; those opening toward the outside are provided
with simple peaked fillers. The Egyptian model is familiar to us from fig-
ure 26, the Mycenaean intermediary from figure 60. The motif developed
further into the double guilloche (fig. 68),[63] which is often found on Ar-
chaic painted terra-cotta, and even on late Roman mosaics.[d]

The decoration in the register directly above the foot in figure 66 has
also not progressed essentially beyond the Egyptian approach to art in
any essential way. Here we see double volutes placed side by side. (Only
half of each motif is visible in the reproduction.) The axils formed by
the converging spirals are filled with palmette-fans, whereas the axils

[63] For example, on a sarcophagus from Klazomenai now in Berlin (*Antike Denkmäler*,
Deutsches Archäologisches Institut, 1, [Berlin, 1886], pl. 1, 44).[f]

Fig. 67. Melian amphora, detail of ornament on neck.

Fig. 68. Klazomenian terra-cotta sarcophagus, detail of painted border.

occurring between the double spirals are occupied by simple peaked fillers.[e]

The two remaining decorative strips on the vase in figure 66 frame the top and bottom of the figurative frieze with the horsemen. We have intentionally saved them for last, because the patterns they contain are so purely Greek in character and, at the same time, so very similar to Mycenaean models that they must be considered direct links between Mycenaean and Hellenic art forms. The lower of the two registers consists of S-spirals placed end to end, which are as un-Egyptian in character as the peaked axil fillers between them. The Mycenaean-Greek quality of the motif is evident in the tendrils, which branch off from the spirals alternately above and below, and from the palmette-fans, which serve as fillers between these tendrils and the spirals, and not in the inner angles of the S-curve, as the Egyptian scheme would have demanded (fig. 25). Figure 69 illustrates the way an Egyptian might have filled the axil of an S-spiral; it is also taken from a Melian vase where it serves as a filler motif between the legs of horses.[63a] The branching tendril in figure 66 forms a "half palmette" together with the fan filling up the axil. The half palmette, which

[63a] [Conze, *Melische Thongefässe*, pl. 4.]

Fig. 69. Painted filler
ornament from a Melian vase.

creates a whole palmette when doubled, later became an extremely im-
portant and fundamental motif in Greek ornament. On the Melian vase in
figure 66, it already exists in all its essentials, although, as we learned
above, it was anticipated by Mycenaean art.[64] It makes no difference
whether the Melian vase painter consciously conceived of the motif as an
independent half palmette[65] or merely as an accidental axil filler of the
S-spiral. What remains beyond question is the link between the Myce-
naean and the pure Greek form of this motif. Any lingering doubt as to
which of the two components, the geometric S-spiral or the plant-like half
palmette, constitutes the main motif will vanish after examining the deco-
rative strip on the shoulder of figure 66, which is enlarged in figure 53.
It shows profile views of lotus blossoms oriented alternately up and
down and linked sequentially in the scheme we termed the intermittent
tendril—the one that first appeared in Mycenaean Shaft Grave VI, and
whose art historical significance we have already discussed in the com-
parison between the Melian and Mycenaean examples in the preceding
chapter.[g]

Let us summarize our conclusions thus far about Melian vegetal orna-
ment. We have discovered that it is still at essentially the same level as
Mycenaean art. As a rule, it weaves back and forth along the borderline
between spiral and tendril ornament. It did not relinquish the decisive
creation of the Mycenaeans—the floral tendril; but there are also no signs
of any further development. The stiff, vertical placement of the floral ca-
lyces and the individual stems, along with the stylization of the lotus blos-
soms and palmettes, all indicate a reversion to the Egyptian manner. The
need to fill axils has become a much more absolute postulate than it had

[64] The pattern under discussion in figure 66 is closest to the border on the grave stele
illustrated by Schliemann (*Mykenae; Bericht über meine Forschungen und Entdeckungen in
Mykenae und Tiryns* [Leipzig, 1878], p. 58, fig. 24).

[65] In my opinion, however, it can be easily demonstrated that Melian vase painters knew
they were using half palmettes. The sphinx on the Melian vase illustrated by J. Böhlau, "Eine
melische Amphora," *Jahrbuch des Deutschen Archäologischen Instituts* 2 (1887): 211–15,
and pl. 12, is wearing one on its head as a crown; it performs a function, therefore, later
frequently taken up by the palmette (O. Puchstein, "Kyrenaische Vasen," *Archäologische
Zeitung* 39 [1881]: 215–50, pl. 13, nos. 2, 3, 6) but not by the isolated spiral.

been in Mycenaean or even Egyptian art. Only Phoenician art is similar in this respect. Assyrian influence seems to be the weakest, unless we decide to accept the bindings that hold the spiral tendrils together at their points of contact in figures 66 and 67 as evidence of this, since they resemble those found on Assyrian arcuated friezes (fig. 33). The reversion to a geometric mode of thinking is particularly evident in the way the entire surface of the vase in figure 66 is painstakingly divided into parallel registers, and in the way numerous filler motifs are scattered about the figurative frieze. And it is also not impossible that the *horror vacui* behind the use of these filler motifs was, in the last analysis, also responsible for the meticulous and consistent use of axil fillers.[h]

4. Rhodian

The next group of monuments includes the so-called Rhodian[66] vases and the closely related terra-cotta sarcophagi from Klazomenai. The basic decorative scheme is essentially the same as that of the Melian vases: the surface is divided up into registers, while filler motifs are abundantly scattered among the neutral spaces around the human and animal figures. But whereas Mycenaean influence dominated the vegetal and spiral ornament on Melian vases, it yielded in Rhodian art to elements of a more Near Eastern character. The degree of Orientalizing varies, however; and this in itself leads to a differentiation among the Rhodian vases, which we, of course, cannot and shall not pursue to any great extent.[a]

For example, the individual blossom motifs, which are neither repeated nor connected to motifs of their own kind, are based unmistakably on the prototypical voluted-calycal blossoms of the Near East or, to be more specific, those created in Egypt. They are usually handled very freely and adjusted to their particular function. Let us examine figure 70,[67] where the decoration has to to fill a hemisphere.[b] In response to this shape, the two volutes that comprise the calyx have been stretched out lengthwise. They curl upward just as Assyrian ones do, though they have their roots in Egyptian prototypes as well. The central axil contains a large fan; significantly, all of the remaining axils have been filled richly and indeed metic-

[66] In spite of the fact that most of these vases were discovered at Kameiros on Rhodes, they are thought to have originated in Argos (See J. Dümmler, "Zu Vasen aus Kameiros," *Jahrbuch des Deutschen Archäologischen Instituts* 6 [1891]: 263–71), which would give them a European origin. I mention this in order to justify why we have not attributed the considerably stronger Near Eastern influences in this group of vases to the geographic proximity of Rhodes to the countries bordering on the eastern Mediterranean.

[67] Detail of a bowl from Kameiros (A. Salzmann, *Nécropole de Camiros* [Paris, 1875] pl. 51).

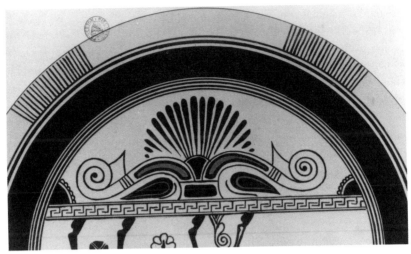

Fig. 70. Painted decoration of Rhodian bowl from Kameiros.

ulously. Figure 71 provides another example. This motif occupies the middle of a register from an oenochoe,[68] symmetrically flanked by birds and sphinxes. Here we find a volute-calyx coiled into spirals of Mycenaean-Greek inspiration. The two pointed calycal leaves above it slant outward; between them is a Greek palmette-fan. All four axils, as one might expect, are appropriately filled. The structure of this motif can no more be attributed to the direct copying of a Near Eastern model than the one in figure 70, even though in the last analysis the Near Eastern volute blossom is unmistakable. The treatment of the motif is Mycenaean, or, if you will, Greek, and it is fundamentally different from its Near Eastern models.[c]

On the other hand, the blossom motifs on Rhodian vases, which are either simply juxtaposed or connected in series, display, as a rule, a much greater dependence on Near Eastern models. Figure 72 reproduces a plate from Kameiros.[69] The row of lotus blossoms and buds on the outer border of the plate, in particular, looks very much like its Egyptian prototypes. Of course, a closer look discloses a number of details that would be inconceivable on a genuine example of Egyptian art. The silhouettes of the Rhodian lotus blossoms have become much more fluid and elegant; the axil between the two calycal leaves, which slant off to either side of each lotus blossom, is filled with a palmette-fan, as in figure 71, not with

[68] Ibid., pl. 37.
[69] Ibid., pl. 52 [Riegl's original citation of this illustration as coming from Salzmann, pl. 34, is incorrect].

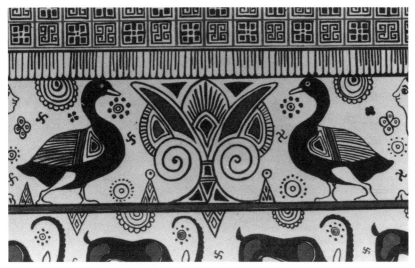

Fig. 71. Painted decoration from a Rhodian oinochoe from Kameiros.

pointed leaves. The un-Egyptian aspects of the plate become even more obvious when we examine the decoration on the middle of the plate. Here the individual palmette-fans alternate with bud motifs, but they totally lack the volute-calyces that would have been unconditionally requisite in Egyptian art. Nevertheless, it should be emphasized that Mycenaean art has so far not produced a single example of this rigid serial arrangement of lotus blossoms and buds conforming to the basic Egyptian scheme.[d]

The simple serial arrangement of lotus motifs as seen in figure 72, was actually rare in Rhodian art. What is typical, in contrast, is the arcuated frieze with lotus blossoms and buds. Figure 73 shows an example that, revealingly enough, decorates the same oenochoe as the Mycenaean-inspired palmette in figure 71. Here, even the calyx of the lotus blossoms is comprised of pointed leaves in the typical Egyptian manner, as opposed to the un-Egyptian combination with the palmette-fan on the border of the plate in figure 72. Of course, not too much weight should be placed on such an unusually close dependence on Near Eastern models: an oenochoe illustrated by Salzmann[69a] for example, has an arcuated frieze with motifs like the ones in figure 73 on its lower part but, above it on the shoulder, another frieze with the motifs of figure 72. At any rate, the motif of alternating lotus blossoms and buds connected as an arcuated frieze also does not occur in Mycenaean art. Therefore, like the unattached

[69a] [Ibid., pl. 44.]

147

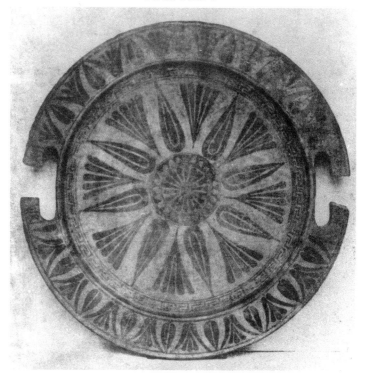

Fig. 72. Rhodian plate from Kameiros.

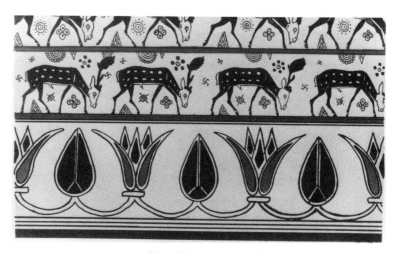

Fig. 73. Arcuated band frieze on a Rhodian oinochoe
from Kameiros.

rows of lotus blossoms and buds, it constitutes further proof of the post-Mycenaean Rhodian borrowings from the Egyptian–Near Eastern stock of decorative forms.[e]

Although it does not matter greatly for our present study whether the arcuated lotus frieze just described was influenced directly by an Egyptian source or via an intermediary, I would still like to respond to the frequent assertion that it is a specifically Assyrian motif. The argument for an Assyrian origin of the arcuated frieze in figure 73 is based, first of all, on the bindings that seem to attach the blossoms[70] to the arcuated bands as they do in figure 33 and second, on the absence of all of the tiny filler motifs, such as rosettes, buds, and so forth, that clutter up the leftover space on the Egyptian arcuated friezes.[71] I still do not think that these features are enough, however, to prove that the Rhodian vases relied on an Assyrian source. As we have seen, Assyrian art itself is basically derivative; its characteristic blossom developed relatively late and never attained the stage of development of Mycenaean ornament. The only Assyrian ornaments that come into question as possible sources for Rhodian vase decoration are the more severely Egyptianizing arcuated friezes from the Sargonid [late Neo-Assyrian] period, and they are scarcely enough earlier than the Rhodian examples themselves to warrant mention.[72]

It is possible that the *guilloche* could be considered proof of Assyrian influence on Rhodian vase painting, since the motif was widespread in Mesopotamian art but neglected in Egyptian. The guilloche occurs in Mycenaean art, however, long before any surviving examples from Assyrian monuments. Moreover, the Rhodian guilloches are clearly distinguished from the Assyrian ones by the axil fillers, which are almost always inserted

[70] And the buds as well on the oenochoe (ibid., pl. 44).

[71] In figure 22, the filler motifs were omitted from the drawing to facilitate appreciation of the basic scheme. They are included, however, in the illustration by A. Prisse d'Avennes, *Histoire de l'art égyptian d'après les monuments, depuis les temps les plus reculés jusqu'à la domination romaine* (Paris, 1878–1879), atlas 1, pl. 13, "Couronnements et frises fleuronnées," no. 6.

[72] Assyrian influence on the development of Greek art has not yet been carefully defined; at present, it is vastly overestimated by scholars such as A.E.J. Holwerda, "Korinthisch-attische Vasen," *Jahrbuch des Deutschen Archäologischen Instituts* 5 (1890): 237–68, who cites the cista from Praeneste in *Monumenti inediti*, Deutsches Archäologisches Institut, 8 (1864–1868), pl. 26, among other things, as proof. [For more recent and accessible illustrations of this work see F. Poulsen, *Der Orient und der frühgriechische Kunst* (Leipzig and Berlin, 1912), 121, fig. 128; P. Ducati, *Storia dell'arte etrusca* (Florence, 1927), pl. 45, nos. 144–45; and M. Torelli, *L'arte degli etruschi* (Rome and Bari, 1985), 32, fig. 15]. I would disagree: the lotus blossoms in this example are stylized in the stiff Egyptian manner, while the palmettes are Hellenized, and neither of the motifs has anything Assyrian about it. At any rate, the artistic activity in the region that would later be known as Greece had already become so strengthened and so far advanced during the Sargonid [Neo-Assyrian] period that the artists involved would hardly have been impressed by contemporary Assyrian art.[f]

into the outer angles. On the "Euphorbos" plate, they are simply peaked;[73] on the two vases in Berlin,[74] their forms are circular or drop shaped; while on the sarcophagi from Klazomenai,[75] they are filled with palmette-fans. This fanatic urge to fill each and every axil is also characteristic of Melian vases, but completely alien to Assyrian art. The drop-shaped axil fillers, on the other hand, can be found in the outer axils of an arcuated frieze of Mycenaean origin.[75a, g]

After this digression on possible Assyrian influence let us return to our discussion of how the blossom motifs on Rhodian vases are connected. The spiral was used extensively in Melian art in combination with blossoms, either as a connecting element or as a motif whose particular capacity to create axils encouraged the formation of blossoms. In Rhodian art, however, its use declines. This decline is symptomatic of what later transpires in the course of Greek vegetal ornament when the spiral, as an independent element, becomes limited to the running-dog motif. Spirals serving as floral calyces enjoy a longer lifespan, but they also shrink in importance as the blossom comes increasingly to dominate the motif. In other words, the spiral conspicuously loses its geometric significance and becomes a vegetal tendril. This process, initiated by the Mycenaeans, was taken a step further by Rhodian art, and therein lies the major significance of Rhodian art for the historical evolution of vegetal ornament.

In light of this, one would expect to find a more extensive use of the specifically Greek undulating tendril in Rhodian decorative art. This, in fact, is the case, as a number of examples will demonstrate.

There are three examples of the continuous tendril from the Rhodian and Klazomenian regions that have come to my attention. The first, on a sherd from Kameiros, figure 74, is distinguished by its surprising angularity.[76] At first glance, it looks like a meander. Unlike the typical (Egyptian) meander, however, which is always oriented in one direction, the rhomboid convolutions in figure 74 fold in toward their centers alternately from above and below using the same basic pattern as the continuous tendril

[73] Salzmann, *Nécropole de Camiros*, pl. 53. The use of peaked fillers to close an axil is obviously the simplest way of satisfying the postulate of axil filling, so that there is no need of explaining them in connection with the pointed leaves of the lotus. However, in the case of the axils created by the double volutes on the shield of Menelaos on this same plate, which each have three peaked fillers, the analogy with the pointed leafed lotus profile, like the ones in figures 55 and 56, is intentional.

[74] A. Furtwängler, "Erwerbungen der Königlichen Museen zu Berlin 1885," *Jahrbuch des Deutschen Archäologischen Instituts* 1 (1886): 139–40.

[75] *Antike Denkmäler*, vol. 1 (1886), pl. 45.

[75a] [Furtwängler and Loeschke, *Mykenische Vasen; vohellenische Thongefässe aus dem Gebiet des Mittelmeeres* (Berlin, 1886), pl. 19, no. 136.]

[76] Salzmann, *Nécropole de Camiros*, pl. 29.

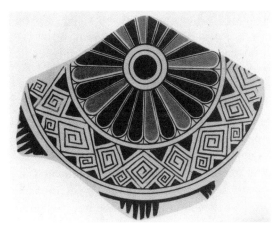

Fig. 74. Fragment of a
Rhodian plate from Kameiros.

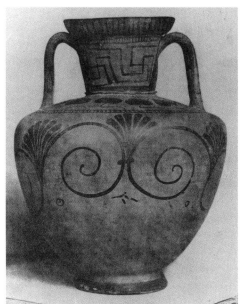

Fig. 75. Rhodian amphora
from Kameiros.

(fig. 50). Finally, the smaller convolutions branching off below the larger ones make it abundantly clear that the motif is basically a tendril. The unexpected angularity of the pattern may be attributable to influence from the Geometric Style, which could have prompted the substitution of rectilinear for initially circular forms.[h]

While the motif in figure 74 is a simple tendril with no other plant-like accessories, the one on the amphora in figure 75 is a fully developed undulating tendril made up of curving spirals whose axils are filled with

151

palmette-fans.[76a] The vase obviously belongs to a more advanced stage of the development, but because it is remarkable in a number of respects, we will deal with it out of chronological order.[i] What requires immediate explanation is the very identification of the motif on this amphora as a undulating tendril. Two separate spiraling lines meet in the middle of the belly; they do not merge but are held together by a binding. Further back on both sides, however, the tendrils split off into spirals curling in the opposite direction, in complete conformity to the basic idea of the continuous tendril. The idea of the geometric spiral has therefore given way to the concept of the tendril. The tendrils do, of course, still dominate the decorative conception as a whole when compared to the palmette-fans filling the axils. The fans, however, which in this case are inserted only into the upper axils,[77] are much larger than is customary for their function as mere incidental fillers.

Let us ignore the details for a moment, however, and concentrate on the decoration as a whole. Immediately we become conscious that there is no longer any arrangements in registers of the type usually found on Rhodian vases as a legacy from the Geometric Style. In their place is a single brilliantly rendered pattern, which is sufficient by itself to adorn the belly of the vase in an attractive way. Since Mycenaean art first exhibited the tendency for this kind of brilliant decoration, is it not justified to claim that the pattern in figure 75 is a recurrence of latent Mycenaean influence? There is simply no other explanation for the pattern on the shoulder of the amphora. Here we find what looks like a row of small ivy leaves arranged slightly at an angle on gracefully curved stems, a manifestation of the same preference for livelier vegetal motifs that had distinguished Mycenaean art so effectively from the arts of the ancient Near East. We might even be tempted to claim the decoration on the vessel— though not its shape—as Mycenaean, were it not for the swastika meander on its neck, which is unknown in Mycenaean art and therefore most likely derived from Egypt. When, finally, we recognize the "Rhodian" stylization of the palmette-fan filler, it no longer comes as a surprise that the vessel, which is by no means a unique example,[78] was discovered at Kameiros together with the other "Rhodian" ceramics. The vase is, in the main, Mycenaean, combined with the Near Eastern influences that are not uncommon on "Rhodian" art works, but lacking any influence from the Dipylon Style. Except for the absence of figural representation, figure 75 represents the most evident link between Mycenaean and Hellenic art.

[76a] [Ibid., pl. 46.]

[77] The fillers in the lower axils are only vaguely suggested.

[78] The next closest example is the amphora by Salzmann, *Nécropole de Camiros*, pl. 47.

The most advanced example of a continuous tendril in the Rhodian style occurs on a sarcophagus from Klazomenai,[79] which is now in Berlin (fig. 76).[j] Here the floral motifs are not just axil fillers but fully developed *half palmettes*. This would have seemed like a sudden jump into the purest Greek ornament had it not been for the intervening Melian example discussed earlier, which led us straight back to its Mycenaean origins. Each of the spaces created by the undulating line and its spiraling branches is completely filled by one half of a palmette-fan. The fan, however, does not grow out of the inner axil but spreads out concentrically from the spiraling calyx like the Mycenaean model in figure 64. The decoration in figure 77 from the same sarcophagus proves that this is not just wishful thinking, and that the Klazomenian sarcophagus decorators really did think of the half palmette as a distinct motif. It is admittedly a section of the lotus-palmette band in figure 79: in the middle is a lotus flanked on either side by half palmettes that are exactly like those in figure 76.[80, k]

Fig. 76. Painted border from a Klazomenian terra-cotta sarcophagus.

Fig. 77. Painted border from a Klazomenian terra-cotta sarcophagus.

The typical form of the intermittent tendril as it occurs at Mycenae or Melos has never been found in Rhodian art.[l] There is, however, at least one Rhodian example where the rhythmic course usually associated with intermittent tendril is latent in the pattern. Figure 78[81, m] shows a portion of the inside pattern of a plate. The four enclosed palmettes are placed crosswise; four palmette-fans have been inserted as fillers, one in each of the outer axils. The enclosed palmettes point toward the center of the

[79] *Antike Denkmäler*, vol. 1, pl. 46, no. 2, top border.
[80] Compare the motif (pear-shaped lotus blossoms crowned by spirals between two leaflike half palmettes) flanked by sphinxes below the lid of the Klazomenian sarcophagus (*Monumenti inediti* Deutsches Archäologisches Institut, 11 [1879–1883], pl. 53). There the basic formula is related to figure 77, but which is almost baffling in its sophistication. A half palmette crowning its own separate branch is found on a Rhodian pitcher in Berlin. Its unusual quality also struck Furtwängler (*Jahrbuch des Deutschen Archäologischen Instituts* 1 [1886] 139, no. 2939). [A detail of this vessel is also illustrated in P. Jacobsthal, *Ornamente griechischer Vasen. Aufnahmen/Beschreibungen und Untersuchung* (Berlin, 1927), pl.9a.]
[81] From Salzmann, *Nécropole de Camiros*, pl. 33. [Riegl's original citation of this illustration as coming from Salzmann's plate 52 is incorrect.]

Fig. 78. Portion of a painted Rhodian plate from Kameiros.

plate, while the fans filling the axils are oriented toward the outer rim in an arrangement resembling that of the lotus blossoms on the Melian vase in figure 53. Of course, the undulating, flowing stems have been suppressed in the Rhodian example, and that is why it is difficult at first to recognize the intermittent scheme.

Figure 78 gives me the opportunity to discuss another aspect of Rhodian vegetal ornament that has so far received no attention. I have just mentioned the *enclosed palmettes* in regard to figure 78. This is the first time that the term "enclosed palmette" has occurred in our discussion; it is not, however, the first time we have come into contact with the phenomenon.[82] The description of fig. 78 could have easily been put another way: we could have described the pattern as an arcuated band frieze arranged in a circle whose palmettes are oriented toward the outside; in the volute axils where the spirals come together, palmette-fans were inserted that fill the calyx and are oriented toward the center. The curving contour of one motif creates the contour of its neighbor, in a way that is also characteristic of reciprocal ornaments. The direct forerunner of the motif of the enclosed palmette is the decorative band on the Melian example in figure 66, which runs around the belly of the vase directly above the foot (and on the shield depicted on the Rhodian "Euphorbos" plate). In this example, the double spirals are still the most important components, while the blossoms serve merely as fillers; in figure 78, however, the opposite is already the case. Obviously, the overlapping alternation of

[82] The "Phoenician" palmette, where enclosing lines form the calyx, is not related to this phenomenon.

palmettes with profile views of lotus blossoms, as in figure 79[83] from a Klazomenian sarcophagus,[84] goes back to the same roots. It is undoubtedly the very same artistic tendency that all of these experiments share.[n]

Fig. 79. Painted border of a Klazomenian
terra-cotta sarcophagus.

The enclosed palmette was used frequently in later ornament up through the Romanesque period. It is therefore important to find out when and how it first came into being. This seems to have taken place even before the date of the Klazomenian sarcophagi. The egg-and-dart cyma on one example already appears in its typical form;[84a] the vegetal character, recalling the original row of lotus buds, is already completely obscured. Was the enclosed palmette invented in the Mycenaean era, as Goodyear seems to assume on plate 55, number 7, when he refers to examples illustrated by Furtwängler and Loeschke?[84b] At any rate, we find Rhodian art going through the same process once again with bands of lotus- palmettes newly introduced from the Near East. It was a process that also contained the seeds of the development that would subsequently take place in Corinthianizing Attic art, as already noted by Holwerda.[85] This circumstance also increases the importance of Rhodian art for the further development of Greek vegetal ornament. Centralized compositions of vegetal motifs similar to the one in figure 78 can already be found in the arts of the ancient Near East, for example in Assyria (fig. 34); the well- known star found in Kameiros, made up of four lotus buds and four palmette-fans, is still closely connected to the ancient Near Eastern versions.[86] However, it was not until spirals came to be used routinely and with complete freedom for forming calyces, and not until blossom motifs were emancipated from mere fillers into independent ornaments, that the

[83] Figure 77, as already mentioned, is only a section of figure 79.
[84] *Monumenti inediti* 11 (1879–1883), pl. 54.
[84a] [*Antike Denkmäler* Deutsches Archäologisches Institut, 1 (Berlin, 1886), pl. 44.]
[84b] [Goodyear, *The Grammar of the Lotus. A New History of Classic Ornament As a Development of Sun Worship* (London, 1891), pl. 55, no. 7; Furtwängler and Loeschke, *Mykenische Vasen*, 49, pl. 28.]
[85] Holwerda, *Jahrbuch des Deutschen Archäologischen Instituts* 5 (1890): 263.
[86] Salzmann, *Nécropole de Camiros*, pl. 2.

shifting and overlapping of alternating lotus blossoms and palmettes could take place. So far as we can determine at present, Rhodian art first attained this stage of development.[87, o]

5. Early Boeotian and Early Attic

The examination of Melian and Rhodian vases enabled us to follow the historical development of vegetal ornament a step beyond the stage attained by Mycenaean art. We learned in particular that the blossom motifs and their connective structure in Rhodian style provided the point of departure for the indisputably Greek development that came next. Now I would like to depart briefly from the task of disentangling this continuing historical process to discuss a few other groups of monuments. These, although they did not play an essential or leading role in the development of Greek vegetal ornament, do possess certain characteristics that facilitate an even better understanding of the process underway, and an even better opportunity to test the validity of the evolutionary sequence presented thus far.

This is especially true of the Boeotian vases described by Böhlau.[87a] Indeed their study will show that at least one example from this group of vases documents yet another advance of considerable importance. Böhlau considered these vases to be the product of a local, isolated phenomenon, and he is probably correct.[a] This does not mean, however, that aside from the geometric decoration highlighted by Böhlau, there is no vegetal decoration worth examining; even Böhlau[88] recognized the "lively plantlike" character of the ornament, at least in regard to the palmette. I would only like to mention in passing the band of lotus blossom and bud motifs illustrated by Böhlau in his figure 14 (338), a pattern he inexplicably mistook for an undulating band in the Mycenaean manner; I would also note the individual flowers on curving stems of Mycenaean type that include both lotus profiles with three pointed leaves and palmettes, which are already completely Greek.[89] But what is most important here for our

[87] The bowl from Kameiros illustrated by Salzmann (pl. 33) is an instructive experiment and surely only one among many less successful attempts. The volute-calyces have been appropriately adapted in a spiral form to accommodate an equal number of palmettes. The painter, however, had trouble filling the intervening spaces: the first two lotus blossoms are fine, but the third intervening space is so narrow that he had to make do with a bud. The solution in figure 78 is classic in comparison.

[87a] [J. Böhlau, "Böotische Vasen," *Jahrbuch des Deutschen Archäologischen Instituts* 3 (1888): 325–61.]

[88] Ibid., 359.

[89] Ibid., fig. 10.

investigation is the occurrence of no fewer than three instances of the continuous tendril.

The border of the kylix in figure 80 is the first example.[90] The undulating tendril rambles along effortlessly and confidently around the edge of the vessel. Floral fillers, which are just barely able to compete with the meandering spirals, are inserted into the axils in the Egyptian manner and do not yet resemble the Klazomenian half palmettes. Böhlau agreed that the floral axil fillers with hemispherical contours at least still reflect the type of palmettes in the Mycenaean vase style defined by Furtwängler and Loeschke, and he noted that the Boeotian motif is also similar to the one on the potsherd from Thera in figure 50. I think that here the axilar flowers with small circles along their edge should be included as well.[b]

Fig. 80. Boeotian kylix.

The second example of a continuous tendril is also illustrated by Böhlau.[90a] In this case the axil fillers are drop shaped, resembling those on the Mycenaean pectoral in figure 60; they fade even more into the background of their accompanying spirals than those in figure 80. The only other noteworthy detail is the binding that fastens each of the branching spirals at their point of inception on the continuous tendril.

Immediately following this Böhlau illustrated the third example of a continuous tendril (our fig. 81), although he himself did not recognize it as

[90] Ibid., 333, fig. 5.
[90a] [Ibid., 335, fig. 7.]

such.[90b] We will begin our analysis on the left-hand side of the middle register. There we see a stem rising from the groundline to the upper edge where it bends over and splits into two spirals held together by a binding and forming the calyx of a palmette-fan. The spiral curling off to the right then splits off into another spiral offshoot that curls downward; together they form a calyx, filled only by a thorn because of spatial limitations. Finally, this last spiral offshoot emits yet another that coils upward to the right; together they form the calyx for a palmette exactly like the first one. If we ignore the flowers for a moment, we have no difficulty recognizing the same basic pattern seen in figures 80 and 50.

Fig. 81. Boeotian kylix.

Why did Böhlau not immediately recognize the continuous tendril in figure 81? He may perhaps have been misled by the abbreviated form of the tendril, but it was more likely the larger size of the palmette-fans compared to the spiral calyces. In figure 80 and even more so in the second of Böhlau's examples, the spiral calyces run clearly and dominantly around the dish, those of figure 81 have in contrast receded behind the axilar palmettes. In other words: the palmettes are becoming the main component of the motif; the spiraling tendrils are reduced to minor incidental connecting elements. And while the motif of the continuous tendril in itself is still tied to the Mycenaean past, it is the tendency manifested in figure 81 that points to the future.

Figure 81 is also significant for the development of Greek vegetal and tendril ornament from another point of view; it represents the first instance where the undulating tendril has left the confines of the narrow

[90b] [Ibid., 335, fig. 8.]

border strip to wander freely as an independent branch.[91] This was the ultimate goal of Greek tendril ornament: the free unwinding of undulating lines over any kind of surface, not just within a long, narrow strip. So while the undulating tendril branch in figure 81, may not be beautifully executed, it is in this respect far more important historically than the one in figure 75, which we had praised earlier. The Rhodian example of figure 75 represents the formal perfection of a motif invented by the Mycenaeans and the final, most formally beautiful stage in the development of a motif that was still constrained by the idea of the border or frieze. The tendril branch in figure 81, on the other hand, has broken through the traditional boundaries and set out in a new and fruitful direction, but who would expect it to attain the solution on the very first attempt?

I would now like to jump ahead in the chronology and discuss a later example of Boeotian vase ornament, because I think it will help to explain the frequent occurrence of the continuous tendril in Archaic Boeotian art. A number of potsherds were found during the excavation of the sanctuary of the Kabeiroi at Thebes, and it is striking how most of them are decorated with the continuous tendril (fig. 82).[92] Winnefeld has proven that the

Fig. 82. Ivy-tendril border from a later Boeotian vase.

vases were of local Boeotian production and do not go back further than the fourth century.[c] Several centuries, therefore, separate the Archaic Boeotian vases, which Böhlau dated to the seventh century, from the Kabeiric potsherds, during which time the continuous tendril came to be used routinely in Greek decorative borders. All the same, what appears odd about the Kabeiric vases is their exclusive preference for the continuous scheme, the overwhelming predominance of so-called ivy leaves of the kind that had been widespread in Mycenaean art and the absence, as Winnefeld put it, of the "ornamental motifs that occur most frequently in

[91] Mycenaean art, as well as most of the Archaic Greek styles (including the Boeotian style discussed here), was, as we have seen, already familiar with tendril branches. It is the undulating tendril branch that we are seeing here for the first time; admittedly, there may be a Mycenaean precedent for this in figure 49.

[92] From H. Winnefeld, "Die Kabirenheiligtum bei Theben. 3, Die Vasenfunde," *Athenische Mitteilungen* 13 (1888): 418, fig. 6.

the other vase categories, e.g., meanders, palmettes, bands, egg-and-dart motifs, and stars."[92a] If we add to this the decided Mycenaean tendency expressed, for example, in the curved stems of the ivy leaves winding alongside the undulating line, it begins to look as though this local Boeotian vase decoration represents very ancient traditions relatively unaffected by the influence of Attic pottery or the predominently Attic artistic mode that became commonly accepted among the Greeks up until the time of Alexander the Great.

In regard to what has already been said about the *ivy leaf*, I would like to clarify once again the sense of this term to avoid any misunderstanding. It has no more to do with an actual ivy leaf than the term "palmette" has to do with a palm tree.[d] These are simply ways of designating certain decorative art forms where we have no idea of what the artists themselves originally had in mind. This does not mean, of course, that artists never had the actual ivy plant in mind, as they surely did in the naturalizing post-Alexandrian period. The ivy leaf is found in Egypt and in Mycenae; we encounter it on the so-called Chalcidian vases and here in Boeotia in the fourth century. In the last two cases, the motif might have had the same meaning, since the geographic proximity of the two areas is so close, but what did it mean in Mycenae or even in Egypt? This is why I shall never be convinced that the leaves in Winnefeld's figure 7 specifically refer to the botanical species *tamus cretica*. I see them as products of the purely stylistic development of "ivy leaves." Winnefeld's figure 9, of course, illustrates what are clearly vine leaves and grapes, for by this point we have already entered upon a naturalizing phase of decorative art. This is mainly characteristic of the Hellenistic period, but the tendency had been growing perceptibly and steadily ever since the Peloponnesian Wars and the appearance of the acanthus motif. Of course, it had always been accompanied at the same time by a stylizing tendency that, for example, could create five-pointed vine leaves.[93] It was this tendency that once again attained a decisive superiority in the Near East during the Late Roman period, where it had in fact never forfeited its power fully during the intervening centuries.

The Early Attic vases also studied by Böhlau[93a] lag behind Melian examples in the development of vegetal ornament. The palmette is by no

[92a] [Ibid., 420.]

[93] On an Etruscan mirror (A. Brückner, "Zum Grabstein des Metrodoros aus Chios," *Athenische Mitteilungen* 13 [1888]: 365, n. 4). [Without illustrations; for an illustration see E. Gerhard, A. Klügman, and G. Körte, *Etruskische Spiegel* (Berlin, 1840–1897), pl. 327.]

[93a] [J. Böhlau, "Frühattische Vasen," *Jahrbuch des Deutschen Archäologischen Instituts* 2 (1887): 33–66.]

means as developed as it was in Melian art. The palmettes on the vase in Böhlau's plate 3 have loosely arranged fans with corncoblike leaves but without spiraling volutes; plate 4, on the other hand, does have volutes, but they are combined with a tightly closed fan of globular leaves. Even the enclosed palmettes on plate 5 are less advanced than those in our figure 66. The hydria illustrated by Böhlau on his page 53, figure 15, has a row of budlike motifs on an angular arcuated frieze, apparently the remains of a band of lotus flowers and buds; in any case, it has no bearing on the development. Böhlau's figure 23 (57), on the other hand, has two double spirals, each curved in the shape of a figure eight, which terminate in palmettes of apparently typical Greek form; the axils between them are filled with palmette-fans. That might seem like something that could transcend even the kind of free treatment of tendrils we associate with Rhodian art were it not for the fact, also noted by Böhlau, that this is the only example of its kind within this category of vases. The motif should not be placed any earlier in development than the Early Attic vase in figure 83 which, as we shall soon see, second marks the beginning of an entirely original new development in vegetal tendril ornament.[e]

6. The Interlacing Tendril

Vessels are currently the main source of information for reconstructing the historical development of vegetal ornament in the earlier Greek period. Ceramic vases comprise the vast majority; metal bowls come second. As I will never tire of saying, there is no essential significance in the choice of material. The motifs themselves, the lotus or the guilloche, were already established before they were painted on clay or engraved in metal. A far more serious obstacle to our understanding of the development of ornament at this time arises from our reliance almost exclusively upon such vessels as a source of information. For, already in the Archaic period, the purely ornamental, nonobjective decoration on these vases begins to give way to figurative representations inspired by the heroic myths of gods and heroes.[94]

The restriction of decoration to bands of registers could not long endure

[94] The source of this driving tendency in Greek art is very difficult to determine at present. It was already undoubtedly present in Mycenaean art (see chapter 3B.1 above), where, as the preceding discussion has sufficiently shown, so many of the productive and fundamental seeds of later Hellenism originated. Dipylon vases are also frequently decorated with figurative scenes: were they a result of Mycenaean influence? And even Near Eastern artists did not exclude figurative compositions from their applied arts as a matter of principle; one need only recall their metal bowls.

under these circumstances. Almost inherently, the figurative scenes continued to appropriate more space, while the animal friezes and finally the geometric and vegetal decoration became progressively restricted. The discernible striving of the tendril ornament on Rhodian vases to spread out across the surface clashed with the similar propensity of the figurative scenes. The tendrils could not unfold freely over larger areas of the vases, because these fields were already occupied by the figurative images. How then did vegetal ornament fare in other media?

Among the other objects available, such as small articles of jewelry in precious metals, the development of the ornament runs completely parallel to that on the vases. It is possible that wall painting gave vegetal ornament freer rein in the period just before the Persian Wars, as it did later in the Hellenistic period, but nothing of the sort has survived. Such a conjecture is not at all outlandish, however, considering how eagerly the tendril ornaments overrun those areas, even on vases, where they are still allowed a certain measure of freedom—on or under the handles. The vegetal tendril ornament on the vases available for study is mainly confined to long and narrow bands or borders. It is, however, from this more restricted format and not from the unbounded fields that the subsequent development took its point of departure.

The next significant aspect in the history of vegetal ornament was the inability of the continuous and the intermittent tendril schemes in their simpler Mycenaean form to satisfy the decorative sensibility struggling to evolve. Figure 83 is a detail from a bowl of Early Attic origin found at Aegina.[95] An amphora found at Athens[95a] has precisely the same pattern.[a] The ornament as a whole is comprised of blossom motifs and strands of tendrils. We will first focus on the blossoms alone.

There are two kinds of motifs: the lotus blossoms, which are distinguished by their widely divergent lateral leaves, and the palmettes or, to be more precise, the palmette-fans. The lotus blossoms are evidently the larger and more important motifs; the palmettes are not only smaller in size, but they apparently lack the volute-calyces that are indispensible in the complete version of the motif. The crowns of both the lotus blossoms and the palmettes are oriented alternately up and down in an arrangement that in itself suggests the familiar rhythm of the intermittent tendril. In order to be certain of this, however, we must examine how the motifs are connected.

[95] A. Fürtwängler, "Schussel von Aegina," *Archäologische Zeitung* 40 (1882), pl. 10, top. [Riegl's original citation of this reference as *Archäologische Zeitschrift* is incorrect.]
[95a] [*Antike Denkmäler*, Deutsches Archäologisches Institut, 1 (Berlin, 1886), pl. 46.]

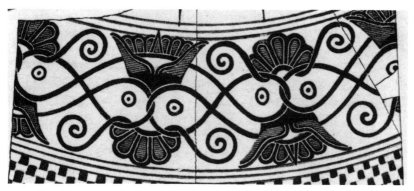

Fig. 83. Interlacing tendril on an Attic bowl from Aegina.

This appears to be accomplished by interlacing, loop-shaped running, linear tendrils. Wherever two loops interlace, there is always a lotus blossom on one side and a palmette on the other. The loops replace the spirals of a volute-calyx, i.e., they function as calyces for the floral motifs above them. When we eliminate the linear tendrils, which lace through the lotus blossoms, dividing them in half, and also the spirals which emerge from either side of the palmettes purely as space fillers, what remains is the bare scheme of the intermittent tendril connecting lotus blossoms on its high and low points. The palmettes are really only accessories; they merely fill the axils of the calyces formed by the tendrils.

The accuracy of this description of the motif is even more striking in figure 84, which was taken from a small bronze plate in the Berlin Antiquarium.[96, b] Here is a clear instance of the basic intermittent scheme: the lotus blossoms, their orientation alternating up and down, are arranged very simply on stems converging from either side without

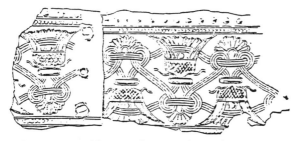

Fig. 84. Decorated bronze plaque in the Berlin Antiquarium.

[96] A. Furtwängler, "Erwerbungen der Königlichen Museen zu Berlin 1890," *Archäologischer Anzeiger* (1891) 125, fig. 12 e.

any intervening spiral volutes or looped calyces; the loops formed by the stems just before they connect to the lotus blossoms are decorative elaborations that clearly reveal the purpose behind the whole motif. The bands that pass through the middle of the lotus blossoms are no longer a source of confusion, since they do not interlace with the intermittent undulating line as they did in figure 83 but run their own separate course above and below. Finally, there is no longer any question that the palmettes are meant to serve merely as axil fillers.

We have now noted two important characteristics of this kind of motif: first, the alternating orientation of the pairs of lotus blossoms and palmette-fan fillers; second, the elaboration of the connecting undulating linear tendrils into loops, which can be grouped with other bands serving only as additional and entirely superfluous elaborations. There is nothing essentially new in this pairing of lotus blossoms and palmettes in alternating directions, known in the prevailing terminology as *opposed lotus blossoms and palmettes*. It occurred first on the Melian example in figure 53, which is essentially the same basic motif, except that the axils are occupied simply by conical elements instead of palmette-fans.

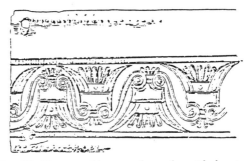

Fig. 85. Decorated bronze plaque from Thebes in
the Berlin Antiquarium.

The detail in figure 85, from a bronze plaque[97] found at Thebes but now in Berlin, will make it easier to understand the situation. It represents a stage midway between the Melian example (fig. 53) and the Early Attic and Theban examples (figs. 83 and 84).[98] The conclusion of this develop-

[97] Ibid., 124, fig. 12 a.
[98] Where the undulating tendril lines converge beneath the lotus bases to form the calyx, they wind around eyes, which helps to explain the circles replacing most of the volute-calyces in figure 53 [One may also compare H. von Brunn and T. Lau, *Die griechischen Vasen, ihr Formen- und Dekorationssystem* [Leipzig, 1879], pl. 8, nos. 1, 5, and then pl. 11, nos. 6–7, which are more evolved.]

ment and that of Attic ornament came in the fifth century, in the rejection of exuberant Archaic ornateness in favor of a limited repertory of simplified, purely ornamental motifs whose representation and consummate form stemmed undoubtedly from the unrestricted dictates of formal beauty. Figure 86 is an example of an intermittent tendril with *opposed* lotus blossoms and palmettes devoid of any spiraling, interlacing, or volute-calyces, although it is not yet representative of the freest of styles.[98a]

Fig. 86. Painted border decoration from a Greek vase.

Let us return to figure 83. The only innovative aspect, as we have seen, is the looped arrangement of the intermittent undulating lines as a continuous running band. This was made possible by the structure of the loops, whose constant interlacement formed the calyces for the applied blossom motifs. We traced the appearance of this motif back to a decorative urge for a greater elaboration of tendril ornament within the confines of the narrow border, since it appeared to develop straight from the intermittent tendril, as figure 84 more than adequately demonstrates. This is not the first time, however, that someone has sought an explanation for the motif. Its obvious connection to the *opposed* lotus-palmette band had already caught the attention of several scholars. Holwerda's study is the most decisive and convincing statement on the subject.[98b]

It goes without saying that Holwerda's interpretation necessarily involves some kind of technique. This time the choice was metalwork. "The interlacing loops were an exact imitation of woven wire metalwork whose

[98a] [Ibid., pl. 11, no. 8.]
[98b] [Holwerda, "Korinthisch–attische Vasen," *Jahrbuch des Deutschen Archäologischen Instituts* 5 (1890): 239–40.]

arrangement is still readily discernible. It was this very artfully" (indeed!) "devised network created by a single metal wire, whose two terminations converged whenever the ornament was placed around an object, which could as a whole accommodate in its windings all of the various elements of the ornament."[98c] He goes on to assume that the blossom motifs were cut from sheet metal and soldered onto the wire. I will not deny that at some time during all of those centuries a Near Eastern goldsmith may have fabricated embossed metal lotus blossoms and palmettes and then soldered coiling tendrils on top of them in the filigree technique. But the unusual technical process described by Holwerda must first be documented, and in any case, the idea that a specific ornamental motif could have emerged from such a source can hardly be taken seriously, even by those who are completely convinced of the technical-materialist origin of primeval motifs in general.

I chose this interpretation from among the countless others that rely on the techniques of metalwork, weaving, carving, and so forth to explain the earlier Greek ornamental forms, because it illustrates so well how scholars who have made indisputable contributions to the field of classical archaeology can become lost in the most abstruse deductions the moment they start out in search of techniques. It would vastly exceed the limits of this book if I tried to consider all of the "technical" explanations for the motifs that have been concocted thus far. However, now that I have gone into more detail in this particular instance, I would like to linger a bit and present another "technical" parallel that might prove more acceptable to the disciples of the technical-materialist theory (even though I do not count myself among them) than the one attempted by Holwerda.

Figure 87 shows a corner of a vest worn by one of the petty bourgeois from a southern Dalmatian city. The material is blue fabric; the embroidery is executed in gold and silver cording placed on the material and tacked down. What immediately catches the archaeologist's attention is the decoration in the upper half that moves off toward the narrow end, for it is nothing less than the lively "opposed" lotus-palmette band, in which even the band itself that winds its way around the motifs recalls that in figure 83. The embroidery was technically executed in the same way as Holwerda's interlacing wires; a specific ornament was drawn on the surface with a continuous thread. The experienced embroiderer is adept at placing the threads so that there are no awkward transitions between one motif and another. The piece in figure 87 is not particularly well done, but

[98c] [Ibid.]

Fig. 87. Dalmatian corded embroidery from Ragusa, Yugoslavia.

this is an exception, because most of the corded embroideries from the Balkan Peninsula are exquisitely designed and expertly executed. The area where they are made extends beyond the Balkan Peninsula and includes the Greek islands and parts of Asia Minor up to Syria. The ornaments are limited in number and idiosyncratic: in those from the Balkan Peninsula the specific Islamic veneer recedes while the autochthonous Byzantine or, one might say antique quality becomes stronger. Consequently, I have no qualms about considering the embroidery patterns in figure 87 as descendants of the Archaic lotus-palmette band. Aside from this, the most widespread border ornaments on the Balkans are the continuous running spirals that roll up into circles and then wind out again from their centers, in complete conformity with the Mycenaean example in figure 59. Balkan ornament is not at all surprising from a historical perspective. There was strong inducement for this corded embroidery to adhere tenaciously to those patterns, which, apart from the simple undulating line, were obviously best suited to border decorations in the corded technique. Nevertheless, it is not inconceivable that the simple spiral motif was reintroduced from an outside source where it had remained in use. The motif in figure 87 is extremely unusual since it never occurred again with such stylization or individuality in the wider sphere of Greek art after the Archaic period; nor was it used in Roman times. The motif does not occur in the Italian Renaissance, which is known to have strongly influenced the Balkan coast by way of Venice; it cannot even be found in

the French Empire, which delighted in the rediscovery of Archaic Greek forms. It could only have survived unchanged for so many millennia in folk art, and this is least improbable in Epirus [Dalmatia]. Moreover, the standard Greek palmette and the rigorous handling of the tendrils also play the main role in the silver inlaid wood, which, for example, is still produced in Bosnia to the present day.

What bearing does this all have on the Early Attic pattern in figure 83? We have just finished examining a closely related pattern that is not executed in a "metal technique" but rather in a "textile technique." And whereas Holwerda's idea about wires soldered onto a piece of sheet metal is totally unfounded, we now have concrete evidence that, at least in more recent times, interlaced patterns with opposed blossoms were embroidered. Would it be so outlandish to assume that the Greeks also did corded embroidery? How else can the running-dog patterns that adorn the hems of himations and chitons in vase painting be explained? According to the antique Egyptian and South Russian finds, of course, the scattered patterns, animal figures, and so forth that decorate garments were mostly woven; is there any reason, however, that the running-dog patterns on hems could not have been executed in corded embroidery like the spiraling borders of the Albanian vests of today? Then there would at least be a halfway palpable intermediary between the fully developed ornament and its alleged technique.

Notwithstanding, I find this sort of conclusion still much too speculative, and I consider it thoroughly false and erroneous. The pattern executed in corded embroidery is also dependent on the artistic conception of the human being who executes it. The threads did not fall into loops simply of their own accord. Archaic artists worked like those of today, beginning with a preparatory drawing of the finished object in its linear contour and plastic articulation, regardless of the material.

The basis of their creative activity was graphic, and from this perspective, it was obviously much more natural for them to paint on clay or engrave the interlacing tendrils known to them from their own traditions or from imported objects than it would have been to solder wires or to arrange cords on clothing fabric. If we were absolutely compelled to choose a technique, then it would have to be painting, drawing with a brush, incising with a stylus, and the like. However, neither the brush nor the stylus can create something by themselves; they must be controlled by the human hand, and the hand in turn by artistic inspiration, which has the irresistible urge to create something new out of inherited traditions and the mind's perception.[c]

However, the motif of interlacing tendril bands with axil filling blossoms was not limited only to long and narrow, continuous registers; it was also used to form self-contained compositions. This kind of motif is especially characteristic of the so-called Chalcidian vases, of which figure 88 is an example.[99, d] The tendril bands initiate from a fixed central point, twist around, sometimes aided by bindings, and then diverge above and below. In the upper register, they terminate in so-called ivy leaves; in the lower part, they are interrupted by similar leaves and then run into spiral calyces. These in turn are filled with palmette-fans; a bird perches on each fan.

In actuality, therefore, we have before us an interlace of regularly undulating tendrils with palmette-fans in their axils. The similarity with figure 83 is striking: the only difference being that figure 83 was conceived essentially as a structurally continuous border pattern, while figure 88 was

Fig. 88. Chalcidian amphora.

[99] K. Masner, *Die Sammlung antiker Vasen und Terracotten in k.k. Österreichischen Museen. Katalog und historische Einleitung* (Vienna, 1892), pl. 3, no. 219.

created as a self-contained composition filling up a closed field. The transition from figure 83 to figure 88 is most clearly expressed where the ivy leaf interrupts the tendril.

The reason that this motif has received so much undeserved attention has to do with the animal figures symmetrically arranged to either side. In the upper half of figure 88, there are two affronted lions; below, a lion and a panther back-to-back; finally, the birds already mentioned are turned toward each other, but with their heads averted, resulting in a rich play of reversing rhythms. This is the scheme of the "Heraldic Style." What we have already said about its alleged origin in textiles is contained in chapter 2. Aside from this, the whole motif is also thought to have been imported from the Near East in the wake of the notorious Persian-Oriental textile art. No one would deny the Near Eastern quality of the animals; this is evident in the species as well as in the placement of the animal's paw on a palmette. The scheme, however, had already occurred in the art of the Greek region before the origin of the Chalcidian and related vases. The Melian example in figure 66 has it on the neck and belly and, moreover, without any Oriental beasts but with spiraling tendril patterns that even Holwerda[100] admits are not Assyrian. Is the interlacing tendril in figure 88 not perhaps related to Near Eastern models?[e]

A number of suggestions have been made in this respect. Let us begin with the Assyrian "sacred tree" as a possible point of departure, since it seems closely related because of the animals. The sacred tree is also trimmed with palmettes, and its branches are often held together by bindings. But there the analogy stops. The sacred tree grows from a lower base just as a tree grows from its roots; the Chalcidian interlacing tendrils, on the other hand, are clustered round a central point. The sacred tree is a cross between a tree and a piece of furniture, while the Chalcidian interlacing tendrils have nothing in common with either. They are simply an interlace of delightfully curved lines responding to purely decorative principles. The Assyrian palmettes are, moreover, not only different in detail; they are also each separately attached to the tree, like fruit. In figure 88, on the other hand, most of the palmettes serve plainly as axil fillers. There are even fewer parallels with the Phoenician palmette-tree, which consists of calyces stacked one above the other, vertically oriented the way a tree grows, whereas the Chalcidian tendrils in figure 88 do not emphasize any direction at all.[f]

Analogies for the interlacing pattern are found more readily on Egyptian soil, for example, on the ceilings reproduced by Prisse d'Avennes

[100] Holwerda, *Jahrbuch des Deutschen Archäologischen Instituts*, 5 (1890): 238.

(fig. 27). The basic pattern is formed by narrow bands and cords that usually coil into spirals, but they are also frequently interlaced. In addition, the axil filling lotus flower plays a decisive role. Here there are indeed no direct parallels for the Chalcidian pattern; however, I do not want to discount completely the possibility that these painted Egyptian ceiling patterns influenced the Chalcidian interlacing tendrils more generally.[101] The spirit of the execution, however, is Greek; the tendrils are Greek; the blossom motifs have been translated into Greek.[g]

The pattern we have been discussing has always been termed Chalcidian; its use, however, actually extends beyond this category of vases. Figure 88 represents the basic type; the pattern occurs in numerous variations. In fact, it is even found arranged in rows as a border pattern, for example on a Proto-Corinthian ointment jar, though not terribly well.[101a] This was an active, enterprising period, ready to try its skill at the most varied combinations.[h]

The Chalcidian interlacing tendril is historically significant because it represents the first instance where tendrils served as a basic pattern used to fill a neutral field.[i] In the Mycenaean style this was the case only with spirals; the tendrils were confined within border strips. The Melian vases represent the preliminary stages of what we find in figure 88.[102] Similar attempts had already been made with tendril branches in Rhodian (fig. 70) and Boeotian (fig. 81) art as well. The Chalcidian solution, however, is the most advanced thus far and leads directly to the subsequent development, as we shall see.

Of course, the interlacing tendrils had no chance of sustaining the prominence that they had enjoyed on Chalcidian vases. Their role, as we have seen, was actually to provide a central fill between flanking animal friezes. As figurative compositions came increasingly to dominate vase decoration in keeping with the artistic tendency of the period, the animal friezes were restricted, and as a result, the interlacing tendrils became superfluous. However, there was still one place left on vases beyond the reach of the figurative scenes, where pure ornament could therefore find refuge—the area around and beneath the handles. It was here that tendril ornament continued its development, at least on vases, which are unfortunately the only material available for study. As we shall see, it begins with centralized interlacing tendrils; the tendrils then become

[101] This could also be true of the interlacing bands that penetrate the lotus blossoms in figures 83–84, since they do not belong to the basic intermittent scheme.

[101a] [A. Furtwängler, "Kentaurenkampf und Löwenjagd auf zwei archaischen Lekythen," *Archäologische Zeitung* 41 (1883), pl. 10, no. 1.]

[102] Fig. 66; see the earlier discussion.

increasingly refined, while the blossoms are increasingly emancipated until they are transformed from incidental axil fillers into fully independent motifs.

I will not waste any time on the small, symmetrical tendril ornaments that often replace the complicated Chalcidian scheme as a central divider between opposing pairs of animals,[103] since they are hardly more advanced in the historical development than the Rhodian tendril fillers in figure 70. All of them are based on the symmetrical arrangement of two short tangent, curved tendrils whose axils are filled either with lotuses or palmettes, or both in opposition.

However, before we consider how tendrils managed to escape their resemblance to continuous geometric spirals and to spread out unimpeded over surfaces of all sizes, following only their own momentum, we shall first examine how they evolved within the narrow confines of the continuous border.

7. The Development of the Tendril Frieze

The earliest means of connecting ornamental vegetal motifs—the arcuated band frieze, attested since the Thutmosid period [Eighteenth Dynasty], also remained current in Greek art. It is one of those enduring forms to which the decorative arts constantly have recourse. Figure 89 illustrates a so-called *Cyrenean* [Lakonian] kylix that has an arcuated frieze extending between the handles in the middle register.[a] The individual motifs, which alternate in the Egyptian manner, are piriform blossoms

Fig. 89. Lakonian kylix.

[103] For example, Brunn and Lau, *Griechischen Vasen*, pl. 8, no. 6.

with three-pronged crowns and simple buds. As a whole, the scheme recalls Egyptian (and generally Near Eastern) examples; the details, however, deviate in a number of ways. The thick stems of the Near Eastern prototypes (figs. 22, 23), which still occur on Rhodian vases (fig. 73), have been replaced by fine, elastically curving tendril lines that we can without reservation ascribe to the Greek decorative spirit. The little bindings were, of course, already a feature of the earlier models, while the dots punctuating the arcuated fields are analogous to the rosettes used in Egyptian art in the same place and for the same purpose (fig. 22, where, however, the rosettes and other fillers were omitted in order to stress the underlying basic scheme). Fundamental departures are also evident on the individual vegetal components, in particular on the blossoms.

I would now like to interject a few words about the way in which Greek art generally transformed the blossom motifs from the Near East, or Egypt, to be more specific. There was, of course, not much change in the bud. The palmette, on the other hand, because it is such a unique combination of views, requires a separate treatment of its own, which we shall save for later. For the moment, we are interested only in the lotus blossom itself. If we do not assume that all of the Mediterranean peoples artistically active in antiquity spontaneously chose or invented the three-leafed profile used to represent flowers in side view, then we are compelled to trace the origin of all these forms either directly or indirectly to Egypt. On the evidence of the earliest monuments, the Egyptians were the very first to create and use three-petalled calyces filled with multipetalled crowns for the profile view of the lotus.

We can no longer determine the degree to which the Mediterranean peoples who first adopted the motif of the three-leafed profile lotus were aware of its significance; or the extent to which they may have ascribed such meaning to their own imitations of the motif. We can be certain, however, that by the sixth century, there were no such associations left in Greek art. The lotus blossom was obviously no longer a hieratic symbol but a purely decorative motif; had it some kind of symbolic significance, we would surely have found some reference to it in the literature. Therefore, by this time the stylization of lotus blossoms was evolving according to artistic considerations alone, of which there were quite a number of possibilities. Once the tradition was broken, there was no longer any reluctance about modifying the customary forms, and there were no longer any limits imposed upon the new variations. What is astounding, however, is that the Greeks, at least initially, were very restrained in transforming the traditional motifs.[b]

The blossoms of the arcuated frieze in figure 89 represent one such variation. There is no mistaking the striking similarity of the three-pronged blossoms to Egyptian lotus profiles. The Cyrenean [Lakonian] lotus narrows to a point at the top; there is, of course, a certain amount of precedence for this in Egyptian art (fig. 37), but whereas the Egyptian motif opens up again into a typical calycal form, the piriform Cyrenean [Lakonian] blossom first tapers down to a narrow neck and then shoots out the three crowning leaves like rays. Let us compare these lotus blossoms with the ones in figures 83 and 85. At first, they don't seem to have anything in common, but nevertheless the basic underlying motif is the same. It is just that the middle leaf of the three calycal leaves in figures 83 and 85 is not clearly accentuated but grouped within the leaves forming the crown; otherwise, the calycal leaves slanting out on either side conform very closely to Egyptian prototypes.[c]

There is also a great difference in the way the lower parts are treated in both cases: the bottom of the motif in figure 89 is rounded into a droplet shape, while the lower parts of the blossoms in figures 83 and 85 are articulated as double arches. This is because the details in figures 83 and 85 are associated with looped or volute-calyces, while the blossom in figure 89 has no calyx. The volute-calyx is, as things now stand, not an absolutely essential component of the lotus blossom: we saw its first humble appearance in Assyrian art (fig. 34), but then especially on Greek examples, where it flourished under the influence of spiral tendril ornament. Wherever the Greek lotus profile occurs in conjunction with a calyx, the lower part is appropriately shaped to accommodate it;[104] when the calyx is omitted, however, the lower part of the blossom is rounded off and sometimes even swells out into bulbous convex forms (figs. 104–6).

Within the historical development of ornament, all of the many varieties of lotus profiles are very narrowly related to one another. That does not necessarily mean that the Greeks never had a particular species of flower in mind. Even if they did, however, it would now be difficult, if not impossible, to determine this precisely, just as it is with the flora used in more recent Persian decoration. Dümmler, for example, may be justified when he terms one of the variations of the three-pronged blossoms a rose,[105] but art historians are undoubtedly correct when they call the same blossom the *lotus in profile view*. The term may have nothing to do with

[104] For example, on Attic cyma moldings (*Antike Denkmäler*, Deutsches Archäologisches Institut, 1 (Berlin, 1886), pl. 50). Compare our figure 98.

[105] F. Dümmler, "Vasenscherben aus Kyme in Aeolis," *Römische Mitteilungen* 3 (1888): 161, and pl. 6.

whatever meaning the Greeks ascribed to the motif, but it no doubt most accurately reflects its art historical position.[d]

After these general comments about the free adaptation of the lotus blossom in Greek art, we can resume our examination of how vegetal forms evolved within the narrow border or frieze and return to the one mode of connection mentioned thus far: the arcuated band frieze. One of its more lively variations, familiar from Assyrian, and then later from Cypriote art, consists of two overlapping arcuated friezes. The Greek spirit is further evident in the arcuated lines—particularly on simple bud friezes (fig. 90)[106]—that also spring over the buds from point to point, so that both rows of arcs balance one another and eliminate the one-sided orientation of the motif.[e]

The guilloche provided a second scheme for connecting vegetal motifs within a narrow band (fig. 91).[107, f] This scheme is already fully developed on the sarcophagi from Klazomenai (fig. 92),[108] though it is still in a stage where the guilloche itself dominates the composition and the palmette-

Fig. 90. Painted ornaments from Attic black-figure vases.

Fig. 91. Painted ornaments from Attic black-figure vases.

Fig. 92. Painted border of a Klazomenian terra-cotta sarcophagus.

[106] It is, however, also possible that the individual elements [buds] were really thought of as blossoms whose crowning lateral leaves run directly into the connecting arches.

[107] This is also a good example of a variation on the profile view of the lotus.

[108] *Antike Denkmäler* 1 (1886), pl. 45.

fans are incidental axil fillers. In figure 91, on the other hand, the guilloche has dwindled away to a minor component, while the blossom motifs have grown to major proportions and no longer serve as mere axil fillers. This emerges very clearly in the fact that not all of the outer axils of the guilloche are filled with a blossom, but only every other one. The idea of placing a lotus or a palmette-fan on two loops instead of on a volute-calyx was, of course, not unusual, as figures 83 and 84 remind us.[g]

A third means of arranging rows of separate vegetal motifs in a frieze is the simple straight line referred to as the *leafy branch*. In the earlier period, the branches were usually trimmed with "ivy leaves"; later in the naturalizing period, with laurel leaves. The frequently curving stems of the motif reveal its specifically Greek character (fig. 93).

The fourth means is the undulating tendril, which, during the black-figure period, was primarily the intermittent tendril. The calyces are frequently omitted at the points of interruption, so that the motifs are placed directly on the tendril stems as they were in Mycenae (fig. 52). On the well-known ivory situla from Chiusi (fig. 94),[109] the blossom forms have become quite rudimentary, but the intermittent tendril is still the basic underlying scheme, as the detail in figure 95 from the same situla where the blossoms at the points of interruption have retained their distinct three-pronged profiles. The piece is, incidentally, so remarkable from the decorative, historical point of view that it deserves special notice.[h]

I would now like to characterize briefly how the floral tendril frieze evolved during the red-figure period before it became distinctly naturalistic. One of the strongest indications of this development toward natural-

Fig. 93. Painted Greek vase ornament.

Fig. 94. Details of ornament on an Etruscan ivory situla from the Pania tomb at Chiusi.

Fig. 95. Ornament on an Etruscan ivory situla from the Pania tomb at Chiusi.

[109] *Monumenti inediti*, Deutsches Archäologisches Institut, 10 (1874–1878), pl. 39a.

ism was the appearance of the acanthus, which dates around 450 to 430 B.C. Nevertheless, the more severely stylized motifs still survived for some time, especially in borders used for trimming where the narrow, cramped space did not encourage a freer treatment of forms.

The red-figure vases, our assessment of which is based almost exclusively on Attic material, are characterized by an increasingly playful treatment not only of the traditional motifs themselves but also the way they are connected. At the same time, the types of motifs are limited in number. The continuous tendril again comes into more extensive use; it twists and turns very elegantly around the attached palmettes, which tilt upward in response, with each leaf delicately adjusted to fill the space (fig. 96).[i] The intermittent tendril (fig. 97) also acquires a more lively rhythm: the palmettes are no longer arranged rigidly and stiffly, up and down, perpendicular to the direction of the frieze, as had always been the case since the Melian example in figure 53, now they are oriented obliquely the way they were in Mycenaean art (fig. 52).[j]

Fig. 96. Painted ornament from Attic red-figure vase.

Fig. 97. Painted ornament from Attic red-figure vase.

There are even more complicated forms aside from these, but they can all be explained as playful combinations of the traditional forms.[110] Figure 98, for example, is a variation on the one-sided lotus-palmette band, which has unconventionally conflated the idea of the arcuated frieze with coiled calyces and enclosed palmettes.[k]

[110] This was less often the case in Attic as in ancient Italic art; compare, for example, the Praenestine cistae (*Monumenti inediti* 8 [1864–1868], pl. 7).[l]

Fig. 98. Painted ornament from Attic red-figure vase.

8. The Further Development of the All-over Tendril Pattern

So long as vegetal tendril patterns could only expand lengthwise within the format of the register or frieze, they did not enjoy complete freedom of movement. This only became possible when they were able to expand in width as well as in length. As indicated earlier, the only area where this could take place was around and beneath the handles of the ceramic vessels that, alas, provide virtually our only source of evidence. Nevertheless, it is still easy to reconstruct the path that vegetal tendrils took as they spread out unrestrictedly over surfaces, while at the same time respecting the basic decorative laws of rhythm and symmetry. At this point, we are really approaching the conclusion and ultimate goal of the entire development.

Before we actually come to that final process, however, there is still another kind of decoration to be considered, which apparently has little to do with the more advanced stage of development. It involves the background patterns encountered on Corinthian vases. For the most part, the vases are decorated with figurative depictions. There is, however, still quite a bit of space left over between the figures, and since this category of vases is obviously still Archaic in date and technique, it comes as no surprise to find incidental motifs filling up the background just as they did in earlier Greek art, first in the Dipylon Style, and then subsequently also in the Melian, Rhodian, Early Attic styles, and others. Why then, one might justifiably ask, wasn't this decorative style treated in an earlier chapter? I have intentionally put aside the discussion of filler decoration on Corinthian vases until now because they reveal in an instructive and interesting way how one could achieve the goal of covering surfaces with a coherent pattern.

The filler decoration on Corinthian vases consists basically of rosettes, just as in Assyrian art.[111] This may indicate a certain amount of Near East-

[111] For example, Layard, *The Monuments of Nineveh: From Drawings Made on the Spot by Austen Henry Layard*, vol. 1 (London, 1849), pl. 48.

ern influence. The peculiar treatment of the rosettes is, on the other hand, absolutely un-Oriental in character. In the Corinthian style, the rosettes are not simply adjusted in size according to the available space, as they are to a certain degree in Assyrian art as well, but also in shape, for their contours are generally made to conform to the shape of the immediately adjacent figural elements. As the style progressed, it was inevitable that the filler decoration would cease to look anything like rosettes. Instead, they assumed any number of irregularly shaped patterns, none of which would fit into the existing repertory of ornamental forms. There is no reason why they should, however, since their form was directly dependent on the figurative depictions surrounding them.[112, a]

Let us turn to the bowl with the dancing figures in figure 99 for an example. The filler decoration is used in the manner just described to fill up all kinds of areas as tightly as possible, while avoiding the monotonous geometric linear configurations characteristic of the Dipylon Style. This is the very same process taking place within tendril ornament, which we are about to follow to its resolution. It is also worth mentioning that Corinthian vases were among the very earliest to exhibit a clear preference for predominantly figurative, representational decoration. This makes it easier to comprehend why Corinthian vase painters did not restrict themselves to using rosettes for filler motifs, as the Assyrians did.[113, b]

Fig. 99. Corinthian skyphos.

[112] Cf. K. Masner, *Die Sammlung antiker Vasen und Terracotten in k.k. Österreichischen Museen. Katalog und historische Einleitung* (Vienna, 1892), 9, fig. 6, the source of our figure 99.

[113] Attic vase painters at the end of the fifth century tended similarly to fill the intervening background space between ornamental tendrils; instead of the rosette, however, they preferred drop-shaped axil fillers that could broaden like ink blots whenever necessary.

Let us now return to our examination of vegetal tendril ornament and see how it develops in the area around the vase handles.[c]

The attached handles, which were stylized into palmettes, may have sometimes influenced the use of the tendrils beneath them, but I certainly do not think it was a hard and fast rule, as is usually assumed. The palmettes applied to handles are obviously based on the same decorative thinking and postulate as the various lotus stylizations used as points of attachment on Egyptian and Assyrian utensils and the like. Painted palmettes are also occur at an early date on Greek vases (though not on the Mycenaean Warrior Vase) in the area of the handle. Oddly enough, however, they are not centered around the handles to mark the points of attachment but occur midway between them, as on Early Attic vases.[113a] There are, of course, in addition, any number of examples from the black-figure (and red-figure) period where palmettes actually serve decoratively to disguise the place where the handles are attached.[114] On the "Cyrenean" [Lakonian] kylix in figure 89, the palmettes lie on their sides horizontally pointing away from each of the handles. Be that as it may, the decisive issue for us is that palmettes were not always used by themselves but also in combination with tendrils.

And for this purpose, a suitable motif was already available that was not restricted in width but capable of forming centralized, self-contained compositions. It is, of course, the interlacing tendril discussed above in regard to the Chalcidian example in figure 88. And, in fact, the basic composition of this motif did provide the point of departure for at least one kind of widespread and influential tendril decoration, the type that developed above and below vase handles in the black-figure period and attained its freest formulation in the red-figure style.

Figure 100 is taken from a drinking cup in the Kunsthistorisches Museum in Vienna.[114a] The interlacing tendril under the handle has been reduced to a very simple form with opposed lotus and palmette motifs; the secondary tendril band passes behind the lotus and then intertwines with the main tendril; the ends of all of the tendrils curl up into spirals.[d]

Figure 101 is an ornament from an Attic black-figure vase also in the Kunsthistorisches Museum.[114b, e] Its centralized arrangement divided up strictly according to symmetry is still very emphatic and completely in the

[113a] [Böhlau, "Fruhattische Vasen," *Jahrbuch des Deutschen Archäologischen Instituts* 2 (1887), pl. 4.]

[114] Masner, *Vasen und Terracotten*, pl. 2, no. 217; here the flat handles have rosettes instead of palmettes.

[114a] [Ibid., no. 107, pl. 5.]

[114b] [Ibid., no 227.]

Fig. 100. Handle ornament of a
Corinthian[izing Attic] drinking cup.

spirit of the Chalcidian interlacing tendril in figure 88, though the details, the subtly rendered flowers and the long thin tendrils, are treated more elegantly and with far greater delicacy.

Figure 102 is from a vase[115] that has the black-figure style on the neck and the red-figure style on the belly. The type of interlace is still clearly the same as in figure 100.[f]

Figure 103, on the other hand, from a vase still in the late black-figure style and belonging to the Nikosthenes group,[116] represents something essentially new. The motif is no longer centralized, nor is the symmetry

Fig. 101. Handle ornament of an Attic
black-figure amphora.

Fig. 102. Handle ornament of an Attic
amphora in mixed red- and black-
figure style.

[115] Ibid., no. 319 (Dike and Adikia).
[116] Ibid., no. 234.

181

Fig. 103. Handle ornament of Attic black-figure amphora.

painstakingly observed. Its single tendril winds one way and then the other, each time giving rise to three spirals; in addition, two spiral tendrils and three lotus blossoms with richly curving stems branch off from the main tendril. The somewhat larger space left over between the two outer spirals at left is filled with a flying bird.[g]

The innovations here are many and sudden, and they deserve closer scrutiny; the most unexpected change is the shift away from symmetry. Against the artistic limitations of Nikosthenes' time, and even later, this must have appeared as a breakthrough, for successors to this important development are rare even in the advanced red-figure period. However, the attempt is still indicative of the dominant tendency of the period, namely, to free tendril ornament from its inherited bonds and to allow it to evolve with the utmost freedom. The motif in figure 103 is an atypically extreme case for its period.

Nor is the result as it appears in figure 103 particularly satisfactory. The red-figure vase painters found a better solution when they arranged their tendril branches around the handles like wreaths (fig. 104).[117, h] Even the so-called Nolan vases with their individual branches under each handle display more respect for symmetry. In one instance,[118] the two branches,

[117] Ibid., 339.

[118] H. von Brunn and T. Lau, *Die Griechische Vasen ihr Formen- und Dekorationssystem* (Leipzig, 1879), pl. 25, nos. 2, 2a.

Fig. 104. Handle ornament of an Attic red-figure
stamnos.

one under each handle, form a frame for the image in the middle of the
vase, so that symmetry is established at least with regard to the two
branches themselves. In another instance (fig. 105),[119] the branch splits
above into two tendrils that symmetrically flank the handle lying between
them. Otherwise, the asymmetrical arrangements of these Nolan vases
are really very close to the scheme in figure 103.[i] Together with this exam-
ple, and others that are less rare, like figure 104, they remain exceptions,
because they were too loosely arranged for the Greek decorative sensibil-
ity. It is, moreover, not surprising that figure 103 adorns a vase from the
circle of Nikosthenes, where we customarily encounter all kinds of strange
combinations of motifs. In the red-figure period (for example, figure
106),[120] on the other hand, smaller, less striking departures from strict
symmetry occur quite frequently in the tendril ornament near the han-
dles.[j] Therefore, the motif in figure 93 represented, so to speak, the first
tendency in this direction: the exaggerated formulation it acquired in
Nikosthenes' circle was not imitated; but apparently it could be applied
more moderately, as something piquant yet agreeable.

The occasional abandonment of strictly symmetrical organization was
a product of its time, and this trend emerges even more clearly in the

[119] Ibid., no. 3.
[120] This example is from the imperial Münz- und Antiken-Cabinett in Vienna, inv. no. 608.
The blossom, which breaks symmetry below, is also of note because of the combination of
lotus profile and closed palmette fan: hence an Egyptian pleonasm, but treated in the Greek
style.

Fig. 106. Handle ornament from an
Attic red-figure vase.

Fig. 105. Handle ornament of a red-figure
"Nolan" vase.

weakening of the centralized arrangement. The ornament still originated
at a definite point, but it was no longer necessarily a central point with
everything else disposed concentrically around it. Instead, the tendrils
unfolded symmetrically and very freely right and left from their point of
origin, traveling up or down as the space available for decoration might
demand. The strict symmetry in the example offered by figure 106 is bro-
ken capriciously by a blossom branching off at the bottom.[121]

The third, unexpected innovation in figure 103 is the insertion of the
flying bird into the decoration. Animals, of course, both quadrupeds and

[121] F. Winter ("Die Henkelpalmette auf attischen Schalen," *Jahrbuch des Deutschen
Archäologischen Instituts* 7 [1892]: 105–17) has recently traced the development of a series
of palmette-tendrils found under the handles of Attic kylixes. They do not start out from a
centralized interlace but from the two loose palmette branches of the so-called Little Master
bowls, one under each handle. The two separate palmettes are then connected to each other
by tendrils. As the development proceeds, the connecting tendrils become richer, freer, and
more dynamic, exactly as they did in the series we have been following in figures 100–108.
Unfortunately, Winter's work appeared too late to be considered in more detail in this chap-
ter. It deals with an area of palmette-tendril ornamentation that is very limited in time and
place of origin, and clearly shows how advantageous a careful and accurate reading of the
purely ornamental subsidiary decoration can be for the attribution and dating of vases.[k]

birds, were by no means foreign to Archaic decoration. However, the playful inclusion of a bird within a tendril branch was a new, and rather fruitful concept, which, as we know, achieved its maximum currency in the decorative art of the subsequent period. All the same, the association of animal figures with vegetal ornament was not completely new in Nikosthenes' time. There are examples from the Archaic period on Melian,[122] Early Attic,[123] and Chalcidian[124] vases. In the second and third cases, however, the animals oppose each other in the absolute symmetry of the stiff, Oriental scheme (Heraldic Style); on the Melian vase, the bird stands on the axil filler of a single tendril branch. When animals began to be included within larger compositions of tendril ornament, the combination then became truly attractive and exceedingly imaginative. Perhaps one of the earliest examples of this kind is figure 107.[125] The composition of the tendril ornament alone is remarkable and, for the black-figure period, surprising: the motif occurs on the neck of an amphora and was therefore not confined to the limited space under the handle. The vegetal ornament includes two rabbits, which are, so to speak, axil fillers and which, furthermore, do not correspond in full symmetry to one another.[1]

The inclusion of animal creatures within tendril ornament engendered decisive and significant progeny in the red-figure period. Figure 108 illustrates the shoulder ornament of a fifth-century Attic lekythos: a branch

Fig. 107. Neck ornament of a black-figure vase.

[122] A. Conze, *Melische Thongefässe* (Leipzig, 1862), pl. 4.
[123] Böhlau, *Jahrbuch des Deutschen Archäologischen Instituts* 2 (1887), pl. 3.
[124] Figure 88.
[125] Brunn and Lau, *Griechische Vasen, Ornamente griechischer Vasen. Aufnahmen/Beschreibungen und Untersuchung* (Berlin, 1927), pl. 11, no. 4. The various eccentricities of this example, which Brunn also discusses in his text on page 24, make one hesitate in good conscience to place the work chronologically according to technique. I think that Brunn's explanation for the asymmetrical placement of the rabbits should give way to the line of reasoning established by our present investigation.

Fig. 108. Shoulder ornament of Attic
white-ground lekythos.

circles around, while a flying Eros who is playfully included among the
tendrils grasps them in his hands.[125a] The motif does not come into matur-
ity or widespread use until the Hellenistic period, as, for example, on the
silver krater from Hildesheim. However, we have been able to trace its
first impulses back to the Archaic period and also to disclose the motivat-
ing tendencies behind its development, tendencies whose basis lies in the
nature of Greek decorative art going back to Mycenaean times.[m]

As far as we can judge from the limited material available for studying
the progress of earlier Greek decoration, the goal of mastering vegetal
tendril ornament was achieved approximately around the first half of the
fifth century; at this point, tendril ornament was capable of covering any
given surface in an attractive way, limited only by a general respect for
symmetry. Aside from this, however, minor deviations from strict sym-
metry were not only allowed but even encouraged, because they height-
ened the appeal, broke the monotony, and yet did not interfere with the
harmonious overall decorative effect required by symmetry in general.
All the same, the space in which tendril ornament could develop in com-
plete freedom was still very limited. Tendrils could wind their way across
areas near the handles of vases, as we had seen, but the large surfaces still
were always reserved for figurative depictions. As long as the develop-

[125a] [From A. Furtwängler, "Weisse attische Lekythos," *Archäologische Zeitung* 38 (1880):
134–37, pl. 11, top.]

ment, especially in sculpture, had not yet reached its zenith, as long as one had yet to perfect the types that could ideally express the heroes and gods of myth for the people of the time, pure ornament would be restricted to subordinate positions on borders, handles, feet, etc. It has often been pointed out that Pheidias had relatively little interest in ornament. Once the general development had climaxed, however, a zest for decoration again emerged to press its claims. This became evident, first of all, when established figural types began to be used for purely decorative purposes, as is especially characteristic for Pompeii. Furthermore, the decorative impulse is apparent wherever the sort of pure decoration, which would have been considered much too trivial in the period leading up to and including Pheidias's, is allowed to spread out over large surfaces, perhaps with some subsidiary figural elements lightheartedly interspersed. This was the moment when the vegetal tendril was able to develop its inherent qualities fully, although, as I have sufficiently demonstrated above its potential was apparent long before the fourth century B.C.

From now on, the vegetal tendril in its fully liberated form appears together with motifs that were apparently unknown in Greek decorative art as we have encountered it thus far. As I have stated repeatedly, it is impossible to investigate every individual vegetal motif in ancient ornament, since we have decided to concentrate on the development of vegetal tendril ornament in general. Nonetheless, the next chapter will investigate the emergence of the acanthus, a motif that, in the history of floral ornament, was epoch making in every respect. And since its development is so similar to the one which we have been following, resulting in the untrammeled spread of vegetal tendrils, we shall devote a separate chapter to the origin of this motif.

9. The Emergence of Acanthus Ornament

The palmette and the three-pronged profile lotus blossom remained the predominant vegetal motifs in the basic Greek decorative vocabulary throughout the Archaic period right down to the time of the Persian Wars. At the same time several other motifs that were also current in ancient Near Eastern art played a subordinate role, the forms that we call the lotus bud, the ivy leaf, and the pomegranate. But even though the number of motifs was limited, it did not, of course, mean that the treatment of the individual forms was somehow inflexible or unchangeable. Each of the motifs possessed a history of its own in the period between the seventh

and fifth centuries B.C., and even if the material available today is insufficient to clarify and validate their individual evolution in minute detail, what remains is still sufficient, in my opinion, to warrant investigation. Since this study is dedicated primarily to the investigation of the vegetal tendril, my attempt to characterize the kind of forces at work in the further development of the lotus and palmette motifs during the earlier Greek period will be short and general. Here the desire for visual elegance is readily apparent as the driving force and the formative impulse. The two basic forms—the three-pronged, pointed leafed calyx and the fan surmounting a volute-calyx—were solidly established; artists simply manipulated them in whatever way they pleased. Inherent in the development was a slight tendency toward naturalism, which could not coexist with the geometric rigidity of the models; it strove instead to endow the forms with movement and life.

In time, the palmette became the most important decorative blossom motif. On red-figured vases, it came to overshadow nearly all of the other motifs inherited from earlier periods. The history of the Greek palmette alone would easily fill a book. Thus far, Furtwängler[126] and Brückner[127] have devoted detailed discussions to particular phases of its development. The various parts of the Greek palmette, as we know them from ancient Egyptian art, remained the same up through the fifth century: the volute-calyx, the conical axil filler, and the crowning fan. Of course, Greek art radically altered the treatment of the individual parts, and the relationship of the parts to one another. In the second half of the fifth century, the same naturalizing tendency that had provided the impulse for the tendrils to unwind freely now began to influence individual vegetal motifs. This is first discernible in certain transformations of the palmette, which no one could mistake for anything else; as far as I know, they are commonly interpreted as such. The second manifestation of these naturalizing tendencies was the emergence of an ornamental motif of unquestionably vegetal character, which has been considered a direct imitation of a particular botanical species, the *acanthus* (bear claw).

The transformations of the palmette during the second half of the fifth century affected the crowning fan as well as the lower portions, the volute-calyx and the conical element. These lower parts either directly assumed the characteristics of the acanthus (fig. 110), or they appeared in combination with it, so they will be discussed later with the acanthus itself. The fan

[126] A. Furtwängler, *Collection Sabouroff monuments de l'art grec* (Berlin, 1883–1887), introduction, 6ff.

[127] A. Brückner, *Ornament und Form der attischen Grabstelen* (Weimar, 1886), 4ff.

of the palmette, on the other hand, generally retained the integrity of its separate, long, and narrow leaves. However, the leaves no longer radiated out stiffly from a central point like a section of a rosette as they had in Egyptian art but were arranged in a more rhythmic manner. The tips of the leaves no longer jut straight out from the center but extend upward along a gently curving line, bending their tips slightly to one side, either to the right or left of the vertical central leaf (fig. 109).[128] We will refer to this variant as the *overflowing palmette*. Another form that was even more characteristic of this basic tendency, because it does not fall neatly into the naturalistic line of development, is the *split palmette* (fig. 110).[129] There the undulating leaves of the fan turn their tips back toward the middle of the fan.

Fig. 109. "Overflowing palmette" from the cornice of the Parthenon.

Fig. 110. "Split palmette" on the acroterion of an Attic grave stele.

This second variation on the palmette with its curved tips, one which provided the point of departure for other significant variations later in the eastern Mediterranean, did not become common until the fourth century. Basically, it resembles the Near Eastern type of palmette, but divided into two half palmettes. There was something about this type that conformed to the conventional Near Eastern pattern, and it prevented them

[128] From the sima molding of the Parthenon pediment. The origin of the arrangement of the leaf fan, however, goes back to the period before the Persian Wars. Compare, among other things, *Antike Denkmäler*, Deutsches Archäologisches Institut, 1, (Berlin, 1886), pl. 38, A 2.

[129] Acroterion of a grave stele from A. F. Quast, *Das Erechtheion zu Athen nebst mehren noch unbekannt gemachten Bruchstücken der Baukunst dieser Stadt übrigen Griechenlands* (Berlin, 1839), vol. 2, pl. 17, no. 3. The large lower acanthus calyx has been omitted. (The example is not among the earliest and serves only to illustrate the mature stage.)

from ever losing their schematic, geometric character completely. The tightly coiled volute-calyces remained, as always, double spirals; within their axils, the conical element functioned as a purely external insertion, while the split palmette, on the other hand, retained the volute-calyx and the closed fan, bringing them both into organic relation with one another. It no longer breaks down into upper and lower parts, into fans and calyces, but into right and left halves, as two half palmettes. On each side there is a bifurcation: two stems, usually rendered in a plantlike manner, rise from below and split immediately into two tendrils. The outer one coils into a spiral at the side, while the inner one winds its way upward in undulating curves in imitation of the long and narrow leaves comprising the fan. Similarly curved leaves, which grow progressively smaller toward the bottom, fill out, so to speak, the axil between the two offshoots of the bifurcated tendril. The split palmettes then result from the symmetrical placement of two bifurcating tendrils.[a]

Of course, I am not suggesting that the motif was consciously created step by step in the way just described; however, in view of the important and specific role that the bifurcation of successive tendrils played within Greek vegetal ornament, there can be little dispute that the bifurcating tendril was a critical influence. Already in the case of the continuous tendril (fig. 50) in Mycenaean art, it is precisely this splitting off which allowed the motif to be perceived as a tendril and not as a geometric spiral in the Egyptian manner.[130]

An even more significant factor than the variations of the palmette just described, however, was the emergence of the acanthus. Its first appearance is as momentous as that of ancient Egyptian lotus motifs, especially for those who still follow prevailing opinion and ascribe the origin of the acanthus ornament to the conscious imitation of a natural vegetal prototype. However, even those of us who do not consider the acanthus a newly invented decorative motif imitated directly from nature but who see it, on the contrary, as a product of the continuous evolution of ornament in history (jumping ahead to some of the conclusions to come), even we do not underestimate the birth of what is by far the most significant vegetal motif in history.

In ancient literary sources, the birth of the acanthus motif was closely associated with the origin of the Corinthian capital, at least according

[130] Even in fourth-century vase decoration, which essentially adhered to the original, Orientalizing type of palmettes, though with the leaves of their fans bending to varying degrees, there is a clear tendency to split up the palmettes interspersed among the tendrils into half palmettes.

to Vitruvius (4.1.9–10), who has passed on a description of how his contemporaries imagined the capital was invented. As the story goes, the sculptor Kallimachos, who was in Corinth at the time, found an acanthus plant that was accidentally sprouting up from under a basket; he was struck by the decorative effect of the combination and, as a result, inspired to create the Corinthian capital. The circumstances surrounding the narrative are so well known that I need not retell them here. The story is obviously fictitious, though admittedly charming, and I doubt that any serious modern scholar would consider defending it. Furtwängler,[130a] moreover, has already shown that the earliest acanthus motifs were used on palmette acroteria that predate the earliest appearance of the Corinthian capital.[b] Brückner[130b] seems to agree, since he even claims to know why the acanthus motif was chosen for the acroteria of grave stelai in the first place. No one[131] as far as I know, however, has ever dared to doubt that the peculiarly serrated vegetal motifs characteristic of the Corinthian capital resulted from the direct imitation of the *acanthus spinosa*, as related in Vitruvius's account. Consequently, and unfortunately, there are no fundamental studies devoted to the earliest development of the acanthus—which is by no means crystal clear. I cannot, of course, go into the topic now in any exhaustive way, since even the philological research that must accompany any investigation of the monuments is beyond my sphere of competence. I will concentrate only on those aspects which have a bearing on ancient vegetal or tendril ornament. However, the pressing need to extend this chapter on the origin of the acanthus into a thorough and basic study will soon become obvious. At the same time, I hope to convince at least some of my colleagues that the acanthus ornament did not result from the direct imitation of a model found in nature but rather from an essentially artistic developmental process within the history of ornament.

Acanthus ornaments in relief sculpture, as they appear, for example, on the Monument of Lysikrates (fig. 111) and on the acroteria of grave stelai during the early decades of the fourth century, display an undeniable resemblance to the leaf of the *acanthus spinosa* (fig. 112).[c] All of them are articulated into separate projecting units, which are in turn subdivided into a number of sharp jagged points; between each of these larger units (the so-called pipes of the sculptural depictions of acanthus), there is a

[130a] [Furtwängler, *Collection Sabouroff*, 9.]

[130b] [Brückner, *Ornament und Form*, 82.]

[131] Not even K. Bötticher (*Die Tektonik der Hellenen*, 2d rev. ed. [Berlin, 1871–1881], 344), in spite of his usual skepticism toward Vitruvius's anecdotes. The one exception involving Stackelberg will be discussed later.

Fig. 111. Corinthian capital from the Choregic
Monument of Lysikrates
in Athens.

Fig. 112. Leaf of *acanthus spinosa*, from life.

Fig. 113. Ornament from the necking of the columns in the
north porch of the Erechtheion in Athens.

deep concavity. This specific type of articulation, however, is absent from
the earliest examples of acanthus ornament.[d]

Let us take a look at the details of a capital from the Erechtheion in
figure 113.[132, e] The individual ribs of the acanthus leaves, rendered

Fig. 114. Painting from an Attic
white-ground lekythos.

entirely in profile, are juxtaposed
analogously like the radiating leaves
of a palmette. The two-dimensional
versions, crowning the stelai on
painted lekythoi (fig. 114), have cut-
out, serrated edges resembling those
of cactus or aloe leaves, a result of
the draftsmanly technique of projec-
tion.[f] In neither case, however, does
the articulation of the contours cor-
respond to that of the *acanthus spi-
nosa*. Moreover, while the project-
ing segments of natural acanthus
leaves alternately branch off from
each side of a central vein (fig. 112),
their counterparts in figure 113 all
arise from a common lower base;
they do not branch off from the cen-
tral leaf but run parallel to its axis.

Consequently, there are two es-

[132] From Quast, *Erechtheion*, vol. 1, pl. 7, no. 2. I found the old reproduction by Quast,
having compared it with plaster casts, to be completely accurate and correct.

sential differences between the characteristics of the *acanthus spinosa* and the typical stylization of the acanthus ornament as we find it on the earliest surviving monuments. Later, we will have ample opportunity to discuss these differences in detail. For the time being, it suffices simply to acknowledge their existence. There are two possible conclusions. Either we may continue to believe that the decorative acanthus motif is a copy of the *acanthus spinosa* and explain the departures from nature in the earliest examples as the result of awkwardness, drastic stylization, or the like, or we may abandon the idea that the *acanthus spinosa* served as the model here and seek a different origin or point of departure for the formation of the acanthus ornament.

Let us briefly consider the first possibility. This sort of explanation described above for the twofold discrepancy between the stylized acanthus ornament and its natural counterpart may very well be credible to those who still accept the literary tradition as valid. According to this view then, the artist created a kind of abbreviated version of the acanthus leaf, which omitted not only the larger projecting segments but also the sharp, jagged edges, for the jagged edges, as represented by figure 114, are missing on the earliest versions of acanthus in sculpture, as we will see in particular. They occur only on the graphic, two-dimensional projections. Therefore, it is the painted version of the acanthus on the Attic lekythos (fig. 114) that has the most jagged edges, whereas the contours of the sculpted version (fig. 113) have scarcely any pointed serrations. Instead, the tips of the individual segments or "ribs" are rounded off, and the only sharp points that occur in the leaf contours are those resulting from the notched grooves between each rib as they appear in perspective rendered from the side. This is clearly evident on the calycal leaves of the lotus flower to the left of figure 113:[133] While the bottom part is rounded off, the contours of the leaves, as they overlap in perspective, form sharp points like the lateral leaves in figure 114.[g]

According to this first interpretation, the stylization of the acanthus plant was initially somehow out of touch with the naturalistic tendencies of the time. Only gradually did the characteristic features of the *acanthus spinosa* come to be appreciated and then applied to the acanthus ornament itself. First the "ribs" lost their three-dimensional form to become concave channels separated by ridges that had formerly been furrows but now projected as pointed serrations. Then each of these individually pointed units was further articulated as multiserrated projections, so that

[133] An even better example is the leaf calyx drawn in perspective in figure 116.

the motif finally began to resemble the natural *acanthus spinosa*. The driving force behind the whole development was the growing urge for naturalism. There may not be anything particularly improbable about the process just described, but doubts about the initial point of departure still remain. And before we opt to support an assumption for the sake of a legendary tradition, it might be wise to consider carefully all the contributing factors that remain and to attempt an explanation predicated on other grounds.

First of all, the only other circumstances relating to the traditional view of the acanthus in fifth-century Greek art as an imitation of nature all belong more in the realm of philological and historical research. Since I am in no position to treat this aspect of the topic thoroughly, I will summarize my own opinion in a few short words at the end of the chapter.[h]

Now, however, I would like to proceed immediately to my view of the origins of the acanthus ornament, how it evolved during an admittedly naturalizing phase, but in response to strictly decorative demands that had nothing to do with a direct imitation of nature.

In my opinion, the acanthus ornament was originally nothing more than a palmette or, in some cases, a half palmette adapted to sculpture in the round. In figures 113 and 114, they are mostly half palmettes. The individual leaves forming the fan in figure 113 do not emerge from a central rib, as on the *acanthus spinosa*, but share a common base below as on a palmette; they attenuate down toward their roots and then expand by the rounded tips just like the palmette-fan. What distinguishes the sculptural acanthus leaf from the two-dimensional palmette-fan is the manner in which the tips of the leaves curl back elastically. Of course, this is not really possible for a palmette projected on a two-dimensional surface, though it is nevertheless suggested to a certain extent, as we shall see later on in the tendril ornament of the Hellenistic period. However, the conventional straight-leafed palmettes found on grave stelai (something like the ones on the Parthenon), also have projecting tips that curve forward into space, because in this case, the sculptural medium made it possible and because they conformed to the general artistic demands of the period as well. The same tendency toward the rhythmic curvature of the tips was also basic to the split palmette [figure 110], so that there are, in my view, sufficient indications that point to the derivation from the palmette as the keystone of acanthus ornament.[i]

Just as there are full and half palmettes, so there are also full and half acanthus leaves. In figure 113, there are only half leaves. If these acanthus leaves really are nothing more than vegetalized sculptural transformations

of half palmettes, then they ought to occur in the same locations on the vegetal tendrils and function in the very same way, and this, in fact, is what they do. Let us look more closely at the tendril in figure 113, which winds its way up to the left of the large palmette. Wherever a tendril bifurcates from the main stalk—and only there—the junction is marked by an acanthus half leaf. But unlike the fan of the half palmette, which is located within the axil between two branching tendrils, the acanthus half leaf wraps around the stem immediately before it bifurcates. Here we are witnessing the conversion of the palmette-fan into a sculptural and vegetal form. The way in which plants sprout in nature owes nothing to the postulate of axil filling. Therefore, the purpose of enveloping the tendril with an acanthus half leaf must have been to allow the fan—a two-dimensional axil filler now translated into a sculptural, vegetal form—to behave in a more natural, plantlike manner, rather than as a decorative insertion between two tendrils. And in fact, one could hardly imagine a better or more successful solution than this sheathing. Not only did this facilitate the preservation of an ornamental motif that had become virtually canonical in artistic tradition, but it also created an attractive way of articulating the tendril. As early as the Erechtheion, acanthus half leaves appear on the tendrils even where there is no evident bifurcation, in the lower part of the S-spirals or on the calycal leaves of the lotus blossom in figure 113.[j]

Aside from the fan, the essential components of the palmette are the conical element and especially the volute-calyx. If the acanthus really is derived from the palmette, then we will have to determine what happened to both these parts. In what form would they have survived the translation into sculpture? The remains of the volute-calyces are, in my opinion, the sheathlike swellings on the tendrils in figure 113, which occur at the bottom of all of the acanthus half leaves. The conical element of the two-dimensional palmette, on the other hand, was nothing more than an axil filler; it disappears in the sculptural version because the flat, frontal volute-calyx is now wrapped around the tendril stem, and there is simply no axil to be filled. In the following period, the sheaths of the acanthus leaves also come to lose their original importance and are eventually omitted.

Whoever is dissatisfied with this explanation for the disappearance of the volute-calyx from the sculptural palmette (i.e., from the acanthus), should refer to the decoration on the famous doorframe of the Erechtheion (fig. 115). Here it seems as if the three-dimensional palmettes have been flattened out again. There is no doubt at all, however, that we are looking at a lotus-palmette frieze. On the bottom are S-spirals which form

Fig. 115. Lotus and palmette molding from the door of the
north porch of the Erechtheion in Athens.

calyces as they come together; filling the space above them are three-
pronged lotus blossoms in profile alternating with palmettes. However,
only at the insertion point of the lotus blossoms do the spiral tendrils form
true calyces. On the palmettes, which normally require volute-calyces,
the ends of the tendril do not coil around like calyces but run directly into
the central rib of the palmette. The reason for this is revealed by examin-
ing more closely how the palmette is stylized in this example. The concave
indentations of the contours show that what we have before us is a full
acanthus leaf; only in this case, like the acanthus on the painted lekythos
(fig. 114), it has already been translated back into two dimensions. As
suggested before, the subsequent development is based primarily on this
painterly form of stylization, corresponding completely with the increas-
ingly painterly tendencies of Greek sculpture during the post-Periclean
period. All we need do is detach the palmettes in figure 115 from their
background and allow them to curl over, and we end up with nothing less
than acanthus motifs. In the present example, however, we still refer to
them as palmettes because they alternate with lotuses. There is another
analogy worth pointing out here. Greek art at that time already possessed
an instance of a two-dimensional floral motif closely related to the lotus-
palmette strip, which had been translated into sculptural terms: the egg-
and-dart motif as the plastic version of a row of alternating lotus blossoms
and buds. The lotus-palmette band undergoes a similar process, albeit in
a more circuitous way.[k]

I have described the palmettes in figure 115 as acanthus motifs that
were converted back into two dimensions. The palmettes, however, do
not actually lie in a flat plane but on the curved, ogival molding of the

doorframe, so that their profile has a truly acanthuslike curve to it. They are full palmettes (whole acanthus leaves), as opposed to the ones in figure 113, where we saw only half acanthus-palmettes (acanthus half leaves). These last forms, moreover, are also found on the crowning cornice of the same door on the Erechtheion and stylized in the same way.

If this stylization really represents a translation of the sculptural palmette back into two-dimensional, painterly, perspectival terms (as seems to be the case and as the painted lekythoi, among other things, have proven), it was, in any event, a later development than the acanthus motif itself, which is to say, the sculptural palmette. As a result, the doorway of the Erechtheion need not be any later than the columns of north porch, which are the source of figure 113, since both kinds of motifs could have coexisted for a while. It is, moreover, generally indicative of the enterprising spirit and joyful creativity of Greek artists during this completely unparalleled period that in a relatively short span of time, they were able to initiate so many great, varied, and yet significant changes using the same motifs that had remained unaltered in their original homeland for thousands of years. This delight in movement, this carefree attitude toward the traditional and the conventional has become an ingrained characteristic of western Mediterranean culture, while Near Eastern cultures have remained basically conservative in their ornament, despite intense contact with the Hellenic world.

In figure 115, the acanthus seems to be synonymous with the palmette; it even functions like the palmette. This is an exception, however, since on almost all of the other monuments with early examples of the acanthus, the motifs appear as half leaves.[1] In figure 113, the main motifs are alternating lotus blossoms and flat palmettes.[133a, m] The acanthus is restricted to less prominent positions: on the one hand, marking the junctions of the bifurcating tendrils as indicated above and on the other, forming the calyx of the lotus blossoms. Anyone who remains unconvinced by the arguments presented thus far and still wishes to maintain that the decorative acanthus is based on the actual plant will find it very difficult to explain the motivation for Greek artists to use acanthus motifs specifically for tendril and blossom calyces. We at least have made the case that the tendril calyces are analogous to the axil-filling half palmettes of the two-dimensional tendril ornament on vases. It is more difficult to single out a specific reason why the calyces of lotus blossoms have been acanthusized, since the

[133a] The conical element of the palmette is decorated with the palmette pattern in relief, while the individual leaves of the fan curve out slightly above; hence, another example of the direct transition from the palmette to the acanthus as conditioned by sculptural demands, which can be clearly seen in the two-dimensional reproduction in fig. 113.

two leaves could just as easily have remained smooth in the sculpted version as well. The curved lines of the calycal leaves, however, lend themselves particularly well to taking on the contours of the acanthus—far better than rigid full palmettes do. This is also probably the reason why there are seldom any full palmettes stylized like acanthus in the first stages of the development. When they appear on the acroteria of grave stelai, they do, of course, project slightly forward on the upper edge; however, this curve was apparently much too shallow, for, even in the later period (fourth century), the two-dimensional version of the palmette is used as a rule on acroteria, so that the naturalizing tendency of the period found expression exclusively in the split variation. It seems to me very likely, therefore, that the first palmettes converted to sculptural acanthus motifs were the calyx-shaped half palmettes and not the motif as a whole. This would concur with Furtwängler's observations that the earliest acanthus motifs are found on funerary reliefs like the Karystos and Giustianini stelai;[133b] in both cases the acanthus is rendered as calyces exactly like those in figure 113, specifically as ribbed counterparts to the smooth calyces and leaves above them.[n]

The ornament of the Erechtheion was apparently very important for the early development of the acanthus. Wherever the motif occurs, whether on the necks of columns, architraves, or doorframes, there are slight variations, which could each serve as a topic of discussion itself, and which

Fig. 116. Detail from the anta capital on the east porch of the Erechtheion.

can all be interpreted in the manner discussed above. There is only one variation (fig. 116)[134] that I would like to single out, since it represents a very important phenomenon. In this case, the lotus blossom not only has a two-leafed calyx with an outline resembling an acanthus like the one in figure 113; it also has another calyx further down with three acanthus leaves that are foreshortened in perspective. It is the evident use of perspective that makes the motif so remarkable in the period in which it first occurs; the innovation, moreover, was received with such enthu-

Fig. 116. Detail from the anta capital on the east porch of the Erechtheion.

[133b] [Furtwängler, *Collection Sabouroff*, Sculptures, pl. 6, and p. 7.]
[134] Quast, *Erechtheion*, vol. 1, pl. 6, no. 1.

siasm that it survives in all subsequent periods and plays a role in all sub-
sequent antique revivals. The middle leaf is simply a palmette fan that has
been turned down and has nothing at all in common with the leaf of the
acanthus spinosa (fig. 112). The lateral leaves, on the contrary, are not half
acanthus-palmettes, as one might expect, but full acanthus-palmettes
foreshortened in perspective. We also see the rounded "pipes," which
clearly mark the transition from leaf to leaf just as they occur between the
various individual sections of the leaves on the later, more developed
acanthus (fig. 111). It would be very difficult to argue at this point that the
characteristics of the *acanthus spinosa* had any influence on the motif:
there is nothing about the foreshortened calyx in figure 116 that would
suggest any closer connection with the *acanthus spinosa* than there was in
figures 113–115. The motif, therefore, must be seen as a product of pure
artistic invention, but one that, of course, reflects the general preference
of the period for more naturalistic vegetal forms.[o]

Until now we have been relying exclusively on the earliest acanthus
examples from the Erechtheion, plus the two grave stelai mentioned
above. It is now necessary to introduce other fifth-century monuments
that will allow us to test the validity of this attempt to derive the acanthus
ornament from a sculptural translation of the palmette. A particularly
good example is the capital from Bassae (Phigalia). It is almost unani-
mously considered the earliest Corinthian capital, and it is often held to
be the point of departure for the development of the acanthus. Since the
work is so important, why, one might ask, did we not treat it at the very
beginning of this discussion instead of the examples from the Erech-
theion? I think that there are good grounds to justify the order I chose.
First of all, the Corinthian capital from Bassae is by no means so well
known that one can evaluate it with certainty, as is often assumed. The
original is now lost, and even when its whereabouts was known, it was
already in very bad condition. Not even a plaster cast of it has survived. In
order to interpret it, therefore, we are forced to rely on graphic reproduc-
tions, and it is immediately apparent that the reproductions in the various
handbooks vary considerably. All of them, however, can be ultimately
traced back to two original drawings, one by Donaldson, the other by
Stackelberg.[134a]

Donaldson's drawing is apparently the more trustworthy, since it repro-
duces the original capital in its mutilated condition. Stackelberg, on the

[134a] For Donaldson's drawing see J. Stuart and N. Revett, *The Antiquities of Athens and
Other Monuments of Greece* (London, 1837), pl. 9, fig. 3; for the other, O. M. Stackelberg,
Der Apollotempel zu Bassae in Arcadien und die selbst ausgegrabenen Bildwerke (Rome,
1826), 44, fig. 117.

other hand, attempts to restore it to its original state. The two drawings deviate from each other in many essential points: above all, the structure of the acanthus is fundamentally different in both cases. Closer observation reveals, however, that the soft, limp way that Donaldson rendered the acanthus is really a result of his hasty, sketchy execution.[135] On the other hand, the individual leaves in Stackelberg's drawing (fig. 117) look

Fig. 117. Corinthian capital from the temple of Apollo at Bassae-Phigalia.

just like the ones on the Erechtheion. Here we see full acanthus leaves arranged in a row around the bottom of the capital and overlapping the lower stems of the various volutes growing above them. Each individual acanthus leaf displays a fan composed of three-dimensionally projecting leaflets. As a result, I would like to give priority to Stackelberg's reproduction, particularly since the author also talks specifically about the shape of the leaves in his text on page 42, thus demonstrating how well he had observed them: "The leaves of the capital are neither those of the olive tree, nor those of the acanthus, but on the contrary, they are copied from a conventional form, from an aquatic plant into the medium of stone." It is astounding just how closely the very first observer and interpreter of this capital perceived the actual situation. He was even right, although probably unconsciously, about the aquatic plant, since the palmette, of course, is derived from the lotus. Moreover, the inclusion of the phrase "into the medium of stone" clearly reveals how already Stackelberg

[135] This is also why I cannot accord any weight to the axil-filling acanthus that appears to be completely equivalent to the axil-filling palmette in the reproduction, even though it offers a convenient confirmation once again that the palmette-fan and the acanthus were originally identical.

201

had intuitively recognized the sculptural impulse as the factor that led to the stylization of the "conventional form."[136, p]

All of the acanthus-palmettes on the capital from Bassae are depicted frontally. The acanthus also occurs, however, on the same building in the form of a calyx, just as it does on the Erechtheion, where, we have discovered, it is based on the half palmette. Stackelberg reproduces a fragment of cyma and a terra-cotta antefix.[137] These correspond to Donaldson's drawings,[138] so that we now have fresh evidence that the acanthus on the capital was also stylized in the same way. The antefix on his plate 5, figure 4, is drawn with particular care so that one can see very clearly how the sharp projecting points of the contours really do represent the grooved, indented furrows on the original relief, and that the projecting ridges in the latter case are the leaves of the fan.

Aside from subsidiary, architectural decoration and the acroteria of grave stelai, there are also painted Attic lekythoi that figure significantly in the earliest history of the acanthus. Because the vases of this category were used in funeral rites, there is usually a grave stele shown in the middle of the vase, which is also associated with burial and the cult of the dead, to the left and right of it the ceremony takes place. These grave stelai are crowned with acroteria. Oddly enough, they rarely resemble the simple palmette acroteria that occur on the stelai that have actually survived.[q] Such an exception is illustrated by Benndorf.[138a] Besides the palmettes, there are usually acanthus leaves, which, however, are completely different in number and arrangement from those decorating the acroteria of actual stone grave stelai. For that reason, the acanthus motifs on grave stelai in vase painting were seen as "completely without precedent and not organically related in any respect to the volutes depicted in the early type of stele."[138b]

However, I find it at least questionable to assume that the majority of stelai painted on vases were actually modeled on the palmette-acroteria of the actual rectangular, slablike stone stelai that have been preserved. On the evidence of the convex line swelling toward the top, which is created by the cyma and taenia moldings that encircle the shaft of the stele

[136] The reproductions based on Donaldson distort the original appearance of the capital to an even greater extent. The example in J. Durm, *Die Baukunst der Griechen* (Darmstadt, 1881), has a double row of acanthus leaves around the base, which are stylized in the fully developed manner of the Monument of Lysikrates.

[137] Stackelberg, *Apollotempel zu Bassae*, the cyma is illustrated on page 45 and the antefix on page 101.

[138] Stuart and Revett, *Antiquities of Athens*, pls. 4–5.

[138a] [O. Benndorf, *Griechische und sicelische Vasenbilder* (Berlin, 1869–1883), pl. 14.]

[138b] [Furtwängler, *Collection Sabouroff*, 8.]

(fig. 114), what we have before us is not a rectangular, slablike pier but a round column.[139] On the contrary, the grave stelai, which are meant to have the shape of a rectangular pier and are distinguished as such by the triangular shape of the acroteria, have cyma moldings that are completely horizontal:[140] this a clear proof that the person who drew the curved line in figure 114 did so intentionally in order to represent a rounded shaft. This is so obvious and undeniable that it cannot be dismissed even on the grounds that no cylindrical grave stelai have survived in the original.[141] If what we see on the lekythos represents a column shaft, however, then the crowning motifs no longer decorate a one-sided acroterion but a circular capital. For this point, let us turn to the five motifs crowning the stele in figure 118.[141a] The way they are depicted in perspective makes it clear beyond a doubt that they are arranged on a hemispherical ground plan. That would also explain the increase in number and the apparently inorganic way the acanthus leaves are juxtaposed. As a result, the acanthus capitals of the grave stelai painted on Attic lekythoi can now be related more closely to the capital from Bassae, and they are therefore indispensable aids in establishing the early history of the Corinthian capital.[s]

Only specialists will be able to find the full explanation for this aspect of the paintings on lekythoi and for the many other features that they contain. Our sole concern at the moment is to clarify the relationship between the palmette and acanthus motifs. In figure 114, the acanthus leaves were represented from the side (acanthus half leaves); the central one, however, from the front (full acanthus leaf). In figure 119,[141b] on the other hand, the palmette placed in the middle between two acanthus half leaves is stylized in the traditional, two-dimensional way. However, even the

[139] Cf. also Benndorf, *Griechische und sicelische Vasenbilder*, pl. 25; F. Duhn, "Charondarstellungen," *Archäologische Zeitung* 43 (1885), pl. 3 (here, fig. 118); and C. Robert, *Thanatos* (Berlin, 1879), pl. 1.

[140] For example, Benndorf, *Griechische und sicelische Vasenbilder*, pl. 18–20.

[141] Hemispherical stelai shafts, however, have been found, see A. Conze, *Die attischen Grabreliefs* (Berlin, 1893), no. 59, p. 20. In this context, I would also like to point out the painting on a lekythos, which has recently been acquired by the k.k. Österreichischen Museum in Vienna from the estate of Count Prokesch-Osten, a former diplomat who traveled widely in the Near East. The grave stele still has a rectangular shape with a straight cyma molding; however, on top there is a chair with a basket beneath it. The artist, therefore, cannot possibly have been thinking in terms of a flat slab but of a square ground plan. Whether or not stelai shaped like square piers really existed at the time is beside the point: the fact remains that four-sided piers existed in the imagination of the artist, and we will have to assume the same about the stelai shaped like cylindrical columns. The lekythos could not be included in the catalog by K. Masner (*Die Sammlung antiker Vasen und Terracotten in k.k. Österreichischen Museen. Katalog und historische Einleitung* [Vienna, 1892]) however, the author expects to publish it shortly, which is why I have not included it here.[r]

[141a] [From F. Duhn, *Archäologische Zeitung* 43 (1885): 2–23, pl. 3.]

[141b] [From Benndorf, *Griechische und sicelische Vasenbilder*, pl. 22, no. 2.]

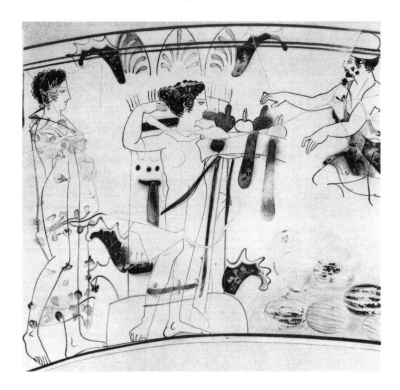

Fig. 118. Painting from an Attic white-ground lekythos.

Fig. 119. Painting from an Attic white-ground lekythos.

lateral half leaves are sometimes rendered as unmistakably flat half palmettes, like those in figure 120.[142] One can only conclude that both two-dimensional palmettes and the ones resembling acanthus were interchangeable and, therefore, originally identical and equal in importance. Finally, let us refer again to figure 118: the full-faced, flat palmette in the middle is shown in the frontal view; the two palmettes flanking it are also

[142] From O. M. Stackelberg, *Die Gräber der Hellenen* (Berlin, 1837), pl. 44, no. 1. Number 2 on the same plate shows a two-dimensional palmette inserted into a three-leafed acanthus calyx, which is awkwardly drawn in perspective.

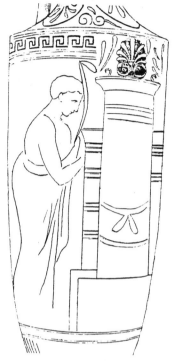

Fig. 120. Painting from an Attic
white-ground lekythos.

two-dimensional but seen in per-
spective. That is to say, they are no
longer completely frontal but also
not purely in profile. Finally, to the
extreme left and right, the palmettes
are shown in the simple profile view
and, as a result, have assumed the
shape of the acanthus.

Therefore, the examination of the
painted acanthus on lekythoi has also
shown initially that the tendency was
to depict these motifs in the profile
view, in the form of a half palmette,
parallel with the sculptural calycal
form found on decorative architec-
tural members. Figure 114[143] also
proves that the thorny points on the
contours of the lateral leaves are
purely a product of the attempt to re-
produce the indentations in perspec-
tive, since the jagged, admittedly
hastily sketched contours of the cen-
tral palmette come to no such em-
phatic points. Thus the results of this inquiry into the painted acanthus
agree completely with what we observed about the sculpted versions of
the acanthus on the earliest monuments.

The preceding arguments furnish, I believe, convincing evidence that
the acanthus ornament was a product of the natural course of artistic de-
velopment and that it did not originate from the sudden imitation of a
particular species of plant without artistic precedent. As far as an assess-
ment of Vitruvius's story is concerned, there is nothing much that can be
said, as I mentioned before, until the subject is studied from a philological
perspective. Generally speaking, I find Vitruvius's report highly question-
able, even on the surface. It would be so typical of the Romans of Vitru-
vius's time, and so typical of their attitude generally to have concocted a
rationalistic explanation, so to speak, for the origin of the acanthus. At any
rate, the Greeks had apparently already noticed the superficial similarity
between the mature acanthus ornament and the *acanthus spinosa*. And

[143] See also Benndorf, *Griechische und sicelische Vasenbilder*, pl. 25.

even if Theokritos, the third-century Greek poet, was, in fact, thinking of the acanthus as an ornament in his oft-quoted passage from *Idyl* 1.55, (although it is highly unlikely, since he referred to it as "moist"), this still contributes very little to our knowledge of how the Greeks originally saw the motif.[t] Above all, we must ask what pressing motivation gave rise to the imitation of the acanthus as an ornament in stone. The burgeoning naturalism in the Greek artistic sensibility after the Persian Wars should not, of course, be understood as a simple compulsion to make direct copies of living organisms. On the contrary, it was a process that infused age-old art forms with new life, rather than a desire to transpose the living forms of nature into lifeless material. There must, therefore, have been some sort of external impulse that prompted the assimilation of the acanthus motif into the repertory of existing decorative vegetal forms—an impulse somewhat akin to the one that prompted the Egyptians to create their lotus motifs.

Brückner is the only one who has recognized the need to answer this question, and he has even attempted to do so: "The acanthus plant, just as it does today, always grew rampant around temples and tombs; the paintings on the white-ground lekythoi document it on graves.[143a] Therefore, when the vivacious acanthus motif appeared next to the ancient conventional palmette in fifth-century sculpture, the grave stelai it decorated slowly began to merge with the surrounding vegetation until they were both virtually inseparable."[144, u]

The situation as Brückner describes it may have sufficed to prompt the introduction of a completely new and artistically significant motif into the history of decoration, but there is at least still room for a difference of opinion. Brückner's assumption, further, is based on a misconception: the acanthus on the painted lekythoi that he saw as a growing plant is, in reality, the acanthus ornament used "tectonically" to emphasize the part where the column begins at the base.[144a] This function corresponds to the postulate discussed in detail above and is completely identical with that of the leafy calyces occurring on the bottom parts of vases.[144b] The ornament

[143a] [Ibid., pl. 14.]

[144] Brückner, *Ornament und Form der attischen Grabstelen*, 82.

[144a] For two-dimensional conventional palmettes functioning in the same way, see *Monumenti inediti*, Deutsches Archäologisches Institut, 8 (1864–1868), pl. 10; for an example carved in stone, Perrot and Chipiez, *Histoire de l'art dans l'antiquité*, vol. 3 (Paris, 1885), 79, fig. 28.

[144b] For acanthus motifs functioning in the same way on a vase where, significantly enough, they rendered in relief, see L. Stephani, "Erklärung einiger in den Jahren 1878 und 1879 im Südrussland gefunderer Kunstwerke," *Compte rendu de la Commission Impériale Archéologique*, St. Petersburg (1880), atlas, pl. 4, no. 8.

is found only here (fig. 118), above the base, and most clearly of all on another example cited by Brückner.[144c, v] There, the acanthus on the lower column shaft is just like the one crowning the "acroterion"; it is a pure ornament and not intended to represent a plant. Of course, this does not preclude the possibility that acanthus plants were growing profusely around temples and tombs by the fifth century. What the lekythos paintings do not support at all, however, is the notion that the sheer existence of this particular weed impressed the Athenians sufficiently for them to have singled it out as being expressly worthy of decorating their grave stelai. This is another instance where modern standards have been imposed upon antique circumstances: the search for "new" ornaments among natural flora is really a product of the most modern artistic sensibility, reflecting to a certain extent the contemporary artistic dilemma.[w] The creation of ornament in antiquity went a very different and essentially more artistic route, which departed from the relatively unimaginative transcription of nature.[x]

The developed acanthus motif with its advanced leaf articulation does not occur at all specifically on any of the earliest monuments that come into question here. The decorative motif does only begin to resemble the *acanthus spinosa* in the course of further development. Certainly, as the acroteria on grave stelai have shown, the development progressed relatively quickly and, moreover, though by no means accidentally, in sculpture and not in painting. Brückner, as well, had already emphasized this circumstance: "It is characteristic of Attic decorative painting, and especially Attic vases, that, among the patterns which have survived, the representations of the acanthus are exceedingly modest."[y]

10. Hellenistic and Roman Tendril Ornament

We have come to recognize the acanthus as the most important vegetal motif that emerged from a thriving new naturalizing tendency in Greek art that began no earlier than the middle of the fifth century, as far as we can see. Even the schematized profile view of the lotus blossom did not remain unchanged in the long run. There began to appear variations of the three-leafed calyx shaped like bells, umbrellas, or pears, which departed much further from the original Egyptian prototypes than any of the other Near Eastern styles or Archaic Greek art. There were also seemingly new blossom types, which were obvious attempts at projecting forms in perspective. At present, one can only speculate that these motifs also

[144c] [Cf. Benndorf, *Griechische und sicelische Vasenbilder*, pl. 14.]

developed from the elements already available within the history of orna-
ment, although a special investigation will be necessary to decide the
issue. The available material consists mainly of Italiote Greek vases from
South Italy,[145] which, unfortunately, have not as yet been compiled and
sorted out, much less researched.[a] The interest in Hellenistic art, of
course, did not really begin until the excavations at Pergamon. Theodor
Schreiber, in particular, has been a sensitive and enthusiastic advocate of
such decoration. It would be extremely helpful if one could thoroughly
and systematically fill the gap that now exists between Attic vase decora-
tion of the fourth century and Pompeiian ornament. The last task in our
present investigation is to demonstrate how Hellenistic art with its strong
decorative tendencies finally brought Greek vegetal ornament to the goal
it had been steadfastly pursuing for centuries.[b]

The structure of the individual vegetal motifs attached to the tendril
lines had, in fact, reached this goal by the Periclean period at the latest.
The acanthus motif represented the extreme which naturalistic vegetal
ornament could attain without falling into direct imitation.[146] The altera-
tions, elaborations, and variations encountered on the blossom motifs of
Hellenistic and Roman tendril ornament should not be seen as the crown-
ing achievements of the preceding development but as the first signs of
the fundamental innovations to follow. The refinements in tendril orna-
ment, which Hellenistic art still had to address, did not focus on the treat-
ment of the individual motifs but rather on the way in which tendrils could
be extended across the available space.

The physical prerequisite, as it were, for a more expansive use of deco-
ration, namely, the free, artistic manipulation of tendril ornament, had
already been fulfilled by black-figure vase painting. Basically, the only
problem left was to provide the necessary space for tendril ornament to
reach its full potential. This came about during the Hellenistic period. It
was not as though the artistic preoccupations of the period centered only
on satisfying a simple decorative urge rather than the solution of greater
artistic problems. Such problems, however, belonged predominantly to
the realm of architecture: the patrons of the Hellenistic monarchies with
their Orientalized conceptions were no longer satisfied with the noble

[145] One could devote an entire monograph to the neck decoration of South Italian vases as
regards their translation of blossom types into "surface ornament," i.e., their creation of
"two-dimensional" vegetal pattern, an achievement usually associated with middle eastern
art.

[146] There are, of course, a few rare cases of blossoms in Pompeiian wall painting that were
copied closely from natural models and, moreover, not apparently for their representative
value but for purely decorative purposes. However, this was obviously just a passing fancy:
naturalistic reproductions of flowers are again missing in later Imperial decoration, while
palmettes and acanthus, on the other hand, continue to be represented.

simplicity of columnar buildings. The fantasies of this epoch concentrated on massive construction and vaulting. They were able to build whole cities in record time and construct magnificent buildings like the Serapeion in Alexandria, where sculpture and painting played a subordinate role as decoration. The goal of sculpture and painting, therefore, was now predominantly decorative, and consequently the time was ripe for the lovely lithe tendrils to come into their own.

Unfortunately, almost nothing remains of the splendid buildings and decorations of the Hellenistic monarchs. We are compelled to assemble the fragments carefully in order to reconstruct the final development of Greek tendril ornament. The vase from Nikopol (Chertomlyk) in the Hermitage, illustrated in figure 121, is an excellent example of tendril

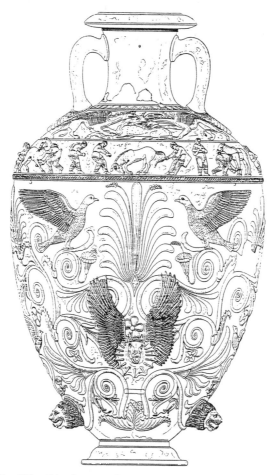

Fig. 121. Gilt silver amphora from Nikopol-Chertomlyk.

ornament decorating the entire belly of a vase.[147] We see only one side of the vessel, but the decoration on the other side is very similar. The sort of figurative frieze of fifth-century Attic vases is now restricted to a narrow band on the shoulder; the largest part of the surface by far is taken up by tendril-work. At the bottom, there is a three-leafed calyx with one full leaf shown frontally between two halves in profile. Two tendril stems sprout up from the calyx, spreading out symmetrically in an undulating motion toward the upper edge. Among the tendrils are a number of acanthus motifs. As sculptural half palmettes, they serve as sheaths for the bifurcations and provide calyces for the lotus blossoms and palmettes; hence, they are stylized in the same way and have the same function as those on the Erechtheion. Alongside these sculptural half palmettes in perspective, there are also the traditional, abstract, two-dimensional types, they are curved and based in part on the split palmette. The blossoms are also often in the form of the early two-dimensional palmettes, although some of them are rendered in perspective with naturalistic details. This coexistence of flat, abstract, and sculptural, perspectival forms is especially characteristic of Hellenistic ornament, and it is observed frequently on the neck decoration of Italiote Greek vases. In addition, the birds interspersed on the Nikopol vase are especially noteworthy. As creatures of the air hovering about, they are ideally suited for the purpose, and thus they appear with half-open wings. The elegant rhythm of the tendrils is clearly very free; symmetry is still observed, but it does not dominate the general impression.[c]

However, Greek art had not struggled through the centuries in vain to perfect the greatest undertaking of all sculpture and painting—the depiction of the human figure. And so finally, the human figure also entered the realm of decoration. It was the task of Hellenistic artists to find an appropriate means of combining human figures and tendril ornament. We have already seen a forerunner for this in Attic art of the fifth century in figure 108. The solution was relatively simple when the format was a border strip or frieze. The diadem from Elaia in figure 122 is an excellent example of the way the problem was handled in Hellenistic art.[148] The seated young male figures to either side of the central palmette are winged Erotes; the floral decoration is stylistically very close to that of the Nikopol vase. A comparison between the continuous tendril filled with half palmette-fans,

[147] From L. Stephani, "Erklärung einiger im Jahren 1863 im Südrussland gefundener Gegenstände," *Compte rendu de la Commission Impériale Archéologique, St. Petersburg* (1864), atlas, pl. 1.

[148] From A. Conze, "Goldschmuck, kleinasiatischer Fundorte," *Archäologische Zeitung* 42 (1884), cols. 90–94, pl. 7, no. 1.

which runs around the diadem, and that on the border of the Klazomenian sarcophagus in figure 76 is also very revealing: on the one hand, the basic scheme is identical; on the other, the stylization of the fans of the half palmette fillers was changed, obviously a result of the intervening tendency toward livelier movement.[d]

Fig. 122. Gold diadem from Elaia.

Fig. 123. Gold diadem from Abydos.

A richer use of human figures occurs on the diadem from Abydos in figure 123:[149, e] Dionysos and Ariadne are seated in the middle on a double acanthus-calyx with figures playing music arranged to either side along the tendril volutes. The motif that terminates the tendrils at both ends played a large role in Hellenistic and later in Oriental art. It is probably the same one that Jacobsthal[150] identified with a plant indigenous to Greece, the *dracunculus vulgaris*. Of course, I doubt this assertion on principle, while I also think that it cannot serve to explain the spread of the motif, particularly in the Near East. Similar motifs, obviously conceived as palms, were already depicted in Egyptian art at the time of the pharaohs, an example of which is figure 124.[150a] In figure 123, the motif

[149] From *Blätter für Kunstgewerbe*, 5, no. 4; also see Conze, *Archäologische Zeitung* 42 (1884), cols. 93–94.

[150] "Sitzungsberichte," *Archäologische Zeitung* 42 (1884), cols. 70–71.

[150a] R. Lepsius, *Denkmäler aus Ägypten und Äthiopien nach den Zeichnungen der von Seiner Majestät dem Könige von Preussen Friedrich-Wilhelm IV nach diesen Ländern gesendeten in den Jahren 1842–1845 angeführten wissenschaft-lichen Expedition* (Berlin, 1849–1856), Abtheilung 3, Blatt 63, top center; cf. Abtheilung 3, Blatt 95. [Riegl's original citation of Lepsius, Abtheilung 3, Blatt 69, was incorrect and has been emended here.]

Fig. 124. Crowning terminals of Egyptian stylized date palms.

functions more or less as the axil-filling termination of the tendril.[f] We now see that combining figures with spiraling tendrils in the format of a frieze was relatively easy. The same was true of pilaster decoration, one of the most brilliant examples of which was found in the Villa Hadriana.[150b] The solution was more difficult, however, when the figures dispersed across a larger area of tendril-work. A consummate example of this kind is the silver krater in Hildesheim.[151] The putti were obviously chosen for their buoyant agility and humorous charm, which makes them more suitable than adult figures for the gay, playful purposes of decoration. In addition, there are tiny sea creatures—crabs, sea horses, and fish—which some of the putti hunt with Poseidon's trident, while others frolic among the spiraling tendrils. The Hildesheim silver krater is sometimes dated to the Roman period. Even if this is true, there is still no doubt that the basic decorative concept of freely unraveling tendrils interspersed with childish figures is Hellenistic in inspiration. The arrangement we find in the early Roman imperial period (Pompeii, Villa Farnesina) is already highly developed and distinctive, at a point that has obviously transcended the preliminary.[g]

In works like the Hildesheim krater, the potential of the decorative vegetal tendril reached its apogee; the cycle had run its course. As a result, the problems that we pursued concerning the development of tendril ornament from its earliest beginnings in Mycenaean art up through its most mature formulations have all been solved, and this chapter could justifiably end here. However, as already suggested, there were further changes and developments during the Hellenistic and Roman Imperial periods pertaining to the detailed treatment of the tendrils and the stylization of the attached blossom and leaf motifs. These should be understood not as conclusions to the process begun in pre-Periclean times but as early indications or beginnings of a new style that would eventually strive for fundamentally different goals. It would, therefore, be useful to examine some of this Hellenistic decoration briefly to facilitate the transition to our discussion of Byzantine and Islamic tendril ornament.

[150b] [L. Canina, *Gli edifizi di Roma antica e sua campagna*, sezione 2, "gli edifizi antichi dei contorni" (Rome, 1856) 5:191; vol. 6, pl. 172, bottom center.]

[151] H. Holzer, *Der Hildesheimer antike Silberfund und seine archäologische und artistische Bedeutung* (Hildesheim, 1870), pl. 3, no. 1.

In the course of the development of Greek tendril ornament, the palmette had gradually become the most important of all the individual motifs we have considered. More specifically, it was the palmette-fan that was best suited to filling the various kinds of axils created by the bifurcations in the tendrils. Whenever the ends of two spiraling tendrils came together to form a calyx, the fan of the full-palmette was there to fill it. If it were only a case of a tendril branching off from the main stem, then it resulted in only one spiraling coil or half of a calyx, which then required only a half-palmette-fan. Finally, if the bifurcation of the tendrils produced a very narrow axil, then an even smaller section of a fan, a fourth or perhaps a third of a full palmette, would suffice.

When in the course of the fifth century, the treatment of vegetal ornament came to display an evident striving for greater life not movement, the most important and significant experiments in this direction centered on the palmette. Of course, this also effected certain naturalistic modifications in the formulae of profile blossom types. Yet the only ones that actually turned out to be enduring or classic were those based on the palmette.

We have become familiar with the split palmette as one of the first of these modifications. The lasting importance of this motif in the later development resulted from the division of the palmette-fan into two parts. The postulate of axil filling, as we have seen, had already prompted the birth of the half palmette, which because of its many functions, became readily more important, more serviceable, and therefore more assured of a greater future than the full palmette. The split palmette responded to that development by abandoning the unified fan and presenting itself unequivocally as the product of the symmetrical juxtaposition of two half palmettes.

The next decisive step was the creation of a perspectival type of palmette, which we call the acanthus. Here, we can also distinguish between the acanthus leaf corresponding to the full palmette and the so-called acanthus tendril, which is really nothing other than half an acanthus leaf running alongside a tendril in profile view and which, therefore, can be understood as a sculptural half palmette. We termed the first motif the *full acanthus leaf* and the second, the *acanthus* half leaf.

From the end of the fifth century onward, both versions coexisted—the two-dimensional and the sculptural-perspectival. They occur together on the Nikopol vase and, as indicated earlier, also on the Italiote Greek vases of the fourth and third centuries. Another example is the diadem from Elaia (fig. 122). Nevertheless, decorations continue to occur centuries after the emergence of the acanthus that are still based on the two-dimensional, stylized palmette-tendril. They appear typically under the vase

handles, which had always provided a refuge for pure ornament. The figurative depictions, in contrast, cover the necks of vases, where at least a human head but often a whole figure provides the focal point of the decoration, thus explaining the use there of sculptural-perspectival acanthus as well. We shall first examine the two-dimensional palmette tendril.[h]

a. Two-dimensional Palmette-Tendrils

What confronts us in figure 125[152] is the same basic system of clustered palmettes familiar from fifth-century Attic vase painting: the large palmette below is enclosed by two linear tendrils, which open up above the crown of the palmette symmetrically to left and right in undulating curves; the numerous axils that result are filled by full palmettes, half palmettes, and segments of palmette-fans. Nevertheless, closer examination does reveal certain peculiarities, some of which are only minimally characteristic of fifth-century Attic palmette-tendrils, while others are entirely different.

Fig. 125. Apulian red-figure vase ornament.

[152] From O. Jones, *The Grammar of Ornament*, (London, 1856) pl. 19, no. 7.

First of all, let us consider the careful manner in which the space is filled. The individual motifs are densely compressed in a way that obviously reveals the artist's intention to leave as little of the black background free as possible. This sort of *horror vacui* is foreign to Attic vase painting, at least during the period before the Peloponnesian Wars. How can we explain its reappearance? Apparently in the same way that we explained its corresponding presence in the Dipylon Style, etc., namely, as a renewed and intensified decorative urge, a tendency that indicates a slow but increasingly powerful desire to cover surfaces with decorative patterns as lavishly as possible. This also concurs with the general character of Hellenistic art. Until the Periclean period, Greek art had been characterized by the drive to depict the objective world and also by the overwhelming ambition to master human anatomy and give concrete form to the religious, ethical, and political concepts motivating Hellenic culture. By the last third of the fifth century, this process had reached a point that could hardly be surpassed. Then the delight in decoration once again stirred, pressing toward the other of the two poles between which all art fluctuates. There were already enough grand and sublime artistic formulae to gratify the eye and spirit. Pompeiian interior decoration, for example, is characterized most immediately by its playful manipulation of the formulae that the preceding age of artistic greatness had created to depict the characters of heroic myth. Naturally, a period such as this required a repertory of purely decorative forms completely different from that of sixth- and fifth-century Greek art, which had been preoccupied primarily with monumental and figurative problems. The appropriate repertory, however, could not be created in a single stroke; the first step, therefore, was simply to effect a more profuse and elaborate use of the traditional decorative forms. This is the stage embodied, among other things, in figure 125. Attic painters of the first half of the fifth century had been content to apply a single branching tendril sporadically under the handles of vases. But now all of the remaining space, both around the handles and around the figural scenes on the bellies of vases, was filled out as much as possible with palmette-tendrils.

The distinction between what we have just described in figure 125 and the earlier Attic manner lies in the overall approach to the tendril ornament. However, this is more a symptom of a new and developing trend than an example of an established rule. The enormous effort that Greek art had clearly devoted to tendril ornament since the Mycenaean period still manifested itself strongly (as we can see, thanks to the increase in available evidence) on certain products of the Hellenistic period, like

the Nikopol vase or the silver krater from Hildesheim. That is why we also consider these two works to represent the consummation of the preceding development, whereas the compressed tendril ornament seen in figure 125 announces a new artistic spirit directed toward other goals.[i]

In figure 125, we still encounter a few peculiarities in the details of the individual vegetal motifs. The thickening of the offshoots from the tendril is worth noting. The intention was apparently to make these offshoots appear more substantial than the fine, coiling spirals. One can observe this in the lower half of the ornament on the offshoots from the tendrils that run up on either side curving toward the middle. Below the tendril forms a spiral; above it broadens out into a shape that resembles a slug, while three leaves of a fan segment fill the axil between. The broadened offshoot was obviously not meant to function as a simple calyx like the spiral tendril, and this allows us to identify the whole motif as a freely terminating half palmette.[j]

I would stress the words "freely terminating" in regard to this half palmette, because in figure 125 there are also a number of half palmettes that do not terminate freely, whose tendrils instead run on beyond their crowns. This is the third basic characteristic to note about this kind of tendril ornament. Let us follow the tendril line that runs up to the right of the lower central palmette. First it forms a calyx at the pointed crown of the lower palmette, together with its mate on the left for the upper middle palmette above it. Then it spirals off to the right, curving downward, while at the same time, it gives rise to a spiraling offshoot. In the axil between the new shoot and the main tendril is the fan of a half palmette whose (half) calyx gave rise to the spiraling offshoot just mentioned. Certainly the half-palmette-fan was originally conceived as no more than a minor axil filler. However, in the present case, the relationship between the spiraling calyx and the fan is already so perfectly refined, and the shape of the half palmette already so apparent to the eye, that it is impossible to believe that the vase painter did not consciously intend it. However, let us see what happens next. The tendril continues from the tip (the crown) of what we have just confirmed as a half palmette; it then coils around again upward to form another half palmette and goes on to enclose a full palmette, ultimately to end in a freely terminating half palmette with its thickened tip curving out energetically to the side.

There are two things worth stressing in all of this. The first is that there are blossom or leaf motifs like the half palmette that clearly resemble plants, although they are not free terminations, since the tendrils continue to run beyond their tips or crown. This is a drastic departure from

the basic law of nature, for leaves and blossoms usually crown the top of a stem. Of course, there was nothing to prevent ornament from taking such liberties, but it is nevertheless extremely important to observe when and how this first took place. It was obviously the result of a purely artistic process. We have witnessed the extent to which the postulate of axil filling was respected throughout the art of antiquity, beginning in Egypt, and there is no doubt that it was this postulate that gradually led to the development of the *embedded* half palmette, as we will call it. I also do not believe that the vase painter of figure 125 conceived of the tips of the crowning parts of the half palmettes as the starting points for the tendrils that continue. The sculptural-perspectival half palmette, which we also refer to as the acanthus half leaf, provides final proof of this. In its original stylization, it appears virtually embedded in the tendril and not shooting off from it. What makes the present example so extremely important for the future development, however, is the fact that the forms are two-dimensional. Later art, which turned away from naturalism and intentionally ignored the original plantlike qualities of the ornament, subsequently took these forms and successfully transformed them into more or less abstract shapes, although the Greek painter of figure 125 probably had no idea that his stylization of the vegetal ornament was clearly at odds with nature.

It is also worth examining the crowning tips of the free half palmettes, whose broadened, substantial forms were discussed earlier. What we want to focus on now is the way they bend in strong, outward curves. Naturally, the free half palmettes could curve around more energetically; however, it is important to note that the embedded half palmettes also tend to bend their crowns. It is the spirit of the split palmette that informs this work, whose expression is of course already facilitated in the embedded half palmettes by the undulating movement of the tendril itself. very good illustration of how the half palmette tends to bend its crowning tip in an outward curve appears in figure 126,[153] where, moreover, the fans of the half

Fig. 126. Greek vase decoration.

[153] Ibid., pl. 20, no. 1.

217

palmettes in the middle are reduced to spherical triangles with no suggestion of leaves, and almost resemble geometricized Arabesques.[k]

The form of palmette-tendril ornament in figure 125 is so important that it easily warrants the inclusion of a second example, which is found in figure 127.[154] The scheme is basically the same as in figure 125, though less richly developed in proportion to the smaller area allotted to the ornament. The ground is filled up in the same sumptuous manner, and there is also the same arrangement of embedded and freely terminating half palmettes. On the inner coils, however, there was not enough room for a complete half palmette-fan, so that the treatment of the axil filling approaches more closely what we observed on the Mycenaean example in figure 64. The free half palmettes with their broadened and curved offshoots have spherical triangles like the ones in figure 126 instead of leafy fans. Figure 128[155] proves that the leafy fan is in fact latent in this geometric form, for even though the half palmettes are closed off by unified contour lines, the interior leaves of the fan are still indicated.

Fig. 127. Painted tendril ornament from an Attic lekythos of the fourth century B.C.

Fig. 128. Ornament from a Greek red-figure vase.

[154] Taken from an Attic lekythos in the k. k. Österreichischen Museum für Kunst und Industrie (K. Masner, *Die Sammlung antiker Vasen und Terracotten in k.k. Österreichischen Museen. Katalog und historische Einleitung* [Vienna, 1892], no. 370). The editing staff of this catalog headed by Dr. K. Masner was often very supportive and helpful to me while I was writing this chapter about antique vegetal ornament, and I would like to take the opportunity to thank my coworker at this time.

[155] From Stephani, "Erklärung einiger im Jahren 1863 im Südrussland gefundener Gegenstände," *Compte rendu de la Commission Impériale Archéologique,* St. Petersburg (1880), atlas, pl. 5, no. 1.

Since Italiote Greek vases are our main source for following the further development of two-dimensional palmette-tendril ornament in the Hellenistic period, it is important to note that the lekythos illustrated in figure 127 comes from Athens, as Masner brought to my attention. This is important because it demonstrates that the special characteristics we have discussed do not simply represent the provincialism of the South Italian Greek cities, but a development that was widespread because it was obviously a natural extension of what had preceded it.[1]

Two-dimensional palmette ornament remained in use during the Roman Imperial period as well, if only to a modest degree. But in the western Empire, it was especially the sculptural-perspectival palmette ornament, the so-called acanthus, that gradually came to dominate. However, even here, there are still isolated cases in the latest period (Spalato) of two-dimensionally stylized split palmettes alternating on one and the same tendril with acanthus-inspired palmettes. Even spiraling undulating tendrils without any plantlike attachments and axil fillers, exactly like the basic scheme of the Mycenaean example in figure 50, remained in use far into late Roman times.[156] Indeed, in the eastern Mediterranean, as Attic art was losing its position of dominance and Greek art had now become supreme in the Near East, two-dimensional types of ornament enjoyed great popularity in a conservative milieu, as opposed to the predominantly naturalizing tendencies current in the West.[m]

The center of the artistic activity and, therefore of ornamental development as well, was first of all not in the Orient but in the West. There is no doubt that contact with monumental works of Near Eastern art often had a beneficial and stimulating effect on the formation of Hellenistic art. However, the decisive factors that engendered the style came from the West, from Greece. If the most important arena for the early formation of Hellenistic decorative art really was Alexandria, as Theodor Schreiber would have us believe, then the city itself offers striking parallels for the art that originated there. It was a Greek colony on Eastern soil, inhabited by Greek citizens and ruled by Greeks, although according to Eastern monarchical principles. In short, it presents us with a mirror image of Hellenistic-Alexandrian art where the grandiose architectural concepts of absolutism (Serapeion), executed in luxurious, costly materials and daring building techniques (vaulting), were still Greek in detail and in their feeling for harmony and balance.[n]

[156] What we see on the beautiful Hellenistic diadem from Abydos (fig. 123) seems to be an undulating tendril; however, the short offshoots that accompany the first spiral to right and left of center are stylized to resemble acanthus. Therefore, it is actually an acanthus tendril, whose bushy leaves were omitted for the sake of the lyre-playing figures set into the spirals.

From this general review of the development of vegetal tendril orna-
ment, we may conclude that the naturalizing tendency, whose powerful
growth was already discernible in the last decades of Attic cultural hege-
mony, also had its effects on the art of the Orientalized courts of the Helle-
nistic monarchs. It is therefore not surprising that the sculptural-perspec-
tival palmette of Hellenistic vegetal ornament, i.e., the acanthus, gained
wide acceptance. And, moreover, it was not so much the full acanthus
leaf, as it might appear arranged around the calathus of a Corinthian capi-
tal, that came into play; it was instead the acanthus half leaf merged insep-
arably with the continuous or the so-called *acanthus tendril*.

b. The Acanthus Tendril

Even though it has long been known that tendrils of acanthus do not exist
in reality, no one has ventured to doubt that the plant itself served as the
model of the ornament. Nothing could indicate better how the influence
of Vitruvius's account has suppressed the true nature of acanthus orna-
ment, which is ultimately an invention of the creative decorative spirit.

If, however, the conclusion offered above is valid, namely that the acan-
thus motif really is nothing but a palmette projected three dimensionally
in perspective, then we can also expect it to appear in the same locations
in tendril ornament that it had occupied in two-dimensional palmette dec-
oration. The continuous undulating tendril will be our main concern be-
cause of its inherent properties; continuous offshoots branch off laterally
from the main tendril and create narrow axils, which the Greek artistic
sensibility required to be filled with half palmette-fans. Second, we will
have to investigate what happens to the acanthus motif when it appears on
the intermittent tendril.

The acanthus was adapted to the continuous tendril relatively soon on
works of art decorated in relief. Figure 129 reproduces the fragment of a
border from an embossed gold relief dating from the fourth century, as
published by Stephani.[156a] The border is divided into two strips; at the
moment, we will concentrate on the upper one.[157] It consists of a continu-
ous tendril, each of whose spiraling, involuted lateral offshoots terminates
in a naturalistic blossom. Each bifurcation in the tendril where the lateral
shoots branch off is sheathed by two acanthus half leaves. As one might
expect from our earlier explanation, they are nothing other than half palm-
ettes conceived three dimensionally in perspective. Just as in figure 125,

[156a] [Stephani, *Compte rendu de la Commission Impériale Archéologique*, St. Petersburg
(1864), atlas, pl. 4.]

[157] We will return to the lower strip when we get to the intermittent acanthus tendril.

Fig. 129. Embossed gold bow case from
Nikopol-Chertomlyk, detail of border.

the crowning tips of the palmettes are broadened and bent backward; the
branching tendril, whose axil has just been filled, extends out from be-
neath the curved crowning tip. At the same time, this energetic outward
curvature proves that Greek artists of the Hellenistic period did not think
to constrain unnaturally the plantlike qualities of half palmettes. Conse-
quently, we can probably also come to the same conclusion about the
two-dimensional, embedded half palmettes discussed above, where the
particular intention of the vase painter seemed so unclear.°

Figure 130, taken from the Sanctuary of Isis at Pompeii,[158] is an exam-
ple of the Roman treatment of the continuous acanthus tendril. Of course,
the Roman acanthus is usually thicker and more luxuriant, so that as a
rule, not much of the tendril stem is left uncovered. However, the exam-
ple I have chosen from an early stage in the development is better suited

Fig. 130. Stucco relief frieze on the Temple of Isis, Pompeii.

[158] From F. Niccolini, *Le case ed monumenti di Pompeii* (Naples, 1854–1896), vol. 1, part
2, "Tempio d'Iside," pl. 10.

for our purposes precisely because its relatively restrained treatment makes it easier to illustrate the structure of the Roman acanthus tendril. Our example is a stone relief, although contemporary wall painting was already making extensive use of the tendrils; some rather classical examples of this kind come from the Sanctuary of Isis as well.[159, p]

First, a few words about the treatment of the acanthus leaf as such. In comparison to the way the individual points project on the typical Greek treatment of acanthus motifs in the Monument of Lysikrates (fig. 111), those on figure 130 are conspicuously softer and more rounded. Some have attempted to explain this distinction in a manner eminently simple but utterly devoid of insight concerning the creative process. According to this explanation, acanthus motifs were rendered differently in the East as opposed to the West—namely with sharp points in Athens and rounded edges in Italy—because the plants that inspired the artists as models in either region were themselves different: the most common species of acanthus plant in Greece was considered to be the *acanthus spinosa*, while in Italy it was the *acanthus mollis*. There was nothing more natural, so the argument goes, than for the Greeks to have copied their own local, thorny acanthus for decorative purposes, while the Italians copied their own softer variety. However, if it already appeared questionable that the Athenians carved acanthus motifs on their grave stelai because they saw them growing around the cemetery, then we must shake our heads altogether at the exaggerated notion that Italian stone carvers, following the example of their Greek colleagues, began eagerly and carefully to make perfect copies of their own local weeds. On the contrary, the softer depiction of acanthus typical of the Roman period resulted from a change in style that was not limited simply to Italy, but also extended to the other formative regions of the Roman Empire, as the monuments in Asia Minor in particular demonstrate.[160] As we shall see, similar changes in the acanthus occurred at the end of late antiquity; the acanthus of the high Renaissance distinguishes itself clearly from that of Louis XIV and the French Empire in the very same way.[q]

Let us now shift our focus in figure 130 to the undulating tendril itself. Wherever a lateral offshoot branches off from the main tendril, the juncture is marked by an acanthus half leaf and, moreover, by a single leaf rather than the doubled, calyx-forming leaves of figure 129. On the other hand, there are more or less acanthus-inspired calyces that interrupt the

[159] Published by Niccolini and Jones, among others.
[160] For example, in Sillyon and Aspendos, see K. Lanckoronski-Brzezie, G. Niemann, and E. Petersen, *Städte Pamphyliens und Pisidiens* (Vienna, 1890–1892).

tendril stem at other points. Especially important, however, is the fact that acanthus half leaves occur even where the tendrils do not bifurcate.[r] This detail is particularly characteristic of Roman acanthus tendrils: as the number of leaves increases, the tendril stems become increasingly difficult to see until, by the Late Roman period, they virtually disappear. Up into the latest period, however, the pointed tip of the acanthus half leaf is always bent back emphatically. It does not merge with the tendril, therefore, but stands out from it as an independent, three-dimensional entity.

Now that we have finished with the continuous acanthus tendril, we must investigate how acanthus motifs were integrated within the scheme of the intermittent tendril. In this case, it was the palmette itself rather than the half palmette that had to be transposed into an acanthus format. Almost all of the material we have to rely on in order to trace this process dates back no earlier than the Roman Imperial period. Nevertheless, we will scarcely err if we conclude, on the basis of Pompeiian examples, that the transformation of lotus blossoms and palmettes with two-dimensional, unarticulated fans into acanthusized leaf forms had already begun in the Hellenistic period, even if it did not end there. All the same, the half palmette or acanthus half leaf manifests the first signs of this change. This is demonstrated by the lower strip of the gold plaque in figure 129. Admittedly, the alternating lotus blossoms and palmettes are not oriented in opposite directions as the scheme usually requires; they are instead juxtaposed in a row as on an arcuated frieze. The calyces under the blossoms, however, consist of curved, S-shaped bands, a feature that qualifies the pattern as an intermittent tendril.[s]

The acanthus motifs in the lower register of figure 129 occur only on the palmettes and, moreover, as half leaves filling the axils between the volute-calyx and the fan. It is basically the same modest use of the acanthus that we encountered at the Erechtheion (fig. 113) at the beginning of the entire development.

Before we investigate how the intermittent acanthus tendril matured during the Roman period, it would be useful to characterize briefly the particular importance that we have ascribed to this motif during the subsequent development of tendril ornament. The intermittent tendril clung to its original, basic Archaic scheme and to the original, two-dimensional stylization of blossom types much more tenaciously than the continuous tendril. That is to say, the intermittent tendril depended less directly on natural prototypes than its continuous counterpart. During the naturalizing artistic development, ivy and grapevines were translated into the continuous scheme, as we see especially in countless Pompeiian wall

decorations; even purely fantastic types of branches, although slightly resembling actual plants, began to be involuted as continuous tendril patterns.[t] The intermittent scheme, on the other hand, as a product of pure artistic fantasy, was inherently ill-suited for such a purpose. Occasionally, figurative motifs such as dolphins, cornucopiae, and the like, were playfully interspersed within the tendril; the blossom motifs themselves, however, retained the early stylized forms of the two-dimensional and perspectival lotus almost without exception up to the latest phase of antiquity. It goes without saying that in the following early medieval period, when a geometricizing tendency once again replaced the naturalism of Greco-Roman antiquity, it was the intermittent tendril with its more rigid form and relatively conservative motifs that became widely current, and consequently it will require our special consideration.

As I have already indicated, the ancient, two-dimensionally stylized palmette motifs survived longest on the intermittent tendril, far longer than on the continuous tendril. As a rule, they are split palmettes: however, palmettes with the old-fashioned radiating fans can still be found on works of the Roman Imperial period (fig. 135). There are two examples of the use of pure tendrils with two-dimensional palmettes such as the one from the Theater of Aspendos in early Imperial times, and that [in the Mausoleum of Diocletian] at Spalato (fig. 131) from late antiquity.[161, u]

Since the Hellenistic period, however, there were also palmettes stylized like acanthus motifs; these, as we have seen, were conceived three dimensionally in perspective. Figure 132, which is also from the mausoleum at Spalato,[162] shows two-dimensional, stylized split palmettes alter-

Fig. 131. Decorated cornice molding from the exterior entablature of the Mausoleum of Diocletian at Spalato.

Fig. 132. Decorated cornice molding from the entablature of the outer colonnade of the Mausoleum of Diocletian at Spalato.

[161] From R. Adam, *Ruins of the Palace of the Emperor Diocletian at Spalato in Dalmatia* (London, 1764), pl. 37, top.
[162] Ibid., pl. 30, top.

nating with palmettes of the type with *overflowing* leaves. But these, how-ever, are no longer flat and geometric like those on the split palmette but rendered with the details of acanthus. The tendrils connecting the motifs, on the other hand, do not have any plantlike qualities and still look, so to speak, like geometricized tendrils.[v]

The detail in figure 133[163] represents a rather decisive step with consid-erable consequences. The blossom motifs, alternately two-dimensional and acanthusized, are all of the overflowing type, but a very significant change has taken place on the curving tendrils connecting them. They are no longer simple geometricized lines but acanthus half leaves.[164] Now we no longer see the crowning tips, which usually bend backward; both ends of the leaf continue on like tendrils, not only from the points of inception but also from their tips or end, ultimately curving around to form the calyx for the neighboring palmette. What we see taking place here is what we had already encountered on the two-dimensional half palmette ornament of figures 125 and 127, although until now, this tendency had always been restrained in sculptural-perspectival tendril ornament by the way that the tips of the half leaves were made to bend back. The acanthus half leaf is now embedded; it has merged with the tendril, metamorphosing, in fact, into the tendril itself by appropriating its connective function. Since in nature, it is usually stems and not leaves that operate in this way, this represents an unmistakably antinaturalistic trend in ornament. The ten-dency, which had begun in the geometricizing, two-dimensional palmette tendril ornament of the Hellenistic period, at least in basic schematic

Fig. 133. Decorated cornice from the door of the temple near
Diocletian's palace at Spalato.

Fig. 134. Decorated cornice molding from upper interior entablature of
the Mausoleum of Diocletian at Spalato.

[163] Ibid., pl. 46, top.
[164] An example of this kind from Asia Minor is from the Nympheum at Aspendos, see Lanckoronski-Brzezie et al., *Städte Pamphyliens und Pisidiens*, vol. 1:100.

terms, assumed a tangible sculptural form in the late Roman period under the fruitful influence of a gradually increasing shift toward the geometric end of the spectrum.

Let us examine figure 134 from the palace at Spalato.[165] It is basically a repetition of figure 133: the same motifs,[166] connected by tendrils, are transformed into acanthus half leaves. These connecting half leaves do not curve from one palmette to the other as a series of regular leaflets; instead, they bifurcate in the middle. The minimal articulation of these bifurcated acanthus half leaves is also noteworthy because it again betrays a tendency toward two-dimensional, geometric schematization.[w]

The examples thus far are all from buildings of the Late Roman period. The complete acanthusization of the motifs and the connecting lines comprising the intermittent tendril, however, had actually taken place much earlier. I offer two examples from the Forum of Nerva. The motifs in figure 135[167] are standard lotus blossoms, alongside palmettes with leaves overflowing laterally, which alternate rhythmically in two-dimensional or acanthusized form. Even the flatly stylized leaves, however, exhibit an

Fig. 135. Frieze from the Forum of Nerva, Rome.

unmistakable naturalism in the way in which the clublike ends curve back. The motifs are all interconnected by acanthus half leaves that completely cover the tendril stems. The pointed tips of the main leaves curve back, of course, in characteristically Roman fashion. However, they emit still other acanthusized leaves instead of stems, and these curve around with their counterparts from the other direction to form the calyx of the next blossom motif. The linear or ribbonlike tendril stems have disappeared not only from the calyx but from the connecting curves as well; in their place are acanthus half leaves, which were inherently unsuited for such a purpose.

[165] Adam, *Ruins of the Palace at Spalato,* pl. 36, top.
[166] The flourishes on the calycal leaves of the split palmettes occur frequently on the acanthus ornament of monuments built under Diocletian (for example on the door of the Temple of Jupiter). A group of gold ornaments found at Nagyszentmiklòs in Hungary has similar characteristics.[x]
[167] J.C.A. Moreau, *Fragments et ornements d'architecture: dessinés à Rome d'après l'antique* (Paris, 1820), pl. 14, no. 3.

Figure 136 represents the end point of the whole development.[168] There is only one blossom motif, the lotus, which alternates with slight variations. Since the pattern is vertically mono-directional, it could almost be mistaken for an arcuated frieze. However, the underlying intermittent scheme is readily discernible in the configuration of the thick, bushy acanthus tendrils.[y]

Fig. 136. Frieze from the Forum of Nerva, Rome.

The following two details in figure 136 are of fundamental importance for the subsequent period: (1) The uppermost calycal leaves (in the form of acanthus half leaves) of every second lotus blossom curve around at the top and wind their way back down as undulating tendrils, turning up again at the bottom to coil around and form the calyx for the next lotus blossom. These are not, however, single acanthus half leaves connecting one point with the other but a number of leaves inserted into one another in a series. The tip of each leaflet is meticulously bent back as if to proclaim clearly that it is not embedded, that it has its own independent existence. However, the last leaf in the series unambiguously comprises the calyx of the next lotus blossom, and as a result, the basic scheme of the entire motif no longer resembles a prototype in nature but actually runs counter to it, despite an evident resistance to this tendency. (2) Each of these connecting acanthus half leaves splits about halfway down, sending another leafy offshoot in the other direction. This new shoot does not run off in a free termination, however, like its counterpart in figure 134, but circles down around to its starting point within the lotus blossom, coiling back to form a calyx together with with its counterpart from the other direction. Here again, the acanthus half leaf is acting like a tendril stem, so that we are fully justified in calling it a *bifurcating tendril*. It surrounds or encloses[169] one blossom motif with one of its arms, while at the same time it links up gracefully to the next blossom with the other.[z]

[168] Ibid., pl. 14, no. 5.

[169] The motif of the enclosed palmette, familiar since the Archaic period, may have actually had some influence on the usage that we see here—allowing the leaves which emerge from the blossom crown to continue on like connecting tendrils. Figure 137, a stucco border from Pompeii, from Niccolini (*Case ed monumenti di Pompeii*, vol. 2, part 2, "Descrizione generale," pl. 45, center), represents an intermediate stage.[aa]

We cannot undertake to determine precisely when these propitious changes first occurred. First of all, there are no preliminary studies at all in this area, since classical archaeology has thus far considered any concentration on the Late Roman period to be more or less beneath its dignity, while scholars of Early Christian and Byzantine art have found that, more often than not, they can do without a closer familiarity with antiquity, especially its later phases. Still it would be exceedingly difficult to come to some objective agreement about when these new tendencies began to manifest themselves in the artistic impulse of the late antique period, or when they came to be consciously observed and applied. Their roots, as we have seen, go back at least to the fourth century B.C. The light and flowing decoration on wall paintings, in particular, may have already been taking liberties in this direction at a time when architectural decoration could not yet tolerate schemes in vegetal ornament that ran counter to nature. Therefore, Pompeiian decoration above all requires systematic study at firsthand. One issue, however, emerges clearly from this review

Fig. 137. Border from a polychromed stucco wall decoration, Pompeii.

of the development of the undulating tendril friezes in the Roman Imperial period. The progressively less naturalistic treatment of this most widespread type of frieze was so advanced by A.D. 400 that it could provide the point of departure for an independent development at the very moment that the universal political authority of Rome had begun to disintegrate, along with the unity of its pan-Imperial art.[aa]

CHAPTER 4

◇

The Arabesque

INTRODUCTION

The basic vegetal tendril ornament of early Islamic art, that is to say, the art of the Near East during the Middle Ages and up into more modern times, is the *Arabesque*.[a] The topic to be treated in this final section, therefore, directly follows the one in the preceding chapter chronologically as well as developmentally. If the definition that we gave initially is correct, then the all-pervasive law of causality impels us to assume a genetic relationship between the ornamental Islamic tendril and its direct predecessor, the tendril ornament of antiquity, a relationship that will be demonstrated carefully and in detail, step by step, in what is to follow. There is no concealing the fact, however, that our definition is by no means generally accepted in art-historical circles today. Therefore, it seems advisable to begin by taking an example of fully developed Arabesque and using it to illustrate those peculiarities which obscure and suppress its vegetal or tendril character. At the same time, this will provide a good opportunity to introduce the most essential individual motifs of Arabesque ornament, in order to gain some insight into the basic character of this important category of ornament before we proceed to tackle the question of its historical origin.

Since we have decided to begin at the end of the development, our choice will be a very late, nearly modern example of decorative wall painting[1] from the palace of the Sultan Abdul Aziz at Tscheragan (fig. 138). There we see an interplay of fine lines that coil up into spirals or form arches, interspersed with various thicker motifs whose contours are also curved. A few major types are repeated in a number of variations:[2]

a and *b* are motifs that split into two parts;

c and *d* are motifs that, in their simplest form, vaguely resemble droplets; more frequently, however they have one or more projections, at which point they begin to look like motif *a*;

[1] *L'architecture ottomane. Ouvrage autorisé par irade impérial et publié sous le patronage de son Edhem Pacha* (Constantinople, 1873), Peintures murales, pl. 3.

[2] Only the most important and characteristic variations were included in the drawing. The rest of them can be readily categorized accordingly.

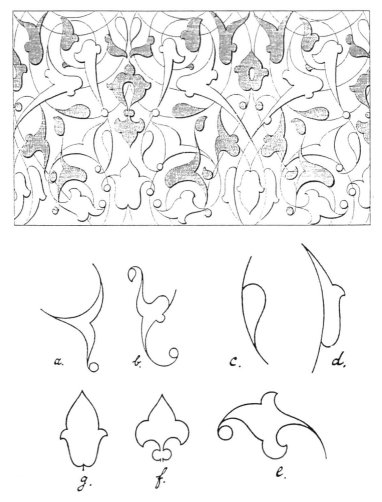

Fig. 138. Painted Arabesque wall decoration from the Palace of
Sultan Abdul Aziz, Istanbul.

e, *f*, and *g* are more elaborately subdivided shapes, some of which
(*f*, *g*) are strictly symmetrical. Motif *g* is generally a doubled version
of *d*.[3]

[3] The little round forms in which most of the tips of the motifs terminate are, as such, only
characteristic of the present example. They can be understood either as little spiraling off-
shoots or schematic variations of tiny leaf
 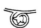 shapes in both the frontal view (palmettes
reduced to the trefoil) or the profile view (half
palmettes); this is proven by the examples
reproduced here from a manuscript from Cairo dating around 1411 which is also the source
of figure 139, where the tendrils have the same rounded ends.

What is the basic meaning of motifs *a–g*? They are obviously not imitations of real things in nature, for the stylization, quite to the contrary, is distinctly and consciously abstract. However, the motifs are not stylized to the extent that they can be subsumed under the Geometric Style. If that were so, then they would have to adhere more strictly to the law of symmetry, which is, in fact, only the case with *f* and *g*. The conclusion is, therefore, unavoidable that these motifs still refer to actual models in reality.

Let us compare the nineteenth-century example in figure 138 with one dating approximately from the middle of the development. Figure 139 illustrates the border of an illuminated manuscript[4] completed at the court of an Egyptian Mamluk sultan, which is dated by inscription to the year 1411.[b] Curving lines form the network of the whole ornament, just as they do in figure 138, but they are thicker. The circling coils are not as important and do not form such pronounced spirals. The arcuated form, however, is still preserved in the treatment of the lines in figure 138. Here we can easily observe one of the characteristic features of the Arabesque, although because the lines are drawn so weakly, it could only be evident

Fig. 139. Detail of frame ornament from the Koran of the
Mamluk Sultan Mou'ayyed, dated 1411, written by
Abdar'Rahman ibn as-Faïgh.

[4] J. Bourgoin, *Précis de l'art arabe et matériaux pour servir à l'histoire, à la théorie et à la technique des arts de l'orient musulman* (Paris, 1892), part 4, pl. 27, center.

to someone already familiar with the nature of such ornament. That is to say, in figure 139 we can see how the lines converge in places to form their own independent patterns, the most striking of which is the one with the darker ground. Since, however, the treatment of the lines depends upon the arc, the contours of these configurations always have convex and concave indentations,[5] and wherever two of these S-shaped lines meet under an acute angle, they consequently delineate a pointed, curvilinear or ogival form.

Let us now focus on the individual motifs that are set into the lines of the underlying network. The most important ones have also been singled out in a drawing and given the same letters as the parallel motifs in figure 138.[6]

While the motifs in figure 138 remained uncertain because they were only drawn as outlines, in figure 139 the motifs have greater definition. The leaflike, jagged lines that provide this greater definition demonstrate beyond any doubt the connection of these motifs to real plants. What we now see in figure 139, a–d, are stylized leaf or blossom forms, and as a result, it is absolutely justified to identify the lines connected to them as tendrils.

Motifs a–d are all seen in profile. A feature notable both on its own terms, and also for the profile orientation, is the volute-shaped, curved line or half calyx included on each of the motifs a–d, toward the bottom, where they begin. Despite this common feature, however, the motifs can be subdivided further into two categories. Motifs a and b appear as bifurcations seen in profile view, so we will designate them accordingly as *bifurcating tendrils*.[7]

Motifs c and d, on the other hand, are single forms; d is close to b because of its articulation. Since d is obviously half of g, we will first examine the last three motifs before we settle on a particular term for c and d.

The motifs e, f, and g are plantlike blossoms shown in frontal view. Of course, they were hardly meant to be accurate, although the two lateral, volutelike curved projections alone, which we recognize as the volute-calyx, already signal the presence of a whole blossom motif. We have

[5] The way the lines are interlaced into hearts in this case makes it more difficult to see the basic pattern in its simplest form.

[6] Only the figures f are not directly analogous. The shoots on the tendrils are sometimes little round forms like the ones on figure 138 (see note 3) and sometimes clearly treated spiraling involutions.

[7] Earlier, in "Ältere orientalische Teppiche aus dem Besitz des allerhöchsten Kaiserhauses," *Jahrbuch des allerhöchsten Kaiserhauses* 13 (1892): 267ff., I referred to this motif as a "two-pronged tendril." In the text of my *Orientalische Teppiche* (Vienna, London, and Paris, 1892), the shorter term is used.

stressed the importance and significance of the volute-calyx for the entire history of ornament ever since we first encountered it in Egyptian art. As it appears in motifs *e–g*, it is not merely drawn in as a half-calyx the way it is in motifs *a–d*; instead it actually creates projections in the silhouette. Since the volute-calyx in antique vegetal ornament was an essential, characteristic component of the combined view of the flower we refer to as the *palmette*, we will call the analogous motif in Arabesque ornament the Islamic *palmette*—reserving for the moment the question of whatever representational significance the motif may have had in the art of Islamic peoples. Within the basic scheme, any number of variations is possible, depending on how elaborately it is subdivided. The simplest form is represented by *g*, which is so extremely common that we will designate it separately as the *Islamic trefoil*.[c]

Now we have the appropriate term for motifs *c* and *d*. Since *d* represents half of the palmette *g*, we will call them Islamic *half palmettes*, all the more because there is also a correspondingly designated analogue in the history of antique vegetal ornament.

We have established these terms for the time being only to facilitate reference to each of the individual motifs when we begin to trace their histories. It is, however, inevitable, since we have been inclined from the outset, to assume that the apparently nominal similarities between antique and Islamic palmette ornament actually have some historical basis, even before we have attempted to justify them. To make our examination of the development of the motifs on both sides a little easier and avoid any misunderstanding, it should be pointed out straightaway that the motifs in Arabesque ornament are not descended directly from the more severely stylized Greek palmette but from the naturalistic versions found in Hellenistic and Roman art. Motifs *c* and *d*, for example, clearly resemble the acanthus rather than the rigid Greek half palmette with its stiff fan. We need only recall the conclusions made earlier regarding the acanthus: the frontal view of the acanthus leaf itself is nothing more than a naturalistic palmette, while the profile view of the acanthus leaf (for example, in the form of the acanthus tendril) is nothing more than a naturalistic half palmette.

That does not mean, however, that more rigidly stylized Greek tendril ornament was fundamentally excluded from Islamic Arabesque ornament. On the contrary, it exists in Islamic art at all times alongside its more naturalizing counterpart, just as Greek palmette and acanthus tendrils appeared side by side throughout the entire Roman Imperial period. Later, we will cite specific monuments to prove this; at the moment, I will

only point to the striking difference between motifs *d* and *g* in figure 139. The half palmette *d* is acanthusized or, as it were, projected in perspective: the full palmette *g*, on the other hand, is a pure "two-dimensional ornament" whose outlines do not suggest a striving to imitate nature more closely.

However, it is the genetic relationship between the Arabesque and the tendril of classical antiquity that we first wish to prove. Thus far, the discussion of the individual motifs in figure 139 has only established that the Arabesque is a vegetal tendril ornament. We will now try to determine what distinguishes the Islamic tendril from that of classical antiquity. In this way, we will quickly come to appreciate the special features of the Arabesque more accurately. In part, these distinctions concern the tendril lines, which form the basic network, and in part, the treatment of the blossom motifs.

There is a fundamental distinction between the way that tendril lines behave in classical decoration as opposed to Arabesque ornament. In classical decoration, the individual tendrils are juxtaposed clearly and independently against the background, whereas in Arabesque ornament, they are allowed to intersect and cut through one another repeatedly. Of course, this definition, like almost all the others involving the highest principles of a particular decorative system, does not apply absolutely and unconditionally in all cases. Intersecting tendrils occurred to a certain extent even in the ornament of antiquity, as the tendril interlace in figure 83 confirms, not to mention the naturalistic blossom tendrils of the Augustan period.[8] On the other hand, we will also find examples of Arabesque fillers (figure 197) whose tendril lines are juxtaposed with clarity and independence, like the more stylized types of Hellenistic ornament, without any interpenetration. However, all of these instances are exceptions; they are far outweighed by the majority of monuments that do in fact justify the definition given above.[d]

The reciprocal intersection of the tendril lines, as already indicated with regard to figure 139, also resulted in another special characteristic of Arabesque tendrils: at regular intervals within the overall pattern, they create enclosed polygonal compartments with curved sides containing the internal flower tendrils. Such an application of the tendril lines required that they attain a more independent and important status in comparison to

[8] The Roman example of the continuous tendril in figure 130 has long tendril stems crowned by blossoms that branch off and intersect repeatedly with the main tendril; this is done, however, in conscious imitation of free, naturalistic, and therefore asymmetrical forms, whereas Islamic tendrils intersect at regular intervals according to a strictly symmetrical and ornamental layout.

the blossom motifs; if their task is to create such distinct compartments, then they must be able inherently to achieve a corresponding degree of importance. The desire to emancipate the palmette had been central to the evolutionary process behind the tendril ornament of classical antiquity. From a modest axil filler inserted into the bifurcation of two tendrils, it developed to a full-blown, independent blossom motif. In other words, the importance of the flower increased at the expense of the connecting tendril. This desire was obviously related to the naturalizing tendency that had been such a dominant factor in Greek vegetal ornament at least since the fifth century, and perhaps even much earlier. The opposing desire discernible within Arabesque ornament was a striving to restore the dominance of the tendril lines: the geometric component of this entire decorative system. In conclusion, we may attribute this retrogressive striving to a concept of vegetal ornament basically opposed to that of Hellenistic art. If the goal of Greek artists had been to reinvigorate palmette tendrils, then Islamic artists had striven, in contrast, to schematize them once more into geometric abstractions.

The point of departure for vegetal ornament in the Near East (Egypt) was the geometric spiral (figure 25), in which blossom motifs served only as accessory axil fillers. The Greeks transformed the spiral into a living tendril whose sheaths emitted beautifully formed blossom motifs. During the Middle Ages, the geometricized tendrils of Islamic art once again display that Oriental spirit of abstraction, which had, as we shall see, already begun to re-emerge in the late antique period. To be sure, the fundamental achievements of the Greeks—the rhythmic, undulating tendril sprawling freely over larger surfaces—were not abandoned; in fact the latter characteristic developed even further along the established course. However, the geometric element had again pressed itself, into the foreground wherever it could: this is manifested most clearly in the polygonal compartments created by the curving tendril lines, which are unquestionably geometric in character.

Here it would appear appropriate to interject a few remarks concerning the extremely rich development of interlaced bands in Islamic art. The ancient Near Eastern guilloche (figure 33) provided the point of departure. The Greeks had used it to a limited extent during the Classical period. In Pompeii it occurs more frequently, but only as a framing device. On the mosaics of the late Roman Imperial period, the number of bands comprising an interlace pattern had increased: in figure 140[9] we can

[9] J. Wilmowsky, *Römische Mosaiken aus Trier und dessen Umgegend* (Trier, 1888), 9–10, and pl. 3.

Fig. 140. Roman mosaic border from the entrance hall of the basilica at Trier.

Fig. 141. Roman mosaic from Simeon-Strasse, Trier.

barely enumerate them, but they are still restricted to the border; in figure 141[10] interlace ornament has finally been considered worthy of decorating an interior field.[e]

This is the crucial point of departure for the entire subsequent development of interlacing band ornament in the Orient as well as in the West. This basically insignificant, geometric element, which had been used in classical art only for subordinate framing purposes, achieved the status of a major decorative motif in late antique art, when the need to give form to significant ideas was suppressed in favor of a pure decorative urge. From here evolved the interlaced bands of Early Christian sarcophagi and ambos, whose numerous fragments are now immured in the porches and cloisters of Early Christian basilicas in Rome, and also from here evolved the Byzantine interlaced designs, which even Bourgoin[11] recognized as the direct predecessors of Islamic interlace and latticework.[f]

This digression into the rich development of medieval interlace was necessary in order to render the antinaturalistic, abstract tendency of Arabesque tendril stylization immediately more vivid and comprehensible. There can no longer be any doubt that it is this same tendency that (on the one hand) encouraged the rich and elaborate development of geometric interlacing bands and on the other, the alternating interpenetrations and intersections of Arabesque tendril lines. At the same time, the general character of Islamic art itself explains how Islamic artists ultimately arrived at a treatment of the tendrils that deviated so clearly and fundamentally from that of classical antiquity.

If the first aspect that distinguishes Arabesque tendril ornament fundamentally from that of classical antiquity involves the rendering of the tendril lines, then the second, and equally essential, point of distinction concerns the treatment of the blossom motifs attached to the tendrils. However, it is not so much the motifs themselves that substantiate the essential distinction. There are examples of Islamic tendril patterns from the fourteenth century (figure 189 b, c) that are very similar to Greek ones of the finest period; on the other hand, there are blossom forms in the fifth century A.D., in the very midst of late antiquity, which already display an advanced retrograde tendency toward abstract stylization (figure 142), that cannot be surpassed even by the examples we have seen from the fifteenth (figure 139) and nineteenth centuries (figure 138). The fundamental distinction between Arabesque and antique ornament resides much more in the way that the flower is attached to the tendril.

[10] Ibid., 18–19, and pl. 8.
[11] J. Bourgoin, *Les arts arabes* (Paris, 1873), 24.

In the tendril ornament of antiquity, the blossom motifs were attached to the ends of the small offshoots that branch off from the main tendril. Therefore, the relationship is the same as it is in nature: the stem or the shaft is the lower part, while the flower is the crowning, free termination.

In contrast, let us examine motif *a* in figure 139, which comes from the border of the manuscript toward the lower right side.[12] The two parts into which this undoubtedly vegetal motif bifurcates do not serve as free terminations for the spiraling tendril from which they spring. Instead, they narrow down toward their ends to form new tendrils: the left one eventually ends in a rounded form based either on a small, spiraling coil or a freely terminating trefoil or half leaf; the right one forms an ogival arch together with a second offshoot from another bifurcating tendil, which then both converge to form a larger trefoil as the free corner solution. In conformity with earlier terminology, we will describe the bifurcating tendril as *embedded*.

The same is true of the half palmette, motif *c*, further up along the same spiraling tendril. The pointed end extends into a tendril, which then expands along the way into the bifurcating tendril we have just examined. However, even on the full palmette, this peculiar way of combining tendrils and blossoms is the same. This is not very striking in figure 139, since the two bifurcating tendrils that branch off from the central trefoil within the darkly shaded polygonal compartment do not emerge from its tip, but from the sides of the pointed arch-shaped leaf. This is easier to observe on the trefoil just to the right of the middle of figure 138.[13]

It makes no difference whether we conceive of these motifs as flowers, leaves, or buds: the characteristic manner in which they are allowed to sprout tendrils from what should be their crowns runs entirely counter to nature. This is another clear manifestation of that distinctly antinaturalistic tendency that we already found to be so decisive in the treatment of tendril lines. The ornament of classical antiquity apparently did not allow itself this freedom—provided that we consider only complete, genuine floral motifs such as palmettes, etc. However, let us recall the conclusions from our examination of the development of the two-dimensional Greek palmette tendril ornament in the Hellenistic period, which proved to be the point of departure for the development of embedded half palmettes. We may also recall the results of our investigation into the acanthus ten-

[12] The situation is, of course, even more pronounced and advanced in the nineteenth-century example in figure 138.

[13] Because of a mistake in copying, the tendril line on the right, which was also supposed to emerge from the pointed tip of the trefoil in figure 138 as its counterpart does, is displaced somewhat to the side.

dril during the Roman period, where we saw the same tendency expand to include three-dimensional naturalistic tendril ornament. If we were not entirely convinced then that artists of antiquity were fully conscious of the antinaturalistic tendency manifested in the embedded treatment of the half palmette, we should certainly be convinced of it now in regard to the Arabesque. That is why we did not hesitate to refer to motifs *c* and *d* in figure 139 as *Islamic half palmettes*. In origin and substance, they are, like the bifurcating tendrils—none other than the axil fillers of the classical antique tendril. Our task in what follows will be to demonstrate in detail the transition from one to the other. There is only one more initial point needed to clarify the relationship sketched out just above between antique axil fillers and the floral motifs of Arabesque ornament: in Arabesque ornament, as a rule, the blossoms that are embedded and treated in an unnaturalistic manner are mainly the half palmettes and the bifurcating tendrils; in relatively few instances are full palmettes used in this way, and this occurs only at a more advanced stage of the development.

THE Arabesque is found in all of the regions that converted to Islam over the centuries. Those that come under primary consideration are North Africa with Lower Egypt, Syria, Asia Minor, Mesopotamia and Persia; hence, all of the provinces that had once comprised the great Roman Empire, regions that were thoroughly familiar with the formal vocabulary of Greco-Roman art, as the monuments all show. As we have seen, vegetal tendril ornament had played by far the most important and dominant role in the decoration of this art. If we now discover that vegetal tendril ornament once again became the most important decorative element in the same geographic area during the Middle Ages, then it seems unquestionable, as already indicated, that the later ornament must somehow have depended genetically on what preceded it, despite its different properties. At any rate, it will certainly be worthwhile to investigate the relationship between them. This is why I find it exasperating—and explicable only as one of the many unfortunate consequences of the materialist theory of art—that even highly experienced specialists still blithely dismiss any possibility of a relationship between the Oriental Arabesque and classical antiquity just as there can be no relation between fire and ice.

In what follows, we will examine the relationship between antique and Islamic tendril ornament, a connection that has until now been regarded with skepticism. Since we have just explained in an introductory fashion what is so typical and characteristic of the Islamic ornament that we understand as the Arabesque, we already know the ultimate goal of the

development. Now we will return to the point of departure and resume our historical investigation. It lies, of course, in the transition from antiquity to the Middle Ages, which is commonly associated with the decisive date of A.D. 476. The development of vegetal tendril ornament up to this time has been treated in the previous chapter. Consequently, we must now begin with the period that in the present system directly followed the collapse of the western Roman Empire. In the West, we have the more mature, Early Christian art and in the eastern Roman Empire, the art of Byzantium. Since we are interested only in the development of the Arabesque, we will restrict the investigation to the vegetal ornament of the eastern Roman Empire and disregard Early Christian tendril decoration in the West, even though there would be much to learn from such a comparison.

A. Tendril Ornament in Byzantine Art

Does Byzantine art not mark the beginning of something completely new? One would tend to think so from the kind of remarks that are commonly made about it. Everyone would agree that there was an historical connection between Byzantine and antique art in general, but we only hear in detail about those aspects of Byzantine art that were completely different in nature from the art of antiquity. This is, of course, true, if by antique we stipulate work like that of Pheidias and Iktinos. However, think of how distant the Parthenon was from Attic architecture, and yet no one would dispute it as a monument of Classical antiquity! Roman Imperial art was pursuing its own course of development, which, moreover, was on the rise and by no means declining, as many would have us believe. In this context, we always hear about the weakness of the newly-commissioned reliefs on the Arch of Constantine in comparison to those which had been reincorporated from the Arch of Trajan, while completely forgetting the astounding fact that it is precisely during the period of Constantine that we encounter the first example of a vaulted basilica! The problem that preoccupied all of Western medieval architecture had already been solved on the most monumental scale by the beginning of the fourth century A.D.[a]

To begin with, Byzantine art is nothing more than the late antique art of the eastern Roman Empire. There is no compelling reason to assume that a new era in the history of art began when Emperor Constantine made Byzantium the capital of his empire. Let us first examine what transpires in architecture. Byzantium and, in its wake, virtually all of the east-

ern Roman Empire adopted the central plan for Christian churches. The domed Greek cross plan was not invented in imperial Byzantium but is found much earlier in the second century A.D. (Musmieh in Syria), where it was obviously the result of Hellenistic architectural ambitions. The adaptation of this pre-existing system to Christian purposes presented no fundamental difficulties at all: seen in this light, the Hagia Sophia is not at all as important architecturally as the Basilica of Constantine. Moreover, it is this very adaptation of a completely developed architectural system that is largely responsible for what we refer to as the stagnation, the "rigid conservatism" of Byzantine art, for a reversion to mannerism is inevitable whenever there is nothing new to discover or no new challenges to meet. We can praise the impeccable technical execution of Byzantine works of art and express our gratitude to the artists who so capably upheld the tradition of Roman technical skills, but Byzantine art will never be counted among the truly creative artistic styles. What we think of specifically as the mature products of the Byzantines were not really their own inventions at all but the heritage bequeathed by the greater artistic energy and creativity of the Hellenistic period.[b]

There is another general characteristic of Byzantine art that should be stressed from the outset, since it will facilitate a closer examination and understanding of the details later on. In spite of its predominantly decorative tendencies, the formative period of so-called Byzantine art was not at all given to the easy and prolific invention of new forms. The artistic activity of the entire period was characterized instead by restraint: the tendency was to abandon the inexhaustible wealth of bright, decorative forms amassed during the Hellenistic and early Roman Imperial periods and to retain only those few elements which were indispensable to architecture.

A look at the kinds of problems confronted by sculpture and painting during the same period will give us a better understanding of the situation. A new cult with a wealth of new religious ideas had created new artistic demands and problems. As we see abundantly in the art of the catacombs, however, there was originally little need to depart from the classical antique decorative tradition. Only gradually were the Orpheus and Hermes figures abandoned and new types created, albeit in classical, traditional poses and dress. However, in the beginning these efforts were nothing but stopgap measures lacking any true artistic conception and execution. It is a characteristic feature of Early Christian images that the value placed specifically on actual artistic considerations was relatively minor. Any one of the new religious ideas could be embodied by any of the figural types that had been handed down, and little significance

was attached to matters of beauty, harmony, and proportion. Form was suffocated by concept, at least to the extent that this was possible at all for artists still working ostensibly under the influence of the classical tradition.[c]

Of course, later a time came when the irrepressible drive for formal beauty stirred once again and exerted its influence upon Christian sculpture and painting, but in the Byzantine empire this drive was almost stifled during the iconoclastic controversy. And even after iconoclasm died out, its impact remained strong enough to constrain the production of religious art through rules and regulations. The desire for beauty and the urge for truly artistic creativity attained a certain degree of expression, but given the nature of the circumstances, it was very limited. Indeed, this revival of religious art may in a certain sense have been the undoing of Byzantine artists. On the one hand, their regulations kept them from striving for the kind of lofty goal that occupied their colleagues in the West; on the other hand, since they were expected to produce primarily figurative religious images, they could never in good conscience indulge in the kind of purely decorative art that satisfied the basic human desire for ornament, a goal that early Islamic artists, as we well know, had pursued to such advantage. Unable to decide whether to grapple with the most abstract concepts of religious art or to perfect a decorative system that provided transitory delight to the eye, Byzantine art vacillated between these two poles throughout its existence, and consequently its achievements in both directions only half succeeded.[d]

Therefore, the East Romans first dealt with the generous inheritance from classical antiquity by reducing the repertory of artistic forms. One has to admit, however, that they made some very good choices: in church architecture, they selected the far superior centrally planned system rather than the Roman basilica, whose unyielding qualities would hamper Western architects throughout the Middle Ages.[e] In the area of ornament, they retained the most flexible and potentially useful forms, especially the ancient conventional systems for the undulating tendril.

Now that we are about to embark upon the detailed investigation of Byzantine tendril ornament, we must once again begin with the unfortunate observation that there are no preliminary studies to rely upon. It is true that certain details, such as cross sections of acanthus leaves, have been addressed and emphasized by authors who were primarily interested in Justinianic architecture. However, the leitmotifs of Byzantine decoration and the larger perspective reflected in each and every detail have been virtually ignored up to this point. This is not the place to

attempt to fill in the existing gaps, since our present task is limited expressly to vegetal tendril ornament. Nevertheless, because of the extreme paucity of pertinent literature, we will be compelled more than once to digress into topics that should have been dealt with long ago in a more general survey of Byzantine art.

I will begin with a monument whose date is firmly established: the Church of St. John Studios in Constantinople, which was built in 463. Figure 142, taken from Salzenberg,[14] shows a capital with an architrave that is also of interest to our theme.

The capital has a so-called composite form: two rows of full acanthus leaves are arranged on top of each other around the basketlike core. Until now, interest in the various facets of the building's decoration has focused on the treatment of the acanthus leaves. The way the edges of the leaves

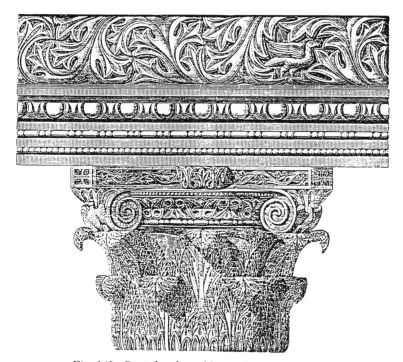

Fig. 142. Capital and entablature from the Basilica
of St. John Studios, Istanbul.

[14] W. Salzenberg, *Alt-christliche Baudenkmale von Constantinopel vom 5. bis 12. Jahrhundert* (Berlin, 1854), pl. 3, no. 1; this reproduction is still obviously more faithful than the one by D. Pulgher, *Les anciennes églises byzantines de Constantinople* (Vienna, 1878), pl. 1.

are carved into long and jagged points was considered a remarkable innovation compared to the soft, more opulent treatment of the Roman acanthus.[15] As conspicuous as the jagged edges may be, they are nevertheless not an essential characteristic. It is easy enough to prove that they are direct descendants of the narrow pointed ones often found roughed out with the drill on numerous Roman monuments right next to the softer versions.[16] If the long and jagged leaf profile were all that we could point to, there would hardly be a basis for speaking in terms of a "Byzantine" acanthus.

The feature that fundamentally distinguishes the Byzantine acanthus is the disintegration of the leaf itself into smaller individual leaves. These divisions are not yet sufficiently conspicuous on the capital in figure 142 because its prototype in the capitals of Roman times had utilized only full acanthus leaves arranged serially in rows.[17] However, closer observation reveals changes even on this capital: the individual groups of pointed leaflets, which combine to create larger points in the contour of the entire leaf, are separated by unusually deep indentations. If the tips of the full leaves did not curl over and project into space, these individual groups of pointed leaflets would appear as a much more prominent feature of the entire leaf. The end result of the process is clearly illustrated by the continuous acanthus tendril decorating the architrave in figure 142. The leaves of the undulating tendril are unquestionably derived from the acanthus half leaf, as a glance back to our discussion of the acanthus tendril will remind us. However, the once unified half leaves are broken up into points, mostly three in number but sometimes four or five, which are detached from the periphery of the acanthus leaf. And what is more, these multiple groupings of leaves already curve around in a different spatial configuration, compressing themselves in varied angles and projects.[f]

To clarify matters fully at this crucial point in the development, let us quickly go back and review what we have concluded thus far about the acanthus. The acanthus emerged from the smooth leaf fan of the palmette. The individual leaves of the fan soon acquired the kind of jagged edges that are found on the Monument of Lysikrates (figure 111). In spite of

[15] J. Strzygowski, "Die Akropolis in altbyzantinischer Zeit," *Athenische Mitteilungen* 14 (1889): 280ff., goes into the most detail on this point and includes an admirable compilation of the widely scattered investigative material largely ignored until now.

[16] See, for example, the ones on Hadrian's Gate at Adalia reproduced in K. Lanckoronski-Brzezie, G. Niemann, and E. Petersen, *Städte Pamphyliens und Pisidiens* (Vienna, 1890–92).

[17] The full acanthus leaf also survived for a long time on the Corinthian capital, far into advanced Islamic art; nevertheless, the subdivisions of the leaves can already be observed on capitals of the early Byzantine period (Salzenberg, *Alt-christliche Baudenkmale*, pl. 5).

these jagged edges, both full and half acanthus leaves were treated consis-
tently as undivided wholes throughout the entire Hellenistic and earlier
Roman Imperial period. Early signs of the coming solutions, however, are
already detectable on the examples from the Forum of Nerva (figures 135,
136), which represent an intermediate stage: there the original independ-
ence of the component acanthus leaves is gradually being compromised
by the interlocking of individual half leaves as larger connecting tendrils.
In the fifth century, the process draws to its conclusion: the separate
groups of pronged leaflets detach themselves from what had once been an
acanthus full or half leaf to produce separate configurations with a signifi-
cance of their own. One can hardly imagine a more appropriate conclusion
to this linear course of development. The "Byzantine" acanthus conse-
quently is the pure product of a process that can be readily traced from the
High Classical period onward; it is by no means the creation of a local
Byzantine genius or the reflection of some kind of original "Oriental" art
that has yet to be discovered.[g]

Some examples of the detached independent pointed shapes of the Byz-
antine acanthus, taken from the church of Sts. Sergius and Bacchus, are
illustrated in figure 143.[18] The most important one is the so-called trefoil
in the middle, which looks something like a heraldic lily. The motif figures
so prominently later, in Byzantine as well as in Islamic art, and ultimately
becomes such a common element of all decoration, that we must discuss
it now a bit more in depth.

Fig. 143. Decorative sculptural details from the Church of Sts. Sergius
and Bacchus, Istanbul.

The trefoil consists of a volute-calyx crowned by a single leaf. Superfi-
cially, therefore, it is practically identical with some of the abbreviated
versions of lotus blossoms found in ancient Near Eastern art (figs. 20, 35).
The abbreviated volute-calyx of the two-dimensional palmette, which was
still common in the fifth century and later, particularly the split type,
surely exerted some influence on the stylization of the trefoil. In addition,
there is still a second factor of essential importance: the formation of the

[18] From Pulgher, *Les anciennes églises*, pl. 3, no. 2.

volute-calyx of the Byzantine trefoil was already naturally encouraged by the deep indentations separating the smaller groups of pronged leaflets, a feature that verges on disintegration even in the early stages of the acanthus leaf. The three-pronged leaflets of the acanthus tendril on the architrave in figure 142 illustrate this point convincingly.

Another noteworthy aspect of the trefoil is the ogival form of its crowning leaf. As is commonly known, this type of arch later became very characteristic of the Islamic style. Its appearance in East Roman art of the fifth century does not come as a total surprise, however, since the acanthus half leaf, as well as the split palmette, had displayed a pronounced tendency throughout the Roman period and earlier to bend back in a curve.

Anyone who has compared all of the relevant capitals from Salzenberg's and Pulgher's publications will soon be convinced that it is this dissolution and shredding of the original unified acanthus leaf, along with the arbitrary use and combination of its separate subdivisions (fig. 143) that essentially distinguishes the ornament of the Justinianic period from that of Greco-Roman times. That is why we must reject any hypothesis that suggests once again that the allegedly idiosyncratic "fleshy and pointed" leaf contour of the Byzantine acanthus has anything to do with the eastern Mediterranean *acanthus spinosa* as opposed to the Italian *acanthus mollis*.[19] According to this hypothesis, the stone carvers under Justinian once again began to study leaves from nature, just as students do in the art schools of today. Perhaps we are actually supposed to assume that the practice had never died out since the days of Kallimachos. Yet the observable process of fragmentation affecting the former unity of the acanthus leaf in the late Roman period completely discredits the idea that there was ever any kind of close dependence upon a specific prototype in nature. It also shows, once again, that decorative art had always sought its own artistic solutions rather then reverting to the imitation of specific botanical species from nature.

We have been concentrating until now only on the changes taking place in the leaves; those on the architrave in figure 142, however, fall into a continuous undulating pattern that will now serve to illustrate our discussion of the early Byzantine tendril.

Does what we see there really qualify as a continuous tendril at all? Initially, the tendril stems or lines themselves seem to be missing, not to mention the offshoots, which are supposed to branch off and spiral back in their characteristic fashion. In order to convince ourselves that the

[19] Strzygowski, *Athenische Mitteilungen*, 14 (1889): 280.

pattern at the top of figure 142 is basically a continuous tendril, we will have to go back and review its history.

The point of departure was the basic tendril (fig. 50). Later, the axils of the branching spirals were filled with half palmettes (fig. 76). During the naturalizing phase, the fans of the half palmettes began to curve back (as in the border from figure 122), or they turned into sculptural-perspectival acanthus half leaves (figs. 129–30). These last two examples, however, still display enormous care in the bending back of the tips of the leaves, leaving no doubt as to their independent status as individual motifs. The tendrils themselves continue on from beneath the curved tips of the half palmettes. On a number of examples (figs. 133–36), we were able to observe clearly how the tendril stems gradually disappear, transferring their function over to the leaves themselves. Once the acanthus half leaf had lost all individuality as it disintegrated into numerous subdivisions, there was no longer any reason to uphold the fiction of an autonomous leaf branching off from a stem. The pattern on the architrave in figure 142 is, so to speak, a single acanthus rib that continuously branches off into individual points.

The *continuous tendril*, which had been confined to a border in figure 142, now coils its way freely over a larger surface in figure 144.[20, h] This

Fig. 144. Relief decoration from the spandrels of the lower nave arcade in the Church of Hagia Sophia, Istanbul.

[20] Arcade decoration from Hagia Sophia, from Salzenberg, *Alt-christliche Baudenkmale,* pl. 15.

simple basic tendril,[21] devoid of any kind of subsidiary figures or other decorative accessories, would never have been allowed to fulfill this function in the Hellenistic or early Roman period. By the late Roman period, the demands upon the significative function of ornament had diminished sufficiently that the acanthus tendril could often be found patterning larger interior fields.[22] On the continuous tendril, the component subdivisions of the once-unified acanthus half leaves are positioned one after the other; they are, moreover, embedded, without any stems of their own. Jones already recognized this as the whole secret of Arabesque ornament, even if his interpretation is not entirely correct. In the section of *The Grammar of Ornament* that deals with Arabic decoration, he makes the following comments concerning the same pattern reproduced in figure 144:

> Be that as it may, this spandril [*sic*] is itself the foundation of the surface decoration of the Arabs and Moors. It will be observed that, although the leafage which surrounds the centre is still a reminiscence of the acanthus leaf, it is the first attempt at throwing off the principle of leafage growing out one from the other: the scroll is continuous without a break. The pattern is distributed all over the spandril, so as to produce one even tint, which was ever the aim of the Arabs and Moors.[23]

Jones was also aware of the fact that the Greek principle of always having leaves branch off separately on their own stems had already slackened by earlier Roman Imperial times: "Roman ornament is constantly struggling against this apparently fixed law."[23a] Nevertheless, he still considered the final step taken during the Justinianic period as a spontaneous invention that resulted in a completely new series of vegetal ornaments. Of course, Jones did not have the benefit of the kind of knowledge and perspective gained from the material that scholarship has since brought to light and that now enables us to trace this process from its genesis and earliest foundation up into Greek times. Furthermore, he was laboring

[21] The same goes for the guilloche. This is one of the most crucial aspects in which late antique and medieval ornament departed from classical precedent.

[22] Apse mosaic of the chapel of Sts. Rufina and Secunda in the Lateran Baptistery, dated according to G. B. de Rossi (*Musaici antichi delle chiese di Roma* [Rome, 1872–99]), around 400; vault mosaic of the presbytery of San Vitale.[i]

[23] Jones did not think of the undulating tendril as continuous and unified but as an arrangement of separate spiral tendrils placed in a series. It would be superfluous to repeat our arguments from chapter 3 exposing the one-sidedness of this interpretation. [Riegl fails to give a page citation from the original source. These English lines are from O. Jones, *The Grammar of Ornament* (London, 1856), 57.]

[23a] [Ibid., 34.]

under the misconception that the essential change in ornament during and after the Byzantine period was the development of leaves growing directly from the continuous tendril, without any intermediary stems. This does not, however, get to the heart of the issue. It is much more essential to recognize that in decoration the leaf relinquished the kind of independent existence that it enjoys in nature. The leaf no longer branches off from the tendril but replaces it and fuses with it. This relationship is not yet so very apparent on the Byzantine ornaments from St. John Studios and Hagia Sophia, because the individual subdivisions of the original acanthus half leaf seem to branch off independently from a tendril one after the other. In these examples, the development is only half complete, and we cannot yet discern the final stage, such as we see it in the Arabesque, where the tendrils are allowed to continue on from the pointed tips of the embedded leaves. Nevertheless, we will soon be able to demonstrate beyond any doubt that this was also the case in early Byzantine art.

Let us return to figure 142 and discuss the two remaining decorative borders on the capital. The first one is the basic intermittent tendril scheme found between the two volutes crowning the capital. A simple, smooth undulating line winds its way from blossom to blossom with no trace of naturalism. The floral motifs have the abbreviated volute-calyx just like the flat palmette on the trefoil in figure 143. The three-leafed blossom crowning the calyx looks very much like the profile view of the three-leafed lotus. There can be little doubt about it: what we see is the ancient Greek intermittent tendril, whose palmettes manifest the fragmentation of the acanthus leaf that had meanwhile taken place.

Finally, the ornamental border on the abacus displays a continuous tendril, but in its ancient Greek form: only the attached leaves are stylized in a way that still betrays their origin from the palmette. The strip is interrupted in the middle by a projecting boss decorated with a row of lotus blossoms and palmettes. The lotus blossoms are stylized like the ones on the intermittent tendril on the preceding border, while the volutes of the palmettes clearly betray the process of fragmentation taking place in Byzantine acanthus ornament.

In figures 142 and 144, the kinds of curves produced by the tendril lines are not conspicuously different from those of Greek art. Initially, this is what makes it so difficult to identify the process that came to distinguish them from the tendril ornament of classical antiquity. The rhythms involved are simply those of the familiar continuous tendril. In fact, classical tendril ornament in general had never attempted to deny its origins from

spiral ornament, even at the very end when the developed acanthus half leaf had completely lost all traces of its original and almost purely geometric function as a mere axil filler, the spiraling coils of the tendrils were still based on the circle.

On the other hand, let us examine figure 145,[24] which is also a detail from one of the arcades in Hagia Sophia.[j] First we will focus on the ornament of the soffit illustrated above. Here the tendrils no longer converge to form rounded shapes but create ovals that are pointed at either end. This detail is very critical to the development of an eastern Mediterranean decorative art that was following new impulses. The change in the relationship between tendril and leaf, which we saw taking place in figure 144 and whose significance Jones had already recognized, was also taken over in western regions, at least as the Byzantines had developed it by the Justinianic period. However, Western art always maintained a preference for tendrils arranged in circular curves, whereas, as we can already see,

Fig. 145. Capital and portion of the intrados decoration
from the Church of Hagia Sophia, Istanbul.

[24] Salzenberg, *Alt-christliche Baudenkmale*, pl. 15, no. 7.

figure 145, from Hagia Sophia, begins to lean toward the pointed oval as the basic shape for its tendril arrangements.[25, k]

The individual leaf motifs in figure 145 consist predominantly of curved half palmettes that converge in symmetrical pairs to form a remarkable number of split full palmettes. The two half palmettes that comprise a full one, however, do not arise from one and the same tendril but from different stems. This is, of course, contrary to nature, where blossoms normally have their own individual stems. Consequently, we may note this as another antinaturalistic feature that would have become characteristic of the Arabesque. At this point, let us re-examine figure 139. To the left, we see bifurcated tendrils repeatedly converging to form shapes like ogival arches, in a manner that corresponds to the movement of both halves of a split palmette. This emerges even more distinctly in the solution used for the corner at the lower right of figure 139. Here the bifurcating tendrils converge from two different sides to form an ogival arch, to which a trefoil is attached as the free termination. Even if the individual vegetal motifs in figure 145 are not yet bifurcating tendrils, since the stylization had not advanced that far by the sixth century, there is still an unmistakable tendency to combine two independent half motifs into one full motif under a curving angle. The points of contact with Greco-Roman ornament for the curving angle are the split palmette and, furthermore, Pompeiian examples like the ones in figure 152. For the tendril stems, which converge from different sides to form calyces, there are modest forerunners like the upper palmette in the middle of figure 125 and the enclosed palmettes to either side.

The volute-calyx of the half palmettes in figure 145 is once again reduced to a fleshy leaf calyx. In stone, the leaves are indicated with the help of round drill holes, which are highly characteristic of the subsequent development. This is a technical process that Islamic artists would also later assimilate.

The tendrils along the central axis of the capital beneath the soffit form interlacing circles flanked by long, curved half palmettes of the split variety, containing the kind of subdivisions of the acanthus leaf seen in figure 143. Intertwining circles alternating in size and used as a surface pattern are familiar from Early Christian art in Rome where they are classified as interlacing bands.[1] As already indicated, the Byzantines took particular delight in this kind of decoration. Its continued development under Islamic artists presupposed a freer treatment of the bands. In their use of

[25] Once again, there are probably quite a number of forerunners for this in Pompeiian decoration.

interlacing bands, the Romans continued to rely basically on the circle, just as they had in regard to tendrils; Islamic artists, on the other hand, were entirely uninhibited about breaking and bending the interlace. If figure 145 made it clear that the Byzantines were the direct forerunners of Islamic artists in freeing tendrils from the constraints of the circle, then the capital decoration in figure 146[26] demonstrates that the transition from circular to angular interlaced bands had already taken place in pre-Islamic Byzantium.[m]

Fig. 146. Capital with entablature from the outer gallery
in the Church of Hagia Sophia, Istanbul.

The next few details will corroborate this opinion and serve to demonstrate further the latent Islamic tendencies in Byzantine art during the age of Justinian. Figure 147 from the Church of Sts. Sergius and Bacchus[27] shows how freely the detached subdivisions of the acanthus leaf could be applied. Here we see a reduced acanthus half leaf inserted into the familiar two-leafed calyx. The same motif in a lobed acanthusized variation became extremely common in later Islamic art.[n]

Figure 148[28] illustrates a type of palmette stylization that was equally common in Byzantine and early Islamic art. It should be compared to its Pompeiian forerunners (fig. 149).[29] In figure 150,[30] the two trefoils are twisted on their stems, while the tips of the additional leaflets are allowed to cross over each other: despite the deliberate retention of its plantlike

[26] Salzenberg, *Alt-christliche Baudenkmale*, pl. 17, no. 4, from Hagia Sophia.
[27] Ibid., pl. 5, no. 3.
[28] Ibid.
[29] Niccolini, *Case ed monumenti di Pompeii*, vol. 1, part 1, "Panteone [Macellum]," pl. 2, top center.
[30] Salzenberg, *Alt-christliche Baudenkmale*, pl. 17, no. 4, from Hagia Sophia.

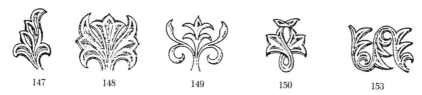

Fig. 147. Details of relief ornament from the Church of Sts. Sergius
and Bacchus, Istanbul.

Fig. 148. Details of relief ornament from the Church of Sts. Sergius
and Bacchus, Istanbul.

Fig. 149. Detail of wall painting from the Macellum at Pompeii.

Fig. 150. Detail of relief ornament from the Church of
Hagia Sophia, Istanbul.

Fig. 153. Detail of relief ornament from the Church of
Hagia Sophia, Istanbul.

qualities, this motif is treated in such a playful way that it could almost be
called Islamic.

Finally, figure 151[31] is from the carved decoration of a wooden tie beam
at Hagia Sophia. In the circle at the far left, two embedded half palmettes
diverge at the bottom and then serve as stems for the two identical half
palmettes sprouting from their crowning tips: thus it exemplifies without
any ambiguity the fully developed principle of the Arabesque. However,
these carved decorations do not date back to the period of Justinian: the
treatment of the details is no longer as sharp and angular but, on the
contrary, flowing and almost geometrically correct. Even though we could
refer to these ornaments without hesitation as Islamic works of the elev-
enth or twelfth century, we know that they still belong to the period of
Christian-Greek rule in Constantinople because of the crosses that occur
on other beams of exactly the same kind.[32] Of course, one could still

Fig. 151. Decoration on a wooden tie beam from the
Church of Hagia Sophia, Istanbul.

[31] Ibid., pl. 20, no. 14.
[32] Ibid., pl. 20, no. 12.

assume that the reliefs were carved directly by Islamic artists under Byzantine patronage or that they show definite influence of Islamic art, which at that time was already gaining strength. However, as all our investigations have shown, there is nothing that compels us to ascribe the stylization in figure 151 to any kind of foreign influence. Its exotic impression results primarily from the round drill holes of the leaf calyces and, second, from the curvature of the leaves, both of which existed already in sculpture of the Justinianic period.° The inclination toward curving, pointed-arched forms was already latent in Greek art, waiting only to be sparked by the desire for greater abstraction that would promote it to a major formal element. To demonstrate this, I also cite the three details from Pompeii in figure 152, in addition to what we already know about split-palmettes, the outwardly curved tips of acanthus half leaves, etc.[33, p]

Fig. 152. Ornamental details of a third style wall painting from Herculaneum.

In the early Byzantine period at Hagia Sophia, moreover, there are also unmistakable examples of leaves sprouting into tendrils, like the ones just examined in the left-hand roundel of figure 151. Figure 153[34] shows three acanthus half leaves sprouting from each other one after another, like tendrils. Figures 154 and 155 are *opus sectile* decorations.[q] The first one, resembling a capital, consists of two half palmettes of the split variety, as the spiraling volute-calyx and the subtly curved individual leaves clearly indicate. The outer rib of each of the leaves, however, curves up and around and then turns into the stem of a palmette. Similarly, in figure 155, the tendrils sprout and branch off from the bottoms of inverted cornucopiae within a border based on familiar Roman patterns; the two central offshoots meet to form a symmetrical pair in a manner similar to the split full palmettes in figure 145. The outer shoots of the bifurcating tendrils, however, provide the stems for buds or fanlike leaves. Beneath every second cornucopia, a palmette is supported by two tendrils treated like

[33] Niccolini, *Case ed monumenti di Pompeii*, vol. 2, part 2, "Descrizione generale," pl. 90, top center.

[34] Salzenberg, *Alt-christliche Baudenkmale*, pl. 17, no. 13.

Fig. 154. Details from the marble *opus sectile* decoration in the Church of Hagia Sophia, Istanbul.

Fig. 155. Details from the marble *opus sectile* decoration in the Church of Hagia Sophia, Istanbul.

leaves; these illustrate the same principle of leaves metamorphosing into tendrils.

The antinaturalistic tendency, which was unquestionably one of the fundamental guiding principles of Byzantine art, resulted positively from profound and significant cultural processes, some of which have already been suggested. However, the circumstances must have been extremely favorable to the process at work in the decorative arts of the Byzantine territories to have encouraged the extremely rapid development at this early stage, such as we see it in the many examples already cited. I would attribute this to the widespread preference in the art of the eastern Mediterranean basin, even during the Roman Imperial period, for the more severe types of Hellenistic tendril ornament. Without this preference, it would not have been possible for the leafless, inherently more abstract, intermittent tendril or for the split palmette to have occupied such a leading position in early Byzantine ornament. Typical examples, such as the one in figure 156 from the Church of the Pantokrator,[34a] still occur in Constantinople during the twelfth century. Another is the abacus of the capital from St. Sophia in Saloniki, illustrated by Texier and Popplewell,[34b] in which horizontal S-spirals and lotus blossoms are set into the axil calyces

Fig. 156. Detail of a cornice from the Church of the Pantocrator, Istanbul.

[34a] [Pulgher, *Les anciennes églises*, pl. 10, no. 4.]
[34b] [C. Texier and R. Popplewell Pullan, *L'architecture byzantine; recueil de monuments des premiers temps du christianisme en Orient, précédés de recherches historiques et archéologiques* (London, 1864), pl. 39, left.]

in complete conformity to the ancient Greek formula, but with leaves stylized in the Byzantine manner; the intermittent tendril on the neck of this capital is no less characteristic. And in fact, the few Roman monuments on Asiatic soil that have so far been considered worthy of more careful study[35] confirm that the intermittent tendril richly elaborated with two-dimensional palmette motifs always played a major role there. Even Salzenberg had already noticed the interrelationship between the Byzantine and the Hellenistic manner, although he missed the point when he abruptly announced that "the (byzantine) leaf ornament is not treated in the Roman manner, but more as it was in the Hellenistic period."[36]

This point is important not only for the formal changes taking place in ornament during the Justinianic period but also for the later development. The East must always have remained faithful to the older ways, whether they were local traditions or technical methods, and especially to the two-dimensional stylization in the ancient Greek manner. Otherwise, there would be no explanation for the fact that we still encounter almost purely Greek tendril decoration on works of art from the twelfth through the fourteenth centuries.

Furthermore, the treatment of the acanthus in the stone sculpture during the Justinianic period was not the only approach to such ornament during early Byzantine times. The soft, lobular acanthus was also used continuously right alongside it, although this will not become apparent until we take up the subsequent development. Certainly, material and technique were fundamental factors in the choice of treatment: the rounded leaf was naturally more appropriate to painting, and the angular approach more suited to stone sculpture. However, local differences will also have had an effect, though these are the kind of differences that could never have left their mark on the established international art of the Roman Empire. Yet at a time when new impulses were appearing and new types of decoration were entering the mainstream, they had a better chance of attaining some importance. Therefore, before we begin our investigation of the actual Islamic monuments, we will spend a little time in the eastern provinces of the Roman Empire to see what remained of the late antique, Greco-Roman tradition in the art of that region.

In relative terms, we are best informed about late antique or early medieval art in Syria. The photographs taken by Count de Vogüé of the ruins of central Syrian cities are already sufficient to form a complete picture of

[35] For example, the monuments published in Lanckoronski-Brzezie et al., *Städte Pamphyliens and Pisidiens.*

[36] Salzenberg, *Alt-christliche Baudenkmale,* 19.

the Syrian ornament of the period, at least as it was applied in architecture. We will limit ourselves in the following discussion, as usual, only to vegetal tendril ornament.

Figure 157 reproduces a frieze from the great pyramidal tomb of El Barah,[37] which de Vogüé dated in the fifth century.[r] The continuous acanthus tendril decorating the frieze immediately recalls a similar monument, the architrave of St. John Studios in Constantinople (fig. 142). When we compare the two, we reach the surprising but inevitable conclusion that the Syrian relief represents an earlier stage of the Constantinopolitan example. The frieze from El Barah still clearly exhibits precisely those characteristics which we missed in figure 142. It has offshoots that branch off individually and spiral back in a direction opposite to the main movement of the tendril, which at first made us hesitate to call the pattern

Fig. 157. Decorated cornice from the Early Christian Church
at El Barah, Syria.

a continuous acanthus tendril. The early classical acanthus leaf is likewise still clearly discernible. And even though the connecting tendril stems have already been suppressed into what looks like a leaf rib running along an undulating path, the edge of the leaf still consists of jagged points that are subordinate to the embedded acanthus half leaves themselves; they are not yet the independent three-or four-pronged subdivisions seen in the Constantinopolitan work of figure 142. There can be no doubt, however, that the Syrian frieze was the point of departure for the next step represented by the frieze from St. John Studios. The stems are already suppressed; the edges of the acanthus leaves are beginning to break down into bifurcating offshoots, and most important of all, the main ribs of the branching leaves continue on beyond the leaf tips as stems that then support freely terminating, angular stylizations of palmettes. What we encounter, therefore, are expressly bifurcating tendrils to which additional stemmed blossom motifs are attached.

The Syrian example demonstrates unequivocally that this tendency in ornament was by no means restricted to a local Byzantine decorative art

[37] C.J.M. de Vogüé, *Syrie centrale* (Paris, 1865, 1877), pl. 76.

that originated in Constantinople and then spread into the provinces of the Empire. On the contrary, the seeds had been scattered everywhere by Greco-Roman art; the cultural climate as well as the forces striving for change and further development were the same throughout the empire. Furthermore, the contrast between the elegant and flowing rendering of the frieze from El Barah (assuming the drawing is an accurate reproduction) and the stiff, sluggish movement of the relief from St. John Studios shows that decorative sculpture in fifth-century Syria had by no means fallen behind what was produced in Byzantium. The Syrian example, moreover, is not an isolated one. De Vogüé's plate 121, for one, shows a similar treatment of the continuous acanthus tendril. Furthermore, the arched doorway of the double portal illustrated by de Vogüé[37a] and the one on the Golden Gate are both decorated with continuous acanthus tendrils, which establishes a tight developmental sequence between El Barah and St. John Studios.[s]

Intersecting tendrils that form polygons filled with leaves and blossoms, hence an intermediary stage of the specifically Islamic decorative scheme, are found repeatedly on Syrian buildings.[37b] There are also other examples, such as the one in figure 158,[38] however, that are strikingly similar to the formulas of the ancient Greek tendril (cf. the continuous tendril in figure 96 from the fifth century B.C.).[t]

Fig. 158. Border from the main apse in the Early Christian Church at Qalb Lozeh, Syria.

Until about a decade ago, virtually nothing was known of late antique Egyptian art. Today there is more Egyptian material at our disposal, at least in regard to ornament, than from any other region in this period. We owe this first of all to the textiles discovered in the tombs of Saqqara, Akhmim, Fayum, etc. and, second, to the examples of Coptic sculpture preserved in the museum at Bulak.[38a]

[37a] [C.J.M. de Vogüé, *Le temple de Jérusalem. Monographie du Haram-ech-Chérif suivi d'un essai sur la topographie de la Ville-sainte* (Paris, 1864), pl. 5.]

[37b] [De Vogüé, *Syrie centrale*, pl. 43.]

[38] Ibid., pl. 129, from Qalb Lozeh.

[38a] [A. Gayet, *Les monuments coptes du Musée de Boulaq*, Mémoires publiées par les membres de la Mission Archéologique Française au Caire (Paris, 1889).]

This material, which is rich beyond all expectations, has of course already been the subject of various studies. Karabacek has investigated the textiles acquired by the k. k. Österreichischen Museum in Vienna (the first of their kind to reach Europe), but he focused mainly on their evident connections with Sassanian-Persian and later Islamic art.[39] I myself have attempted to clarify, at least in general terms, the late antique connections of the purely decorative aspects of the textiles in the catalog published on the collection by the k. k. Österreichischen Museum.[40] As for the Coptic sculptures, besides Gayet, Ebers has dealt with them most thoroughly.[41] This author also vastly underestimated their close connection with late Roman-Byzantine art because of his bias toward an alleged renaissance of indigenous Egyptian artistic traditions, as I have proven in detail.[42, u] Notwithstanding all these initial attempts, no one has as yet compiled the kind of comprehensive overview of the material that would certainly yield highly significant results; we will have to confine ourselves in the following discussions to those monuments which can tell us something about the development of tendril ornament in early medieval Egypt.

Fig. 159. Decorated late antique pediment from Ahnas, Egypt.

The most significant example of all is reproduced in figure 159,[43] a fragment of a carved stone pediment.[v] Visible to the right are the two leaves of the split palmette fan from the corner acroterion; above them is an animal. The middle of the gable is occupied by two not particularly

[39] J. Karabacek, *Katalog der Th. Graf'schen Funde in Aegypten* (Vienna, 1883).

[40] A. Riegl, *Die ägyptischen Textilfunde im k.k. Österreichischen Museum* (Vienna, 1889).

[41] G. M. Ebers, *Sinnbildliches. Die koptische Kunst, ein neues Gebiet der altchristlichen Sculptur und ihre Symbole* (Leipzig, 1882).

[42] A. Riegl, "Koptische Kunst," *Byzantinische Zeitschrift* 2 (1893): 112–21.

[43] Gayet, *Les monuments coptes*, pl. 6, identified by him and by Ebers as an imported Byzantine work.

well- executed figures, whom Gayet identifies as David and Bathsheba. Our interest will focus on the ornament consisting of two interlacing tendrils found within the reversing border strip of the broken pediment. The leaves, which are three-pronged subdivisions of the acanthus leaf (wherever they are not straightforward though weak imitations of the two-dimensional half palmette), do not branch off freely on their own stems from the tendrils but intersect them. One of the three leaflets that comprise each of the larger leaves curves back in a manner that qualifies it as a calycal leaf; the two other leaves are oriented in the direction of the tendril. When these two leaves are isolated and given a firm, smooth outline, they begin to look like one of the most common of all of the patterns used in Islamic borders, particularly for decorating pilasters. The basic idea relates once again to the new freedom of the tendrils to continue from the tips of embedded acanthus half leaves or half palmettes. Wherever the tendrils finally do run out, however, the free terminations are punctuated by full leaves, or possibly even by full palmettes, for that matter, since the stylization makes it hard to determine exactly which are involved.

This kind of stylized tendril decoration, as one might expect from its frequency in mature Islamic art, occurs repeatedly on Egyptian sculpture of the transitional type characteristic of Byzantine art. Examples of this kind appear in Gayet.[43a] Gayet, of course, is trying to prove that the accompanying figurative depictions, illustrated on his plates 4 and 6, are of Byzantine origin and that the reliefs therefore are imports. Those of us who do not find any justification for Gayet's differentiation between Byzantine and indigenous Egyptian art in the sixth and seventh centuries will have no trouble assigning this sculpture an Egyptian origin. However, even if Gayet were right, it would not essentially alter our thesis: we have already established that the tendency leading up to the incorporation of the profile leaf within the tendril, characteristic of Islamic art, (which proved to be the underlying scheme of figure 159), was already present on any number of monuments from the eastern Roman Empire, including those originating in Constantinople. Figure 159 represents a very straightforward and decisive step in this direction, something we would sooner expect in the region that later gave rise to pure Arabesque ornament than within the precincts of Byzantium, where art continued to vacillate between an adherence to tradition and a susceptibility to the decorative inclinations of the period."

[43a] [Ibid., pls. 4, 93.]

Fig. 160. Decorated border from a late antique or early medieval
Egyptian grave stele.

The other examples of tendril ornament in Coptic sculpture all tend in
the same direction, if not at the same quick pace. I call attention here
simply to the frequency with which the tendril splits in figure 160.[44] This
would not have been possible without the basic principle that began to
govern the treatment of leaves and tendrils and was already a major factor
in figure 159. The elaborate way in which the offshoots splitting off from
the continuous tendril break down further into richly branching subsidi-
ary tendrils[45] is at odds with the antique tradition, which in the same situa-
tion generally insisted on one free termination for each single spiral at this
point. This innovation manifests a neo-Oriental preference for small,
dense, and evenly distributed overall patterning. In addition, there are
examples of basic spiraled undulating tendrils like the original Mycenaean
scheme (fig. 50), which are enriched only by simple peaked forms serving
as the equally primitive axil fillers.[46] This is not insignificant, considering
that the same typically early tendril forms still frequently occur even after
the Arabesque had become dominant.[x]

AT THIS point, we must end our discussion of the extensive Egyptian
material and turn to the early medieval monuments of the other Asiatic
regions that maintained ties with Constantinople. There is, unfortunately,
so little accessible material published about the art of Asia Minor that we
can bypass it without any great loss. One can probably safely assume,
moreover, that the western headland of Asia Minor followed Byzantium's
lead more closely than any other region.[y] On the other hand, a small but
valuable group of monuments originated along the eastern periphery of
Mediterranean culture, a region that was an artistic rather than a political
province of the Roman Empire.

The Persians of the Sassanian period (A.D. 224–643) are usually ac-
corded an important and in fact vital role in the development of the so-
called Islamic style of the medieval Orient. This prevailing view sees the

[44] Ibid., pl. 98. [45] For example, ibid., pls. 98, 30. [46] Ibid., pl. 27.

decoration on surviving Persian monuments of this period as closely related to that on the truly Islamic monuments themselves. At the very least, Persian ornament is claimed to be the immediate predecessor of Islamic work. Consequently, we need to advance a different view of the Sassanian-Persian monuments, one that would include them as part of the Byzantine transformations of antique tendril ornament.

It is indeed astonishing to think that we are still compelled even today, to justify our approach. At the same time, this situation results once again from a blind adherence to art-historical materialism and its corollary that virtually every category of art developed autochthonously with its own national character. The scholars of forty years ago or more, as we shall see, those who still worked with open minds and an unbiased view of historical developments, did not for an instant doubt the close connection between Sassanian and Western art. But the surging movement that would approach art primarily as the spontaneous result of material mechanisms rather than as a traditional process of study and imitation has, in the interim, managed to obscure and suppress the conceptual insight achieved initially by unprejudiced investigators. Therefore, in dealing with a few of the more characteristic monuments of Sassanian art published in Flandin and Coste,[46a] our purpose will not only be to investigate the development of vegetal tendril ornament but also to determine more precisely the position of this entire group of works within the history of art.

Our first example is from the vaulted grotto built at Taq-i-Bustan by the penultimate Sassanian king, Chosroes II (Khusrau Parwiz), which presumably dates from around A.D. 600.[z] There are in addition a number of architectural fragments that Flandin and Coste discovered in Isfahan, and which are so similar in general character and detail to the decoration of Chosroes's grotto that we can without hesitation assign them an approximately similar date. In Byzantium at this time, the innovations we encountered in Justinianic architecture had already come to maturity, although not enough time had elapsed since the collapse of the Roman Empire for the art of the provinces to have made any substantial progress. In other words, the Sassanian architectural decoration we are about to investigate comes from the very period of transition that now preoccupies us.

Let us first examine the capital in figure 161. The decoration consists of a single vegetal motif articulated as a number of component parts. It has a thick stem interrupted by rings and sheaths. Below to either side leaf

[46a] [E. N. Flandin and P. Coste, *Voyage en Perse* (Paris, 1851–1854), atlas 1, pls. 6, 17 bis.]

Fig. 161. Sassanian Persian impost capital
from Bisutun, Iran.

tendrils circle downward in a spiraling curve and terminate in flowers.
Then come large, luscious leaves that branch off on both sides above the
tendrils; the leaves immediately next to the stem curl toward the middle
like volutes, while the outer ones curve around in the opposite direction
to reveal tendril stems beneath their tips that terminate in half leaves and
flowers. Finally, there is a flower crowning the main stalk that has volutes
emerging from the sheath of the stem and a number of leaf calyces enclos-
ing its oval core.[aa]

The structure of the motif is familiar to us in every respect from any
number of Roman monuments, and the same is true of the leaves, which
consist exclusively and entirely of acanthus. Moreover, they are not the
kind of geometricized acanthus motifs that predominate on buildings of
the early Byzantine period but a type of bushy, luscious, plastic acanthus
still very similar to the Roman acanthus itself. The indentations between
the main groups of pointy leaflets are already quite deep, but they do not
yet succeed in destroying the integrity of the leaf as a whole. The curving
tips of the large, lateral acanthus half leaves recall the marked preference
of later Islamic artists for lines that wind into ogival arches; nevertheless,
they are still entirely Roman. This is also confirmed by the way the ten-
drils emerge from beneath the leaves and not from their tips. The em-
phatic volute-calyces that occur at the points in the stem where the large
lateral leaves and the central flower emerge are also antique. Neverthe-
less, stylistically they do not so much reflect Roman sensibilities, which
often preferred to omit the two-dimensionally conceived volute-calyx
from the sculptural acanthus. They are closer to the more rigid Greek
form of stylization, which of course had once held sway over this part of

Asia before the arrival of the strongly naturalizing tendencies that came with Roman classical art.

The prototypical qualities of figure 161, which appear to anticipate the specifically Islamic manner, reside not so much in the handling of the tendrils but in the articulation of the leaves and blossoms. This includes first of all the way that the lateral ribs of the acanthus leaf are drawn together tightly side by side; second, the way the edge of the leaf is echoed by a jagged, interior line running parallel to it on most of the leaves;[47] and finally, but not least important, the way the acanthus half leaves appear to be folded in half, so that a number of them, functioning as calyces, fit easily into one another to form larger blossoms like the one in figure 161. This is a very important feature, because later in Arabesque ornament we will encounter vegetal forms that look as though they are doubled-over versions of rounded calycal leaves.

In order to gain a more profound understanding of the fundamental decorative laws governing the formation of Sassanian blossoms, we would have to go back and systematically investigate the development of blossoms since the Hellenistic period, since they apparently started out from such naturalizing roots. As yet, no one has attempted this potentially rewarding task. Later, however, we will have an opportunity to point out some particularly significant details.

Let us now examine the pilaster capital in figure 162 from the grotto of Chosroes at Taq-i-Bustan. On the neck is a row of acanthus calyces that are doubled up in the way just described; the "pipes" are indicated by drill holes. The plant on the capital itself has the same thick, candelabralike stem as figure 161. The leaves that branch off to either side in profile are initially hard to identify. At first they seem to be acanthus half leaves, because of the relative dearth of volute-calyces. However, when compared to the two lower spiraling leaves, which are straightforward, if slightly unconventional acanthus half leaves, we see that they are actually two-dimensional half palmettes. The flowers perched on the tip of each half palmette clearly manifest, once more, the antinaturalistic law governing the combination of flowers and tendrils, a subject that has now been sufficiently discussed. In addition, there is a row of trefoil motifs like the one in figure 143, each of which is circumscribed by a heart, decorating the abacus.[bb]

These two examples of Sassanian ornament are sufficient to justify Owen Jones's statement that "the ornaments are constructed according to

[47] See figure 163 from another capital of the same group. [From Isfahan (Jones, *The Grammar of Ornament*, pl. 14, no. 22).]

Fig. 163. Detail of an
acanthus leaf on a Sassanian
Persian impost capital
from Isfahan.

Fig. 162. Pilaster capital in the
grotto of the Sassanian
Persian king Chosroes II
at Taq-i-Bustan, Iran.

the same principles as Roman ornaments, though the modeled surfaces
are treated more like the variations found on the Byzantine ornaments
which they strikingly resemble."[47a] Anyone who still sees these motifs as
the typical expression of a supposedly indigenous Persian culture must
answer the question as to just when and how this "national" art actually
developed. As we discovered in chapter 3, the ornament on Sassanian
monuments had nothing to do with the Persian art of the Achaemenid
period. Did it come from central Asia with the Parthians perhaps? That is
also not very likely, since, as we know from the Turks and the Mongols,
only geometric forms managed to reach the West from that region. There-
fore, the only assumption left is that the Persians themselves invented a
kind of vegetal tendril ornament ex nihilo, parallel with the Greco-Roman
development, i.e., that on their own, in a few centuries, they were able to
accomplish what had taken the other cultures of antiquity no fewer than
two millennia to develop. I fear, however, that this assumption would find
few supporters.

The acanthus motifs in figures 161 and 162, as mentioned before, are
rendered in the luxurious, naturalizing Roman manner. The pointy, con-
ventionalized units or subdivisions, which we saw in early Byzantine art
and which look as though they had been plucked from the full leaf,
also occur on the border of another Sassanian capital, a detail of which is
reproduced in figure 164.[cc] At first glance, it looks completely Islamic, and

[47a] [Jones, *The Grammar of Ornament*, 30.]

Fig. 164. Lower border of a Sassanian impost capital
from Bisutun.

yet no amount of close scrutiny can disclose a single detail that is not familiar to us from early Byzantine monuments. Below there are split palmettes like the one in figure 148; in the middle trefoils, comparable to figure 143 and circumscribed by ovals that are even more antique than the heart-shaped one in figure 162; and, finally, at the top, pairs of diverging trefoils that also recall figure 143. This indicates how closely the early Byzantine approach already approximated the Islamic ornament and how a similar process had been developing steadily in all of the regions once dominated by East Roman art. There was really little more that was necessary to transform them into the floral and leaf motifs of the pure Arabesque: only in the treatment of the tendrils, however, was there still one more crucial step to be taken; although, as we have seen, the basic course had already been set.[dd]

B. Early Islamic Tendril Ornament

Now that we are finally about to discuss the Islamic monuments produced several centuries after the new religion had emerged, let us review the specific properties that characterize the mature Islamic tendril ornament, the so-called *Arabesque*.

1. The tendrils have once more become linear, more or less geometricized connecting elements. In their movements, however, they very often abandon the circular path that had remained a constant and characteristic feature of classical antique spiral ornament. Instead, they wind around in oval, eccentric curves, even forming polygonal shapes when, as is often the case, they converge from different

directions. This is especially true when the tendrils are treated as bands, i.e., when tendril ornament combines with banded interlace. In this case, the main bands follow the new scheme, be it polygonal or curvilinear, while the fine tendrils filling up the interstices maintain beautiful, swelling, circular curves.

2. The motifs resemble either the two-dimensional palmettes or the acanthus half leaves of antiquity, or, lastly, their Byzantine derivatives. The same antinaturalistic tendency, which had already restored the geometric quality of the tendrils, also manifested itself in individual motifs, firstly through the reduction or suppression of the separate leaves. Secondly, it appears in the pronounced, general preference for symmetrical schematization; and thirdly, in the way the pointed shapes, such as leaf tips for example, tend to curve back on themselves. In addition to the motifs that are stylized in a completely geometric manner, such as trefoils, there are also more naturalistic ones whose modeling unequivocally betrays their genetic relationship to the sculptural acanthus leaf. However, even in this case, there are smooth, unarticulated outlines around the perimeter of the delicately notched edge that leave a geometric impression. It is also characteristic for two half leaf motifs serving as the terminations of converging tendrils to curve together at an angle into a whole motif. Later we shall discuss how this relates to a very specific, fundamental law of Islamic surface ornament, the infinite rapport.

3. The relationship between the tendrils and blossom motifs is ultimately such that the blossoms are no longer *attached* as offshoots to the tendrils but *merge* to become more or less integral, embedded portions of the tendrils.

To begin our survey of the monuments, we will consider the stucco ornaments from the Mosque of Ibn Tulun in Cairo, completed in 878 after two years of construction. Prisse d'Avennes[48] has published all of them; the only one that does not belong to the ninth century is the wide filler number 17, found on the middle of the plate, which will have to be ascribed to a later period (twelfth or thirteenth century). Any one of the remaining thirty-six fragments of border patterns would serve to demonstrate the close relationship to classical vegetal ornament; however, the comprehensive task that we have set out to accomplish here compels us to limit the material as much as possible.

[48] A. Prisse d'Avennes, *L'art arabe d'après les monuments de Caire, depuis le VIIe siècle jusqu'à la fin du XVIIIe* (Paris, 1877), pl. 44. Many of these are also illustrated in Jones, *The Grammar of Ornament* (London, 1856), pl. 31. [Riegl's original citation of Jones as pl. 30 is incorrect.]

Above all, we encounter the old familiar, undulating tendril schemes. Figure 165[49] is an intermittent tendril with alternating three-pronged lotus blossoms and palmettes connected by bifurcating tendrils (figs. 134–36). Figure 166[50] has the same scheme enriched by half palmettes (or acanthus half leaves), whose ends lead directly into the full palmette, merging unambiguously with the undulating tendril. The two bifurcating tendril motifs, which had functioned as connectors in figure 165, are used in figure 166 to flank and frame the other motifs while filling the space between them. It is also noteworthy that these bifurcating tendrils provide the five-pronged full palmette with a smooth outer contour line, just as the outer leaves of the three-pronged lotus blossom accomplish this for the four indentations of the half palmettes that interrupt the tendrils.

Fig. 165. Stucco ornament from the Mosque of
Ibn Tulun, Cairo.

Fig. 166. Stucco ornament from the Mosque of
Ibn Tulun, Cairo.

[49] Prisse d'Avennes, *L'art arabe*, pl. 30, no. 31.
[50] Ibid., pl. 30, no. 34.

Fig. 167. Stucco ornament from the Mosque of
Ibn Tulun, Cairo.

Figure 167[51] is a continuous tendril with an offshoot bifurcating from
each undulation of the main tendril. At first, these offshoots create circular
curves in the antique manner. But, instead of terminating in palmettes,
their outer leaves[52] continue as tendril stems running in a direction oppo-
site to the original circular spirals, and then they bifurcate once again.
There are two things that distinguish the early Islamic undulating tendril
from the version of classical antiquity: (1) the way the offshoots from the
continuing tendrils double back in the opposite direction; (2) the fact that
the palmettes, which are clearly characterized as such by the volute-caly-
cal leaves at their lower points of inception, do not terminate the offshoots
freely but merely interrupt them. However, figure 167a, which translates
the pattern back into the antique mode, demonstrates how extensively
the ancient Greek scheme already prefigured these apparently fundamen-
tal distinctions. The tendrils do not continue on as single strands but split
so that the palmettes become mere axil fillers.[53] The intermediary Byzan-
tine stage is found in figure 160.

Fig. 167a. Greek "translation" of
fig. 167.

[51] Ibid., pl. 30, no. 33.

[52] Specifically in the case of half palmettes; however, whenever full palmettes are in-
volved, then the tendrils continue on from one of the two available calycal leaves.

[53] This schematic version is, moreover, vastly in evidence in the Middle Ages as well; see
the portable altar in F. Spitzer, La collection Spitzer, antiquité, moyen-age, renaissance
(Paris, 1890–1891), "Ivoires," pl. 13.

There are still two important details in figure 167 that require our attention. First, there are the distinctly drop-shaped axil fillers in the angles produced where the main offshoot departs from the principal tendril. The postulate of axil filling, which had been very strong in the Pharaonic period, as mentioned earlier, remained in widespread use in Islamic Egypt as well. Good examples of this occur among the Coptic miniatures reproduced by Stassoff,[54] although the overextended oval buttons in the axils of the tendrils are rather ungainly and jarring. The second noteworthy detail in figure 167 is the use of slots resembling commas that bisect each palmette or, better said, each half palmette. They represent a subdivision of the merged blossoms that is coordinated with the serrated articulation of the leaf contours. The next example will better demonstrate how important this detail was for the subsequent development.

In figure 168[55] the tendrils meet to form pointed elliptical shapes. Two tendrils rise from within the bottom of each pointed ellipse to expand into

Fig. 168a. Islamic wood carving
of the twelfth century.

Fig. 168. Stucco ornament from
the Mosque of Ibn Tulun, Cairo.

[54] W. Stassoff, *Ornement slave et oriental, d'après les manuscrits anciens et modernes* (St. Petersburg, 1887), pls. 132–35.
[55] Prisse d'Avennes, *L'art arabe*, pl. 44, no. 6.

two half palmettes, each of which serves as half of the fan of a split palmette. These half palmettes, however, are not yet the free terminations of the tendrils but merely additional enrichments, since the tendrils continue on from the pointed tips of the two fan-halves to double back and converge once again in the trefoil motif that finally terminates the pattern. Even for this type of tendril treatment, it would not be difficult to trace out the underlying classical scheme. However, there is no need to do so, since, surprisingly enough, we already have such a Greek translation on a genuine Islamic wood carving of the twelfth century, which will be discussed later (fig. 168a). Consequently, it is no accident that in Byzantine art as well, we often find precisely this motif—a split palmette whose fan-halves continue above like tendrils, double back toward the interior, and finally terminate (freely) in a common trefoil. Nor can we explain such Byzantine examples as borrowings from Islamic art.[56] The generally exotic "Oriental" appearance of figure 168 resulted neither from the treatment of the tendrils nor from the stylization of the blossom motifs. It arose from the absorption of the blossoms within the tendrils, for it is very difficult for anyone to discern at first glance where the tendrils stop and the blossoms begin, and vice versa. Originally, in the ornament of classical antiquity, on the other hand, the tendrils and the palmette-fan-fillers were clearly and precisely differentiated, as they remained even in Byzantine ornament, where the embedded acanthus half leaves can still be distinguished fairly easily from the tendrils. The Islamic artists consciously resolved to expand upon the inherited germ of an idea that had already begun to sprout among the people of antiquity; in this respect as well, the difference between late antique and Islamic ornament seems to be merely a matter of degree rather than some deep-seated distinction.

Let us look again at the serrated half palmettes, which converge to form a split palmette within the pointed elliptical outline. The projecting points probably represent the individual leaves of the fan; however, the leaf veins themselves are not indicated; the tendrils forming the pointed elliptical shape provide smooth, outer contour lines. Furthermore, these half palmettes once again have the comma-shaped apertures that similarly divide each palmette approximately into two parts. These apertures clearly reveal a tendency to bisect and split the embedded half palmettes, resulting ultimately in the Arabesque bifurcated tendril (fig. 189a).

The two tendril bands that form the pointed elliptical frame for this filler motif divide once again at the top to form another pointed ellipse,

[56] See Stassoff, *Ornement slave et oriental*, pl. 124, no. 12. Moreover, it is by no means rare in Western art of the tenth through the twelfth centuries.

the bottom of which is just barely visible in figure 168. Wherever the two tendril bands meet between the pointed elliptical shapes of this narrow frieze, it partially produces semicircular spaces to the left and right. Let us examine the elements that fill these spaces identically to either side. Closer scrutiny reveals that they are simply half portions of the same motif that fills the pointed ellipse. The schematic, antinaturalistic quality that characterizes this developing Islamic tendril ornament is more striking here than any discussion of the individual motifs can demonstrate. These artists transformed into lifeless geometry what was originally a vegetal motif that had conformed to the laws of natural life. They subdivided it and transposed it as they saw fit, depending on the geometric or symmetrical demands of the space to be filled.

If we compare the motifs filling the lateral segments of figure 168 with the offshoots in figure 167, on the other hand, they suddenly appear to be nothing more than simple sections or offshoots from a continuous tendril. The only difference is that the palmettes in figure 168 are more elongated and have more jagged edges, in order to fill the larger segmental space. From this, we can also deduce that the filler motif within the pointed ellipse in figure 168 is no more than a duplication of the offshoot of the continuous tendril in figure 167.[57] This can, of course, only serve to strengthen our observations concerning the schematic quality of this kind of tendril ornament. At the same time, it reveals a very essential and fundamental principle regarding the structure of Arabesque decoration and Islamic surface ornament in general. As a rule, a simple element—even if it is a composite one—provides the basis of the entire decorative conception: either by duplication or division, so as to establish a continuous pattern of interrelation. This principle, of course, had long been known and practiced in geometric design: networks of squares and diamonds are the earliest attempts of this kind. The achievement of Islamic artists was the establishment of this law of infinite rapport as a dominant principle in their vegetal tendril ornament.

Another penetrating look at these ninth-century ornaments will soon demonstrate why we are justified in considering this a real achievement in the history of ornament. It is by no means obvious that the fillers on the sides of figure 168 are simply half portions of the central motif filling the pointed ellipse; this fact can only be detected after careful analysis. Even less striking is the connection between the motif in figure 168 and the

[57] This also explains the tendency we have seen repeatedly (chapter 4 A, fig. 145, and the beginning of chapter 4 B) allowing two half motifs joining to form one whole symmetrical motif.

undulating tendril in figure 167, and this is precisely what is so character-
istic of Arabesque ornament: the individual motifs vary only slightly and
then repeat continuously, and yet they never become monotonous. The
pattern as a whole seems infinitely richer than it actually is; in fact, for the
uninitiated Western observer, it often appears so confusing and compli-
cated that there would seem to be little hope of ever untangling the
"thread of Ariadne" at all, even though those familiar with the basic princi-
ples governing the formulation of the Arabesque would have little trouble
doing so.[a]

Now that we have raised the subject of infinite rapport, we shall discuss
it a bit further from an historical perspective, even though it means di-
gressing somewhat from our main topic. When does *infinite rapport* first
appear in surface ornament? Is it also found in pre-Islamic periods? Obvi-
ously, these questions aim at determining the creative contribution of Is-
lamic artists to this kind of surface decoration. The theme is, of course, so
broad and the material so extensive, that only a book-length treatment
could hope to succeed in exhausting it. Here we are compelled to restrict
ourselves to delineating the main points of the development.

Infinite rapport appears very early on in geometric styles in the form of
checkerboard and diamond patterns. However, they are hardly more ad-
vanced than rudimentary banded registers. Infinite rapport becomes in-
teresting for our purposes only when the motifs have moved beyond the
geometric stage. This first took place, as far as we know, in Theban ceiling
decoration of the New Kingdom in Egypt. The basic structure of this dec-
oration, to be sure, consists of winding spirals, but the intervening fillers
are often animal or vegetal motifs. In Prisse d'Avennes's reproductions,[58]
there are frequent instances where, for example, the whole palmettes that
serve as fillers are rendered as halves when they abut the border at the
edge of a pattern. The concept of the infinite rapport is clearly implicit
here, for it is easy to imagine the half palmette doubling into a whole motif
and running beyond the interrupting border. However, the variant that
sets off the patterns at the edges and borders in this way is, to judge from
Prisse d'Avennes's reproductions, by no means the rule;[59] the final deci-
sion would depend on the study of the originals themselves.

After what we have learned about the objectives and tendencies of
Greek vegetal ornament in chapter 3, it will come as no surprise that

[58] For example, A. Prisse d'Avennes, *Histoire de l'art égyptian d'après les monuments,
depuis les temps les plus reculés jusqu'à la domination romaine* (Paris, 1878–1879), atlas 1,
"Ornementation des plafonds; postes fleuronnées," no. 9.
[59] Compare, for example, our figure 23.

infinite rapport did not play a leading role in Greek decorative art.[60] As long as Greek art gradually but consistently maintained its course toward naturalism, there was no place for vegetal *infinite* tendril patterns. It is only after the Hellenistic period, when naturalism had reached its high point and the initially subtle but then ever stronger inclination to stylize nongeometric decorative motifs first became apparent, that we can start looking for nongeometric infinite patterns in antique art.[b]

The city of Pompeii, that invaluable resource, can again provide us with some very important evidence. Despite the fact that Pompeiian decoration represents the quintessence of free tendril ornament and figurative scatter patterns, it also has examples of geometricizing wall decoration based on infinite rapport. First of all, there is the basic diamond pattern;[61] in this case, it is only the variation in color of the individual diamond fields that produces the decorative pattern. Then there is more complicated diamond patterning, which consists of larger diamonds alternating on a background of smaller, variously colored smaller diamonds.[62] Here again, it is the coloring alone that creates the decorative effect. In both cases, however, there are triangles along the outer edges, or to be more specific, half diamonds that plainly announce the presence of an infinite rapport.

The Romans of Pompeii, however, were not satisfied with these rather simple patterns. There are also a number of highly remarkable attempts (fig. 169)[63] to subdivide a surface into a series of basically geometric but varied shapes. They include triangles, squares, diamonds, and hexagons, several of which combine to form larger, more complex configurations (dodecagons, stars, etc.). These larger configurations, bounded by angular, broken bands, are the most immediate and closely related prototypes of Islamic polygonal ornament.[c] Geometric configurations alone, however, were not enough to satisfy the sensibility of classical antiquity. That is why we find small ornamental motifs inserted into the individual hexagons and other subdivisions in figure 169—although in this case, they are very simple basic geometric forms. Nevertheless, they are already enough to distort and disrupt the infinite rapport at the edges: the filler motifs were not sufficiently geometric or, to put it another way, not sym-

[60] It is, however, definitely found in Mycenaean art: in a wall painting illustrated by H. Schliemann (*Tiryns: der prähistorische Palast der Könige von Tiryns* [Leipzig, 1886], pl. 11) and in vase painting (ibid., pl. 27). In the latter example, the polygons bordering the upper edge have surely been cut in half as opposed to the filler motifs, which are clearly derived from plants. The situation requires more careful observation.

[61] Niccolini, *Case ed monumenti di Pompeii* (Naples, 1854–1896), vol. 2, part 2, "Descrizione generale," pl. 47.

[62] Ibid., pl. 36, center.

[63] Ibid., vol. 1, part 2, "Tempio d'Iside," pl. 2, bottom.

Fig. 169. Mosaic pavement from the temple of Isis, Pompeii.

metrical enough to be bisected arbitrarily. And this is primarily why the
infinite rapport never attained the prominence in the Roman period that
it achieved later in the Middle Ages: the Romans were never satisfied with
insignificant geometric fillers alone; they simply would not give up figura-
tive elements.

Several other examples can be cited as proof of this. In figure 169, the
geometric compartments on the edges are still relatively independent. In
another case,[64] however, the pointed ellipses forming the diamond net-
work are cut off at the edges in approximately three-quarter lengths,
merely in order to accommodate the floating Eros figures and Bacchantes,
as well as the graceful floral boughs within the concave, square compart-
ments framed by each set of four-pointed ellipses. It was obviously consid-
ered preferable to sacrifice the infinite rapport and the clarity of the basic
ornamental scheme than to restrict the decorative figures in any way.

An extremely important step toward the refinement of more richly
varied surface decoration based on geometric schemes is represented
by the type of ceiling decoration (fig. 170)[65] that has circles alternating
with curved polygons joined together by intertwined bands. Do we really
require any further proof that the polygonal interlacing bands of Islamic
art evolved directly from late antique beginnings? Is it not quite apparent
that they are nothing more than the final and logical consequence of a
geometricizing tendency in surface decoration, whose first faint and tenta-

[64] Ibid., vol. 2, part 2, "Descrizione generale," pl. 46.
[65] Ibid., vol. 1, part 2, "Terme presso la porta Stabiana," pl. 3, 4.

Fig. 170. Polychrome stucco vaulting decoration from the
Apodyterium of the Stabian Baths at Pompeii.

tive impulses can be traced to the late Hellenistic period and whose con-
tinued application can be easily attested by any number of mosaic floors
from Trier to [North] Africa?[d]

In figure 170, all of the spherical subdivisions are also filled with figura-
tive motifs; as a result, the same problems arise with regard to the edges
as discussed above. Pompeiian art, however, was also able to'find a com-
promise between the basic geometric scheme and the desire for nongeo-
metric fillers by using appropriately stylized vegetal motifs to comprise
the geometric compartments themselves. The mosaic column in the Mu-
seum in Naples (figure 171) displays such a solution.[66] The network of
diamonds is formed by blossom calyces arranged along straight diagonal
lines; the intersections are marked by rosettes that give rise to four three-
pronged blossom profiles arranged in a cross. Rosettes are also used to fill
the diamonds, obviously because the rosette is the most symmetrical and,
consequently, the most geometric view in which a flower can possibly be
depicted.[e]

There can never be too much emphasis placed on the importance of this
type of Pompeiian surface pattern for the history of ornament as a whole.
It is a perfect example of an infinite rapport composed of appropriately

[66] Ibid., vol. 2, part 2, "Descrizione generale," pl. 63, center.

Fig. 171. Mosaic column from the Villa of the Mosaic Columns near Pompeii.

selected and stylized vegetal motifs. For the first time we encounter a scheme that would become enormously important later in Islamic decoration, especially in the ornament of carpets and tiles: halves of floral profiles occur along the edges, which become whole again in our imagination, thus allowing the pattern to expand infinitely. It is especially surprising to find an example like this in Pompeiian ornament, considering how the Romans even in much later times still insisted on preserving the integrity of vegetal elements within the composition. Figure 172 serves to exemplify this latter approach to vegetal motifs in Roman surface ornament.[67]

There is still one more issue that must be addressed to avoid any misunderstanding. As in all of the other

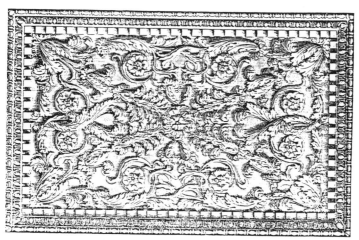

Fig. 172. Decorated marble soffit from the architrave of the Temple of Jupiter Tonnans, Rome.

[67] A. B. Desgodetz, *Les édifices antiques de Rome* (London, 1771–1795), "Temple du Jupiter Tonnant," pl. 3.

ornamental systems, there have been attempts to trace the origin of the infinite rapport, in the advanced stage represented by figure 171, back to a particular technique—in this case, specifically, to laying tiles. This hypothesis relies on the observation that the infinite rapport as a rule is based on polygonal and often square units. The advantage for the technique of mosaic tiling, of course, was that tiles could be fired in great numbers with the same pattern, and when placed side by side, they would yield a complete and relatively elaborate pattern. But this once again reverses the causal relationship. It was only natural for those engaged in the fabrication of tiles or in actually laying tiles to adopt avidly a decorative system so perfectly suited to the technique. However, the notion that the infinite rapport first occurred on tiles is absolutely untenable. Not a single example can be cited from the Roman period: all of the relevant Pompeiian monuments introduced above were, without exception, executed either in painted stucco, fresco, or inlaid mosaic, and never in larger units of tile. On the other hand, glazed tiles were used very early in areas such as Babylon and then later in Assyria, where stone was unavailable and fired clay was required to take its place. However, the square enameled tiles from ancient Mesopotamia are not decorated with patterns based on the infinite rapport but with objective representations like the ones from Khorsabad[67a] or with rows of vegetal ornaments connected by arches, as in our figure 33.[f]

We come, therefore, to assume that there were artistic rather than technical factors involved in the creation and formation of patterns like the one in figure 171. And in the final analysis, these may have been the very same factors that were contributing to the gradually less naturalistic approach to the acanthus and the tendril. In fact, both phenomena run parallel to each other from now on. Wherever we meet the first clearly stylized acanthus motifs, like those of the eastern Roman Empire in the fifth and sixth centuries, we also find the infinite rapport occurring more frequently in wall decoration. Furthermore, both tendencies seem to have advanced to a stage approximately halfway in the development toward the ultimate conclusion represented by Islamic art. Figure 144 shows tendril ornament which, while already greatly transformed in detail, is still conceived in a completely antique spirit. In figure 145, the shift to a basically geometric scheme is complete, but the infinite rapport is not yet resolved in a satisfactory manner. In fact, the only place it comes to expression is on the lower edge, where one can imagine the half

[67a] [V. Place, *Ninive et l'Assyrie* (Paris. 1867–1870).]

palmettes duplicating into the fans of split palmettes. Salzenberg's repro-
duction[67b] is, however, a resolved example of an infinite rapport: in its
arrangement and even its motifs, it has so many points of contact with the
Pompeiian example in figure 171 that I have not bothered to reproduce it.
Moreover, the quantity of relevant material preserved on East Roman
monuments is so great that it deserves its own separate treatment. There-
fore, I shall only illustrate a particularly characteristic example from
Betursa (Syria) in figure 173.[68] Each of the bands, which twist partly into

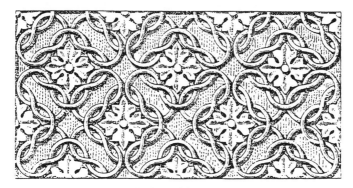

Fig. 173. Relief panel from Betursa, Syria.

quatrefoils and partly into pretzel-like interlacings, follows a path shaped
like a cross tilted on its side— something that the casual observer surely
would not notice. Here we already find a clear manifestation of the ten-
dency, so characteristic of Islamic art, to render the interlacing patterns
difficult to follow. The infinite rapport is indicated at the edges by half
rosettes in half quatrefoils, while the motifs in the upper corners, consis-
tently enough, have been quartered.[g]

We can now resume our examination of the tendril ornament on early
Islamic monuments. Figure 174[69] shows the carved front side of an ivory
box that is now located in the Musée des Arts Décoratifs in Paris. An
inscription on the lid refers to the year A.D. 966, indicating that it dates
approximately a century later than the stucco ornaments from the Mosque
of Ibn Tulun in Cairo.[h] Since each of the sections to the left and right of the
lock is completely identical, we will focus on only one side. In a number
of details, figure 174 does not seem to be as advanced in the development
as earlier examples. The close connection to antique tendril ornament is

[67b] [Salzenberg, *Alt-christliche Baudenkmale*, pl. 25, no. 2.]
[68] From de Vogüé, *Syrie centrale*, pl. 43.
[69] G. L. Schlumberger, *Un empereur byzantin du XIème siècle* (Paris, 1890), 125.

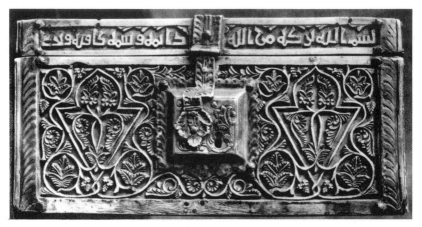

Fig. 174. Moorish ivory casket from Spain, dated A.D. 965.

still clearly visible in the spiraling of the offshoots, in the way the larger blossoms are attached to stems, and also in the minor role accorded the small, embedded half palmettes. This antique quality also emerges in the modeling of the leaf motifs in a distinctly plantlike manner with fine, featherlike leaflets: we have already explained how this treatment resulted from stylistic changes in the acanthus leaf. This is finally corroborated by figure 175, where some of the acanthus motifs still have pipes indicated by the round drill holes between the individual indentations.[70] Moreover, the leaves are not circumscribed by smooth outer lines, but have retained their finely serrated contours. In spite of all this, no one would ever question the Islamic origin of this box even at first glance. It is clear especially from the characteristic, polygonal shape, which the main tendril delineates over the entire height of the field, but also from the manner in which the tendrils intersect, and last—or so it seems at least initially—from the treatment of some of the blossom motifs.

Characteristically, the process that transformed the naturalistic antique tendril into the geometric, stylized Arabesque began simultaneously in various places. Moreover, its subsequent development was by no means even: in some instances, the schematization of the motifs advanced more quickly, while in others, it was the treatment of the tendril. This is hardly surprising, considering the process was taking place over a far-flung region that extended from the Pyrenees to the Hindu Kush. Surely further study of the history of Islamic art will eventually enable us to recognize

[70] Incidentally, examples of acanthus motifs treated in precisely the same way are not at all rare in Western art (ivory carvings, manuscript illumination) of this period.[i]

and isolate the characteristics of individual local schools. Today we are still preoccupied with establishing the common denominator of the development as a whole, a development whose roots—and whose only possible roots, I might add—went back to the common experience of late antique-Byzantine art, i.e., the art that dominated all of these regions across three continents when Islam first emerged.[j]

Now let us briefly discuss the specifically Islamic motifs in figure 174 already pointed out above. First of all, there is the main tendril, which curves inward to form a polygon with partially curved sides. This form then encloses a configuration of two tendril branches that intersect twice. Especially characteristic is the way the half leaves intersect at the bottom to form a kind of whole leaf. The blossom motifs are made up of acanthu-sized leaves and are of two types. There are those with double calyces packed into one another and crowned by a leaf resembling a palmette fan, and then (within the ogival arch) there are those with long fans curving off to the side above a calyx of circular, coiled volutes. The genealogy of these blossom forms will occupy us further, below.

But let us first examine another ivory box (fig. 175), which is so closely connected to the dated piece in figure 174 that it must have originated at

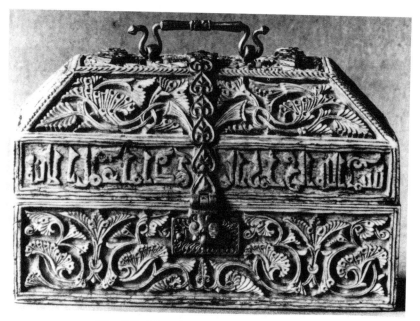

Fig. 175. Moorish ivory casket from Spain.

approximately the same time. Granted, the distinctly antique-inspired formation of the acanthus and the lack of a polygon as seen in figure 174 may well appear to suggest that figure 175 represents an earlier stage of development, as do the spiral tendrils that burst forth from the half palmettes along the upper edge of the front panel and serve more or less as axil fillers. But just the same, there is no paucity of evidence to demonstrate the distinctly Islamic character of figure 175, such as, for example, the abundance of interlace (particularly on the lid), the intersecting of leaves and tendrils, and the stylization of the individual leaf motifs. Full acanthus leaves, which are indented in the middle, have been inserted into the bifurcations that occur to the right and left of the lock on the front panel: they are true Islamic bifurcating tendrils (cf. figures 138, and 139, motifs *a, b*). The pronounced indentations in the middle of these motifs are also related developmentally to the apertures of the palmettes in figures 167 and 168, which can now be explained. The tendril in which we encounter the bifurcations just described is located directly below a large acanthus leaf. The leaf can be identified as a half palmette by the volute—albeit stylized as an acanthus—that appears at its point of inception. This is a rather characteristic feature for this stage of Islamic ornament as a whole, namely, that the general outlines are adopted from the two-dimensional palmette types, which tend to be geometric, while the treatment of details, on the other hand, is based for the most part on the acanthus. Even this acanthusized half palmette is now beginning to resemble the Islamic bifurcating tendril very closely; and it is, of course, derived from these two roots: i.e., the bifurcating tendril with acanthusized axil fillers and the half palmette. And after all, our study of the historical development of the vegetal tendril in antiquity has demonstrated that these two roots were ultimately one and the same.

There is still one last important detail to observe in figure 175: the tendril that we have just been discussing also gives rise to an embedded half leaf fan just before it terminates in the half palmette. The fan overlaps the main tendril and meets an equivalent motif coming from the opposite side to form a symmetrical pair, just as we have seen half palmettes combining into split palmettes time and time again. Because the acanthusized details make such a dominant impression, this genuinely "Arabesque" motif is lost within the overall effect, as in the works mentioned earlier.

The origin of the box in figure 175 within the Hispano-Moresque cultural domain seems to be fairly certain, since its inscription includes the name of a Spanish caliph.[k] In that case, it is quite revealing to see that Christian-Spanish art made use of the same acanthus stylizations. Figure

176 serves as proof. Here we find a straight, upright stem from which two symmetrical pairs of acanthus half leaves branch off to left and right. The leaves closest to the stem are clearly rolled up into volutes, but they are as finely serrated as any of the other leaf units. The stem is crowned by a five-part palmette flanked by the two half fans of a split palmette. The quality of the acanthus is also evoked here by the deep indentations between the individual leaf sections, while the contours are all serrated in the same fine manner as figures 174 and 175; aside from that, one is outlined smoothly in a fashion that is at least not typically non-Islamic. Finally, the five-leafed fan that gives rise to the stem also has the same acanthusized details.

Fig. 176. Illuminated ornament from the Codex Vigilanus in the Escorial, ninth century.

Figure 176 is taken from the Codex Vigilanus in the Escorial and, moreover, from an illuminated page accompanied by a text that still has a strongly cursive paleographic style. As a result, it cannot be dated earlier than the ninth century and is surely later than the caskets in figures 174 and 175. What makes figure 176 particularly important, however, is the caption "arbor" frequently accompanying this motif. Spanish miniaturists of the Carolingian period apparently interpreted an arrangement of this kind, trimmed with acanthus leaves, as an ideal tree, so to speak. Does it not follow necessarily that the meaning of the arrangement, at least in the beginning, was the same for the Islamic artists who were their pupils?

We saw in figure 174 that the acanthus leaf was used not only as the basis for the stylization of the half palmette-fan, which is to say, in its traditional, historical function, but also for the articulation of the volutes, that occur in the form of half calyces at the insertion point of every acanthus half palmette of this type, likewise following a traditional, historical scheme. Finally, it comprised the larger blossom motifs, which are the free terminations of the tendrils. We would be obliged to see this extensive use of the acanthus leaf as nothing short of amazing in an art oriented toward the abstract, the symmetrical, and the schematic, if we considered it to be something new. However, it is nothing but an heirloom handed

down from late antiquity. Now is time for us to delve more deeply into the role that the acanthus played as an independent vegetal motif in late antique and early medieval art. We must do so first of all in order to account for certain forms typical of Islamic art, and, second, to determine what became of the most important ornamental motif of antiquity by far—the acanthus—once it reached the medieval Orient. This is a question that has never before been posed, because of the crippling restrictions arising from the pervasive attitude that laws of causality can never be unconditionally valid for ornament.

Mature Hellenistic art is once again the point of departure. Figure 177 shows the relief decoration of a cylindrical stone altar from Pompeii.[71] The ornament has all the characteristic features of Hellenistic decorative art.

Fig. 177. Marble puteal or well head from Pompeii.

The attributes of Hercules, slung together in a loop, call to mind the requisite myths of gods and heroes, but they are treated in a playful, decorative manner and arranged like trophies. Behind them, two crossed branches diverge below and join up with branches that converge from the other side to form festoons. There is a faint echo, to be sure, of the circular motion of ornamental tendrils; all we actually see, however, are knotted, leafy branches. Thus far, everything breathes with naturalism. However, when we focus on the foliage of the branches, we find ourselves in a predicament. Of course, there is no question that with the exception of a small number of budlike terminations, what we see are leaves. What happens, however, when we try to ascertain their botanical species? We quickly discover that they do not represent a particular, identifiable type of southern flora, but are purely ornamental. Now, there could hardly be

[71] Niccolini, *Case ed monumenti di Pompeii*, vol. 2, part 2, "Descrizione generale," pl. 96, top.

a more perfect example of Hellenistic naturalism than figure 177. Acanthus ornaments are used to create foliage that has a purely ornamental origin and and a purely ornamental reason for being; at the same time, however, the viewer clearly understands them as leaves. Whereas in the case of the old, rigidly stylized palmette, for example, we ask not only what species of flower it depends upon but above all, whether it even represents a flower at all, no problem of that sort arises in regard to the leaves in figure 177. In this case, the intention of the artist to depict ornamental foliage is unambiguous, and for this purpose the artist used the acanthus ornament, which had been traditionally handed down and reserved for such purposes. The naturalism of Hellenistic artists never included the direct transcription of nature:[72] decorative art always preserved its own domain, even if the forms that it produced were more closely connected to the real, natural world of living things than had ever been the case in the art of all preceding periods.

This point is of such great consequence and significance—not only for Greco-Roman vegetal ornament but for the decorative arts of all centuries, from the past up to most recent times—that it warrants one more illustration. Figure 178[73] shows the relief decoration of another stone altar

Fig. 178. Marble puteal or well head from Pompeii.

[72] Except, however, when the intention was expressly representational; in this case, Hellenistic artists were very astute at recording nature's characteristics. Of course, it is often hard to keep objective and decorative intentions strictly separate, for example, in cases such as *Antike Denkmäler* Deutsches Archäologisches Institut, vol. 1 (Berlin, 1886), pl. 11, wall painting from the Villa of Livia at Prima Porta. [For more recent and accessible photographs of this monument see R. Bianchi-Bandinelli, *Rome: The Center of Power. 500 B.C. to A.D. 200* (New York, 1970), figs. 130, 131, and 133; and D. Strong, *Roman Art*, 2d ed., (Harmondsworth, 1988), figs. 47–48.] What examples like these do seem to show, however, is that the art of the Augustan period tended toward realism, though it was almost immediately abandoned, only to be taken up once again in more recent times, this time, however, much more decisively.

[73] Niccolini, *Case ed monumenti di Pompeii*, vol. 2, part 2, "Descrizione generale," pl. 96, bottom.

from Pompeii.[1] Two tendrils sprout up from a double leaf calyx that grows both upward and downward, a type that gave rise to an endless succession of followers. They unwind to the right and left according to the familiar Hellenistic scheme (fig. 121), curling up into spirals and even intertwining. This example is one of the exceptions where the botanical species is explicit: the tiny grapes tell us, namely, that these are grapevines branching out over the surface of the cylinder in the ancient Greek scheme of the decorative undulating tendril. But let us examine the leaves: it cannot be said that they deviate in a very startling way from the appearance of the leaves on an actual grapevine, but botanists would surely consider them very inaccurate copies from nature. "These grape leaves are not exact facsimiles of nature," they might say, "something from the artist's imagination seems to have infiltrated their rendering." And what triggered the imagination of the artist in this case is immediately clear at a glance: the stylization of these grape leaves is based once again upon the acanthus ornament with its rounded projections and deep indentations resembling pipes. Nevertheless, the considerable extent to which the arrangement approaches natural appearances, as evidenced particularly in the scattered clusters of grapes, is still exceptional, although it has deep-seated causes that can be explained. First of all, there is the representational and symbolic meaning that has become associated with wine and things related to wine since earliest historical times; at the same time, however, the striking similarity between the ornamental tendril and the grapevine was surely also a factor. This is why we already find the grapevine arranged in a continuous tendril on relatively early examples such as the so-called Alexander Sarcophagus from Sidon.[73a] Again it is the pipes that tell us that the acanthus ornament was the model for the stylization of the grape leaves, although their contours in this example are, quite typically, sharply indented like the Greek acanthus (cf. Figure 111), in contrast to the soft and lobed formation of the Roman version in figure 178.[m]

Let us return to figure 177. The individual acanthusized leaves are varied in length and width according to need. There is only one type, however, that requires our attention: the ones that are folded over and drooping down. They need only to have their outwardly curving, pointed tips placed along a tendril and they would qualify as acanthus half leaves. It is, of course, this very same doubled-over acanthus motif, resembling a cabbage leaf, that survived down through the late Roman period into the Middle Ages and provided the basis for the formation of new blossom motifs of great significance.

[73a] [T. Reinach and O. Hamdi Bey, *Une nécropole royale à Sidon* (Paris, 1892).]

However, the idea of using the acanthus to create new, complex blossom motifs was no longer new in the Byzantine period. There are already compelling examples at Pompeii. The right-hand spiral of the continuous tendril in figure 179[74] terminates in a common rosette; the one on the left, however, concludes in a bushy formation that, though it is unquestionably composed of acanthus leaves, is certainly not meant to be a leaf but a flower and, what is more, an ornamental flower.[n]

Fig. 179. Frieze with acanthus tendril and blossoms from the Temple of the Genius Augusti (Temple of Vespasian) at Pompeii.

The best examples of complicated, bushy, floral calyces made up of folded acanthus leaves from earlier Byzantine times occur on the remains of Sassanian architecture; figures 161–63 illustrate some good examples.

No one has so far succeeded in determining clearly the period in which the ornament from the East Roman provinces that fell to Islam began to diverge noticeably from the decoration produced in the areas that remained Byzantine. The impression that clearly emerges from our review of the monuments thus far, however, is that the subsequent development that took place throughout the long centuries of the early Middle Ages initially respected no political boundaries but followed the same direction in both regions. Naturally, the pace of the development was faster in areas where figurative representation was deliberately inhibited, if not outrightly suppressed by religious statutes and where art, as a result, was essentially limited to satisfying the decorative urge and to ornament alone. Here tendril ornament eventually developed much more quickly than in Byzantine art, where in spite of iconoclastic tendencies, no one was able or willing to abandon the figurative representation of religious subjects.

It was in the ninth century on the stucco ornaments of the Mosque of Ibn Tulun in Cairo that we first saw Islamic ornament begin to diverge from the Byzantine. Initially, however, the development must have proceeded very slowly, since there is only minimum progress detectable on the ivory carvings that date almost one hundred years later. In fact, one may speculate that when our knowledge of Byzantine ornament eventually comes to be based on a larger and more comprehensive body

[74] Niccolini, *Case ed monumenti di Pompeii*, vol. 1, part 2, "Tempio detto volgarmente di Mercurio [Temple of the Genius Augusti (Temple of Vespasian)]," no. 8.

of material, the differences between the Byzantine and the Islamic Arabesque will diminish even more, while the extent of their shared development will increase even further.[75] It is not until the twelfth century, as we shall see, that the more or less full-fledged Islamic Arabesque appears. It is then that the various characteristic features comprising the Arabesque occur not only individually but as an integrated whole, resulting in an ornament whose connections with classical tendril ornament are no longer so evident or direct. Consequently, even if it is still not possible, as indicated initially, to establish a precise date for the divergence of medieval Byzantine and Islamic tendril ornament, we can nevertheless place it generally within the tenth and eleventh centuries, a long span of time, which is surely justified, in view of the uneven and very irregular pace the development must have taken within the far-flung regions that eventually came under Islamic control.[o]

The decorative elements involved in the more accelerated Islamic development that departed from strictly Byzantine formulations were naturally those which had earlier led to the common development in the eastern Mediterranean in Christian Byzantine as well as Islamic art.

If we are now going to assume that Byzantine and Islamic ornament began to diverge sometime during the tenth and eleventh centuries, then we will have to look very carefully at the vegetal tendril decoration of certain Byzantine origin from this period, since it not only represents the last phase of the shared Byzantine-Islamic development but at the same time, the point of departure for the initial phase of purely Islamic ornament. The best sources of information about the Byzantine art of this period are illuminated manuscripts, whose production was widely patronized at the time. As a rule, the decoration of religious books was very rich and colorful. Conveniently enough for us, their main decorative elements were vegetal, and it was especially the blossom form that characterized this type of ornament.

These blossom forms consist of the combinations of acanthus leaves that have been familiar to us since the Pompeiian period. Figure 180 shows the simplest and the most common form, which is also widespread in the Romanesque art of the West: the *acanthus calyx*. Two acanthus half leaves folded in half (cf. figures 177, 161–63) converge to form a calyx. This describes, so to speak, only the basic scheme; the lively manner of its execution in miniature painting is illustrated in figure 180.[76] Here the

[75] The examples illustrated in Stassoff, *Ornement slave et oriental*, pls. 120–24, already provide convincing evidence of this.

[76] Figures 180–83, from a manuscript of the eleventh century, after Stassoff, *Ornement slave et oriental*, pl. 124, no. 24.

180 181 182 183

Fig. 180–83. Blossoms based on the acanthus, from a Byzantine
illuminated manuscript of the eleventh century.

Fig. 184. Decorative heading from a Byzantine illuminated manuscript
of the tenth century.

calyx is articulated with small paired hatchings and furnished with an axil
filler that was no less of a requirement for the medieval artistic sensibility
than it had been in antiquity.

More complicated versions appear in figures 181 and 182. The lower
part of the first example consists of a calyx similar to the one in figure 180.
Above it is a second calyx, whose upper edges are inverted downward like
volutes. Moreover, there are also hatched lines and axil fillers. What ap-
pears characteristic is the tendency for the edges to fold or turn back and
for the leaf tips to move in curves. (Compare this also with the flower in
the spiraling acanthus tendril in figure 194). Occasionally, this movement
is quite energetic, as in figure 182, where the acanthus half leaves are
neither arranged according to strict symmetry nor oriented in the same
direction but appear to be turning up and down into one another.[77]

Figure 183 is a form that occurs very frequently. Basically, it is nothing
more than an acanthus half leaf with its sides folded in, rising out of an
acanthusized volute-calyx.[P]

Now that we have described figures 180–83, it will no longer be difficult
to recognize the essentials of the corresponding variations in figure 184.[78]

[77] Although this chapter cannot possibly touch upon every aspect of mature Islamic deco-
rative flora, I would like to mention briefly that the capricious kind of leaf treatment seen in
figure 182 was also adopted by Islamic art, as numerous carpets, miniatures, and tiles from
the late Middle Ages and from the beginning of the modern period all prove. This is an
emendation of my earlier opinion ("Ältere orientalische Teppiche," *Jahrbuch des all-
erhöchsten Kaiserhauses,* 13, [1892]: 303) that this particular leaf treatment should be attrib-
uted to Chinese influence. Now that I see the situation more clearly, I also detect the same
tendency in the articulation of the leaf edges in numerous Arabesque motifs from the four-
teenth and fifteenth centuries.

[78] From Stassoff, *Ornement slave et oriental,* pl. 124, no. 17.

The most frequent types are the trefoils whose volute-calyces and slightly curved, leafy crowns are stylized like acanthus. This trefoil, therefore, unites the characteristics that are typical of Islamic vegetal ornament: geometric outlines combined with details treated like plants. Thus, even figure 183 seems to be just a richer and more luxurious formulation of this type of acanthusized trefoil. In the central roundel of figure 184, a trefoil is encircled by two bifurcated tendrils: this is a genuine Islamic motif, even though it clearly has plantlike qualities and originated within the Byzantine artistic sphere. Finally, the form of the blossoms within the two outer roundels in figure 184 is related to the version found in figure 181.[q]

When we discussed the ornament of the ivory caskets in figures 174 and 175, we postponed the interpretation of their freely terminating blossom motifs. Now they can be easily clarified by simple reference to the forms found in figure 181 and 183.

In this period specifically, Byzantine miniature painting was zealously imitated in the Armenian monasteries. One such instance, thought to date from the eleventh century, whose significance I have already pointed out in another context,[79] was published by Collinot and Beaumont.[79a] The section from their plate 28, which is reproduced in our figure 185, is a very

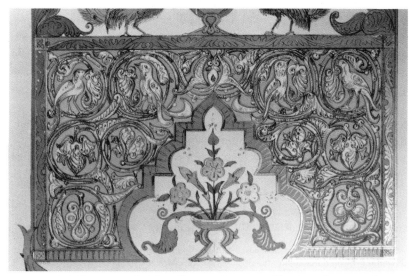

Fig. 185. Decorative heading from an Armenian illuminated manuscript.

[79] A. Riegl, *Altorientalische Teppiche* (Leipzig, 1891), 166ff.
[79a] [E. Collinot and A. Beaumont, *Ornements turcs: receuil des dessins pour l'art et l'industrie* (Paris, 1883), pl. 27–29.]'

revealing example of the last stages in which Byzantine and Islamic orna-
ment were still closely related: embedded acanthus half leaves (in a much
more rigid stylization resembling a palmette fan), bifurcating tendrils, and
blossom types like the ones in figures 181 and 183, whose encircling ten-
drils are completely classical apart from the way that they intersect one
another.[80, r]

It is not necessary for us to examine any more examples of Islamic art
from this period, since the characteristics of Islamic tendril ornament had
clearly come to maturity by this stage. Here our observations and endeav-
ors are intended to demonstrate the inherent genetic connection with the
preceding classical or Byzantine tendril ornament and offer examples that
illustrate the long-standing existence of the relevant motifs in their origi-
nal form. The bulk of the evidence is taken almost exclusively from Prisse
d'Avennes's, *L'art arabe* and consequently relies heavily on monuments
from Cairo of the twelfth through the fourteenth centuries.

Figure 186 shows the openwork
fill of a window from the Mosque of
Al Zahir, which, according to Prisse
d'Avennes, dates from the thirteenth
century. The decoration with its
acanthus offshoots curling into circu-
lar tendril volutes could readily be
taken for Byzantine. One also begins
to realize just how much the undu-
lating movement itself encourages
the convergence of the tendrils into
pointed ellipses, in other words, how
an essential characteristic of the Ara-
besque was already latent in the un-
dulating tendril of classical antiquity.

Figure 186 is not an isolated exam-
ple. Among the other similar works
illustrated by Prisse d'Avennes, is a

Fig. 186. Window grill from the
Mosque of Al Zahir, Cairo.

[80] The "palmette moldings" of Armenian book illustration cited by J. Strzygowski (*Das
Etschmiadzin Evangeliar. Beiträge zur Geschichte der armenischen, ravennatischen und
syro-ägyptischen Kunst* [Vienna, 1891], 91), are nothing but bifurcating tendrils arranged on
top of each other along interlacing, undulating lines in a pilasterlike format for which the
original historical prototype is in figure 159. I would be the last to dispute their connection
to Sassanian decorative variations like the ones in figures 161–63; however, the connection
is by no means obvious and can only be truly and profoundly appreciated after one has
examined and become familiar with the common, shared development that I have attempted
to outline above.

second window decoration from the same mosque and, furthermore, two windows from the Mosque of Tala'i Abu-Riziq one of which is still almost purely Justinianic while the other, with its convoluted Arabic script, is similar to figure 186.[s]

Prisse d'Avennes places the last two examples in the twelfth century; if they, in fact, can be dated this late, then they bear astonishing witness to how conservatively the artisans of Cairo clung to particular technical aspects of tendril ornament that were purely Byzantine in style. The ornaments from the marble chancel [Mihrab] in the Mosque of Cordova are at approximately the same stage, as figure 187 demonstrates.[81] It shows a section of a border strip with a row of acanthusized lotus blossoms and palmettes on an arcuated frieze. The round drilled pipes leave no doubt as to the acanthusizing process that has taken place. An inscription refers to the year A.D. 965. Consequently, the chancel dates from the second half of the tenth century and would therefore be several centuries older than figure 186, even though it is actually more advanced in development. Also worthy of note in figure 187 is the calyx of the lower blossom, consisting of two acanthus half leaves. (It takes the place of the palmette in the ancient lotus blossom–palmette scheme.) The close specific identity of this sculptural calyx with the painted version in figure 180 is eminently clear.[t]

Fig. 187. Frieze from the mihrab of the
Great Mosque at Cordoba.

[81] From Girault de Prangey, *Essai sur l'architecture des arabes et des mores en Espagne, en Sicile, et en Barbarie* (Paris, 1841), pl. 4, no. 8. [Riegl's original citation here as pl. 4, no. 6 is incorrect.]

On the other hand, the system of ornament encountered in the Sicilian works produced by subject Islamic artists for the Norman kings, primarily in the twelfth century, is closely related to that on tenth-century ivories (figs. 174, 175). The example in figure 188[82] is part of the stucco decoration of a dome in the Cuba near Palermo. The feathery acanthus leaves very much resemble those on the ivory carvings. The palmettes, with their laterally spread acanthus half leaves and crisply

Fig. 188. Stucco ornament from the Cuba, Palermo.

drilled volute-calyces, also occur in figures 174 and 175, whose Byzantine predecessors we already encountered in figure 183.

Figure 189 illustrates a consummate example of Arabesque design.[83, u] The decoration consists solely of tendrils, with the exception of the dotted band that winds its way through the middle of the decorative frieze in an alternately round and angular path like that of a window valance dividing the field into two interlocked zones. The movement of the lines is already quite diverse and complicated, no longer limited to circular patterns. The motifs, however, with the exception of the little sprouting spirals and

Fig. 189. Carved wooden chancel from the mimbar in the Mosque of Al Amri at Qus, Egypt

[82] Ibid., pl. 12, no. 1.

[83] From the carved, wooden chancel of the Mosque of Qus, dated to the twelfth century, from Prisse d'Avennes, *L'art arabe*, pl. 79.

acanthus offshoots in the early Byzantine manner (see above), are half palmettes and bifurcating tendrils outlined by smooth contours, along with some full or frontal motifs.[84] Since the first two types are more important, we will discuss them in detail.

In figure 189a, we see two half palmettes (or acanthus half leaves with precisely rendered fans) combining to form a whole motif something like the split palmette; the calyx and fan are articulated in a vegetal manner, as in figure 174, for example, but they have a smooth contour. Moreover, there are apertures in the middle of each half leaf.[85] Both fans continue as tendrils, which then turn into similar bifurcating tendrils, and so forth.

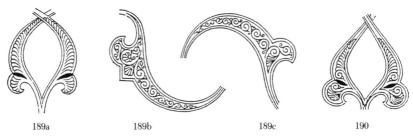

189a 189b 189c 190

Fig. 189a–c, 190. Details from fig. 189.

The plantlike articulation of figure 189a is missing in the half palmette of figure 189b. Only its curved calycal leaf and fan, and the projecting axil filler between them, are readily distinguishable. However, what does occupy the interior of this Arabesque motif is more precious to us than any amount of acanthusized detail, for it is no less than a genuine Greek tendril complete with all of its distinctive traits. A palmette-fan oriented toward the axil filling projection of the outer contour is inserted where the tendril first bifurcates. To the left the tendril terminates immediately in a regular Greek full palmette, while to the right it curls into a typical continuous tendril with spiraling offshoots and axils meticulously filled.

Let us proceed to the half palmette in figure 189c. The same things apply as for figure 189b, except that the design in this case includes a conspicuous half palmette of the ancient Greek type (fig. 126). Figure 190, taken from another part of the same chancel, represents the transition from the pure and independent palmette-tendril to the acanthusizing treatment of the half palmette shape in Arabesque decoration. Prisse

[84] The frontal motifs in figure 189 resembling palmettes are probably based on the type represented by figure 181.
[85] Compare figures 167, 168.

d'Avennes reproduces a vast number of leaves of the second type with details that merit a separate and thorough study and discussion of their own. We only have time to mention figure 168a; it consists of two tendrils with half palmette fans resembling the split palmette that fill the axils and that terminate freely above in a full palmette. The astonishing relation between this seemingly pure Greek type of tendril ornament and the Islamic design in figure 168 has already been indicated. But the analysis of figures 189–90 demonstrates that this was by no means an isolated instance of copying or a reminiscence of an ancient pattern but a fixed, vital component of Islamic ornament. Consequently, there can be no doubt that even highly developed Islamic art still knew and applied the pure two-dimensional palmette-tendril ornament of the best Greek type. Nor is it difficult to bridge the gap in this process from the fifth century B.C. to the twelfth century A.D. Our discussion of late antique tendril ornament already demonstrated how the two-dimensional palmette-tendril remained continuously in use even when the acanthus reigned supreme, and how early medieval art in the East Roman Empire, understandably enough, revived the predilection for stylized Hellenic blossom and tendril forms. The intermediary stages in Byzantine art are documented by miniature illumination of the tenth and eleventh centuries, such as, for example, figure 191.[86]

Fig. 191. Tendril decoration from a Byzantine manuscript.

Arabesques, in addition, are still found on works produced in Cairo during the late Middle Ages. We find them without any interpenetrations of forms and no polygonal formations; here the Islamic character is betrayed exclusively by the abstract treatment of the individual motifs (whole and half palmettes). Figure 192 is such an example;[86a] Figure 192a provides a translation of the pattern according to Greek principles.

The graceful classical palmette-tendril ornament, therefore, was able to survive in Islam far into the later Middle Ages in particular techniques.

[86] From Stassoff, *Ornement slave et oriental*, pl. 123, 10.
[86a] [From Bourgoin, *Précis de l'art arabe*, part 1, pl. 32.]

Fig. 192. Arabesque filler ornament from a circular wall inset in the house of the fourteenth-century Emir Bardak in Cairo.

Fig. 192a. Greek "translation" of fig. 192.

For example, on wood carvings, it is still documented by the now famous filler designs from the Maristan [mosque hospital] of the Sultan Kalaun from the end of the thirteenth century.[87] However, the fact that Greek palmette-tendril ornament was used on the carvings of the chancel at Qus specifically as the filler decoration of the large, abstractly outlined half palmettes is, in my opinion, a definite sign that Islamic artists were well aware of the close and essential connection between their Arabesque decoration and earlier classical tendril ornament. I especially emphasize the "essential" and not the historical connection, for the latter was never a concern in the ornamental production of the earlier, truly creative centuries.

Figure 193 illustrates a decorated screen from the pulpit [*mimbar*] in the funerary Mosque of the Sultan Barquq in Cairo from the late fifteenth century.[v] The Arabesque half palmettes are inscribed with fine, linear versions of the same motif. Here we truly approach the sort of treatment seen in figure 139, which we used earlier to define the basic characteristics of Arabesque decoration. Now the question arises as to whether the inscribed fillers of the motifs in figure 193 derive from the classical half palmette, as one may indeed gather from the discussion of figure 189b–c,

[87] On the robe of the centaur, as I have already pointed out in another context (*Altorientalische Teppiche*, 161), with a reproduction from Prisse d'Avennes also found in S. Lane-Poole, *Art of the Saracens in Egypt* (London, 1888; [reprint, Lahore, 1976], 143, fig. 46. [Riegl's original citation here of the illustration on Lane-Poole's p. 125 is incorrect.]

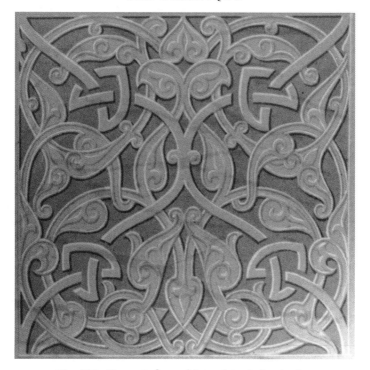

Fig. 193. Decorated panel from the mimbar in the
Mosque of Barquq, Cairo.

and figure 190, or whether they should be interpreted as stylized varia-
tions of acanthus half leaves whose edges are folded over (figs. 180–83).

This question is not trivial, since the abstract character of Islamic blos-
som motifs renders it difficult in most cases to decide whether they are
based on the acanthus or on the two-dimensional version, the palmette-
fan. It is mainly the interior detail of the motifs in figure 193 and in figure
139 (especially of 139 *b* and *c*) that makes one think of them first as ver-
sions of the two-dimensional half palmette; the volute-calyx is indicated at
the bottom of each incised leaf, a detail that has been an essential and
inseparable component of the palmette since ancient Egyptian times. The
volute-calyces on the Islamic half palmettes and bifurcating tendrils in
figures 193 and 139 do not, however, come from the ancient Greek palm-
ette volute but from a peculiar characteristic of the acanthus itself, namely
from the rounded pipes always encountered between the pointed projec-
tions. Earlier we saw the extent to which this had already been a formative
and characteristic element of the tendril offshoots already in early Byzan-
tine acanthus. Figure 194 reproduces, furthermore, a portion of the apse

297

Fig. 194. Acanthus tendril-
volute from the apse mosaic
of the Church of
San Clemente, Rome.

mosaic from San Clemente in Rome,[88] which was executed in the twelfth
century, perhaps by Byzantine artisans, but at any rate under the domi-
nating influence of the *maniera greca*, at least as far as the ornament is
concerned. Here we find the historical or developmental progeny of the
sculptural pipes indicated clearly and consistently at the point of inception
or root of every leaf, by means of the volute-shaped spiral on the acanthus
half leaves that comprise the acanthus tendril.[w]

BECAUSE of the highly unsystematic conceptions that prevail concerning
the nature and origin of Islamic ornament, and especially its most impor-
tant expression, the Arabesque, it was essential to describe its formation
and growth from a unified standpoint. The provenance of the examples
used as evidence was of minimal interest; most of them originated in
Cairo, whose unique climate has preserved the richest and least damaged
selection of works. Particular local variations must also have developed,
and it will now be the task of future research to investigate the distinctions
within the geographically far-flung regions of Islamic culture and to estab-
lish the nature of the variation. However, our task, I repeat, was to accom-
plish the opposite: we sought primarily to demonstrate the historical and
genetic continuity in the development of vegetal tendril ornament from
antiquity up to more modern times, and toward this end, we have as-
sumed a larger, all-encompassing perspective rather than to seek or estab-
lish similar distinctions.

[88] From Rossi, *Musaici antichi delle chiese di Roma*, pl. 21. It is worth noting how the
petals of the freely terminating blossom in the center of the scroll curl over like the ones in
figures 181–83.

The task is now complete, for we have convincingly demonstrated that the allegedly geometric motifs of mature, fully-developed Arabesque decoration in the art of Cairo at the beginning of the fifteenth century are essentially and unmistakably plantlike at the core. The preceding third chapter, however, revealed how vegetal ornament had maintained a strictly historical course since the earliest known records of human artistic activity. Plants were adopted as decorative motifs for reasons that can no longer be determined, though possibly for representational, symbolic purposes. Once this began, the cultures that, in historical succession, appropriated and then furthered the artistic achievements of their forerunners consistently relied only on the types of vegetal decoration handed down by their predecessors. These they reformulated according to their own artistic sensibility and passed on to their successors. At no time did the creation of ornament involve an arbitrary dependence upon the natural plant world to the extent usually assumed.[89] When this did occasionally occur,[90] it never produced any lasting results. In contrast, the stylized palmette, acanthus, and other such ornaments have maintained a timeless, classic importance, even into the recent period of realism. The line of development exemplified by certain stylized blossom forms such as the palmette did not essentially deviate from its course even through the latest stage of antiquity, and we may as well extend this claim to include the late Middle Ages. Our next task was to establish the connection between late antique vegetal tendril ornament and Arabesque decoration by illustrating the intervening phases of the development with dated examples. Hopefully we have accomplished this even though there are almost no preliminary studies of the material.

Our last topic seems to involve only a particular region within the totality of Islamic art. Yet, if this chapter on Arabesque decoration concludes by discussing a type of decoration apparently of no more than local significance, we do so because it impinges directly upon questions of more general importance.

The art of the Islamic East also includes a kind of vegetal tendril ornament that can be characterized as naturalistic. It is preserved mainly on knotted carpets and ceramic tiles originating for the most part in Persia.[91] Of course, many of these works date to within the last three centuries, when European influence had become pervasive not only in Turkey but

[89] Therefore, as has been frequently pointed out, not for their representational value.

[90] For example, in Mycenaean or Greco-Roman art.

[91] Indian vegetal tendril ornament is totally dependent on Persian-Islamic decoration; once again, only those biased by a belief in the autochthous origin of all decorative art have attempted to maintain the opposite.

also in Iran. However, some examples allow us to trace naturalistic vegetal tendril decoration back to the fifteenth century.

Figure 195 illustrates the corner portion of the border from a Persian carpet[92] dated stylistically in the sixteenth century.[x] The basic scheme and treatment resulted in an intermittent tendril of general Islamic type: the

Fig. 195. Border from a Persian carpet of the Safavid period.

blossom motifs form pointed ellipses in the geometric Arabesque manner, while the rhythmic tendrils between them are also broadly stylized in the same way. Within these Arabesque shapes, however, there are fine, vegetal tendrils that also follow the intermittent tendril scheme, in conformity with the main pattern. In the space remaining between the large intermittent motifs, the tendrils assume the continuous undulating scheme.[93] Only some of the blossoms actually branch off from the tendrils; the larger motifs, in particular, are almost all of the embedded type and merge with the tendril. Thus far, all the elements are familiar characteristics of Islamic tendril ornament in general. It is only when we look closely at the individual motifs that we find deviations from the typical Arabesque patterns as we came to know them in figure 139.

Let us focus first of all on the large pointed ellipse in the middle of the border. Here we find a number of petals arranged to either side of a rounded core that echoes the shape of the larger motif on a smaller scale. These petals grow up from their base in undulating movements that recall

[92] It is lavishly illustrated in my *Orientalische Teppiche*, pl. 2.
[93] The so-called cloud ribbons found meandering among the tendrils, which are considered to be evidence of Chinese influence, will not be discussed here.

the fan of the split palmette. The edges of the leaves that fill the sharp axils between each of the petals are treated like acanthus motifs. For the sake of brevity, we will refer to the basic form of this motif as the *calyx-palmette*.

This motif is repeated a number of times; for example, in the middle of each of the undulating elements. There the edges of the curving petals encircling the core like a calyx are both folded together and acanthusized. Another example occurs inside the pointed ellipse of the corner motif. This time it is surrounded by an outer wreath of petals whose edges are no less finely serrated. Returning to the undulating element, however, we notice, in addition to the calyx-palmette, two more large blossom motifs that repeat frequently: it appears above, a flat, serrated, oblong plate that gives rise to the spadix, the so-called *fan-palmette*. Below, on the other hand, is a *palmette-wreath*, which can be easily distinguished from the calyx-palmette because the petals appear like a wreath oriented around straight axes instead of having the petals end in curved points around the core of the motif like a calyx.

The idiosyncratic stylization of the leaf edges is also characteristic of these motifs, and it must have been considered a rather essential feature since it occurs to a greater or lesser degree on almost all of the motifs discussed. In order to explain this in historical terms, initially we must investigate the Arabesque blossom motifs of the preceding medieval period to determine whether they qualify as prototypes for the palmettes in question, perhaps under the influence of the naturalistic trend that developed toward the end of the Middle Ages in Oriental art. However, we can hardly explain the naturalizing palmettes of the Persian carpet in figure 195 as a direct artistic formal development and transformation of the typical Arabesque designs seen in figure 139. As a result, only two other possibilities remain: either we are forced to see these motifs as specifically Persian, i.e., as products of an autochthonous, local development, or we must look for their roots outside the realm of Persian and Islamic art. Even now the first assumption has the greater number of adherents, in accordance with the general trend of the times. However, we are no more inclined to accept the notion that decoration develops ex nihilo or from obscure technical premises regarding this allegedly indigenous Persian ornament than we were in other instances. Our only alternative, therefore, is to turn to the art of other regions, starting, of course, with that closest at hand.

In the calyx-palmette, the acanthusizing treatment of the leaf edges and the upwardly curving movement of the folded petals already indicate that

this entire category of motifs can be interpreted as blossom-shaped arrangements of acanthus leaves similar to those discussed earlier, which appear from the Roman period onward. The course of development of the calyx-palmette can, in fact, be reconstructed fairly accurately. Persian ornaments of the Sassanian period (fig. 161) represent the point of departure; their Roman character was clarified sufficiently above. Any remaining suspicion that the calyx-palmette might still be a product of a national Persian art should be dispelled by the fact that it occurs in the early medieval period even outside Persia. One such example appears in the mosaics of the Dome of the Rock in Jerusalem (fig. 196),[94] usually considered to be the work of Byzantine artists and executed before the end of the seventh century.[y] During the later phase of development, Byzantine versions like the ones in figures 180–85 essentially run parallel to the motif of the calyx-palmette;[95] intermediary examples occur especially on silks, though it is debatable in most cases whether they are Byzantine or Islamic in origin. The calyx-palmette appears fully matured, and in a pure Islamic form, in Mesopotamian art of the thirteenth and fourteenth centuries on numerous examples of metalwork, some of which are dated.[96] The example in figure 197 is from the niello writing implement of a Mamluk sultan of Cairo from the fourteenth century.[97, z] In this instance, it is important to observe how the vegetal tendril ornament of this group of works is generally stylized in the Arabesque manner and how it depends, almost exclusively, on schematically outlined palmettes with

Fig. 196. Calyx-palmette from the mosaic decoration in the Dome of the Rock, Jerusalem.

[94] From de Vogüé, *Temple de Jerusalem*, pl. 21.

[95] Even the axil-filling leaves of the palmettes from figure 195 have corresponding counterparts in figures 180–83.

[96] See Lane-Poole, *Art of the Saracens in Egypt*, 180–239.

[97] From Prisse d'Avennes, *L'art arabe*, pl. 171, left, "Écritoire du soultan Bahrite-Schâban." The playfulness of Islamic vegetal tendril ornament is evident in the remarkable way that figures of birds are allowed to replace some of the half palmettes on the Mesopotamian metalwork mentioned above, and apparently only in these instances: see the continuous undulating tendrils with diverging birds illustrated by Prisse d'Avennes, *L'art arabe*.

Fig. 197. Calyx-palmette and tendril decoration from a
"Mosul Bronze," the inlaid copper inkstand of the
Mamluk Sultan Bahrit Shaban.

volute-calyces (fig. 197), some of which have simple feathered fans. This
proves that the use of the calyx-palmette as such is not peculiar to a
definite naturalizing tendency and that it had long existed as a fully devel-
oped ornamental motif when in fact, as a number of factors suggest, a
naturalistic tendency did begin to appear in certain techniques and in
certain regions toward the end of the Middle Ages. However, there is a far
better explanation for naturalistic forms like the ones in figure 195. Both
kinds of vegetal tendril ornament—one basically two-dimensional, the
other more sculptural, one allied with Arabesque decoration, the other
naturalistic—coexisted side by side with each other in mature Islamic art,
just as they always had in antiquity and the early medieval period, above
all in those techniques that were tightly bound by tradition. The second—
or sculptural-naturalistic type—was such that it led directly from late
Roman overlapping acanthus leaf calyces to the calyx-palmettes on carpets
made in the royal workshops of sixteenth-century Persia.

A recent attempt[98] to account for the naturalistic blossoms on Persian
knotted carpets of the fifteenth and sixteenth centuries has revived the
thesis of Sir George Birdwood, who first wrote about their connections
with ancient Egyptian and Mesopotamian lotus blossoms. The author was

[98] W. Bode, "Ein altpersischer Teppich im Besitz der königlichen Museen zu Berlin
(Studien zur Geschichte der westasiatischen Knüpfteppiche)," *Jahrbuch der königlichen
Preussischen Kunstsammlungen* 13 (1892): 134.

presumably unaware that his argument was basically the same as what I had already suggested in *Orientalische Teppiche* loudly and clearly enough to be audible for those with an active interest in the development of ancient floral ornament. We can now move beyond the position assumed by Birdwood and other scholars on these questions, since we have at our disposal the evidence that this ingenious researcher could only hypothesize intuitively. As the result of further specialized studies, we can now replace the vague clues of the past with definite links that combine to form a continuous chain of development. However, I would be the last to take issue with the fundamental ideas long ago expressed by Birdwood, Owen Jones, de Vogüé, and others, insofar as they agree with the views advanced above. In fact, I would not hesitate to say that our knowledge of medieval art would now be better and more mature had we not strayed from the straight and narrow path of the purely historical approach practiced by scholars like de Vogüé.

The ornamental flower types of Persian carpets cannot be traced back directly to Achaemenid-Persian or Assyrian sources; a fundamentally different stratum of art and culture separates the ancient Near East from the world of Islam in the late Middle Ages, a phase initiated by the triumphant advance of Hellenism and its subsequent development into the so-called Byzantine period. But even aside from these general historical considerations of style, the flowers on Persian carpets still do not qualify as the direct autochthonous progeny of ancient Near Eastern art for the simple reason that there is simply nothing ancient Near Eastern about the medium itself, the oriental knotted carpet.[99] The generally accepted notion that Oriental carpets have been in use in western Asia from time immemorial is contradicted when we observe that there is no evidence at all in the ancient Near East of the more modern Oriental practice of using carpets in place of chairs and tables, although it is certain that furniture was in use at that time.

It is typical as well of the shallow, mechanical approach to the subject that the Oriental "carpets" mentioned in ancient texts were so automatically assumed to be knotted rugs and that no one felt the need to test the suggestion against the evidence of artistic depictions. What these reveal, however, is that while chairs, beds, and tables were in use across the ancient Near East from the time of the early Pharaohs up to and including the Achaemenid-Persian period, there is not a single depicted instance of

[99] Elsewhere I have discussed this crucial point in more detail; see A. Riegl, "Die Heimat des orientalischen Knüpfteppichs," *Oesterreichischen Monatsschrift für den Orient* (Jan. 1892), 9ff.

carpets used in their stead. It was the central Asiatic tribes of Turkic origin—those who were accustomed to living without furniture in a nomadic existence and who migrated continually into western Asia throughout the Middle Ages—who first brought the knotted carpet and its characteristic use to the West. Wherever the migrating nomadic tribes continued to maintain their original way of life, they also continued to decorate their carpets with indigenous primitive geometric patterns consisting of linear motifs arranged according to abstract symmetry in the same way that so-called nomadic carpets are still decorated to a large extent today. But wherever they established large and splendid courts, such as in Persia and Asia Minor, they adopted the more highly developed ornament of the surrounding culture for their luxury carpets, i.e., the vegetal tendril ornament handed down by classical antiquity.[aa]

Therefore, neither the knotted carpet nor its "flowering" patterns are indigenous to western Asia, as is usually assumed. The carpet originated in central Asia, though there may already have been a few scattered exceptions in antiquity: for example, in the mountains of the Caucasus. The floral pattern, however, is only typically Oriental in the sense that the classical antique decorative motifs that are the direct forerunners of Islamic vegetal ornament did in fact ultimately originate in the Orient. In the third and fourth chapters of this book, I hope to have forged the various links of this chain in an unbroken sequence, thereby connecting the mysterious flower of the Nile Valley and the spiral tendril of the even more enigmatic island culture of the Mycenaeans with the wondrous achievements of the Arabesque.

ANNOTATIONS

———— ◇ ————

NOTE: For the reader's convenience, full references will be supplied the first time a source is cited in a chapter.

CHAPTER 1. THE GEOMETRIC STYLE

a. See annotation (m) just below.

b. Here Riegl is referring to A. Conze, "Zur Geschichte der Anfänge griechischer Kunst," parts 1 and 2, *Sitzungsberichte, Kaiserliche Akademie der Wissenschaften, Wien,* Philosophische und Historische Classe, vol. 64 (1870): 505–34, esp. 522–23, 529; vol. 73 (1873): 221–50, esp. 228, 240.

c. Were he writing today, Riegl could cast an even larger net in documenting the widespread currency and homogeneity of the geometric style among Old World cultures in antiquity. At present, archaeological research has uncovered a broad range of artifacts in Europe, the Mediterranean, and western Asia from the sixth to the first millennia B.C. that fall under the rubric of "geometric art." A thorough and general survey of such early geometric arts can be found in M. J. Mellink and J. Filip, *Frühe Stufen der Kunst,* Propyläen Kunstgeschichte, vol. 13 (Berlin, 1974). For Europe and the Mediterranean see N. K. Sandars, *Prehistoric Art* (Harmondsworth, 1968), 100–225; for the eastern Mediterranean, S. Hood, *The Arts in Prehistoric Greece* (Harmondsworth, 1978), 27–32, 136–39, and P. Demargne, *The Birth of Greek Art* (New York, 1964), 26–77; for Egypt and western Asia see E. J. Baumgartel, *The Cultures of Prehistoric Egypt,* vols. 1–2 (Oxford, 1955–1960); H. Frankfort, *The Art and Architecture of the Ancient Orient* (Harmondsworth, 1985), 17–18, 333–34; W. Stevenson Smith, *The Art and Architecture of Ancient Egypt* (Harmondsworth, 1984), 25–28; E. Porada, *The Art of Ancient Iran* (New York, 1965), 21–33. B. Otto has recently published an excellent study of the morphology and development of geometric ornament in Anatolia, Mesopotamia, and the Aegean in the Neolithic, Chalcolithic, and Bronze Ages, *Geometrische Ornamente auf anatolischer Keramik. Symmetrien frühester Schmuckformen im Nahen Osten und in der Ägäis* (Mainz, 1976). The connections between the early geometric arts of different cultures and regions still remains problematic, but Otto (169–86) has greatly clarified the larger evolution of such ornament in eastern Europe, the Aegean, and Anatolia during the Neolithic and Bronze Ages.

d. The direct links between the cultures of northern and central Europe and the Mediterranean during the Bronze Age are now amply documented. On the evidence for trade and cultural connections or imports from the south in northern regions see R. Hachmann, *Die frühe Bronzezeit in westlichen Ostseegebiet und ihre mittel- und südosteuropäischen Beziehungen,* Beihefte zum Atlas der Urgeschichte (Hamburg, 1957); E. Sprockhoff, "Ein mykenische Bronzetasse von Dohnsen, Kreise Celle," *Germania* 39 (1961): 11 ff.; S. Piggott, *Ancient Europe from the Beginnings of Agriculture to Classical Antiquity* (Chicago, 1965), 133–39; J. Mellaart, "Anatolian Trade with Europe and Anatolian Geography and Cultural Provinces," *Anatolian Studies* 18 (1968): 187–202, esp. 194–96; B. Hänsel, *Beiträge zur Chronologie der mittleren Bronzezeit im Karpatenbecken,* Beiträge zur ur- und frühegeschichtliche Archäologie des Mittelmeerkulturraumes 7–8 (Bonn, 1968); J. Bouzek, "The Aegean and Central Europe: An Introduction to the

Study of Cultural Interrelations. 1600–1300 B.C.," *Památky Archeologiké* 57 (1968): 242–76; idem, *The Aegean, Anatolia, and Europe. Cultural Interrelations in the Second Millennium B.C.* Studies in Mediterranean Archaeology 29 (Göteborg, 1985); A. Harding, "Mycenaean Greece and Europe: The Evidence of Bronze Tools and Implements," *Proceedings of the Prehistoric Society* 41 (1975): 183–202; N. K. Sandars, *The Sea Peoples. Warriors of the Ancient Mediterranean 1250–1150 B.C.* (London, 1978), 81–l03.

e. The international aspect of the Late Bronze Age civilizations throughout the eastern Mediterranean is fundamental to the modern understanding of this period. See the seminal studies by H. J. Kantor, *The Aegean and the Orient in the Second Millennium B.C.* (Bloomington, Ind., 1947), and W. Stevenson Smith, *Interconnections of the Ancient Near East. A Study of the Relationships between the Arts of Egypt, the Aegean, and Western Asia* (New Haven, Conn., 1965), as well as the more recent works by Bouzek and Mellaart cited in the preceding annotation.

f. Scholars now generally recognize the impact of Mycenaean geometric ornament on the contemporary Mitannian art of Syria and that of Egypt, as well as on the decorative metalwork and bone carving of Late Bronze Age Europe. For the Oriental and Egyptian material see Kantor, *Aegean and Orient*, 21–32; L. Woolley, *Alalakh, an Account of the Excavations at Tel Atchana, 1937–1949* (Oxford, 1955), 290; and D. Collon, *The Seal Impressions from Tel Atchana*, Alter Orient and Altes Testament, Bd. 27 (Neukirchen-Vluyn, 1975), 134–37. For the Mycenaean impact on geometric ornament in Europe see the last paragraph of annotation q for chapter 3B. 1. The Greek Geometric Style itself now appears as the outgrowth of an international artistic development including Cyprus and the Levant during the transition from the Late Bronze to the Early Iron Age. See V. R. Desborough, *The Last Mycenaeans and Their Successors. An Archaeological Survey ca. 1200–ca. 1000 B.C.* (Oxford, 1964), esp. 147–214; and K. Nicolaou, "On the Origin of Greek Geometric Pottery and the Question of Continuity," in *Symposium on the Dark Age of Greece*, Archaeological Institute of America, New York Society, ed. E. Davis (New York, 1977), 21–31.

g. Geometric ornament constituted an important component of the "civilized" decorative arts of Egypt, the ancient Near East, and the Aegean, as Riegl goes on to show in chapter 3A and 3B. Concerning the advanced nature of the Dipylon Style see annotation (i), just below.

h. Riegl is referring here to the concentric half circles or circles and undulating bands typical of very Late or Sub-Mycenaean and Protogeometric pottery in the twelfth to tenth centuries B.C. See V. R. Desborough, *Protogeometric Pottery* (Oxford, 1952), pls. 1–11; idem, *The Last Mycenaeans*, pls. 14–17; A. M. Snodgrass, *The Dark Age of Greece* (Edinburgh, 1971), 33–37, figs. 3–7; 45–46, figs. 12–13.

i. Works of the Dipylon Style or workshop are indeed anything but primitive. They are now seen as the mature culmination of three centuries of Attic Geometric vase painting. See J. N. Coldstream, *Greek Geometric Pottery* (London, 1968), 29–42; idem, *Geometric Greece* (New York 1977), 109–19. A connection with the Dorian Greek "invaders" of the Dark Age for the style is no longer tenable, however. Attic ceramic traditions evolved without a break from Late Mycenaean times right down to the Dipylon Style. See P. Kahane, "Die Entwicklungsphasen der attisch-geometrischen Keramik," *American Journal of Archaeology* 44 (1940), esp. 465–67; K. Kübler, *Die Nekropolen des 10. bis 8. Jahrhunderts*, Kerameikos. Ergibnisse der Ausgrabungen 5 (Berlin, 1954), 159–60; Desborough, *The Last Mycenaeans*, 112–19; Snodgrass, *Dark Age Greece*, 28–54. Riegl was therefore correct

to doubt that weaving or textile art provided the immediate source for the Dipylon Style, since its decorative vocabulary can be traced back consistently in Greek vase painting to products of the tenth or eleventh centuries B.C., and in some cases, the twelfth. Cf. Snodgrass, *Dark Age Greece*, 45–53, figs. 12–21. Within two decades, Riegl's arguments had already instilled in some scholars a more cautious attitude toward the role of textiles in the origin of the motifs or patterns comprising the Geometric Style; see E. Buschor, *Beiträge zur Geschichte der griechische Textilkunst. Die Anfänge und der orientalische Import* (Munich, 1912), 9–10. Nevertheless the thesis of textiles as the major source of the Dipylon Style still found later adherents before the Late and Sub-Mycenaean connections of Greek Geometric ceramic ornament had become clear; see K. M. Elderkin, "The Contribution of Women to Ornament in Antiquity," in *Classical Studies Presented to Edward Capps on His Seventieth Birthday* (Princeton, N.J., 1936), 125–26.

j. The incised ceramics from the lower levels at Troy-Hissarlik and Cyprus are now dated securely to the third millennium B.C. or Early Bronze Age. Riegl knew them from the pioneering but spotty publications by Heinrich Schliemann such as *Ilias: The City and Country of the Trojans. The Result of the Researches and Discoveries on the Site of Troy and throughout the Troad in the Years 1871–72–73–78–79* (London, 1880), 220, 225, 227, 231; nos. 43, 53–54, 58, 72. See W. Dörpfeld, *Troja und Ilion Ergbnisse der Ausgrabungen in der vorhistorischen und historischen Schichten von Ilion, 1870–1894*, vol. 1 (Athens, 1902), 243–80, for a thorough treatment of the date and decoration of this pottery, and more recently C. Blegen, *Troy and the Trojans* (New York, 1963), 53–55. For the Cypriote examples see Demargne, *The Birth of Greek Art*, 41–42; V. Karageorghis, *Ancient Cyprus. Seven Thousand Years of Art and Archaeology* (Baton Rouge and London, 1981), 34–39, nos. 16–24; idem, *Cyprus from the Stone Age to the Romans* (London, 1982), 43–47. Today one could substantiate Riegl's argument about the antiquity of such ornament even further with incised and painted ceramics from Neolithic Europe almost a millennium older (Sandars, *Prehistoric Art*, 112, fig. 40, pls. 129–131) or those of Neolithic Anatolia and Mesopotamia (Otto, *Geometrische Ornamente*, 73–83; pls. 1–12).

k. Sandars (*Prehistoric Art*, 111, 170, 173) has in fact suggested the impact of textiles on the incised ceramics in eastern Europe during the Neolithic period (fifth to fourth millennium B.C.), and implicitly in the Late Middle Bronze Age ceramics, which she dubs the "embroidered style." Burials of the Late Hallstatt period in Germany (sixth century B.C.) have produced actual embroidered textiles with rectilinear geometric ornament closely related to contemporary ceramic and metalwork in Central Europe; see J.V.S. Megaw, *Art of the European Iron Age. A Study of the Elusive Image* (New York and Evanston, Ill., 1970), no. 7, and more recently, *Trésors des princes celtes. Galeries nationales du Grand Palais 20 octobre 1987–15 février 1988* (Paris, 1987), 137–46, figs. 183–95. Although Riegl successfully challenged the primacy of textile art as *the* source of Greek Geometric vase decoration (cf. Buschor, *Griechische Textilkunst*, 9–10), this does not preclude the occasional influence of textiles on ceramics or other types of object; see B. Schweitzer, *Greek Geometric Art* (London, 1971), 27, 30. There is no doubt that textiles and various other media shared a common repertory of Geometric decoration in Europe and the Mediterranean from the Bronze Age onward, but one has yet to determine the medium in which such ornament originated.

l. See annotation *f*, just above.

m. For photographic reproductions of the kind of work illustrated in figures 1 and 2, see P. Graziosi, *Palaeolithic Art* (New York, London, and Toronto, 1960), pls. 32–40, 60–73 (fig. 1 = Graziosi, pl. 33b); and Sandars, *Prehistoric Art*, pls. 27,

29, 52, 65–68. Also consult the very well illustrated surveys by A. Leroi-Gourhan, *Préhistoire d'art occidental* (Paris, 1965) and *The Dawn of European Art* (Cambridge, 1982). As far as scholars can now judge, sculpted and engraved objects in bone, antler, and stone occur contemporaneously in the late Palaeolithic period. It is therefore improbable that a strict developmental and chronological sequence from three- to two-dimensional media and techniques actually applies to the particular objects that Riegl had in mind here. But modern research would verify the main lines of Riegl's argument concerning the chronological priority of sculpture in the round over developed pictorial art during the Palaeolithic period. Freestanding sculpture like the Willendorf "Venus" first appears in the Aurignacian-Gravettian phase sometime after 30,000 B.C., with engraved drawing emerging somewhat later within the same general period. Relief is no longer seen as an intermediate stage but rather as a fusion in the late Perigordian or subsequent Solutrean period of concepts and techniques that had already become established in sculpture in the round and drawing. The developed, polychrome cave paintings are still later, flourishing above all in the Magdalenian period. See esp. Graziosi, *Paleolithic Art*, 45–64, 141–48; Sandars, *Prehistoric Art*, 8–12, 16–22, 48–59; and A. Leroi-Gourhan, "The Evolution of Paleolithic Art," *Scientific American* (Feb. 1968), 58–74. For the absolute and relative chronology of datable works also see, P. J. Ucko and A. Rosenfeld, *Palaeolithic Cave Art* (New York and Toronto, 1967), 66–70. On the relation of Palaeolithic relief to drawing and sculpture in the round see H. Delaporte, "Typologie et technologie de l'art paléolithique mobilier," in *Les Courants stylistiques dans l'art mobilier au paléolithique supérieur*, Colloque 14, 9e Congrès Internationale des Sciences Préhistoriques et protohistoriques (Nice, 1976), 37–53, esp. 49ff. One might tend to see the priority of representational sculpture in the round as a reflex of technology, since tool making is itself a form of sculpture whose origins may be traced back considerably earlier than the artistc production of the Late Palaeolithic.

n. For recent opinions on the possible aesthetic and creative artistic motivations of Palaeolithic sculpture and painting see Ucko and Rosenfeld, *Palaeolithic Cave Art*, 115–23, 165–74; E. Hadingham, *Secrets of the Ice Age. The World of the Cave Artists* (New York, 1979), 197–203.

o. Here one senses the overtly deterministic or teleological basis of Riegl's approach, as he first advances his theory of the artistic impulse or *Kunstwollen*, and the haptic-optic interplay of tactile and painterly or visual qualities that he saw as a vital factor within the larger development of sculpture in antiquity. Riegl would subsequently explore these issues as central concerns in *Die spätrömische Kunstindustrie nach den Funden in Österreich-Ungarn* (Vienna, 1901). The latter work has recently appeared in an English translation by R. Winkes, *Late Roman Art Industry* (Rome, 1984). Riegl's contention that the full development of pure painting only came about during the Middle Kingdom in Egypt cannot, however, be substantiated. Although much more rarely preserved, wall painting already appears in a mature form in the Fourth Dynasty, as in the Chapel of Atet at Medum; see Smith, *Ancient Egypt*, 83–84, figs. 74–75. For the Middle Kingdom paintings at Beni Hassan and other sites, see Smith, *Ancient Egypt*, 191–202, figs. 185, 189–90, 197–98.

p. Although he stressed the creative artistic motivations, Riegl also seems to anticipate the interpretation advanced by Reinecke in 1903 that Palaeolithic animal representations were related to magical religious beliefs and practices that sought to control the primitive environment and subsistence of the early hunters. For a recent assessment of Reinecke and similar theories see Ucko and Rosenfeld, *Palaeolithic Cave Art*, 123–38, 174–95; A. Laming-Emperaire, *La signification de*

l'art rupestre paléolithique (Paris, 1962); D. K. Bhattacharya, *Palaeolithic Europe. A Survey of Some Important Finds with Special Reference to Central Europe* (Oosterhout, 1977), 374–75; A. Leroi-Gourhan, "La Fonction des signes dans les sanctuaires paléolithiques," *Bulletin de la Société Préhistorique Française* 55 (1958): 307–21; idem, "Le Symbolisme des grandes signes dans l'art pariétal paléolithique," *Bulletin de la Société Préhistorique Française* 55 (1958): 384–98; idem, "The Religion of the Caves: Magic or Metaphysics?" *October* 37 (Summer 1986): 6–17.

q. Since the studies of Desborough and Coldstream cited above, the origin of the vessel shapes of Greek Geometric pottery now appears as part of an independent ceramic development beginning in the Late or Sub-Mycenaean phases and continuing without interruption through the Geometric period proper. For a concise demonstration of this continuity see Snodgrass, *Dark Age Greece*, 28–54. While this does not preclude the added occasional impact of metal, wood, leather, and even wickerwork vessel forms (cf. Snodgrass, *Dark Age Greece*, 43), Riegl was undoubtedly justified in disputing the role of woven baskets as the primary models of Greek Geometric pottery.

r. Here Riegl's objections to Kekulé's thesis have also been amply borne out by subsequent inquiry. At present the origins of Greek Geometric ornament are much clearer owing to the many advances in Late Bronze Age and Dark Age archaeology. The fundamental reductive basis of this art is no longer seen as primitive or naive but rather as the outcome of a long and complex process of pictorial and decorative simplification that began in Late Mycenaean art. See C. Praschniker, "Mykenai-Kreta-Dipylon," *Wiener Jahrbuch für Kunstgeschichte* 16, 2 (1923): 14–35; Schweitzer, *Greek Geometric Art*, 26–27. The motifs themselves—concentric and linked circles, meander, triangles, zigzags, and checkers, etc.—all come from the repertory of Mycenaean decorative arts in various media. See W. Kraiker and K. Kübler, *Die Nekropolen des 12. und 10. Jahrhunderts*, Kerameikos Ergibnisse der Ausgrabungen, 1 (Berlin, 1939), 167–69, 174–77; K. Kübler, *Neufunde aus der Nekropole des 11. und 10. Jahrhunderts*, Kerameikos 1 (Berlin 1943), 9–18; Kübler, Kerameikos 5 (Berlin, 1954), 159–60, 170–71, 182; Kahane, *American Journal of Archaeology* 44, (1940): 465–67; Schweitzer, *Greek Geometric Art*, 26–27.

s. Experts now stress the abstract conceptual logic of the Greek Geometric Style as an expression or response to the order of the natural environment; see annotation *f* for chapter 3B.2. Schweitzer (*Greek Geometric Art*, 15–16, 26, fig. 5) has specifically demonstrated how the most abstract geometric vase decorations evolved gradually as progressive stylizations of organic natural forms, along the same lines that Riegl already suggested here.

t. Once again, Riegl's observations display enormous insight. Scholars now consider figural scenes (especially those of the Dipylon Style) as the most advanced and sophisticated achievement of Greek Geometric vase painting. See Coldstream, *Geometric Greece*, 109–14; J. Schafer, "Steps Toward Representational Art in Eighth-Century Vase Painting," in R. Hagg, ed., *The Greek Renaissance of the Eighth Century B.C.: Tradition and Innovation*, Proceedings of the Second International Symposium at the Swedish Institute in Athens, 1–5 June 1981, 75–81. Some would attribute this development in figural art to the impact of Mycenaean antiquities discovered in Late Geometric times, and to a renewed interest in the mythic "heroic" past (J. L. Benson, *Horse, Bird, and Man. The Origins of Greek Painting* [Amherst, Mass., 1970], esp. 83–88, 108–23—(for an opposing view see J. Boardman, "Symbol and Story in Geometric Art," in W. G. Moon, ed., *Ancient Greek Art and Iconography* [Madison, Wis., 1983], 15–36). Others would

explain the new pictorial interest and sophistication through the influence of contemporary Oriental and Egyptian art (Benson, *Horse, Bird, and Man*, 88–89; G. Ahlberg, *Fighting on Land and Sea in Greek Geometric Art* [Stockholm, 1971]; J. Carter, "The Beginnings of Narrative Art in the Greek Geometric Period," *Annual of the British School at Athens* 67 [1972]: 25–58). All these explanations have a certain merit. Collectively, they more than justify Riegl's insistence that Greek Geometric figural art did not originate in the patterns or techniques of primitive textile industry.

u. For the most recent attempts at the highly problematic interpretation of the abstract and animal forms and symbols of Greek Geometric vase painting see B. Fellmann, "Zur Deutung der frühgriechische Körperornamente," *Jahrbuch des Deutschen Archaologischen Instituts* 93 (1978): 1–29, esp. 9–10; K. Stähler, "Zur Bedeutung der Tierfriese auf attisch reifgeometrischen Vasen," in D. Metzler, B. Otto, and C. Muller-Wirth, eds., *Antidoron. Festschrift für Jürgen Thimme* (Karlsruhe, 1983), 16–11; and Boardman, "Symbol and Story," in Moon, *Ancient Greek Art and Iconography*, 16–22.

CHAPTER 2. THE HERALDIC STYLE

a. Near Eastern archaeology would eventually verify Riegl's claim. The system of superimposed registers or friezes was in use thousands of years before such Assyrian textiles, in relief sculpture like the alabaster vase of Protoliterate date from Uruk or in multicolored engraved inlay like the "Standard of Ur" from Early Dynastic times (see H. Frankfort, *Art and Architecture of the Ancient Orient*, [Harmondsworth, 1985], pls. 10–11, 76–77).

b. This Semperian metaphor still has modern adherents. P. Albenda has recently examined the sculptured doorsills of Assyrian royal palaces in an article entitled "Assyrian Carpets in Stone," *Journal of the Ancient Near Eastern Society of Columbia University* 10 (1978): 1–34. For the type of Sassanian Persian and related Byzantine or early Islamic silks treated by Curtius, see R. Ghirshman, *Persian Art. 249 B.C.–A.D. 651* (New York, 1962), 227–37, figs. 275–90.

c. The decorated garments shown in Assyrian wall reliefs do in fact relate to earlier Babylonian prototypes like the skirt of the king on the stele of Marduk-nadin-akhe, ca. 1100 B.C. (see K. S. Brown, "The Question of Near Eastern Textile Decoration of the Early First Millennium B.C. as a Source for Greek Vase Painting of the Orientalizing Style," [Ph.D. diss., University of Pennsylvania, University Microfilms International, Ann Arbor, 1980], 30–31, and annotation *n* for chapter 3A.2). On the figural decorations of Assyrian textiles also see J. V. Canby, "Decorated Garments in Ashurnasirpal's Sculptures," *Iraq* 33 (1971): 31–53. For a more extensive sample of the type of garment illustrated in Riegl's figure 4, see Frankfort, *Ancient Orient*, fig. 224; idem, *Cylinder Seals. A Documentary Essay on the Art and Religion of the Ancient Near East* (London, 1939), 308–9, fig. 109; G. Perrot and C. Chipiez, *Histoire de l'art dans l'antiquité*, vol. 2 (Paris, 1884), figs. 443–44; E. Wallis Budge, *Assyrian Sculpture in the British Museum, Reign of Assurnasirpal II, 885–860 B.C.* (London, 1914), pls. 49–52; J. Meuszynski, "Contribution to the Reconstruction of the Northwest Palace in Kalhu (Nimrud)," *Etudes et Travaux du Centre d'Archéologie Méditerranéenne de l'Académie Polonaise des Sciences* 5 (1971): 42–50, figs. 1–14.

d. To his great credit, current scholarship can answer Riegl's question with a resounding no. The theories portraying textile design and technique as the *fons oriens* of ancient Near Eastern iconographic formulae and compositional principles are even more untenable than the related arguments concerning the impact of

textiles on Greek Geometric art. If any one medium now appears to have played a formative role in the development and diffusion of Near Eastern pictorial art, it was the cylinder seal, a major class of object that was still largely unexcavated or unpublished when Riegl wrote. Should one really require "technical" explanations, then it was the continuous relief compositions on these cylinders, rolled out as strips onto wet clay tablets, that provided the source for the multiple serial repetition of figural elements as friezes in ancient Near Eastern art, the so-called tapestry or carpet style (*Teppichstil*); see Frankfort, *Cylinder Seals*, 308, pls. 4a, 4k, 5b, 5f, 8g, 8h, 8k, for representative examples. Like the serial designs, the bilaterally symmetrical or "heraldic" arrangement of human, animal, and plant motifs is as old as Near Eastern art itself, appearing already on the earliest cylinder seals, reliefs, and freestanding sculpture (Frankfort, *Cylinder Seals*, pls. 3a–b; 4j and l; 5g and i; idem, *Ancient Orient*, pls. 12, 17, 19).

Riegl's criticism of Curtius's theory has also been corroborated by the new discoveries and extensive research in Near Eastern and central Asiatic textiles over the last several decades. The recent study by Brown, *Near Eastern Textile Decoration*, has shown that simple geometric patterns were far more common than figural textile decoration (see esp. 663–69). Though several centuries later than the Assyrian examples, the well-preserved textiles from the nomadic burials at Pazyryk in Siberia support the opinion of Riegl and Semper that such figural textile decoration in the ancient Near East was generally embroidered or sewn on as appliqués rather than woven as part of the structure of the fabric itself (see the studies of Albenda and Canby cited just above in annotations *b* and *c*; cf. Brown, *Near Eastern Textile Decoration*, 39–40, 43, 662). In this case neither the individual motifs nor their composition are likely to have arisen from true weaving techniques or processes. Where craftsmen did actually weave human and animal forms as part of the fabric itself, as on the Persian or Persian-influenced weavings and pile carpet from Pazyryk, the angular and blocklike treatment of the figures demonstrates the difficulties of adapting such figures to the grid structure of the textile process. Albenda (*Journal of the Near Eastern Society of Columbia University* 10 [1978]: 1–34) has explained the all-over patterns of the painted and sculptured wall and floor decoration of Assyrian palaces as copies of wall hangings and carpets, but she never suggests that their decorative repertory *originated* in textile art. Brown, (*Near Eastern Textile Decoration*, 18), plausibly concludes that figured textiles or garments reproduce in miniature the same themes that were current in other Assyrian arts like monumental painting and wall relief, as Riegl long ago maintained. For a detailed treatment of the Pazyryk textiles see S. I. Rudenko, *The Frozen Tombs of Siberia. The Pazyryk Burials of Iron Age Horsemen* (Berkeley and Los Angeles, 1970), esp. 295–307, appliqués pls. 168–73; embroidery, pl. 178; woven figured decoration, pls. 174–75, 177; R. Ghirshman, *The Arts of Ancient Iran from Its Origins to the Time of Alexander the Great* (New York, 1964), figs. 466–67; E. D. Phillips, *The Royal Hordes. Nomad Peoples of the Steppes* (New York, 1965), figs. 91–93, 97–98; K. Jettmar, *Art of the Steppes*, (New York, 1967), figs. 59, 99, 103, pls. 16–19, 25. Also see Canby, *Iraq* 33 (1971): 33–53, and K. R. Maxwell-Hyslop, *Western Asiatic Jewellery ca. 3000–612 B.C.* (London, 1971), 254, on the use of metal appliqués as figural decoration in Near Eastern textiles.

CHAPTER 3. A. 1. NEAR EASTERN—EGYPTIAN

a. As the following annotations will show, Riegl's basic argument following the researches of Goodyear that the stylized flowers of Egyptian art all derive from the natural model of the lotus, and not from the papyrus or any other plants, is essen-

tially untenable. The use of the lily and papyrus as distinct heraldic symbols of upper and lower Egypt respectively was a leitmotiv of Pharaonic art, especially in pairs to symbolize the unity of both kingdoms. The most monumental and famous examples are the reliefs on the twin pillars in the Hall of Annals built by Tuthmosis III in the temple of Amon-Ra at Karnak. The decoration from one of these pillars is illustrated in Riegl's figure 20, although his erroneous and potentially confusing reference to it as a column capital has necessarily been emended in the text; see S. Lloyd and H. W. Müller, *Ancient Architecture* (New York, 1980), 128, fig. 196. A more common symbol of this unity, however, was the *sma* motif, in which the glyph for the "breath of life," the lungs and windpipe, appeared entwined by the stems of stylized lily or palm and papyrus plants disposed antithetically to either side. This symbol is already attested by the Fourth Dynasty; it appears on the sides of the throne on the seated statue of Khafre (Cephren) from Giza; see W. Stevenson Smith, *The Art and Architecture of Ancient Egypt* (Harmondsworth, 1981), fig. 107; I. Wallert, *Die Palmen im Alten Ägypten. Eine Untersuchung ihrer praktischen, symbolischen und religiösen Bedeutung*, Münchener ägyptologische Studien (Berlin, 1962), 74–81. Also see L. Borchardt, *Die ägyptische Pflanzensäule. Ein Kapitel zur Geschichte des Pflanzenornaments* (Berlin, 1897), 18–24, figs. 30, 36, 37. Riegl's figures 7–10 are generic simplifications of the basic Egyptian floral stylizations. For photographic illustrations of actual paintings or reliefs with such ornament, see Smith, *Art and Architecture*, figs. 119, 168, 195, 202, 263, 283, 336, and 369. In general one should also consult the excellent and detailed study of Egyptian and related Near Eastern vegetal or floral ornament by H. J. Kantor, *Plant Ornament. Its Origin and Development in the Ancient Near East* (Ph.D. diss., University of Chicago, 1945), *Dissertation Conspectus*, which was based largely on Riegl's initial efforts. Unfortunately, this work was never published, and it remains available only in an abbreviated and unillustrated form.

b. It does not necessarily follow that the conflation of the features of different Nilotic plants was the result of confusion. Egyptian artists could easily have done so in full cognizance of the botanical distinctions involved. In any case there can be no doubt that the features of the lotus, papyrus, and the lily or palm as well were freely combined at least as early as the Old Kingdom (see annotations g–i, m, p–q, just below).

c. For illustrations of the Pompeian pavements depicting these Nilotic flora, see E. Pernice, *Die hellenistische Kunst in Pompeji. Pavimente und figürliche Mosaiken*, vol. 6, (Berlin, 1938), pl. 68, nos. 1–4; P. Charbonneaux, R. Martin, and F. Villard, *Hellenistic Art* (New York, 1973), figs. 165–67.

d. Goodyear's arguments here have been substantiated by subsequent discoveries. The "egg-and-dart" or "leaf-and-dart" borders of Ionic Greek entablatures and column moldings were all derived from Aeolic Greek precursors that depended in turn upon the increasingly stylized lotus or lily and bud patterns on column capitals and bases of Neo-Hittite, Levantine, Urartian, and Neo-Assyrian architecture. See E. Akurgal, *The Art of Greece. Its Origins in the Mediterranean and Near East* (New York, 1966), 83–89, figs. 30–45; 221–22, figs. 167–71; A. W. Lawrence, *Greek Architecture* (Harmondsworth, 1967), 130–31; P. Betancourt, *The Aeolic Style in Architecture. A Survey of its Development in Palestine, the Halicarnassos Peninsula, and Greece* (Princeton, N.J., 1977).

e. Riegl was undoubtedly correct to insist that the rosette represented the frontal or top view of an open flower rather than the ovary stigma, as Goodyear argued. Also see G. Streng, *Das Rosettenmotiv in der Kunst und Kulturgeschichte* (Munich, 1918). But in view of the many archaeological discoveries since Riegl's time, it is improbable that the Nilotic lotus was the natural analog that originally inspired

the rosette, or that Egyptian artists first created this ornamental form; see annotation *f*, below.

f. In the case of the rosette, the archaeological data from Mesopotamia, Syria, and Lebanon that have accumulated since 1900 have thoroughly substantiated von Sybel's claim for an Asiatic origin. Today it is clear that the rosette was already current in the painted pottery of the Tel Halaf and Al Ubaid or Gawra periods in Mesopotamia during the fifth millennium B.C., and that it continued directly into the arts of the Protoliterate period of the fourth millennium where it was widespread in glyptic, stone relief, and inlay; see E. D. Van Buren, "The Rosette in Mesopotamian Art," *Zeitschrift für Assyriologie* 45 (1939): 99–107; B. L. Goff, *Symbols of Prehistoric Mesopotamia* (New Haven, Conn. and London, 1963), 12–13, 112, 132–33, figs. 67–68, 72, 461, 553–55; E. Strommenger and M. Hirmer, *Five Thousand Years of the Art of Mesopotamia* (New York, 1964), 376, 383–84, 388, pl. 2, nos. 7, 16–17, 38; A. Moortgat, *Die Kunst des Alten Mesopotamien* (Cologne, 1967), 19, 24, and pls. 18, 24; and H. Frankfort, *Cylinder Seals. A Documentary Essay on the Art and Religion of the Ancient Near East* (London, 1939), pl. 6, e, g, and j. All-over patterns of polychrome rosette studs also occur as wall decoration in the Protoliterate "Eye Temple" at Tel Brak in Syria (H. Weiss, ed., *Ebla to Damascus. Art and Archaeology of Ancient Syria* [Washington, D.C., 1985], 87–89, fig. 13), and in the Eanna Level 3 sanctuary at Warka (Goff, *Prehistoric Mesopotamia*, 116, fig. 480).

The rosette first occurs in Egypt as a leafy form on the relief palettes and mace heads of the late Pre- and Protodynastic periods of the very late fourth millennium B.C., where it is associated as a glyph with the figure of the Pharaoh or his attendants (Smith, *Ancient Egypt*, 32–34, figs. 12–14). It only occurs sporadically in the succeeding period, on the crown of the Fourth-Dynasty statue of Princess Nofret cited by Riegl; on the collar of a female brewer statuette of the same date, and in the minor arts of the Middle Kingdom. See K. Michalowski, *Art of Ancient Egypt* (New York, 1969), pl. 16, and Smith, *Ancient Egypt*, figs. 78, 88d, 209. As Riegl noted, it does not become common until the New Kingdom; cf. the wall paintings and decorative arts in the Eighteenth Dynasty (Smith, *Ancient Egypt*, figs. 246, 284, 338, 346). The evidence indicates an Asiatic rather than Egyptian origin for the rosette. Its transmission to the Nile Valley would appear to parallel the impact of Mesopotamian cylinder seals of Jemdet Nasr type and Sumerian brick architecture with niched facades in Egypt during the late Gerzean and Protodynastic periods, or the well-known ivory knife handle from Gebel-al-Arak, which clearly imitates the relief sculpture of Protoliterate Mesopotamia (Michalowski, *Art of Ancient Egypt*, pl. 180). On the contacts between Egypt and western Asia at this time see H. Frankfort, *The Birth of Civilization in the Ancient Near East* (New York, 1953), appendix, 100–111; H. Kantor, "The Final Phase of Predynastic Culture," *Journal of Near Eastern Studies* 3 (1944): 110–36; idem, "Further Evidence for Early Mesopotamian Relations with Egypt," *Journal of Near Eastern Studies* 11 (1952): 239–50; P. Gilbert, "Synchronisme artistique entre Egypte et Mésopotamie," *Chronique d'Egypte* 26 (1951): 225–36; E. J. Baumgartel, *The Cultures of Prehistoric Egypt* (London, New York, and Toronto, 1960), vol. 2, esp. 140–54; W. B. Emery, *Archaic Egypt* (Harmondsworth, 1961), 30–31, 38–40, 165, 167, 177, 189–91; W. A. Ward, "Relations between Egypt and Mesopotamia from Prehistoric times to the End of the Middle Kingdom," *Journal of the Economic and Social History of the Orient* 7 (1964), 1–45; R. W. Ehrich, ed., *Chronologies in Old World Archaeology* (Chicago and London, 1965), 1–17, a fine synthesis of earlier scholarship with extensive bibliography; Smith, *Ancient Egypt*, 35–37; and most recently, K. M. Boehmer, "Orientalische Einflüsse auf verzierten Messer-

griffen aus dem prädynastichen Ägypten," *Archäologische Mitteilungen aus Iran* 7 (1974): 15–40. The studies of Kantor and Ward are especially lucid; they explain the connections with Protoliterate Sumer as indirect, transmitted via the intermediary Semitic peoples of Syria and the Levant with whom Egypt would long be in contact.

g. The three forms that Riegl explains here as variant stylizations of the lotus are in reality the lotus, the papyrus, and a conflation derived from the features of both plants. I. Kleemann, *Der Satrapen-Sarkophag aus Sidon.* Istanbuler Forschungen, 20 (Berlin, 1958), 53–57 has justly criticized Riegl and Goodyear for explaining all these forms as artistic transformations of the same natural form or analog. Any careful comparison with the actual plants demonstrates that the stylized flowers illustrated in figures 8, 14, and 21 do indeed represent the papyrus and not the lotus.

h. Figure 7 is the lotus as Riegl maintains, although the reversed or bell-shaped contour of Riegl's example already shows some accommodation to the features of the papyrus. Actual examples display a slightly convex or straight-sided triangular contour; cf. those depicted in the Fifth- and Sixth-Dynasty painted tomb reliefs of Mehou, Ptahhotep, and Mereruka at Saqqara; see K. Lange and M. Hirmer, *Egypt. Architecture, Painting, Sculpture, in Three Thousand Years* (New York, 1968), 414–15, pls. 70, 72, 74, VIII.

i. Figure 13 is a conflation or hybrid stylization. It displays the bell-shaped contour and smooth, arcuated linear upper edge of the papryus stylization; cf. those of the reliefs in the Fifth-Dynasty Weserkaf Temple at Saqqara, in Smith, *Ancient Egypt*, fig. 119. But it combines this form with the full-length sepals of the lotus rather than the short sepals of the actual papyrus. This conflated form already appears in the Fifth-Dynasty tomb of Ptahhotep (Lange and Hirmer, *Egypt*, pl. 70, center right) and in the reliefs of the Sixth-Dynasty tomb of Idut at Saqqara (R. Macramallah, *Fouilles à Saqqarah. Le Mastaba d'Idout* [Cairo, 1935], pls. 11b; 16a–b; 19, top left). The generic form of figure 13 is almost identical to the lotuses depicted in the Twelfth-Dynasty reliefs from the temple of Sesostris I at Lisht (Smith, *Ancient Egypt*, fig. 168).

j. This variant, figure 8, is definitely a papyrus. The argument that the lack of detail resulted purely from artistic simplification is arbitrary. Examples with precisely this shape and with all their details indicated appear at least as early as the Fifth Dynasty (cf. the example from the Weserkaf Temple cited in the preceding annotation), and they display the same short sepals and parallel radiating striations as the inverted flowers of Riegl's figure 21, clearly stylizations of the anatomical details of the actual papyrus. See Borchardt, *Ägyptische Pflanzensäule*, 25–27, figs. 42–47. Stylized papyri of this type in relief sculpture were often smooth, with the details painted, like the capitals of the pilasters on the Third-Dynasty mortuary complex of Zoser at Saqqara (Smith, *Ancient Egypt*, figure 40; Lloyd and Müller, *Ancient Architecture*, figure 151). Unfortunately the added polychromy of the Saqqara capitals is not sufficiently preserved for scholars to be certain whether they showed the details of the papyrus filaments, or whether they already conflated this shape with the full-length sepals and petals of the lotus like Riegl's figure 13.

k. The bold contour of three-dimensional or very high relief papyrus capitals with applied details of lotus sepals and petals may well have provided the origin of this hybrid type with the arcuated upper edge. It would then have been translated into low relief or wall painting as a secondary development. The papyrus capital in figure 14 is from the Nineteenth-Dynasty hypostyle hall of the temple at Karnak (= R. Lepsius, *Denkmäler aus Ägypten und Äthiopien nach den Zeichnungen der*

von Seiner Majestät dem Könige von Preussen Friedrich-Wilhelm IV nach diesen Ländern gesendeten in den Jahren 1842–1845 angeführten wissenschaftlichen Expedition, [Berlin, 1849–1856], Abtheilung I, Blatt 80); for a photographic reproduction see G. Legrain, *Les temples de Karnak* (Brussels, 1929), 184–88, figs. 119–20; K. Lange and M. Hirmer, *Egypt*. pls. 231, LIII.

l. As Riegl suggests here, the Egyptian papyrus capital and also the palm capital probably evolved initially as the blossom crownings of freestanding, stelelike emblemata that only later came to be used or imitated as support members in architecture. The ribbed horizontal moldings just below the corolla on the capital in figure 14 clearly represent the bindings that once fastened a series of real flowers or palm fronds to the tops of wooden trunks and poles, perhaps those which may have stood in the open air as symbolic "sacred trees" or plants; see Lloyd and Müller, *Ancient Architecture*, 118, fig. 183a, 183e. This suggestion is also supported by the evidence of Egyptian wooden furniture that utilized free-ending shafts with such emblematic vegetal embellishments. The Fourth-dynasty tomb of Queen Hetep-heres contained a carrying chair whose handle poles terminated in golden palm capitals (Smith, *Ancient Egypt*, 90, fig. 83). The use of such forms as symbolic or decorative load-bearing members in architecture was a secondary development that could also well have occurred in wood before it was done in stone. In any case the stylistic details were vestiges of the materials and techniques in which they were originally constructed. On the evolution of the palm capital in Egypt see Borchardt, *Ägyptische Pflanzensäule*, 44–49, and the more recent study of Wallert, *Die Palmen im Alten Ägypten*, 121–26.

The "lotus bud" capital in Riegl's figure 15 (cf. Lepsius, *Denkmäler aus Ägypten*, Abtheilung 1, Blätter 47, 81) is another matter. Historians of Egyptian architecture consider this to be a wooden or petrified version of actual plant columns, i. e., bundles of papyrus or other plant stalks bound together at intervals and used as composite trunklike supports in the vernacular reed architecture that still exists today in the Nile Valley. The capital that Riegl termed a stylized lotus bud actually represented the compressed clusters of the corollas belonging to the multiple papyrus stalks below. Such columns appeared either as "lotus bundles" or "papyrus bundles," depending upon the details on the capital and the sepals at the base, which could be rendered as either type of plant; see Lloyd and Müller, *Ancient Architecture*, 117–18, fig. 183b–c; Borchardt, *Ägyptische Pflanzensäule*, 6–8, 31–35. On the different types of columns with floral crowns or capitals in Egyptian architecture also see the specialized study of G. Foucart, *L'ordre lotiforme. Etude d'archéologie égyptienne* (Paris, 1897).

Here again the explanations of these different capital and column types offered by Riegl and Goodyear are problematic because they are predicated upon the assumption of a purely formal, artistic elaboration of only one natural model, ignoring the impact of multiple prototypes in nature, as well as the influence of earlier craft processes. So earnestly did Riegl wish to refute and correct the excesses of *Kunstmaterialismus* that he in turn exaggerated the role of the creative or stylistic capacity of the artists, to the detriment of those natural and technical considerations that really were a factor in the origin of these decorative forms. Strangely enough, the formalistic artistic impulse did assert itself in the process examined here, but it did so in the imaginative conflation of the different floral prototypes, a phenomenon that Riegl refused to acknowledge.

m. The various elements of Riegl's palmette with the volute-calyx no longer appear as creations of New Kingdom art, since they can be documented individually by Old and Middle Kingdom times. The volute-calyx consisting of two broad petals with bulbous terminals occurs as part of the *sma* motif on the throne of a

Fourth-Dynasty Cephren statue (Smith, *Ancient Egypt*, fig. 88f). It appears with true volute terminals and pendant droplets or lateral axil fillers on an imported Egyptian gold cloisonné ring of Middle Kingdom date found in the royal tombs at Ebla in Syria; see M. P. Matthiae, "Campagne de fouilles à Ebla en 1979: les tombes princières et le palais de la ville basse à l'époque amorrhéenne," *Académie des Inscriptions et Belles Lettres, comptes rendus* (Jan.–Mar. 1980): 95–118 and figure 8; idem, "Die Fürstengräber des Palastes Q in Ebla," *Antike Kunst* 13, no. 1 (1982): 11, fig. 24.

The "palmette," i.e., palmlike radial clusters or aggregates of drop-shaped leaves or petals, also turns up as a floral terminal in the *sma* motif on Cephren's throne and in the plant or *su* hieroglyphs of Third- and Fourth-Dynasty reliefs, as well as in related vegetal forms depicted in the Fifth-Dynasty reliefs of Sahura's pyramid temple; see Smith, *Ancient Egypt*, figs. 49, top left; 77, top; and 88e–f; Borchardt, *Ägyptische Pflanzensäule*, 20, fig. 35. It appears in a rather developed form as the blossoms of the drooping plant stems carved in relief on a Middle Kingdom sandstone altar later inscribed with the name of Thutmosis III (*Ägyptens Aufstieg zur Weltmacht* [Mainz, 1987], 194, no. 110). The palmette was also applied more abstractly as a space filler in the radial floral patterns on the Twelfth-Dynasty cloisonné crown of Sat-hathor-yunet and a mica cap ornament from Kerma, and in the spiral patterns on incised grey-ware from Lisht (Smith, *Ancient Egypt*, figs. 204, 205d, 212). The palmette serves as the axil filler of a leafy calyx (although without volutes) on the painted ware from Kerma of the second Intermediate Period (Smith, *Ancient Egypt*, fig. 210 top left). The particular blend of elements in Riegl's figure 17 is certainly more common in New Kingdom art. Yet all the components originated much earlier, and it is very possible that they had already been combined by Middle Kingdom times. In her discussion of the origins of the palmette and volute calyx, C. Kepinski (*L'arbre stylisé en Asie occidentale au 2e millénaire avant J.-C.* [Paris, 1982], 1: 59–65) ignores the earlier Egyptian material; she sees the palmette and volute-calyx largely as a creation of Middle Bronze Age Aegean art.

n. The capitals to which Riegl refers here are the "proto-Ionic" type current in the Levant from the very end of the Bronze Age and early Iron Age, and their "Aeolic" derivatives in Greek art of the seventh and sixth centuries B.C. The turn of the century saw intense interest in the problem of such capitals in the studies by Borchardt, *Ägyptische Pflanzensäule*, 18–24; M. von Groote, *Die Entstehung des jonischen Kapitells und sein Bedeutung für die griechische Baukunst* (Strassburg, 1905); O. Puchstein again, *Die ionische Säule als klassisches Bauglied orientalischer Herkunft* (Leipzig, 1907); R. von Lichtenberg, *Die ionische Säule als klassisches Bauglied rein hellenischem Geiste entwachsen* (Leipzig and New York, 1907); F. von Luschan, "Entstehung und Herkunft der ionischen Säulen," *Der Alte Orient* 13, no. 4 (1912): 7–43. The problem was examined later by W. Andrae, *Die ionische Säule, Bauform oder Symbol* (Berlin, 1933); R. Engberg, "Tree Designs on Pottery, with Suggestions Concerning the Origin of the Proto-Ionic Capitals," in H. G. May, *Material Remains of the Megiddo Cult* (Chicago, 1935); K. Schefold, "Das äolischen Kapitell," *Jahresheft des österreichischen archäologischen Instituts* 31 (1939): 42ff.; A. Ciasca, "I capitelli a volute in Palestina," *Rivista degli studi orientali* 36 (1961): 189–97; D. Auscher, "Le problème des chapiteaux dits 'Proto-Ioniques'," *Vetus Testamentum* 17 (1967): 27–30; Akurgal, *Art of Greece*, 221–22; Betancourt, *The Aeolic Style*, esp. 27ff., with extensive bibliography on the monuments of individual sites; and most recently, E. Akurgal, "Frükarchaische Kapitelle vom Tempel der Athena in Alt-Smyrna," *Annuario della Scuola Archeologica di Atene e della Missione Italiana in Oriente* n.s. 43 (1981): 127–32; idem, *Griechische und römische Kunst in der Türkei* (Munich, 1987), 44–53.

Scholars are today unanimous in tracing the Aeolic and Ionic capital to Near Eastern predecessors, but the origin of the Levantine Proto-Ionic capital itself is less settled. Some, like Auscher, see its development as a purely local western Asiatic phenomenon. But since *Stilfragen* appeared, scholars like Borchardt, Puchstein, and Betancourt have stressed the Egyptian background. New Kingdom reliefs and wall paintings often depict architectural structures with rather fanciful columns surmounted by voluted floral capitals, probably reflecting wooden prototypes; see Puchstein, *Ionische Säule*, fig. 27a–c, and Betancourt, *The Aeolic Style*, figs. 1–3. Columns of this sort actually occur in engaged form as the relief decoration of the pilasters from the mortuary temple of Rameses III at Medinet Habu; cf. Betancourt, *The Aeolic Style*, 19–23, pl. 3. If Betancourt and the others are correct in identifying such works as the general protoypes of the Levantine volute capitals, it would support the opinion of Riegl and Goodyear that Egyptian decorative art provided the point of departure for the later western Asiatic and Greek developments.

o. The tendency to fill the axils created by the involution and juxtaposition of petals was undoubtedly a basic principle of Egyptian ornamental design, as Riegl argued, but his purely formalistic explanation of the central axil filler in these patterns ignores the evidence of natural analogs (see annotation *q*, just below).

p. The volute-calyx on the Egyptian cloisonné ring from Ebla, (Matthiae, *Antike Kunst* 13, no. 1 (1982): 11, fig. 24) might seem to corroborate Goodyear's suggestion here. On this ring, the central calyx is flanked by lotus buds on stems that are consciously made to play upon the similarity to the adjacent drop-shaped fillers in the exterior axils of the terminal volutes. But like the "droplets" of figures 16, 17, and 19, and unlike the lotus buds proper, the fillers on the Ebla ring curve outward in the manner of the individual components of the palmette-fan. This feature suggests that they originated from such leaf or petal-like forms rather than buds. Von Luschan, (*Der Alte Orient* 13, no. 4, [1912]: 20) provided a similar explanation. He considered the volute-calyx to be a stylization of the date palm, in which the droplike axil fillers were simpified renderings of the date clusters.

q. In reality, the central filler of the pattern illustrated in figure 20 was neither purely aesthetic nor symbolic in origin. It is instead traceable to the natural prototype behind the art form, since the heraldic flower of the pillar at Karnak in figure 20 is a stylized rendering of the lily, even though it also includes small papyrus sepals. Any comparison to the actual appearance of lilies shows that the central element is nothing more than the foreshortened projection of another petal on the opposite side of the flower, seen between the two lateral petals. Its appearance here is analogous to the treatment of the additional petals of the lotus in figure 7. In the course of time it was varied formally, either becoming a flatter triangular filler in conjunction with a palmette above it as in figures 16 and 21, or becoming a longer leaflike element projecting beyond the lateral volutes as in figures 19 and 23. Consequently, Goodyear's alternative explanation of this central filler was on the right track, apart from his insistence that the flower was a lotus rather than a lily. On the development of the lily motif, see Borchardt, *Ägyptische Pflanzensäule*, 18–22; M. Flinders Petrie, "The Egyptian Lily," *Ancient Egypt* (1928–1929): 65–73; G. Bénédite, "La cueillette du lis et le 'lirinon'," *Académie des Inscriptions et Belles Lettres. Comptes rendus* 25 (1921–22): 1–28; H. Danthine, *Le palmier-dattier et les arbres sacrés dans l'iconographie de l'Asie occidentale ancienne* (Paris, 1937), 180–83; Kleeman, *Satrapen-Sarkophag*, 53–54, 57. For a photographic reproduction of the Karnak pillar in figure 20, see annotation *a*, just above.

r. Here Riegl seems to be reversing the process as it actually occurred. Once it is apparent that the pattern in figure 20 represents the lily, as distinct from the

lotus and papyrus or the palmette, one must see it as a separate and independent form. The stylized lily had already come into being by the Fourth Dynasty in works like the crown on the seated statue of Princess Nofret, (Smith, *Ancient Egypt*, figs. 78, 88d), and in the cloisonné crown of the Twelfth-Dynasty Princess Kanument from Dashur (E. Vernier, *Catalogue général des antiquités égyptiens. Bijoux et orfèvreries* [Cairo, 1927], pl. 67). By the Eleventh Dynasty in the reliefs of the temple of Mentuhotep I at Deir-el-Bahari, it appears in a form close to that on the Karnak pillar (Michalowski, *Ancient Egypt*, figure 270, left). It maintained this form in later Middle Kingdom works like the gold pectoral of Amenemhat III or the faience jars from Kerma, (Smith, *Ancient Egypt*, figure 205f; idem, *Interconnections of the Ancient Near East, A Study of the Relationships between the Arts of Egypt, the Aegean, and Western Asia* [New Haven, Conn., 1965], figs. 20e, 27). This stylization is therefore not a simplification of the kind of pattern illustrated in figures 16 or 19.

The bulbous or spiraled treatment of the petal terminals on Riegl's volute-calyx is more problematic. This form is also attested by the Fourth Dynasty on the throne ornament of one of Cephren's statues (Smith, *Ancient Egypt*, fig. 88 f), and it is tempting to explain it as a more involuted stylization of the curling tips of the lily petals, perhaps reflecting the impact of spiral ornament; see Borchardt, *Ägyptische Pflanzensäule*, 18–19. But some scholars would interpret the involuted motif on the Cephren throne as a stylized palm rather than a lily, especially since the tendril that it emits ultimately terminates in a three-leafed palmette; see Smith, *Ancient Egypt*, 94, and Wallert, *Die Palmen im Alten Ägypten*, 74–76, who makes her argument on the grounds of heraldry and religious symbolism. And as already indicated, von Luschan, (*Die Alte Orient* 13, no. 4 [1912]: 20) would interpret the more developed Egyptian volute-calyx, the so-called lily of Upper Egypt specifically as a stylized date palm. Even Borchardt, (*Ägyptische Pflanzensäule*, 21), who favors the lily interpretation, identifies the flowers on the Cephren thrones as palmlike lilies. Kantor (*Plant Ornament. Its Origin and Development, Dissertation Conspectus*, 4–13), prefers the term "south flower," in view of the difficulty in identifying the specific botanical species behind this stylization, a problem one may also avoid by retaining Riegl's more neutral and descriptive term, the volute-calyx.

s. The use of arcuated bands as a connecting matrix is not a New Kingdom development; it can already be documented on the Middle Kingdom faience pottery from Kerma, Smith (*Ancient Egypt*, figure 205 f; idem, *Interconnections*, figure 20e), where it is used to connect stylized lilies. On the Egyptianizing gold pendant of late Middle Minoan times from the Aigina Treasure it connects several lotuses. But there it is somewhat flattened, doubling visually as a boat or support for the deity above; see P. Demargne, *The Birth of Greek Art*, (New York, 1964), figure 150; S. Hood, *The Arts in Prehistoric Greece*, (Harmondsworth, 1978), fig. 193.

t. The smaller flowers of figure 22 are stylized papyrus alternating with lotus flowers and buds.

u. The use of arcuated bands or tendrils as a connecting matrix for floral stylizations is in fact ubiquitous in Orientalizing and Archaic Greek and Etruscan art of various media.

v. The solution illustrated in figure 24 is a more continuous or tendril-like adaptation of the floralized spiral ornament in figure 25.

w. This pattern of circles connected by diagonal lines is common on Geometric Greek art of all media, including metalwork as well; see B. Schweitzer, *Greek Geometric Art* (London, 1971), figs. 10–11, 26, 55, 64, 82, pls. 211–12.

x. Here Riegl is referring to the *sma* motif commonly depicted on royal paraphernalia and used especially as the decoration of thrones. See the Cephren statue

and the throne of Amenhotep III depicted in the tomb paintings of Onen at Thebes (Smith, *Ancient Egypt*, figs. 107, 255) and the actual thrones or footstools from the tomb of Tutankhamen (C. Desroches-Noblecourt, *Tutankhamen. The Life and Death of a Pharoah* [New York, 1978], pls. 4a, 6, 11, 12; H. S. Baker, *Furniture in the Ancient World. Origins and Evolution 3100–475 B.C.* [New York, 1966], figs. 89, 95, 97, pls. 7 and 8.

y. In his assessment of these floralized spiral patterns Riegl was absolutely correct to stress the visual and developmental priority of the geometric matrices themselves, whatever their configuration. Plain spiral ornament of this kind had been well established in the eastern Mediterranean for millennia; it constituted a major decorative theme of Cycladic art and the Early Minoan and Early Helladic phases of Crete and the Greek mainland; see Demargne, *Birth of Greek Art*, figs. 49, 56–57; Hood, *Prehistoric Greece*, figs. 129–30, 212; and M. C. Heath, "Early Helladic Clay Sealings from the House of the Tiles at Lerna," *Hesperia* 35 (1966): 116, pl. 22, nos. S46-S47. They remained prominent in Middle Minoan art and became current in the contemporary glyptic and wall painting of Syria and northwest Mesopotamia and in the tomb painting and minor arts of Middle Kingdom Egypt. For spiral ornament in Old Syrian cylinder seals see D. Collon, *The Seal Impressions from Tell Atchana/Alalakh*, Alter Orient und Altes Testament, 27 (Neukirchen-Vluyn, 1975), nos. 55, 84, 86, 93, 106, 160; cf. 143–44 for their dating, 1720–1650 B.C. Also see the slightly earlier painting from the palace at Mari, P. Amiet, *Art of the Ancient Near East* (New York, 1977), pl. 65, and Moortgat, *Alten Mesopotamien*, 75, fig. 49a. For the spiral decoration of Old and Middle Kingdom scarabs, see A. Rowe, *Catalogue of Egyptian Scarabs, Scaraboids, Seals, and Amulets in the Palestine Archaeological Museum* (Cairo, 1936), pl. 2, nos. 57, 62; pl. 3, nos. 97, 117; H. J. Kantor, "The Aegean and the Orient in the Second Millennium B.C.," *American Journal of Archaeology*, 51 (1947), pl. 3a–i; and W. Flinders Petrie, *Egyptian Decorative Art* (London, 1895), 17–28, figs. 11–46.

The process by which such patterns were then elaborated with floral accessories was not initially a new Kingdom development as Riegl thought, or one that necessarily began in Egypt. In Middle Minoan glyptic and painted ceramics, simple leaf or petal forms fill the axils of true spiral and false spiral patterns (i.e., those comprised by strings, S-shaped lines, or elements and circles); see Demargne, *Birth of Greek Art*, figs. 92–93, 124–25, and Hood, *Prehistoric Greece*, figure 11. They are found in contemporary Old Syrian glyptic as well; Collon, *Impressions from Tell Atchana*, nos. 160, 161, 163. Simplified flowers also fill the axils of a false spiral pattern on Twelfth-Dynasty Egyptian scarabs; see F. S. Matouk, *Corpus du scarabée égyptien*, vol 1, *Les scarabées royaux* (Beirut, 1971), 178, no. 42b. Also see M. C. Shaw, "Ceiling Patterns from the Tomb of Hepzefa," *American Journal of Archaeology* 74 (1970): 26–30, pls. 5–6, on the connection of such spiral ornament in Middle Kingdom Egypt with contemporary Crete. If Petrie, (*Egyptian Decorative Art*, 22, fig. 18), is correct in dating his figure 18 on page 22 to the Twelfth Dynasty, then the use of lotus flowers and buds as axil fillers of a running spiral pattern may already belong to the Middle Kingdom. The addition of large and detailed floral stylizations as fillers in more complex all-over spiral patterns, however, is generally a later phenomenon and may be an Egyptian elaboration (see annotation *n* for chapter 3. B. 1, below).

The New Kingdom painted ceilings with patterns like those of figures 26–27 and 56 are seldom reproduced in photographs. Many, like figures 21, 23, and 26, no longer exist; they are preserved only in the drawings and polychrome watercolor copies of antiquarians and early archaeologists. For a black-and-white reproduction of the actual work, see Smith, *Interconnections*, figure 53; idem, *Ancient*

Egypt, figure 284; for rare color photographs, see W. Westendorf, *Ancient Egypt. Painting, Sculpture, and Architecture* (New York, 1968), ill., p. 130, and Lange and Hirmer, *Egypt*, pl. XLV.

z. Cow heads like those of figure 27, in a quadrangular all-over spiral network, were later discovered in the fragments of the ceiling paintings from the Eighteenth-Dynasty palace at Malkata near Thebes, where they have similarly been interpreted as symbols of Hathor; see Smith, *Ancient Egypt*, figure 284; idem, *Interconnections*, 113, figure 53.

aa. For photographs of the Maori prows and other wood carvings with spiral ornament like that of figure 28, see J. Guiart, *The Arts of the South Pacific* (New York, 1963), figs. 372–73. For Maori wooden statues with incised facial ornament like the tattoos of figures 31–32, see Guiart, *South Pacific*, figure 267.

bb. Riegl's emphasis on formal or aesthetic motivations for the development of spiral ornament is once again a retort to *Kunstmaterialismus*, or more specifically, to the technical or materialist explanation advanced by L. von Sybel (*Kritik des aegyptischen Ornaments* [Marburg, 1883], 19, 22–23), where such patterns are said to have originated in wire bending. On available evidence, the earliest spiral ornament in the Mediterranean appears to have been carved or incised, like the ones in Maori art; cf. the Cycladic examples cited in annotation *y*, just above. Nevertheless, the "purely ornamental" quality of such decoration in any culture remains to be proven. Several Cycladic examples include fish among the spirals, suggesting that they served as a decorative representation of water; see Demargne, *Birth of Greek Art*, fig. 49; H.-G. Buchholz and V. Karageorghis, *Prehistoric Greece and Cyprus* (New York, 1973), 67, no. 857. This can be corroborated by the spiral borders of a wall painting from the palace at Mari in Mesopotamia, which are located directly beneath scenes of goddesses dispensing flowing, wavy streams of water, or by the statue of such a deity from the same site where the undulating streams running down her skirt terminate in spirals along the hem (Amiet, *Ancient Near East*, pls. 62, 65). Also see Collon (*Impressions from Tell Atchana*, 193–94), who uses such evidence to interpret the related spiral patterns on the seals as glyphs for water. In the Neo-Assyrian reliefs from Sennacherib's palace at Nineveh, the waters of rivers are also stylized as spirals (Amiet, *Near East*, pl. 120). Since the plants used in the floralized spiral ornament of figures 25–27 and 55–57 are exclusively aquatic, these patterns are most readily intelligible as decorative expressions of lotus and papyrus in the natural habitat of the life-giving Nile.

cc. Riegl's objection to Goodyear here is a sound one, but the data that have come to light since he wrote obviate any recourse to ethnographic comparisons to prove the point. Spiral ornament evolved as an independent form originally unrelated to floral decoration. And, as annotation *r* just above indicated, the involution of the petals in floral stylizations like figures 16, 17, and 19 was the secondary development, probably stimulated by preexisting traditions of spiral ornament. This will become even clearer in the annotations accompanying Riegl's discussion of Mycenaean ornament.

dd. Riegl's attribution of the earliest vegetal or floral stylizations to Egypt is no longer tenable in the light of archaeological research on the early phases of Mesopotamian culture; see annotation *f*, just above.

ee. Riegl's views here are not far from the concluding remarks of von Sybel (*Kritik*, 41). The reader may of course dispute the opinion that the Egyptians had not already accomplished such an integration of aesthetic and iconographic concerns in their art; such judgments are always relative and subjective. But this perspective was based upon the larger historical view of antiquity that informed

Stilfragen—the notion that the achievements of ancient art were a cumulative process involving successive cultures who each passed on what they had inherited while adding their particular contribution in turn. This is a thesis that Riegl would take up again in *Spätrömische Kunstindustrie.*

CHAPTER 3. A. 2. NEAR EASTERN—MESOPOTAMIAN

a. Sites exemplifying the rapid advance of urban civilization in Mesopotamia during the fourth millennium are distributed all across the region, but scholars agree that the heartland of this Protoliterate phase was in the southern portions of the Fertile Crescent or Sumer, and it appears that neighboring Elam already shared in the development. During the early second millennium, northern Mesopotamian sites like Mari still displayed the impact of Neo-Sumerian and Old Babylonian culture from further south. But scholars have come increasingly to appreciate the importance of local traditions or developments in northern Mesopotamia and Syria during the later third and second millennia, and especially the reverse impact that the more westerly centers of Old Syrian and Mitannian culture exerted on Assyria between 1800 and 1400 B.C. It was the kingdom of Mitanni that contributed most directly to the formation of the decorative arts in northern Mesopotamia during the Middle Assyrian period, and particularly in the transmission of elements or motifs ultimately of Egyptian origin. For a recent and thorough archaeological overview of the Syrian developments throughout these periods see H. Weiss, *Ebla to Damascus. Art and Archaeology of Ancient Syria* (Washington, D.C., 1985), 75–313. On the role of Mitanni in Middle Assyrian art, see A. Moortgat, *Die Kunst des Alten Mesopotamien* (Cologne, 1967), 116–28. In the area of ornament specifically, see H. J. Kantor, *Plant Ornament. Its Origin and Development in the Ancient Near East*, (Ph.D. diss., University of Chicago, 1945), *Dissertation Conspectus*, 17–22, and B. Hrouda, "Zur Herkunft des assyrisches Lebensbaumes," *Baghdader Mitteilungen* 3 (1964): 41–51.

b. Even today, the guilloche remains rare in surviving examples of Egyptian decorative art; cf. W. Flinders Petrie, *Egyptian Decorative Art* (London, 1895), fig. 66.

c. Despite Riegl's formalistic interpretation here, the guilloche and other simple interlace patterns may well have come about as symbols of running water or moisture; see J. Six, "De la glyptique syro-hittite jusqu'à Praxitèle," *Syria* 6 (1925): 206–8; E. D. Van Buren, *The Flowing Vase and the God with Streams* (Berlin, 1933), 4. More recently, H. Seyrig ("Les dieux de Hiérapolis," *Syria*, 37 [1960]: 240 n. 1, and pl. 9, no. 12), and D. Collon *The Seal Impressions from Tell Atchana*, Alter Orient und Altes Testament, 27 [Neukirchen-Vluyn, 1975], 194), have also argued that the guilloche, like the spiral, served as a decorative glyph for water in ancient Near Eastern religious art. This is especially clear in a Neo-Assyrian relief of Ashurbanipal at Nineveh, where the liquid pouring from the king's libation bowl is stylized as a regularly interlacing guilloche; see the above works by Six and Van Buren, as well as Moortgat, *Alten Mesopotamien*, pl. 288.

d. Riegl's assessment here of the differences between the early and later phases of Neo-Assyrian ornament vis-à-vis Egypt was on the right track, although it must be modified in the light of later discoveries. Assyrian lotus and palmette patterns of the eighth and seventh centuries B.C., when there were direct contacts with the Nile Valley, do correspond more closely to Egyptian forerunners than do the ninth-century examples seen in figure 33, which were then the earliest known Assyrian works. Riegl's attempt to explain these disparities by hypothesizing an earlier and indirect reception of Egyptian patterns was deeply intuitive. There was

indeed an earlier process of just this kind, during the Middle Assyrian period between 1500 and 1200 B.C., when Egyptian-derived patterns first reached northern Mesopotamia via the intermediary cultures of Syria or Mitanni. This material was still largely undiscovered when Riegl wrote, and to some extent it verifies his explanation of the later Assyrian development.

However, the indirect connection with Egypt in these second millennium precedents does not account for the stylistic qualities of the ninth-century works. Middle Assyrian examples of the lotus and palmette frieze connected by arcuated bands, like those in the thirteenth-century B.C. wall paintings of the palace of Tukulti Ninurta I near Assur, are relatively close in style to Egyptian forerunners, like the later Neo-Assyrian patterns exemplified by figure 34. Thus, the less Egyptian-looking patterns, like the glazed brick ornament from Nimrud in figure 33 and the closely related ornament on the robe of the king in the contemporary reliefs of Ashurnasirpal II at the same site, represent a temporary phase in which Neo-Assyrian artists for a time explored new decorative possibilities before returning to the more established treatment of the lotus frieze. See the studies on Middle Assyrian art and ornament cited in annotations *a* and *k*, just above and just below. For the Tukuluti Ninurta I paintings, also see W. Andrae, *Farbige Keramik aus Assur*, (Berlin, 1923); Moortgat, *Alten Mesopotamien*, 122, fig. 89; Frankfort, *Ancient Orient*, figs. 152–53; and W. Stevenson Smith, *Interconnections of the Ancient Near East. A Study of the Relationships between the Arts of Egypt, the Aegean, and Western Asia*, (New Haven, Conn. 1965), 113–14, figs. 143, 145. For the robe ornaments in the reliefs of Ashurnasirpal II from Nimrud, see annotation *c* for chapter 2.

e. Figure 34, an alabaster doorsill from Nineveh, period of Tiglathpileser III, is taken from A. H. Layard, *Monuments of Nineveh: From Drawings Made on the Spot by Henry Austen Layard* vol. 2 (London, 1853), pl. 56; also see P. Albenda, "Assyrian Carpets in Stone," *Journal of the Ancient Near Eastern Society of Columbia University* 10 (1978): 1–19, esp. 14–16, pls. 8, 14–16. Albenda has revived the theory that these sculptured doorsills are "petrified" versions of woven carpets or hangings. However, the closest that one comes to such actual Assyrian textiles is the woven horse cloth from the tomb of Tutankhamun or the knotted carpet found in the nomadic burial at Pazyryk in Siberia; see M. A. Littauer and J. H. Crouwel, *Chariots and Related Equipment from the Tomb of Tut'ankhamun* (Oxford, 1985), 88 and pl. 62; S. I. Rudenko, *Frozen Tombs of Siberia. The Pazyryk Burials of Iron Age Horseman* (Berkeley and Los Angeles, 1970) pls. 174–75, 177; K. Jettmar, *Art of the Steppes* (New York, 1967) fig. 103, pl. 19; E. D. Phillips, *The Royal Hordes. Nomad Peoples of the Steppes* (New York, 1965), fig. 92; and R. Ghirshman, *The Arts of Ancient Iran from Its Origins to the Time of Alexander the Great* (New York, 1964), fig. 466. The Egyptian example and the central pattern of the Pazuryk carpet are both clearly related to the radial floral compositions of the inner squares on the stone doorsill, but on the loom-woven textiles, the rendering of the design is somewhat awkward, angular and simplified, lacking the subtle curvilinear treatment and detail of the sort in figure 34.

If the doorsills did have precise analogies in textiles, they were probably works in appliqué and embroidered technique that could more easily imitate the subtle contours of decorative forms in various other media. J. N. Canby ("Decorated Garments in Ashurnasirpal's Sculptures," *Iraq* 33 [1971]) maintains that the figured textiles in the Assyrian reliefs reproduce garments with metal appliqués. In surviving Greek textiles of the late Classical or Hellenistic period, finely-proportioned, curvilinear floral ornament is embroidered or sometimes even painted; for examples from the Scythian burials of South Russia, see L. Stephani, "Erklärung

der einiger Kunstwerke der Kaiserilchen Ermitage und anderen Sammlungen," *Compte rendu de la Commission Impériale Archéologique, St. Petersburg* (1878–1879) atlas, pl. 3, nos. 2–3; E. Minns, *Scythians and Greeks* (Cambridge, 1913), fig. 113; G.M.A. Richter, *A Handbook of Greek Art* (London and New York, 1969), 380–83, figs. 506–7. For the newly discovered example from the royal Macedonian tomb at Vergina, see *The Search for Alexander. An Exhibition* (Boston, 1980), 36, figure 19.

The type of lotus and palmette friezes on the doorsills appears in a nearly identical form in Assyrian palatial wall painting. See the examples from Khorsabad (H. Frankfort, *The Art and Architecture of the Ancient Orient* [Harmondsworth, 1985], fig. 196) and the Assyrian governor's palace at Til Barsip in Syria (F. Thureau-Dangin, *Til Barsib*, Bibliotheque Archéologique et Historique 23 [Paris, 1936], pls. 45–47; A. Parrot, *The Arts of Assyria* [New York, 1961], figs. 342–43). The medium in which these particular patterns were first created can no longer be determined.

f. See the Egyptian forerunners for such arcuated band friezes in A. Prisse d'Avennes, *Histoire de l'art égyptien d'après les monuments, depuis les temps les plus reculés jusqu'à la domination romaine* (Paris, 1878–1879), atlas 1, pl. 54, "Frises fleuronnées," nos. 6, 15.

g. The Egyptian pattern illustrated in figure 37 is known as the *khaker*, and it probably derives from balusters or crownings made of papyrus bundles once common in the vernacular architecture of the Nile Valley; cf. Petrie, *Egyptian Decorative Art*, 101–2. The Assyrians were familiar with the khaker since they used it as a border on the glazed brick wall decoration of Shalmaneser III at Nimrud, although substituting its crownings with pomegranate and lotus buds; see J. E. Reade, "A Glazed Brick Panel from Nimrud," *Iraq* 25 (1963): 28–47, pl. 9; W. Orthmann, *Der Alte Orient*, Propyläen Kunstgeschichte, vol. 14 (Berlin, 1975), figure 98, pl. 19. However, the pattern in figure 38 (from Layard, *Monuments of Nineveh*, vol. 1, pl. 87, bottom) has no connection with the khaker; it probably resulted from a similar substitution of pomegranates for the usual lotus flowers and buds within an arcuated band frieze of standard Egyptian or Assyrian type.

h. A fine example of such overlapping arcuated band friezes also appears in the garland surrounding the sacred tree on the reliefs of Ashurnasirpal II's palace at Nimrud; see P. Amiet, *Art of the Ancient Near East*, (New York, 1977), pl. 121, and S. M. Paley, *King of the World, Ashur-nasir-pal II of Assyria 883–859 B.C.* (New York, 1976), pls. 12, 17a. This pattern became widely popular in Greek and Etruscan art of the seventh and sixth centuries B.C. (O. Brendel, *Etruscan Art* [Harmondsworth, 1978], figs. 32, 36, 37, 53; cf. Riegl's figure 90).

i. Despite Riegl's skepticism, subsequent discoveries in glyptic art, wall painting, and monumental relief have confirmed that the stylized sacred tree of ancient Near Eastern art of the second and first millennia B.C. had a deeply symbolic function. It appears not only as an isolated ornamental motif but as part of larger representations including deities and rulers. The Assyrian example shown in figure 39 itself comes from just such a representation, where it is flanked by winged deities with horned crowns (Layard, *Monuments of Nineveh*, vol. 1, pl. 7). See N. Perrot, *Les représentations de l'arbre sacré sur les monuments de Mésopotamie et d'Élam* (Paris, 1937), and H. Danthine, *Le palmier-dattier et les arbres sacrés dans l'iconographie de l'Asie occidentale ancienne* (Paris, 1937), 90–92, 94–104, 111–21, 136–164, with extensive bibliography on such tree symbolism, 217–20. For more recent opinions on the religious iconography of the stylized sacred tree or tree depictions in the art of the ancient Orient, see A. Moortgat, *Tammuz. Der Unsterblichkeitsglaube in der altorientalischen Bildkunst* (Berlin, 1949), esp. 99–

134; H. Frankfort, *Cylinder Seals: A Documentary Essay on the Art and Religion of the Ancient Near East* (London, 1939), 205–215; idem, *Ancient Orient*, 137; G. Widengren, *The King and the Tree of Life in Ancient Near Eastern Religion*, Uppsala University Arskrift 4, (Uppsala, 1951); Moortgat, *Alten Mesopotamien*, 163; Paley, *King of the World*, 22, 24, and n. 31; I. Wallert, *Die Palmen im Alten Ägypten. Eine Untersuchung ihrer praktischen, symbolischen und religiösen Bedeutung*, Müchner ägyptologische Studien (Berlin, 1962), esp. 63ff.; H. Genge, "Zum 'Lebensbaum' in den Keilschriftkulturen," *Acta Orientalia* 33 (1971): 321–34; H. York, "Heiliger Baum," in D. O. Edzard, ed., *Reallexikon der Assyriologie und Vorderasiatischen Archäologie*, vol. 4 (Berlin, 1972–1975), 277–78; and E. Hermsen, *Lebensbaumsymbolik im alten Ägypten. Eine Untersuchung*, Arbeitsmaterialen zur Religionsgeschichte (Cologne, 1981).

j. Also see for example, the landscape scenes in Smith, *Ancient Egypt*, figs. 197–98, 258, 368–70, and K. Michalowski, *Art of Ancient Egypt* (New York, 1969), endpapers (tomb of Rekmire) and figs. 120, 402.

k. Others besides Riegl have interpreted the structure of the Assyrian sacred tree as a reflection of furniture of some sort. S. Smith, (*Early History of Assyria* [London, 1928], 123), and Frankfort (*Ancient Orient*, 137), argued that such patterns were replicas of wooden trunks or poles decorated with bound palm leaves or fronds displayed in religious celebrations. The baldachin supports illustrated in figure 35 certainly look like constructions of this sort, and these may be Mesopotamian counterparts of emblematic trunks bound with palm fronds used in ancient Egypt, which eventually gave rise to the Egyptian palm capital (see annotation *l* for chapter 3A.1, above). The horizontal moldings below the volutes and palmettes of the Assyrian sacred tree may therefore be vestigial bindings, derived from such decorative tree-trunk constructions. The bindings would have been retained when the palmette with volutes was adapted as a separate motif in arcuated band friezes. There they now appeared to function as "junctures" for the arcuated bands, and they continued to be used even when other floral or vegetal elements like lotuses, pomegranates, or pinecones were substituted (cf. figs. 35 with 39 and 33–34 and 38).

Paley (*King of the World*, 23–24) has severely criticized Smith's thesis of the sacred tree as a derivative of decorated ceremonial tree trunks. As he and others have argued, the sacred trees and palmette garlands depicted in Neo-Assyrian art derive from earlier Middle Assyrian ornament that depended in turn upon Mitannian and Canaanite traditions of decoration. But the adaptation of bindings from ceremonial emblemata to ornamental patterns could well have occurred earlier, in the second millennium, as part of the development. For second millennium forerunners of Neo-Assyrian floral ornament, see the wall paintings of Tukulti Ninurta I, the alabaster vase and Nuzi ceramics from Assur, and Middle Assyrian glyptic, in B. Hrouda, *Die bemalte Keramik des zweiten Jahrtausends in Nordmesopotamien und Nord Syrien* (Berlin, 1957), pls. 2, no. 3; 4, no. 7; Frankfort, *Art and Architecture of the Ancient Orient*, figs. 152–53; Moortgat, *Alten Mesopotamien*, 116–22, figs. 81, 85, 89, pl. K, no. 7. For a detailed discussion of the evolution of these patterns see Danthine, *Les arbres sacrés*, 28–84; Frankfort, *Cylinder Seals*, 205–15; E. Porada and B. Buchanan, *Corpus of Ancient Near Eastern Seals in North American Collections. The Collection of the Pierpont Morgan Library* (Washington, D.C., 1948), 67–71; Hrouda, *Baghdader Mitteilungen* 3 (1964): 41–51; York, "Heiliger Baum," *Reallexikon der Assyriologie und Vorderasiatischen Archäologie*, vol. 4, 274–80; and most recently C. Kepinski, *L'arbre stylisé on Asie occidentale au ze millénaire avant J.-C.* (Paris, 1982), 1: 53–76, 101–14.

l. Cf. the reliefs of the royal footstool, C. Desroches-Noblecourt, *Tutankhamen. The Life and Death of a Pharoah* (New York, 1978), pl. 11a–c.

m. In sacred tree patterns the surrounding string of palmettes connected by arcuated bands is also derived from Middle Assyrian and Mitannian or Syrian forerunners like the Nuzi ware sherd and the wall paintings cited in annotation *k* just above or cylinder seals (Orthmann, *Der Alte Orient*, pl. 433 a; Kepinski, *L'arbre stylisé*, vol. 3, no. 1163). Also see Kepinski's discussion of this form of elaboration around the tree (1:37–39, 97–99). The additional diagonal undulating bands connecting the palmettes to the vertical trunk in figure 39, however, are a new feature, and one that may have evolved for symbolic as well as decorative purposes. Paley (*King of the World*, 26–27 n. 31) has suggested that this network was suggestive of life-giving canals or streams of water, following the conventions of earlier Mesopotamian art like the statue and painting from Mari, where flowing water was undoubtedly suggested by such undulating lines (see annotation *bb* for chapter 3A.1, above). His suggestion is further supported by the similar network patterns of multiple streams running from vases in Neo-Sumerian reliefs (Van Buren, *The Flowing Vase*, figs. 34–35) and by the reliefs of Sennacherib from Nineveh (Amiet, *Ancient Near East*, pl. 120), where the river waters are stylized as diagonal, abutting undulations terminating in spirals, not unlike the network of the sacred tree in contemporary Assyrian art.

n. For the sacred trees incised along the hem of the king's robe on the stele of Marduk-nadin-akhe, a Babylonian work of the Kassite period, see Frankfort, *Ancient Orient*, figure 147; Amiet, *Ancient Near East*, pl. 518; and Kepinski, *L'arbre stylisé*, vol. 3, nos. 979–80. Similar trees appear on contemporary Kassite cylinder seals, and in fact the motif of the stylized sacred tree was already well established in Kassite Babylonian art of the fourteenth and thirteenth centuries B.C.; see Smith, *Interconnections*, figs. 147–48; T. Beran, "Die babylonische Glyptik der Kassitenzeit," *Archiv für Orientforschung* 18, no. 2 (1958): 255–78, figs. 9–11, 13–14, 16, 23, 28–30; M. Trokay, "Glyptique cassite tardive ou postcassite?" *Akkadica*, 21 (198?): 14–43, figs. 1–22; and Kepinski, *L'arbre stylisé*, vol. 1, nos. 103–4; vol. 3, nos. 452, 456, 462, 892, 894, 981–82, 1090–91, 1096, 1170. Nevertheless the chronological priority of such Kassite Babylonian examples does not demonstrate that the evolution of this motif in western Asiatic art was initially a Mesopotamian development, as Riegl suggested here. The Neo-Assyrian examples like those in figure 39 evolved out of earlier Middle Assyrian patterns of this kind, which were contemporary with and possibly infuential upon those of Kassite Babylonian art to the south. But all such Mesopotamian examples were ultimately derived from Late Bronze Age Mitannian and Canaanite or Syrian forerunners, as indicated in annotation *k* just above and in the annotations for the following chapter. The Iron Age Phoenician examples of the sacred tree that Riegl had in mind here are indeed later than those of Kassite or Middle Assyrian art, but it was their immediate forerunners in Levantine art of the Late Bronze Age that provided the basis for the development of the sacred tree in Assyrian and Babylonian art during the second millennium B.C. This earlier Syrian or Phoenician and Mitannian art was still largely unknown in Riegl's day, but it would soon prove to be the vital link between Egyptian and Mesopotamian floral ornament.

CHAPTER 3. A. 3. NEAR EASTERN — PHOENICIAN

a. To some extent, the original significance of motifs may be lost or altered in highly synthetic or eclectic export art like that of Phoenicia in the early first millennium B.C., but one can never be certain that art forms lose all meaning in such a process. The Phoenician sacred tree, or "palmette-tree," as Riegl preferred to call it, generally appears in the same distinctive, heraldic context as the Neo-Assyrian examples and their precursors in earlier Mesopotamian and Syrian art. It is flanked

by pairs of divinities or composite beings, and it must to some degree retain the basic function as a symbol of divinely inspired renewal and prosperity.

b. Here Riegl and von Sybel are both referring to representations of Egyptian formal bouquets made up of bundles of superimposed flowers. Such bouquets are most common from the Eighteenth Dynasty on, but they already appear by the Fifth Dynasty in the relief of King Men-kau-hor (K. Michalowski, *Art of Ancient Egypt* [New York, 1969], fig. 234). The form and usage of these bouquets have been studied extensively by S. Schott, "Das schöne Fest vom Wüstentale. Festbräuche einer Totenstadt," *Abhandlungen der Akademie der Wissenschaften und der Literatur in Mainz*, Geistes- und Sozialwissenschaftlichen Klasse 11 (1952); esp. 812–27, 879–83, figs. 13–15, pls. 2, 6. In the international setting of the eastern Mediterranean during the Late Bronze Age, if not earlier, representations of such bouquets also became current in Canaanite or Phoenician art; cf. G. Loud, *The Megiddo Ivories* (Chicago, 1939), pl. 8., nos. 27–30. The principle of superimposing floral components basic to such bouquets may well have been a factor in the early development of the sacred tree (see annotation *k*, paragraph 3, just below).

c. For a color photographic reproduction of the sacred tree pattern in figure 40, see W. Westendorf, *Ancient Egypt. Painting, Sculpture, and Architecture* (New York, 1968), ill., p. 130, and K. Lange and M. Hirmer, *Egypt, Architecture, Painting, Sculpture, in Three Thousand Years* (New York, 1968), pl. XLV, where it appears as the vertical border for an all-over spiral composition. The downward-curling volutes of figure 40 are identical to Riegl's "volute-calyx" in figures 16 and 19, although the type of flower may be a lily or perhaps a stylized palm, rather than a lotus (see annotations *q* and *r* for chapter 3A.1). The crowning flowers of figure 40 are papyri.

d. Here Riegl is assuming that Cypriote works like this capital are simply reflections of Phoenician art, originating as part of the extensive maritime commercial connections between Cyprus and the Levant at this time. Some, like R. Dussaud (*Civilisations préhelléniques* [Paris, 1914], 308ff., 321ff.) have argued for an autochthonous aspect in Cypriote works of this style, but continued research confirms the decisive impact of Phoenician motifs and craftsmanship in their development. The two-staged arrangement of the capital in figure 41 is more elaborate than the typical Levantine Proto-Ionic capitals of this period, but all the same, it directly reflects Phoenician prototypes, those in the minor arts like ivories or metalwork. On these connections see H. Danthine, *Le palmier-dattier et les arbres sacrés dans l'iconographie de l'Asie occidentale ancienne* (Paris, 1937), 208–9, fig. 1116, and H. Frankfort, *The Art and Architecture of the Ancient Orient* (Harmondsworth, 1985), 322–23. For a closer Cypriote copy of Levantine Proto-Ionic capitals, see the sixth-century tomb at Tamassos, in V. Karageorghis, *The Ancient Civilization of Cyprus* (New York, 1969), figure 143.

e. The history of the Amathus bowl since its discovery by Cesnola is somewhat unclear, but it did not come to New York along with the other objects in Cesnola's collection acquired by the Metropolitan Museum, and it has been in the British Museum since 1931. Riegl's original attribution of the bowl to New York repeats the error of G. Perrot and C. Chipiez (*Histoire de l'art dans l'antiquité*, vol. 3 [Paris, 1885], fig. 547). For a thorough discussion and survey of the bowls of this type see J. L. Myres, "The Amathus Bowl," *Journal of Hellenic Studies* 53 (1934): 25–39; E. Gjerstad, "Decorated Metal Bowls from Cyprus," *Opuscula Archaeologica* 4 (1946): 1–18; and most recently, G. Markoe, *Phoenician Bronze and Silver Bowls from Cyprus and the Mediterranean*, University of California Classical Studies, vol. 26 (Berkeley, Los Angeles, and London, 1985), esp. 172–74, 177–78, ills., pp. 248–49, 256–59. All consider the bowls as products of Phoenician crafts-

men settled in Cyprus, or perhaps working in Phoenicia or Syria itself; cf. Frankfort, *Ancient Orient*, 327–28, 407 n. 193. The sacred tree patterns on the bowls have close parallels in contemporary Phoenician ivories; see M.E.L. Mallowan, *Nimrud and Its Remains* (New York, 1966), vol. 2, figs. 425, 467, 477; R. D. Barnett, *A Catalogue of the Nimrud Ivories with Other Examples of Ancient Near Eastern Ivories in the British Museum* (London, 1957), pl. 9; Frankfort, *Ancient Orient*, figs. 379, 381.

f. For sacred tree patterns in Phoenician or Syrian art of the late second and early first millennia (i.e., the palmette tree), Riegl's observation still holds true; the "common palmette" (with drooping petals like those of figures 16 or 21) was not used to fill pairs of upward-curling volutes. The concave lower profile of such palmettes was better suited to fill the axil formed by the downward-curling volute-calyx of patterns like those of figures 16 or 21. But the crowning "bulrush" or "leaf shafts" that appear typically between the upward-curling volute pairs of the Egyptian or Phoenician examples as in figures 40–41 are nevertheless variant forms of the palmette. The latter type with its rectilinear contour is known as the "Syrian palmette." It first became current in Levantine or Mitannian works of the later second millennium like the wall paintings from Nuzi or Canaanite ivories (Frankfort, *Ancient Orient*, figure 291; Loud, *Megiddo Ivories*, pls. 6, 13–14). From there it passed into currency in the sacred trees of Phoenician or Syrian art of the first millennium B.C., like those of figures 40a–41.

g. Strictly speaking, it is no longer correct to say that there were no forerunners for the Neo-Assyrian palmette with an upward-curling volute-calyx. Second millennium sacred trees like those of the Nuzi painting, as indicated in the preceding annotation, already used a rectilinear or Syrian palmette in this way, and although the combination of the drooping or "common palmette" with upward-curling volutes still appears to be unparalleled in Egyptian and Syrian art, there were nevertheless late second millennium precedents of this kind in Middle Assyrian art. These first occur in the wall paintings of Tukulti Ninurta I and on a contemporary cylinder seal impression from Tell al Rimah; see Frankfort, *Ancient Orient*, figs. 152–53; C. Kepinski, *L'arbre stylisé en Asie occidentale au 2e millénaire avant J.-C.* (Paris, 1892), vol. 3, nos. 438, 448–50.

As far as one can judge, it was the desire to incorporate this "common" form of palmette as the filler of the topmost pair of upward-curling volutes on the sacred tree that was the primary factor in this development. The increased horizontality of the volute pairs in the Tukulti Ninurta paintings and their Neo-Assyrian descendants in figures 33 and 39 evidently came about to facilitate the addition of this large drooping palmette. Once this change had occurred, the palmette and volute-calyx could then be disengaged from the sacred tree itself to serve as more complex blossoms in arcuated band friezes or even as separate patterns; cf. figures 33 and Frankfort, *Ancient Orient*, figure 224, lower center. In this sense Riegl was absolutely correct in characterizing the Assyrian palmette with upward-curling volutes as a distinct and self-contained motif or unit, like the Egyptian or outward-curling volute-calyx palmette of figures 16 or 21.

h. The Phoenician phase exemplified by the objects in figures 40a–42 is certainly no earlier than the first millennium B.C., as Riegl argued. But while the term Phoenician is generally applied to the later coastal culture of the Levant, it was a direct continuation of the second millennium Canaanite or Syrian civilization that reached back unbroken to the Middle Bronze Age cultures of Byblos and Ugarit; see the recent survey of A. Parrot, M. Chéhab, and S. Moscati, *Les Phéniciens. L'expansion phénicienne. Carthage* (Paris, 1975), which treats the second and first millennia in this region as a unity.

i. On the problem of the representation of the "Kafa"—Bronze Age Syro-

Phoenicians or Canaanites—and other foreign tribute bearers in Eighteenth-Dynasty tomb paintings, see H. J. Kantor, *The Aegean and the Orient in the Second Millennium B.C.* (Bloomington, Ind., 1947), 41–49, with earlier bibliography; J. Vercoutter, *L'Egypte et le monde égéen préhellénique* (Cairo, 1956), esp. 201–368; and W. Stevenson Smith, *The Art and Architecture of Ancient Egypt* (Harmondsworth, 1984), 244–45. The most important paintings are those in the tombs of Rekmire, Useramon, Menkheperra-seneb, Amenemheb, and Senmut, where the Asiatics often appear in the company of Aegean peoples or "Keftiu." Many of the objects in these paintings, especially those decorated with spirals and animal heads, are now recognized as offerings from the "Keftiu" rather than the Asiatics. For illustrations, see above all Vercoutter, pls. 35–60; also see Kantor, *Aegean and Orient*, pl. 9; W. Stevenson Smith, *Interconnections of the Ancient Near East. A Study of the Relationships between the Arts of Egypt, the Aegean, and Western Asia* (New Haven, Conn., 1965), figs. 44b, 90–92; and Smith, *Ancient Egypt*, figs. 239–42, as well as p. 455 n. 29 for the more extensive monographic publication of these tombs. Archaeological discoveries in Syria and Cyprus have confirmed that the paintings accurately depicted the "spindle bottles" and "oil horns" brought as tribute by the Asiatics. For a well-illustrated comparison of the paintings and such vessels see W. Culican, "The First Merchant Venturers. The Sea Peoples of the Levant," in S. Piggott, ed., *The Dawn of Civilization. The First World Survey of Human Cultures in Early Times* (New York, Toronto, and London, 1961), 138, pls. 9–10.

j. Here Riegl is probably referring to the North Syrian or Neo-Hittite reliefs of the ninth and eighth centuries B.C. illustrated in G. Perrot and C. Chipiez, *Histoire de l'art dans l'antiquité*, vol. 4, (Paris, 1887), figs. 275–82; cf. Frankfort, *Ancient Orient*, figs. 346–47, 360–64; and K. Bittel. *Les Hittites* (Paris, 1976), figs. 309–22. The role of the Hittites and Anatolia in the development of the sacred tree pattern was peripheral. The motif only enjoyed a limited currency in second-millennium Hittite art (cf. Kepinski, *L'arbre stylisé*, 1: 106). The examples in the Neo-Hittite monuments of the first millennium were reintroduced from Syrian art, where the pattern had remained in use since Mitannian times.

k. Today the ultimate origin and early development of the stylized sacred tree with volutes is still a complex problem that has not been entirely resolved. In this century, most scholars who have studied such compositions tend toward a western Asiatic or Syrian origin, since the earliest recognizable patterns of this kind occur in the cylinder seals and seal impressions of the nineteenth to seventeenth centuries B.C. found at Ugarit (Ras Shamra) and Tell Atchana (Alalakh). However, the development was clearly an international process based upon a lively interaction of decorative motifs and concepts across the triangle formed by the Nile Delta, Crete, and the western Levant. The recent and comprehensive studies by C. Kepinski ("Un motif figuratif, l'arbre stylisé à Nuzi Alalakah durant la période mitannienne," in T.-M. Barrelet, ed., *Problèmes concernant les hurrites* [Paris, 1984], and *L'arbre stylisé*, 1: 54–58) have correctly stressed the impact of spiral ornament in this process, especially the so-called sacral ivy pattern of Early and Middle Minoan art. It consisted of strings of heart-shaped pairs of spirals clearly ancestral to the superimposed upward-curling volutes of a very early sacred tree pattern from Ugarit (Kepinski, *L'arbre stylisé*, 1: 54–58, 108, ill. p. 56, nos. 1–4; vol. 3, no. 648).

But Kepinski does not sufficiently emphasize the Egyptian contribution to this development. The downward-curling volute pairs of the sacred tree are clearly adapted from the Egyptian voluted flower of Old and Middle Kingdom times (cf. M. Flinders Petrie, *"The Egyptian Lily,"* [1928–1929], 68–70; Danthine, *Les arbres sacrés*, 181–83, 211; and B. Hrouda, "Zur Herkunft des assyrischen Le-

bensbaumes," *Baghdader Mitteilungen* 3 [1964]: 46, who have argued for the impact of lily stylizations in the evolution of the sacred tree). The imported Egyptian cloisonné ring from Ebla even documents the diffusion of the motif to Syria in the eighteenth century B.C. The subordinate shoots of papyrus that already decorate the early sacred tree pattern in a seal impression from Alalakh are also borrowings from Egypt (D. Collon, *The Impressions from Tell Atchana*, Alter Orient und Altes Testament, 27 (Neukirchen-Vluyn, 1975), 60, no. 111, and frontispiece). On the example from Ugarit too, the leafy base or trunk of the volute tree is based upon an Egyptian plant hieroglyph, and one that Egyptian artists had already applied as decoration (cf. Smith, *Ancient Egypt*, figs. 43, 47, 76, 88e).

An even more important borrowing from Egypt in the creation of the sacred tree pattern was the basic principle of superimposing multiple floral sylizations as a larger vertical composition (Danthine, *Les arbres sacrés*, 181–82, 211). This is traceable to Egyptian formal bouquets (see annotation *b* just above) and the more direct imitation of such bouquets in sacred tree patterns can even be documented in Old Syrian glyptic at Alalakh; see Collon, *Impressions from Tell Atchana*, 48–49, nos. 82, 85. It is also significant that the Syrian incunabula of the sacred tree from Ugarit and Alalakh appear in depictions including other distinctive Egyptian symbols like the ankh or the winged disk. These works belong to a period in which Syrian culture assimilated many elements from Egypt through trade and diplomatic contacts, a process best exemplified by the importation and local imitation of Egyptian artifacts in the royal tombs of Byblos; see Parrot, Chéhab, and Moscati, *Les Phéniciens*, 39–44, figs. 27–32, 68; cf. Smith, *Interconnections*, 15–17, figs. 26, 28.

The stylized sacred tree may initially have emerged in Old Syrian culture, but it drew extensively upon artistic conceptions from the outside, and not only those of Crete, but especially from Egypt. H. J. Kantor (*Plant Ornament. Its Origin and Development in the Ancient Near East* [Ph.D. diss., University of Chicago, 1945], *Dissertation Conspectus*, 13–20, 34) argued extensively in support of Riegl's thesis that western Asiatic vegetal ornament as a whole was based largely on earlier Egyptian developments. When elaborate sacred tree stylizations became more widespread in the second half of the second millennium B.C., they continued to evolve as an international phenomenon, current not only in Syrian or Mitannian and Canaanite art but also in Egypt, Mesopotamia, and the more outlying regions of Iran and Anatolia. Kepinski's study is an excellent survey of the body of such artifacts and the rich and almost endless regional variation that the pattern came to enjoy at this time. On the overall process see especially her concluding discussions in volume 1:102–4, 108–10, 112, 115–16.

On present evidence, the relationship between Riegl's Assyrian sacred tree and the Phoenician palmette tree (von Sybel's Phoenician bouquet) during the first millennium B.C. would appear to be cousinly or cognate rather than direct. Both were ultimately derived from the type current in Mitannian, Canaanite, and Egyptian art in the later second millennium, as in figure 40. In the case of the Assyrian variant, the upward-curling volutes retained their reverse or S-shaped contour, but they became flattened or horizontal to facilitate the addition of a larger drooping palmette (figure 39). In the Levant, the upward-curling volutes retained the more vertical or diagonal orientation, but they became more convex or cuplike as well, while continuing to use the more rectilinear palmette of Syrian type (figs. 40–41).

In the end, Riegl and von Sybel were both partially correct in their assessment of this development. It began, as von Sybel argued, in western Asia or the Levant but incorporated many elements and design principles whose origin was Egyptian, as Riegl maintained. Moreover, the particular treatment of the Phoenician pat-

terns of figures 40 and 41, using outward-curling volute calyces or lilies, droplike axil fillers, and additional subordinate papyrus or lily flowers, adhered far more closely to Egyptian variants of the sacred tree seen in figure 40. And indeed, the highly Egyptianized style of the Phoenician works in which these sacred trees appear, whether in metalwork or ivory, still attests to the age-old connections between Egypt and the Levant that had been such a vital factor in the original development of this pattern.

l. Riegl and von Sybel were both incorrect in their assumptions about the enclosed palmette. This motif was neither a Greek nor Phoenician development but a creation of Neo-Assyrian art (see annotation *e* for chapter 3B.3, below).

CHAPTER 3. A. 4. NEAR EASTERN—PERSIAN

a. Riegl was not alone in his rather ungenerous assessment of the Persian art of this period, and it has persisted into this century as well. However, the derivative aspects of Achaemenid art no longer appear as a sign of creative weakness; scholars have come to approach the style established under Dareios and Xerxes as a deliberate resynthesis of earlier Near Eastern artistic traditions that corresponded to the multinational and culturally retrospective imperial ideology of the Persian kings and their ruling class. The modern art historiography on the subject is succinctly treated by M. Cool Root, "The Persepolis Perplex: Some Prospects Born of Retrospect," in D. Schmandt-Besserat, ed., *Ancient Persia: The Art of an Empire* (Malibu, Calif., 1980), 5–13, and the following essay in the same volume by A. Farkas, "Is There Anything Persian in Persian Art?" 15–21. For the most recent and extensive study of the selective and imaginative adaptation of preexisting Near Eastern artistic traditions basic to the formation of Achaemenid art, also see Root's earlier work, *The King and Kingship in Achaemenid Art: Essays on the Creation of an Iconography of Empire*, Acta Iranica, 19 (Leiden, 1979).

b. For more recent photographs of the monument from which figure 43 comes, see F. Sarre, *Die Kunst des alten Persien* (Berlin, 1923), pls. 38–39. Achaemenid floral ornament entirely bypassed the decorative tradition of the sacred tree and the more complex floral stylizations crowning it. The Persians utilized the palmette mostly in arcuated band friezes based upon the simpler Neo-Assyrian and Neo-Babylonian prototypes, in which the palmettes filled the axils created by the tapered ends of the arcuated bands themselves, as in the surrounding garland of figure 39. The best parallel for the Persian example in the glazed brick relief of figure 43, however, is the ornament in the same technique from the facade of the throne room of Nebuchanezzar II at Babylon (A. Moortgat, *Die Kunst des Alten Mesopotamien* [Cologne, 1967], pl. 292, upper center; and P. Amiet, *Art of the Ancient Near East* [New York, 1977], fig. 675). The close correspondence is hardly surprising since the Achaemenid works in this medium clearly followed the Late Babylonian and Elamite precedents in the same medium (E. Porada, *The Art of Ancient Iran* [New York, 1965], 160).

c. The stylized sacred tree with volutes as it had existed commonly in Syria, the Levant, and Mesopotamia did not in fact have much impact on Achaemenid Persian art; for rare examples see H. Danthine, *Le palmier-dattier et les arbres sacrés dans l'iconographie de l'Asie occidentale ancienne* (Paris, 1937), fig. 49, and A. Moortgat, *Vorderasiatische Rollsiegel. Ein Beitrag zur Geschichte der Steinschneidekunst* (Berlin, 1966), no. 767. The kind of sacred tree in figure 44 depends upon a less common Neo-Assyrian or Syrian prototype consisting of a number of superimposed lily or lotus flowers. It appears on the ivories from Nimrud (R. D. Barnett, *A Catalogue of the Nimrud Ivories with Other Examples of Ancient Near*

Eastern Ivories in the British Museum (London, 1957), pl. 9, fig. 3, and M.E.L. Mallowan, *Nimrud and Its Remains*, figure 441), where it is repeated within an all-over pattern. This variant may derive ultimately from Egyptian prototypes where stylized lilies were superimposed more loosely, as on the enamel decoration on the hilt of the royal dagger in Desroches-Noblecourt, *Tutankhamen*, pl. 21, bottom. Or perhaps this vertical lotus motif is a variant of Egyptian and related north Syrian or Babylonian patterns in which multiple voluted lilies were superimposed with crowning palmettes. For examples of the latter, see the decorated chariot from the tomb of Yuia and Tuiu in M. A. Littauer and J. H. Crouwel, *Chariots and Related Equipment from the Tomb of Tut'ankhamun* (Oxford, 1975), pl. 70; the north Syrian reliefs from Sakjegözü in Frankfort, *Ancient Orient*, figure 354; and the glazed brick decoration from the throne room facade of Nebuchadnezzar II at Babylon in Moortgat, *Alten Mesopotamien*, pl. 292, center. In the reliefs at Persepolis, the motif is simply repeated laterally, as on the glazed brick decoration from Susa (fig. 44), or it may serve as the blossoms of arcuated band friezes (E. Schmidt, *Persepolis*, [Chicago, 1953], pls. 22, top; 63, top). The adoption of such relatively unusual patterns from earlier Near Eastern art, and the relatively limited range of prototypes that the Persians took over, testifies to the conscious and selective tastes or attitudes that informed the creation of the Achaemenid style in the late sixth and fifth centuries B.C.

d. The role of Greek sculptors in the development of the Achaemenid style has provided a significant focus for scholarship during the last five decades, beginning especially with the work of the classicist G.M.A. Richter, "The Greeks in Persia," *American Journal of Archaeology* 50 (1946): 15–30. Experts like Frankfort ("Achaemenian Sculpture," *American Journal of Archaeology* 50 [1946]: 6–14; idem, *Ancient Orient*, 365–66), and Porada, (*Ancient Iran*, 158) have concurred. The problem was taken up most extensively by A. Farkas (*Achaemenid Sculpture* [Istanbul, 1974], 33–34, 77–78, 83–116). Others like R. Ghirshman (*The Arts of Ancient Iran* [New York, 1964], 215 and 223) have remained circumspect; also see the reviews of Farkas by O. W. Muscarella, *Bulletin for the American School of Oriental Research* 223 (1976): 71–72, and P. Calmeyer, in *Zeitschrift für Assyriologie* 67 (1977): 299–308. See the article by Root cited just above in annotation *a*, pp. 10–11, for the most recent discussion of the problem.

In the case of Achaemenid floral ornament, the issue of Greek influence is not particularly relevant; the repertory of patterns that the Persians adopted came essentially from Neo-Assyrian and to a less extent, Levantine traditions, although possibly involving Neo-Babylonian intermediaries as well. Achaemenid arcuated band friezes with lotus and palmettes like the one cited by Riegl in note 80 for this chapter sometimes display a marked similarity to Archaic East Greek counterparts, and I. Kleemann (*Der Satrapen-Sarkophag aus Sidon*, Istanbuler Forschungen, 20 [Berlin, 1958], 62) has suggested that East Greek versions may have influenced the Persian examples, in addition to the native Near Eastern sources. But such analogies may reflect no more than the common derivation of East Greek and Achaemenid ornament from earlier Mesopotamian and Levantine forerunners.

CHAPTER 3. B. 1. GREEK—MYCENAEAN

a. Riegl's belief in the specifically Hellenic background or origin of the earliest floral decoration found in the area later known as Greece is of course no longer tenable. The evidence of the Linear B tablets from the Pylos and the later occupation at Knossos has proven that the mainland inhabitants or Mycenaeans were a

Greek-speaking people. See M. Ventris and J. Chadwick, "Evidence for Greek Dialect in the Mycenaean Archives," *Journal of Hellenic Studies* 73 (1953): 84–105; J. Chadwick, *The Decipherment of Linear B* (Cambridge, 1958); idem, in *Cambridge Ancient History*, 3d ed., vol. 2, part 2, (Cambridge, 1975), chap. 39a, 805–19, esp. 812ff.; and S. Dow, in *Cambridge Ancient History*, 3d ed., vol. 2, part 1, (Cambridge, 1973), chap. 13, 582–608. But the work of Sir Arthur Evans, which began not long after *Stilfragen* appeared, eventually established that Bronze Age Aegean civilization was initially formed by the people of Crete; see A. Evans, *The Palace of Minos at Knossos*, 4 vols. (London, 1921–1936). The monumental art of the mainland sites like Tiryns, Mycenae, or Orchomenos is later than that of the Middle and Late Minoan sites on Crete, and like mainland minor arts of the Late Bronze Age, it clearly depended upon Minoan precedent. On these relations see T. L. Shear, Jr., "Minoan Influence on the Mainland: Variations in Opinion since 1900," in *A Land Called Crete*, Smith College Studies in History (Northampton, Mass., 1968); S. Hood, *The Arts in Prehistoric Greece* (Harmondsworth, 1978), 40, 77, 155–63, 166–70, 174–76, 197–206, 226–27.

The precise linguistic and ethnic background of the Minoans is still uncertain, but it was these people who were responsible for the highly naturalistic qualities or innovations that Riegl stressed throughout this chapter. Within the expanded view of Bronze Age Aegean civilization first made possible by Evans's discoveries, the later Mycenaean development actually represents a gradual process of abstraction or geometric simplification that moved away from the organic and sinuous qualities of Minoan art and led ultimately to the Greek Geometric styles of the first millennium. B. Schweitzer (*Greek Geometric Art* [London, 1971], 14–15), sees the geometric tendencies in Late Helladic III pottery as a resurgence of the indigenous artistic traditions of the Middle Helladic period, which had for a time yielded before imported Minoan fashions of aristocratic Mycenaean art. The distinctive naturalism and dynamism of the works illustrated in figures 46–52 did not therefore result from a peculiar Greek artistic consciousness or sensibility, as Riegl believed. Nevertheless, his analysis of the Bronze Age Greek material as a largely autochthonous development fundamentally different from Near Eastern or Egyptian ornament represents a turning point in our understanding of this art. One need only substitute the term Minoan, or perhaps the more neutral label "Aegean," to see how useful and valid Riegl's observations have remained.

b. The definitive study of the Mycenaean ceramic ornament illustrated in figures 45–48 and 49–52 is A. Furumark, *Mycenaean Pottery*, 2 vols., Acta Instituti Atheniensis Regni Sueciae, ser. 4, no. 22 (Stockholm, 1972), 1–2. He provides an extensive and systematic analysis and classification, explaining the patterns as progressive transformations of Minoan or earlier Mycenaean traditions of decoration. Furumark interprets the pattern in figure 45 as a hybrid stylization incorporating features from earlier lily and papyrus ornament (see 284–86, and fig. 42, nos. 10–11).

c. The ultimate connection with Egyptian papyrus and lotus forms is traceable through late Minoan Palace Style vases of the fifteenth century B.C.; see P. Demargne, *The Birth of Greek Art* (New York, 1964), figs. 205–6, 208; Furumark, *Mycenaean Pottery*, 265, fig. 34e, and nos. 31–36.

d. Although Evans (*Palace of Minos*, vol. 2, 480) also saw this pattern as an adaptation of Egyptian forms (papyrus), the voluted forms of figure 49 are not stylized flowers but leaves, the so-called sacral ivy of Minoan origin. See Furumark, *Mycenaean Pottery*, 140–41, 268–73, and fig. 35, no. 1. Also see M. Möbius, "Planzenbilder der minoischen Kunst in botanischer Betrachtung," *Jahrbuch des Deutschen Archäologischen Instituts* 48 (1933): 21–34, and I. Cerceau, "Les représentations végétals dans l'art égéen: problémes d'identification," in *Iconographie minoenne*, Bulletin de correspondence hellénique, suppl. 11 (Athens,

1985): 182–84. For an actual photograph of the vase from which the detail in figure 49 comes, see G. Karo, *Die Schachtgräber von Mykenai* (Munich, 1930), 68, no. 199, pl. 159.

e. Cf. Furumark, *Mycenaean Pottery*, 271, fig. 36, nos. 17–26.

f. Ibid., 278–79, fig. 39, no. 14, where Furumark has convincingly explained figure 47 as a derivative of the stylized palm trees in Minoan glyptic and ivories of the Mycenaean East.

g. Despite the lack of floral accessories, certain features of figure 50 support Riegl's interpretation of the pattern as a stylized tendril—the mono-directional or forward-running orientation of all the volutes, their overall structure as continuous, bifurcating shoots or stems, and their symmetrical configuration according to slide reflection, imitating the common pattern of bifurcation in real plants. The interpretation is confirmed by the decoration of a Late Minoan Palace Style vase, of which figure 50 is a simplification, where the volutes terminate in small flowers or rosettes, and stylized axil fillers occupy the angles between the volutes; see Hood, *Prehistoric Greece*, fig. 19a. For a discussion of slide reflection and other forms of symmetry used in ornament, see A. O. Shepard, *The Symmetry of Abstract Design, with Special Reference to Ceramic Decoration*, Contributions to American Anthropology and History, 47 (Washington, D.C., 1948), esp. 219, fig. 2.

h. For the pattern in figure 51, see the "foliate Band" in Furumark, *Mycenaean Pottery*, 396–99, fig. 69, no. 1. This seems to be a more regular and simplified descendant of the elaborate tendril or seaweed ornament on Middle Minoan Palace Style vases (see Demargne, *Birth of Greek Art*, fig. 128).

i. In the main, Riegl's emphasis on continuous, running tendril ornament as a distinct and widespread feature of Aegean art, in contrast to that of Egypt and the ancient Near East, is valid. But such tendril ornament was not unknown in the Nile Valley, Syria, or Mesopotamia. Bifurcating tendril patterns with volute-palmettes, extended by the symmetry of translation, appear in Eighteenth-Dynasty Egyptian tomb paintings and leatherwork, although in a less dynamic or naturalistic form than Aegean examples (see T. Virey, *La tombe des vignes à Thèbes au Tombe de Senufer* [Paris 1889], pls. 140, 142; P. Fortova-Samalova and M. Vilimkova, *Egyptian Ornament* [London, 1963], figs. 329–30; H. J. Kantor, *The Aegean and Orient in the Second Millennium B.C.* [Bloomington, Ind., 1947], pl. 11 A–E; K. Lange and M. Hirmer, *Egypt. Architecture, Painting, Sculpture, in Three Thousand Years* [New York, 1968], pl. xxiv; and W. Stevenson Smith, *Interconnections of the Ancient Near East. A Study of the Relationships between the Arts of Egypt, the Aegean, and Western Asia* [New Haven, Conn., 1965], fig. 50b). Riegl's figure 24 has similarly been "tendrilized" through the addition of bifurcating stems of lotuses and buds. Bifurcating tendrils appear as the subordinate decoration of the sacred tree pattern on the Nuzi ceramic from Assur (Smith, *Interconnections*, fig. 151). Entirely asymetrical tendrils also figure prominently in later Syrian ivories like the bed head from Nimrud, where figures brandish bifurcating stems that terminate in stylized lotuses (M.E.L. Mallowan, *Nimrud and its Remains* [New York, 1966], figs. 392–93). It was probably the relatively unusual Oriental prototypes of this kind that inspired the Greek development of post-Geometric times, rather than the remote and long-gone examples of Mycenaean art, however numerous they had once been.

j. For an actual photograph of the vase illustrated in figure 52, see Karo, *Schachtgräber von Mykenai*, 164, no. 945, pl. 175. Figure 52 is yet another variant of the "sacral ivy" pattern of Minoan origin. Furumark (*Mycenaean Pottery*, 270, fig. 35, no. 5) characterizes it as an "alternating spray." His figure 35, number 7 shows it in a more even, alternating form that is much closer to the schema of

Orientalizing examples of the intermittent tendril, as seen in figure 53. Still, it appears unlikely that this Aegean pattern alone could account for the later Greek development. In Riegl's day, the intermittent tendril—a string of S-shaped bands or volutes outfitted with lotuses or palmettes—appeared to be a Hellenic invention. M. Schede (*Antikes Traufleisten-ornament* [Strassburg, 1909], 2) considered it entirely unknown in the ancient Near East, and half a century later, I. Kleemann (*Der Satrapen-Sarkophag aus Sidon*, Istanbuler Forschungen, 20 [Berlin, 1958], 65) still reiterated this view. However, Near Eastern art had already developed such patterns.

A splendid example occurs on an ivory goblet from Megiddo, dating to the late second millennium (see G. Loud, *Megiddo Ivories* [Chicago, 1939], pl. 21, no. 124; and C. Decamps de Mertzenfeld, *Inventaire commenté des ivoires phéniciens et apparentés decouverts dans le Proche-Orient* (Paris, 1954), 95, pl. 50, no. 411). It consists of broad S-shaped volutes connected by bindings, very similar to Riegl's figure 85, although the axils between the volutes are outfitted with palmettes rather than lotuses. In the border of an Egyptian tomb painting, A. Prisse d'Avennes, (*Monuments égyptiens, bas-reliefs, peintures, inscriptions* [Paris, 1847], pl. 50—cf. M. Flinders Petrie, *Egyptian Decorative Art* [London, 1895], fig. 119), there is an intermittent tendril connected to lotus blossoms, essentially the same as figure 53, although it has an additional undulating band weaving above and below the lotuses like the later Greek interlacing tendril in figure 84. A Syrian or Phoenician ivory plaque from Nimrud (Mallowan, *Nimrud and Its Remains*, 528, fig. 441) shows that such ornament survived well into the first millennium B.C. in the Near East. This pattern has multiple staggered and superimposed intermittent tendrils with lotus or lily blossoms, arranged as an interlacing all-over pattern. The sort of tendril illustrated in figure 52 also appears in the Nimrud ivories, although in a somewhat simpler and more irregular or natural form (see Mallowan, *Nimrud and Its Remains*, figs. 392–93).

Such Levantine and Egyptian forerunners come far closer to the Orientalizing Greek intermittent tendril of figures 53 and 85–86 than the Mycenaean ivy pattern of figure 52, and it was undoubtedly Near Eastern works of this kind in the first millennium that stimulated the development of the Greek examples. In view of such evidence and the Nimrud ivories cited in the preceding annotation, it is preferable to consider both variants of the tendril in post-Geometric Greek art, intermittent and continuous alike, as borrowings or extensions of Oriental traditions of decorative art, along with the rest of the new patterns that distinguish the Greek repertory of the Orientalizing period.

k. As indicated earlier, this pattern is now understood as a stylized rendering of the ivy vine. It did indeed come to Mycenaean art from an outside culture, that of Crete, where it was well established in the landscapes of palatial wall painting by the beginning of the Late Minoan phase; see the examples from Hagia Triada and Knossos in Hood, *Prehistoric Greece*, figs. 34, 50a, and Demargne, *Birth of Greek Art*, fig. 198.

l. For the Orchomenos ceiling and its relation to other works, see Kantor, *Aegean and Orient*, 25–26, pl. 2; and Hood, *Prehistoric Greece*, 76–77, fig. 58a–b. For the analysis of such spiral network ornament in Mycenaean minor arts, see Karo, *Schachtgräber von Mykenai*, 272–80.

m. Virtually the same pattern as that in figure 57 occurs on an ivory border found in the House of the Sphinx at Mycenae (J. C. Poursat, *Les ivoires mycéniens*. *Essai sur la formation de l'art mycénien*, Bibliothèque des Ecoles d'Athènes et de Rome, fasc. 230 [Paris, 1977], 46–47, pl. 13, 145/7750). The details of the floral axil fillers on this ivory are actually closer to those of the ceiling from Orchomenos.

n. For figure 54 see Karo, *Schachtgräber von Mykenai*, 51, no. 50, pl. 26. Riegl was right to associate such stylized blossoms with Egyptian art, although the connection probably came about via Minoan intermediaries. The basic three-petaled form of figures 54, 55, and 57 is traceable to the sepals of the lotus stylization. In figure 54 felines have displaced the usual intervening petals. The more elaborate versions set amidst the spiral patterns from Orchomenos and Tiryns, however, suggest a connection with the papyrus as well. This papyrus quality emerges more clearly in the related flowers on Late Minoan Palace Style vases; cf. Demargne, *Birth of Greek Art*, figs. 203–4. Furumark (*Mycenaean Pottery*, 263–64; fig. 33, nos. 23–30) identifies the flowers of this kind in Mycenaean ceramics as papyrus derivatives, based upon Minoan precedents ultimately of Egyptian inspiration. Möbius (*Jahrbuch des Deutschen Archäologischen Instituts* 48 [1933]: 17–20) had earlier suggested an Egyptian derivation for Minoan papyrus stylizations. Recalling that Egyptian art had already conflated the papyrus and the lotus, the hybrid aspect of the Minoan and Mycenaean counterparts is not surprising.

Riegl considered not only the flowers of figures 55 and 57 but also their application within overall spiral patterns as a borrowing from Egyptian art. Today scholars have no doubts about the relationship between these Mycenaean examples and the Egyptian versions as seen in figures 25, 26, 56 (see Smith, *Interconnections*, 80, 156). Like Riegl, Evans (*Palace of Minos*, 2: 1, 202–7), also took the Cretan and mainland Greek examples of this kind to be adaptations of Egyptian fashion. Kantor (*Aegean and Orient*, 26) disputes this; she sees the Aegean as the home of such decoration. Elaborate spiral patterns themselves are clearly a native phenomenon, long-attested in Aegean art, and the Aegean may well have stimulated the development of pure spiral ornament in Egypt from time to time, as Kantor and others have argued (see annotation *r* just below). Even the basic principle of elaborating spiral networks with simple floral axil fillers is attested best and earliest in Crete.

The inclusion of complex floral stylizations in such patterns, however, may well be another matter. The flowers themselves are Nilotic, and they reflect stylistic details and a formal conflation of lotus and papyrus elements that were already established in Egyptian art. It may well have been the Egyptians who first elaborated the Aegean concept of plain spiral or simpler floralized spiral patterns with their own native lotus or papyrus stylizations, a trend that soon spread to Crete and mainland Greece, using the existing local adaptations Egyptian floral motifs. The examples from Tiryns and Orchomenos are Late Helladic III; such Aegean ornament cannot be shown to be earlier than Eighteenth-Dynasty Egyptian counterparts (figs. 25–26, 56).

o. For zoomorphic patterns of this kind in Mycenaean pottery and their evolution from earlier Minoan precedents, see Furumark, *Mycenaean Pottery*, 145–47, 302–5, figs. 48–49. The examples to which Riegl refers are early Mycenaean and come from the shaft graves at Mycenae. For such motifs see M. A. Gill, "Some Observations on Representations of Marine Animals in Minoan Art and their Identification," in *Iconographie minoenne*, Bulletin de correspondence hellénique, suppl. 11 (Paris 1985): 63–81; and in the same volume, R. Laffineur, "Iconographie minoenne et iconographie mycénienne à l'époque des tombes à fosse," esp. 252–55, 259. For such patterns as well as figure 58, also see Karo, *Schachtgräber von Mykenai*, 44, no. 6; 303–5, pls. 26–28, 34; and Hood, *Prehistoric Greece*, 203–5, figs. 203–5.

p. Figure 59, from a shaft grave at Mycenae, is not wood, as Riegl's text originally stated, but ivory, and it has been amended accordingly (see Poursat, *Les ivoires mycéniens*, 8, pl. 1, 3/1002; cf. another example from chamber tomb 88 at Mycenae, ibid., 98–99, pl. 33, 313/3210).

q. The sequence of discontinuous interlocking S-shaped lines or so-called running-dog pattern in the middle of figure 63 is actually the border decoration of an altar depicted on this portion of the vessel. See Karo, *Schachtgräber von Mykenai*, 94–5, no. 390, pls. 112–13, for discussion and photographs made after the incrustation was properly cleaned.

Contrary to the evidence available when Riegl wrote, the rectilinear meander and fretwork patterns were actually not unknown in Aegean art. They already appear on Early Minoan seals and Early Helladic seal impressions like those from Lerna, and in a late Middle Minoan fresco at Knossos (see Kantor, *Aegean and Orient*, pls. 4c, 10a–c, and M. C. Heath, "Early Helladic Clay Sealings from the House of Tiles at Lerna," *Hesperia* 35 [1966], pl. 21, nos. S25, S32, S34). They occur on Late Mycenaean ivories from Pylos (Poursat, *Ivoires mycéniens*, 127, and pl. 40, nos. 384/7832–385/7833); a sword hilt from the shaft graves at Mycenae (Karo, *Schachtgräber von Mykenai*, 103, no. 435, pl. 87, and Hood, *Prehistoric Greece*, fig. 175c); and in Late Mycenaean vase painting (J. N. Coldstream, *Kythera. Excavations and Studies Conducted by the British School at Athens* [Park Ridge, N.J., 1973], pl. 38, no. 73). On the less common Mycenaean forerunners of later Greek meander ornament, also see N. Himmelmann-Wildschutz, "Der Mäander auf geometrischen Gefässen," *Marburger Winckelmann-Programm* (1962): 1–43, esp. 24 and n. 70.

Yet Riegl was right in emphasizing the Mycenaean (and ultimately Minoan) preference for curvilinear forms of the meander like those of figures 61–62. He was also correct in arguing for the fundamental unity between such undulating curvilinear patterns and spiral ornament. The essential difference between them lies in the relative degree of convolution and the resulting circular masses of the volutes in spiral patterns; cf. figure 60 as opposed to figures 61–62. On the ornament of figure 60 see Karo, *Schachtgräber von Mykenai*, 122, no. 625, 279, figs. 121–23, pl. 55. For figures 61–62, ibid., 46, no. 16; 169, no. 1430, pls. 8, 29.

On present evidence, the curvilinear meander ornament of figures 61–62 was originally an Aegean phenomenon. Circular or radial examples ancestral to figure 61 occur in the Early Helladic seal impressions from Lerna; see *Hesperia* 35 (1966), pl. 20, nos. S3–S9, pl. 20, no. S19. These are radial variants of the elongated pattern in figure 62. This type of ornament also figures prominently in Palace Style and Kamares-ware vase painting of Middle Minoan times (C. Zervos, *L'art de la Crète néolithique et minoenne* [Paris, 1956], figs. 326, 328, 339; cf. P. Betancourt, *The History of Minoan Pottery* [Princeton, N.J., 1985], figs. 70k, 85a). By the Middle Kingdom simple patterns of this type had become current in Egypt on scarabs (F. S. Matouk, *Corpus du scarabée égyptien*, vol. 1, (Beirut, 1971), 178, nos. 59, 61–63). The many variations of this type of ornament according to different types of symmetry, and the addition of small discs or "eyes," as in the finds of the shaft graves at Mycenae, may be a Late Bronze Age elaboration, possibly centered on the Greek mainland. During this period, such patterns also spread to western Asia. At Alalakh they appear on imported Mycenaean painted ceramic and carved ivory objects identical in style to the metalwork and ivory examples from the shaft graves (L. Woolley, *Alalakh, an Account of the Excavations at Tell Atchana, 1937–1949* [Oxford, 1955], 290, and pl. 77, nos. 38/275, pl. 127.

At the same time, the curvilinear meander also became widely current in Bronze Age Europe, as a result of trade connections with the Mycenaean south. On the broader issue of such connections see annotation *d* for chapter 1, above. For curvilinear meander patterns in central and northern Europe see N. K. Sandars, *Prehistoric Art* (Harmondsworth, 1968), 180–81; S. Piggot, *Ancient Europe from the Beginnings of Agriculture to Classical Antiquity* (Chicago, 1965), 134–37;

T.G.E. Powell, *Prehistoric Art* (New York and Toronto, 1966), 130–37; E. Aner, "Das Grab von Oster Velling, zur Geschichte einer Ornaments," in E. Klaus, W. Haarnagel, and K. Raddatz, eds., *Studien zur europäischen Vor- und Frühgeschichte* (Neumunster, 1968), 377ff.; and J. Vladár, "Osteuopäische und mediterrane Einflusse im Gebiet der Slowakei während der Bronzezeit," *Slovenská Archeológia* 31, 2 (1973): 243–357. The most recent review of the problem by A. F. Harding, *The Mycenaeans and Europe* (London, Orlando, Fla., 1984), 189–209, remains skeptical. Nevertheless the analogies between the Mycenaean and central or northern European works of this kind are quite detailed and specific, involving not only the patterns themselves but even the types of object and the way that they are applied to the object. As such they cannot be fortuitous. With the exception of Karo (*Schachtgräber von Mykenai*, 267–72) specialists in Aegean and Near Eastern art have shown little interest in the classification or analysis of curvilinear meander ornament. The best studies to date are those by the experts on the central and northern European material; see especially the article by E. Aner, cited above, and J. Dezort, "Styky Moravy jihovychodem v dobe bronzové," *Obzor Prehistoriky* 13 (1946): 57–63.

r. There can, of course, no longer be any question of the cultural inferiority of Aegean civilization with respect to that of Egypt, although one should bear in mind that the cultures of Bronze Age Crete and Greece were still barely known when Riegl wrote *Stilfragen*. In the eastern Mediterranean at least, spiral ornament already appears to have attained a highly advanced level of development by the third millennium that cannot be paralleled in western Asia or Egypt at this time. It is likely that the Aegean continued to lead in the development of spiral ornament down into the Late Bronze Age, when such ornament became more popular in western Asia and especially in Egypt. See Kantor, *Aegean and Orient*, 21–27, with extensive earlier bibliography; Smith, *Interconnections*, 18, 40, 44; and F. Matz, *Die frühkretische Siegel* (Berlin and Leipzig, 1928), 178; idem, "Zur Frühgeschichte der Spirale. Eine aigaiische-anatolische Siegelstudie," in *Mansel'e Armagan. Mélanges Mansel*, (Ankara, 1974), 171–83; and Matz's contribution to the *Cambridge Ancient History*, 3d. ed., vol. 2, part 1, (Cambridge, 1973), ch. 4(b), pp. 159, 163. The ultimate origin of spiral ornament current in western Asia, the eastern Mediterranean, and Europe during the earlier Bronze Age, Chalcolithic, and Neolithic periods is still debated. For the most recent survey of opinion, see B. Otto, *Geometrische Ornament auf anatolischer Keramik. Symmetrien frühester Schmuckformen im Nahen Osten und in der Ägäis* (Mainz, 1976), 169–86.

s. For figures 64–65, see Karo, *Schachtgräber von Mykenai*, 47, no. 22; 77, no. 271, pls. 15, 67.

t. As indicated earlier, Riegl's knowledge of Assyrian culture was essentially limited to Layard's discoveries of the Neo-Assyrian phases at Nineveh and Nimrud some four decades earlier. The German excavations at Assur (Qalat Shergat) only began at the beginning of this century, but they soon demonstrated that Assyrian palatial and religious architecture and decoration were already well developed by the later second millennium. Nevertheless, Middle Assyrian palace decorations like the wall paintings of Tukulti Ninurta I are too rare and fragmentary for it to be certain that they had already achieved the more structured relation of pattern to frame or border that Riegl considered so important. But at various points there are in fact diagonally-oriented floral motifs at the corners of the patterns, foreshadowing the treatement of the corner lotuses in the Neo-Assyrian doorsill of figure 34. The best illustrations of the paintings are those originally published by W. Andrae, *Farbige Keramik aus Assur* (Berlin, 1923), pl. 3, but see as well the reproduction in Smith, *Interconnections*, fig. 145, upper right and center.

u. For the "Warrior Vase" from Mycenae see Demargne, *Birth of Greek Art*, fig. 331. For the niello cup with human heads see *Archaiologike Ephemeris* (1888): 159, pl. 7, no. 2; S. Marinatos and M. Hirmer, *Crete and Mycenae* (London, 1960), pl. 196, top; cf. the fragmentary niello vessel with similar decoration from Pylos, Hood, *Prehistoric Greece*, 168–70, fig. 164B.

v. Also see Riegl's later discussion of the Vapheio cups, "Zur kunsthistorischen Stellung der Becher von Vafio," *Jahreshefte des Oesterreichischen Archäologischen Instituts* 9 (1906): 1–19. In the light of the many examples of this theme that have accumulated in Bronze Age Aegean painting and sculpture since Riegl wrote, it is clear that Minoan and Mycenaean representations of bull taming and leaping are not simply genre scenes. Already by the beginning of this century, A. Riechel ("Die Stierspiele in der kretisch und mykenischen Kultur," *Athenische Mitteilungen* 34 [1909]: 85–99), had begun to investigate the cultural significance of such events or games and their representation in art; the later study by O. Lendle, "Die kretische Stiersprungspiel," *Marburger Winckelmann-Programm* (1962): 30–37, treats such scenes as acrobatic sport. On the formal or physical aspects of these events as they appear in art also consult J. G. Younger, "Bronze Age Representations of Aegean Bull-Leaping," *American Journal of Archaeology* 80 (1976): 125–37. For a recent evaluation of the types of scene on the cups and the dagger blades, see E. Davis, "The Vapheio Cups: One Minoan and One Mycenaean," *Art Bulletin* 56 (1974): 473–87.

w. For such Cypriote pottery (Cypro-Archaic I), see V. Karageorghis, "Some Cypriote Painters of Bulls in the Archaic Period," *Jahrbuch des Deutschen Archäologischen Instituts* 80 (1965): 1–17, figs. 1–14; idem, *The Ancient Civilization of Cyprus* (New York, 1969), figs. 104–6, 108–10; idem, *Ancient Cyprus. Seven Thousand Years of Art and Archaeology* (Baton Rouge and London, 1981), 139–41, nos. 105–7; T. Spiteris, *The Art of Cyprus* (London, 1970), ills. pp. 108–23; and especially V. Karageorghis and J. des Gagniers, *La céramique chypriote de style figuré. Age du fer (1050–500 Av. J.-C.)*, suppl. (Rome 1978).

CHAPTER 3. B. 2. GREEK—THE DIPYLON STYLE

a. As indicated earlier, the transition from Late Mycenaean to Geometric styles of ceramic decoration no longer appears as an absolute break or discontinuity but rather as an acceleration of the tendencies toward abstraction and simplification already quite advanced by the Late Mycenaean IIIB and C phases; cf. B. Schweitzer, *Greek Geometric Art* (London, 1971), 26. The most significant change was the abandonment, at least temporarily, of human and animal forms, although this is already evident in many Late Mycenaean vases like those of the "Close Style." The so-called Dipylon Style—Attic Geometric of the later eighth century B.C.—represents the culmination of a long development, connected ultimately to the Sub-Mycenaean and Proto-Geometric phases of the eleventh and tenth centuries. On this continuity see annotations *i* and *q* for chapter 1. On the the return of the human figure and degree of sophistication in Attic Late Geometric vase painting, see annotation *t* for chapter 1.

Pace Riegl, the use of painted registers to divide the surface of the vessel into different zones is one of the clearest and most important survivals from Late Mycenaean ceramic traditions. It is well represented in the Late Mycenaean III phase, H.-G. Buchholz and V. Karageorghis, *Prehistoric Greece and Cyprus* (London, 1973), nos. 1620, 1623–30, 1633–39, 1646–48. See V. R. Desborough, *The Last Mycenaeans and Their Successors. An Archaeological Survey ca. 1200–ca. 1000 B.C.* (Oxford, 1964), pls. 1–4, 8, 10, 14, for a complete sequence demonstrating

the continuity of the register system from the Mycenaean "Close" or "Granary Style" into Sub-Mycenaean works. Also see Schweitzer, *Greek Geometric Art*, pls. 4–7, for a similar comparison between Late Mycenaean and Proto-Geometric examples.

b. The earlier Mycenaean or Minoan works that Riegl used to illustrate his discussion in chapter 3B.1 do not generally display the "horror vacui" of the Dipylon Style. But by the Late Mycenaean III B and C phases, geometric space fillers had become fairly common in the stylized figural depictions of painted vases; see Buchholz and Karageorghis, *Prehistoric Greece and Cyprus*, no. 1620; and V. Karageorghis, *The Civilization of Prehistoric Cyprus* (Athens, 1970), pls. 128–29. Even the vase from which Riegl's figure 49 was excerpted already had such space fillers surrounding the stylized ivy tendril, although they were originally cropped out in his original illustration; see A. Furtwängler and G. Loeschke, *Mykenische Thongefässe. Festschrift zu fünfzigjährigen Bestehens des Deutschen Archäologischen Instituts in Rom* (Berlin, 1879), pl. 2. For examples of such filling in the Dipylon Style, see Schweitzer, *Greek Geometric Art*, pls. 35–37, 40–41.

c. The influence of Egypt and the Near East has also been suggested more recently as a factor in the trend toward figural depiction in Late Geometric vase painting; see the studies by Ahlberg, Benson, and Carter cited in annotation *t* for chapter 1.

d. The use of geometric space fillers on vases of the Orientalizing period undoubtedly continues the practices of Geometric predecessors; for a recent study of these fillers in the vase painting of the eighth and seventh centuries B.C., see B. Fellmann, "Zur Deutung der frühgriechische Körperornamente," *Jahrbuch des Deutschen Archäologischen Instituts* 93 (1978): 1–29.

e. Today, following the researches of Desborough, the Geometric Style is regarded as an initially Attic development during the Proto-Geometric phase. From Attica, the Proto-Geometric style spread to the neighboring regions on the mainland and then eastward to Crete and the Aegean islands, and to the Greek colonies of Asia Minor. Attic influence gave way to local variation after about 900 B.C., but it began to affect the ceramic development throughout the Greek regions again in the later ninth century. See J. N. Coldstream, *Greek Geometric Pottery. A Survey of Ten Local Styles and Their Chronology* (London, 1968): 335–46. B. Schweitzer ("Untersuchungen zur Chronologie und Geschichte der geometrischen Stile," *Athenische Mitteilungen* 43 [1918]: 79) had already suggested the sort of pattern of diffusion that Coldstream's study now confirms.

f. The notion of a conscious artistic striving for discipline and organization has remained a a significant issue in the appraisal of Greek Geometric art and its motivations; see, for example, F. Matz, *Geschichte der griechischen Kunst*, vol. 1 (Frankfurt, 1950), 37–101, esp. 44–67, 96–101; Schweitzer, *Greek Geometric Art*, 78; H. Marwitz, "Kreis und Figur in der attisch-geometrischen Vasenmalerei," *Jahrbuch des Deutschen Archäologischen Instituts*, 74 (1959): 59–64; N. Himmelmann-Wildschutz, "Der Mäander auf geometrischen Gefässen," *Marburger Winckelmann-Programm* (1962): 1–43, esp. 11–12; and most recently, B. Schmaltz, "Volumen und Schwerkraft in der Kunst der geometrischen Zeit," *Marburger Winckelmann-Programm* (1980): 3–36.

g. In Riegl's day, the trend toward a purely geometric art in the latest phases of Mycenaean culture was not yet known or documented by archaeological research. Thus, the apparent disparity between earlier Mycenaean and Geometric art proper was explained by ascribing the latter to a disruption in the population, i.e., to the arrival of different peoples (the Dorians) who were eventually assimilated by the indigenous Mycenaeans. Such a model seemed to explain both the rise of a

new geometric style as well as the continued usage of its most prominent motifs like the rectilinear meander in post-Geometric art, when the older native preference for floral motifs supposedly reasserted itself. Now it is clear that the people who produced the latest phases of Mycenaean culture in Attica and those who first created the Geometric Style were largely one and the same. The relative stability and continuity of the population, culture, and technology of Attica during the last two centuries of the second millennium B.C. were instrumental in the rise of Proto-Geometric art and the leading role that Athens continued to play in its subsequent diffusion and development (see Schweitzer, *Greek Geometric Art*, 24, and A. M. Snodgrass, *The Dark Age of Greece* [Edinburgh, 1971], 43–94). What this continuity cannot explain, however, is the resurgence of vegetal ornament in the Greek art of the late eighth and seventh centuries, since such decoration had entirely dropped out of the artistic repertory from the Sub-Mycenaean period onward.

CHAPTER 3. B. 3. GREEK—MELIAN

a. This class of Orientalizing Greek vases is certainly of Cycladic origin, although the precise locale of their manufacture is sometimes disputed (P. E. Arias and M. Hirmer, *A History of One Thousand Years of Greek Vase Painting* [New York, 1962], 278, pl. 22). For the problems of classification and decoration see C. Dugas, *La céramique des Cyclades* (Paris, 1925); H. G. Payne, "Cycladic Vase Painting of the Seventh Century," *Journal of Hellenic Studies* 46 (1926): 203–12; P. Bocci, *Ricerche sulla ceramica cicladica*, Seminario di archeologia e di storia dell'arte greca e romana dell'Università di Roma. Studi miscellanei, 2 (1959–1960); and most recently, D. Papastamos, *Melische Amphoren*, Orbis Antiquus, 25 (Münster Westfalen, 1970), who supports the origin on Melos. On Riegl's figure 66 see Arias and Hirmer, *One Thousand Years of Greek Vase Painting*, pl. 23, bottom; Papastamos, *Melische Amphoren*, pls. 4–5. C. Vogelpohl (in *Zur Ornamentik der griechischen Vasen des siebenten Jahrhunderts* [Ph.D. diss., Ludwig-Maximilians-Universität zu München, 1972], 28–62) has extensively studied the ornament of Cycladic Orientalizing vases in general; for the Melian types, see 50ff. Unfortunately, Vogelpohl's work is unillustrated.

b. In Orientalizing Cycladic, Melian, and Attic vase painting generally, the borrowed Egyptian or Oriental floral motifs were consistently transformed according to a process of linear reduction in which the broader bands and petal volutes of the prototypes became the sinuous and highly involuted spirals that appear all across figure 66. In this case, the forms between the legs of the horses would be adaptations of Riegl's Egyptian palmette with a volute-calyx beneath it, as in figures 16 or 21, with the petals now schematized as a simple pair of spirals. However, the Greek pattern only depended indirectly on Egyptian forms; the immediate source was probably Syrian or Phoenician minor arts decorated with such ornament; cf. R. D. Barnett, *A Catalogue of the Nimrud Ivories with Other Examples of Ancient Near Eastern Ivories in the British Museum* (London, 1957), pl. 8, A3; pl. 40, S129; pl. 55, S108. Dugas (*Céramique des Cyclades*, 206–7) and Papastamos (*Melische Amphoren*, 101) suggest a Mycenaean derivation for the spiral elements on these vases.

c. As indicated previously, the concept of unifying lotuses as the blossoms of an undulating reverse tendril appears in a somewhat more irregular form on the ivory plaques of the Syrian bedhead from Nimrud, and in earlier Egyptian wall paintings (see annotation *j* for chapter 3B.1 above). The individual lotus stylizations of the pattern along the shoulder of figure 66 (i.e., fig. 53) depend upon Egyptianizing

Syrian or Phoenician precedents like that on another ivory from Nimrud (Barnett, *Nimrud Ivories*, pl. 3, C4). The Nimrud example displays the same horizontal linear division of the flower into upper and lower zones, as a reduction of the sepals of the original Egyptian form.

The large pair of lotuses on the neck of figure 66 find their closest parallels in Egyptian art itself—a tomb painting from Beni-Hassan, where the outline of the flower and the row of tiny pointed petals are nearly identical (W. G. Goodyear, *The Grammar of the Lotus. A New History of Classic Ornament As a Development of Sun Worship* (London, 1891), pl. 45, no. 5). The large surrounding spiral volutes, however, are an Orientalizing Greek addition or elaboration, and very likely independent of Egyptian or Aegean patterns like those of figures 26–27. On the neck ornament of this vase, also see Papastamos, *Melische Amphoren*, 92–96, figs. 3–4; 104–5, fig. 6. On Melian lotus patterns, see Vogelpohl, *Ornamentik griechischer Vasen*, 61–62.

d. The pattern in figure 67 (from sides of the neck on fig. 66) is certainly not a Melian invention, but it is not derived primarily from the floralized spiral patterns of Bronze Age Egyptian and Mycenaean art either. Patterns like figure 67 already appear in rudimentary form on early or transitional Proto-Corinthian vase painting of the late eighth or early seventh century (K. Friis Johansen, *Les vases sicyoniens* [Copenhagen, 1923; reprint Rome, 1966], 59, fig. 36; H. G. Payne, *Protokorinthische Vasenmalerei* [Berlin, 1933; reprint Mainz, 1974], pl. 9, nos. 3–4; and Vogelpohl, *Ornamentik der griechischen Vasen*, 64–65). They also appear in Orientalizing Boeotian and Cretan vase painting (D. Levi, "Arkhades. Una città cretese all'alba della civiltà ellenica," *Annuario della Scuola Archeologica di Atene e delle Missione Italiano in Oriente* 10–12 [1927–1929]: 119, fig. 98; E. Kunze, *Kretische Bronzereliefs* [Stuttgart, 1931], 148, fig. 22 a–b); and as attributes of the Mother Goddess on a Cretan Orientalizing vase from Arkhades (Levi, *Annuario della Scuola Archeologica di Atene* 10–12 [1927–1929], 330, fig. 437; P. Demargne, *The Birth of Greek Art* [New York, 1964], fig. 444; and P. Blome, *Die figürliche Bildwelt Kretas in der geometrischen und früharchaischen Periode* [Mainz, 1982], pl. 19, no. 1). These examples show that the pattern is based on the voluted sacred tree of Phoenician and Syrian art, especially as it appears on certain ivory plaques from Samaria; cf. J. M. Crowfoot, *Early Ivories from Samaria*, Samaria: Sebaste Reports of the Work of the Joint Expedition in 1931–1933 and of the British Expedition in 1935, no. 2 (London, 1938), pl. 21, nos. 4–5.

The Greek versions of such ornament, however, were also influenced by the Near Eastern guilloche, plain and floralized, of the sort ancestral to Riegl's figure 68. For examples of this kind see L. J. Delaporte, *Catalogue des cylindres, cachets, et pierres gravées de style oriental*, Musée du Louvre (Paris, 1920–1932), pl. 100, 4b; and W. A. Ward, *The Seal Cylinders of Western Asia* (Washington, D.C., 1910), 274, fig. 827. For patterns related to figure 67 in contemporary Greek relief ceramic and metalwork, see J. Boardman, *Pre-Classical. From Crete to Archaic Greece* (Harmondsworth, 1967), fig. 534, and H. V. Herrmann, "Bronze Beschlage mit Ornament," in E. Kunze and F. Winter, *VI Bericht über die Ausgrabungen in Olympia 1953/54–1954/55* (Berlin, 1958), esp. pls. 56–57, 61–62.

e. This pattern, consisting of a lateral series of C-shaped volutes with palmette fillers, is a variant of the "enclosed palmette." The basic motif was not derived from the Phoenician palmette (fig. 42) as von Sybel suggested, since the structure is different in a significant way. In the Phoenician type the palmette grows outward from the interior of the surrounding volute; the enclosed palmette, in contrast, grows inward from the axil between the volutes, filling the interior space (cf. figs.

66 and 78). However, the enclosed palmette was not a Greek creation, as Riegl maintained; it already existed as an islolated motif in Neo-Assyrian art; cf. Barnett, *Nimrud Ivories*, pl. 120, T16.

The solution of extending the enclosed palmette laterally as a frieze is attested in Proto-Corinthian and Early Attic as well as Melian vase painting in the period approaching the mid seventh century; see Friis Johansen, *Vases sicyoniens*, pl. 27, no. 1; H. Payne, *Necrocorinthia. A Study of Corinthian Art in the Archaic Period* (Oxford, 1931), pl. 2; idem, *Protokorinthische Vasenmalerei*, pl. 20, no. 5; S. P. Morris, *The Black and White Style. Athens and Aigina in the Orientalizing Period* (New Haven, Conn. and London, 1984), pl. 20. It also appears as an elaborate, extended pattern on the garment of the seated female statue from Gortyn (J. Boardman, *Greek Sculpture. The Archaic Period* [New York and Toronto, 1978], fig. 30; and Blome, *Die figürliche Bildwelt Kretas*, pl. 19, no. 3). Although as Riegl argued, the enclosed palmette was a form distinct from the so-called Phoenician palmette of figure 42, extended versions or friezes of the latter motif in Phoenician art may have prompted Greek artists to treat the enclosed palmette of Assyrian type in the same manner. For Phoenician palmette and volute friezes of this kind, see Crowfoot, *Early Ivories from Samaria*, pl. 2, no. 2.

f. The most recent and comprehensive study on these works is R. M. Cook, *Clazomenian Sarcophagi* (Mainz, 1981). See pls. 7, no. 1; 18, no. 1; 25, no. 2; 47, nos. 2–3; 51, no. 2, for examples with the border illustrated in figure 68. For the immediate Near Eastern precedents behind figure 68, see Delaporte, *Catalogue des cylindres, cachets etc*. pl. 100, 4b, and Ward, *Seal Cylinders of Western Asia*, fig. 827.

g. The pattern in the border immediately below the horses on figure 66 is a variant of the intermittent tendril, but one extended by repeated inverse symmetry (180-degree rotation), rather than the symmetry of repeated reflection used in the examples of figures 53 or 85. So far, only the reflected type of intermittent tendril can be paralleled in the Near East; the inverse type may therefore be a Greek adaptation, and one that may well have been inspired by spiral patterns with floral accessories like those in figure 25. But it is distinguished from such forerunners by the use of distinct, separate volutes that remain tangent or proximate instead of running together to form a single tighter volute (cf. figs 25 and 66). The pattern on the Mycenaean grave stele cited by Riegl in note 64 as a prototype for the inversely symmetrical intermittent tendril is neither a spiral nor a tendril pattern in the true sense but a slightly tendrilized variant of the curvilinear meander as seen in figure 61. For a clearer illustration of this stele, see S. Hood, *The Arts in Prehistoric Greece* (Harmondsworth, 1978), fig. 81.

h. Since Riegl's study, others have also suggested that aspects of the floral ornament on Orientalizing Melian vases somehow derived from Mycenaean forerunners (see Dugas, *Céramique des Cyclades*, 198–99, 206–7, and Papastamos, *Melische Amphoren*, 101). The decided emphasis on spiral ornament that Riegl's analysis of the Melian vases disclosed is indeed reminiscent of Aegean Bronze Age decoration, but spiral ornament only begins to reappear in Greek art in transitional Late Geometric vase painting in various regions, preceding the Orientalizing phase proper (cf. Friis Johansen, *Vases sicyoniens*, pls. 1–3). This resurgence is difficult to explain. The spiral is entirely absent in vase painting and other minor arts of Greece in the Early and Middle Geometric periods, and it cannot even be attested as a survival from Mycenaean times in Crete and Cyprus, as Kunze (*Kretische Bronzereliefs*, 134), had indicated. Nor can it have been borrowed from the Near East during the early first millennium, where it is also unknown (Kunze, *Kretische Bronzereliefs*).

Unless one is prepared to assume that spiral patterns were entirely reinvented by Greek artists during the later eighth century B.C., the only explanation is a conscious revival, perhaps based on the remains of monumental and small-scale Minoan or Mycenaean decoration that was still accessible in Greece or Crete in Late Geometric times, when there was a marked upswing in the concern with ancient or Bronze Age traditions (on the latter point see J. L. Benson, *Horse, Bird, and Man. The Origins of Greek Painting* [Amherst, Mass., 1970], 83–88, 108–23). There is, in fact, archaeological evidence for physical contact with Bronze Age remains in the first millennium, as Benson (ibid., 109, 115, 121), and A.T.M. Snodgrass *The Dark Age of Greece* [Edinburgh, 1971], 394 ff.), have noted. Geometric objects have been found as later offerings in Mycenaean tombs side by side with Bronze Age artifacts, and through such contacts the Greeks of the Late Geometric period may actually have encountered Late Mycenaean vase painting or metalwork. This might explain not only the revival of spiral ornament but also the striking analogies in the use of space fillers and stylized plants between the legs of human and animal figures in Late Mycenaean, Late Geometric, and Orientalizing Greek vase painting; cf. Riegl's figure 66 and Demargne, *Birth of Greek Art*, figs. 349, 355. However, Kunze (*Kretische Bronzereliefs*, 133–52), has also demonstrated the connection of such "space-filling plants" in Orientalizing Greek art with earlier Near Eastern traditions.

CHAPTER 3. B. 4. GREEK—RHODIAN

a. The Rhodian origin of the class of Greek ceramic illustrated in figures 70–75 and 78 is no longer in any doubt. The standard work on Rhodian pottery of the seventh century is W. Schiering, *Werkstätten orientalisierender Keramik auf Rhodos* (Berlin, 1957). For the related ornament on the terra-cotta sarcophagi, which are a century or more later than the vases illustrated in this chapter, see R. M. Cook, *Clazomenian Sarcophagi* (Mainz, 1981), esp. 80–96. The proximity of Rhodes to the Near East was very likely a factor in the pronounced Oriental character of this style, but on the whole, the Rhodian material is a later development within the Orientalizing process, only gaining momentum toward the middle of the seventh century (Schiering, *Werkstätten*, 8–12), well after the Proto-Corinthian and Proto-Attic styles were under way on the mainland. The earliest Orientalizing Rhodian works reflect the impact of local Phrygian and North Syrian art. The Phoenician and Assyrian decoration that was so vital for the larger Orientalizing process only exerted an impact on later seventh- and sixth-century Rhodian ceramics (C. P. Kardara, "Oriental Influences on Rhodian Vases," in *Les céramiques de la Grèce de l'Est et leur diffusion à l'Occident* [Paris, 1978], 66–70). Rhodes, therefore, did not play a formative role for the rest of the Greek world in the assimilation of Near Eastern motifs and themes. Also see G. M. Hanfmann, "Ionia: Leader or Follower?" in *Harvard Studies in Classical Philology* 61 (1953): 15–17, and L. V. Kopeikina, "The Orientalizing Style: The Conditions and Characteristics of Its Formation in East Ionian Greece," *Vestnik Drevnej Istorii* no. 1 (1975): 103–16 (Russian with English summary).

b. For the pattern of figure 70 and a photograph of the kind of of object from which it comes, see Schiering, *Werkstätten*, pl. 8, and Beilage 9. Riegl's suggestion of an Assyrian source for this pattern is confirmed by the garment decoration of the king in the reliefs at Nimrud; see H. Frankfort, *The Art and Architecture of the Ancient Orient* (Harmondsworth, 1985), fig. 224, where the volute-palmettes below the sacred tree in the center and on the dagger handles also appear as isolated or independent motifs. By comparison with the Assyrian prototype, the

addition of pointed fillers in the axils of the volutes on the Rhodian pattern is, as Riegl maintained, a Greek elaboration.

c. For Rhodian works with the motif of figure 71, see Schiering, *Werkstätten*, 70, and Beilage 7. This elaborate lotus stylization follows Syrian prototypes like the ivory from Nimrud; R. D. Barnett, *A Catalogue of the Nimrud Ivories with Other Examples of Ancient Near Eastern Ivories in the British Museum* (London, 1957), pl. 53, S122). But here, as in the Melian examples, the Rhodian artist has reduced the petal volutes of the Near Eastern model to linear spirals, in the manner of Bronze Age Aegean lily or papyrus stylizations (cf. A. Furumark, *Mycenaean Pottery*, 2 vols., Acta Instituti Atheniesis Regni Sueciae, ser. 4, no. 22 (Stockholm, 1972), figs. 23–24). Hence Riegl's comment on the Mycenaean treatment of the motif.

d. The lotus with palmette axil fillers is not a Rhodian or Greek conflation of Near Eastern precedents; it already occurs on Phoenician ivories. See J. M. Crowfoot, *Early Ivories from Samaria*, Samaria: Sebaste Reports of the Work of the Joint Expedition in 1931–1933 and of the British Expedition in 1935, no. 2 (London, 1938), pl. 15, no. 4a. The arrangement of the lotuses in figure 72—simply juxtaposing them without a linking series of arcuated bands—has Egyptian precedents; see A. Prisse d'Avennes, *Histoire de l'art égyptien d'après les monuments, depuis les temps les plus reculés jusqu'à la domination romaine* (Paris, 1878–1879), atlas 1, pl. 13, nos. 7, 9, 11; pl. 32, no. 7; and pl. 54, nos. 2, 6, 8, 15; and I. Woldering, *The Art of Egypt. The Time of the Pharaohs* (New York, 1963), pl. 49.

e. For a full view of the type of oinochoe from which figure 73 is taken, see P. E. Arias and M. Hirmer, *One Thousand Years of Greek Vase Painting* (New York, 1962), pl. 26. The Egyptian qualities still show through, but once again the prototype was probably Levantine; see F. Poulsen, *Der Orient und die frühgriechische Kunst* (Leipzig and Berlin, 1912), 89, and K. Friis Johansen, *Vases sicyoniens* [Copenhagen, 1923; reprint, Rome, 1966], 121. The ivory plaques from Samaria show a nearly identical pattern, with the same tripartite treatment of the lotus buds. See Crowfoot, *Early Ivories From Samaria*, pl. 16, nos., 1–2; and Barnett, *Nimrud Ivories*, 100–101. The sepal-less rendering of the lotuses in figure 73 is closely paralleled in the Syrian ivories from Nimrud as well (M.E.L. Mallowan, *Nimrud and Its Remains* [New York, 1966], figs. 395–97). The use of bindings at the ends of the arcuated bands in the Rhodian and Phoenician patterns of this type is not an Egyptian or Levantine feature; it may be a borrowing from contemporary Assyrian arcuated band patterns, as in figures 33, 34, and 38; see E. Kunze, *Kretische Bronzereliefs* (Stuttgart, 1931), 101.

f. One can certainly not agree with Riegl's contention that Assyrian art would have failed to impress the Greeks of the seventh century B.C. But he was right to stress the relatively limited impact of specifically Assyrian floral motifs in the Orientalizing Greek process. Figure 70 is an exception, as is the enclosed palmette of Assyrian derivation. In the main, the Greeks seem to have depended on the floral ornament that was current in the decorative art of the Levant and Syria, and the similarity of Greek works to Egyptian forerunners is largely explicable through the fidelity of such Levantine prototypes to Egyptian and earlier Syrian or Mitannian forms.

g. For the guilloche with simple axil fillers in Rhodian vase painting, see J. Boardman, *Pre-Classical. From Crete to Archaic Greece* (Harmondsworth, 1967), fig. 55. For the Euphorbos plate, see Arias and Hirmer, *One Thousand Years of Greek Vase Painting*, pl. 27, and K. Schefold, *Myth and Legend in Early Greek Art* (New York, 1966), pl. 75. For Klazomenian sarcophagi with "palmettized" guilloche decoration, see figures 68 nd 92, and Cook, *Clazomenian Sarcophagi*, pls. 16

and 18 among others. The concept of elaborating the guilloche in this way is probably of Levantine or Syrian origin. For an Old Syrian example with palmettes, see W. A. Ward, *The Seal Cylinders of Western Asia* (Washington, D.C., 1910), fig. 827. The guilloche with simple or drop-shaped axil fillers is paralleled by a pot from Kahun in Egypt (W. Flinders Petrie, *Egyptian Decorative Art* [London, 1895], 93, fig. 170).

h. The alternating orientation to which Riegl refers is the symmetry of slide reflection. It is a common pattern of alternation in the bifurcation of actual plants or tendrils. It is also the symmetry seen in figures 50, 52, 76, 80, and 82, patterns that, despite their stylization, emulate the natural structure of plant forms. The arrangement of the meander in figure 74 may well have resulted from the impact of tendril or floral ornament, causing the symmetries of rotation and translation customary in meander patterns to be replaced by slide reflection. Nevertheless, figure 71 is a meander pattern, not a tendril.

i. The class of vase illustrated in figure 75 is a later, sixth-century spin-off of the Rhodian development. It is named the "Fikellura Style" in honor of the site (near Kameiros in Rhodes) where it first became known. For an extensive treatment of this type, see R. M. Cook, "Fikellura Pottery," *Annual of the British School at Athens* 34 (1933–1934): 1–98. For other patterns like figure 75 and a discussion of such ornament, see esp. 79–82, figs. 3–4, and pl. 7; and P. Jacobsthal, *Ornamente Griechischer Vasen. Aufnahmen/Beschreibungen und Untersuchung* (Berlin, 1927), pl. 20a.

j. In the past, scholars have linked the decoration of Klazomenian sarcophagi with Rhodian vase painting; see K. Friis Johansen, "Clazomenian Sarcophagi Studies: The Early Sarcophagi," *Acta Archaeologica* (1942): 9–16, 28–30. But the more recent survey by Cook (*Clazomenian Sarcophagi*, 94–95) discounts any direct connection. The sarcophagi were manufactured in Klazomenai, in Ionia, well north of Rhodes, and they are now known to be considerably later, beginning about 530, and more than half dating to the fifth century. Cook maintains that the connections with vase painting would involve the contemporary local fabric of the north Ionian region. He sees textiles as the main sources of their decoration, and to a lesser extent furniture, which could have preserved and transmitted the older repertory of Rhodian vase painting to the makers of the sarcophagi. For the Ionian vase painting of this region see R. M. Cook, "A List of Clazomenian Pottery," *Annual of the British School at Athens* 47 (1952): 123–42.

k. For the patterns of figures 76, 77, 79, 92 on Klazomenian sarcophagi, see Cook, *Clazomenian Sarcophagi*, 89–93, figs. 56–57; and I. Kleemann, *Der Satrapen-sarkophag aus Sidon*. Istanbuler Forschungen, 20 (Berlin, 1958), 61.

l. The intermittent tendril is also difficult to parallel in the later Rhodian derivatives, the Fikellura vases.

m. Although this type of vase was found at Kameiros and elsewhere, it is now considered "Vroulia pottery;" see E. R. Price, "Pottery from Naucratis," *Journal of Hellenic Studies* 44 (1924): 188–89, fig. 14, for an example identical to figure 78.

n. On the origin of the enclosed palmette, see annotation *e* for chapter 3B.3, above. Like contemporary examples in Proto-Corinthian ware, the pattern just above the foot of the amphora in figure 66 is already in its essentials a frieze of enclosed palmettes. Figure 78 has simply increased the prominence of the palmettes themselves, as Riegl indicated. Although Riegl only hints at it here, M. Schede (*Antikes Traufleisten-ornamente* [Strassburg, 1909] 21ff.) later attempted to derive patterns like those in figure 79 from such friezes of enclosed palmettes. Kleemann (*Satrapen-Sarkophag*, 62–63), however, has correctly stressed that it is simply a variant of the arcuated band frieze with lotuses and palmettes. The con-

tinuous contour of the lotus petals and the voluted arcuated bands beneath them may appear to imitate the visual scheme of sequential enclosed palmettes, but the involution of the arcuated bands supporting the palmettes in figure 79 derives from Levantine or Phoenician forerunners. In the friezes on several ivories from Samaria, the linking arcuated bands run smoothly into the voluted petals of lilies above them, which are surmounted in turn by palmettes (Crowfoot, *Early Ivories from Samaria*, pls. 15, no. 9, 16, nos. 3–4). Such patterns were clearly the inspiration for the more involuted treatment of the arcuated band frieze in figure 79. An example on a seventh-century Melian vase (Friis Johansen, *Vases sicyoniens*, fig. 84) illustrates an earlier stage of the Greek version. Archaic Greek patterns of this type were not limited to the painted sarcophagi; they also occur in East Greek architectural sculpture like the Siphnian or Knidian treasuries at Delphi, and in the Caeretan painted hydriae manufactured in Etruria by migrant Ionian craftsmen. See P. Charbonneaux, R. Martin, and F. Villard, *Archaic Greek Art (620–480)* (New York, 1971), figs. 105, 234, 236; Arias and Hirmer, *One Thousand Years of Greek Vase Painting*, pls. 79–80, and 27; and esp. J. M. Hemelrijk, *Caeretan Hydriae* (Mainz, 1984), 96–97, 169–70, pls. 1–7, 10–13, 135–39, 163–68, for a detailed treatment of this particular pattern and its background in East Greece. For the Euphorbos plate and its ornament, see annotation g just above.

o. To judge by the fragments of the wall paintings of Tukulti Ninurta I at Assur, this stage of lotus and palmette frieze had already been achieved in Middle Assyrian art of the late thirteenth century B.C.; see Frankfort, *Ancient Orient*, fig. 152, and W. Stevenson Smith, *Interconnections of the Ancient Near East. A Study of the Relationships between the Arts of Egypt, the Aegean, and Western Asia* (New Haven, Conn., 1965), figs. 143, 145.

CHAPTER 3. B. 5. GREEK—EARLY BOEOTIAN AND EARLY ATTIC

a. The attribution of this pottery to Boeotia by J. Böhlau, in "Böotische Vasen," *Jahrbuch des Deutschen Archäologischen Instituts* 3 (1888), 325–61, has been confirmed by P. N. Ure, in "Boeotian Pottery of the Geometric and Archaic Styles," *Classification des céramiques antiques* 12 (1926), esp. 6–10.

b. Mycenaean or Minoan forerunners of such tendril patterns on the late fifteenth-century-B.C. Palace Style jar from Argos (S. Hood, *The Arts in Prehistoric Greece* [Harmondsworth, 1978], fig. 19a) provide a striking parallel for the Boeotian pattern of figure 80.

c. For these Kabeirian vases also see Ure, *Classification des céramiques antiques* 12 (1926): 19ff.

d. Some scholars, like H. Danthine (*Le palmier-dattier et les arbres sacrés dans l'iconographie de l'Asie occidentale ancienne* [Paris, 1937], have argued strenuously for a fundamental connection between the palmette and the natural analog of the date palm, although the relationship is often obscured by the process of stylization. However, figure 82, and figures 49 and 52 as well, are undoubtedly decorative renderings of ivy tendrils, and Riegl's insistence to the contrary is perhaps one of the clearest examples of the sometimes excessive formalism of his approach.

e. For more recent studies of Early Attic vase painting see K. Kübler, *Altattische Malerei* (Tubingen, 1950); and J. D. Beaezly, *The Development of Attic Black-Figure* (Berkeley, 1951; rev. ed. Berkeley, Los Angeles, and London, 1986), 1–11. Most recently, S. B. Morris (*The Black and White Style. Athens and Aigina in the Orientalizing Period* [New Haven, Conn. and London, 1984]) has reattributed some of the finest works of this kind, like the Cyclops vase from Eleusis, to a

workshop at Aigina inspired by Attic traditions. The vases to which Riegl refers, in J. Böhlau's original publication, "Frühattische Vasen," *Jahrbuch des Deutschen Archäologischen Instituts* 2 (1887): 33–66, are also illustrated in Kübler's more recent study; for Böhlau's pl. 3, see Kübler, *Altattische Malerei*, fig. 4, pl. 10; Böhlau's pl. 4 – Kübler, pl. 12; and Böhlau, pl. 5 – Kübler, pl. 46.

CHAPTER 3. B. 6. GREEK—THE INTERLACING TENDRIL

a. On figure 83, see K. Friis Johansen, *Vases sicyoniens* (Copenhagen, 1923; reprint, Rome, 1966), 127–28, and figure 104. As Johansen also indicated, the pattern on this bowl is identical to the one on the neck of the name vase by the Nessos Painter; cf. K. Kübler, *Altattische Malerei* (Tubingen, 1950), pl. 87; P. E. Arias and M. Hirmer, *One Thousand Years of Greek Vase Painting*, (New York, 1962), pl. 20; J. Boardman, *Athenian Black Figure Vases* (New York, 1974), fig. 5. J. D. Beazley (*Development of Attic Black-Figure* [Berkeley, 1951; rev. ed. Berkeley, Los Angeles, and London, 1986], pl. 11.4) reproduces a louterion by the same painter with a border that is also identical. An earlier example of this pattern, with thicker tendrils and lacking the extra volutes on the palmettes, occurs on an Orientalizing terra-cotta revetment from Crete (F. Halbherr, "Cretan Expedition. Report on the Researches at Praesos," *American Journal of Archaeology* 5 [1901]: 391, fig. 22, and Johansen, *Vases sicyoniens*, 127–28, fig. 105). Johansen saw the Attic patterns like those in figure 83 and the related examples in Proto-Corinthian vase painting as common derivatives of Cretan Orientalizing forerunners.

b. Cf. Friis Johansen (*Vases sicyoniens*, 126–27, fig. 103), who identifies the plaque in Riegl's figure 84 as a Corinthian work that he once again derives from Orientalizing Cretan forerunners, like the relief pithos from Sitia in his fig. 89 on p. 122, which still lacks the additional undulating strands running through the lotuses; cf. D. Levi, "Early Hellenic Pottery on Crete," *Hesperia* 14 (1945): 30–31 and pl. 30, no. 1; idem, "Arkhades. Una città cretese all'alba della civiltà ellenica," *Annuario della Scuola Archeologica di Atene e della Missione Italiana in Oriente* 10–12 (1927–1929): 71, fig. 49. The type of pattern on the Cretan pithos also occurs in Early Attic vase painting, although with more thinly-proportioned interlacing tendrils (Kübler, *Altattische Malerei*, fig. 5). The noninterlacing intermittent tendril on the accompanying bronze plaque in Riegl's figure 85 is probably also Corinthian work related to the similar patterns of earlier Cretan Orientalizing vase decoration; cf. Levi, *Annuario della Scuola Archeologica di Atene* 10–12 (1927–1929): 88 and 192, figs. 63a and 212 from Arkhades.

c. There is indeed evidence that stylized floral ornament was embroidered onto Greek textiles, at least in the later Classical or Hellenistic periods. See annotation *e*, paragraph two, for chapter 3. A. 2, above.

d. H.R.W. Smith ("The Origin of Chalcidian Ware," *University of California Publications in Classical Archaeology* 1, 3 [Berkeley, 1932]: 85–145) and G. Vallet (*Rhégion et Zancle. Histoire, commerce et civilisation des cités chalcidiennes du détroit de Messine* [Paris, 1958], 211–28), have attempted to attribute the production of these vases to Magna Graecia or Etruria, but the standard monograph is still A. Rumpf, *Chalkidische Vasen* (Berlin and Leipzig, 1927). Also see the new study by J. Keck, *Studien zur Rezeption fremder Einflüsse in der chalkidischen Keramik: ein Beitrag zur Lokalisierungsfrage*, Archäologische Studien, 8 (Freiburg, 1988). For Riegl's figure 88 in Vienna, see Rumpf, pl. 71, and another nearly identical at the Asmolean Museum, on pl. 66. This style belongs primarily to the second half of the sixth century. Riegl's explanation of Chalcidian patterns like figure 88 as a sprawling and unrestricted elaboration of the type of border decora-

tion in figures 83–84 is entirely correct, but the process began earlier, in Corinthian and Attic black-figure painting of the early Archaic period. For such precursors, see H. Payne, *Necrocorinthia. A Study of Corinthian Art in the Archaic Period* (Oxford, 1931), 146–53, figs. 53, 57, 59–60; for Attic counterparts by Sophilos and Kleitias, see Boardman, *Attic Black Figure*, figs. 24, 26, 46; and Arias and Hirmer, *One Thousand Years of Greek Vase Painting*, pl. 40.

e. Riegl's criticism of Holwerda has stood the test of subsequent research. The derivation of patterns like figure 83 from interlacing wire jewelry remains unsupported by the evidence. Spiral and floral ornament in openwork technique composed of wires and soldered repoussé plaques certainly existed in Phoenician jewelry like the bracelets and earrings from Aliseda (A. Parrot, M. Chéhab, and S. Moscati, *Les Phéniciens. L'expansion phénicienne. Carthage* [Paris, 1975], figs. 292–94), and it can be found in the tendril decoration of later Greek jewelry as well (*The Search for Alexander. An Exhibition* [Boston, 1980], no. 114, pl. 11). But surprisingly, no interlacing tendril patterns executed in this technique have yet come to light in Near Eastern or early Greek art. Interlace patterns, with and without floral accessories, are common enough in the Near East and Egypt, but in various other media. They appear engraved on scarabs (A. Rowe, *Catalogue of Egyptian Scarabs and Scaraboids, Seals, and Amulets in the Palestine Archaeological Museum* [Cario, 1936], pls. 2–3, nos. 81–88; M. Dunand, *Fouilles de Byblos*, vol. 1 (Paris, 1939), pl. 201, nos. 11772, 11468, 11476; pl. 127, no. 1732; pl. 129, no. 2891; 130, nos. 1420, 1423; vol. 2, pl. 199, no. 7532). They occur in Egyptian wall painting (A. Prisse d'Avennes, *Monuments égyptiens, bas-reliefs, peintures, inscriptions* [Paris, 1847], pl. 50); on Syrian and Anatolian seals (H. Bossert, *Altsyrien* [Tubingen, 1951], no. 828); in relief ceramics, (P. Amiet, *Elam* [Auvers-sur-Oise, 1966], 496, no. 373); and incised and painted on ivories (M.E.L. Mallowan, *Nimrud and Its Remains* [New York, 1966], fig. 441). There is nothing to suggest that any one technique or medium was responsible for such ornament, and the evidence of wire jewelry is especially lacking. This is equally true of the Orientalizing Greek material, where patterns like those in Riegl's figures 83–84 and those cited in annotations *a* and *b* just above turn up simultaneously in painted ceramics, incised ivory, relief metalwork, and terra-cotta reliefs of various scales.

The more extensive body of Greek and Near Eastern material now available enables us to achieve a clearer understanding of the evolution behind such ornament than was possible in Riegl's time. The basic concept of the intermittent tendril with lotuses or palmettes was, as indicated earlier, an Egyptian and Levantine development, but so was the idea of elaborating this scheme as an interlacing pattern. As evidence of this there are the Egyptian wall painting and the Nimrud ivory cited just above. Such prototypes were taken up directly in Orientalizing Greek and Archaic decorative art; cf. the rim border on the Chigi vase (Friis Johansen, *Vases sicyoniens*, 126, fig. 102, and pl. 30, no. 1a; Arias and Hirmer, *One Thousand Years of Greek Vase Painting*, pl. 16), and an Archaic terra-cotta revetment from Rome (A. Andrén, *Architectural Terracottas from Etrusco-Italic Temples* [Lund, 1940], pl. 109. no. 389).

Greek artists, however, were not content simply to imitate the interlacing tendril ornament that they encountered from the Orient; they elaborated and transformed the borrowed types, stimulated by the various forms of pure interlace also inherited from Near Eastern or Egyptian art. This resulted initially in patterns like Friis Johansen's figure 89, which was elaborated further into Riegl's figure 84 by adding the extra undulating bands running through the lotuses. The type of pattern in figure 83 was a parallel development. It evolved out of intermittent tendrils whose voluted terminals were initially transformed into loops running on a bit further into smaller spirals; cf. Friis Johansen, *Vases sicyoniens*, pl. 23, no. 1 d,

and H. G. Payne, *Protokorinthische Vasenmalerei* (Berlin, 1933; reprint, Mainz, 1974), pl. 10, nos. 5–6. From this stage it was a short jump to Riegl's figure 83, or to its immediate antecedents in Corinthian and Orientalizing Cretan art. One had only to connect the ends of the loops to form an undulating band running through the lotuses, analogous to figure 84 but now producing a pattern articulated by a single continuous strand. Whether Greek artists first realized these innovations working in the freer medium of painting, as Riegl suggested here, or in the media of metalwork, terra-cotta, or ivory carving, one can no longer say. But the development was far too complex to be reduced to the experiments of wire-bending jewelers. It involved instead a lively and imaginative response to a repertory of interlacing tendril patterns encountered from a wide range of Oriental decorative crafts.

f. Despite Riegl's objection, the Chalcidian centralized interlacing tendril pattern of figure 88 and the Attic forerunners cited in annotation *d* just above are nevertheless adaptations of the old Near Eastern heraldic theme of the stylized sacred tree flanked by animals or fantastic beings. The Chalcidian examples have lions next to the floral pattern; in the Attic works the flanking creatures are sirens and sphinxes. A Greek bronze relief plaque from Olympia follows the ancient Near Eastern formula more faithfully, see E. Kunze, "Schildbeschlage," in *VI Bericht über die Ausgrabungen in Olympia*, (Berlin, 1958): 92–94, pl. 23. It is especially close to the versions of this heraldic theme on the North Syrian bronze relief cauldron stands imported into Greece and Etruria (H. V. Herrmann, *Die Kessel der Orientalisierende Zeit*, Olympische Forschungen 6 [Berlin, 1966], pls. 71, 74). The Attic and Chalcidian patterns have simply replaced the sacred tree with a centralized interlacing tendril composition. This is not surprising, since interlacing variants of the Near Eastern sacred tree had already appeared on early Orientalizing Greek works like the Proto-Corinthian pyxides from Samos and Cumae; see Friis Johansen, 60, fig. 41; Payne, *Protokorinthische Vasenmalerei*, pl. 8, no. 1; J. Boardman, *Pre-Classical. From Crete to Archaic Greece* (Harmondsworth, 1967), fig. 41; and C. Vogelpohl, "Zur Ornamentik der griechischen Vasen des Siebenten Jahrhunderts," (Ph.D. diss., Ludwig-Maximilians-Universität zu München, 1972), 67–68.

g. Riegl's figure 27 does offer some analogies to the Chalcidian pattern and its Corinthian and Attic antecedents (figs. 83–84, 88), but on the whole the Egyptian patterns on the scarabs and wall painting cited just above in annotation *e* provide much closer parallels or prototypes for the later Greek examples.

h. On earlier Greek precedents for the Chalcidian pattern in figure 88, see annotations *d* and *f* just above.

i. Strictly speaking, Minoan and Egyptian art had already applied stylized tendril ornament to fill large surfaces; see the Egyptian leatherwork and tomb paintings cited in annotation *i* for chapter 3B.1, above, and the Palace Style jars from Knossos (S. Hood, *The Arts in Prehistoric Greece* [Harmondsworth, 1978], fig. 19b). In the Orientalizing period, works like the pxyides cited just above in annotation *e* or the neck decoration on the Early Attic amphora in the Metropolitan Museum of Art (P. Jacobsthal, *Ornamente Griechischer Vasen. Aufnahmen/Beschreibungen und Untersuchung* [Berlin, 1927], pl. 48, and Beazley, *Development of Attic Black-Figure*, pl. 5, no. 3), already show a development that would culminate in more expansive Archaic Greek tendril patterns as seen in figure 88.

CHAPTER 3. B. 7. GREEK—THE DEVELOPMENT OF THE TENDRIL FRIEZE

a. The type of pottery illustrated in figure 89 was initially thought to be Cyrenean, because the most famous example of the style depicted Arkesilas, the king

of Cyrene, directing commerce. This pottery, however, is now known to be Lakonian in origin, manufactured at Sparta. In the interest of clarity, Riegl's references to the old term "Cyrenean" have been emended to the correct designation, "Lakonian." For an extensive treatment of the form and decoration of this ware see E. A. Lane, "Lakonian Vase Painting," *Annual of the British School at Athens* 34 (1933–1934): 98–190, esp. 128ff.; and C. M. Stibbe, *Lakonische Vasenmaler des sechsten Jahrhunderts v. Christus* (Amsterdam and London, 1972). For examples like figure 89 and the famous "Arkesilas cup," see P. E. Arias and M. Hirmer, *One Thousand Years of Greek Vase Painting* (New York, 1962), pls. 74 and XXIV; and Stibbe, *Lakonische Vasenmaler*, pl. 5, no. 5, 61–62.

b. There are numerous examples in Greek vase painting where deities hold stylized lotus or lily tendrils as attributes: (J. Boardman, *Athenian Black Figure Vases* [New York, 1974], fig. 161; idem, *Athenian Red Figure Vases. The Archaic Period* [New York and Toronto, 1975], figs. 159, 295; E. Simon, *Die Götter der Griechen* [Munich, 1969], figs. 207, 235). Representations of deities in vase painting and sculpture also show gods holding scepters crowned with such stylized flowers (Simon, *Die Götter*, no. 111 [the famous Eleusis relief], and no. 232; Boardman, *Red Figure*, figs. 310, 339, 355). Similarly, Zeus's attribute, the lightning bolt, is generally stylized in the form of addorsed lotuses or lilies, symbolizing the fertilizing power of his rains (Simon, *Die Götter*, figs. 166, 200–201; Arias and Hirmer, *One Thousand Years of Greek Vase Painting*, pl. 47, bottom; Boardman, *Red Figure*, figs. 54, 187). This would seem to indicate that Greek floral stylizations retained something of the kind of symbolism that they had enjoyed in Egyptian and Near Eastern art. But even so, this would not have prevented Greek artists from continuing to transform and embellish such motifs, as their Oriental predecessors had done. On the possible significance of the floral ornament in later Greek red-figure vase painting see K. Schauenburg, "Zur Symbolik unteritalischer Rankenmotive," *Römische Mitteilungen* 64 (1957): 198–221.

c. For details of the type of arcuated frieze in figure 89 and a discussion of its use in Lakonian vase painting, see Lane, *Annual of the British School at Athens* 34 (1933–1934): 172–74, fig. 22; and Stibbe, *Lakonische Vasenmaler*, 52–56, 91, 11, 127, 157, pl. 5, nos. 3, 5; pl. 27, no. 7; pl. 29, no. 4. The more detailed rendering of the examples in Stibbe's plates 21–22 confirms the identification of the blossoms as lotuses, whose closed, piriform contour may represent a bud just beginning to open.

d. In many cases, it is difficult to be certain whether the profile flowers of Orientalizing and Archaic Greek ornament, as in figure 86, for example, represent lotuses or lilies, while those in figure 102, on the other hand, still resemble the papyrus. It is likely that in Greek art the original Egyptian prototypes had become conflated into decorative forms whose botanical identity was no longer clear or specific, especially since the floral stylizations of Near Eastern art had already blurred such distinctions. See the blossoms on Syrian ivories, which combine the qualities of the lotus and lily equally (M. E. L. Mallowan, *Nimrud and Its Remains* [New York, 1966], figs. 388, 392–93).

e. Riegl does not cite the source of figure 90, but identical patterns are common in Attic black-figure of the third quarter of the sixth century B.C.; cf. P. Jacobsthal, *Ornamente griechischer Vasen. Aufnahmen/Beschreibungen und Untersuchung* (Berlin, 1927), pl. 6a; and D. C. Kurtz, *Athenian White Lekythoi. Patterns and Painters*, (Oxford, 1975), figure 2a–d, pls. 1, no. 1; 4, no. 3; 56, nos. 1–2; 59, nos. 1–4. Kurtz (*Athenian White Lekythoi*, 7–8), associates the inception of this pattern on the shoulders of Attic lekythoi with the activity of the Amasis Painter.

f. Figure 91 is also a common pattern in Attic black-figure in the period of Exekias (Jacobsthal, *Ornamente griechischer Vasen*, pls. 15b, 37a); cf. J. D. Beazley,

Development of Attic Black-Figure [Berkeley, 1951; rev. ed. Berkeley, Los Angeles, and London, 1986], pls. 62, 69–72, and Arias and Hirmer, *One Thousand Years of Greek Vase Painting*, pls. 63–66 and *XVIII*. For earlier versions of this pattern see Jacobsthal, *Ornamente griechischer Vasen*, pl. 18a–b.

g. The Klazomenian sarcophagus in figure 92 is actually later than the patterns of this type in Attic vase painting, although it may preserve an earlier stage of development before the palmette had come to dominate the composition, as in figure 91. The basic concept of such patterns is, in any case, originally Near Eastern (see annotation g for chapter 3B.4).

h. Etruscan late seventh-century ivory situla from the "Pania Tomb" at Chiusi; for photographs, see O. Brendel, *Etruscan Art*, (Harmondsworth, 1978), figure 37; M. Cristofani, "Le due pissidi della Pania," *Nuove letture di monumenti etruschi* (Florence, 1971), 67–70 and pls. 31–32. For other Greek examples in which the reverse volutes of the intermittent tendril have become similarly compressed or vertical, see the ivory plaque from Ephesos (D. G. Hogarth, *Excavations at Ephesos. The Archaic Artemisia* [London, 1908], pl. 42, no. 19).

i. Fig. 96, which developed in Attic red- and black-figure vase painting and related painted architectural decoration at the end of the sixth century, is a variant of the continuous tendril like that of figures 80 or 81, but one in which the spiral volutes of the tendril with palmette axil fillers have become a continuous string of enclosed palmettes. For the example from the Athenian treasury at Delphi, see W. B. Dinsmoor, "The Athenian Treasury as Dated by its Ornament," *American Journal of Archaeology* 50 (1946): 86ff., who associated the pattern specifically with the vase painter Psiax. Also see Kurtz (*Athenian White Lekythoi*, 20–26, figure 3a–b, pls. 3a, nos. 12–13; 57, no. 3, on the origin and currency of this pattern. For additional examples like figure 96, see Jacobsthal, *Ornamente griechischer Vasen*, pl. 92, by Smikros; Arias and Hirmer, *One Thousand Years of Greek Vase Painting*, pl. 105; cf. Boardman, *Red Figure*, figure 32, as well as figs. 24 and 26 by Euphronios; Beazley, *Development of Attic Black-Figure*, pl. 84, nos. 2–3, 5, from the Leagros Group. To some extent, this pattern may have been inspired by another type of border in late Archaic black- and red-figure that Riegl did not include here. This consisted of a series of tangent, enclosed palmettes that were all oriented in the same direction as the border itself; cf. Boardman, *Red Figure*, figure 29, and Arias and Hirmer, *One Thousand Years of Greek Vase Painting*, pls. 108, 113–15. In this case, patterns like figure 96 would have come about simply by connecting the encircling tendril volutes in alternation as a continuous tendril-like series.

j. The pattern of figure 97 is also a late sixth-century development, appearing in the works of Epiktetos (H. Payne *Necrocorinthia. A Study of Corinthian Art in the Archaic Period* [Oxford, 1931], 333). However, it becomes far more common in the fifth century; cf. Jacobsthal, *Ornamente griechischer Vasen*, pl. 61b and Boardman, *Red Figure*, figure 196. It is a variant of the intermittent tendril extended by inverse symmetry, descended from the one just above the foot of the Melian amphora in figure 66. The new feature is the staggered, diagonal orientation of the tendril volutes, which facilitated the use of larger palmettes within the narrow confines of the border frame.

k. The pattern of figure 98 first appears in the terra-cotta sima decorations of the Athenian Acropolis around the turn of the sixth to fifth centuries; see E. Buschor, *Tondächer der Akropolis* (Berlin and Leipzig, 1929–1933), 1:25, fig. 20, and pls. 1–2; cf. I. Kleemann, *Der Satrapen-sarkophag aus Sidon*. Istanbuler Forschungen, 20 (Berlin, 1958), 66, fig. 19. The pattern continued in fifth-century Attic vase painting in works by the Niobid and Kleophon Painters (Arias and

Hirmer, *One Thousand Years of Greek Vase Painting*, pls. 173, 196). Figure 98 comes closest to the later example.

l. Here Riegl is referring to the fourth-century Etruscan engraved bronze cistae manufactured at Palestrina; see T. Dohrn, *Die Ficorini Ciste in der Villa Giulia in Rom*, Monumenta Artis Romanae 11 (Berlin, 1972); Brendel, *Etruscan Art*, figs. 274, 277; M. Moretti, G. Maetzke, and L. von Matt, *The Art of the Etruscans* (New York, 1970), ill., pp. 202–5. For the new corpus of these objects see, G. Bordenache Battaglia, *Le ciste prenestine*, vol. 1 (Rome, 1979–).

CHAPTER 3. B. 8. GREEK—THE FURTHER DEVELOPMENT OF THE ALL-OVER TENDRIL PATTERN

a. The use of these fillers developed especially in Early and Middle Corinthian vase painting; see H. Payne, *Necrocorinthia. A Study of Corinthian Art in the Archaic Period* (Oxford, 1931), pls. 28–29, and P. E. Arias and M. Hirmer, *One Thousand Years of Greek Vase Painting* (New York, 1962), pl. VIII.

b. Although Proto-Corinthian vase painting already displays a marked and at times sophisticated use of figural or mythic narrative, it was predominantly a decorative style relying on floral and animal ornament. Today, Proto-Attic and Early Cycladic vase painting appears to have taken the lead in figural or mythic depictions during the Orientalizing period.

c. For handle decorations of this kind in Lakonian vase painting, see E. A. Lane, "Lakonian Vase Painting," *Annual of the British School at Athens* 34 (1933–1934): 174–75, fig. 24; and C. M. Stibbe, *Lakonische Vasenmaler des sechsten Jahrhunderts v. Christus* (Amsterdam and London, 1972), 59, 92, pls. 5, no. 5; 16; 39, no. 2; 62, nos. 1–2.

d. Figure 100 is not Corinthian but Attic work closely modeled on Corinthian exemplars (P. Jacobsthal, *Ornamente griechischer Vasen. Aufnahmen/Beschreibungen und Untersuchung* [Berlin, 1927], 112 n. 193). On this phase of Attic handle decoration generally see ibid., 23–45. For the Corinthian prototypes, see Payne, *Necrocorinthia*, 148–53.

e. Figure 101 is taken from R. Feldscharek, *Ornamente griechischer Thongefässe herausgegeben vom K.K. Österreichischen Museum für Kunst und Industrie* (Vienna, 1868), pl. 4a. For similar works, see Jacobsthal, *Ornamente griechischer Vasen*, pls. 25c–27a, and pp. 47–54. There he explains Attic black-figure patterns like those of figures 101–2 as derivatives of Chalcidian prototypes, using the same set of four undulating tendrils arranged according to strict radial or axial principles of design. For similar handle ornaments on Attic lekythoi of the early fifth century, see D. C. Kurtz, *Athenian White Lekythoi. Patterns and Painters* (Oxford, 1975), 91–93, and figure 25a–c.

f. Figure 102 is taken from Feldscharek, *Ornamente griechischer Thongefässe*, pl. 3. For a photograph of this work, see Jacobsthal, *Ornamente griechischer Vasen*, pl. 43a. Similar but somewhat more developed Attic black-figure examples of this kind appear in Jacobsthal, *Ornamente griechischer Vasen*, pls. 22a–b, 23a, 24a–b, 25a, 25c.

g. Figure 103 comes from Feldscharek, *Ornamente griechischer Thongefässe*, pl. 3c. See Jacobsthal, *Ornamente griechischer Vasen*, pl. 49a, which reproduces the other side of the vase, a mirror image of figure 103. Since the vase duplicates the pattern in reverse on both sides, this decoration is not in the strict sense asymmetrical. Riegl's initial foray into the issues of this chapter largely inspired Jacobsthal's subsequent and more extensive analysis of the handle ornaments on black- and red-figure Attic vases. This later research showed that the development

did not proceed directly from works like figures 101–2 to those like figures 103–4. There was an intervening phase or group that elaborated the concept of handle ornament as longer and more convoluted strings of alternating spiral volutes with simple leaves or palmettes filling the axils formed by successive bifurcations. These were essentially all-over versions of the longitudinal frieze patterns of this type like figures 80 or 81. For this process see Jacobsthal, *Ornamente griechischer Vasen*, 56–72, pls. 35–42.

These black-figure spiral types of the third quarter of the sixth century gave way in the following decades to patterns like figure 103–4 in black- and red-figure technique. Basically, this new type transformed the earlier spiral overall continuous tendril compositions by restructuring the pattern as a continuous series of enclosed palmettes. Or to put it differently, they adapted longitudinal examples like figure 96 to produce the more sinuous overall versions of figures 103 and 104. For this development, see Jacobsthal, *Ornamente griechischer Vasen*, 73–80, and his more specific treatment of the stamnoi with such decoration on pp. 133–42; also see Kurtz, *Athenian White Lekythoi*, 93–99, 149–50, figure 26b, pls. 55–56, 58–59, 69, 72. Early Attic vase painters had already achieved something quite similar, although without any immediate progeny (J. D. Beazley, *Development of Attic Black-Figure* [Berkeley, 1951; rev. ed., Berkeley, Los Angeles, and London, 1986], pl. 5, no. 3). Egyptian patterns from Eighteenth-Dynasty tomb paintings and leatherwork also offer a striking but probably unrelated precedent (see annotation *i* for chapter 3B.1).

h. Figure 104 is taken from Feldscharek, *Ornamente griechischer Thongefässe*, pl. 2a. For a photograph, see Jacobsthal, *Ornamente griechischer Vasen*, pl. 95b. As Jacobsthal indicated, Feldscharek's drawing has reversed the actual pattern.

i. For works like figure 105 see Jacobsthal, *Ornamente griechischer Vasen*, pl. 61a. Jacobsthal, (81–80) characterized this type of palmette tendril as a "Palmettenbaum" or palmette tree, since it appears to grow from a thicker stem or trunk rooted in the ground line of the pattern field. Red-figure examples like this recall the Orientalizing counterparts common in the Boeotian style, figure 66 and 81, and in Early Attic and Cycladic vase painting; see K. Kübler, *Altattische Malerei* (Tubingen, 1950), pls. 12, 14, 69; Beazley, *Development of Attic Black-Figure*, pls. 5, 10; S. P. Morris, *Black and White Style. Athens and Aigina in the Orientalizing Period* (New Haven, Conn. and London, 1984), pls. 3, 6, 16, 27.

j. For patterns like figure 106, see Jacobsthal, *Ornamente griechischer Vasen*, pl. 88b, by the Eucharides Painter, and Boardman, *Red Figure*, figure 149, by the Berlin Painter. On the problem of their development, see Jacobsthal, *Ornamente griechischer Vasen*, 142–58, who characterized the late Archaic and Classical red-figure compositions of this kind as the "palmette lyre." Similar patterns are common as shoulder ornaments on lekythoi (Kurtz, *Attic White Lekythoi*, 26–48, figures 18–24, pls. 11c, 25, nos. 1–4; 28, nos. 2–3; 32; 37, no. 2). More recently A. Lezzi-Hafter (*Der Schuwalow-Maler. Ein Kannenwerkstatt der Parthenonzeit* [Mainz, 1976]) has extensively reexamined the further development of these bilaterally symmetrical tendril palmette patterns on Attic red-figure vases in the course of the fifth century; see especially pp. 36–51, and pl. 37–63, 77c, 78–79, 83c, 84c, 157, and 165–73.

k. On the handle ornaments of Attic kylixes also see Jacobsthal, *Ornamente griechischer Vasen*, 111–33, and pls. 69–73a.

l. The addition of animals as inhabitants of floral stylizations was not a Greek invention. It first appears in Egyptian and Near Eastern works like the paintings of the tomb of Kenamon at Thebes or the palace of Tukulti Ninurta I near Assur, where monkeys and goats inhabit the sacred trees respectively; see W. Stevenson

Smith, *Interconnections of the Ancient Near East. A Study of the Relationships between the Arts of Egypt, the Aegean, and Western Asia* (New Haven, Conn.), 1965, figs. 50, 143; H. Frankfort, *The Art and Architecture of the Ancient Orient* (Harmondsworth, 1985), fig. 152. Similar works occur in the first millennium; griffins in the sacred tree on Phoenician ivories, (M.E.L. Mallowan, *Nimrud and Its Remains*, [New York, 1966], figs. 526–27; R. D. Barnett, *A Catalogue of the Nimrud Ivories, with Other Examples of Ancient Near Eastern Ivories in the British Museum* [London, 1957], pl. 9) and lions in the tree on the gold plaque from Ziwiyeh (E. Porada, *The Art of Ancient Iran* [New York, 1965], pl. 38 bottom). Works like the last three examples inspired Orientalizing images of this kind, like those of Cretan relief ware (D. Levi, "Arkhades. Una città cretese all'alba della civiltà ellenica," *Annuario della Scuola di Atene e della Missione Italiana in Oriente* 10–12 [1927–1929]: 68, fig. 47) or the seventh-century terra-cotta plaque from Gortyn where griffins again climb the stylzed tendrils flanking a deity (P. Arias, *L'arte della Grecia*, [Turin, 1967], figure 126; P. Blome, *Die figürliche Bildwelt Kretas in der geometrischen und fr001harchaischen Periode* [Mainz, 1982], pl. 16, no. 1; and A. Lempesa, "To elephantino eidolio tou neou apo ta Samo," *Annuario della Scuola di Archeologia di Atene*, n.s. 45 [1983]: 320, figure 21). The Archaic examples and those that followed were descended from this Near Eastern and Orientalizing tradition.

m. The early fifth-century lekythos of figure 108 is by the Syriskos Painter. For a photographic reproduction and discussion of its ornament see Kurtz, *Athenian White Lekythoi*, 31, 127–28, pl. 8, no. 1b. For more recent bibliography on the Hildesheim silver krater and Hellenistic Greek tendril ornament with putti, see annotation g for chapter 3B.10, below.

CHAPTER 3. B. 9. GREEK—THE EMERGENCE OF ACANTHUS ORNAMENT

a. The split palmette in figure 110 is from a fourth-century grave stele and represents, as Riegl noted, an advanced phase of the development. The earliest well-preserved datable example of this type from the Athenian temple at Delos (425–17 B.C.) and the closely related sima molding from Naxos both illustrate his explanation of the pattern more effectively. On these earlier works, the more attenuated and sinuous naturalized leaves or sheaths that emit the palmettes function much more clearly like tendrils branching off from the spiral volutes, so as to provide an axil of sorts from which the palmette appears to grow. Because of their longer and more slender proportions, one can also appreciate how the leafy sheaths on these works echo or imitate the undulating form of the palmette leaves above more readily than those in figure 110. For the reliefs from Delos and Naxos, see H. Möbius, *Ornamente griechischer Grabstelen klassischer und nachklassicher Zeit* (Berlin, 1929; 2d rev. ed., Munich, 1968), pl. 5a; and G. Gruben, "Naxos und Paros I. Vierter vorläufiger Bericht über die Forschungskampagnen," *Archäologischer Anzeiger* (1982): 170–71, figs. 10–11. On the date of the Delos temple, see F. Courby, *Les temples d'Apollon*, Exploration archéologique de Délos, 12 (Paris, 1931), 204–5, 220–25.

There was, however, a third type of palmette in this development, which Riegl did not discuss and which was immediately ancestral to the "split" type, since it first appeared a decade or two earlier. This was the so-called *Flammenpalmette* or flame-palmette. A palmette of this type is visible at the top center of figure 122. H. Thompson ("Buildings on the West Side of the Agora," *Hesperia* 6 [1937]: 41–45) would place its origin in the 430s. It was identical to the split type except that it

still retained the upright central leaf and sometimes even the roughly triangular basal element as well, functioning traditionally as an axil filler for pairs of volutes. When the volutes were moved apart, and the separate palmette halves were made to emerge from leafy sheaths, as in figure 110, the central leaf and basal element could no longer be retained. For the earliest examples of this "flame-palmette" see the corner acroteria of the sarcophagi from Sidon, ca. 430–420 B.C. (I. Kleemann, *Satrapen-Sarkophag aus Sidon*. Istanbuler Forschungen, 20 [Berlin, 1958], pls. 18b, 21c; Möbius, *Ornamente griechischer Grabstelen*, pl. 1a, d–e) and a bit later on the Salamis stele (Möbius, *Ornamente griechischer Grabstelen*, pl. 5b). Riegl's "overflowing palmette" is even earlier; it first appears on the roof or gable borders of the Ilissos temple and the Hephaisteion at Athens in the 440s or 430s; see W.A.P. Childs, "In Defense of an Early Date for the Frieze of the Temple on the Ilissos," *Athenische Mitteilungen* 100 (1985): 245–47, figs. 5, 7.

b. The earliest known examples of acanthus ornament are the Giustianini stele and the acroteria from the temples at Sounion and Caulonia, both before 440 B.C., while the earliest known Corinthian capital from Bassae (Phigalia), figure 117, is no earlier than 420 B.C. For these works see Möbius, *Ornamente griechischer Grabstelen*, pl. 2a; P. Jacobsthal, *Ornamente griechischer Vasen. Aufnahmen/Beschreibungen und Untersuchung* (Berlin, 1927), pls. 133a–b, 139a; and A. Delivorrias, *Attische Giebelskulpturen und Akrotere des fünften Jahrhunderts v. Chr.* (Tubingen, 1974), pl. 18b, and Falttaffel 5; and P. Orsi, "Caulonia II," *Monumenti antichi* 29 (1934): 444, pl. 10. For their relative and absolute chronology see Kleemann, *Satrapen-Sarkophag*, 83–86; H. Gropengiesser, *Die pflanzlichen Akrotere klassischer Tempel* (Mainz, 1961): 52–53; Möbius, *Ornamente griechischer Grabstelen*, 11–12, 103; and Delivorrias, *Giebelskulpturen*, 82–86.

c. For photographs of the Choregic monument of Lysikrates, see J. Travlos, *Pictorial Dictionary of Ancient Athens* (New York and Washington, D.C., 1971), 348–52, ill., pp. 450–52. For a detailed discussion including antiquarian drawings and more recent photographs of the now-mutilated capitals, see H. Bauer, *Korinthische Kapitelle des 4. und 3. Jahrhunderts v. Chr.*, Athenische Mitteilungen, Beiheft 3 (Berlin, 1973), 72–80, and pl. 24–29; idem, "Lysikratesdenkmal, Baubestand und Rekonstruktion," *Athenische Mitteilungen* 92 (1977): 197–227, esp. 206ff., and figs. 3a–3b.

d. If, as examples, one considers the monuments cited just above in annotation *b* or the acroteria of the Sidon sarcophagi (Kleemann, *Satrapen-Sarkophag*, pls. 18–21), Riegl's point is especially well taken. The rendering of the acanthus in these works with simple rippled or serrated edges is considerably less naturalistic than later examples of this type of ornament.

e. The pattern in figure 113 comes from the small necking friezes between the columns and capitals of the north porch on the Erechtheion and from the nearby anta capitals and moldings as well. For more recent monographs on the Erechtheion with detailed photographs and drawings of the ornament, see J. M. Paton and G. P. Stevens, *The Erechtheum* (Cambridge, Mass., 1927) and C. Picard and F. Boissonas, *L'Acropole, le plateau supérieure, L'Erechtheion, les annexes sud* (Paris, 1930). For Riegl's figure 113 see Picard and Boissonas, *L'Acropole*, pls. 25–30; Paton and Stevens, *Erechtheum*, pls. 23; 36, nos. 5–6; 37, no. 2; and A. W. Lawrence, *Greek Architecture* (Harmondsworth, 1967), pls. 74–75. Also see the recent study by E. M. Stern, "Die Kapitelle der Nordhalle des Erechtheion" (*Athenische Mitteilungen* 100 [1985]: 405–26, esp. 415ff.), in which he discusses the evidence for the original polychromy on these decorations.

f. Figure 114 is taken from O. Benndorf, *Griechische und sicelische Vasenbilder* (Berlin, 1869–83), pl. 15. For this class of vase see A. Fairbanks, *Athenian White*

Ground Lekythoi (New York, 1907–1914); W. Riezler, *Weissgrunde attische Lekythen* (Munich, 1914); and the more recent studies by J. Mertens, *Attic White-Ground. Its Development on Shapes Other Than Lekythoi* (New York and London, 1977); and I. Wehgartner, *Attische weissgrundige Keramik*, (Mainz, 1983).

g. The contours of the acanthus leaves are rendered in a sharper, pointed manner in figure 116 from the east porch of the Erechtheion, contemporary with the rounder treatment in figure 113 from the north. They are also pointed on the Giustianini stele, probably the earliest extant example of acanthus ornament (Möbius, *Ornamente griechischer Grabstelen*, pl. 2a). Yet none of these examples is as spiky as the actual *acanthus spinosa* itself.

h. Not long after *Stilfragen*, F. Noack, ("Der Akanthus der Griechen und Römer," in *Festschrift Ludwig Friedländer* [Leipzig, 1895], 340ff.) made an extensive study of the literary testimonia regarding the conception of this plant in classical culture.

i. The forward projection or curvature of the palmette leaves of the traditional (presplit) type in Classical Greek sculpture is difficult to make out in photographic reproductions since these are always taken head-on. One can just glimpse it in Kleemann (*Satrapen-Sarkophag*, pl. 21a–b) or Möbius, (*Ornamente griechischer Grabstelen*, pl. 3a). This curling structure became more pronounced on acroteria with the split palmette (Möbius, *Ornamente griechischer Grabstelen*, pls. 13a–b, 22a, 26a–b, 28a–b).

j. The vaginal sheath (Riegl's *Verhülsung*) is indeed a typical phenomenon in real plant life of various sorts where, as in figure 113, the sheaths may occur just before a bifurcation or at some point along a single, branchless stem. Consequently, its use in works like figure 113 must be regarded as a direct emulation of actual vegetation, now inserted into decorative floral patterns, rather than purely as a "naturalizing" transformation of the earlier system of palmette axil fillers. To this extent, Kleemann (*Satrapen-Sarkophag*, 75–76) was justified in criticizing Riegl's explanation for the acanthus half or profile leaf in such ornament.

Nevertheless, the portions of the *acanthus spinosa* that were imitated in acanthus tendril decoration are not vegetal sheaths of this kind. M. Meurer ("Das griechische Akanthusornament und seine natürlichen Vorbilder," *Jahrbuch des Deutschen Archäologischen Instituts* 11 [1896]: 117–26, figs. 1–8) demonstrated convincingly that the details of the ornament were based on the flat basal leaves of the plant like the one illustrated in figure 112 and on the tiny "bracts" that grew on the upper part of the central stalk of the plant and supported the acanthus blossoms. These forms are all terminal leaves or calyces rather than sheaths that envelop and spew forth portions of a longer running stem or tendril. Thus the solution illustrated in figure 113 may have incorporated individual acanthus elements, but it did not in the end follow the structure of the acanthus plant. Instead it "acanthusized" the kind of vaginal sheath that one encounters more generally in vegetation.

But one cannot appreciate this process fully without reference to the *incunabula* of acanthus ornament cited in the annotations above. Before these acanthusized sheaths evolved on the monuments sometime after 420 B.C., the initial solution had been to "acanthusize" the slightly curled and pointed tendril terminals from the standard type of palmette tendril pattern, as in figures 105–6. The rippled or serrated versions of this form on the acroteria of the sarcophagi from Sidon are the earliest extant examples of the new acanthusized variant, ca. 430–420 B.C. (Kleemann, *Satrapen-Sarkophag*, pls. 18a–b, 21b–c; cf. Möbius, *Ornamente griechischer Grabstelen*, pl. 1a–c). Subsequently, these acanthusized tendril terminals gave way to the broader, sheathlike profile acanthus leaves (Riegl's acanthus half

leaf), as they appear in figures 110 and 113, but they sometimes recur alongside the sheath type in later works like figure 121 (beneath the birds). Riegl's derivation of the acanthus half leaf primarily from the half palmette was excessively formalistic, but he was correct to ascribe the process to a more general emulation of plant forms and their natural qualities rather than simply to the direct imitation of the acanthus itself. And it is clear that the process did indeed evolve by gradually introducing elements or features of the acanthus within the existing system of floral or tendril ornament.

k. The lower part of the drawing in Riegl's figure 115 is inaccurate. The pattern does not consist only of frontal acanthus leaves above reverse tendril volutes; there are also two small profile leaves running conterminously with the volutes. The resulting formulation was analogous to the "acanthus calyx" crowning the stele in figure 114 or the one at the bottom center of figure 121. For photographs of the actual molding on the door of the Erechtheion, see Picard and Boissonas, *L'Acropole*, pls. 35, no. 1; 36, no. 1; Paton and Stevens, *Erechtheum*, pls. 25, 30, no. 18; 37, no. 6; Meurer, *Jahrbuch des Deutschen Archäologischen Instituts* 11 (1896): 142, fig. 35; and the more accurate drawing in Kleemann, *Satrapen-Sarkophag*, 79, fig. 31. In this pattern the acanthus leaves have undoubtedly appropriated the formal function of the palmette, and there are other examples in Classical Greek sculpture and painting like it; see Möbius, *Ornamente griechischer Grabstelen*, pl. 3a and Jacobsthal, *Ornamente griechischer Vasen*, pl. 129b. This does not, however, prove that the motif of the acanthus leaf originated from the palmette, only that it came to function like a palmette as it was introduced into floral decoration. See Kleemann, *Satrapen-Sarkophag*, 78–79.

l. By about 430 B.C., the acroteria on the Satrap Sarcophagus have large frontal leaves flanked by the profile type, an early example of the acanthus calyx like that of figure 114 (Kleemann, *Satrapen-Sarkophag*, pl. 18a–b).

m. Although the identity of the stylized flowers in earlier Greek decorative art is often unclear, those of figures 113 and 116 appear to be lilies, like those on the raking sima of the Parthenon; see Kleemann, *Satrapen-Sarkophag*, 52, fig. 2; 64, fig. 18.

n. Meurer (*Jahrbuch des Deutschen Archäologischen Instituts* 11 [1896]: 135–42) tried to explain the motif of the lotus or lily emerging from the acanthus calyx as a copy of the bracts on the acanthus plant, which emit several drooping leaves or petals. But more often than not, the bracts grow individually or in irregular clusters rather than as symmetrical pairs the way that Meurer drew them in his figure 32. Since Riegl's time, scholars have continued to see the blossoms of figures 113 or 116 as acanthusized versions of earlier floral stylizations. The first known example is the acroterion of the Giustianini stele, where a multistaged lotus or lily of Near Eastern derivation, supporting a palmette (as in figure 44), appears with the lowermost pair of petals rendered as acanthus half leaves. On the acroterion of the closely related Karystos stele, the second stage of petals is also acanthusized. Although individually these leaves reflect the appearance of the bracts on the acanthus plant, their arrangement plainly follows the structure of the type of pattern into which they were inserted. As in the case of the profile acanthus leaf sheaths used in tendril patterns, they exemplify a process in which the acanthus elements gradually entered the domain of ornament by appropriating the design or arrangement of existing floral stylizations. Despite the general naturalizing emphasis and the imitation of specific natural details, the development was predicated largely on formal artistic considerations, as Riegl maintained. For the Giustianini and Karystos stelai and the phenomenon of acanthusized blossoms, see Jacobsthal, *Ornamente griechischer Vasen*, 195–96, pl. 139a–b; Kleemann, *Satrapen-*

Sarkophag, 83–84; R. Hauglid, "The Greek Akanthus: Problems of Origin," *Acta Archaeologica* 18 (1947): 108; idem, *Akantus fra Hellas Til Gudbrandsdal*, (Oslo, 1950), 1:13–20; and Möbius, *Ornamente griechischer Grabstelen*, 12, 103 nn.

o. The pattern in figure 116 occurs not only on the moldings between the columns and capitals of the east porch of the Erechtheion but also on the anta capitals of the Caryatid porch; see Picard and Boissonas, *L'Acropole*, 37, figure 37, and pls. 20, 43, no. 2; Paton and Stevens, *Erechtheum*, pls. 26; 36, nos. 1–3; and Lawrence, *Greek Architecture*, pl. 73b. Despite Riegl's contention here, the three drooping fronds beneath the acanthusized blossom in figure 116 probably do reflect the form and distribution of the basal leaves on the actual acanthus plant, although their juxtaposition with the acanthus calyx just above has no analogy with the plant itself. As a whole, the motif is an artistic confection or elaboration.

p. On the Corinthian capital type in general see E. Weigand, *Vorgeschichte des korinthischen Kapitells* (Würzburg, 1920). For a more up-to-date discussion of the unreliability of the drawings and the problems involved in reconstructing the capital from Bassae-Phigalia, as well as its place within the overall development, see M. Gütschow, "Untersuchungen zum korinthischen Kapitell," *Jahrbuch des Deutschen Archäologischen Instituts* 36 (1921): 44 ff.; Hauglid, *Acta Archaeologica* 18 (1947): 98 n. 10, with additional bibliography; A. Wotschnitzky, "Zum korinthischen Kapitell im Apollontempel zu Bassae," *Jahreshefte des Österreichischen Archäologischen Instituts in Wien* 37 (1948): 53ff.; and G. Roux, "Deux études d'archéologie peloponnesienne. 2. Le chapiteau corinthien de Bassae," *Bulletin de correspondence hellénique* 77 (1953): 124–38. The recent monograph of Bauer (*Korinthische Kapitelle des 4. und 3. Jahrhunderts v. Chr.*, 14–65, pls. 1–17, and Beilage 7–8) provides an excellent review of the problem up to this point along with a new reconstruction of the capital.

q. For examples of the earlier type of palmette acroteria, see G. M. Richter, *The Archaic Gravestones of Attica* (Greenwich, Conn., 1961), figures 74, 103a–b, 110–111, 138, 140–141, 144–145, 147.

r. For illustrations of lekythoi with such a plinthlike grave monument surmounted by a seated figure or chair, see E. Pfuhl, *Malerei und Zeichnung der Griechen* (Munich, 1923), no. 553; D. C. Kurtz, *Athenian White Lekythoi. Patterns and Painters* (Oxford, 1975), pl. 33, nos. 1–3; and M. Pfanner, "Zur Schmückung griechischer Grabstelen," *Hefte des Archäologischen Seminars der Universität Bern* 3 (1977): 9, fig. 6. To the annotator's knowledge, Riegl never published this lekythos as he intended.

s. For illustrations of other lekythoi with such acroteria, see Meurer, *Jahrbuch des Deutschen Archäologischen Instituts* 11 (1896): 126–29, figs. 10–14; Pfuhl, *Malerei und Zeichnung*, nos. 532, 534, 544, 550–52; Wehgartner, *Attische weissgrundige Keramik*, pl. 3, no. 2; and P. E. Arias and M. Hirmer, *One Thousand Years of Greek Vase Painting*, (New York, 1962), pl. 201. The kind of interpretation that Riegl advanced for the acroteria depicted on the lekythoi as forerunners of the Corinthian capital reappeared in the work of T. Homolle, "L'origine du chapiteau corinthien," *Revue archéologique*, ser. 5, vol. 4 (1916): 17–60. Homolle maintained that the decorations of the stelai on the lekythoi evolved from wreaths of acanthus leaves tied onto flat-topped columnar grave stelai. This kind of decoration, he argued, was directly ancestral to the radial corolla of acanthus leaves such as it appears in the capitals in figures 117 or 111. In the original edition of his monograph on Attic grave stelai, Möbius, however, flatly denied that the monuments depicted on the lekythoi directly reflected actual works of funerary sculpture, primarily because no such columnar stelai with acanthus crownings have ever been discovered. For him these monuments are fantasies created by vase

painters, and he reasserted this opinion even more forcefully in the revised and updated version of his study; see *Ornamente griechischer Grabstelen*, 13, 103 nn. The observations of Riegl and Homolle that the curved contour of the moldings on the monuments of the vases was meant to depict columnar stelai in perspective are certainly plausible. And the Greeks did indeed decorate their grave stelai with bindings and vegetal wreaths. Hauglid (*Acta Archaeologica* 18 [1947]: 112) has noted the reference in Athenaeus, *Deipnosophistae*, 580b to such practices, and Pfanner *Hefte des Archäologischen Seminars der Universität Bern*, 3, [1977]: 9) has studied these ritual embellishments at length. But this cannot corroborate Homolle's assertion that the stelai depicted on the lekythoi in figures 114 or 118 originated by fixing actual acanthus leaves to column shafts. Basal acanthus leaves are considerably smaller than the frontal leaves shown on the vases, while the acanthus bracts, which the profile leaves of figures 114 and 118 resemble most closely, are only an inch or two long. It would be far more logical to follow Meurer, *Jahrbuch des Deutschen Archäologischen Instituts*, 11 [1896] 127–30) that the stelai on the lekythoi sprouting acanthus leaves along their length imitated in monumental form the emerging bracts of the central acanthus stalk itself.

For the most recent evaluation of the problem posed by the monuments on the lekythoi, see E. Kunze-Götte, "Akanthussäule und Grabmonument in der Herstellung eines Lekythenmalers," *Athenische Mitteilungen* 99 (1984): 185–97. The basic columnar shaft is not unknown in the traditon of monumental Greek funerary art. The details of the acanthus crownings also clearly reflect actual works of sculpture, but probably the acroteria of temples or other buildings, as Kunze-Götte suggests. The overall form of the monuments on the lekythoi may well be the lively and fantastic creations of vase painters who freely adapted and recombined elements drawn from the decorative vocabulary of contemporary Greek sculptural decoration of various sorts, along the lines that Möbius had argued. Nevertheless, these Attic funerary lekythoi of the third quarter of the fifth century are still important. Along with the acroteria of the sarcophagi from Sidon, they document the earliest appearance of the three-leaved acanthus calyx that would become a constant feature of acanthus ornament for centuries to come (cf. figures 121 and 123). And while the acroteria in examples like figures 118–20 do not prove that the acanthus originated literally as a sculptural adaptation of the palmette, they do demonstrate once again that both forms soon came to be understood as interchangeable, as part of a process that gradually assimilated the features of the acanthus plant into the existing repertory of Greek floral ornament.

t. On this passage from Theokritos see Hauglid (*Acta Archaeologica* 18 [1947]: 93), who cites the closely related imagery in Vergil's *Eclogue* 3.44–48; Propertius's *Elegies* 3.9.14; and Ovid's *Metamorphoses* 13.681–701. In what would become a *topos* for his Roman followers, Theokritos was describing the visual delight offered by the acanthus border on a decorated piece of tableware. The adjective that he applies to the acanthus border—*hygros*—means "fluid" or "running," referring in this context to the dynamic and lively configuration of the tendril rather than to its moistness.

u. Hauglid (*Acta Archaeologica* 18 [1947]: 100) notes that the acanthus still grows commonly in Greek cemeteries.

v. Cf. Jacobsthal, *Ornamente griechischer Vasen*, pl. 130b.

w. For lekythoi of the type that Riegl had in mind here, also see Homolle, *Revue archéologique*, ser. 5, vol. 4 (1916): 23–28, figures 1, 3–4, 6–7. See annotation *s* just above on the interpretation of these leaves as decorative embellishments of the stelai. F. Day (*Nature in Ornament* [London, 1892; reprint, New York and London, 1977]) and A.E.V. Lilley and W. Midgley (*A Book of Studies on Plant*

Form and Design. Some Suggestions for Their Application to Design [London and New York, 1916]) provide good examples of the contemporary late nineteenth- and early twentieth-century design theory on the use of floral forms in the decorative arts.

x. The motivation behind Riegl's discussion of acanthus ornament related fundamentally to the whole conceptual premise of *Stilfragen*. In Riegl's view, the exaggerated role accorded to natural analogs or prototypes in the development of ornament was in every sense an extension of the positivist-materialist explanation of art. Like the emphasis on technical factors, it negated or seriously undercut the role of artistic creativity and the continuity of artistic creation as an ongoing historical process. If natural analogs were the primary determinants of floral stylizations, then such decorative forms had no real or distinct evolution of their own. They would be seen to arise periodically and incidentally as unconnected responses to the flora that all artists and cultures experienced. Perhaps the most strident exponent of this naturalist brand of art historical materialism in the study of the decorative arts was M. Meurer, whose initial study in the *Jahrbuch des Deutschen Archäologischen Instituts* 11 (1896), appeared just three years after *Stilfragen*, although Meurer articulated this view much more extensively over a decade later in his *Vergleichende Formenlehre des Ornaments und der Pflanze* (Dresden, 1909). In the concluding paragraph of his earlier work, Meurer stated expressly that human freedom and individual artistic will or creativity only played a minor role in the development of ancient ornament.

Riegl's insistence upon the palmette rather than the natural prototype as the source of the basic acanthus stylizations was certainly overstated, not unlike his arguments concerning the lotus as the inspiration for all Egyptian floral motifs. But one begins to sense that this may have been a conscious rhetorical device on his part. It was in any case intended to topple the tyranny of the natural analog, whose significance had come to overshadow other factors. By minimizing the extent to which the patterns depended upon natural prototypes, Riegl strove to focus once again on the role of formal design and earlier artistic tradition in the development of floral ornament, and especially the acanthus motif.

It is, of course, essential to recognize that the basic acanthus elements themselves, the half- and full-leaf forms, were directly modeled on the lower fronds and upper bracts of the *acanthus spinosa*; students of ornament are indebted to Meurer for this observation. And Kleemann and Möbius were undoubtedly right in pointing out that the use or placement of the palmette in earlier Greek tendril patterns cannot alone account for the structure of acanthus ornament. But Riegl himself never denied the basic connection with the acanthus, just as he initially recognized the impact of natural vegetal forms in the use of acanthus half leaves as sheaths rather than axil fillers. Scholarship has, on the whole, come down on Riegl's side in the final analysis. The concept that acanthus decoration developed not as a direct imitation of the plant but rather by introducing its details within an ongoing tradition of stylized floral ornament remains basic to our understanding of the motif, as the studies of Weigand (*Korinthische Kapitells*, 49–65); Jacobsthal (*Ornamente griechischer Vasen*, 191–98); F. Kempter (*Akanthus. Entstehung eines Ornamententenmotivs* [Leipzig, 1934]); Hauglid (*Acta Archaeologica* 18 [1947]: 101–2, 108–9; idem, *Akantus*, 22); and even Kleemann (*Satrapen-Sarkophag*, 78–85), have reaffirmed again and again.

y. C. Nordenfalk ("Bemerkungen zur Entstehung des Akanthusornaments," *Acta Archaeologica* 5 [1934]: 257–65) has especially praised Riegl's insights regarding the fundamentally sculptural quality of acanthus decoration and its basis in the new conception of the third dimension that developed in Greek relief sculp-

ture during the course of the fifth century B.C. The more extensive study of Jacobsthal (*Ornamente griechischer Vasen*, 191) confirmed the observation that acanthus ornament only made a limited impact on the traditional forms of tendril palmette ornament current in vase painting. The few examples of this kind are attributable to the impact of contemporary sculpture. For the most recent discussion of the timidly acanthusized decoration of late fifth-century Attic red-figure, see A. Lezzi-Hafter, *Der Schuwalow-Maler. Ein Kannenwerkstatt der Parthenonzeit* (Mainz, 1976), 47–49.

CHAPTER 3. B. 10. GREEK—HELLENISTIC AND
ROMAN TENDRIL ORNAMENT

a. Here Riegl is referring to the highly three-dimensional or spatial acanthus tendril patterns that became a hallmark of Apulian red-figure and Gnathia vase painting in Southern Italy in the second half of the fourth century B.C. In place of the two-dimensional, planimetric projection of forms that had dominated all ancient floral ornament up to this point, Apulian patterns of this kind utilized a system of overlapping helical volutes that appeared to spiral in depth ("corkscrew spirals"), along with many new types of floral accessories foreshortened in a three-quarter view. This largely eliminated the dominance or presence of the ground-plane, and it clearly reflected the advanced spatial-pictorial techniques of contemporary monumental figural painting. M. Robertson ("Greek Mosaics," *Journal of Hellenic Studies* 85 [1965]: 72–89; and 87 [1967]: 133–36, and *History of Greek Art* [Cambridge, 1975], 486–88) has attributed this development in floral ornament to the Sicyonian painter Pausias, who was famed for his realistic depictions of flowers and garlands (Pliny 35.124). A. D. Trendall and A. Cambitoglou (*The Red-Figure Vases of Apulia*, vol. 1, [Oxford, 1978], 189–90) accept Robertson's view. M. Pfrommer (*Studien zu alexandrinischer und grossgriechischer Toreutik frühhellenisticher Zeit*, Deutsches Archäologisches Institut, Archäologische Forschungen, vol. 16 [Berlin, 1987], 140–41), however, sees Pausias's work more in terms of still life or flower painting rather than as ornament.

It is unfortunate that Riegl only mentioned such decoration briefly, especially considering his emphasis of spatial or pictorial projection as a key aspect of the initial development of acanthus ornament. P. Jacobsthal, (*Ornamente griechischer Vasen. Aufnahmen/Beschreibungen und Untersuchung* [Berlin, 1927]) also preferred, like Riegl, to restrict his discussion of red-figure floral ornament to the more traditional, two-dimensional type of tendril palmette ornament that continued in use below the vessel handles along with the more advanced typed of pattern on the necks of Apulian vases. R. Pampanini ("Le piante nell'arte decorativa degli etruschi," *Studi etruschi* 4 [1930]: 293–320, esp. 295–302) first attempted a closer analysis of the complex new blossom types depicted in perspective in related fourth- and third-century Etruscan decorative arts. More recently, however, M. Pfrommer ("Grossgriechischer und mittelitalischer Einfluss in der Rankenornamentik frühhellenistischer Zeit," *Jahrbuch des Deutschen Archäologischen Instituts* 97 [1982]: 119–90) has finally provided an extensive study of the spatial-pictoral qualities of such ornament in the later fourth and third centuries, and the wealth of new floral accessories that this development brought about. He has stressed the importance of Central and South Italy in the origin of the process and the role of Macedonia in the further diffusion of these innovations to other centers of Greek art. Also see the discussion of tendril ornament in his more recent monograph, *Toreutik*, esp. 125–41.

For examples of such decoration in vase painting see annotation *h*, just below.

For related examples in minor arts of other kinds see Pfrommer, *Jahrbuch des Deutschen Archäologischen Instituts* 97 (1982): 119–90, figures 28–32, 35, and L. Byvanck-Quarles van Ufford, " 'Die Ranken der Ara Pacis.' Étude sur la décoration à rinceaux pendant l'époque hellénistique," *Bulletin Antieke Beschaving* 30 (1955): 42–49, and figures 4–10. For monumental counterparts in architectural decoration, see L. Bernabò Brea, "I Rilievi tarantini in pietra tenera," *Rivista dell'Istituto Nazionale d'Archeologia e Storia dell'Arte*, n.s. 1 (1952): 85–87, figures 55–59; 224–33, figures 209–11, 223–24; A. W. Lawrence, *Later Greek Sculpture and Its Influence on East and West* (London, 1927), pl. 90b; and P. Petsas, *Ho Taphos ton Leukadion* (Athens, 1966), pl. 1, no. 1. For such ornament in the Greek mosaics at Pella, Vergina, Dyrrhachium, and Sicyon, see Robertson, *Journal of Hellenic Studies*, 87 (1967), pl. 24, and idem, *History of Greek Art*, pls. 152c–153a; P. Petsas, "Mosaics at Pella," in *Colloque internationale sur la mosaïque gréco-romaine, Paris, 29 Aug.–3 Sept. 1963* (Paris, 1965), 41–56, figure 7; P. Charbonneaux, R. Martin, and M. Villard, *Hellenistic Art 320–50 B.C.* (London, 1973), pl. 108; P. Petsas, *Pella, Alexander the Great's Capital* (Thessaloniki, 1978), 83–129, and figure 12; D. Salzmann, *Untersuchungen zu den antiken Kieselmosaiken von den Anfängen bis zum Beginn der Tesseratechnik*, (Berlin, 1982), 14–20, cat. nos. 33, 102, 103, 105, 118, 130; and Pfrommer, *Toreutik*, 128–30. For the rather splendid examples in Macedonian goldwork, see the mount from Stavroupoli and the larnax from the royal tomb at Vergina (*The Search for Alexander. An Exhibition* [Boston, 1980], nos. 114, 172, pls. 11, 25).

b. There is no longer any such gap between fourth-century Attic and Roman or Pompeian art. The extensive archaeological research in Central and Southern Italy has produced a voluminous corpus of vase painting, metalwork, and architectural sculpture from the fourth and third centuries, just as the knowledge of artistic production in Hellenistic Macedon has grown in leaps and bounds during this century. Even the elusive image of Alexandrian art has become clearer as a result of new discoveries and careful study. The bibliography on these areas is cited appropriately in the annotations that follow.

c. For photographic reproductions of the amphora from Nikopol-Chertomlyk, see Jacobsthal, *Ornamente griechischer Vasen*, pls. 142–43; Byvanck-Quarles van Ufford, *Bulletin Antieke Beschaving* 30 (1955): 50–52, figure 12; D. E. Strong, *Greek and Roman Gold and Silver Plate* (Ithaca, N.Y., 1966), pl. 21; M. I. Artamonov, *The Splendor of Scythian Art. Treasures from Scythian Tombs* (New York and Washington, D.C., 1969), pls. 162–65, 171–73; and B. Piotrovsky, L. Galanina, and N. Grach, *Scythian Art* (Oxford and Leningrad, 1987), pls. 265–66. Though produced for Scythian patrons (including a representation of Scythian culture on the shoulder of the vessel), the floral decoration is purely Greek in style and the work of a Greek craftsman. For closely related ornament see the gilt silver dish from the same burial (Byvanck-Quarles van Ufford, *Bulletin Antieke Beschaving* 30, [1955]: 53, fig. 15; Artamonov, *Scythian Art*, pls. 177–79; and Pfrommer, *Toreutik*, 125–127). A bronze mirror in the Metropolitan Museum of Art offers another excellent parallel (G.M.A. Richter and C. Alexander, "A Greek Mirror— Ancient or Modern," *American Journal of Archaeology* 51 [1947], pl. 42; and G.M.A. Richter, *The Metropolitan Museum of Art. Handbook of the Greek Collection* [Cambridge, Mass., 1953], pl. 106a; D. von Bothmer, *A Greek and Roman Treasury*, Metropolitan Museum Bulletin, Summer 1984, [New York, 1984], 51, no. 88). The relatively classical or two-dimensional treatment of the tendril volutes in the Chertomlyk vessels and the mirror, despite the inclusion of three-dimensionally rendered acanthus leaves and flowers, is also paralleled in the black and white pebble mosaics from Pella Sicyon and in the wall decoration of the pronaos

in the tomb of Petosiris near Hierapolis in Egypt; see Robertson, *Journal of Hellenic Studies* 87 (1967), pl. 24; Pfrommmer, *Toreutik*, 129–30; and G. Lefebvre, *Le tombeau de Petosiris* (Cairo, 1923), pl. 20 (acanthus tendrils carried as gifts by offering bearers).

Opinions on the date of the amphora have ranged from the late fifth to the third century B.C. (see Richter and Alexander, *American Journal of Archaeology* 51 [1947]: 226 n. 21). Most scholars have favored the mid fourth century; cf. Jacobsthal, *Ornamente griechischer Vasen*, 223; Strong, *Greek and Roman*, 86, and Artamonov, *Scythian Art*, 57. Byvanck-Quarles van Ufford placed it in the third, and Pfrommer (*Jahrbuch des Deutsches Achäologischen Instituts* 97 [1982]: 156) has now revived the argument for an early Hellenistic date (no earlier than 300 B.C.) for the Chertomlyk burial and related Scythian tombs. Also see A. Alexeyev, "About the Time of the Building of the Chertomlyk Barrow," *Archeologiceskij Sbornik Gosuduartsvennyj Ordena Lenina Ermitaz* 22 (1981): 75–83. Pfrommer (*Toreutik*, 140) also dates the Sicyon pavement to the early third century B.C., although most scholars place this and the related pavement at Pella in the mid to late fourth century; see Salzmann, *Kieselmosaiken*, 18–19, 25–26, and nn. 230, 233. So perhaps a somewhat earlier date is likely for the metalwork with such ornament. Nevertheless, the more planimetric or classicizing treatment of the tendrils on the amphora did remain current into Hellenistic times, as the metalwork molds from Mit Rahine in Egypt demonstrate; cf. C. Reinsberg, *Studien zur hellenistischen Toreutik. Die antiken Gypsabgüsse aus Memphis* (Hildesheim, 1980), cat. nos. 11, 20, and figs. 20, 33; and Pfrommer, *Toreutik*, pl. 54d.

d. On the diadem from Elaia, see B. Segall, *Griechische Goldschmiedekunst des 4. Jh. v. Chr.* (Wiesbaden, 1966), 22–23. For the motif of winged figures in acanthus tendril compositions of this general period, see K. Schauenburg, "Flügelgestalten auf unteritalischen Grabvasen," *Jahrbuch des Deutschen Archäologischen Instituts* 102 (1987): 199–232, esp. 206 ff., with figs. 14–15. Schauenburg stresses the problems in distinguishing at times between androgynous representations of Eros in such ornament and naked depictions of Nike, who may actually appear on the Elaia diadem.

e. For the diadem from Abydos, also see Segall, *Goldschmiedekunst*, 22, 1. Although Segall cited it as lost, this work has now been traced to the Victoria and Albert Museum; see A. Greifenhagen, "Römischer Siberbecher," *Jahrbuch des Deutschen Archäologischen Instituts* 82 (1967): 35–36, who provides a photograph in figures 11–12. A nearly identical diadem said to be from Madytos (also on the Dardanelles), is now in the Metropolitan Museum of Art; see Richter, *Handbook*, 156, pl. 129d; G. Becatti, *Oreficerie antiche dalle minoiche alle barbariche* (Rome, 1955), pl. 86 (cited there as unprovenanced); H. Hoffmann and P. Davidson, *Greek Gold. Jewelry from the Age of Alexander* (Boston, 1965), 67–68, figure 7b; Segall, *Goldschmiedekunst*, pl. 40, and R. Higgins, *Greek and Roman Jewellery*, 2d. ed. (Berkeley and Los Angeles, 1980), 158, pl. 45c.

f. Riegl's figure 124 actually depicts the crownings of stylized date palms that flank the sacred tree or "Egyptian palmette" in the paintings of the Eighteenth-Dynasty tomb of Kenamun at Thebes (W. Stevenson Smith, *Interconnections of the Near East. A Study of the Relationship between the Arts of Egypt, the Aegean, and Western Asia* [New Haven, Conn., 1965], fig. 50). The drawing here follows the somewhat inaccurate reproduction in Lepsius, so it only approximates the form the original motif generally. The appearance of such blossoms in acanthus tendril ornament of the pronaos frieze of the early Ptolemaic tomb of Petosiris (Lefebvre, *Tombeau de Petosiris*, pl. 20) seems to support Riegl's suggestion that the Hellenistic examples of this kind derive from Egyptian traditions. But they

also appear on the gold larnax from the royal Macedonian tomb II at Vergina (*The Search for Alexander*, no. 172, pl. 35). This floral motif actually resembles the flowers of another member of the acanthus family, the *aphelandra squarrosa* or *dania*; see A. B. Graf, *Exotica 9. A Pictorial Encyclopedia of Exotic plants* (Rutherford, N.J., 1968), no. 1496. In any case, despite the attempts of Pampanini to identify the species of many new blossom types in fourth- and third-century floral ornament (*Studi etruschi* 4 [1930]: 295–302), the degree of stylization and fantasy is still enormous in the patterns of this kind. The realistic pictorial technique with which these blossoms were depicted in the decorative arts in no way requires or demonstrates that they actually reproduced real botanical species.

g. The Hildesheim krater, like the bulk of the treasure from this site, is now considered early Roman Imperial; see Strong, *Silver Plate*, 133. For good reproductions of the krater and the find in general, see E. Pernice and F. Winter, *Der Hildesheimer Silberfund* (Berlin, 1901), pls. 32–33; U. Gehrig, *Hildesheimer Silberfund in der Antikenabteilung Berlin* (Berlin, 1967), pls. 2–4; and R. Brilliant, *Roman Art* (London, 1974), figure 3, no. 36. The motif of the acanthus tendrils inhabited by putti was, however, already a feature of Hellenistic decorative arts; for early examples in metalwork, see O. Rubensohn, *Hellenistisches Silbergerät in antiken Gypsabgüssen* (Berlin, 1911), 64ff. and pl. 2, no. 49; Reinsberg, *Studien zur hellenistischen Toreutik*, 300, fig. 23. For a later Hellenistic example see the borders of the Hephaisteion Mosaic in Palace V at Pergamon (G. Kawerau and T. Wiegand, *Altertümer von Pergamon, Die Palast und Hochburg*, vol. 5, no. 1 [Berlin, 1930], text plate 16, 29; E. Rohde, *Pergamon. Burgberg und Altar* [Munich, 1982], 49, figs. 31–32). For a Late Republican Roman example derived from such forerunners, see the upper border of the "Room of the Mysteries" at the Villa Item near Pompeii (E. Pernice, *Die hellenistische Kunst in Pompeji. 6, Pavimente und figürliche Mosaiken* [Berlin, 1938], pl. 43, no. 2; and U. Pappalardo, "Il fregio con eroti fra girali nella 'Sala dei Misteri' a Pompei," *Jahrbuch des Deutschen Archäologischen Instituts* 97 [1982], figures 1–4, 15, 17). The best overall treatment of this theme remains the study by J.M.C Toynbee and J. B. Ward-Perkins, "Peopled Scrolls: A Hellenistic Motif in Imperial Art," *Papers of the British School at Rome* 18 (1950): 1–43. But also see the study by Schauenburg cited in annotation *d*, just above; V. Scherf, *Flügelwesen in römisch-kampanischen Wandbildern* (Hamburg, 1967); and R. Stuveras, *Le putto dans l'art romain*, Collection Latomus, 99 (Brussels, 1969), esp. 74–80.

h. For Attic and Italiote Greek red-figure vase paintings that insert perspectival, three-dimensional acanthus leaves and flowers within otherwise two-dimensional palmette-tendril patterns of traditional type, see Jacobsthal, *Ornamente griechischer Vasen*, pls. 114a, 130a–b, and annotation *y* for chapter 3B.9, above. For an outstanding example, see B. Shefton, "The Krater from Baksy," in D. Kurtz and B. Sparkes, eds., *The Eye of Greece. Studies in the Art of Athens* (Cambridge, 1982), 152, figure 4, pls. 43d, 44b. In such vase paintings the old palmette tendril matrix still dominates the composition. Although the the Nikopol-Chertomlyk relief vase (fig. 121) combines this traditional planimetric approach with the more open and spatial conception of such ornament in monumental sculpture, it was nevertheless a far more typical and widespread practice, at least in Apulian red-figure, to segregate both types; the old two-dimensional patterns were applied beneath the vessel handles, with the more three-dimensional and pictorial treatment of the acanthus tendrils reserved for the neck of the vase. For examples of the latter type with human heads, busts, or whole figures amidst the foliage, see A. D. Trendall, *Red Figure Vases of South Italy and Sicily* (London, 1989), figures 146, 179, 186–90, 204, 209–10, 231, 236, 238, 240, 251, 384; A. D. Trendall and A. Cambitoglou, *The*

Red-Figure Vases of Apulia, vol. 2 (Oxford, 1982), pls. 161–62, 165–66, 168, 198–99; K. Schauenburg, "Zur Symbolik unteritalischer Rankenmotive," *Römische Mitteilungen* 64 (1957): 198–221, and pls. 36, 39–41, 44–45; idem, *Jahrbuch des Deutschen Archäologischen Instituts* 102 (1987): 201–30, figs. 4, 10, 16, 22, 31, 36; and M. E. Mayo, *The Art of South Italy. Vases from Magna Graecia* (Richmond, 1982), 78–196, nos. 51, 61, 68, 69, 71–77. H. Jucker (*Das Bildnis im Blätterkelch*, [Olten, Lausanne, and Freibourg, 1961]) has devoted an entire study to this motif and its iconography in Greek and later Roman art.

i. The vase in figure 125 is not Attic but Apulian. Attic red-figure vases come mostly from Italian tombs, but in Riegl's day, scholars only began to distinguish between such exports and local South Italian red-figure products like figure 125, which gradually came to dominate the markets in the fourth century B.C. On such vases generally, see A. D. Trendall, *South Italian Vase Painting*, 2d ed. (London, 1976); Trendall and Cambitoglou, *Red Figure Vases of Apulia*; and Mayo, *Vases from Magna Graecia*. For Apulian handle ornaments like this one see Jacobsthal, *Ornamente griechischer Vasen*, 147, 150–51, 161–62, and pls. 111a–d, 113a–b; and Mayo, *Vases from Magna Graecia*, 78–196, nos. 32, 51. Etruscan (especially Faliscan) imitations of such South Italian vase painting exaggerated the compression of the tendrils and floral axil fillers (Riegl's *horror vacui*) even more emphatically; see Jacobsthal, *Ornamente griechischer Vasen*, pls. 115c–d, 144a, 147a–b, 148a; J. D. Beazley, *Etruscan Vase Painting* (Oxford, 1947), pls. 27, no. 3; 19, no. 1; 36, no. 1; and M. del Chiaro, *Etruscan Red-Figure Vase Painting at Caere* (Berkeley, Los Angeles, and London, 1974), pls. 5, 54, 58.

j. The swelling of the tendril terminals, as in figure 125, was characteristic of Apulian, Campanian, and Paestan red-figure of the fourth century; see the examples in Jacobsthal cited in the preceding annotation; cf. Mayo, *Vases from Magna Graecia*, 198ff., nos. 87, 95, 104, 109, 112. But it is even more pronounced in the Etruscan examples; see Beazley, *Etruscan Vase Painting*, and del Chiaro, *Vase Painting at Caere*.

k. Figure 126 probably comes from a work of Paestan red-figure. The source of the illustration (O. Jones, *The Grammar of Ornament* [London, 1856]) identifies it only as coming from a Greek vase in the British Museum or the Louvre.

l. Riegl was absolutely correct to stress the widespread currency of the type of red-figured ornament illustrated in figures 125–27. The two-dimensional tendril palmette ornament of fourth-century Attic red-figure, the so-called Kertch Style, like figure 127, also became more compressed than fifth-century Attic forerunners, and thus more akin to South Italian red-figure. But the Kertch Style never achieved the same degree of compression in the overall composition, or the swelling of the tendril terminals common in the vase painting of the south Italian Greek cities. The drawing of figure 127 has perhaps exaggerated this quality somewhat. The ornament of Kertch vases is not well illustrated in the studies of this style, which have focused on the figural decoration. The best examples are still Jacobsthal, *Ornamente griechischer Vasen*, pls. 110a, 116a–b, 123b, 131b. Jacobsthal's plates 116a and 131b come especially close to figure 127 with the highly geometricized axil fillers reminiscent of the Mycenaean example in figure 50.

m. In this connection, it is worth noting again how the recent study by Pfrommer, *Jahrbuch des Deutsches Achäologischen Instituts* 97 (1982): 110–90, has argued for the western or Italiote Greek origin of the new, more spatially complex or realistic acanthus ornament that became widely current in the Greek world during late Classical and Hellenistic times.

n. Throughout our own century the role of Alexandria in the development of Hellenistic Greek art and in the formative phase of Roman Imperial art has re-

mained a hotly debated topic, although few scholars would still insist upon the supreme importance once ascribed to Alexandrian art. For the more recent studies, see I. Noshy, *The Arts in Ptolemaic Egypt* (London, 1937); F. Poulsen, "Gab es eine alexandrinische Kunst," *From the Collections of the Ny Carlsberg Glypotek* 2 (1938): 1–52; A. Adriani, *Documenti e ricerche d'arte alessandrina*, vols. 1–4 (Rome, 1946–1959); B. Brown, *Ptolemaic Painting and Mosaics and the Alexandrian Style* (Cambridge, Mass., 1957); B. Segall, *Tradition und Neuschöpfung in der frühalexandrinischen Kleinkunst* (Berlin, 1966); and G. Grimm and D. Johannes, *Kunst der Ptolemäer und Römerzeit im Ägyptische Museum, Kairo* (Mainz, 1975). N. Bonacasa and A. di Vita, eds., *Alessandria e il mondo ellenistico-romano. Studi in onore di Achille Adriani* (Studi e materiali, Istituto di Archeologia, Università di Palermo, vols. 5–6 [Rome, 1984]) is an extensive collection with contributions on many different media and issues. For the most recent general overview see J. J. Pollitt, *Art in the Hellenistic Age* (Cambridge, 1986), 250–63, 275–77; for metalwork, M. Pfrommer, *Toreutik.*

With regard to the decorative arts in Ptolemaic Egypt, Riegl's emphasis on the primarily Greek aspect of the development is corroborated to some extent by the available material. A large number of plaster molds were excavated at the site of Mit Rahine on the outskirts of Memphis, the site of a a toreutic workshop active for a considerable period. The floral and figural designs on the pieces attributable to Hellenistic times show no influence of native Egyptian artistic tradition, which only sets in on the molds datable to the Roman period; see Reinsberg, *Studien zur hellenistischen Toreutik*, 276–82. Other examples of Ptolemaic toreutic do, however, reflect the continuation and admixture of native Egyptian and oriental floral motifs; see, for example, the works treated by Pfrommer (*Toreutik* 33–34, 63–74). On the syncretism of Ptolemaic art more generally also see G. Grimmm, "Orient und Occident in der Kunst Alexandriens," in *Alexandrien. Kulturbegegnungen drier Jahrtausende im Shmelztiegel einer mediterranen Grossstadt* (Mainz, 1981), 13–25 and 116–22; and Grimm and Johannes, *Kunst der Ptolemäer*, 2–4.

Scholars now tend to see Alexandria as part of a larger network of influence and exchange across the Greek world. Byvanck-Quarles van Ufford (*Bulletin Antieke Beschaving* 30 [1955]: 42–47) and B. Segal ("Alexandrien und Tarent. Ein tarentinische Fundgruppe des Frühenhellenismus," *Archäologischer Anzeiger* [1965]: 553–88) have stressed the connections between the decorative arts in Alexandria and the centers of Southern Italy; cf. Pfrommer, *Toreutik*, 122. In the light of the new discoveries from northern Greece, Pfrommer (*Jahrbuch des Deutschen Archäologischen Instituts* 97 [1982]: 175–90) has also emphasized the intermediary role of Macedonia in this process of exchange and diffusion.

o. Figure 129 is an excerpt from Stephani's drawing of the gold bow case or *gorytos* from the Scythian burial at Chertomlyk, the site that also yielded the gilt silver amphora in figure 121. The entire drawing is reproduced again in E. Minns, *Scythians and Greeks* (New York and Cambridge, 1913), 285, figure 206. For photographic reproductions see Minns, *Scythians and Greeks*, 164, figure 53; Artamonov, *Scythian Art*, pl. 181; Pfrommer, *Jahrbuch des Deutschen Archäologischen Instituts* 97 (1982): 153–55, fig. 29; and Piotrovsky, Galanina, and Grach, *Scythian Art*, pl. 224. Virtually identical bow cases, probably made from the same mold or die, have been found at Ilyintsy, Kiev, and the region of the River Don; see *From the Lands of the Scythians. Ancient Treasures of the U.S.S.R 3000 B.C.– 100 B.C.* (New York, 1975), 128, no. 186. The upper tendril border of the bow case is closely related to the gold headdress ornament from the nearby Deev Barrow (Artamonov, *Scythian Art*, figure 121), as Pfrommer (*Jahrbuch des Deutschen Archäologischen Instituts* 97 [1982]: 155) points out.

p. On the Temple of Isis at Pompeii and its decorations, see J. Overbeck and A. Mau, *Pompeji in seinen Gebäuden, Alterthümern, und Kunstwerken*, 4th ed., (Leipzig, 1884), 104–10. Riegl's figure 130 reproduces part of the stucco frieze (not stone as Riegl mistakenly states) that once decorated the upper exterior walls of the temple and is now almost entirely destroyed. It is closely paralleled by the lower border of the stucco decoration in the tepidarium of the Forum Baths at Pompeii; see V. Spinazzola, *Le arti decorative in Pompeii e nel Museo Nazionale di Napoli* (Milan, Rome, Venice, and Florence, 1928), pls. 165–66. Acanthus friezes of this kind recur in the painted decoration on the interior of the Isis temple; see O. Elia, *Le pitture del tempio d'Iside*, Monumenti della pittura antica scoperti in Italia, ser. 3, fasc. 3–4 (Rome, 1942), figures 1, 5, pls. 6–7; Tran Tam Tinh, *Essai sur la culte d'Isis à Pompéi* (Paris, 1964), 35, pls. 2–3; Toynbee and Ward-Perkins, *Papers of the British School at Rome* 18 (1950), pl. 6, no. 3; and J. B. Ward-Perkins and A. Claridge, *Pompeii. A.D. 79* (Boston, 1978), 2:180, no. 178.

The delicate, naturalistic stage of the acanthus tendril ornament exemplified in figure 130 was perfected in the late Hellenistic and early Roman Imperial periods. Today, the most famous example is the Ara Pacis Augustae, the Augustan Altar of Peace originally erected in the Campus Martius, with its lavish all-over tendril decoration; see T. Kraus, *Die Ranken der Ara Pacis. Ein Beitrag zur Entwicklungsgeschichte der augusteischen Ornamentik* (Berlin, 1953); E. Simon, *Ara Pacis Augustae* (Greenwich, Conn., 1967), figures 3, 4, 18; and E. La Rocca, *Ara Pacis Augustae in occasione del restauro della fronte orientale* (Rome, 1983), ill., pp. 21–23. It is unfortunate that Riegl did not include this work in his discussion here, but the monument was poorly known before the researches of Petersen beginning in 1894 and the gradual process of reconstruction that followed from his and other studies. Longitudinal friezes or borders comparable to figure 130 appear on the Maison Carrée and the theater at Nimes, the building of Eumachia at Pompeii, and the Temple of Augustus and Roma at Pola, all of the Augustan period; see Kraus, *Die Ranken der Ara Pacis*, pl. 10; Spinazzola, *Le arti decorative*, pl. 21b, 22; D. E. Strong, *Roman Art* (Harmondsworth, 1976), figure 97; and H. von Hesberg, *Konsolengeisa des Hellenismus und der frühen Kaiserzeit*, Römische Mitteilungen, Erganzungsheft 24 (Mainz, 1980), pl. 34. Generally similar acanthus borders also occur in the domestic wall painting at Pompeii; see Spinazzola, *Le arti decorative*, pl. 105; Kraus, *Die Ranken der Ara Pacis*, pl. 5; Toynbee and Ward-Perkins, *Papers of the British School at Rome* 18 (1950), pl. 3, no. 3; and K. Schefold, *Vergessenes Pompeji* (Munich, 1962), pls. 27; 90, no. 1; 100.

The especially elegant and attenuated treatment of the tendrils in figure 130 was also current on Augustan or Julio-Claudian silver and bronze tableware, like the cups from Boscoreale, the cup and situla from Herculaneum, the Hildesheim krater, and a group of cups in the British Museum (A.M.A. Héron de Villefosse, *Le trésor de Boscoreale*, Monuments Piots [Paris, 1899], nos. 9–10; R. Bianchi Bandinelli, *Rome: The Center of Power* [New York, 1970], pl. 227; F. Baratte, *Le trésor d'orfèvrerie romaine de Boscoreale* [Paris, 1986], ills. pp. 36, 50, 58–59, 85; Spinazzola, *Le arti decorative*, pls. 231, 275; M. R. Boriello, M. Lista, et al., *Le collezioni del Museo Nazionale di Napoli* [Rome, 1986], 186–87, no. 102; 210–11, no. 35; Gehrig, *Hildesheimer Silberfund*, pls. 2–4; S. Haynes, "Drei neue Silberbecher im Britischen Museum," *Antike Kunst* 4 [1961]: 30–36, pl. 16, nos. 1–4; P. E. Corbett and D. E. Strong, "Three Roman Silver Cups," *British Museum Quarterly* 23, no. 3 [1961]: 79–80, figures 3–4 and pls. 32 a–b c, d 35–37; and Strong, *Roman Art*, figures 41–42.

q. Riegl's criticism of the attempts to explain the softer, more naturalistic treatment of the acanthus tendril in Roman art as a Western development reflecting a

different natural prototype has been confirmed by subsequent research. The development exemplified by figure 130 began in later Hellenistic times, in the Greek East, and its continued evolution in Rome from the Augustan period onward stemmed directly from the assimilation of such eastern or Hellenistic prototypes under imperial and aristocratic patronage. Kraus (*Ranken der Ara Pacis*, 64–76, pls. 19–21) has especially emphasized the role of Pergamene forerunners; in support of Pergamene influence in Late Republican tendril ornament cf. the review of Kraus by D. E. Strong, *Journal of Roman Studies* 44 (1954): 141–42, and W. von Sydow, "Die Grabexedra eines römischen Feldherrn," *Jahrbuch des Deutschen Archäologischen Instituts* 89 (1974): 206–13. G. Sauron ("Les modèles funéraires classiques de l'art décoratif néo-attique au Ier siècle av. J.-C.," *Mélanges de l'Ecole Française d'Athènes*, 91, no. 1 [1979]: 183–211) has, on the other hand, argued for the impact of Neo-Attic floral ornament in this process. C. Borker ("Neuattisches und pergamenisches an den Ara Pacis-Ranken," *Jahrbuch des Deutschen Archäologischen Instituts* 88 [1973]: 288–317) also stresses the Pergamene background, but he rejects the second-century B.C. date adduced by Kraus and others for such prototypes, preferring a date in the earlier first century B.C., closer in time to the Ara Pacis.

r. This feature already appears on the friezes of the Erechtheion, figure 113, and on contemporary Attic grave stelai (Möbius, *Ornamente griechischer Grabstelen*, pl. 5b).

s. The lower border of the Chertomlyk bowcase in figure 129, like the closely related friezes of the Erechtheion in figure 113, or the sima of the Argive Heraion (H. Möbius, "Attische Architekturstudien," *Athenische Mitteilungen* 52 [1927]: 178–81, Beilage 22.6), are based on a new late Archaic and Classical form of intermittent tendril that only applied blossoms and palmettes *above* the volute matrix. For examples of the earlier, nonacanthusized friezes of this type, see I. Kleemann, *Satrapen-Sarkophag aus Sidon.* Istanbuler Forschungen, 20 (Berlin, 1988), 66–69, figs. 20–25.

t. Here Riegl probably had in mind the sort of continuous tendril patterns with realistic or pseudorealistic vegetal detail like those in the third style wall paintings from the villa at Boscotrecase (P. von Blanckenhagen, *The Paintings at Boscotrecase*, Römische Mitteilungen, Erganzungsheft 6 [Heidelberg, 1962], pls. 16, 17, no. 2).

u. The buildings to which figures 131–34 belong are part of the palatial complex of the Emperor Diocletian at Spalato (ancient Aspalathos), erected at the beginning of the fourth century A.D. Riegl based his study of the decoration of this monument on the drawings of the noted eighteenth-century artist and designer Robert Adam, whose studies were done when the specific identification and function of the various buildings were as yet unknown. The definitive monograph on the site is still G. Niemann, *Der Palast des Diokletians in Spalato* (Vienna, 1910), but also see J. Marasovic and T. Marasovic, *Diocletian Palace* (Zagreb, 1970) for excellent illustrations of this monument. Adam's drawings of the ornamental details do not appear accurate in more than the most general terms when compared to the drawings and photographs in these more recent monographs. Thus Riegl's observations and conclusions here must be treated with some caution. Following Adam, Riegl's text originally cited figure 131 as coming from the temple of Jupiter, now identified as Diocletian's mausoleum. It compares fairly well to the cornice of the mausoleum vestibule, and also to the door frame of the vestibule to the imperial palace itself; see Niemann, *Der Palast des Diokletians*, 46, figs. 56, 57, 70.

v. Adam, Riegl's source, originally identified figure 132 as coming from the outer colonnade of the Jupiter Temple (i.e., the octagonal mausoleum) at Spalato; cf. Niemann, *Der Palast des Diokletians*, 68, figures 84–85. It is also similar to the cornices on the lower order of the building's interior published by Niemann (ibid., 74–75, figures 93–94). Cf. W. B. MacDonald, *The Architecture of the Roman Empire*, vol. 2, *An Urban Appraisal* (New Haven, Conn. and London, 1986), fig. 164, and E. Hebrard and J. Zeiller, *Spalato. Le Palais de Dioclétien* (Paris, 1911), ill., p. 33.

w. Figure 133, Adam's drawing of the cornice above the door of the small temple near Diocletian's palace (the so-called Temple of Aesculapius), is highly inaccurate. It simplifies the foliate detail of the palmettes and acanthusized blossoms, while acanthusizing the tendril volutes, which are in reality only simple bands; cf. Niemann, *Der Palast des Diokletians*, ill., p. 85 and pl. 17. The leafy treatment of the S-shaped tendrils in figure 133 is, however, paralleled by portions of the outer entablature of the mausoleum; ibid., 67, figure 82. Figure 134, was cited by Adam as coming from the upper interior order of the Jupiter Temple (i.e., the mausoleum), but it too does not compare reliably to any of the published details of this part of the building; cf. ibid., 74–75, figures 93–94, and Marasovic, *Diocletian Palace*, figures 57, 59–60.

x. For this hoard of metalwork, see N. Mavrodinov, *Le trésor protobulgare de Nagyszentmiklós*, Archaeologica Hungarica, 29 (Budapest, 1943), and G. László, *The Art of the Migration Period* (Coral Gables, Fla., 1970), pls. 146–62.

y. The development of early and middle imperial architectural ornament has been thoroughly studied by P. von Blanckenhagen, *Flavische Architektur und ihre Dekoration* (Berlin, 1940); M. E. Bertoldi, *Ricerche sulla decorazione architettonica del Foro Traiano*, Seminario di archeologia e di storia dell'arte greca e romana dell'Università di Roma. Studi miscellanei, 3 (Rome, 1960–1961), 1–34; and esp. C. F. Léon, *Die Bauornamentik des Trajansforums und ihr Stellung in der früh- und mittelkaiserzeitlichen Architekturdekoration Roms* (Vienna, Cologne, and Graz, 1971). For figure 135, see Léon, *Die Bauornamentik*, 123, 130, 275, and pl. 47, no. 1, with similar examples from the same monument in pls. 48, no. 2; 53, no. 3. Related decoration already occurs in the Flavian palace on the Palatine, in the Aula Regia, and the Paedagogium (Léon, *Die Bauornamentik*, pls. 40, no. 2; 134, no. 1). For Riegl's figure 136, see Léon, *Die Bauornamentik*, 103, 130, and pl. 35, no. 1; cf. pl. 43, no. 1. From Léon's extensive survey it is clear that the acanthusized intermittent tendril friezes of the Nerva Forum are a development of the Flavian period, whose origins go back already to Julio-Claudian architectural ornament like that of the tomb of Servilius Quadratus (*Die Bauornamentik*, 170, and pl. 70, no. 2, and von Hesberg, *Konsolengeisa*, pl. 35, no. 2). The pattern on this tomb is actually an acanthusized arcuated lotus and palmette frieze. Since the intermittent tendril version of figure 136 evolved from such precedents, it may help us to understand the residual effects of the arcuated scheme noted by Riegl. The Flavian innovations led directly to the architectural decoration of the Trajanic, Hadrianic, and Antonine periods, as Léon's analysis demonstrates. For the further development connecting the second-century monuments to the architectural decoration of the fourth century, see R. Hauglid, *Akantus fra Hellas Til Gudbrandsdal* (Oslo, 1950), 36–38; L. Budde, *Severisches Relief in Palazzo Sacchetti*, Jahrbuch des Deutsches Archäologischen Instituts, Erganzungsheft 18 (Berlin, 1955), 39–49, figs. 33–50; and S. Neu, "Römisches Ornament. Stadtrömische Marmorgebälke aus der Zeit von Septimius Severus bis Konstantin," (Ph.D. diss., Westfälischen Wilhelms-Universität zu Münster, 1972).

z. Despite their analogy to the enclosed palmette, figures 136–37 are based upon the variant of the intermittent tendril discussed in annotation *s* just above. For generally similar patterns in Pompeian wall painting, see P. Gusman, *Mural Decorations of Pompeii* (Paris, 1924), pls. 30, 32.

aa. The pronounced Roman tendency toward abstraction with its progressively less natural or plantlike treatment of the overall structure, as exemplified in figures 131–36, may well have begun in the less conservative medium of painted wall decoration. Already in the third style, in works like the paintings from Boscotrecase, one encounterrs a highly formalized approach to traditional pattern types in which the interstices of the tendril lines were set off in different colors, giving prominence to the background forms, and thereby engendering the new and more abstract versions of familiar stylizations illustrated in figure 137. Through such a process, the basic structure of the old standard patterns was transformed into ever more abstract or unnatural schemata. See von Blanckenhagen, *Paintings from Boscotrecase*, pls. 9; 19, no. 2; and M. L. Anderson, *Pompeian Frescoes in the Metropolitan Museum of Art*, Metropolitan Museum Bulletin, Winter 1987–88 (New York, 1988), figures 11, 47, 50. Similar decorations appear at Pompeii in the House of Marcus Lucretius Fronto, House I-9-2, and the House of Cecilius Giocondus (Spinazzola, *Le arti decorative*, pls. 100–101; D. Joly, "Aspects de la mosäique pariétale au Ier siècle de notre ère d'après trois documents pompéiens," in *La mosäique gréco-romaine*, 57–71, figs. 4 and 22; cf. other examples of this sort in Gusman, *Mural Decorations of Pompeii*, pls. 32–33.

Perhaps it is possible to trace this tendency back to the rather fantastic and abstract decorations in the late second or transitional early third style wall paintings discovered beneath the Villa Farnesina in Rome, or to the Aula Isiaca and the upper cubiculum of the House of Augustus on the Palatine (Bianchi Bandinelli, *Center of Power*, pls. 123, 128–29; G. Carettoni, *Das Haus des Augustus auf dem Palatin* [Mainz, 1983], pls. 19–20, 22, W, Y4). The origin of such fantasy and formal elaboration may go back still further to Hellenistic Egypt, as Carettoni (90–92) suggests, bringing us somewhat closer to the abstraction of fourth-century B.C. Greek vase painting. But the decisive move toward a conception of floral ornament no longer based on or restrained by the actual qualities of plant life was primarily a development of Roman times, and one that Riegl would come to explore more closely in his later study, *Spätrömische Kunstindustrie*.

Chapter 4. The Arabesque—Introduction

a. Since the appearance of *Stilfragen*, there have been only two further attempts at a comprehensive examination or discussion of the so-called Arabesque and its development, that of E. Kühnel, *Die Arabesque. Sinn und Wandlung eines Ornaments* (Wiesbaden, 1949), English translation by R. Ettinghausen, *The Arabesque. Meaning and Development of an Ornament* (Graz, 1977); and F. Shafi'i, *Simple Calyx Ornament in Islamic Art. A Study in Arabesque* (Cairo, 1957). Various other scholars have focused on the formative stages of Islamic ornament in the Ummayad and Abbasid periods, and these works will be cited appropriately below. Several, however, deserve special notice; E. Herzfeld, "Die Genesis der islamischen Kunst und das Mshatta Problem," *Der Islam* 1 (1910): 27–63; idem, *Der Wandschmuck der Bauten von Samarra und seine Ornamentik*, vol. 1, *Die Ausgrabungen von Samarra, forschungen zur islamischen Kunst*, 1 (Berlin, 1923), esp. 6–7, 9, 13–14; M. S. Dimand, "Studies in Islamic Ornament, 1. Some Aspects of Omaiyad and Early Abbasid Ornament," *Ars Islamica* 4 (1937): 293–337; H. G. Franz, "Wesenzuge omayyadischer Schmuckkunst," in *Beiträge zur Kunstge-*

schichte Asiens in Memoriam Ernst Diez (Istanbul, 1963); idem, *Palast, Moschee und Wüstenschloss. Das Werden der islamischen Kunst 7.–9. Jahrhundert* (Graz, 1984). O. Grabar (*The Formation of Islamic Art* [New Haven, Conn. and London, 1973; 2d rev. ed., New Haven, Conn., 1987] 188–205) has also provided a useful overview of the factors that shaped the development of ornament in the early stages of Islamic art.

b. Fig. 139 is from the Koran of the Mamluk Sultan Mou'ayyed, written by Abdar'Rahman ibn as-Faïgh in A.D. 1411. For related works of the same school, see B. Moritz, *Arabic Palaeography. A Collection of Arabic Texts from the First Century of the Hidjira until the Year One Thousand* (Cairo, 1905), pl. 74; J. Bourgoin, *Précis de l'art arabe et matériaux pour servir à l'histoire, à la théorie, et à la technique des arts de l'Orient musulmane* (Paris, 1892), part 4, pl. 28; and Kühnel, *The Arabesque*, 28–29, fig. 19, pl. 19. The recent study by D. James, *Qur'ans of the Mamluks* (New York, 1988) only surveys the development up to the end of the fourteenth century, However, the works by the illuminator al-Ahmidi, about a generation earlier than figure 139, already display very similar composition and detail in their frame or border ornament; see James, *Qur'ans*, 198–210, esp. figs. 139, 140.

c. The most thorough and comprehensive treatment of the blossom motifs in Arabesque ornament is Shafi'i, *Simple Calyx Ornament*, cited above. For the forms used in figure 139 see Shafi'i, 36–43, 122–23, and 146–49, pls. 27k, 39s, u, 40c, d, m, and o. Shafi'i prefers to classify these motifs as calyces rather than tendrils, since they are the blossoms as opposed to the tendril or stem proper, although Riegl himself had already made this distinction. Thus the bifurcating tendril of his figures 139a–b is the "two sepal split calyx" in Shafi'i's system; Riegl's Islamic trefoil, figure 139 e–g, corresponds to Shafi'i's "three sepal calyx with cleft base."

d. On the use of intersecting, overlapping, or interlacing tendrils in Greek vase painting see P. Jacobsthal, *Ornamente griechischer Vasen. Aufnahmen/Beschreibungen und Untersuchung* (Berlin, 1927), 199–200. The studies by Byvanck-Quarles van Ufford and Pfrommer cited in annotation *a* for chapter 3. B. 10, above, have treated the use of such overlapping forms in late Classical and Hellenistic Greek tendril ornament, when it became fairly widespread. In the late Hellenistic period there was a gradual return to the more rigidly planimetric projection of the main tendril against a uniform ground-plane, with the more spatial or perspective treatment of forms limited to the blossoms and acanthus leaves, and to the finer network of subordinate tendrils in the interstices of the larger two-dimensional tendril matrix. The ornament of the Ara Pacis Augustae represents the culmination of this development; see the works by Kraus and Borker cited in annotations *p* and *q* for chapter 3.B.10, above.

e. Figures 140–141, from the entrance hall of the basilica and from Simeon-Strasse at Trier, are datable archaeologically to the fourth century A.D. For a more recent discussion of these mosaics see K. Parlasca, *Die römische Mosaiken in Deutschland*, Römisch-germanische Forschungen, 23 (Berlin, 1959), 51–52, 58–59, pl. 8, no. 2; 57, no. 3. The progressive elaboration during late antiquity and the early Middle Ages of this simpler Roman looped and plaitwork interlace has been studied in detail by J. Romilly Allen, *Celtic Art in Pagan and Christian Times* (London, 1912), 244–79; E. Lexow, "Hovedlinierene i entrelacornamentikkens Historie," *Bergens Museums Aarbok*, Hist.–antikv. raekke, no. 1 (1921–1922): 9–92; W. Holmquist, *Kunstprobleme der Merowingerzeit*, Kungliga Vitterhets Historie och antikvitets akadamiens Handlingar, 47 (Stockholm, 1939), 29–97; R. Gabrielsson, *Kompositionsformer senkeltisk orneringsstil. Sedda mot bakgrunden*

av den allmäneuropeiska konstutvecklingen, Kungliga Vitterhets Historie och antikvitets akademiens Handlingar, 58, no. 2 (Stockholm, 1945), 13–41, 54–72; and N. Aberg, *The Occident and the Orient in the Art of the Seventh Century*, Kungliga Vitterhets Historie och antikvitets akademiens Handlingar, 56, nos. 1–3 (Stockholm, 1943–1947), 1:31–35; 2:30–32, 69–75.

 f. Here Riegl is referring to the interlace decoration used widely on the marble chancel screens and other church fittings in Italy and the Byzantine East from the sixth to the ninth centuries. For such material see G. Bovini, ed., *Corpus della scultura paleocristiana, bizantina ed altomedioevale di Ravenna* (Rome, 1968–1969); and *Corpus della scultura altomedioevale* (Spoleto, 1959–), which treats the material regionally in an ongoing series of publications. For a more analytical approach to these works and their decoration see R. Kautzsch, "Die römische Schmuckkunst in Stein von 6. bis zum 10. Jahrhundert," *Römisches Jahrbuch für Kunstgeschichte* 3 (1939): 1–73; idem, "Die langobardische Schmuckkunst in Oberitalien," *Römisches Jahrbuch für Kunstgeschichte* 5 (1941): 1–48; and Gabrielsson, *Kompositionsformer*, 29–41.

CHAPTER 4. A. TENDRIL ORNAMENT IN BYZANTINE ART

 a. Riegl's reference to the Arch of Constantine has to do with the incorporation of spolia or reused reliefs along with those actually made for the monument. However, these spolia are now known to include not only Trajanic but Hadrianic and Antonine material as well. By the seventeenth century antiquarians had erroneously come to associate these spolia entirely with Trajan; see J. Forte, "Deconstruction and Reconstruction in Poussin's Decoration of the Grande Galerie of the Louvre," in D. Castriota, ed., *Artistic Strategy and the Rhetoric of Power. Political Uses of Art from Antiquity to the Present* (Carbondale and Edwardsville, Ill., 1986), 57–61. In Riegl's day these spolia were believed to been taken from a lost arch in Rome that would have commemorated Trajan's victories. At present, the original location of the various reused reliefs on Constantine's arch is still uncertain. For the most recent discussion and the earlier scholarship on these spolia, see G. M. Koeppel, "Die historischen Reliefs der römischen Kaiserzeit III. Stadtrömische Denkmäler unbekannter Bauzuhörigkeit aus trajanischer Zeit," *Bonner Jahrbücher* 185 (1985): 149–53, 173–83, cat. no 9; and idem, part 4, "Stadtrömischer Denkmäler unbekannter Bauzuhörigkeit aus hadrianischer bis konstantinischer Zeit," *Bonner Jahrbücher* 186 (1986): 5, 9–12, 26–33, 56–75, cat. nos. 4–11, 26–33. For a restored photograph of the reused Trajanic reliefs as an unbroken composition, see R. Bianchi Bandinelli, *Rome: The Center of Power* (New York, 1970), 229–30, fig. 255. The most thorough monograph on the Arch of Constantine generally is still H. P. L'Orange and A. von Gerkan, *Der spätantike Bildschmuck des Konstantinsbogen* (Berlin, 1939); on the dating of the reused reliefs see 161–62, 183–84, and 187–88.

 It is surprising that here Riegl defends Constantinian art purely by invoking the superior qualities of the architecture in this period, since, in his *Spätrömische Kunsindustrie*, he would later reconsider the whole basis for the perceived inferiority of the contemporary reliefs on the Arch of Constantine and late antique art in general. The vaulted basilica to which Riegl refers is that begun by Maxentius and completed by Constantine, the Basilica Nova on the Velia at the edge of the Roman Forum; see J. B. Ward-Perkins, *Roman Imperial Architecture* (Harmondsworth, 1981), 426–28, and E. Nash, *A Pictorial Dictionary of Ancient Rome*, vol. 2 (London, 1968), 268, for the extensive bibliography on this building.

 b. On the evolution of the domed cross-plan church and its sources in earlier east Roman art, see R. Krautheimer (*Early Christian and Byzantine Architecture*

[Harmondsworth, 1975], 253–58), who traces the immediate origin of the type to the timber-roofed cruciform basilicas of the Constantinian period. Despite Riegl's contention the transition to the domed construction does indeed appear to be a Justinianic development originating in the capital of the Byzantine Empire. Many scholars have emphasized the general debt of Justinianic centrally-planned church architecture to the tradition of Roman vaulted basilicas, palaces, bath buildings, and rotundas; see G. T. Rivoira, *L'architettura romana* (Milan, 1921); W. R. Zaloziecky, *Die Sophienkirche in Konstantinopel* (Rome, 1936); G. de Angelis d'Ossat, *Romanità delle cupole romane* (Rome, 1946); S. Bettini, *L'architettura di San Marco* (Padua, 1946); and especially J. B. Ward-Perkins, "The Italian Element in Late Roman and Early Medieval Architecture," *Proceedings of the British Academy at Rome* 33 (1947): 163–84; also see Krautheimer, *Early Christian Architecture*, 237, 509 nn. F. W. Deichmann, however (*Studien zur Architektur Konstantinopels im 5. und 6. Jahrhundert nach Christus*, Deutsche Beiträge zur Altertumswissenschaft, 4 [Baden-Baden, 1956], 38–40), stresses the Roman vaulted architectural traditions of Asia Minor as the immediate source. But whatever its origins, the particular solution exemplified at Hagia Sophia was a brilliant achievement, as Krautheimer (215–26) has so effectively demonstrated. The subsequent evolution of Byzantine architecture may largely have reiterated the innovations of the Justinianic period. But in emphasizing its continuity with antique traditions, Riegl has understated the spatial and technological breakthroughs of the earlier Byzantine or Justinianic development.

c. The conception of early Christian art as a direct adaptation of the pagan artistic vocabulary to a Christian purpose was first articulated by L. von Sybel, *Christliche Antike. Einführung in der altchristlichen Kunst* (Marburg, 1906–1909). This still remains a basic tenet in the study of early Christian art and symbolism, and in more recent times it is perhaps best exemplified by A. Grabar, *Christian Iconography* (Princeton, N.J., 1968). Riegl's apparently low opinion of Early Christian art here is again surprising in view of the impassioned defense or reconsideration of late antique art that he would soon advance in his *Spätrömische Kunstindustrie*.

d. During the period of Iconoclasm and the decades following, Byzantine artists, at the instigation of their patrons, did in fact begin to affect the more sumptuous and stylized forms of vegetal decoration current in Islamic art, as figure 151 makes clear; see C. D. Sheppard, "A Radiocarbon Date for the Wooden Tie Beams in the West Gallery at St. Sophia, Istanbul," *Dumbarton Oaks Papers* 19 (1965): 237–40. Sheppard especially stresses the Islamic tastes of the emperor Theophilos, who had a large palace built in imitation of those in Abbasid Baghdad. He cites as well the Islamicized decoration of the Byzantine church at Skripu near Thebes erected about 874. On the impact of Islamic decoration in Byzantine art also see G. C. Miles, "Byzantium and the Arabs: Relations in Crete and the Aegean Area," *Dumbarton Oaks Papers* 18 (1964): 1–33; idem., "Material for a Corpus of Architectural Ornament of Islamic Derivation in Byzantine Greece," *Yearbook for the American Philological Society* (1959): 486–90; A. Grabar, "Islamic Art and Byzantium," *Dumbarton Oaks Papers* 18 (1964): 69–88; and D. Talbot-Rice, "The Pottery of Byzantium and the Islamic World," in *Studies in Islamic Art and Architecture in Honor of K.A.C. Creswell* (Cairo, 1965), 194–235.

e. Riegl would later return to this issue in his article "Zur Entstehung der altchristlichen Basilika," *Jahrbuch der Zentralkommission*, N.F., 1 (1903): 195ff.

f. On the capitals and architraves from the church of St. John Studios erected in Constantinople during the 460s, see R. Kautzsch, *Kapitellstudien. Beiträge zu einer Geschichte des spätantiken Kapitells im Osten vom vierten bis in siebente Jahrhundert* (Berlin and Leipzig, 1936), 135 and pl. 27, no. 434; Deichmann, *Ar-*

chitektur Konstantinopels, 69–72, figs. 17–18; and Krautheimer, *Early Christian Architecture*, 109–11, figs. 55–56. The actual sculptures are now largely destroyed, but judging from the limited remains, as well as from older photographs and the line drawing in figure 142, the particular treatment of the leaves in the upper borders of capital and the architrave had been established for some time in Constantinopolitan building ornament. It is already discernible in the architectural decoration of the Golden Gate and the propylon of the original church of Hagia Sophia built by Theodosius II at the beginning of the fifth century. See E. Weigand, "Neue Untersuchungen über das Goldene Tor in Konstantinopel," *Athenische Mitteilungen* 39 (1914): 1–64, pl. 1, nos. 1–5; Deichmann, *Architektur Konstantinopels*, 63–69, and figs. 5–14; Krautheimer, *Early Christian Architecture*, 108–9, figs. 53, 54.

g. The ultimate origin of the development exemplified by figure 142 is complex, and certainly not a creation of Constantinopolitan Byzantine art alone. The finely serrated acanthus forms of the capital itself depended most immediately upon the architectural decoration of later Roman Imperial Asia Minor, as A. M. Schneider (*Die Grabung im Westhof der Sophienkirche*, Istanbuler Forschungen, 12, [Berlin, 1941], 11ff., has shown; cf. Deichmann, *Architektur Konstantinopels*, 56–63, and Weigand, *Athenische Mitteilungen* 39 (1914): 40–45. The precise origin of the highly abstracted, spiky type of acanthus tendril on the architrave above the capital is difficult to pinpoint. An early stage of this pattern appears in the border of a Palmyrene votive relief to the Goddess Ashtar; cf. H. Klengel, *The Art of Ancient Syria* (South Brunswick, N.J. and New York, 1972), ill., p. 157; later it is attested on the the doorframe of Diocletian's mausoleum at Spalato (G. Niemann, *Der Palast des Diokletians in Spalato* [Vienna, 1910], 66, fig. 81) and in the fourth-century North African mosaic pavements at Tabarka and Carthage (R. Bianchi Bandinelli, *Rome: The Late Empire. Roman Art A.D. 200–400* [New York, 1971], figs. 207–8). But despite their similar level of geometric abstraction or simplification, these earlier examples still adhere to the basic concept of successive acanthus sheaths, emerging distinctly from one another. The treatment of the tendril as an undifferentiated flow of leafy acanthus volutes (cf. fig. 142, top) seems to have evolved in the fifth century, when it became common all across the eastern Roman provinces. For this later material see the studies of Kautzsch and Weigand, and also E. Kitzinger, "Notes on Early Coptic Sculpture," *Archaeologia* 87 (1938): 181–215, esp. 193ff., and Deichmann, *Architektur Konstantinopels*, 13–14.

The more abstract and angular rendering of the acanthus forms themselves in the architrave can be traced back further to the architectural sculpture of Syria and northern Mesopotamia, at sites like Palmyra and Hatra, along the interface between the Roman and Parthian empires during the first and second centuries A.D., which may in turn reflect contacts with the Hellenized art of Iran, India, and central Asia. For works of this kind see E. Weigand, "Baalbek und Rom, die römische Reichskunst in ihr Entwickelung und Differenzierung," *Jahrbuch des Deutschen Archäologischen Instituts* 29 (1914): 37–91; D. Schlumberger, "Les formes anciennes du chapiteau corinthien en Syrie, en Palestine et en Arabie," *Syria* 11 (1933): 283–318; and H. Seyrig, "Ornamenta Palmyra Antiquiora," *Syria* 18 (1940): 277–337, esp. 289–91, figs. 8, 15–18, pls. 29–35. On the problems of the connection between Mediterranean and Parthian art, and the larger sphere of "Greco-Iranian" and north Indian art at this time, also see D. Schlumberger, "Nachkommen griechischen Kunst ausserhalb des Mittelmeerraums," in F. Altheim and J. Rehork, eds., *Der Hellenismus in Mittelasien* (Darmstadt, 1969), 281–405.

Beginning in 1901, J. Strzygowski would dispute the view of late antique ornament as an internal and essentially independent Mediterranean transformation that Riegl had advanced in *Stilfragen* and later in *Spätrömische Kunstindustrie*. Strzygowski argued instead that such transformations were due to the ever increasing impact of artistic forms and spiritual concepts originating in central Asia and Iran. He first expounded this thesis in his monumental study, *Orient oder Rom. Beiträge zur Geschichte der spätantiken und frühmittelalterlichen Kunst* (Leipzig, 1901—see Riegl's response, "Spätrömisch oder orientalisch?" *Münchener Allgemeine Zeitung*, nos. 93–94 [1902] and the criticisms of Weigand, *Athenische Mitteilungen* 39 [1914]: 51 ff.). Strzygowski continued to develop this view in subsequent works, such as *Kleinasien, ein Neuland der Kunstgeschichte* (Leipzig, 1903), and "Iran, Asiens Hellas," *Ars Islamica* 4 (1937): 42–53. In his *Altai-Iran und Völkerwanderung. Ziergeschichtliche Untersuchungen über den Eintritt der Wander- und Nordvölker in die Treibhäuser geistigen Lebens* (Leipzig, 1917), 70–73, 123–36, 223–37, he specifically challenged Riegl's explanation of late antique floral ornament as the source of the Arabesque.

There can be little doubt that the East Roman provinces became increasingly familiar with Oriental or non-Western forms of decoration in the centuries leading up to the end of antiquity, but such Oriental ornament was itself permeated with motifs and schemata of Hellenistic derivation by this time. Today few scholars would still ascribe to the Orient the overwhelming role in the development of late antique decorative arts once claimed by Strzygowski and his followers. Early Byzantine ornament evolved primarily as the final phase of an unbroken development reaching back to Classical times, as Riegl long ago maintained, and as subsequent studies like those of Weigand and Deichmann have repeatedly confirmed.

h. Figure 144, the spandrel decoration of the lower nave arcade in Hagia Sophia. For photographic illustrations see E. H. Swift, *Hagia Sophia* (New York, 1940), pls. 24, 27; H. Kähler, *Hagia Sophia* (New York and Washington, D.C., 1967), pls. 70, 74; and A. Grabar, *The Golden Age of Justinian from the Death of Theodosius to the Rise of Islam* (New York, 1967), fig. 314. For a discussion of the decoration see Deichmann, *Architektur Konstantinopels*, 76–84, esp. 77, fig. 21.

i. The apse mosaic in the atrium or chapel adjoining the Lateran Baptistry in Rome probably dates to the remodeling of the building under Pope Sixtus III between 432 and 440; see G. Matthiae, *Mosaici medioevale delle chiese di Roma* (Rome, 1967), pl. 76; W. Oakeshott, *The Mosaics of Rome from the Third to the Fourteenth Centuries* (Greenwich, Conn., 1967), fig. 72; G. Bovini, *Mosaici paleocristiani di Roma (secoli III–VI)* (Bologna, 1971), 133–35, fig. 23; and H. P. L'Orange, "The Foral Zone of the Ara Pacis Augustae," *The Roman Empire. Art Forms and Civic Life* (New York, 1985), fig. 134. For the vault mosaics of the presbytery of San Vitale in Ravenna, see Grabar, *Age of Justinian*, fig. 123; F. W. Deichmann, *Ravenna, Hauptstadt des spätantiken Abendlandes*, vol. 3 (Wiesbaden, 1958), pl. 311; Krautheimer, *Early Christian Architecture*, fig. 190. The scheme of these Roman and Ravennate mosaics is traceable to Hellenistic and Roman forerunners; cf. esp. the lower zone of the Ara Pacis Augustae in Rome where a central acanthus calyx emits two horizontal tendrils along the base of the composition from which a series of additional vertical tendrils emanate (E. Simon, *Ara Pacis Augustae* [Greenwich, Conn., 1967], pls. 3–4, 18), or the House of Menander at Pompeii where such a tendril composition already decorates an apse in stucco (A. Maiuri), *La casa del Menandro e il suo tesoro di argenteria* [Rome, 1933], 92–96, fig. 44, pl. 10). The more diagonal, undulating schema of figure 144, however, is paralleled more closely by the acanthus tendril decoration of the lower zone in the Orthodox

Baptistry in Ravenna (Deichmann, *Ravenna*, pls. 40, 88–95; and Grabar, *Age of Justinian*, fig. 19; Krautheimer, *Early Christian Architecture*, 142).

j. For the Hagia Sophia capitals of the kind shown in figure 145 and their decoration see Kautzsch, *Kapitellstudien*, 194–95, and pl. 38, no. 644a; and Deichmann, *Architectur Konstantinopels*, 79–80, fig. 23.

k. The pointed elliptical or ogival configuration of the tendril to which Riegl refers here resulted initially from simpler patterns that juxtaposed two parallel continuous running tendrils. By late Hellenistic and Roman times paired tendrils in this repeating ogival schema were commonly applied to pilasters or vertical borders in architectural decoration; see J.M.C. Toynbee and J. B. Ward-Perkins, "Peopled Scrolls: A Hellenistic Motif in Imperial Art," *Papers of the British School at Rome* 18 (1950): 21, and pl. 18; P. Pensabene, "La decorazione architettonica di Cherchel: cornici, architravi, soffitti, basi, e pilastri," in *150-Jahr-Feier des Deutschen Archäologischen Instituts, Rom, 4–7 Dezember, 1979*, Römische Mitteilungen, Erganzungsband, 25, (Mainz, 1982), 116–79, esp. 149ff., pls. 44, no. 1; 49, no. 6; 52, nos. 3–4; 53, no. 4; D. E. Strong, *Roman Art* (Harmondsworth, 1976), fig. 37; and Simon, *Ara Pacis Augustae*, pl. 6. The basic scheme could also be extended as an all-over pattern like that on the intrados of the arch above the capital illustrated in fig. 145. But this more elaborate arrangement already appears on a Late Classical or Hellenistic Greek textile from Kertch, a portion of which is reproduced in G.M.A. Richter *A Handbook of Greek Art* [London and New York, 1969], fig. 506). It is adapted to a radial format on the gilt silver dish from Chertomlyk (M. I. Artamonov, *The Splendor of Scythian Art. Treasures from Scythian Tombs* [New York and Washington, D.C., 1969], pls. 177, 179). What distinguishes the early Byzantine version in figure 145 from such antecedents is the more abstract treatment of the vegetal detail and the greater symmetry or regularity in the overall repetition of the basic elements. For patterns similar to figure 145 in the contemporary Sassanian Persian architectural decoration at Nizamabad, see J. Kroger, *Sasanidischer Stuckdekor*, Baghdader Forschungen, 5 (Berlin, 1982), pl. 66, nos. 1–3.

l. Regarding this so-called Constantinian interlace see E. Lexow, "Hovedlinierene i entre lacornamentikkens Historie," *Bergens Museums Aarbok* (1921–1922): 26–36; R. Gabrielsson, *Kompositionsformer i senkeltisk orneringsstil. Sedda mot bakgrunden av den allmäneuropeiska konstutvecklingen*, Kungliga Vitterhets Historie och antikvitets akadamiens Handlingar, 58, no. 2 (Stockholm, 1945), 19–28, and N. Aberg, *The Occident and the Orient in the Art of the Seventh Century* Kungliga Vitterhets Historie och antikvitets akadamiens Handlingar, 56, nos. 1–3 (Stockholm, 1943–1947), 2:30–32, 69–75.

m. For figure 146, from the outer galleries at Hagia Sophia, see Kautzsch, *Kapitellstudien*, 197, pl. 39, no. 651; H. Jantzen, *Die Hagia Sophia Kaisers Justinian* (Cologne, 1967), pl. 17. Simple looped interlace patterns arranged in this more angular trapezoidal manner are fairly common in the late antique art of the Roman East; they occur on imported marble church furnishings in Ravenna, the mosaic pavements of Palestine and the Levant, and the wall paintings of monasteries in Egypt. See Lexow, *Bergens Museums Aarbok* (1921–1922): 29, pl. 3; Aberg, *Occident and Orient*, 2:32, and fig. 27; Deichmann, *Ravenna*, vol. 1, fig. 79; G. Bovini, ed., *Corpus della scultura paleocristiana, bizantina ed altomedioevale di Ravenna*, vol. 1, P. A. Martinelli, *Altari, amboni*, etc., (Rome, 1968), fig. 124; J. W. Crowfoot and C. Kraeling, *Gerasa, City of the Decapolis* (New Haven, Conn., 1938), pls. 13a–b, 77, and M. Avi Yonah, "Mosaic Pavements in Palestine," *Quarterly of the Department of Antiquities of Palestine* 3 (1939): 51, no. 342, pl. 15, no. 1 (republished as M. Avi Yonah, *Art in Ancient Palestine. Selected Studies* [Jerusalem, 1981], pl. 45, 1).

The pavements and wall paintings of this region indicate the development of new and more complex types of interlace in the early Byzantine provinces of the East that often went well beyond the level of elaboration achieved in the late antique West. See, for example, Avi Yonah, *Quarterly of the Department of Antiquities of Palestine* 3 (1939), pl. 15, nos. 2–3, and idem, "The Byzantine Church at Suhmata," *Quarterly of the Department of Antiquities of Palestine* 3 (1939): 94–96, and pls. 27, no. 2; 29, nos. 2, 8 = Avi Yonah, *Ancient Palestine*, pls. 45, nos. 2–3; 48, no. 3; M. Chéhab, "Les caractèristiques de la mosaïque au Liban," in *Colloque internationale sur la mosaïque gréco-romaine, Paris, 29 Aug.–3 Sept. 1963* (Paris, 1965), 333–37, fig. 10; W. Harvey, "Recent Discoveries at the Church of the Nativity in Bethlehem," *Archaeologia* 87 (1938), pl. 7; J. Clédat, *Le monastère et la nécropole de Baouit* (Cairo, 1904), pls. 57–71; J. Quibell, *Excavations at Saqqara*, III (Cairo, 1909), pls. 9 and 10, no. 1. For a closer analysis of the interlace decoration in these regions in late antiquity and its impact upon other areas see W. Holmquist, *Kunstprobleme der Merowingerzeit*, Kungliga Vitterhets Historie och antikvitets akadamiens Handlingar, 47 (Stockholm, 1939), 29–97; and Gabrielsson, *Kompositionsformer*, 55–66. It was these forerunners from the immediately pre-Islamic period in Egypt and the Levant that led directly to the even more complex interlace patterns produced under early Arab rule at sites like Khirbat al-Mafjar; see Lexow, *Bergens Museums Aaarbok* (1921–1922): 84–89; Gabrielsson, *Kompositionsformer*, 70–72; Aberg, *Occident and Orient*, 2:62–68; O. Grabar, *The Formation of Islamic Art* (New Haven, Conn. and London, 1973; 2d rev. ed., New Haven, Conn., 1987), fig. 71; R. Ettinghausen and O. Grabar, *The Art and Architecture of Islam: 650–1250* (Harmondsworth, 1987), fig. 25; and R. W. Hamilton, *Khirbat al-Mafjar* (Oxford, 1959), pls. 79–82, 84, 87–88, 97–99.

n. On the acanthus ornament in the church of Sts. Sergius and Bacchus see Deichmann, *Architektur Konstantinopels*, 72–76, figs. 19–20.

o. For the tie beam and see A. M. Schneider, *Die Hagia Sophia zu Konstantinopel* (Berlin, 1939), figs. 34, 42; Grabar, *Age of Justinian*, fig. 312; and esp. C. Sheppard, *Dumbarton Oaks Papers* 19 (1965): 237–40. Scientific analysis now places the decorated covering of the beams firmly in the first half of the ninth century. Sheppard discusses the circumstances that may have contributed to the apparent Islamic quality of these ornaments. Although he points to the evidence for Islamicizing current in the imperially sponsored decorative arts in early ninth-century Byzantium, Sheppard follows the earlier opinion of A. Grabar (*Sculptures byzantines de Constantinople IV–X siècles*, Bibliothèque archéologique et historique de l'Institut Français d'Archéologie d'Istanbul, 17 [Paris, 1963], 100–122), who explains such ninth-century ornament as part of a revival of Justinianic decoration that was already strongly orientalized.

Central to the problem of Oriental connections in Justinianic art are the sumptuous decorations from the Church of Hagios Polyeuktos in Constantinople erected by Juliana Anicia between 524 and 527. These, as scholars have long noted, display the evident impact of contemporary Sassanian Persian floral ornament; see C. Mango and I. Sevcenko, "Remains of the Church of Polyeuktos at Constantinople," *Dumbarton Oaks Papers* 15 (1961): 243–47; R. M. Harrison and N. Firatli, "Examinations at Sarachane in Istanbul. Preliminary Reports," *Dumbarton Oaks Papers* 19 (1965): 231–36, figs. 8–11; 20 (1966): 223–38, figs. 12, 14; 21 (1967): 273–78, figs. 11–14; R. M. Harrison, *A Temple for Byzantium: The Discovery and Excavation of Anicia Juliana's Palace-Church in Istanbul* (London, 1989). Also see Krautheimer, *Early Christian Architecture*, 230–33, figs. 176–77; and F. W. Deichmann with J. Kramer and U. Peschlow, *Corpus der Kapitelle der San Marco zu Venedig* (Wiesbaden, 1981), 138–41, with additional bibliography. Aberg (*Occident and Orient*, 2:36–61, esp. 42–49) had already attempted a detailed considera-

tion of such decoration and the wider problem of connections between the arts in early Byzantium and those of the Sassanian empire, although the few sculptures from Hagios Polyeuktos that were known at the time had not yet been attributed to this church. The Polyeuktos sculptures represent the earliest and most direct phase of a Sassanian impact that continued into later Justinianic art, including various details of the Hagia Sophia decorations as seen in figure 155. The relation between Sassanian and early Byzantine ornament is a complex and problematic issue that will be treated more fully in the last annotation for this chapter. But Riegl was clearly on the right track in looking to Justinianic precedent to explain the orientalizing quality of later Byzantine ornament like figure 151.

p. The decorations in figure 152 are the details of a third style wall painting from Herculaneum now in the Museo Nazionale in Naples (inv. 9878). For photographs see V. Spinazzola, *Le arti decorative in Pompeii e nel Museo Nazionale di Napoli* (Milan, Rome, Venice, and Florence, 1928) pl. 100, and M. R. Boriello et al., *Le collezioni de Museo Nazionale di Napoli* (Rome, 1986), 130–31, cat. no. 47. For similar third style painted ornament see annotation *aa* for chapter 3B.10, above.

q. For figures 154–55, marble *opus sectile* incrustation from the nave arcade and piers of the gallery story in Hagia Sophia see Schneider, *Hagia Sophia*, n. 29, figs. 45, 49; Swift, *Hagia Sophia*, pl. 44, Kähler, *Hagia Sophia*, pls. 64, 70; and Deichmann, *Architektur Konstantinopels*, 78, 80, fig. 22. On these decorations also see Strzygowski (*Altai-Iran und Völkerwanderung*, 231–32, fig. 189), who claimed the impact of Iranian art and even Iranian craftsmanship for such marble inlay ornament.

r. For the pyramidal monument at El Barah, whose frieze is illustrated in fig. 157, see H. C. Butler, *Early Churches in Syria. Fourth to Seventh Centuries*, E. Baldwin Smith, ed. (Princeton, N.J., 1929), 225, ill. 234D. For the decoration of the frieze itself, see Aberg, *Occident and Orient*, 2:48–50, fig. 47; and E. Kühnel, *The Arabesque. Meaning and Development of an Ornament* (Graz, 1977), pls. 1a–1b. Very similar ornament also appears at the site of Babiska in Syria (Butler, *Early Churches*, 228, ill. 246). Also see G. Tchalenko, *Villages antiques de la Syrie du nord*, Institut Français d'Archéologie de Beyrouth, Bibliothèque Archéologique et Historique, 1 (Paris, 1953–1958), 32 n. 1, pl. 12. On the late fifth-century date of the buildings at El Barah, see Krautheimer, *Early Christian Architecture*, 150.

s. More recent scholarship tends to see the Studios decorations and their forerunners in the Golden Gate and propylon of Hagia Sophia as the immediate outgrowth of the architectural sculpture of Roman Asia Minor (see annotation *f* just above). Moreover, the El Barah tomb and the other Syrian monuments in this style cannot be considered the prototypes of the frieze in the Studios basilica since they are probably two or more decades later, and they may in fact reflect the impact of imperial initiative and patronage under the emperor Zeno in the eastern provinces between 475 and 491 (see Krautheimer, *Early Christian Architecture*, 149–65). But as indicated earlier in annotation *f* above, the sharply stylized acanthus ornament exemplified by the frieze from El Barah was widespread all across the Eastern provinces during the fifth century, and its origins are ultimately traceable to the more easterly regions of the empire in earlier imperial times.

t. Figure 158 is from the border of the apsidal arch in the church at Qalb Lozeh; see Butler, *Early Churches in Syria*, 223, ill. 232 B; and Grabar, *Age of Justinian*, fig. 48. On the date of this church ca. A.D. 500, see Krautheimer, *Early Christian Architecture*, 160.

u. For a more recent evaluation of the role of native Egyptian vs. Greco-Roman traditions in the formation of the Coptic or late antique art of Egypt, see K. Wes-

sel, *Coptic Art* (New York, 1965); and P. du Bourget, *L'art copte* (Paris, 1968), 72–108. E. Kitzinger (*Archaeologia* 87 [1938]: 181–215) has stressed the Hellenistic sources of the body of sculpture exemplified by figure 159, whose upper-class patrons he considers to have been of Greek extraction.

v. For the pediment from Ahnas (Herakleopolis) in figure 159, see Kitzinger, *Archaeologia* 87 (1938), pl. 70, no. 4; J. Beckwith, *Coptic Sculture 300–1300* (London, 1963), 20, fig. 68; and du Bourget, *L'art copte*, pl. 14. The figural scene is thought to represent Orpheus and Eurydice. Since Riegl's time, the best analysis of the acanthus ornament on these sculptures and their relation to the architectural decoration in the other eastern provinces is still that of Kitzinger (esp. 183–93) who, despite their pagan imagery, dates them to the mid fifth century, about contemporary with the Studios basilica. Beckwith also accepts this later chronology, but du Bourget prefers a fourth-century date. For a more recent review of the archaeological evidence supporting the earlier date, see H. G. Severin, "Zur Süd-Kirche von Bawit," *Mitteilungen des Deutschen Archäologischen Instituts Abteilung Kairo* 33 (1977): 121, and n. 60.

w. Here again see Kitzinger, *Archaeologia* 87 (1938): 193ff., who explains these Coptic sculptures as a distinct regional variation of a more abstract approach to acanthus ornament current in the other East Roman provinces at this time.

x. Cf. Grabar (*Formation of Islamic Art*, 204–5), who has observed that the Arabesque in its more typical form never fully supplanted the more traditional types of tendril ornament in Islamic decorative arts.

y. In the course of time the Byzantine provinces of western Asia Minor would come to reflect the styles and developments of the capital, although initially in the fourth and earler fifth centuries it was the western Asiatic coastland that had played the formative role in the development of architectural decoration in early Constantinople. When Riegl wrote, the evidence for this development was still largely unknown; the systematic archaeological exploration of Asia Minor would only begin in the early twentieth century. For surveys of this material see Strzygowski, *Kleinasien, ein Neuland des Kunstgeschichte*; H. Rott, *Kleinasiatische Denkmäler* (Leipzig, 1908); W. M. Ramsay and G. L. Bell, *The Thousand and One Churches* (London, 1909); J. Keil and A. Wilhelm, *Denkmäler aus dem Rauhen Kilikien* (Manchester, 1931); S. Guyer, *Grundlagen mittelalterlicher abendländischer Baukunst* (Einsiedeln, Zurich, and Cologne, 1950); G. H. Forsyth, "Architectural Notes on a Trip through Cilicia," *Dumbarton Oaks Papers* 11 (1957): 223–36; and E. Rosenbaum, G. Huber, and S. Onurkan, *A Survey of Coastal Cities in Western Cilicia* (Ankara, 1967). Also see Krautheimer, *Early Christian Architecture*, 112–17, 170–76, 496–97 nn., 499 nn., for a good overview and additional bibliography. The architectural decoration of these monuments is related to that in contemporary Syria, and as such it illustrates the same tendencies as the other material utilized here by Riegl.

z. For the most recent survey of the rock-cut barrel-vaulted iwan or grotto of Chosroes II (Khusrau Parviz) at Taq-i-Bustan, see S. Fukai and K. Horiuchi, *Taq-i-Bustan*, 2 vols. (Tokyo, 1969–1972). The monument has been the focus of numerous modern studies, beginning with that of E. Herzfeld, *Am Tor von Asien* (Berlin, 1920), 57–139. K. Erdmann ("Das Datum des Tak-i Bustan," *Ars Islamica* 4 [1937]: 79–97) attributed the monument to the reign of Peroz (457/59–484). The following year, Herzfeld ("Khosraw Parviz unter Taq-i-Vastan," *Archäologische Mitteilungen aus Iran* 9 [1938]: 91–158) challenged Erdmann's thesis, making a strong case for connecting the large iwan and its reliefs with Chosroes II (590–628), as earlier scholarship had done. Despite Erdmann's repeated attempts to sustain the earlier dating, scholars have generally accepted and confirmed Herzfeld's attribution to the late Sassanian period. For a thorough and critical discussion of the

controversy and the evidence for Chosroes II, see H. Luschey, "Zur Datierung der sasanidischer Kapitelle aus Bisutun und des Monuments von Taq-i-Bostan," *Archäologische Mitteilungen aus Iran*, N.F., 1 (1968): 129–42. For photographs of the overall monument see K. Erdmann, *Die Kunst Irans zur Zeit der Sasaniden* (1943; reprint, Mainz, 1969), pls. 7–8; F. Sarre, *Die Kunst des alten Persien* (Berlin, 1923), pl. 84; Herzfeld, *Am Tor von Asien*, pl. 42; R. Ghirshman, *Persian Art. The Parthian and Sassanian Dynasties 249 B.C.–A.D. 651* (New York, 1962), fig. 235; A. U. Pope and P. Ackerman, eds., *Survey of Persian Art* (Oxford, 1938–58), vol. 4, pls. 159–60, 167–68; and Fukai and Horiuchi, *Taq-i-Bustan*, vol. 2, pl. 1.

aa. Figure 161 illustrates a capital now located at the site of Taq-i-Bustan, but which came originally from a Sassanian monument at Bisutun. This illustration does not reproduce the more reliable archaeological drawings of Flandin and Coste; instead it comes from O. Jones's pattern book, *The Grammar of Ornament* (London, 1856), pl. 14, which erroneously depicted this capital and the similar example from Isfahan as relief patterns projected against a larger background plane, like the rock-cut pilaster capital in figure 162 (which is accurately portrayed). In reality, the capitals from Bisutun and Isfahan were of a freestanding, pyramidal, or "impost" type decorated on all four sides; figure 161 shows the ornament on one of the faces of the Bisutun example. For Sassanian capitals of this kind see Herzfeld, *Am Tor von Asien*, 104–21, pls. 57, 59–60; K. Erdmann, "Die Kapitelle am Taq-i-Bostan," *Mitteilungen des Deutsches Orient-Gesellschaft* 80 (1943): 2ff.; M. van Berchem, in K.A.C. Creswell, *Early Muslim Architecture*, vol. 1, *Umayyids* (Oxford, 1932), 206–7; and above all Luschey, *Archäologische Mitteilungen aus Iran*, N.F. 1 (1968): 137–42, fig. 2, pls. 51–54. Good illustrations of the capital in figure 161 also appear in Sarre, *Alten Persien*, pl. 93; Pope and Ackerman, *Survey of Persian Art*, vol. 4, pl. 153b; A. U. Pope, *Persian Architecture: The Triumph of Form and Color* (New York, 1965), pl. 61; and Kroger, *Sasanidischer Stuckdekor*, pl. 40, no. 2.

The Sassanian impost capitals are of the same type as the Byzantine example illustrated in figure 146. Deichmann (*Architektur Konstantinopels*, 49–55) considered the Byzantine examples to be a Constantinopolitan development of the sixth century in which the previously distinct elements of the capital and the truncated pyramidal impost above it merged into a single, unified form (cf. the early example at Sts. Sergius and Bacchus, in Deichmann, fig. 20). He was inclined to see the Sassanian examples as a separate development, although Kautzsch (*Kapitellstudien*, 205) had already suggested a Byzantine inspiration for those in Iran. The detailed and critical reconsideration of the problem by Luschey, *Archäologische Mitteilungen aus Iran*, N.F. 1 [1968], esp. 137–42) has fully confirmed Kautzsch's opinion. The basic concept of the capital had not played as significant a role in the development of Sassanian architecture as it had in the Mediteranneanean world, where the evolutionary process leading to the creation of the impost capital in late antiquity is entirely clear. Luschey's arguments concerning the chronology of the Sassanian examples are also decisive; they all date to the end of the sixth or early seventh century, well after the type had become established in Byzantine architecture.

bb. Figure 162 is a pilaster capital carved in low relief into the living rock of the iwan or grotto at Taq-i-Bustan. The capital form is unusual among stone monuments. Herzfeld (*Am Tor von Asien*, 104–8, and *Iran in the Ancient East* [London and New York, 1941], 210–12) compared it to examples in the wooden vernacular architecture of Iran; cf. O. Reuther in Pope and Ackerman, *Survey of Persian Art*, 1:520–21. For photographic illustrations see Herzfeld, *Am Tor von Asien*, pl. 54; Sarre, *Alten Persien*, pl. 92; Erdmann, *Die Kunst Irans*, pl. 9; Pope and Acker-

man, *Survey of Persian Art*, vol. 3, 2701, fig. 908; vol. 4, pl. 168a; Pope, *Persian Architecture*, pl. 59; Creswell, *Early Muslim Architecture*, 207, fig. 254; and Fukai and Horiuchi, *Taq-i-Bustan*, vol. 2, pls. 56–59, 61–62.

cc. Figure 164 is the lower border another Sassanian impost capital from Bisutun, and also now at Taq-i-Bustan; see Pope, *Persian Architecture*, pl. 62, top; Erdmann, *Die Kunst Irans*, pl. 13, bottom; and Herzfeld, *Am Tor von Asien*, pl. 59, bottom.

dd. Since Riegl's time, the art of Sassanian Iran has been the object of considerable study; for a good introduction and overview, see the works of Herzfeld, *Am Tor von Asien*; Pope and Ackerman, *Survey of Persian Art* 1:493–830; Erdmann, *Die Kunst Irans*; Ghirshman, *Persian Art*, 119–254; and E. Porada, *The Art of Ancient Iran. Pre-Islamic Cultures* (New York, 1965), 192–225. These works are an excellent source for earlier bibliography. The more recent monograph by Kroger, *Sasanidischer Stuckdekor*, addresses a wide range of issues beyond the immediate scope of his subject, and it is also an excellent bibliographic resource.

Here it is impossible to do justice to the complex and problematic nature of post-Achaemenid Persian art. Nevertheless, the subject has enormous bearing upon the validity of Riegl's thesis, particularly concerning the Greco-Roman contribution to Arabesque ornament, and it therefore requires some discussion. One should not, of course, underestimate the role of ancient Near Eastern artistic and architectural traditions, techniques, and principles of design that remained current beyond the Achaemenid period, or that may even have been revived under the Sassanian dynasts as a conscious reference to their ancient Iranian origins; see Porada, *Ancient Iran*, 192; Ghirshman, *Persian Art*, 257–78; and R. N. Frye, "Achaemenid Echoes in Sasanian Times," *Archäologische Mitteilungen aus Iran*, Erganzungsband, 10 (1983): 247–52. Yet Sassanian art was very much an outgrowth of the new cultural and political circumstances that resulted in the centuries following the Greek conquest and domination of western Asia under Alexander and his successors.

Even after the expulsion of the Seleucid Greek rulers from Mesopotamia and Iran, Hellenistic modes or styles remained a significant component in the art of the succeeding Parthian dynasty, just as they did in the contemporary Greco-Bactrian art of Central Asia, and the Kushan and Gandaharan or Greco-Buddhist art of northern India. In the course of time, the foreign, Hellenistic element in this "Greco-Iranian" art often gave way to native Asiatic traditions in all these areas, only to be rekindled periodically by new Western contacts. The studies by Ghirshman (*Persian Art*, 257–78) and especially D. Schlumberger ("Descendants non-méditerranéens de l'art Grec," *Syria* 37 [1960] 142ff.; idem, "Nachkommen der griechischen Kunst ausserhalb des Mittelmeerraums," in F. Altheim and J. Rehork, *Der Hellenismus in Mittelasien* [Darmsdtadt, 1969]; and Schlumberger, *L'Orient hellénisé. L'art grec et ses héritiers dans l'Asie non-méditerranéene* [Paris, 1970]) provide the most thorough and extensive overview of the evidence and earlier scholarship on the interaction of Greek and Asiatic art across this vast region between the third century B.C. and the second century A.D. However, M.A.R. Colledge (*Parthian Art* [Ithaca, N.Y., 1977], 138–44) has questioned the degree of unity or interrelation that Schlumberger would ascribe to the overall process.

In the third century A.D., the art of the Sassanian empire emerged as the direct heir to the Parthian and related arts from Mesopotamia to central Asia and North India. It had come about as the progeny of a long and widespread process of adaptation of Hellenistic or Greco-Roman forms by the indigenous peoples throughout

these areas. Yet it is clear that the Greek or Mediterranean impact did not arrive in any one stylistic phase, period, or region; it was erratic and cumulative, the product of many successive stages of assimilation and transformation according to varied native Asiatic tastes and sensibilities. Consequently, the Hellenistic artistic component or legacy had by Sassanian times become an integral feature whose foreign aspect was no longer wholly clear or readily definable.

One can no longer follow Riegl in including Sassanian Persian art bodily within the later antique Mediterranean artistic tradition. But his approach to this material marked a turning point in the recognition of the formative role played by Greek and Roman art in the arts of later pre-Islamic Mesopotamia and Iran. The basic motifs and schemata of most Sassanian floral ornament did not depend directly on the native Near Eastern traditions that had survived intact up to Achaemenid times. In the aftermath of the Achaemenid collapse, the old Oriental decorative forms and patterns had gradually given way to the newer Hellenized transformations or versions of the ancient types, especially the acanthus; there are, in fact, few Sassanian floral patterns whose components or overall structure are not most immediately traceable to Mediterranean forerunners, as various scholars have repeatedly observed; cf. J. Baltrusaitis, "Sassanian Stucco," in Pope and Ackerman, *Survey of Persian Art*, 1:621–27; Aberg, *Occident and Orient*, 2:44–46; Porada, *Ancient Iran*, 211–12; and most recently, Kroger, *Sasanidischer Stuckdekor*, 68, 95–96, 101, 127. Even the so-called Sassanian palmette or palmette tree is traceable to the type of acanthusized palmettes in the friezes of Diocletian's buildings at Spalato (cf. Kroger, fig. 55, pl. 39, to Riegl's figs. 133–36, and Niemann, *Palast des Diokletians*, figs. 82, 107). In this sense and to this extent, Riegl's approach to Sassanian floral ornament remains valid. The point is of considerable importance since subsequent scholarship has shown that Sassanian decorative arts were a vital factor in the formation of early Islamic ornament, in addition to early Byzantine forerunners. The Arabesque was indeed derived from Greco-Roman sources, although not only directly via late antique or Byzantine prototypes but also from the Hellenized Iranian artistic traditions that had long evolved across the regions from Mesopotamia to India.

The dynamics of the continued interaction between early Byzantine and later Sassanian floral ornament are not easy to determine, since this process was certainly not one-sided. From the third century on, the Romans and their early Byzantine successors in the East competed constantly with the vast and wealthy Sassanian empire beyond the Euphrates, which led inevitably to the exchange of goods, craftsmen, and ideas through war, diplomacy, or trade. In the domain of the decorative arts, such interchanges became ever easier as the taste for the abstraction or stylization of vegetal forms among the Romans or Byzantines of Late Antiquity gradually came more into line with transformations of Hellenistic floral ornament that had long been current in Mesopotamia and Iran. On the Sassanian side, this resulted in the borrowing of the Byzantine truncated pyramidal or impost capital with acanthus or tendril ornament (see annotation *aa* just above). In the corresponding decorative arts of Constantinople, one encounters acanthus or palmette ornament with distinctive Sassanian features, as in the sculptures of Hagios Polyeuktos and certain of the decorations in Hagia Sophia (see annotation *o* just above). There are also striking similarities between the typical acanthus palmette decorations of Sassanian stucco reliefs and fifth-century architectural sculpture in Antioch; cf. Grabar, *Age of Justinian*, fig. 301. And while the acanthusized palmette trees of the so-called Visigothic sarcophagi produced in southwest France in the later fifth and sixth centuries are intelligible as the progeny of earlier Mediterranean forerunners, they often come quite close to Sassanian patterns; see

J. B. Ward-Perkins, "The Sculpture of Visigothic France," *Archaeologia* 87 (1938): 79–128, esp. 94, fig. 3, no. 7, and pls. 31, no. 9; 32, nos. 4, 6–7; 35, nos. 2, 3, 6–7; B. Briesenick, "Typologie und Chronologie der südwest-gallischen Sarkophage," *Jahrbuch des Römisch-Germanischen Zentralmuseums in Mainz*, 9 (1962): 76ff., pls. 20, nos. 2–3; 21, nos. 1–3; 23, no. 4; and Grabar, *Age of Justinian*, fig. 295; cf. Kroger, *Sasanidischer Stuckdekor*, 99, fig. 55, pl. 39.

Late Sassanian works like the sculptures from Taq-i-Bustan also reflect the impact of the Hellenized floral ornament of India and Central Asia; see M. Dimand, "Studies in Islamic Ornament. 2, The Origin of the Second Style of Samarra Decoration," in G. Miles, ed., *Archaeologia Orientalia in Memoriam Ernst Herzfeld* (Locust Valley, N.Y., 1952), 67–68; and Kroger, *Sasanidischer Stuckdekor*, 100. The elaborate blossoms like the one on the capital in figure 161 derive from an Indian type that first appears in the sculptures at sites such as Sanchi and Pitalkhora in the second or early first century B.C. The lush and exuberant treatment of the acanthus on figure 161 and the closely related flanking reliefs of the main iwan at Taq-i-Bustan (Sarre, *Alten Persien*, pl. 90; Erdmann; *Die Kunst Irans*, pl. 10; Pope and Ackerman, *Survey of Persian Art*, vol. 4, pls. 167, 168c; Kroger, *Sasanidischer Stuckdekor*, pl. 40, no. 3) is also analogous to Indian forerunners like those in the Amaravati sculptures of the second century A.D., and examples in sculpture and painting from Deogarh, Ajanta, and Maisur of the fifth or sixth and seventh centuries. The smaller lateral blossoms of figures 161–62 have parallels in the ornament of the fifth to sixth century Sarnath Buddha and the cave paintings at Madhya Pradesh and Ajanta. For these Indian comparisons see P. Stern and M. Bénisti, *Evolution du style indien d'Amaravati* (Paris, 1961), pls. 9, 16a, 48a, bottom; C. Sivaramamurti, *The Art of India* (New York, 1974), fig. 104; C. Sivaramamurti and M. Bussagli, *Five Thousand Years of the Art of India* (New York, 1971), fig. 128; H. Härtel and J. Auboyer, *Indien und Südostasien*, Propyläen Kunstgeschichte, 16 (Berlin, 1971), figs. 28, 53b, 104b, 116; pl. 7; J. C. Harle, *The Art and Architecture of the Indian Subcontinent* (Harmondsworth, 1986), figs. 33, 84, 85, 87, 95. If Seyrig (*Syria* 18 [1940]: 289–91) was correct in seeing a connection between the vegetal architectural decoration of Palmyra and that of Amaravati during the earlier Roman and Parthian periods, then the Hellenized Indian elements of late Sassanian monuments like Taq-i-Bustan may only represent the adavanced stage of a more long-standing artistic relationship. And in the light of such connections, one begins to sense the true extent and complexity of the Hellenistic or Greco-Roman and Asiatic artistic melange that contributed ultimately to the formation of the Arabesque.

CHAPTER 4. B. EARLY ISLAMIC TENDRIL ORNAMENT

a. The patterns of figures 165–68 represent what is now generally acknowledged as the "beveled style" of early Islamic ornament. The most comprehensive source for the rich and varied decorations of this kind in the Mosque in Ibn Tulun shown here is still A. Prisse d'Avennes, *L'art arabe d'après les monuments de Caire, depuis le VIIe siècle jusqu'à la fin du XVIIIe* (Paris, 1877), pl. 44. Also see the abbreviated survey by the same author, *La décoration arabe* (Paris, 1885), which reproduces the same set of patterns on plate 91. For the decorated stucco and wood panels of this kind from the Mosque and elsewhere in Egypt, also see E. Herzfeld, "Die Genesis der islamischen Kunst und das Mshatta Problem," *Der Islam* 1 (1910): 36–49, figs. 1–10, and pl. 3; K.A.C. Creswell, "Some Newly Discovered Tulunid Ornament," *Burlington Magazine* 35 (1919): 180–88; idem, *Early Muslim Architecture*, vol. 2, *Early Abbasids and Tulunids* (Oxford, 1940), 342–45,

pls. 100–114; idem, *A Short History of Muslim Architecture* (Harmondsworth, 1958), 289–90; *The Mosques of Egypt*, Egyptian Ministry of Waqfs, Survey of Egypt (Giza, 1949), pl. 8; F. Shafi'i, *Simple Calyx Ornament in Islamic Art. A Study in Arabesque* (Cairo, 1957), 195–97, 224–30, and pls. 21, 48, 52; J. Sourbel-Thomine and B. Spuler, *Die Kunst des Islam*, Propyläen Kunstgeschichte, 4 (1973), pl. 133a–c; L. Golvin, *L'essai sur l'architecture réligieuse musulmane*, vol. 3, L'architecture réligieuse des "Grands Abbasids" (Paris, 1974), 94–120, esp. 117 and fig. 59; and E. Kühnel, *The Arabesque. Meaning and Development of an Ornament* (Graz, 1977), 16, fig. 6, and pl. 6.

When *Stilfragen* appeared, these Egyptian decorations were still considered the most representative examples of ninth-century Islamic ornament. In less than two decades, the excavations at the mid ninth-century Abbasid capital of Samarra in northern Mesopotamia would prove that this was the region where the beveled style of Islamic monumental art had first come to maturity (E. Herzfeld, *Der Wandschmuck der Bauten von Samarra und seine Ornamentik*, vol. 1, *Die Ausgrabungen aus Samarra*, forschungen zur islamischen Kunst, 1 [Berlin, 1923]). In his discussion of the material, Herzfeld built extensively on Riegl's analysis and terminology; he emphasized the "Samarra Style" as the beginning of the Arabesque proper, and his extensive and detailed treatment of the material largely reaffirmed Riegl's thesis that such decoration was ultimately traceable to Hellenistic or Greco-Roman traditions of floral ornament that had existed in the East Roman Empire up through the period of the Islamic conquest (see esp. 10–14, 34–35). The more recent reviews of the origins of the Samarra or beveled style by Shafi-i (*Simple Calyx Ornament*, 216–20) and H. G. Franz (*Palast, Moschee und Wüstenschloss. Das Werden der islamischen Kunst 7.–9. Jahrhundert* [Graz, 1984], 139–56) have emphasized the radically innovative quality of this ornament within the early Islamic development, but once again stressing the ultimately Hellenistic or Greco-Roman sources.

Herzfeld's findings were extremely important, since a few years earlier Strzygowski had challenged this view of Islamic decoration. In *Altai-Iran und Völkerwanderung. Ziergeschichtliche Untersuchungen über den Eintritt der Wander- und Nordvölker in die Treibhäuser geistigen Lebens* (Leipzig, 1917), 88–98, and 175–98, J. Strzygowski questioned the basic vegetal aspect or origin of such ornament and its Mediterranean background, preferring instead to trace the Samarra and Tulunid styles to an abstract, geometric, or zoomorphic decorative tradition that he considered indigenous to the Iranian and Turkic nomads of central Asia, whose impact could be discerned from ancient China to central Europe in the early Middle Ages. This hypothesis, at least regarding the origin of the beveled or Samarra styles, has found adherents among specialists in Islamic art, who have explained the putative nomadic impact in connection with the portable artifacts or personal adornments of central Asiatic Turkic tribesmen, many of whom were recruited as mercenaries under the Abbasids; see E. Diez, *Die Kunst der islamischen Völker*, Handbuch der Kunstwissenschaft (Berlin, 1917), 68; M. Dimand, "Ornament in Near Eastern Art," *The Metropolitan Museum of Art Bulletin* 28 (1933): 141–45; idem, "Studies in Islamic Ornament, 2," G. Miles, ed., *Archeologia Orientalia Ernst Herzfeld* (Locust Valley, N.Y., 1952), 64; Creswell, *Early Muslim Architecture*, 2:286–88; E. Kühnel, *Die Kunst des Islam* (Stuttgart, 1962), 395; D. Talbot-Rice, *Islamic Art* (New York and Washington, D.C., 1965), 33; and A. Aziz Hameed, "The Origin and Characteristics of Samarra's Bevelled Style," *Sumer* 22 (1966): 83–86.

The excavations at Samarra never produced any objects to support the thesis of a Turkic presence or artistic impact at the Abbasid court in Mesopotamia. Much further east, at another early Islamic site on the Iranian periphery, Nishapur,

excavators did uncover a group personal adornments of this kind reflecting indisputable contacts with the decorative metalwork current among the nomadic peoples from central Asia to eastern Europe during the eighth and succeeding centuries; see J. W. Allan, *Nishapur: Metalwork of the Early Islamic Period* (New York, 1982), 28–30. But even here there were few objects in a true beveled style, and only one (Allan, *Nishapur,* no. 7) that displayed any real similarity to the monumental wall decorations in the beveled style either at Nishapur or at Samarra. The chronology of the Nishapur adornments is also inconclusive, since their specific find spot at Tepe Madraseh can only be dated broadly to the period between the eighth and tenth or thirteenth centuries (Allan, *Nishapur,* 13). Like much of this metalwork throughout eastern Europe and central Asia, these finds are not necessarily earlier than the monumental Islamic decorations in question, and only generally related in style.

Nor does such nomadic decorated metalwork represent a purely autochthonous Asiatic artistic tradition, as Strzygowski and his adherents assumed. On the weakness of this supposition see Shafi'i (*Simple Calyx Ornament,* 9, 221–22), who summarizes and reaffirms the earlier objections of Zaki Hasan. G. Laszlo (*The Art of the Migration Period* [Coral Gables, Fla., 1974], 44–61) provides a good synthesis of the scholarship on the Avaric metalwork of this kind from Hungary between the sixth and ninth centuries A.D. The research has consistently stressed the Persian and Byzantine background of the ornament on such artifacts wherever they appear from eastern Europe to central Asia, as the result of cultural influences and technologies stemming ultimately from the Mediterranean and the Near East. See Laszlo (appendix, B.1) for specific bibliographic references. The nomadic central Asiatic or "Altaic" decorations of this kind probably represent a cognate development, parallel to the Samarra and Tulunid styles; all are in the end traceable to the common mixed decorative tradition of late antiquity that existed across the East Roman or early Byzantine provinces and the Sassanian empire, where stylized floral decoration in compressed schemata and a beveled technique had long been current; cf. the sculptures in figures 142–45 and 157, and Sassanian patterns as in figure 164, or the many stuccoes illustrated in A. U. Pope and P. Ackerman, eds., *Survey of Persian Art* (Oxford, 1938–1958), vol. 4, pls. 171, 173–74; J. Kroger, *Sasanidischer Stuckdekor,* Baghdader Forschungen, 5 (Berlin, 1982), esp. pls. 57, 62, 84–85, 88–89.

The most recent discussions of the problem essentially reject the thesis of central Asiatic origins; see R. Schnyder, "Zur Frage der Stile von Samarra," *Akten des VII Internationalen Kongresses für Iranische Kunst und Archäologie, Munich, 7–10 Sept. 1976,* Archäologische Mitteilungen aus Iran, Suppl. 6 (Munich, 1979), 371–79, and Franz, *Palast, Moschee und Wüstenschloss,* 126–28, 152–53. Like Herzfeld, these scholars see the immediate background of the beveled style in earlier Abbasid works from further west in Syria, which already display the abstract and compressed treatment of the forms with gently beveled edges. For such forerunners see the capitals from Raqqa; Herzfeld, *Samarra,* 1:47, and pl. 24; R. Ettinghausen, "Originality and Conformity in Islamic Art," in A. Banani and S. Vryonis, Jr., *Individualism and Conformity in Classical Islam* (Wiesbaden, 1975), 92, pls. 29–30; idem., "The Beveled Style in the Post-Samarra Period," in *Archaeologia Orientalia Ernst Herzfeld,* 73 (= R. Ettinghausen, *Islamic Art and Archaeology. Collected Papers,* ed. M. Rosen-Ayalon [Berlin, 1984], 98, 131, 183); and Franz, *Palast, Moschee und Wüstenschloss,* 126, pls. 54–55, nos. 137, 139–41. Although M. Dimand had earlier espoused the central Asiatic thesis, he too recognized the connection of the Samarra style to earlier Abbasid works like the Raqqa capitals ("Studies in Islamic Ornament, 1. Some Aspects of Omaiyad and Early Abbasid Ornament," *Ars Islamica* 4 [1937]: 308–15, 323–24, figs. 22–25, 40–45).

Also see R. Ettinghausen and O. Grabar, *The Art and Architecture of Islam: 650–1250*, (Harmondsworth, 1987), 102–5, figs. 78–80.

Despite the extensive work of Herzfeld and those who followed him, there is still much that remains to be done in tracing the origins of the Abassid and Tulunid Arabesque back into the Hellenized repertory of Early Byzantine and Sassanian Persian floral ornament. No one nowadays would question the classical origin of the patterns illustrated in figures 165–68 as Riegl originally sketched it out. Many of the more elaborate all-over or infinite rapport patterns at Samarra, however, compare not only to early Byzantine works like the intrados ornament in figure 145, but perhaps even more closely to Sassanian counterparts like the stuccoes from Wasit, Nizamabad, or Damgan; cf. O. Grabar, *Formation of Islamic Art* (New Haven, Conn. and London, 1973; 2d rev. ed., New Haven, Conn., 1987), fig. 125; Ettinghausen and Grabar, *The Art and Architecture of Islam*, fig. 80; and Kroger, *Sasanidischer Stuckdekor*, 158–59, figs. 92–93, pls. 66, 88, no. 2. In general, Islamicists now tend to see the Sassanian contribution to the Arabesque as a direct process, stemming from the political unification of Iran and Mesopotamia with the more westerly provinces of Asia under the Ummayads and Abbasids.

However, the intermediary role of late antique Syria and Palestine deserves much closer examination. Fifth-century Antioch has produced friezes and complex all-over acanthus tendril reliefs in marble closely related to Sassanian architectural decorations (see A. Grabar, *The Golden Age of Justinian from the Death of Theodosius to the Rise of Islam* [New York, 1967], figs. 301–2). These works also compare closely to the elaborate decorations at Samarra and related sites; see the relief published by F. Sarre, "Eine frühislamische Wanddekoration aus Nord Mesopotamien," *Archiv fur Orientforschung*, Beiheft 1 (1933): 93–96, pl. 3. It is still crucial to determine the impact that such "Orientalizing" tendencies in the art of the eastern Byzantine provinces at the very end of antiquity may have played in the creation of the architectural decoration of Ummayad sites like Khirbat al-Mafjar and Qasr al-Hayr, just as the subsequent role of Ummayad ornament in the formation of true Arabesque in the Samarra or beveled style requires more detailed and critical investigation. Only when the scholarship has finally come to terms with these problems will it be possible to refine and expand the initial efforts of Riegl in mapping out the sequence of transformations that gradually led to the Arabesque. For the Ummayad monuments and their origins, see Grabar, *The Formation of Islamic Art*, 195–99, figs. 65, 80, 104, 118–19; R. W. Hamilton, "Khirbat Mafjar. Stone Sculpture, 1," *Quarterly of the Department of Antiquities of Palestine*, 11 (1942): 42–66; idem, "Khirbat Mafjar. Stone Sculpture, 2," *Quarterly of the Department of Antiquities of Palestine* 12 (1945–1946): 1–19; idem, "Pilaster Balustrades from Khirbat al-Mafjar," *Quarterly of the Department of Antiquities of Palestine* 13 (1947–1948): 1–58; idem, *Khirbat al-Mafjar* (Oxford, 1959); idem, "Carved Stuccoes in Ummayid Architecture," *Iraq* 15 (1953): 43–56; D. Schlumberger, "Qasr al-Hayr," *Syria* 20 (1939): 195–373; O. Grabar, R. Holad, J. Knustad, and W. Trousdale, *City in the Desert: Qasr al-Hayr East*, Harvard Middle Eastern Monograph Series, 23–24 (Cambridge, Mass., 1978); and Ettinghausen and Grabar, *The Art and Architecture of Islam*, 46–71, figs. 16–46. H. G. Franz ("Wesenzuge ommayadischer Schmuckkunst," in *Beiträge zur Kunstgeschichte Asiens in Memoriam Ernst Diez* [Istanbul, 1963], 69–86) is perhaps the most lucid and thorough discussion of the Byzantine and Coptic sources behind the very earliest Islamic decoration. Also see Franz's more recent survey of the Ummayad monuments in *Palast, Moschee und Wüstenschloss*, 37, 41–60.

b. Riegl's generalization here still holds good. The use of symmetrically repeating all-over patterns was not very common in Classical and early Hellenistic floral

ornament, where larger surfaces were generally covered by expansive bilaterally symmetrical tendril patterns (cf. fig. 121) or by repeating a vertical tendril composition laterally across the field; see the fragmentary Late Classical textile from Kertch, G.M.A. Richter, *A Handbook of Greek Art* (London and New York, 1969), fig. 506. In post-Archaic Greek art infinite rapport patterns first began to be common in late Hellenistic or late Republican Roman and early Roman Imperial times, in the geometric ornament of pavements; see E. Pernice, *Die hellenistiche Kunst in Pompeji. 6 Pavimente und figürliche Mosaiken* (Berlin, 1938), pls. 11, no. 4; 12, nos. 2–3; 15, no. 2; 18, no. 2; 23, nos. 3–4; 27, no. 5; 31, no. 6; 33, no. 1; 36, no. 6; 39, no. 1; 45, no. 2; 46, no. 6; and H. Joyce, "Form, Function, and Technique in the Pavements of Delos and Pompeii," *American Journal of Archaeology* 83, no. 3 (1979), pls. 33, 35, 36, and figs. 3, 14, 20.

c. For Pompeian examples see Pernice, *Die hellenistische Kunst in Pompeji*, vol. 6 pls. 25, no. 5; 38, no. 1; 47, no. 6. For later Roman examples of such all-over geometric pavements, see R. Gabrielsson, *Kompositsionsformer senkeltisk orneringsstil. Sedda mot bakgrunden av den allmäneuropeiska konstutvecklingen*, Kungliga Vitterhets Historie antikvitets akademiens Handlingar, 58, no. 2 (Stockholm, 1945), 13–18, pl. 1; J. Lancha, *Mosaïques géométriques, les ateliers de Vienne (Isère). Leurs modeles et leur originalité dans l'empire romain* (Rome, 1977); and the following contributions in *Colloque internationale sur la mosaïque gréco-romaine, Paris, 29 Aug.–3 Sept. 1963* (Paris, 1965): H. Stern, "Ateliers de mosaïstes rhodaniens d'époque gallo-romaine," 235–44, esp. figs. 1–15; K. Parlasca, "Neues zur Chronologie der römischen Mosaiken in Deutschland," 77–80, and figs. 6–9; H. Kenner, "Römische Mosaiken in Österreich," 85–93, figs. 1, 15–16; M. Fendri, "Mosaïques dans une station à Djebel Oust," 157–71, figs. 2, 7–11, 13–14; and E. Kitzinger, "Stylistic Developments in Pavement Mosaics in the Greek East from the Age of Constantine to the Age of Justinian," 341–52, figs. 1, 3, 6, 11. The eastern examples of this kind in late antiquity were immediately ancestral to the complex Islamic geometric patterns. For the latter, see K. Albarn, "Aspects of Islamic Pattern," *Studio International* 172 (Nov. 1971): 182–85; K. Albarn, J. M. Smith, S. Steele, and D. Walker, *The Language of Pattern. An Inquiry Inspired by Islamic Decoration* (New York, 1974); R. Critchlow, *Islamic Pattern: An Analytical and Cosmological Approach* (New York, 1976); and I. El-Said and A. Parman, *Geometric Concepts in Islamic Art* (London, 1976).

d. For a discussion of figure 170, the stucco ceiling from the apodyterium of the Stabian Baths in Pompeii, see Gabrielsson, *kompositionsformer*, 20, and pls. 2, 5; H. Mielsch, *Römische Stuckreliefs*, Römische Mitteilungen, Erganzungsband, 21 (Heidelberg, 1975), 142–46, cat. K54b, pls. 51–52; and Mielsch's contribution in H. Escherbach, *Die stabianer Thermen in Pompeji* (Berlin, 1979), 76–77, and pl. 61. For good photographs also see V. Spinazzola, *Le arti decorative in Pompeii e nel Museo Nazionali di Napoli* (Milan, Rome, Venice, and Florence, 1928), pls. 170–71; and T. Kraus and L. von Matt, *Pompeii and Herculaneum. The Living Cities of the Dead* (New York, 1973), fig. 61. Interlace all-over patterns became common all across the Roman provinces in middle and later Imperial times. The pavements of this kind in Palestine, Lebanon, and Syria are the direct forerunners of the early Islamic types like those at Khirbat-al-Mafjar; see annotation *m* for chapter 4A, above.

e. On figure 171 from the Villa of the Mosaic Columns at Pompeii, see Spinazzola, *Le arti decorative*, pl. 192, and especially the recent studies by D. Joly, "Aspects de la mosaïque pariétale au 1er siècle de notre ère d'après trois documents pompéiens," in *Mosaïque gréco-romaine*, 57–71, fig. 5; F. Sear, *Roman Wall and Vault Mosaics*, Römische Mitteilungen, Erganzungsband, 23 (Hei-

delberg, 1977), 83, no. 49, pl. 30; and M. R. Boriello et al., *Le Collezioni del Museo Nazionale di Napoli* (Rome, 1986), 122–23, cat. no. 58.

f. In the light of the many discoveries in Mesopotamia and southwest Iran, where polychrome brick or tile wall decorations were first developed and widely applied, Riegl's argument here remains cogent. In the earliest decoration of this type, the painted cone mosaics of the pillared hall at Uruk (Protoliterate Period, later fourth millennium B.C.), there is no direct connection between the tiles and the pattern. In the later glazed brick ornaments from Assur, Nimrud, and Babylon, or their Achaemenid successors at Susa (cf. figs. 43–44), the decoration consists of extended symmetrical friezes, but again there is no fixed or basic structural connection between the basic pattern components and the individual tile units, i.e., nothing to indicate that the patterns themselves evolved by experimenting with the arrangement of the tiles or bricks. Here the floral designs were a preexistent concept applied arbitrarily to the surface of the mass-produced bricks as a practical expedient to facilitate the decoration of large wall surfaces. For such decoration see W. Andrae, *Farbige Keramik aus Assur* (Berlin, 1923), pls. 6–10, 26–27, 29; E. Porada, *The Art of Ancient Iran. Pre-Islamic Cultures* (New York, 1965); pl. 14; A. Moortgat, *Die Kunst des Alten Mesopotamien* (Cologne, 1967), pls. 1–2, 292.

In all such cases the patterns were extended only by repeated horizontal or transverse reflection, never according to radiating axes of symmetry as an omnidirectional, infinite rapport composition. In the Near East, Egypt, and Crete, all-over floral or floralized spiral ornament had long existed in the media of stone relief, stucco, or painting, crafts in which there was no immediate relation between the formal structure of the pattern and the technique of its fabrication (cf. figs. 23, 26–27, 55–56). This remained true in the Near East down to Parthian and Sassanian times, when all-over infinite rapport patterns were still produced in stucco rather than glazed tile or brick. And even where such stucco decoration was built up from a number of prefabricated plaques, there was no direct or governing correspondence between structure of the component motifs or pattern elements and the constructive units or plaques; see Kroger, *Sasanidischer Stuckdekor*, figs. 50–53, 54, 85–88, 92–93.

g. Figure 173 from Betursa is composed of a series of interlocking cruciform bands or loops whose ends intertwine to form figure-eight knotwork. The pattern is well attested in Roman mosaic pavements from Lebanon and Palestine to North Africa; see J. W. Crowfoot and C. Kraeling, *Gerasa, City of the Decapolis* (New Haven, Conn., 1938), pl. 77b; C. Picard, "Un thème du style fleuri dans la mosaïque africaine," in *Mosaïque gréco-romaine* 1:125–32, fig. 9; M. Chéhab, "Les caractéristiques de la mosaïque au Liban," in *Mosaïque gréco-romaine*, 333–37, fig. 10. The tendency to complicate the so-called Constantinian or simple looped and plaitwork interlace patterns of the middle and late Imperial repertory was stronger in the eastern provinces; cf. for example, the typical Constantinian pattern with the far more elaborate and confused version of the same motif on two reliefs from the sixth-century monastery at Bawit (E. Chassinat, *Fouilles à Baouit*, vol. 1 (Cairo, 1911), pl. 80, nos. 1–2. For more examples of this tendency in Coptic wall paintings or the mosaic pavements of early Byzantine Palestine, and their Ummayad progeny, see annotation *m* for chapter 4A, above.

h. On the ivory caskets in figures 174–75, see E. Kühnel, *Maurische Kunst* (Berlin, 1924), pl. 18, top; idem, *Islamische Elfenbeinskulpturen* (Berlin, 1971), 33, 35–36, nos. 21, 25; idem, *The Arabesque*, pl. 29a; J. Beckwith, *Caskets from Cordoba* (London, 1960), 8–9, 15–16, fig. 32, pl. 13. For the blossoms on them see Shafi'i, *Simple Calyx Ornament*, 116–17, pl. 24, motifs k–o. Some, like Beckwith

(*Caskets from Cordoba*, 34) have suggested that figure 175 may be a modern imitation, although Kühnel (*Islamische Elfenbeinskulpturen*, 33), remains more committed to its authenticity.

i. For examples of such ornament in western medieval ivories, see A. Goldschmidt, *Die Elfenbein skulpturen aus der Zeit der karolingischen und sächsischen Kaiser, VIII–XI Jahrhundert*, new ed. (Berlin, 1969–1970), vol. 1, nos. 61, 155, 160, 174; vol. 2, no. 160. For illuminated manuscripts, see M. Rickert, *Painting in Britain in the Middle Ages* (Harmondsworth, 1965), pls. 70, 85b, 87, 88b; and C. de Hamel, *A History of Illuminated Manuscripts* (Boston, 1986), figs. 83, 89, 91, 99.

j. Subsequent study has confirmed Riegl's assessment of the simultaneous unity and regional variety in Islamic ornament. The initial diffusion of Islamic culture across western Asia and the southern Mediterranean under the Ummayads had been conditioned from the outset by the unified though varied aspect of the late Roman substratum. Regional distinctions of course increased in the wake of the breakup of the Islamic empire under the later Abbasids. The initial phase of the true Arabesque as it appears in the Samarra and Tulunid styles never had any real impact in Spain, where the independent Ummayad dynasty continued to foster the sort of ornament current in the Islamic East in the seventh and eighth centuries, thus explaining the more Hellenized aspect of Hispano-Mauresque ornament right into the tenth century; cf. figs. 174, 175, and 187; see Shafi'i, *Simple Calyx Ornament*, 10–11. Grabar (*Formation of Islamic Art*, 204–5) has also observed generally that more classically-derived types of ornament often survived alongside the Arabesque in early Islamic times as part of this regional pattern of variation.

k. Kühnel (*Islamische Elfenbeinskulpturen*, 35, fig. 41) has convincingly localized these caskets to Madinat al-Zahara (Cordoba), on the evidence of their close connection to the stucco architectural ornament of the Salon Rico in the tenth-century Moorish palace at that site. Cf. B. Pavon Maldonado, *El arte hispanomusulmán en su decoración floral* (Madrid, 1981), pls. 1–2, no. 5; Beckwith, *Caskets from Cordoba*, fig. 2; and Ettinghausen and Grabar, *The Art and Architecture of Islam*, 145–55, figs. 127–28.

l. For the marble puteal or wellhead in figure 178, see Spinazzola, *Le arti decorative*, pl. 46. For decorated monuments of this type generally, see E. Pernice, *Die hellenistische Kunst in Pompeji. 5, Hellenistische Tische, Zisternmündungen, Beckenuntersätze, Altäre und Truhen,* (Berlin and Leipzig, 1932), esp. 12–37.

m. Riegl's point here concerning the acanthusized rendering of the grape leaves in Roman decorative sculpture is well taken, and the Pompeian work in figure 178 can be paralleled in this regard by other examples from all across the empire, even as far as Palmyra; see H. Seyrig, R. Amy, and E. Will, *Le temple de Bel à Palmyre* (Paris, 1975), pl. 44. This process of conflation can be traced to late Hellenistic relief and mosaics, especially in Athens and Pergamon, where grapevines and grape clusters were sometimes "grafted" onto acanthus tendril patterns. The practice continued in late Roman Republican and early Imperial mosaics and public monuments like the Ara Pacis. For these Hellenistic and Roman works see E. Rohde, *Pergamon. Burgberg und Atar* (Munich, 1982), figs. 31–32; T. Kraus, *Die Ranken der Ara Pacis. Ein Beitrag zur Entwicklungsgeschichte der augusteischen Ornamentik* (Berlin, 1953), pls. 18, 21; C. Borker, "Neuattisches und pergamenisches an den Ara Pacis-Ranken," *Jahrbuch des Deutschen Archäologischen Instituts* 88 (1973): 283–317, figs. 1–3, 10–12; W. von Sydow, "Die Grabexedra eines römischen Feldherrn," *Jahrbuch des Deutschen Archäologischen Instituts* 89 (1974): 209–10, fig. 21. Simon, *Ara Pacis Augustae*, fig. 4; and E. La Rocca, *Ara Pacis Augustae in occasione del restauro della fronte orientale* (Rome, 1983), 20,

ill. The definitive study of the vine and viticulture in Greco-Roman religious belief, economy, and artistic monuments is still R. Billiard, *La vigne dans l'antiquité* (Lyon, 1913). For the Alexander Sarcophagus, see F. Winter, *Der Alexandersarkophag von Sidon* (Strassburg, 1912); K. Schefold, *Der Alexandersarkophag* (Berlin, 1968); and V. von Graeve, *Der Alexandersarkophag und seine Werkstatt*, Istanbuler Forschungen, 28 (Berlin, 1970). For good illustrations of the grapevine decoration on this work and on the accompanying Sidonian sarcophagi, also see especially von Graeve, *Der Alexandersarkophag*, pls. 5–7, 10–16, 19–21; J. J. Pollitt, *Art in the Hellenistic Age* (Cambridge, 1986), fig. 38; and E. Akurgal, *Griechische und römische Kunst in der Türkei* (Munich, 1987), pl. 134.

n. Such vegetalized blossoms began to evolve in late Hellenistic acanthus ornament. See the examples from Pergamon, which were directly ancestral to those on the Ara Pacis; (Kraus, *Die Ranken der Ara Pacis*, pls. 2, 20; Borker, *Jahrbuch des Deutschen Archäologischen Instituts* 88 (1973), figs. 6, 7, 9; and Simon, *Ara Pacis Augustae*, figs. 5–6.

o. In view of Herzfeld's discoveries at Samarra one can now fix the date of this divergence somewhat earlier, at least as far back as the ninth century, when the beveled style first matured in North Mesopotamia and the closely related Tulunid monuments of Egypt. In their reduction or suppression of the primary floral or tendril elements to thin lines or interstices, along with the simultaneous tendency to emphasize the beveled background forms, this style departed radically from what had gone before in Asia or the Mediterranean, even in Islamic art, as Shafi'i (*Simple Calyx Ornament*, 215–23) has stressed. The patterns illustrated in figures 165–68 are perhaps not the most representative examples of the beveled style, and they do not demonstrate its distinctive qualities sufficiently. By comparison, even the more developed Arabesques of figures 189 or 193 display a relatively traditional or classical relation of figure and ground, despite the greater stylization of the tendrils and blossoms themselves. On balance, it was the Samarra style and its forerunners in late eighth-century Syria that marked the real divide between the Islamic and Mediterranean or Greco-Roman decorative traditions.

p. For acanthusized blossoms like those in figures 161–63 or figures 180–83 in Byzantine illumination and monumental painting, see K. Weitzmann, *Die byzantinische Buchmalerei des 9. und 10. Jahrhundert* (Berlin, 1935), 22–32; and C. Lepage, "L'ornementation végétale fantastique et pseudo-réalisme dans la peinture Byzantine," *Cahiers archéologiques* 19 (1969): 191–211, esp. figs. 7, 10, 12, 14–16.

q. Weitzmann, (*Die byzantinische Buchmalerei*), remains the basic study of such Byzantine manuscript decoration; see esp. pls. 19, 21, figs. 104–5, 112–14. For similar works of the eleventh to thirteenth centuries see G. Vikan, ed., *Illuminated Greek Manuscripts from American Collections. Exhibition in Honor of Kurt Weitzmann* (Princeton, N.J., 1973), figs. 22, 75, 91–92.

r. A manuscript with a very similar ornament is illustrated in S. der Nersessian, *Armenian Manuscripts in the Freer Gallery of Art* (Washington, D.C., 1963), pl. 71, fig. 201. This example dates to the thirteenth century, and a similar or later date is likely for figure 185. Decoration of this kind continued in Armenian illumination down to the seventeenth century; cf. der Nersessian, pls. 83–99, and idem, *An Introduction to Armenian Manuscript Illumination. Selections from the Collection in the Walters Art Gallery* (Baltimore, 1974), W541, fig. 35. Figure 185 dates to the period when the art of the peripheral region of Armenia no longer reflected purely Byzantine fashions but also contemporary Islamic or Turkish styles. As such it does not demonstrate the sort of underlying genetic relationship or parallelism between Islamic and Byzantine art that Riegl had in mind.

s. Figure 186 in the Mosque of Al Zahir (El Daher) comes from Prisse d'Aven-nes, *L'art arabe* (pl. 8). For the window grills from the Tala'i Abu Riziq see Prisse d'Avennes, pl. 5. Similar window decorations also occur in the mosque of As-Salih Tala'i (K.A.C. Creswell, *The Muslim Architecture of Egypt*, vol. 1, [Oxford, 1952], 285, fig. 171, pl. 100a).

t. Figure 187 comes from the Mihrab of the Great Mosque of Cordoba. On this portion of the mosque and its decoration see Grabar, *Formation of Islamic Art*, 199 and fig. 55, top right; Ettinghausen and Grabar, *Art and Architecture of Islam*, 137–140, figs. 111 and 117; Kühnel, *Maurische Kunst*, pl. 15, top left; L. Golvin, *L'essai sur l'architecture réligieuse musulmanne*, vol. 4, *L'art hispano-musulman* (Paris, 1979), 115–57, esp. 123, and fig. 35; Sourbel-Thomine and Spuler, *Islam*, pl. 89; Pavon Maldonado, *El arte hispanomusulmán*, 79–80, no. 10, and pl. XI-25, no. 218; and most recently, C. Ewert and J. P. Wisshak, *For-schungen zur Almohaddischen Moschee*, Lieferung 2, *Die Mosche von Tinmal (Marokko)*, Madrider Beiträge, 10 (Mainz, 1984), pl. 58b. For the blossoms of this example see Shafi'i, *Simple Calyx Ornament*, 116–17, pl. 24h–j.

u. For figure 189, the wooden chancel of the mimbar at the Mosque of Al Amri at Qus, see F. Shafi'i, "Characteristics of the Decorated Woodwork of the Fatimid and Abbasid Styles in Egypt," *Bulletin of the Faculty of the Arts, Cairo University* 16, no. 1 (1954): 57–94, pl. 6B; and C. J. Lamm, "Fatimid Woodwork, Its Style and Chronology," *Bulletin, Institut d'Égupte* 18 (1936): 84–85, and pl. 10. For blos-soms with filler ornament like those of Riegl's fig. 189a and 189d, see Shafi'i, *Sim-ple Calyx Ornament*, 27, fig. 12; 54–55; 150–51, pl. 41; 201–3. On this phase of Islamic ornament and its relation to the preceding stages also Herzfeld, *Der Islam* 1 (1910): 50–53, figs. 14–17.

v. The stone pulpit or mimbar whose decoration appears in figure 193 was erected in 1483 by the Kait Bey in the Funerary Mosque of Barquq. Concerning its date and decoration see S. Lane-Poole, *Art of the Saracens in Egypt* (London, 1888; reprint, Lahore, 1976), 99–100, fig. 16. The detail in figure 193 is from Prisse d'Avennes, *L'Art arabe*, pl. 49. Cf. the similar blossoms in Shafi'i, *Simple Calyx Ornament*, 146–49, pls. 39–40.

w. On the twelfth-century apse mosaic at San Clemente in Rome, see Matthiae, *Mosaici medioevale della chiese di Roma*, pls. 234–46 and LI; and Oakeshott, *The Mosaics of Rome*, 238, fig. 73, pl. 24.

x. For the Persian carpet of the Safavid period whose border is illustrated in figure 195, see F. R. Martin, *A History of Oriental Carpets* (Vienna, 1908), 47, fig. 122; W. Bode and E. Kühnel, *Antique Rugs from the Near East* (New York, 1922), 23, fig. 22; and F. Sarre and H. Trenkwald, *Old Oriental Carpets* (Vienna, 1926–29), vol. 1, pl. 10. Cf. the very similar example in Sarre and Trenkwald, pl. 9.

y. On the Dome of the Rock generally, see E. T. Richmond, *The Dome of the Rock in Jerusalem. A Description of its Structure and Decoration* (Oxford, 1924); O. Grabar, "The Ummayad Dome of the Rock in Jerusalem," *Ars Orientalis* 3 (1959) Ettinghausen and Grabar, 23–62; *Art and Architecture of Islam*, 28–34. On the mosaic decorations like that in figure 196 see Ettinghausen and Grabar, *Art and Architecture of Islam*, 32–34, fig. 9; E. Diez, *The Mosaics of the Dome of the Rock* (London, 1924), and the detailed study by M. van Berchem in Creswell, *Early Muslim Architecture*, 1:173–216, esp. 206–10, pls. 5–8, 14–16. While the decoration of this and other Ummayad monuments is still demonstrably close to Byzantine precedent, the type of elaborate stylized blossom or "calyx-palmette" illustrated in figure 196 is best paralleled by Sassanian forerunners, as the analysis of van Berchem and others has shown; cf. R. W. Hamilton, "Some Eighth-Century Capitals from Al-Muwaqqar," *Quarterly of the Department of Antiquities of Pales-

tine 12 (1945–1946), 63–72. On such Sassanian blossoms also see Pope and Acker-man, *Survey of Persian Art*, vol. 3, 2678–2742, esp. 2690 ff. Since these blossoms are ultimately traceable to the Hellenized floral ornament of India (see annotation *dd* for chapter 4A, above), one tends to view them as part of the eastern or Sas-sanian legacy in early Islamic art. Nevertheless, Byzantine luxury arts like the cross of Justin II also display a very simlar type of ornament, probably reflecting Sassanian fashion; see Grabar, *Age of Justinian*, figure 359. And as indicated ear-lier, Antioch has also produced fifth-century architectural sculpture in such a style. Thus it is possible that the more Iranized artistic traditions in immediately pre-Islamic Syria and Palestine itself may have provided the direct sources for the Dome of the Rock decorations. For blossoms like that in figure 196, also see Shafi'i, *Simple Calyx Ornament*, 36–41.

z. For the so-called Mosul Bronzes (silver inlaid bronze or brass), the discussion of Lane-Poole (*Art of the Saracens in Egypt*, 182–84, 204–20) is still useful, as is G. Migeon, *Manuel de l'art musulman* (Paris, 1907), 165–219, (2d ed. 37–84). Islami-cists now recognize that such works were produced not only in Mesopotamia but in Syria, Egypt, and Iran as well through a broad period from the twelfth to the fifteenth centuries. The general scheme of simple interlace roundels and filler ornament of tendrils with heart-shaped blossoms on the fourteenth-century Mamluk writing box in figure 197 is closely paralleled by works in this style from the preceding century; see F. Sarre and M. van Berchem, "Das Metallbecken des Atabeks Lulu von Mosul in der königlichen Bibliothek zu München," *Münchener Jahrbuch der bildenden Kunst* 2 (1907): 18–37, figs. 1–3, 13; E. Baer, "An Islamic Inkwell in the Metropolitan Museum of Art," in R. Ettinghausen, ed., *Islamic Art in the Metropolitan Museum of Art* (New York, 1972), 199–212, figs. 7–9; E. Baer, *Metalwork in Medieval Islamic Art* (Albany, N.Y., 1983), 78–79, fig. 59; and Et-tinghausen and Grabar, *The Art and Architecture of Islam*, 337, 341, 364–66, 371–73, figs. 357, 361, 386, 392.

aa. After nearly a century of new discoveries and further study, the origin of the knotted carpet, its role within the material culture of the ancient Orient, and its connection with central Asiatic or nomadic crafts are issues that remain unre-solved. There is no doubt that the upper strata of ancient Near Eastern society made extensive use of furniture, as Riegl observed. This is clear not only from the many funerary and palace reliefs from Egypt, the Levant, Anatolia, Mesopotamia, and Iran but also from the remains of actual objects that have survived. See H. S. Baker, *Furniture in the Ancient World. Origin and Evolution, 3100–475 B.C.* (New York, 1966), Egyptian examples, figs. 154–220, and figs. 249–373 from the Near East; W. Stevenson Smith, *Art and Architecture of Ancient Egypt* (Har-mondsworth, 1984), figs. 31–32, 47, 76, 255, 280; H. Frankfort, *The Art and Ar-chitecture of the Ancient Orient* (Harmondsworth, 1985), 186, 200, 217, 315–317, 361, 430; E. Akurgal, *The Art of Greece. Its Origins in the Mediterranean and Near East* (New York, 1966), pl. 13, 28, 33, 169–70; M.E.L. Mallowan, *Nimrud and Its Remains* (New York, 1966), vol. 2, figs. 382–85, 390, 402. Also see B. Hrouda (*Die Kulturgeschichte des assyrischen Flachbildes* [Bonn, 1965], esp. pls. 13–16), who has reconstructed the furnishings of the Assyrians on the basis or artistic depictions.

Although none has been preserved, there is, however, evidence in pictorial representations that carpets were also used to some extent in the ancient Near East and Egypt; P. Albenda, "Assyrian Carpets in Stone," *Journal of the Ancient Near Eastern Society of Columbia University* 10 (1978): 2, fig. 1. Nevertheless, the technique of the carpets in such representations remains uncertain. There is no evidence that the Assyrian doorsills (fig. 34) copy knotted pile rugs, as Albenda

suggests; they could equally have imitated textiles in some other technique (see annotation *e* for chapter 3. A. 2, above), and the knotted technique cannot be documented in the Near East before the eleventh century A.D.; see K. Erdmann, *The History of the Early Turkish Carpet* (London, 1977), 3. The similar ornament and layout of the only knotted carpet that has actually survived from antiquity in the nomadic burial at Pazyryk might appear to support Albenda's suggestion. The Pazyryk carpet is often taken to be an imported Persian work because of its decoration, and on the basis of ancient sources that testify to the importance of Assyria, Babylon, Media, and Persia as centers for the manufacture of highly prized carpets (S. I. Rudenko, *The Frozen Tombs of Siberia. The Pazyryk Burials of Iron Age Horsemen* [Berkeley and Los Angeles, 1970], 298–300). But these are classical texts of the fourth century B.C. or later, and the Pazyryk carpet itself is no earlier than the fifth century B.C. If this work is indeed Persian, it is very possible that it represents a specifically Iranian rather than Near Eastern knotted carpet industry, and one that originated in the nomadic, central Asiatic background of the Medes and Persians.

It is equally possible, however, that only the decoration of the Pazyryk carpet derives from Persia or the Near East. Many of the other textiles or hangings from the Pazyryk burials, which are clearly local work, display the marked impact of western Asiatic figural and floral ornament, just as the textiles of the Hunnic burials at Noin Ula in the early centuries A.D. are decorated with floral and figural ornament of a more Hellenized character; cf. R. Ghirshman, *The Arts of Ancient Iran from Its Origins to the Time of Alexander the Great* (New York, 1964), fig. 468–72; K. Jettmar, *The Art of the Steppes* (New York, 1967), figs. 59, 74, 99; pls. 16, 18, 25; E. D. Phillips, *The Royal Hordes. Nomad Peoples of the Steppes* (New York, 1965), figs. 93, 97, 134, 137; S. I. Rudenko, *Die Kultur der Hsiung-Nu and die Hügelgräber von Noin Ula*, Antiquitas, ser. 3, vol. 7 (Bonn, 1969), 89–98, figs. 68, 71, 75; pls. 52–55, 64–67, 68–69; idem, *Frozen Tombs of Siberia*. The Pazyryk carpet may represent a similar adaptation of foreign themes or motifs to a local industry, craft, or technology, in Siberia or the central Asiatic regions just beyond the Iranian periphery.

Little is known of the truly indigenous central Asiatic traditions of decoration that the nomadic peoples may have used on their rugs in this early period. Yet it is significant that woven rugs or hangings from Pazyryk that appear to be made in a purely local idiom consist of geometric decorations (apart from those with native "Animal Style" ornament); see Rudenko, *Frozen Tombs*, pl. 157, and Jettmar, *Art of the Steppes*, fig. 68. Similarly, the earliest preserved Turkish pile carpets of the Seljuk period in Anatolia consist of all-over geometric patterns or radically geometricized vegetal designs, which are in either case unrelated to the ornamental traditions of the Near East or the Mediterranean, and traceable to the native central Asiatic traditions of the incoming Turkic tribesmen; see Erdmann, *Early Turkish Carpet*, 7–19, figs. 1–8; D. Talbot-Rice, *Islamic Art*, 177, figs. 178–82; and T. Talbot-Rice, *The Seljuks in Asia Minor* (New York, 1961), 183–86, figs. 55–58, pls. 69, 76. On the carpets of the Turkic nomads in central Asia that have continued to be produced into the modern period, there is still a marked preference for geometric or highly geometricized vegetal patterns rather than the overtly floral, Arabesque ornament typical of Persian and later Ottoman Turkish rugs; see C. Dunham Reed, *Turkoman Rugs* (Cambridge, Mass., 1966).

All this tends to corroborate the main lines of Riegl's claim that nomadic central Asiatic peoples created the knotted carpet technique and introduced it to the regions further south and west, as well as his opinion that these nomadic peoples came to adopt the long-evolving repertory of floral ornament for such textiles

mainly as a result of contacts with the Near East, particularly after their migration and settlement in Anatolia and Iran; see Erdmann, *Early Turkish Carpet*, 2–3, 25–26, 36–38. Perhaps new discoveries in central Asia like Pazyryk or in the dry climate of Egypt will someday provide the evidence to settle the question of the origins of the knotted carpet once and for all. But there can in any case no longer be any controversy about the background of the elaborate floral ornament applied to the rugs of Asiatic peoples. It was undoubtedly descended from the vegetal decoration that had evolved continuously from the ancient Orient into Greek, Roman, late antique, and Sassanian Persian times, culminating in the final transformations of mature Islamic decorative art, as Riegl's analysis and the many studies that followed have by now firmly established.

GLOSSARY OF TERMS AND CONCEPTS
USED BY RIEGL

———— ◇ ————

Acanthus — A species of weed (*acanthus mollis* and *acanthus spinosa*) common in the regions of the Mediterranean. In the decorative arts, a form of ornament based on the adaptation or stylization of such natural analogs, beginning in Classical Greek art during the later fifth century B.C. and remaining the major class of vegetal ornament in later Hellenistic, Roman, and late antique art. *See pp. 10, 123, 176, 187–207, 213, 219–27, 233, 238, 242–52, 254, 256–58, 260, 263, 267, 278, 280, 282–95, 297–98, 302–3.*

Acanthus-Calyx (Akanthuskelch) — A bilaterally symmetrical, vessel-like grouping of three or more acanthus leaves, with lateral profile or half leaves flanking one or two full leaves at the center (fig. 114). In Classical, Hellenistic, and Roman art, this formulation occurs most often as the source or basal calyx for the main tendrils of a larger acanthus composition, as in figures 121 and 123, and the corners of figure 172. *See pp. 211, 288.*

Acanthus Half Leaf (Akanthushalbblatt) — An acanthus leaf depicted in half or profile view and generally acting as a sheath or husk along a tendril that emits additional offshoots or blossoms (figs. 113, 116, 121, 129–30, and 179). Riegl explained this form as a more naturalized, sculptural transformation of the half palmette only loosely based upon the leaves of the actual acanthus plant, although subsequent research indicates that the half leaf probably imitates the bracts on the upper part of the acanthus. Also see *Sheath. See pp. 196, 198, 213, 217, 220, 222–23, 225, 227, 244, 246–47, 249–50, 252, 289.*

Acanthus-Palmette — A variant term used by Riegl to denote acanthus half and full leaves as derivatives or transformations of two-dimensional half and full palmettes. Also referred to as the sculptural palmette. See *Acanthus Half Leaf* and *Full Acanthus Leaf. See pp. 124, 198, 200, 202.*

Acanthusized — A term used by Riegl to characterize an ornamental form or pattern in Classical and later Greek and Roman art whose stylized components have been "naturalized" or adapted to resemble the leaves or bracts of the acanthus plant. The term may apply to the paired petals or sepals of a stylized blossom (figs. 113, left, 116) or, more commonly, to half and full palmettes or portions of tendrils treated in this way (figs. 115, 121, 129, bottom, 135–36). Generally speaking, Riegl conceived of all acanthus ornament as an "acanthusized" transformation of earlier, more stylized types of vegetal ornament. See *Naturalizing. See pp. 198, 223, 225–26, 234, 252, 281–83, 252, 281–83, 286, 289–90, 292, 294, 301.*

Acroterion — A crowning decoration, sometimes figural but more often consisting of vegetal ornament, that surmounted monumental stelai and pediments or roof gables in Greek and Roman architecture and sculpture. Stelai decorated in this way appear in figures 114 and 120. Figure 110 is excerpted from a stele of this type. *See pp. 203, 207, 259.*

All-over Tendril (Ranken-Füllung) — A variant of the continuous, undulating tendril in late Archaic and Classical Greek art, applied to more expansive pattern fields as a larger, convoluted composition (figs. 103–6, 121, 125).

Arabesque — A highly abstract or stylized form of tendril ornament, based on the acanthus tendril of late antique or early Byzantine and Sassanian Persian art, which developed in the Islamic regions from the ninth century A.D. onward.

For early examples see figures 165–68, and for its more advanced phases, figures 139, 174–75, 189, 193. *See pp. 11–12, 218, 229–40, 248–49, 251, 253, 260–61, 264, 266, 271–73, 280, 282, 288, 291, 293–96, 298–305.*

Arcuated Band Frieze or *Arcuated Frieze (Bogenfries)* — A type of pattern distinguished by a longitudinal matrix consisting of adjacent arcs or arcuated bands arranged in series and connecting to rows of stylized flowers, buds, fruits, or palmettes, or combinations of these. Originally an Egyptian scheme, but common in ancient Near Eastern and Greek decorative art as well. See figures 22, 33–34, 38–39, 43, 73, 79. *See pp. 68–69, 71, 93, 104, 113–14, 145, 147, 149–50, 154, 161, 172, 174–75, 177, 223, 227, 292, 397.*

Artistic Materialism (Kunstmaterialismus) — A theory of artistic development widely held in the last century, in which the form and composition of ornamental and figural motifs were seen to originate from the artist's experience of the physical properties or propensities of the raw materials used, and from the dictates of the techniques of fabrication. *See pp. 4, 12, 86, 262.*

Axil (Zwickel) — The acute angle or interstice formed by a spiral where it curls in on itself, or by two convergent or divergent curvilinear forms such as petals, tendrils, or spirals. *See pp. 131–32, 141–47, 149–50, 58, 62, 98, 100, 119–22, 125–26 and passim.*

Axil Filler (Zwickelfüllung) — An ornamental form, usually vegetal or floral, which is used to occupy an angle or interstice created by the involution of a spiral or by the proximity of two curved or involuted elements. This function may be accomplished by a simple geometric form (fig. 67), by individual vegetal elements (figs. 19, 20), or by more elaborate vegetal stylizations such as the palmette and lotus (figs. 21, 25–27, 101–10). See *Postulate of Axil Filling. See pp. 64–65, 96, 107–8, 121–22, 124–26, 131, 141–47, 149–57, 163–64, 169–70, 172, 176, 185, 188, 196, 216, 219, 235, 239, 250, 261, 269–70, 282, 289, 294.*

Band Ornament — See *Curvilinear Meander.*

Bifurcation (Gabelung) — The splitting or branching of a new offshoot from the main stem in real plants, and in ornamental tendril patterns related to such natural forms; see figures 50, 76, 80, 103–6, 121–23, 125–27. *See pp. 190, 196, 210, 213, 220, 232, 235, 282.*

Bifurcating Tendril (Gabelranke) — A form of stylized tendril beginning in the acanthus ornament of Roman imperial times and developing especially in the Arabesque of Islamic art, in which the distinction between tendril and blossom becomes progressively blurred, and the blossoms themselves assume the function of splitting or branching more appropriate to the tendril (fig. 136, 139a–b, 174–75, 189, 193). *See pp. 190, 198, 227, 232, 238–39, 251, 254, 257, 268, 282, 291, 294, 297.*

Bindings (Junktur) — Small clamplike bands that appear to link the adjacent components of arcuated band friezes in Assyrian and later Greek art (figs. 33–34, 38–39, 79, 89). *See pp. 89, 92, 104, 145, 149, 169, 170, 173.*

Byzantine Acanthus — A type of acanthus or continuous tendril ornament that evolved in the Aegean and East Roman provinces during late antiquity, characterized by an increasingly angular, abstract, or geometricized treatment of the vegetal detail and the suppression of the main tendril stalk as an element distinct from the leafy acanthus sheaths or calyces (figs. 142, 144, 157, 159). Also known as the Byzantine tendril. *See pp. 244–46, 249, 297.*

Byzantine Tendril — See *Byzantine Acanthus*

Byzantine Trefoil (Byzantinische Dreiblatt) — A tripartite terminal or detail typical of late antique or early Byzantine acanthus ornament in the eastern Mediterranean, consisting of a "volute calyx" crowned by a single leaf (figs. 142,

top, 143). Also a three-leaved blossom common in later Byzantine vegetal ornament (figs. 183–84). *See pp. 245–46.*

Calyx (Kelch) — The cuplike array of leafy sepals enclosing the corolla of a flower or blossom. Riegl applied the term to designate any grouping of two adjacent sepals, petals, leaves, arcs, or voluted tendrils forming an angle or "vessel" that could be filled by additional stylized floral or vegetal elements, such as the lotus or palmette. See figures 19, 21, 26–27, 33, 39, 70, 76–77, 96–97, 107, 109, 175. *See pp. 11, 51, 54, 66, 87–89, 91, 98, 131–32, 158, 174, 188, 198–200, 207, 213, 216, 226–27, 251–52, 288–89, 292, 301.*

Calyx-Palmette (Kelchpalmette) — An elaborate stylized blossom current in Islamic vegetal ornament from its very inception, and characterized by pointed S-shaped petals arranged radially and symmetrically around an ogival core (figs. 195–97, center). Riegl considered the earliest examples, like figure 196 from the Dome of the Rock, to be essentially Byzantine, and adapted from the acanthus blossoms current in earlier Roman art. They now appear to be derived from Sassanian Persian foreruners based ultimately upon the Hellenized floral ornament of India. *See pp. 301–3, 398.*

Cone or *Conical Element (Zapfen* or *Zapfchen)* — A curvilinear triangular or drop-shaped form used as a filler for the central axil of a volute calyx in ancient Egyptian, Phoenician, and Syrian art (figs. 19–20, 23, 40). Also used as the base or source of the palmette in Egyptian, Near Eastern, and Greek ornament (figs. 16, 19–21, 33, 39, 70, 97–98). *See pp. 62, 64–65, 107–8, 164, 188, 190, 196.*

Common Palmette — See *Full Palmette.*

Continuous Tendril (fortlaufende Wellenranke) — A variant of the undulating tendril consisting of successive tendril volutes like the intermittent tendril, but distinguished from the latter by its unidirectional emphasis and unbroken structure, with each volute or stem emerging bodily from that which precedes it. The basic undulating matrix may be left bare or outfitted with leaves, as in early Aegean examples (figs. 49–50), but in Greek art of the Orientalizing and later periods it generally includes palmettes or simple leaf forms in the axils produced by successive bifurcations (figs. 80–81). In terms of overall composition, this pattern may assume a strictly symmetrical, longitudinal form (figs. 80, 121), or it may spread in a more irregular and convoluted fashion across a larger field (figs. 101–5, 121, 125). *See pp. 112–14, 116, 118, 136, 150–53, 157–59, 190, 210, 220, 223–24, 246–49, 258, 261, 269, 272, 286, 287, 294.*

Curvilinear Meander (Bandmuster or *abgerundete Mäander)* — A class of geometric ornament, apparently of Aegean origin, consisting of continuous, regularly undulating, convoluted bands, arranged in various configurations, especially as radial (fig. 61) or longitudinal patterns (fig. 62). A simple longitudinal variant extended according to repeated inverse symmetry is commonly referred to as the "running-dog," *(laufenden Hund)*, although more often than not this term is applied indiscriminately to a pattern of similar configuration consisting of a series interlocking but discontinuous S-shaped bands or lines (fig. 63, center). *See pp. 128–30, 150, 157, 237.*

Cyma — A type of molding used in Greek and Roman architecture, distinguished by its reverse or S-shaped contour, as opposed to the sima, which was entirely convex in section. The "cyma recta" curved outward toward the bottom edge, while the "cyma reversa" or "cymation" curved outward toward the top edge of the molding. Figure 115 from the door of the Erechtheion and the moldings from Spalato in figures 133–34 are examples of the cyma recta. *See pp. 56, 59, 155, 202–3.*

Dipylon Style — A class of Attic Geometric pottery produced in the later eighth century B.C., named for the Dipylon Cemetery at Athens where it was first discovered. Its decoration consisted largely of geometric ornament, but it included various animal and human or narrative representations as well. See *Geometric Style. See pp. 20–5, 117, 135, 137–40, 178–79, 215.*

Egg-and-Dart — A pattern applied to moldings (especially the cyma reversa) in Greek and Roman architecture. See the second molding from the top in figure 142, and the inner molding of figure 172. It consisted of ovoid forms alternating with tripartite clusters of pointed elements, and probably evolved as a simplification of serial lotus and bud patterns like the outer border of figure 72. Also known as "leaf-and-dart." *See pp. 56, 155, 160, 197.*

Egyptian Palmette — See *Lotus Palmette.*

Embedded (unfrei) — A term used by Riegl to characterize the abstract or unnatural use of blossoms in tendril ornament (e.g., palmettes or the bifurcating tendrils of Arabesque decoration) as forms that do not end freely like real flowers but serve like tendrils to run on and emit further offshoots as the pattern continues. (See the interior half palmettes of figures 121 and 125, and figures 139, right corner, 139a). Also see the opposing term, *Freely terminating,* and *Bifurcating Tendril. See pp. 217–18, 221, 225, 227, 238–39, 248–49, 253, 257, 260, 267, 271, 280, 282, 291, 300, 399.*

Enclosed Palmette (umgeschriebene Palmette) — A type of palmette of Assyrian or ancient Near Eastern origin, entirely circumscribed by an approximately circular volute or tendril whose spiral terminals furnish the supporting axil for the internal palmette (fig. 78). In Orientalizing Greek art the basic form was disposed longitudinally in friezes or radially, as in figure 78. In late Archaic and Classical times, the enclosed palmette became integrated within the format of the continuous tendril, both in simple border patterns or friezes (fig. 96), and within the more elaborate allover compositions (figs. 103–6 and 125). *See pp. 153–55, 161, 177, 251.*

Fan — See *Palmette.*

Fanless Palmette — See *Volute-Calyx.*

Freely terminating (frei endigen) — A term used by Riegl to describe blossoms and half or full palmettes in Greek, Roman, and Islamic ornament that approximate the natural placement or function of terminal leaves and flowers in actual vegetation (figs. 102–6, 125, bottom exterior, 130). See the opposite term, *Embedded. See pp. 67, 216, 218, 238, 257, 290.*

Full Acanthus Leaf (Akanthusvollblatt) — An acanthus leaf depicted in frontal or full view, and resembling the general form and sometimes the function of the full palmette in earlier ornament (figs. 115, 117, bottom row). *See pp. 197, 203, 213, 220.*

Full Palmette (Vollpalmette) — The bilaterally symmetrical variant of the palmette in which the size of the radiating fronds or fan diminishes as they curve out to either side of the central frond. Ideally suited to fill the more symmetrical axils of evenly configured volutes, especially along the central axis of a pattern or composition. Riegl also referred to the earlier versions of this motif in Egypt and the Near East as the "common palmette" (*gewöhnliche Palmette*) (fig. 16, 33, 67, 70, 78–79, 101–6). *See pp. 88, 198–99, 213–14, 216, 234, 238–39, 251, 254, 260, 268, 294–95.*

Geometric Style — A class of decoration widespread in many cultures and periods, consisting of simple geometric elements used singly or in groups, and often arranged as larger, extended patterns. Also a mode of representation in which figural (animal or human) forms are rendered by approximating such

simple geometric components (figs. 3, 59, 61–62). *See pp. 3, 5–6, 14–40, 46, 129, 137–39, 151–52, 231, 273.*

Guilloche (Flechtband) — A simple two-strand interlace pattern widespread in ancient Near Eastern decorative arts. Originating in western Asia, it became common in Greek and Roman art as well. It was often used alone as a border decoration, but it could also be elaborated with vegetal axil fillers or palmettes (figs. 33, center, 68, 90–92, and 121, central border). *See pp. 85–86, 93, 97, 102, 142, 149–50, 161, 175–76, 235.*

Half Calyx (Halbkelch) — A voluted element with a reverse contour that may combine with other forms to produce the stylized blossoms of Arabesque or Islamic tendril ornament (figs. 139a–d, 193). *See pp. 232–33.*

Half Palmette (Halbpalmette) — An asymetrical variant of the palmette made up of radiating fronds or leaves of diminishing size. Ideally suited to fill the asymmetrical axils produced by the divergence of a longer, less curved section of band or tendril and a shorter spiral volute (figs. 76, 121, 125, 127). *See pp. 131–32, 143–44, 153, 157, 189–90, 195–96, 198–99, 202, 204–5, 210–11, 213–14, 216–18, 220–21, 223, 225, 233–34, 238–39, 247, 251, 253–54, 260, 264, 268, 270–71, 273, 280, 282–83, 294–97.*

Heraldic Style — A class of decoration originating in the ancient Near East but current in Egypt, the Aegean Bronze Age cultures, and later Greek, Roman, and Oriental art, consisting of stylized animal or human and vegetal forms arranged around a central element or axis as a bilaterally symmetrical composition (figs. 4–5, 54, 66, 121, 123). *See pp. 6–9, 41–47, 84, 94, 170, 185.*

Horror Vacui — A tendency or predilection for filling up the available space of a composition, ornamental or otherwise, by means of additional or incidental elements. Figure 99 provides an excellent example. See the *Postulate of Axil Filling*, which is a special case of this tendency. *See pp. 32, 65, 81, 137–38, 145, 215.*

Infinite Rapport (unendliche Rapport) — A mode of composition widespread in Egyptian, ancient Near Eastern, Roman, late antique, and Islamic ornament in which the basic elements (fundamental portion) of a pattern are constantly repeated about multiple, intersecting, regularly spaced axes of reflection in allover radial symmetry (figs. 169–73). Figure 145, top, illustrates a less complicated variant in which the axes of reflection are all parallel, with only one additional horizontal axis or median establishing radial symmetry. The earlier Mycenaean and Egyptian allover spiral patterns of figures 55–56 display a related type of composition utilizing repeated axes of 180-degree rotation. *See pp. 267, 272–76, 278–79.*

Interlace or Interlacing (Flechtmuster or Schlinge) — A mode of pattern configuration that approxmates the overlapping and looping of strands, cords, or plaited braidwork, often according to strict principles of symmetrical repetition. This form of composition may appear as purely geometric ornament (figs. 33, center border, 140–41, 170), sometimes with added vegetal embellishment (figs. 68, 91–92), or it may be used to elaborate essentially vegetal or tendril patterns (figs. 83–84, 88, 174, 193). *See pp. 70–71, 95, 127, 161–71, 181, 234–37, 251–52, 267, 275, 279, 282.*

Interlacing Tendril (Rankengeschlinge) — A variant of the Orientalizing and Archaic Greek intermittent tendril in which the ends of the reverse elements or volutes are elaborated as looped or plaited strands (figs. 83–84, 88). See *Interlacing* and *Intermittent Tendril*. *See pp. 161, 163, 168–71, 180–81, 260, 234.*

Intermittent Tendril (intermittierende Wellenranke) — A variant of the undulating tendril, probably of Syrian or Phoenician origin but more common in

Greek and later art, consisting of discrete, discontinuous S-shaped elements or volutes arranged in series, and usually embellished with stylized leaves or blossoms. The reverse tendril elements may be disposed either according to repeated bilateral symmetry in a horizontal, vertical, or diagonal orientation (figs. 53, 85–86, 95, 129, bottom, 131–36, 165–66), or by inverse symmetry (fig. 66, center border, and fig. 97). Such patterns are sometimes elaborated as interlacing compositions (figs. 83–84). *See pp. 114, 119, 135, 144, 153, 162–63, 165, 176–77, 220, 223–24, 226, 249, 255–56, 268, 300.*

Islamic Half Palmette (saracenische Halbpalmette) — A bisected or abbreviated variant of the Islamic palmette (figs. 139c–d, 193). *See pp. 233, 239, 297.*

Islamic Palmette (saracenische Palmette) — A highly stylized adaptation of the acanthusized blossoms inherited from Greek and Roman ornament, typical of the mature Islamic tendril or Arabesque. It is characterized by its bilaterally symmetrical form, a doubly-involuted or bulbous base where it joins the tendril proper, and a central petal or leaf of ogival form (figs. 139 g, 193, top center). Also see *Islamic Trefoil. See p. 233.*

Islamic Tendril — See *Arabesque. See pp. 212, 229, 234, 237, 239, 266, 272, 288, 291, 300.*

Islamic Trefoil (saracenische Dreiblatt) — A three-leaved blossom or vegetal terminal of variable form (subvariant of the "Islamic palmette"), current in Arabesque ornament (figs. 139 g, 165, center, 193, top center). *See p. 233.*

Lotus — A Nilotic flower (nymphaea lotus), actually a member of the lily family (fig. 18), that was commonly stylized in Egyptian decorative art. Riegl distinguished three types: the "profile view" (figs. 7, 11, 13, and 24), the "full view" or rosette (fig. 12), and the "combined view" or lotus palmette (figs. 16 and 21). On present evidence only the "profile view" appears to be related to the actual lotus plant: see *Rosette* and *Lotus Palmette.* From Egypt, this stylization spread to the Near East, and to Greece in the Late Bronze Age and later in the Orientalizing period (figs. 34, border, 55, 73). *See pp. 7–8, 15, 38, 46, 50, 53–70, 86–92, 94, 97–100, 103–4, 108–9, 114–16, 120–23, 125–26, 135, 140–42, 144, 146–49, 161–65, 173–75, 196–99, 245, 249, 268, 292, 303 and passim.*

Lotus-Palmette — A composite stylization in which the axil between the pointed petals of a lotus is filled by a palmette. This form is most common in ancient Near Eastern and especially in Greek art (figs. 44, 79, 83–85, 129), although Riegl applied the term equally to earlier Egyptian patterns (the "Egyptian Palmette") in which the petals forming the axil were voluted and lilylike, as in figures 16 or 21. Riegl maintained that the palmette itself was a segment of the "full view" of the lotus or rosette; consequently he dubbed the juxtaposition of both types the "combined view." His explanation of the palmette in this way, however, is doubtful. Also see *Palmette, Petal, Rosette,* and *Volute-Calyx. See pp. 64, 87, 91, 95, 98–100, 121, 124, 140, 153, 155, 162–67, 177, 196–97.*

Materialism — See *Artistic Materialism.*

Meander — See *Curvilinear meander* and *Rectilinear Meander.*

Motif — An element or aggregate of elements that functions as a distinct and recurring component in a pattern or established class of ornament; e.g., the lotus, palmette, volute calyx, or acanthus half leaf.

Naturalizing (naturalisierende) — A tendency in Classical, Hellenistic, and Roman decorative art to infuse or reinfuse stylized vegetal patterns with the qualities or details of real plants and flowers. See *Acanthusized.* Also see the opposite term, *Stylization. See pp. 53–53, 119, 160, 176, 188, 195, 199, 207, 219–20, 226, 233, 235, 247, 264–66, 301, 303.*

GLOSSARY

Ogive or *Ogival (kielbogenartig)* — A space or design element delineated by two tangent reverse or S-shaped curves. Originating apparently in India, but common in Islamic art and architecture, especially as an arch form; see figure 185, center, or the lower portion of the dark area at the center of figure 139, where the ogive is inverted. *See pp. 197, 232, 238, 246, 251, 263, 287.*

Overflowing Palmette (überfallende Palmette) — A Classical Greek variant of the full palmette that evolved around the middle of the fifth century B.C., distingushed by the fluid, reversed contour of the fronds, which bend gently toward the exterior (figs. 109, 113, right, 121, 129). *See p. 189.*

Palmette — A vegetal stylization, probably based upon the date palm, consisting of a series of three or more petals or fronds, arranged radially as a spray or "fan" *(Fächer)* that emerges from a small conelike element (see *Cone*). Palmettes generally serve as space fillers in the angles formed by adjacent or convergent petals and spiral or tendril volutes (see *Calyx* and *Volute-Calyx*). Originally widespread in the Orient and Egypt, the palmette became common in Greek art from the Orientalizing period onward. Also known as the "two-dimensional palmette". See figures 16, 21, 33, 39, 42, 67, 70, 76–79, 81, 100–8, 125–27. In the Classical period and later times it assumed a more sinuous and attenuated form, especially in conjunction with the evolution of "acanthus" ornament (figs. 109–11, 121–22). Also see *Lotus Palmette, Half Palmette, Full Palmette, Split Palmette, Overflowing Palmette,* and *Volute-Calyx. See pp. 46, 62, 64, 66, 68–69, 86–88, 94, 98–100, 107–8, 153–54, 158, 160–65, 187–90, 195–98, 202, 204–05, 210, 213–14, 216, 218, 224, 233–35, 238, 244, 268–72, 294–95, 300–3 and passim.*

Palmette-Tendril (Palmettenranke) — Any instance of the stylized, undulating, continuous tendril ornament, either as a border pattern or a larger, allover composition, that utilizes palmette axil fillers extensively or prominently (figs. 95, 103–8, 125). *See pp. 213–15, 218–19, 225, 235, 238, 294–96.*

Palmette Tree (Palmettenbaum) — A variant of the stylized sacred tree current in Egypt, Syria, Phoenicia, and Persia during the second and first millennia B.C. In Egyptian and Syrian art it is distinguished by the use of superimposed petal-volutes or volute calyces that curl alternately upward and downward, and are surmounted by a palmette (fig. 40). In Phoenician art the upward-curling petal-volutes assume a prominent cuplike form enveloping the palmette (fig. 41). In the Persian variant the superimposed petals are lotuslike, without any involution (fig. 44). Also see *Phoenician Palmette, Volute-Calyx,* and *Sacred Tree. See pp. 97–100, 102–3, 137, 170.*

Papyrus — A marsh plant native especially to the Nile Delta and commonly stylized in Egyptian decorative art. The ornamental form is distinguished by a smooth, convex upper edge, short sepals, and simple radial striations indicating the "filaments" of the actual papyrus plant, as opposed to the large triangular sepals and four-sided, pointed petals of the lotus sylization (cf. figs. 7 and 9). Also see figure 21, where the papyri appear upside down, and figure 22, where they alternate with larger lotus stylizations and buds. *See pp. 53–55, 59, 67–68.*

Pattern — The arrangement of forms in a particular configuration according to variable principles a balance, rhythm, and proportion. Such arrangement may be irregular, it may involve some form of symmetry or symmetrical repetition, or a combination thereof. The notion of pattern is basic to all ornamental composition; as a term it is often used to denote a specific instance or type of ornament. See *Symmetry.*

Petals — the interior portion of the corolla of a flower or blossom. In ancient floral stylizations they are generally pointed (figs. 24–25, 34, 86, and 98) and slightly curled or involuted in the case of the lily (fig. 20). *See pp. 53, 58–59, 62–67, 93, 100, 108, 110, 300–1.*

Phoenician Palmette — An abbreviated version or exerpt of the Phoenician palmette tree, consisting of a single, continuous, upward-curling, convex volute calyx with an internal palmette; see figure 42. *See pp. 97, 100, 102.*

Postulate of Axil Filling — A principle of composition requiring that the angles or interstices produced by convergent curvilinear forms be filled by additional elements of the appropriate configuration. See *Axil, Axil Filler*, and *Horror Vacui. See pp. 64–65, 96, 102, 126, 152, 142, 196, 217, 270.*

Rectilinear Meander (eckige Mäander) — A class of geometric ornament of indeterminate origin, consisting of convoluted straight-edged lines or bands that turn at right angles. A rectilinear variant of the curvilinear meander. Also known as fret or fretwork patterns. Such ornament was current in New Kingdom Egypt, although less popular in the Late Bronze Age Aegean and the ancient Near East. Meander patterns were a leitmotiv of the Iron Age European and Greek Geometric Styles, and remained widespread in later Mediterranean art as well. See figure 66, bottom, and the borders of figures 74–77, 114, 117, 119–20. *See pp. 129, 150, 152.*

Rosette — A floral stylization of western Asiatic origin, consisting of tapered petals with rounded or pointed tips, arranged radially as an approximately circular mass around a central circle or disk, and probably representing a flower as seen from above (fig. 12). This form may occur independently in series as a border pattern or frieze (figs. 34, 38, 43), or it may serve as a subordinate space filler in larger compositions (figs. 24–25). Riegl correctly interpreted the rosette as the "full view" of an open flower seen from above, although it did not, as he maintained, originate in Egypt from the lotus. See *Lotus. See pp. 46, 48, 56–58, 64, 84–85, 93–94, 100, 108–10, 173, 178–79, 276, 279 and passim.*

Running Dog — See *Curvilinear Meander. See pp. 150, 168.*

Sacred Tree (heiliger Baum) — A complex vegetal stylization of combined western Asiatic, Aegean, and Egyptian derivation, consisting of one or more tiers of volute calyces whose curvature may alternate inward and outward, and surmounted by a crowning palmette fan. See *Palmette Tree* and figures 40–41. The later Assyrian variants of this type, emphasized the "trunk" or treelike element of the pattern and often added a surrounding mesh of arcuated band friezes with additional palmettes (figs. 4, 39). *See pp. 47, 92, 94–95, 99–101, 103, 170.*

Sculptural Palmette (plastische Palmette) — A variant term used by Riegl to denote the acanthus half leaf and full acanthus leaf as derivatives or three-dimensional transformations in Classical Greek relief ornament of the two-dimensional palmette. Equivalent to the *Acanthus Palmette*. Also see *Acanthus Half Leaf* and *Full Acanthus Leaf. See pp. 196, 198.*

Sepals — The leafy, roughly triangular elements that comprise the calyx and enclose the petals on the corolla of a flower or blossom. In the Egyptian lotus stylization, they rise to the full height of the petals (figs. 22, 24). On the stylized papyrus, lily, and voluted blossoms of Egyptian art (figs. 20–21, 23, 40), they are much smaller. In Greek art the sepals (or sepalless external petals?) acquire a bulbous lower contour; see figures 73, 86, 105–8. See *Calyx. See pp. 63–64.*

Sheath or *Sheathing (Verhülsung)* — The husklike coverings (vaginal sheaths), which appear along the stems of actual plants, especially preceding a bifurcation or offshoot, and probably inspired the similar use of acanthus half leaves in Classical and later tendril ornament (figs. 113, 121, 129–30, 179). *See pp. 56, 67, 94, 196, 210, 220, 235, 265.*

Spiral Ornament — A class of geometric ornament consisting of interlocking strings or series of cuvilinear lines or bands that periodically curl into approximately circular involuted masses. Such patterns may be arranged as single, longitudinal series or borders (fig. 59), or as larger networks according to omnidirectional axes of symmetry (fig. 60). They may also be further elaborated through the inclusion of floral axil fillers (figs. 25–27, 55–57). *See pp. 72–80, 95–96, 124–132, 250, 266.*

Split Palmette (gesprengte Palmette) — A Classical Greek variant of the full palmette that evolved in the "naturalizing" acanthus ornament of late fifth century. It is distinguished by the sharper, more attenuated and inward-curving configuration of the fronds, but mainly by the division of the palmette fan into two bilaterally symmetrical but distinct halves, each of which appears to "grow" separately from the acanthus half leaves located along two adjacent tendril volutes, below (figs. 110–11). *See pp. 123, 189–90, 195, 210, 213, 217, 219, 224–25, 246, 251, 254–55, 259, 266, 271, 279, 282–83, 295, 301.*

Stylization — The conscious mutation, distortion, simplification, or exaggeration of overall structure or detail in the representation of forms derived from nature. The term may also refer specifically to a given representation of this kind that results from an established and consistent formal approach, as in the case of a "lotus stylization," (figs. 22, 24). See the opposite term, *Naturalizing. See pp. 10, 38–39, 48, 50–51, 56, 59, 65–66, 71, 88, 94, 116, 119, 121, 123, 135, 144, 152, 173, 180, 194, 197–98, 202, 211–12, 217, 223–24, 231, 237, 245, 251–52, 254, 256–57, 260, 263, 271, 282–83, 286, 291, 300–1.*

Symmetry — A mode of composition in which the basic component elements of the pattern are repeated or displaced spatially one or more times about or across an axis. Such motion may involve 120- or 180-degree rotation about a fixed point (rotational and inverse symmetry, fig. 97), reflection across an axis (bilateral and longitudinal symmetry, figs. 121–23, 125), simple forward displacement (translation), or a more complex application of these basic schemes involving multiple repetitions (transverse symmetry, figs. 22, 79; radial symmetry, figs. 34, center, 61), and combinations of the different types (slide reflection, figs. 76, 93; alternating inverse symmetry and reflection, figs. 62, 83–84; and combined translation and longitudinal reflection, fig. 67). Larger patterns may be built up according to omnidirectional repeating axes (all-over inverse symmetry, figs. 55–56; or all-over reflection, fig. 170). *See pp. 6, 9, 32–33, 44, 46–47, 60, 78, 86, 178, 180–86, 210, 231, 289, 305.*

Technical Materialism — See *Artistic Materialism.*

Tendril (Ranke) — The small curling or helical stems by which a vine attaches itself to some stationary prop or support. In Riegl's terminology it denotes any type of stylized vine ornament, particularly those including spiral volutes (figs. 49–50, 76, 83–86, 101–5, 121–22, 125, 129–30). *See pp. 8–9, 11–12, 70, 106, 112–19, 132–33, 135–36, 138, 150–53, 157–58, 162–63, 168–71, 176–88, 190, 196, 207ff., passim.*

Trefoil (Dreiblatt) — A "triple leaf." More generally, any tripartite vegetal stylization arranged as a bilaterally symmetrical, radial, or asymmetrical form. See

Byzantine Trefoil and *Islamic Trefoil*. *See pp*. *119–20, 122, 238, 245–46, 249, 251–52, 264, 266–67, 271–290.*

Two-dimensional Palmette (Flachenpalmette) — See *Palmette*. *See pp*. *195–96, 204, 214, 219–22, 224, 245, 256, 267, 282, 295.*

Undulating Tendril (Wellenranke) — A stylized vinescroll pattern current in Bronze Age Aegean art, rare in Egypt and the ancient Near East, and most common later in Greek, Roman, late antique, and early Islamic art. Its composition approximates wave motion in regularly alternating curvature, usually in extended repetition as a frieze or across larger fields, either in an irregular scheme, or according to strict symmetry. See figures 52–53, 83, 103–4, 121–22, 125, 129–34, 156–59, 165–68. For specific variants see *Intermittent Tendril, Continuous Tendril, Interlacing Tendril, All-over Tendril*, and *Palmette-Tendril*. For purely geometric patterns in an undulatiing configuration see *Curvilinear Meander*. *See pp*. *115–19, 132–33, 136, 150–51, 157–58, 169, 176, 219–20, 222, 227–28, 235, 268–69, 273, 286, 291.*

Vegetal Ornament — A class of decoration consisting of variably stylized renderings of plants or flowers, arranged freely or according to various types of symmetry. This type of ornament includes the majority of works treated in Riegl's study here.

Volute — An element of variable length and width or thickness whose end or ends curl into a spirals or bulbous involutions. The term may apply equally to a floral petal or sepal, a tendril, or abstract spiral elements (figs. 23, 25–27, 41, 76, 78, 104, 125). *See pp*. *62, 87, 91, 97–98, 102, 107–9, 115, 119, 131, 140, 142, 145, 161–63, 263, 281–83, 289, 297–98 and* passim.

Volute-Calyx — A floral or vegetal stylization, probably of mixed ancient Egyptian, Aegean, and Syrian origin, consisting of two adjacent and divergent volutes, the angle or axil between which may be filled by additional floral forms: simple conical elements, palmette fans, triangular elements approximating the form of the palmette, or still other volutes. In its earlier form the volutes are broad or petal-like (figs. 16, 19, 21, 23, 33, 40–41). In Greek and later art, the volutes become more attenuated or tendril-like, often functioning as part of a tendril pattern (figs. 66–67, 81, 101, 107, 109–10). Since Riegl considered the volute calyx an essential component of the overall palmette motif (see *Lotus-Palmette*), he sometimes referred to volute-calyces without any palmettes as "fanless" (*fächerlos*) palmettes (e.g., those on the trunk of the sacred tree pattern in fig. 39). *See pp*. *62–67, 80, 91, 97–100, 104, 107–9, 115, 123, 142, 146, 163, 174, 176, 188–90, 196, 223, 232–33, 245–46, 249, 251, 254, 263, 289–90, 293, 297.*